American Art
in
the 20th Century

Patrons of the Exhibition

Her Majesty The Queen

Dr Richard von Weizsäcker
President of the Federal Republic of Germany

William J. Clinton
President of the United States of America

Advisory Committee

Felix Baumann
Walter Hopps
Richard Koshalek
Thomas Krens
William S. Lieberman
Franz Meyer
David Ross
Katharina Schmidt
Wieland Schmied
Nicholas Serota

American Art
in
the 20th Century

Painting and Sculpture
1913–1993

Edited by

Christos M. Joachimides and Norman Rosenthal

Co-ordinating Editor

David Anfam

Essays by

Brooks Adams, David Anfam, Richard Armstrong, John Beardsley,
Neal Benezra, Achille Bonito Oliva, Arthur C. Danto, Abraham A. Davidson,
Wolfgang Max Faust, Mary Emma Harris, Christos M. Joachimides,
Thomas Kellein, Donald Kuspit, Mary Lublin,
Karal Ann Marling, Barbara Moore, Francis V. O'Connor,
Stephen Polcari, Carter Ratcliff, Norman Rosenthal,
Irving Sandler, Wieland Schmied, Peter Selz,
Gail Stavitsky and Douglas Tallack

Prestel

This is the fourth volume to appear in conjunction with the series
of exhibitions of twentieth-century art shown at the Royal Academy of Arts,
London. Already published:

German Art in the 20th Century: Painting and Sculpture 1905–1985 (1985)
British Art in the 20th Century: The Modern Movement (1987)
Italian Art in the 20th Century: Painting and Sculpture 1900–1988 (1989)

First published on the occasion of the exhibition
'American Art in the 20th Century: Painting and Sculpture 1913–1993',
held at the Martin-Gropius-Bau, Berlin, 8 May–25 July 1993, and the
Royal Academy of Arts and the Saatchi Gallery, London,
16 September–12 December 1993.

Exhibition organized by Christos M. Joachimides and Norman Rosenthal.

Cover illustration: Robert Rauschenberg, *Canyon*, 1959 (detail, Cat. 137)

Translation from the German: David Britt (Christos M. Joachimides), John Brownjohn (Thomas Kellein),
John William Gabriel (Wieland Schmied) and John Ormrod (Wolfgang Max Faust)
Translation from the Italian: Joachim Neugroschel (Achille Bonito Oliva)
Picture research: Elisabeth Hartung

Prestel-Verlag, Mandlstrasse 26, D-80802 Munich, Germany
Tel. (89) 38 17 09 0; Fax (89) 38 17 09 35

Distributed in Continental Europe by Prestel-Verlag
Verlegerdienst München GmbH & Co. KG
Gutenbergstrasse 1, D-82205 Gilching, Germany
Tel. (8105) 38 81 17; Fax (8105) 38 81 00

Distributed in the USA and Canada on behalf of Prestel by te Neues Publishing Company,
16 West 22nd Street, New York, NY 10010, USA
Tel. (212) 6 27 90 90; Fax (212) 6 27 95 11

Distributed in Japan on behalf of Prestel by YOHAN Western Publications
Distribution Agency, 14-9 Okubo 3-chomo, Shinjuku-ku, J-Tokyo 169
Tel. (3) 32 08 01 81; Fax (3) 32 09 02 88

Distributed in the United Kingdom, Ireland and all remaining countries on behalf of Prestel by
Thames & Hudson Ltd., 30-34 Bloomsbury Street, London WC1B3QP, England
Tel. (71) 6 36 54 88; Fax (71) 6 36 16 59

Cover designed by Nicolaus Ott + Bernard Stein
Typeset by Gerber Satz GmbH, Munich
Offset lithography by VSO Merk & Steitz, Villingen-Schwenningen
Printed by Appl, Wemding
Bound by MIB Conzella, Aschheim

Printed in Germany
ISBN 3-7913-1261-8 (English edition) · ISBN 3-7913-1240-5 (German edition)

Contents

Lenders to the Exhibition

Amsterdam, Stedelijk Museum
Baltimore, The Baltimore Museum of Art
Basle, Öffentliche Kunstsammlung Basel, Kunstmuseum
Berne, Kunstmuseum Bern
Bloomington, Indiana University Art Museum
Boston, Museum of Fine Arts
Budapest, Múzeum Ludwig
Buffalo, NY, Albright-Knox Art Gallery
Cambridge, MA, Fogg Art Museum, Harvard University Art Museums
Chicago, The Art Institute of Chicago
Chicago, Museum of Contemporary Art
Cologne, Museum Ludwig
Dallas, Dallas Museum of Art
Des Moines, IA, Des Moines Art Center
Detroit, The Detroit Institute of Arts
Düsseldorf, Kunstsammlung Nordrhein-Westfalen
Eindhoven, The Netherlands, Stedelijk Van Abbemuseum
Fort Worth, TX, Modern Art Museum of Fort Worth
Houston, The Menil Collection
Humlebaek, Denmark, Louisiana Museum of Modern Art
Iowa City, The University of Iowa Museum of Art
Lincoln, NE, Sheldon Memorial Art Gallery, University of Nebraska
London, Tate Gallery
Los Angeles, The Museum of Contemporary Art
Madrid, Thyssen-Bornemisza Collection
Minneapolis, Walker Art Center
Newark, The Newark Museum
New Haven, Beinecke Rare Book and Manuscript Library, Yale University
New Haven, Yale University Art Gallery
New York, The Brooklyn Museum
New York, Solomon R.Guggenheim Museum
New York, The Metropolitan Museum of Art
New York, Whitney Museum of American Art
Norfolk, VA, The Chrysler Museum
Pully/Lausanne, FAE Musée d'Art Contemporain
Oberlin, OH, Allen Memorial Art Museum, Oberlin College
Otterlo, The Netherlands, Rijksmuseum Kröller-Müller

Pittsburgh, The Carnegie Museum of Art
Rotterdam, Museum Boymans-van Beuningen
St. Louis, The Saint Louis Art Museum
San Diego, Museum of Contemporary Art
San Francisco, San Francisco Museum of Modern Art
Schaffhausen, Hallen für neue Kunst
Seattle, Seattle Art Museum
Ulm, Ulmer Museum
Utica, NY, Munson-Williams-Proctor Institute, Museum of Art
Washington, DC, Hirshhorn Museum and Sculpture Garden, Smithsonian Institution
Washington, DC, National Gallery of Art
Washington, DC, The Phillips Collection
Wichita, KS, Wichita Art Museum
Youngstown, OH, The Butler Institute of American Art
Zurich, Kunsthaus Zürich

Courtesy Thomas Ammann Fine Art, Zurich
Galerie Bruno Bishofberger, Zurich
Courtesy Galerie Bruno Bishofberger, Zurich
Courtesy Marc Blondeau, Paris
Collection Irma und Norman Braman
Eli and Edythe L. Broad Collection
Eli Broad Family Foundation, Santa Monica, California
Collection Leo Castelli, New York
Cohen Gallery, New York
Paula Cooper, New York
Douglas S. Cramer
Andrew J. Crispo Collection, New York
Stefan T. Edlis Collection
Collection of the Mr and Mrs Barney A. Ebsworth Foundation, St. Louis
Mrs Jack M. Farris
Richard L. Feigen, New York
Collection FRAC de Bourgogne, Dijon
Fröhlich Collection, Stuttgart
JW Froehlich UK, Ltd
Galerie 1900 △ 2000, Paris
Collection of Mrs Victor W. Ganz
Courtesy Barbara Gladstone Gallery, New York
Mr and Mrs Ronald Greenberg, St. Louis
Galerie Karsten Greve, Cologne and Paris
Gabriele Henkel Collection, courtesy Hans Strelow, Düsseldorf
The Estate of Eva Hesse and courtesy Robert Miller Gallery, New York

Audrey and Sidney Irmas, Los Angeles
Jedermann Collection, N.A.
Dakis Joannou, Athens
Jasper Johns
Ellsworth Kelly
Courtesy Galerie Rudolf Kicken, Cologne, and Galerie Alain Paviot, Paris
Collection of Jon and Barbara Landau
Collection of Richard E. Lang, Jane M. Davis, Medina, WA
Galerie m, Bochum, and Richard Serra
Collection M. and Mme Adrien Maeght, Paris
Collection Loic Malle, Paris
Lewis and Susan Manilow
Brice Marden, courtesy Matthew Marks Gallery, New York
The Margulies Family Collection
Courtesy of Marlborough Gallery, New York
Marlborough International Fine Art
Marx Collection, Berlin
Galerie Hans Mayer, Düsseldorf
Galerie Marion Meyer, Paris
Adriana and Robert Mnuchin
Honoria Donnelly Murphy, courtesy Salander-O'Reilly Galleries, Inc., New York
Patsy R. and Raymond D. Nasher, Dallas
Muriel Kallis Newman
Onnasch Collection, Berlin
The Pace Gallery, New York
Ron and Ann Pizzuti
Richard and Lois Plehn, New York
Collection of Kate Rothko Prizel
Regis Corporation, Minneapolis, Minnesota
Collection of Christopher Rothko
Saatchi Collection, London
Seibu Department Stores, Ltd, Tokyo
Sonnabend Collection, New York
Southwestern Bell Corporation, San Antonio, TX
Mr Hiroshi Teshigahara
Lucien Treillard
S. and J. Vandermolen
Collection Ronny Van de Velde, Antwerp
Galerie Michael Werner, Cologne and New York
Mr and Mrs Bagley Wright
Donald Young Gallery, Seattle

and lenders who wish to remain anonymous

Foreword

'American Art in the 20th Century' is the fourth exhibition in a series initiated by the Royal Academy of Arts which has attempted to survey the most important artistic developments of this century country by country. The series began in 1985 with 'German Art in the 20th Century', followed two years later by 'British Art in the 20th Century' and, in 1989, by 'Italian Art in the 20th Century'.

The exhibition of American art has been organized jointly by the Royal Academy of Arts and the Zeitgeist-Gesellschaft in Berlin, where it was seen earlier this year at the Martin-Gropius-Bau. It has been selected by Norman Rosenthal, Exhibitions Secretary of the Royal Academy, and Christos M. Joachimides, Secretary General of the Zeitgeist-Gesellschaft. 'American Art in the 20th Century' differs from the previous surveys in two significant ways. First, it has not been selected by experts from the country in question, but rather is presented from a European point of view. Secondly, this exhibition highlights art created between 1945 and 1970, while its predecessors were weighted towards the first decades of the century. It can be said with little fear of contradiction that, during those twenty-five years, American art was the driving force behind many, if not most, developments in art throughout the world. Our aim has been to present the essence of America's contribution to the visual arts.

We are deeply honoured that Her Majesty The Queen, Dr Richard von Weizsäcker, President of the Federal Republic of Germany, and Mr William J. Clinton, President of the United States of America, have graciously accepted to act as Patrons of the exhibition.

It was clear from the outset that the galleries of the Royal Academy were never going to be large enough to represent adequately all the artists we might have wished to include, many of whose works make very particular spatial demands. So we are especially grateful to Charles Saatchi, who has made his Gallery in Boundary Road available to us. For years it has been among the finest spaces in London for showing contemporary trends in art and has an international reputation of the highest calibre. We trust that visitors to the Royal Academy will not fail to make the journey to the Saatchi Gallery to complete their impression of this ambitious exhibition.

We are greatly indebted to Merrill Lynch, whose generous contribution has allowed us to go ahead with this project. We are also most grateful for the support of *The Daily Telegraph*, whose enthusiastic commitment has given us much encouragement. American Airlines have provided valuable help in kind with transport costs.

We have benefited greatly from the expertise, advice and constructive suggestions of a disinguished Advisory Committee.

Our greatest thanks, however, are owed to the lenders, both public institutions and private collectors on both sides of the Atlantic, in Japan and Australia, who have generously agreed to part with so many outstanding works of art for the duration of the exhibition. We would particularly like to mention Mary Keough Lyman and her colleagues at the University of Iowa Museum of Art, who have enabled Jackson Pollock's *Mural* of 1943 to be shown in Great Britain for the first time.

We are grateful to David Anfam who, together with Gerti Fietzek, has contributed profound knowledge of the subject to the editing of this catalogue.

Close and constant collaboration between the Royal Academy and the Zeitgeist-Gesellschaft has enabled us to bring together the exhibition and we wish to thank members of the staff of both institutions, without whose unceasing work and unhesitating commitment it would have been impossible to realize this enterprise.

Sir Roger de Grey KCVO
President, Royal Academy of Arts

Acknowledgments

The Royal Academy and the Zeitgeist-Gesellschaft wish to extend their warmest thanks to the following: H. E. The Honorable Raymond G. H. Seitz, Ambassador of the United States of America, William Acquavella, the late Thomas Ammann, Richard Armstrong, Heiner Bastian, Douglas Baxter, Neal Benezra, Drusilla Beyfus, Irving Blum, Jenny Blyth, the late Dominique Bozo, Marie-Puck Broodthaers, Leo Castelli, Betty Churcher, Michel Cohen, James Corcoran, Jack Cowart, Philippe Daverio, Susan Davidson, Jeffrey Deitch, James Demetrion, Lisa Dennison, Anthony d'Offay, Andrew Fabricant, Richard L. Feigen, Agnes Fielding, Konrad Fischer, Marcel Fleiss, Robert H. Frankel, Rudi Fuchs, Stephen Gangstead, Kate Ganz, Ivan Gaskell, Barbara Gladstone, Arnold B. Glimcher, Michael Govan, Jan and Ronald Greenberg, Karsten Greve, Anne d'Harnoncourt, Steven Harvey, Antonio Homem, Barbara Jakobson, Hugues Joffre, Jasper Johns, Piet de Jonge, Bill Katz, Tetsuo Kawai, Ellsworth Kelly, Christian Klemm, John R. Lane, Tomas Llorens, Jörg Ludwig, Edward McBride, Loic Malle, Jan van der Marck, Brice Marden, Matthew Marks, Silvia Menzel, Jörn Merkert, Samuel Miller, Lucy Mitchell-Innes, Charles Moffett, Anne F. Moore, Adriana and Robert Mnuchin, Francis Naumann, Sasha Newman, Ute and Reinhard Onnasch, Lord Palumbo, Count Giuseppe Panza di Biumo, Edmund Pillsbury, Earl A. Powell III, Marla Price, Stephen Prokopoff, Emily and the late Joseph Pulitzer, Peter Raue, Urs Raussmüller, Barry Rosen, Mark Rosenthal, Lawrence Rubin, Jennifer Russell, Charles Saatchi, Douglas Schultz, Ileana Sonnabend, Theodore Stebbins, Jr, Hans Strelow, Jeremy Strick, Charles Stuckey, David Sylvester, Sarah Taggart, Alain Tarica, Lucien Treillard, Samuel L. Trower, Maurice Tuchman, Paul Winkler, Daniel Wolf, Charles Wright, Heribert Wuttke, Donald Young, Louis A. Zona.

Exhibition Executive Committee

Sir Roger de Grey, President, Royal Academy of Arts
Allen Jones, RA, Chairman, Royal Academy Exhibitions Committee
Piers Rodgers, Secretary, Royal Academy of Arts
Norman Rosenthal, Exhibitions Secretary, Royal Academy of Arts
Christos M. Joachimides, Secretary General, Zeitgeist-Gesellschaft
Simonetta Fraquelli, Curatorial Assistant, Royal Academy of Arts
Ruth Seabrook, Sponsorship Manager, Royal Academy of Arts
Katherine Jones, Press Officer, Royal Academy of Arts
Claudia J. Kahn, Vice President, Corporate Public Relations Services,
 Merrill Lynch & Co., Inc.
Richard Spiegelberg, Executive Director of Corporate Communications,
 Merrill Lynch Europe Limited
Nigel Horne, Editor, Telegraph Magazine
Michèle Marcus, PR Consultant, The Daily Telegraph
Kim Medhurst, Manager, Marketing Services UK and Ireland, American Airlines

Secretary to the Committee: Annette Bradshaw

Exhibition Organization

London: Simonettta Fraquelli, Curatorial Assistant
 Susan Thompson, Administrator
Berlin: Tina Aujesky, Administrator
 Karin Osbahr, Curatorial Assistant
 Thomas Büsch, Project Co-ordinator
 Jeanne Greenberg, Exhibition Assistant (New York)

Christos M. Joachimides

Wrenching America's Impulse into Art
Notes on Art in the USA

> These things
> astonish me beyond words.
> William Carlos Williams

> Art is produced by a succession of individuals expressing
> themselves; it is not a question of progress.
> Marcel Duchamp

'American Art in the 20th Century' is an exhibition devised from a European view-point, based on an understanding of art and history that has taken shape on this side of the Atlantic. It is a view through a telescope: perception is concentrated on essentials, and the result is not a broad panorama but a critical focus. At the same time, it is a retrospect – an attempt to learn lessons, to take up positions, to make value judgments, from the vantage-point of the end of the century.

Rather than to establish a consensus or to achieve encyclopaedic completeness, this exhibition seeks to open a debate on the way in which the art of the USA has helped to define both the appearance and the intellectual history of art in our century. In European art all the major innovative achievements – Cubism, Expressionism, Fauvism, Suprematism, Dada, and on to Surrealism – belong to the opening decades of the century; the evolution of American art has followed a reverse pattern. First there was a lengthy period of incubation and exploration, marked by a number of outstanding artistic personalities: from Man Ray and Georgia O'Keeffe, by way of Edward Hopper, to Alexander Calder and Joseph Cornell. Then, in New York in the mid-1940s, there emerged a generation of artists who radically expanded and transformed prevailing ideas of art. New York now became the focus of artistic production and artistic debate, and very soon it had taken over from Paris, which had been the uncontested centre of the art world since the eighteenth century. In a rapid succession of creative explosions – Abstract Expressionism, Neo-Dada, Pop Art, New Abstraction, Minimal Art, Antiform, Conceptual Art – the art of the USA dominated the international art debate for a quarter of a century, until well into the 1970s. It is developments in American art during that quarter of a century that define its essential contribution to the art of our time.

*

Even before Marcel Duchamp actually arrived in New York in 1915, bought a snow-shovel in a hardware store and wrote on it 'In Advance of the Broken Arm' (Cat. 18), he was already at the centre of discussion there about the avant-garde. The enormous impact – not to say scandal – created at the 1913 Armory Show by his painting *Nude Descending a Staircase* (1912; Fig. 3, p. 40) marks the onset of a personal influence on the evolution of American art, an active partisanship and orchestration of manifestations and activities, that is without parallel in the entire history of modernism.

The Armory Show kindled the first public discourse on modernism in the USA. A sizeable group of both American and European artists organized the exhibition, but its legendary significance stems wholly from its European section, which was a survey of the epoch-making creative developments in art since Impressionism. The turn-of-the-century avant-garde was represented in force, by Henri Matisse and Pablo Picasso, Constantin Brancusi and Wilhelm Lehmbruck, Wassily Kandinsky and Francis Picabia – and, not least, by Duchamp.

Duchamp's first encounter with Man Ray, directly after his arrival in New York, was to lead to a unique and lifelong artistic friendship and creative collaboration. In New York in 1920, together with Katherine S. Dreier and Man Ray, Duchamp founded the *Société Anonyme*, in effect the first museum of modern art in the USA.

From his first ready-mades (1915), by way of *The Large Glass* (1915–23; Fig. 2, p. 27), to *Etant donnés* (1946-66), and to the introduction of language as a formal and expressive resource of visual art, Duchamp left his mark on American art as no other artist of this century has done, and at the same time radically changed the conception of what art can be. As Craig Adcock has put it: 'The pluralistic art of the present day, which is characterized by strategies of appropriation and an "anything goes" attitude, would be unthinkable without Duchamp's example.'

*

The more closely we engage with American art, the more clearly we perceive the polarity that exists within it, both in attitudes to art and in their concrete manifestation in the work of art. The two faces of a Janus – two phenomena that are fundamental to our understanding of America and also to America's understanding of itself – are reflected and formulated in American art of this century.

One of the poles can be described as an inward longing for the transcendental: this is what Barnett Newman described as 'the abstract sublime'. It is a longing that finds its earliest artistic expression in landscape. The landscape paintings of the 1850s and 1860s by Frederic E. Church and Albert Bierstadt are surprising in their evocative power; the formal counterpart of this power lies in the artists' use of large, mostly horizontal formats. These imposing landscape paintings reflect the experience of an untouched vastness that acts as a metaphor – a parable, even – for an overwhelming cosmos, as overwhelming as the real landscape itself must have been to the earliest settlers. The ideological impact of these paintings is echoed in the title of an exhibition shown at The Metropolitan Museum of Art in New York some years ago: 'American Paradise'. In the early twentieth century this pole of the American experience is best represented by the formal language of the sublime in the work of Georgia O'Keeffe.

In altered form, this concern with landscape played a part within the radical change to abstraction that took place in the 1940s. In the large canvases of Jackson Pollock, and later in the powerful landscape abstractions of Clyfford Still, it acquires a heroic, pagan dimension. At the same time, the sublime, transcendental element resounds through the colour fields of Mark Rothko; it is invoked in the stringent austerity of Newman and, with yet greater rigour, in the 'Black' paintings of Ad Reinhardt. Here, too, the message is compellingly reinforced by the use of a large-sized canvas. Gradually, abstraction freed itself from the materiality of the painting and turned into an immaterial projection, a light-filled space – as, for instance, in the work of James Turrell. This marks the conclusion, so far, of a process that has run through American art since Church, disclosing – in a variety of idioms – the heritage of European Romanticism.

The other face of Janus shows itself in the reality of the big city, the dirt on the streets, Coca-Cola and Marlboro, pulp literature and sex – 'popular culture' – or, equally, in the isolation of human beings in the metropolis, as so tellingly captured in the paintings of Hopper. Catastrophes and disasters, suicides and raw violence among the skyscrapers form the opposite pole to the metaphor of landscape as Elysium. The outstanding representatives of this early polarization are, respectively, Hopper and O'Keeffe.

A minute observation of technological civilization and of the work of industry, and a coolly hyperbolic presentation of objects of use and consumption, marked the works of the realists of the 1920s. However, it was not until the 1950s that this second pole of American art fully came into its own, when Robert Rauschenberg and Jasper Johns took a far more painterly approach, which had developed out of the Abstract Expressionist experience, and united it with elements drawn from the everyday environment to create highly personal codes and symbols of urban culture.

From the early 1960s onwards, with Pop Art, artists such as Roy Lichtenstein and Andy Warhol took up the theme of city life, along with the fetishized common object, advertising and comic strips – a second-hand reality with which they also confronted themes of war and violence. Their strategy, that of a distanced appropriation of reality, has remained in use to this day, with an added extreme of analytical detachment – the impartiality of the chronicler – in the works of, for example, Jeff Koons and Mike Kelley.

The longing for an abstract apotheosis of reality, and the urge to dissect and appropriate it, are the two faces of Janus. Nor are these restricted to visual art. Parallel versions of the same polarity are to be found in American literature, with Walt Whitman's hymns to nature at one extreme and Williams S. Burroughs's raw delineations of outcasts and casualties at the other.

*

It is one of the purposes of this exhibition to tell the story of American art as a history of innovations. The selection concentrates on the moment at which the artist invents something essentially new, or at which he succeeds in a specific act of concentration that endows a work with exemplary character. For instance, we do not show Man Ray as one of the Paris Surrealists, but with his pioneering works of the second decade of the century, when, with Picabia and Duchamp, he initiated New York Dada.

I Saw the Figure 5 in Gold by Charles Demuth (Cat. 45), *Razor* or *Villa America* by Gerald Murphy (Cat. 42, 43) and *Odol* or *Lucky Strike* by Stuart Davis (Cat. 49, 50) are 'icons' of the 1920s, simultaneously magical and precise; they evoke an American reality that is emblematic in the extreme. The New York cityscapes of O'Keeffe and Hopper, metaphors of isolation from the same period, complete an 'American Image of Life' that first crystallized at an early stage in American art of this century. Alexander Calder and Joseph Cornell are represented largely by their works of the 1930s, which bear witness to an original, creative dialogue with European Surrealism. We present the first stirrings of Abstract Expressionism in 1943, in such works as Arshile Gorky's *Waterfall* (Cat. 81) and Pollock's *Mural* and *Guardians of the Secret* (Cat. 86, 87), which mark the decisive breakthrough to a new language of expression. Willem de Kooning and Barnett Newman are also represented by works of the 1940s, the moment when each found his own unmistakable style (see Cat. 95, 107). Almost all the other works that give voice to this historic upheaval stem from the 1950s, the decade in which Still, Rothko, Reinhardt, Franz Kline and Sam Francis decisively set their mark on the image of Abstract Expressionism.

Again, the great shift that infused new substance into American art's dialogue with reality is captured at the moment of its genesis: in the 1950s. The early works of Robert Rauschenberg, *Untitled (Red Painting)* or *Pink Door* (Cat. 135, 136), like Jasper Johns's *Target* and *White Numbers* (Cat. 146, 147), combine subjective painterliness with objects from daily life (a door, a window frame, a clock, a cup, a chair). This combination introduces a new experience of reality, based on the Dadaist collage principle, conveyed through a highly personal artistic language of great evocative force.

The 1950s brought a number of different answers to Action Painting: for example, that of Cy Twombly, with his unique sign language of scripts from a journal of the imagination, of ciphers that encode a poetic cosmos, as in *Free Wheeler* (Cat. 142); and that of the new, radical abstraction in Ellsworth Kelly's *Black, Two Whites* and *White, Two Blacks* (Cat. 130, 131) or Frank Stella's *'Die Fahne Hoch!'* and *Marriage of Reason and Squalor* (Cat. 153, 155).

A decisive turning-point in the evolution of the American attitude to art came at the onset of the 1960s, with the emergence of Pop Art, an art that makes its comments on everyday events and experiences with a cool detachment and an ostensibly impersonal imagery marked by an alienating appropriation of the formal principles of commercial design. Here, again, we have tried to capture the way it all began, through works by Claes Oldenburg, Roy Lichtenstein, Andy Warhol and Richard Artschwager, almost every one of which dates from this early period.

From the same decade, we show two different artistic approaches at the moment of their first appearance: the sculptures of Minimal Art, in which Donald Judd, Carl Andre and Dan Flavin were developing an art that took over and redefined space, and the work of such artists as Eva Hesse, Richard Serra and Bruce Nauman, who worked with the spontaneous, unmediated human reaction to materials, objects and visions and put their own existential experiences into new, radical forms of sculpture. In presenting developments since the late 1970s we have, once again, attempted to pinpoint the moment of their genesis. In fact, the guiding principle behind this exhibition has, throughout, been to trace the artistic process to its inception.

Norman Rosenthal

American Art: A View From Europe

> Max Ernst, around 1950, speaking at the Arts Club on Eighth Street in New York City said that significant changes in the arts formerly occurred every three hundred years whereas now they take place every twenty minutes.
>
> John Cage[1]

The evidence lies in the paintings and sculptures produced in America during this century: 1943 was the year of parthenogenesis. In a way it was a response to the works of the European artists in America, many of them refugees, who appeared to be threatening to take over the New York art world. They were on show at Peggy Guggenheim's Art of This Century Gallery at the end of 1942 – Picasso, Max Ernst, Piet Mondrian, Marcel Duchamp, Giorgio de Chirico, Joan Miró, Kasimir Malevich, Alexander Archipenko, Alberto Giacometti, Paul Klee, Jacques Lipchitz, Amédée Ozenfant, Yves Tanguy, Ben Nicholson. The exhibition excluded Americans, with the exception of the virtually honorary European, Alexander Calder. There were other big names in New York at the time: Salvador Dalí, Fernand Léger, André Masson, Roberto Matta and, above all, André Breton, the high priest of Surrealist orthodoxy. With the exception of Matta, they generally kept to themselves, partly for linguistic reasons and partly because they regarded most American artists as provincial cousins.

American art had had many previous injections from Europe, most famously the 1913 Armory Show, but America in 1943 still felt like a young country in every cultural sense; ambitious certainly, but deeply conscious of its provinciality and, in the case of artists like Thomas Hart Benton and Grant Wood, defiantly so. The possibilities opened up by the Armory Show were immediately curtailed by the First World War, but a major impact was made in the person of Duchamp. He invented himself as a significant cultural figure by sending *Nude Descending a Staircase* (Fig. 3, p. 40) from Paris, where it had been a little-noticed, marginal Cubo-Futurist work, to New York, where it became the modernist painting *par excellence*. Ultimately, beyond the bringing of news from Europe to New York in the form of work by Van Gogh, Cézanne, Picasso and Matisse, all of whom were avidly acquired by the discerning collectors, little attention was paid to indigenous artists.

Alfred Stieglitz, a photographer, working in a field in which America had always been highly innovative, even extraordinary, and in which it could effortlessly hold its own with its transatlantic counterparts, for a short time ran a gallery called 291 that showed such painters as Arthur Dove, Marsden Hartley, John Marin and, above all, Georgia O'Keeffe (see Cat. 1–3, 33–41). But artists like these had few outlets in New York, and none at all in Europe, where reputations had to be made. Only Man Ray and Calder were to integrate themselves successfully into the contemporary European art world, the hierarchy of which in the 1920s was largely determined on the Boulevard Montparnasse in Paris. In 1928 the *New York Times* announced, presumably having received the press release from Stieglitz himself: 'Artist who paints for love, gets $25,000 for six panels.' It was referring to six flower paintings by O'Keeffe, apparently bought by a French collector. It was not until 1991 that this purchase, involving 'the biggest sum ever paid for so small a group of modern paintings by a present day American', was revealed as a hoax on Stieglitz's part to encourage the sale of further works by the artist.[2] O'Keeffe's work at its best might have found a proper place in the European consciousness of art; as it is, even today there are practically no works by her or her contemporaries – Dove, Stuart Davis, Charles Demuth,

1 *A Year from Monday*, London, 1968, p. 30.
2 See Benita Eisler, *O'Keeffe and Stieglitz: An American Romance*, New York, 1991, p. 370.

Charles Sheeler (see Cat. 44–54) – in the leading museums and collections in Europe. The career of John Covert, whose few surviving works show him to have been at least as imaginative an artist as the far more famous Dove, is perhaps a paradigm of the situation in America in the first decades of this century. After a few years' involvement in the circle of Duchamp, Man Ray and New York Dada, Covert abandoned art in 1923 to become a travelling salesman in California, where he died in obscurity in 1960.

After Stieglitz, the next heroic attempt to invent an American art was made by Franklin D. Roosevelt's government as part of its New Deal policy in response to the Depression. The WPA (Works Progress Administration) was established to patronize artists – hundreds of them – by providing them with commissions for, among other things, murals in schools, aerodromes, post offices, railway stations and any number of other public buildings. When, in 1942, the United States entered the war, Roosevelt gave the WPA, in his own words, 'an honorable discharge'. Many of the murals were covered up and thousands of easel paintings were removed from public institutions, many to be destroyed. Most were paintings that illustrated aspects of the American way of life, though abstract works had also been commissioned. It was an extraordinary episode in the history of American art – the United States potentially imitating the early years of Russian Soviet society but, alas, there was no Malevich or El Lissitzky, no sense of innovation except in the field of photography, ultimately the lasting and most worthwhile legacy of the WPA.

By the end of 1942 the predicament of art in America must have seemed desperate. Europe was destroyed, and artistically exhausted, yet the 'degenerate' artists from that continent were arrogantly asserting their moral and artistic superiority in the United States. It just happened that it was at this very moment, just when all seemed lost, that Jackson Pollock produced his first real masterpieces, destined to reopen the territory of Western art. In 1943 he created such epoch-making paintings as *The She-Wolf* (Fig. 1), *Pasiphaë* (Metropolitan Museum of Art, New York), *Guardians of the Secret* (Cat. 87) and *Mural* (Cat. 86) – works that were to suggest endless possibilities for the language of the visual arts, as he himself undoubtedly believed they would. These amazing pictures, beautiful in their aggressive crudity; at once primitive and culturally highly informed, with their totemic references to Egyptian, Roman and American Indian cultures; heavily encrusted like a Byzantine iconostasis, were unlike anything seen in painting since Picasso's *Desmoiselles d'Avignon* of 1907 (in New York's Museum of Modern art since 1934), and the great 1913 compositions of Wassily Kandinsky, on show in New York at Solomon Guggenheim's Museum of Non-Objective Painting, where Pollock had worked for a short time as a security guard.

These works by the American went beyond the innovations of Picasso and Kandinsky in a very profound sense. If Picasso fractured the figure, making it visible from a number of different viewpoints, and Kandinsky attempted in a utopian manner to enter the spirit, Pollock contrived with his painting to get under his own skin, inside his own brain, and attempted to describe his own personal and cultural anguish, even

Fig. 1 Jackson Pollock, *The She-Wolf*, 1943. The Museum of Modern Art, New York; Purchase, 82.44

Fig. 2 Roberto Matta, *Invasion of the Night*, 1941. San Francisco Museum of Art; Bequest of Jacqueline-Marie Onslow Ford

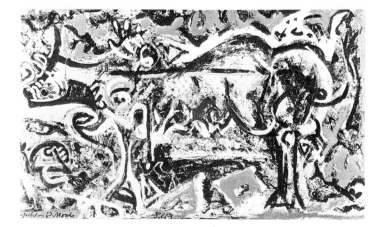

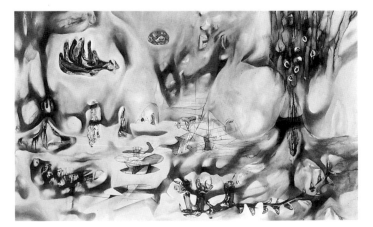

to celebrate a personal abyss in a way that art since the Renaissance had, in its search to describe the outside world, consciously avoided. Frank O'Hara, the New York poet of the 1950s who was also a curator at The Museum of Modern Art and the friend of countless American artists, describes Pollock's interest in the myth of Romulus and Remus – the birth of Rome, perhaps a metaphor for New York, and the feasting that Romulus established there 'in honor of the god Consus, held in great secrecy to which were borne kidnapped virgins. It is these festivals, perhaps, that *Guardians of the Secret* is celebrating, a painting which is a marvel of spatial confinement and passionate formalism, formalism brought to the point of Expressionistic defensiveness.'[3] *Mural*, Pollock's largest canvas, painted for Peggy Guggenheim's apartment in one frenzied night after months of staring at the empty canvas, was interpreted by O'Hara as 'the bacchanalian festival attending this resolution, imbued as it is with the abstract ardor of the images in the other paintings of this group'.[4] But *Mural* can equally convincingly be read as an endless, wide-screened forest of Indian totem poles or a heavy stampede of buffalo driving across the plains of middle America. No painting ever created in America could compare with it in raw energy. As has been noted, it is the veritable *Rite of Spring* of American art,[5] even if at that time there was no public audience either to cheer it on or to drown it in catcalls. But Pollock's peer group – Willem de Kooning, Arshile Gorky, Robert Motherwell, Barnett Newman, Mark Rothko, Clyfford Still and the others – knew, and they could do nothing but accept the challenge of the painting itself. It was too large by eight inches to fit into Peggy Guggenheim's apartment; under Duchamp's supervision eight inches were cut off one end, and shortly after the war the work was given to the University of Iowa Art Museum, far from the madding art crowd.

From 1943 through to the early 1950s the Action Painters, as they were christened by Harold Rosenberg, or Abstract Expressionists, as they were called by Clement Greenberg, each in his own way and at his own pace made a significant contribution to the reinvention of the contemporary language of art. Without a trace of irony, except perhaps in the case of de Kooning, and responding in no small part to the political realities of the time – the War, the Holocaust in Europe, the apparent threat of imminent world destruction by the atomic bomb, the conservative reaction in America (McCarthy), even the intensified hurly-burly of city life – each retreated into a hermetic stylistic cosmos to make a statement of his own in painting about this new world. At this time any sense of banality in art was rejected; in the cases of Pollock and Rothko art was so deadly serious that it led ultimately to more or less premeditated self-destruction. By 1952 Still, whose paintings became translations of the sublimity of American space into abstract forms – rocky landscapes, with metamorphic forms created as if by a prehistoric race of giants – was able to write how 'we are now committed to an unqualified act not illustrating outworn myths or contemporary alibis. Each must accept total responsibility for what he executes'.[6] This was the achievement of each of the abstract painters. Ad Reinhardt, who, with his black square paintings of the late 1950s and their conscious reference to Malevich and Suprematism, arrived at what he termed 'timeless' art (see Cat. 125), had in 1943 already anticipated 'painting that is not illustration, not pictures of fat men with big cigars [a premonition of the late Philip Guston] or pictures at all. An artist said: a painter is not a man in love with scenery, but a man in love with painting.'[7]

A formalist interpretation of the painting of this time is not helpful. Each artist had his own agenda, or rather subject-matter. Rothko arrived at his mature style around 1949–50 with his translucent veils of thinly applied colour suggestive of quite specific cosmic experiences that relate both to dissolution and death but which none the less require from the viewer a conscious empathetic effort to complete the effect (see Cat. 113–18). Not for nothing were his final cycles of paintings – for example, those for the Seagram Building, New York, and in the Rothko Chapel in Houston – conceived as meditative environments in which the beholder must first lose and then rediscover him- or herself. Rothko's paintings, like those of Newman, are quasi-religious experiences, yet always relevant to his time. The titles of Newman's own paintings – *Onement, Cathedra, Shimmer Bright, The Promise, Outcry* and, finally, *Stations of*

3 O'Hara, *Jackson Pollock*, New York, 1959, p. 18.
4 Ibid.
5 David Anfam, *Abstract Expressionism*, London, 1990, p. 100.
6 Quoted in Alfred H. Barr Jr.'s introduction to *The New American Painting*, the catalogue of the international travelling exhibition of that name organized by The Museum of Modern Art in New York and shown at the Tate Gallery, London, in February and March 1959.
7 Reinhardt, lecture of 1943, in Barbara Rose, ed., *Art-as-Art: The Selected Writings of Ad Reinhardt*, Berkeley, 1991, p. 47.

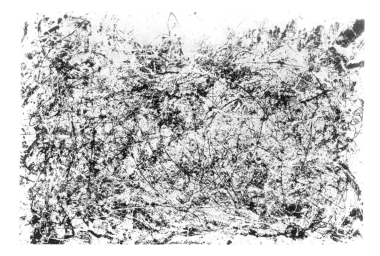

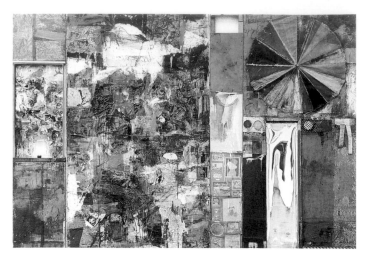

the Cross – translate metaphors of Judeo-Christian belief into a new kind of contemporary painting. They were intended to act as an aid to the viewer, but also bound the works into the European art tradition, so long concerned with conflicts between reality, the sublime and renewal. Newman believed that the evolution of modern art in Europe in previous centuries had been so preoccupied with questions of beauty that the essence of art was somehow demeaned. As he wrote in a famous essay in the magazine *The Tiger's Eye* in 1948, just as he was about to find his true style with the first of his *Onement* paintings (see Fig. 8, p. 90):

> Here in America, some of us, free from the weight of European culture, are finding the answer, by completely denying that art has any concern with the problem of beauty and where to find it…. We are freeing ourselves of the impediments of memory, association, nostalgia, legend, myth, or what have you, that have been the devices of Western European painting. Instead of making *cathedrals* out of Christ, man or 'life', we are making [them] out of ourselves, out of our own feelings. The image we produce is the self-evident one of revelation, real and concrete, that can be understood by anyone who will look at it without the nostalgic glasses of history.[8]

This effort of Newman's, and indeed of all his great contemporaries, to break away from the European tradition was heroic but in part, as indicated by the ethos of titles like those quoted above, ultimately doomed.

It was incredibly hard for these artists to break free of Europe, dependant as they had been for so long on Cubist or Surrealist modes of making art. Gorky, born in 1904, was almost forty years old before he found his authentic voice during the last five years of his life with works like *Waterfall* (Cat. 81), after having progressed through Fauvism and variations on Picasso's themes. Arguably, he never emancipated himself completely from Surrealism, though among his American contemporaries, largely with the help of Matta (see Fig. 2), the Chilean artist who came to New York from Paris in 1939, he created a personal, ultimately transcendent, technique that at the end of his life finally demonstrated his own feeling rather than reliance upon European models. With Still, de Kooning, Rothko, Newman and others it was not until 1949–50 that they succeeded in jettisoning their European baggage; even Pollock, who, as we have argued, first achieved maturity around 1943, developed a lighter, less anguished freedom with the legendary works of 1948–50, such as *Number 1* (Fig. 3), *Autumn Rhythm* (Metropolitan Museum of Art, New York), *Lavender Mist* (National Gallery of Art, Washington) and *Number 2* (Cat. 89). For most critics, these paintings represent the pinnacle of Pollock's achievement, and they are indeed extraordinary, strangely elusive, highly individual works that render in great detail, and with the utmost authenticity and refinement, states of mind and nervous spatial energies both within and without the body – filigree-like X-rays of the mind, body, psyche and sex, free of inhibition yet totally precise in their delineation of mood. To be with these works is to be in the presence of the artist in a very particular way.

Fig. 3 Jackson Pollock, *Number 1*, 1948. The Museum of Modern Art, New York; Purchase, 77.50

Fig. 4 Robert Rauschenberg, *Charlene*, 1954. Stedelijk Museum, Amsterdam

8 Newman, 'The Sublime is Now' (1948), reprinted in David and Cecile Shapiro, eds., *Abstract Expressionism: A Critical Record*, Cambridge, MA, 1990, p. 328.
9 Rosenberg, 'The American Action Painters' (1952), reprinted in Shapiro, op. cit., pp. 75–85.
10 O'Hara, 'Cy Twombly at Stable Gallery', *Artnews*, January 1955, p. 57.

If 1943 was the first big moment in American art, 1950 was the second. Harold Rosenberg described it in an article published in 1952: 'many of the painters were "Marxists" (WPA unions, artists congresses) – they had been trying to paint Society. Others had been trying to paint Art (Cubism, Post-Impressionism) – it amounts to the same thing.…The big moment came when it was decided to paint.…Just *To Paint*. The gesture on the canvas was a gesture of liberation, from Value – political, aesthetic, moral.'[9]

It had taken just seven years for artists and critics to reach this point. Caught between existential anxiety that dominated aesthetic thinking on both sides of the Atlantic and attitudes of an almost pragmatic matter-of-factness in the face of the complexities of the American predicament, the American painters worked alone, whether in New York or elsewhere, yet bound to one another by affinity as well as by the critical context. Their philosophy tied them to Europe; the originality of their matter-of-fact attitudes and sense of scale, appropriate to their situation, was uniquely American. This latter, Newman claimed, was their first priority, and there the future of American art lay. It was certainly not long in coming.

It was, in fact, almost simultaneously invoked by the next generation of American artists – figures such as Ellsworth Kelly, Robert Rauschenberg, Cy Twombly and Jasper Johns (see Cat. 132–52). As early as 1951 Kelly, living in Paris after having been stationed in Europe as a young GI, produced his first mature works, and Rauschenberg, born in 1925, just two years later than Kelly, created his own radical black-and-white paintings and exhibited them at the Betty Parsons Gallery, where only three seasons earlier Pollock had held his first epoch-making exhibition.

Nineteen-forty-nine to 1952 were the legendary years of Black Mountain College, where John Cage, Rauschenberg and Twombly came together. Rauschenberg was to create seemingly anarchic works, such as *Charlene* (Fig. 4) and *Bed* (1955; Museum of Modern Art, New York), at a time when many of the greatest canvases of Newman, Still, Rothko and even Pollock himself had either just been, or were about to be, painted. Twombly invented his own graphic and painterly methods which, as early as 1955, were described by Frank O'Hara as 'drawn, scratched and crayoned over and under the surface with as much attention to aesthetic tremors as to artistic excitement'.[10] Johns's earliest visual statements of fact date from around 1954, the time of his first *Flag*.

The reaction to Abstract Expressionism was fast and furious, and might almost be regarded as the other side of the same coin: one generation pitting itself against another in the same boxing ring, as it were. This untidy concurrence of diverse artistic activity in America continued throughout the late 1950s and early 1960s, during which period artists such as Roy Lichtenstein, Andy Warhol and Claes Oldenburg, as well as Jim Dine, Edward Kienholz, James Rosenquist and George Segal, quickly established their own canons of factuality, which Newman had so precisely defined as the way forward for American art. But by now it was not only the facts of the sublime, abstract definitions of the space of America – its mountains and endless plains, as well as its skyscrapers looking up towards infinity – but rather the facts of the trash of street life, blatant sexuality, instantaneous imagery drawn from comics, newspapers and advertising that became part of the reality of art. The resulting works, for a short time perceived, perhaps even by the artists, as a rebellion, ultimately paid homage to the language of Abstract Expressionism, if only by virtue of the grand scale that art seemed capable of reaching in the United States.

The increasing prosperity of post-war America, and of New York in particular, in spite of political threats to the nation's well-being, from Korea to Vietnam, encouraged for the first time the development of a real market for contemporary art. Dozens of galleries sprang up – by the 1980s there were hundreds – and the artists, their production and the entire infrastructure of the art world industry centred on New York, servicing an apparently insatiable demand. Whereas in the first half of this century there had been virtually no call for contemporary American art (throughout the 1920s and 1930s Old Masters and Impressionist works of art had poured into American collections from Europe), suddenly the country opened itself to a new perspective in

which the past counted for very little and contemporaneity was all. By the mid-1960s Abstract Expressionism seemed old-fashioned and, ten years later, its practitioners could be regarded as Old Masters belonging to a mythical past. The truth was, however, that they were very much part of the present, which was about to undergo a further transformation in the works of both the Minimal and the post-Minimal artists.

This new group worked without a trace of irony – if anything, with an increased seriousness, and a heightened awareness of the sublime effects that could be achieved through simple matter-of-factness. Now using transformed sculptural material – not cast metal or welded assemblage (as in the case of David Smith and Mark di Suvero), but rather simple everyday, industrial materials often presented serially – they rediscovered in a decisive way the potential of sculptural space. Ultimately, this was only a further consequence of the moves that had been made in the second half of the 1940s and were still being made, in particular, by Newman and Rothko, who in the meantime had virtually become Minimalist artists themselves. Donald Judd, Carl Andre, Sol LeWitt, Dan Flavin and Walter De Maria ignored painting (see Cat. 201–10), but within a given area, using steel, bricks, glass, plywood and fluorescent light tubes, their works evoke spaces defined not only by Newman and Rothko, but also by Reinhardt (see Cat. 123–5). The canvas as a field for action was by no means abandoned, and Agnes Martin, Frank Stella, Robert Ryman, Brice Marden and Robert Mangold (see Cat. 153–5, 193–200) all contributed in their different ways to extending the language invented barely two decades earlier.

Each of these artists is to be understood as part of a kaleidoscope of strategies which, born in 1943, achieved their first artistic expression around 1950. Suddenly, there was scope for endless invention, a struggle for ever greater purity based on an apparent formalism that, nevertheless, justified itself by its intense focus on the materiality of the everyday. By this time similar movements were springing up in Europe, where, on the whole, Minimal Art received a more favourable public response than in America; but in Europe such strategies were surrounded by more complex and ambiguous cosmologies, as in the case of, say, Joseph Beuys, Jannis Kounellis, Richard Long and Mario Merz. It could certainly be maintained, however, that an American sense of scale had been absorbed fully by the European avant-garde.

Another related group of sculptors, including Eva Hesse, Bruce Nauman and Richard Serra (see Cat. 211–20), followed two seasons later on the heels of the Minimalists and turned the aesthetic upside-down, advancing still further aspects of positions first adopted by Pollock and Newman in the 1940s and 1950s. Serra, even to this day, can be appreciated as an Abstract Expressionist sculptor of heroic ambition (see Fig. 5).

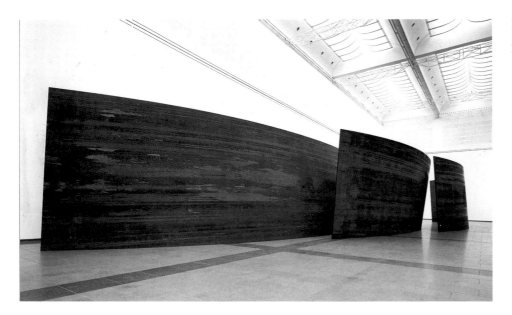

Fig. 5 Richard Serra, *Running Arcs (For John Cage)*. Installation in the Kunstsammlung Nordrhein-Westfalen, Düsseldorf, 1992

Recent theories of art have suggested that at some time in the mid-1970s in the United States and in Europe a breakdown in modernism occurred, perhaps similar to that which almost took place in Europe at the end of the 1930s, resulting in a kaleidoscopic, multi-layered attitude to style. The essence of this new approach, christened 'post-modernism', was held to be appropriation (stylistic theft) – as though nothing similar had happened before in the history of art. The unprecedented extent of the appropriation has admittedly made post-modernism fundamentally different from comparable phenomena in the history of art. The explosion of the art market on both sides of the Atlantic in the late 1970s surpassed anything experienced even in the 1960s and found its perfect expression in New York. It caused immense confusion, rendering it ever more difficult to make aesthetic judgments. The artist, the traditional outsider, appeared to have moved to the centre; the sub-culture position almost became the norm; the politics of deconstruction affected not only art itself, but also the consumers of that art. Aesthetics were increasingly informed by ostensibly anti-élitist positions, with market mechanisms alone (certainly not art criticism) determining hierarchies. The 'new painting' of the early 1980s, perceived by some critics as anti-modernist, was rapidly replaced by post-modernist, media-orientated art that attempted to decode – or rather re-code, for art at its best remains a hermetic language – patterns of creativity within the various areas of the visual arts. Problems relating to race, gender, sexuality and dispossessed groups became the subject-matter of art. Discussion no longer centred exclusively on America: Western Europe saw – and sees – itself as an equal partner in the dialogue. (That is partly the result of the swift communication permitted by modern technology: the ease with which artists and those involved with art cross the Atlantic compared to even twenty years ago should not be forgotten.) The stock exchange of art ideas and art goods, particularly during the 1980s, was almost everywhere; certainly in those areas of the world where easy money was at hand.

That America, and New York in particular, is the focus for the culture of our last half-century cannot be disputed. When Leo and Gertrude Stein, John Quinn, the Arensbergs, Katherine Dreier and any number of other committed modernist collectors – far more committed, incidentally, than their European contemporaries – made their way to Europe they were preparing the ground for the future success of American art. Gertrude Stein, writing about Picasso in France just before the Second World War and not really in touch with the New York art scene, remarked:

> I knew that a creator is contemporary, he understands what is contemporary when the contemporaries do not yet know it, but he is contemporary and as the twentieth century is a century which sees the earth as no one has ever seen it, the earth has a splendor that it never has had, and as everything destroys itself in the twentieth century and nothing continues, so then the twentieth century has a splendor which is its own and Picasso is of this century, he has that strange quality of an earth that one has never seen and of things destroyed as they have never been destroyed.[11]

Whether Gertrude Stein would have understood Pollock is perhaps beside the point, but there were a number of Americans on both sides of the Atlantic, particularly in New York, who did comprehend the liberating possibilities of that new art. Ultimately, Pollock freed art itself, rather than its appreciation, from purely local concerns. In this he was going against the grain and, unlike the earlier artists of the Stieglitz circle, he did so successfully. In one of his rare public statements Pollock said that 'the idea of an isolated American painting, so popular in this country during the thirties, seems absurd to me just as the idea of creating a purely American mathematics or physics would seem absurd…in another sense the problem doesn't exist at all or if it did, it would solve itself: an American is an American and his painting would naturally be qualified by that fact whether he wills it or not, but the basic problems of contemporary painting are independent of any one country'.[12]

Shortly before he died in May 1956 Pollock gave an interview. He cared little for the term Abstract Expressionism and even less for the terms non-objective and non-representational. 'I am very representational some of the time and a little all the time…but when you are painting out of your unconscious, figures are bound to

11 Stein, *Picasso*, New York, 1938, p. 50.
12 Selden Rodman, *Conversations with Artists*, New York, 1957, quoted in Francis V. O'Connor, *Jackson Pollock*, exhibition catalogue, New York, Museum of Modern Art, 1967, p. 73.

emerge…painting is a state of being…painting is self-discovery. Every good artist paints what he is.'[13]

Of course, this is true of all great artists, but with Pollock there is a difference. His art broke through into a new field where things became possible that were not possible before. Pollock's paintings have sculptural, environmental, theatrical and temporal implications that no previous painting had possessed. The ideas of chance, of inherent self-destruction and of art occupying areas of real life were extended way beyond Dada and Surrealism. Pollock, noted de Kooning, was like a cowboy,[14] and indeed his Clint Eastwood-like behaviour is amply documented. Perhaps it was this attitude as much as anything else that enabled Pollock, at the age of thirty-one, to cut American art from its European shackles and run loose. He was more or less conscious of the fact that this was an act of will on his part; his own generation followed quickly. The time was right, the market was right, and it was perhaps inevitable that after 1945 the American way should become the role model in art as much as in architecture, popular music, advertising and film. Pollock, not only because of his life style and the manner of his death, but also because of the aesthetic qualities of his painting, became every bit as much a role model as James Dean or Jack Kerouac, and it did not take long for that message to reach Europe. In 1958 and 1959 an exhibition entitled 'The New American Painting' made a triumphant tour of Europe, organized by the International Council of the Museum of Modern Art. Will Grohmann, the doyen of German art critics, wrote at the time: 'Pollock is more than the originator of the movement. Standing in front of his tremendous canvases one does not think of styles and slogans, but only of talent and singularity. Here is reality not of yesterday but of tomorrow…an exuberance of the continent, the oceans and the forests, the conceiving of an undiscovered world comparable to the time 300 years ago when the pioneers came to his country.'[15]

In 1958 memories of the horrors of the Second World War were still very real in Europe, as was the optimism of the American Dream in the United States. Over the years that dream has become tarnished, to say the least, and America brought down to earth again. The development of the country's art over a comparatively short period reflects that process as well as, if not better than, any other branch of cultural activity. Rauschenberg's *Canyon* of 1959 (Cat. 137), showing the American eagle with a weight suspended from it, demonstrates how quickly this self-critical awareness evolved. By the mid-sixties an acutely self-referential process was already taking place within the visual arts, assuming a thousand different shapes and styles. When Jenny Holzer exhorts us with 'Truisms' (see Cat. 240), such as 'Protect me from what I want', she is giving expression to Pollock's own ambition for modern art, which was 'nothing more than the contemporary aims of the age that we're living in'.[16] From Jasper Johns's *Target* (Cat. 147) to Keith Haring's graffiti paintings (Cat. 235, 236); from de Kooning's *Woman V* (Cat. 98) and Warhol's car crash paintings (Cat. 189) to Julian Schnabel's *Hospital Patio* (Cat. 231); from Frank Stella's *Marriage of Reason and Squalor* (Cat. 155) and Bruce Nauman's *Green Light Corridor* (Cat. 216) to Robert Gober's *Untitled, Closet* (Cat. 251) and Cindy Sherman's self-portraits (Cat. 242–5), there can be no doubt about the contemporaneity of American art, its endless obsession with the here and now. The selection of works presented in this exhibition and the accompanying catalogue attempts to document some of the more exalted expressions of that most legitimate concern of art. Viewed from this perspective, America still has art in Europe panting for breath.

13 Pollock, radio interview with William Wright, in O'Connor, op. cit., p. 79.
14 De Kooning on Pollock, *Partisan Review*, Autumn 1967, reprinted in Shapiro, op. cit., pp. 372–4.
15 Grohmann, 'Die neue amerikanische Malerei', *Der Tagesspiegel* (Berlin), 7 September 1958.
16 Pollock, interview published in *Arts and Architecture*, February 1944, reprinted in O'Connor, op. cit., p. 33.

Arthur C. Danto

Philosophizing American Art

The Triumph of the New York School (1984; Fig. 1), by the post-modern American master Mark Tansey, is a droll and wily allegory of a shift in the cultural geography of modern art, whereby New York replaced Paris as the artistic centre of the world. Tansey shows the leaders of both schools in battle garb, taking the term 'avant-garde' in its literal military sense, and depicts the surrender in a monochrome, rotogravure style that appears to document something that really took place. André Breton, for the French, is ceding victory to Clement Greenberg, leader of the American forces. Each signatory is flanked by his own set of champions: Pablo Picasso, Henri Matisse, Joan Miró and others for the Parisians; Jackson Pollock, Willem de Kooning, Robert Motherwell and others for the Yanks. The work becomes richly comical when we observe the French in vintage uniforms of the First World War, while the Americans wear those of the Second World War. Picasso swaggers in the fur coat of a flying ace, doubtless alluding to the fact that he and Georges Braque addressed one another as Orville and Wilbur and thought of the invention of Cubism as parallel to the conquest of the air in those rickety planes that Tansey once said reminded him of nothing so much as Cubist compositions. The painting is dense with sly jokes and pungent details. But the sharpest comment of all is the way the painting subverts, systematically, everything for which the New York School stood: it is representational rather than abstract; it repudiates the 'flatness' seized upon by Greenberg as the mark of modernism; it has nothing to do with the physicality of paint or the urgency of the drip; it is witty instead of grandiose; and Tansey clearly presents himself as an intellectual – a label with which Motherwell was so uncomfortable that he had to apologize for not being what he described as 'a feeling imbecile'. The triumph of the New York School turned out to be a local engagement in the sinuous history of modernism, rather than the style war to end all style wars. And the fact that Tansey's painting was even possible suggests that the doctrines and ideologies of the New York School had long been overridden. Everything is put in a distant historical light, one in which the art of Paris and that of New York were far less opposed than may have seemed the case – a light so distant that the two world wars become a single confused event.

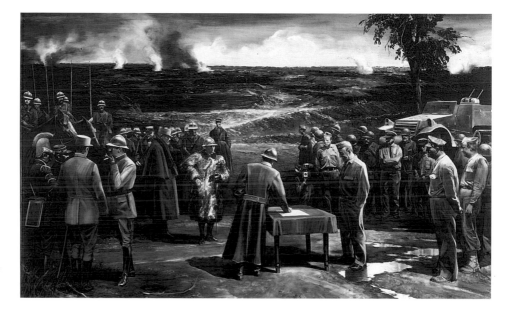

Fig. 1 Mark Tansey, *The Triumph of the New York School*, 1984. Whitney Museum of American Art, New York; Promised Gift of Robert M. Kaye

In fact, there was very little perceived difference between the ideals of the two 'schools'. In a lecture, 'Reflection on Painting Now', delivered at Provincetown in 1949, Motherwell said: 'We artists of the School of New York are a collection of co-existing separate pasts. So are the individuals who constitute the School of Paris. These two handfuls of individuals are closer to each other in their essential acts than either is to the herd of individuals who constitute his natural culture, French or American.' New York painting, Motherwell seems to say, was nearer to the School of Paris than either of these was to the previous painting in each country. Historical counterfactuals are difficult to prove, but there was certainly nothing in American painting before the Armory Show of 1913 to suggest that modernism would have evolved spontaneously out of it. In 1910, for example, the advanced New York painters, under the leadership of Robert Henri, defined themselves in opposition to the National Academy. This was reflected in surface and in subject-matter: Henri counselled his followers to throw away their little brushes and to take their subjects from street life – from boxing matches and the pleasures of ordinary people. But differences that seemed astronomical in 1910 proved all but negligible when representative works from either side were set alongside Picasso, whose canvases were shown in Stieglitz's 291 gallery in 1911. An astute critic wrote of Henri's 'Independents' that 'already they are back numbers, and we shall soon see them amalgamate with the much abused old National Academy of Design'. Artists constitute their own pasts, by and large, and confer a shape on history rather than merely being products of it.

I recently asked Greenberg himself how he would explain the emergence of the great American painting of the late 1940s in New York. His answer was that the artists there were able to see and study many more works by Picasso, Matisse and Miró than were on view in Paris at the time. His thought is that they remained more fixated on these masters than Paris artists were, who had begun to regard them as somewhat 'old hat', and had gone on to other preoccupations. One can certainly sense a change in the Parisian atmosphere by comparing the sort of paintings Gertrude Stein bought in the 1920s and 1930s – Christian Bérard, Pavel Tcheletchew, Francis Rose – with the Cézannes, Matisses and Picassos she had bought before. In truth, the Parisian painters paid a considerable price for abandoning the masters, if Greenberg's analysis is right, for French painting between the wars and after the Second World War exemplifies so protracted a decline that the final three-quarters of twentieth-century art could be written with scarcely a mention of France. New York, by contrast, gained momentously by being a province of Parisian culture. Greenberg recalled walking through an exhibition of American art held in the 1960s in Japan with a Japanese critic who commented on how French it all looked – a response that would have pleased Pollock and delighted Motherwell, even if Barnett Newman and Mark Rothko would have resented it. But, besides taking Matisse and Picasso seriously, the New Yorkers, Greenberg said, simply 'bore down harder' than anyone else. So in his view the triumph of the New York School was, as the familiar American expression has it, nine-tenths perspiration and one-tenth inspiration. The question for historical explanation is whence came the inspiration, which, mingled with all the heavy study of French forms, produced something finally so distinctive and perhaps distinctively American?

In a marvellous 1947 essay in the magazine *Horizon*, Greenberg wrote: 'The American artist with any pretensions to total seriousness suffers still from his dependency on what the School of Paris, Klee, Kandinsky, and Mondrian accumulated before 1935.... The three, four, or five best artists in the country yearn back to Paris as it was, almost, in 1921, and live partly by time transfusions.' He told me how New York artists vied to be the first to get hold of *Cahiers d'art*, on sale at Brentano's, even if they had to imagine the colours from the black-and-white reproductions. So New York, still in 1947, was a bubble of Paris *circa* 1921, afloat in an alien sea; and as artists, the Americans lived in their own country as if in another time and place: 'They cannot cultivate the present for any standard of quality or style.' Greenberg singled out Pollock as 'the most powerful painter in contemporary America and the only one who promises to be a major one'. He did not think him quite the most *original* painter of

the moment, mentioning Morris Graves and Mark Tobey as the 'most unique [*sic*] and differentiatedly American'. But he saw them, rightly, as far more limited in ways Pollock was not; and he makes the point that 'the feeling [Pollock's work] contains is perhaps even more radically American'. The question to which I would like an answer is in what this 'radical Americanness' consists, and Greenberg offers us a clue. He writes that Pollock's art 'dwells entirely in the lonely jungle of immediate sensations, impulses, and notions, therefore it is positivist, concrete'. The odd word 'jungle' is, I think, an unwitting give-away: there is in Pollock something primitive, savage, wild – something regarding which Greenberg is exceedingly uncertain, and against which he issues a certain warning. 'We have had enough of the wild artist', he had said. 'He has by now been converted into one of the standard self-protective myths of our society: if art is wild, it must be irrelevant.' In fact, the image of the Wild Artist had entered sufficiently into the definition of the True Artist for Motherwell, once again, to have to apologize for such activities as writing and reading and theorizing, when he ought instead to have exhibited an essential wildness in his personality and in his art. Wildness was not a myth imposed by outsiders to certify the irrelevance of art: it was a myth imposed by insiders as a way of certifying the authenticity of their art.

There is a famous and influential essay by Philip Rahv, an editor of *Partisan Review*, in which American artists are classified as 'Palefaces' and as 'Redskins'. It is the mark of the Paleface to be European in taste and criterion, as was Henry James. Walt Whitman was of course a Redskin. Rahv's duality is an Americanization of the great distinction between Apollo and Dionysus in Nietzsche's *The Birth of Tragedy*: 'The continuous development of art is bound up with the Apollonian and the Dionysian duality – just as procreation depends on the duality of the sexes, involving perpetual strife with only periodically intervening reconciliations.' Apollo emblemizes form, and the paradigmatic Apollonian art is sculpture. Nietzsche opposed it to the 'non-imagistic' Dionysian art of music, and, indeed, in 1871 music was the only non-imagistic art conceivable. But in the 1940s, in New York, painting had become vehemently non-imagistic. Most abstract art up to then had been residually Apollonian because it was so geometrical and seemingly rational. New York School painting achieved a non-imagistic or even anti-rationalistic form of painting, which was, as it were, the half-breed offspring of a Paleface and a Redskin, just as, in Nietzsche's view, Greek tragedy was the child of Apollo and Dionysus. Or, less mythically, it was the product of School of Paris colour and form with that kind of Redskin wildness which Pollock genuinely emblematized, and the latter brought in an element missing from the School of Paris in the period of its long twilight. To be sure, it was a Paleface concept of Redskinnedness.

In the more sober idiom of historical explanation, it seems clear to me that this element is less something purely American than itself a European import, brought into the New York art world by the Surrealists, who were marginal to the School of Paris in Paris, but who, by their displacement to New York, where they became a vital force, fertilized that city's small art world with their visions and attitudes. The Surrealists celebrated primitive thought and primitive art, though *their* immediate sources were European, and derived from Dada and from psychoanalysis. Perhaps their ideas found a special receptiveness in America where, after all, the cowboy, the Indian and the outlaw remained constant myths: Robert Henri wore a ten-gallon hat and boasted that his father had shot an opponent dead in a card game; and Pollock's teacher, Thomas Hart Benton, in his talk as in his life, sought to add the artist to his pantheon of wild men. The important fact is that the ideas of the Surrealists, lionized by New York artists because of their Europeanness, spoke directly to New Yorkers, who adopted those ideas with the enthusiasm of converts.

The one glaring anachronism in *The Triumph of the New York School* is the representation of Breton as Greenberg's opposite number. Whatever Breton may have meant in Paris, it was in New York that he found his best audience. Surrealism had an external and an internal doctrine to transmit: the former insisted that beneath appearances there was a surreality to which we must connect ourselves, the latter that within

each of us there are subrational and creative impulses with which we must reunite. The thought that there is something within each of us of the very highest value is perhaps deeply American, but the strategies for getting in touch with it were uniquely Surrealist, and included a procedure such as automatic writing, where we detach and disengage the governing mind to allow the unconscious to find a way to externalize itself. The Surrealists were especially close to Peggy Guggenheim's Art of This Century Gallery, the most European gallery in New York, and one in which Motherwell and Pollock internalized the imperatives of Surrealist liberation. This had little to do with the content of the typical Surrealist canvas – with Salvador Dalí's limp watches or René Magritte's unsettling conjunctions. It had to do with procedures and addresses, and it is out of these that Pollock's drip, de Kooning's vivid brushiness and what Motherwell called his 'doodles' arose. It was the gestural which was, I think, the chief contribution made by the Surrealists to the New York School, so much so that Motherwell once speculated that rather than Abstract Expressionism, the movement should have been called Abstract Surrealism.

Preoccupation with what psychoanalysis designates as 'primary process' is not altogether synonymous with 'the extreme situations and states of mind' Greenberg warned against. Motherwell was an exemplarily rational man, while Pollock's violent personality was independent of his pursuit of the unconscious in the Surrealist parlor games in which he participated with Motherwell and Roberto Matta: he would have been moody and sullen even if his art were as academic as John Singer Sargent's. My sense is that the exploration for a passage to the creative founts of the 'UCS' system, as Freud calls it, in which the New York painters participated, perhaps had a model in the spontaneity with which the jazz musician is credited, and it connects as well to the justification for hard drinking that the artists of the 1950s ritually provided, and beyond question to the recourse to drugs, when these overtook American urban society in the next generation. The argument was that they enhanced creativity by dissolving the constraints of reason. The term 'expression', which found its way into the self-image of New York painting, had little to do with the conventional repertoire of feelings – anger, melancholy, anxiety and the like, which are externalized in bodily gesture and facial disposition. It has rather to do with processes believed too deeply submerged beneath the veneers of civilization and super-ego to be expressed at all, save in distorted fashion, as in dreams and in neuroses. Formally speaking, the language of painterly gesture may be explicable against the idea that the artist is not abstracting from an objective reality but allowing the brush to make objective inner feeling to which he or she has no other access.

One senses that Greenberg was opposed in every particular to the exaltation of irrational or subrational process. 'The art of no country can live and perpetuate itself exclusively on spasmodic feeling, high spirits, and the infinite subdivision of sensibility', he wrote. And he apparently thought Surrealist-inspired automatism a phase American art would outgrow, in the development at last of 'a bland, large, balanced, Apollonian art in which passion does not fill the gaps left by the faulty or omitted application of theory, but takes off from where the most advanced theory stops, and in which an intense attachment informs all'. Greenberg advocated an art 'resting on rationality but without permitting itself to be rationalized', by which I take him to be paraphrastically echoing the thought of Kant that art cannot be reduced to rules, though it itself is a rational activity. So my sense is that Greenberg was out of sympathy with a lot of the art with which he has been so closely identified. And the kind of 'bland, large, balanced' art he prescribed was perhaps exemplified in the Colour-Field painting that followed on the heels of Abstract Expressionism, and then in Minimalism after that.

Whatever the merit of the theory of non-rational creativity and the technologies of automatism, what cannot be overemphasized is the degree to which being members of a 'school' devoted to the production of a new and extraordinary mode of painting enhanced the work of the individual artists who were part of it. New York had a very small art world whose members knew one another and impinged on one another's sensibilities. Indeed, looking at their work before the New York School

materialized as such, and then looking at the masterpieces each produced after that, one cannot help thinking that many of the major artists would have been minor without the transformational possibilities of the new style. Franz Kline, I feel, became a great painter almost overnight. Arshile Gorky would have been a tepid disciple of Miró, Rothko a pale emulator of Milton Avery, had not the movement's actual momentum raised them to a new level. If not the royal road to the unconscious, the New York style was a gateway into unoccupied aesthetic territory, and the New York painters rushed through it as into the Fourth Dimension, which an earlier modernism had speculated might be a whole new plane of being. Or, to use a more American metaphor, they entered virgin territory like homesteaders, each staking his own aesthetic claim. The newness must have been intoxicating. But it must also have implied so considerable a discontinuity with previous painting that the level of theoretical and even of historical discussion was nearly as intense as the painting itself. So much of what had been believed essential to the art of painting had been jettisoned that the discussion of its nature and indeed the nature of art – defined in terms of painting – generated an atmosphere of talk within which the work went on. The Cedar Bar in Greenwich Village was the seminar room of the new art.

That atmosphere survived the collapse of the New York School as a style, scarcely a decade after its triumph. In my own recollection, as a philosopher who had been deeply moved by Thomas Kuhn's *The Structure of Scientific Revolutions*, I thought that a new 'paradigm', to use Kuhn's term, had somehow replaced the Renaissance paradigm. And I thought that surely, if the latter had defined Western art for half a millennium, it was not too much to suppose the New York paradigm would evolve an art history, the shape of which nobody could then, of course, anticipate, but which would last for centuries. Kuhn's book appeared in 1962, and though neither I nor anyone else, I think, recognized it, the New York School of painting was already by then a finished thing. What *survived* the School of painting was what one might call the New York School of *art-talk*.

It may sound contradictory to speak of New York art-talk surviving Abstract Expressionism's demise, when the theory of the movement seemed to celebrate the inchoate, the non-verbal, the emotional, the primitive; and when true intellectuals, like Motherwell, were put on the defensive. The difference is this. Motherwell's was an academic background. He knew what philosophy really was, having studied it at Harvard before going to Columbia to pursue art history. The New York School artists were not so much anti-intellectual as anti-academic. They read psychoanalysis, anthropology, metaphysics and theology. Newman constantly invoked Kant. In the next generation, artists went to colleges and universities to study what their predecessors had merely read. The irony was that rather than academic discourse replacing the wild and woolly intellection of the down-town painter, New York art-talk penetrated the academy, so that the ensuing art theory and criticism had a certain pungent incoherence and inconsequence, which was merely heightened by the infusion of a later generation of French theoretical writing from the 1960s and 1970s: Jacques Derrida, Jacques Lacan, Michel Foucault and, later, Jean Baudrillard. But I am speaking for the moment of the wild metaphysical haymakers that were the favoured verbal vehicles of the Abstract Expressionists, the verbal counterparts, often, of the punches and counter-punches of the bar-room brawl.

It is difficult to convey how dogmatic vintage New York art-talk was: how righteous, denunciatory, intolerant, prohibitional, and how altogether certain its pronouncements were. It was an atmosphere of nearly religious orthodoxy, whose closest historical counterpart must have been the iconoclastic disputations of the Byzantine empire. There was a radical insistence on the narrowest interpretation of what painting essentially is and is not, and on what can and what cannot be art. There were of course image-painters then, but there was a sense of almost doctrinal defiance on the part of those who persisted in heretical paths. The standard critical utterance of the time was 'You can't do that!' Certainly, an air of scandalized betrayal arose when de Kooning showed his *Woman* paintings at the Sidney Janis Gallery in 1953 (see Cat. 97, 98). Ten years later, in an interview with David Sylvester, de Kooning said, 'it's

really absurd to make an image…. But then all of a sudden it was even more absurd not to.' By 1963, of course, the premises of the discourse were crumbling away. I recall seeing Roy Lichtenstein's *Look Mickey* (National Gallery of Art, Washington) in the early 1960s when I was living in Paris, and I thought that if it was possible to show, let alone paint, a picture like that, anything could be painted, and shown. The thought voiced by Andy Warhol, that anything can be art, expresses to perfection the sudden sense that history, rather than narrowing itself into a thinner and purer stream of art, had begun to flow and tumble in innumerable directions, so there was no longer a direction or even a mainstream. But just as de Kooning's remark of 1963 was possible only then, and not in the year it purported to describe, the objective reality it articulated was perhaps not even visible then. There instead was the acute shock of Pop, from which the New York School never recovered.

In fact, I was more impressed by the philosophical implications of Pop than by the metaphysical pretensions of Abstract Expressionism, with its heavy lacings of Surrealist *blague*. But in the early 1960s I was a newly tenured professor at Columbia University, with a strong interest in analytical philosophy and a strong revulsion, in consequence of my education at the hands of Logical Positivists, at the very idea of metaphysics, which philosophers of my generation had been taught to impugn as nonsense. And though one must be cautious in speaking of the *Zeitgeist*, I have often wondered if Logical Positivism, which was the advanced view in American universities of the period, was not the philosophical counterpart at least of the negative part of Pop, directed as the latter was against the extravagant sublimities of Abstract Expressionism. I would venture even further along this limb. In the early 1950s the late philosophical writings of Ludwig Wittgenstein began to be widely studied in philosophy departments, and it is difficult to repress the thought that one strong component in Wittgenstein must correspond to another in Pop. Wittgenstein insisted tirelessly that ordinary language is language at its best, that philosophical aberration begins when one loses touch with common discourse and begins to use words without the constraints of ordinary usage. This view was taken further still by the Oxford philosopher J. L. Austin, with whom ordinary language became canonized. By the 1960s, then, philosophy had become at once anti-metaphysical and pro-ordinary language, and this almost perfectly matches the postures of Pop: anti-New York School pretensions and celebratory of the most ordinary of ordinary things in the common lives of ordinary men and women – corn flakes, canned soup, soap pads and the images of screen idols.

In so far as the New York School pictured itself through the categories made central by Greenberg's writings, its artists had to have seen themselves as occupying a certain position in the history of modernism. Greenberg, in fact, constructed a philosophical narrative of modernist history, which in a way underwrites his formalistic criticism. Modernism, for him, was a movement in which 'content is to be dissolved so completely into form: that abstraction is the inevitable result'. But the abstraction in question was the very antithesis of the sort we might characterize as abstraction *from* – where the motif is reduced and reduced until displayed in its essentials on the surface of the canvas. Abstraction *from* evidently played a certain role in Mondrian's work, or at least in the pictorial philosophy of De Stijl: there is a famous series by Theo van Doesburg, in which – in eight stages – the image of a woman in the studio is progressively reduced to a composition of squares and oblongs (a process parodied by Lichtenstein in a series of images of a cow). And beyond question abstraction *from* was strongly emphasized in Motherwell's first defences of abstract art in the 1940s. This was not the way Greenberg viewed abstraction. It was, instead, a turning away altogether from subject-matter to 'the medium of his own craft' – so that the medium was the subject of the modern artist, and that coincided completely with the work. In Van Doesburg's series, the woman remains the subject, but in a most attenuated representation of herself; whereas the subject in that sense was radically expurgated in Greenberg's vision of modernism. 'Purity in art', he wrote in 'A Newer Laocoon', consists 'in the acceptance, the willing acceptance, of the limitations of the medium of the specific art.' And that means finally a surrender to the

Fig. 2 Marcel Duchamp, *The Large Glass*, 1915–23; photographed between 1946 and 1953 in the home of Katherine S. Dreier, Milford, Connecticut

physical properties of paint, canvas, shape, surface. He saw artists, and artists saw themselves, as essentialists, pursuers of essences, discarders of whatever is accidental and peripheral to the deep truth of art. It was as if art were committed, collectively and cumulatively, to a philosophical programme, that of defining art through the practice of art. Hence the 'You can't do that!' of New York art-talk, which meant: you must not do that if you wish to be modern and *correct*.

The flat, matt, self-referential painting became the philosophical terminus of the history of high art. This high ground was seized by Ad Reinhardt who, in the final years of his life, painted, over and over again, the same painting. 'The problem and process of painting is reduced to something that has only to do with essence', he said, characteristically, in an interview with Bruce Glaser published in *Art International* in December 1966. It was as though, now the truth had been exposed, there was nothing further to do beyond painting the same again and again: 'The one thing you say needs to be said over and over again and that thing is the only thing for an artist to say.' Oddly, with Reinhardt, almost the last thing one is conscious of in his work is the thematization of the physical parameters of painting: the work instead seems overwhelmingly spiritual, and even mystical. When Glaser said 'some critics have seen in your all black painting some kind of relationship to the negative acts of dada artists such as Duchamp', Reinhardt demurred: his work was 'the exact opposite of Duchamp'.

And indeed, the 'Road Toward Flatness', as Kirk Varnedoe wittily characterized the story of modernism according to Greenberg, had no room in it for Duchamp, even though he, as much as the modernists, was pressing to identify the philosophical boundaries of art. The modernists identified it with the physical matter of painting, Duchamp with the conceptual border between art and life, the agency of which were the 'ready-mades' of 1913–19. The most dramatic of these was the notorious transfigured *Fountain* of 1917 (Cat. 22), whose rejection, by the hanging committee of the allegedly jury-free exhibition of Independent Artists, climaxed and ended the avant-garde movement in America before the First World War. Duchamp returned, after the war, to work on his *Large Glass* (Fig. 2); and settled in New York permanently in 1942. It is reasonable to say that New York, between the wars, was not an especially active centre of art, possibly because Duchamp was elsewhere. What remains to be appreciated is the quiet influence of Duchamp, once he had settled in the city. How quiet it was can be inferred from the fact that his name appears only once in Greenberg's writings of the period, and that as a decidedly minor Cubist in an exhibition at Peggy Guggenheim's gallery. Duchamp played no role in the 'Triumph of

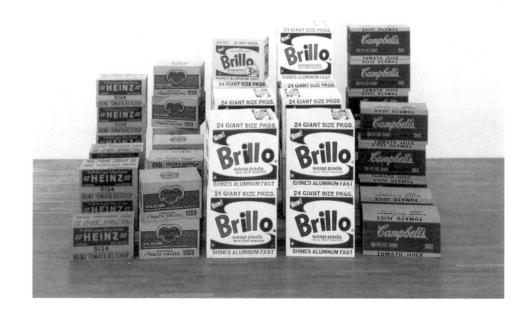

Fig. 3 Andy Warhol, *Various Boxes*, 1964. The Estate of Andy Warhol

the New York School' (Tansey places him on the French side, just opposite Joseph Cornell, who is shown looking longingly towards the French). The deep historical question is why Duchamp's ideas should have detonated in the mid-1960s with the twin movements of Pop and Minimalism – the one concerned to erase the boundaries between high art and low, the other between fine and industrial art. Conceiving the history of modernism on Greenbergian lines, Pop was absolutely unpredictable, and Minimalism altogether incomprehensible.

When the Pop artists first displayed their irreverent works, they had very little connection, except for mockery, with the programmes of purification and purgation that defined the New York School. It is ironical that they, rather than the heavy breathers of Abstract Expressionism, should have stated the problem of the nature of art in its philosophical form. What Warhol achieved, with the Brillo boxes (Fig. 3) he displayed in 1964, was a demonstration that what makes the difference between art and reality is not visually definable or visually discoverable – for nothing looks more like an artwork (the *Brillo Box*) than the commonplace Brillo boxes of the supermarket. Philosophy's problems always have that form: why two indiscernible things, like dream and waking experience, for example, should be so momentously different, and how that difference is to be defined.

I have argued, in a number of places, that with the emergence into general consciousness of the philosophical nature of art, the history of art in the West had reached its end. This largely Hegelian thesis draws on the thought that history terminates in the consciousness of its own processes. Art had gone as far as it could, in seeking its philosophical identity: the task was now up to philosophy to articulate that identity in a proper definition. But of course in its post-philosophical – and, in my view, in its post-historical – moment, art-making can go on and on. It need not continue in the second-order matter of Tansey's deep caricatures, nor in the sorts of appropriation which characterized so much art-making in the 1970s, famously in the case of the photographs of photographs of Sherrie Levine. What the end of art meant was the liberation of artists from the burden of history. Art could now be put at the service of human ends and not simply of the internal end of probing for the essence of art. The 1970s was a period of immense creativity in which the search for purity was marginalized. It lingered in the blank abstraction of Robert Ryman, but it was no longer the overriding imperative of art as art. The marginalization of purity entailed the marginalization of painting, which was its chief arena: the scene of art was invaded by photography, video, performance, installation. Post-historical art is pluralist to the core, a confederation of artistic cultures which includes painting as but one.

Douglas Tallack

Culture, Politics and Society in Mid-Century America

Introduction

Compared with the exuberance of the American 1920s, the individual and collective dramas of the Depression and wartime years, and the radicalism of the 1960s, the middle years of the century come down to us in images of conformity (see Fig. 1) and excessive materialism. Here was a stereotypical America, self-satisfied and ready to export its representations of affluence globally. Even what passed for popular exposés of everyday life in the 1950s (Sloan Wilson's *The Man in the Grey Flannel Suit*, 1955, William Whyte's *The Organization Man* and Vance Packard's *The Hidden Persuaders*, both 1956) seem to be fascinated by suburban and down-town life-styles, peer-group behaviour and advertising. And yet many of the more crucial works of American intellectual and cultural history came out of the era of 'kaffee klatches' and fantastic automobiles.

Having emerged from the Second World War as the most powerful military nation in the world, the United States developed a booming consumerist economy (GNP rose by 250% between 1945 and 1960, consumer credit increased by 800% in the ten years after the war) and became locked into the Cold War and McCarthyism (see Figs. 2, 3). American intellectuals and their European émigré counterparts assessed where they stood, how their preoccupations related (or failed to relate) to the mass society around them and how recent European traditions of thought would mesh with a peculiarly home-grown amalgam of idealism and pragmatism. Social and political theorists such as Daniel Bell, David Riesman, J. K. Galbraith, C. Wright Mills, Paul Goodman and Hannah Arendt, alongside Theodor W. Adorno, Max Hork-

Fig. 1 American suburban housing estate, *c.* 1955

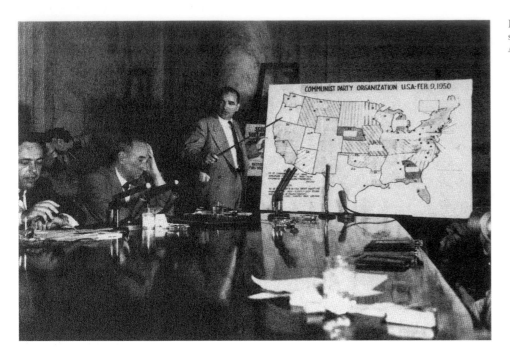

Fig. 2 Senator Joseph McCarthy during a Senate sub-committee hearing, 1954. Counsel for the US Army, Joseph Welch, is on the left

heimer and Herbert Marcuse of the Frankfurt School in exile; the historians Richard Hofstadter, Arthur Schlesinger Jr. and Daniel Boorstin; the novelists Saul Bellow and Norman Mailer; the literary and cultural critics Lionel Trilling and Dwight Macdonald; and the art critics Clement Greenberg and Harold Rosenberg – all, in different and often conflicting ways, assimilated the lessons of the 1930s and reflected anxiously about the meaning of modernity, in a society where that process was most blatantly underway.

An Intellectual Vocation

We can begin to appreciate the tension between post-war intellectuals and American society, and the ways in which they pulled important strands of thought together, if we drop back to the years just before the First World War and to the critic Randolph Bourne. Bourne carried into the twentieth century the role of cultural critic that had been forged by Henry David Thoreau in the 1830s and 1840s. Whereas Thoreau's protest against slavery, made in the essay 'Civil Disobedience' (1849), and his antipathy towards materialism led him to spend two years in a hut by Walden Pond, Bourne opposed American involvement in the First World War and, as a self-aware intellectual, took a critical look at a society close to becoming recognizably modern. Bourne argued that if intellectuals did not resist the 'war spirit' and insist on keeping the verbal arguments going, then no one else would and military logic would take over. But it is Bourne's understanding of the convergence of culture, politics and society which clearly anticipates the chief preoccupation of American intellectuals down to the present day. In his essay 'The War and the Intellectuals' (1917) Bourne asked how liberal, progressive intellectuals of his era could oppose the untrammelled expansion of big business and yet find themselves on the same side as the East Coast moneyed interests that, for both financial and cultural reasons (British ancestry), supported America's going to war. 'War', Bourne later observed presciently, 'is the health of the State.' In his 1916 essay 'Trans-National America' he maintains that the spread of mass culture through radio, cinema and advertising, in tandem with the homogenizing influence of an external threat during the approach to war, neutralized cultural differences between ethnic groups – the very differences which, in a federal political system, could have been a model for the peaceful coexistence desperately needed in Europe. Moreover, control of that mass culture, Bourne recognized, was in the hands of the affluent business class. Bourne's uncompromising stance, whereby

Fig. 3 Alan Dunn, 'Oh, dear, I'd really be enjoying this if it weren't for Russia', *The New Yorker*, 1947

mass culture is criticized not for its lack of quality so much as for its economic and political underpinnings, combined with his hopes for what a 'trans-national America' might achieve, established an intellectual vocation and a characteristic mode of analysis. These we can now trace on to and out of the 1930s, a period in which, as perhaps never before, culture and politics occupied a common arena in both European and American society.

The 1930s: Marxism, Modernism and the Popular Front

The use of culture for political purposes was at once less dangerous and more subtle in the United States than in Europe. The stakes in Europe were higher during the rise of fascism and Stalinism, and the threat of a second world war was geographically much closer. The economic crisis triggered off by the Wall Street Crash in 1929 produced a marked move to the Left by American intellectuals, who had already been disturbed by capitalist excesses earlier in the decade and by an ideology of 'normalcy' that had fomented hostility towards radicals during the 'Red Scare' and its aftermath. Many of these intellectuals had previously adopted what may be described as a 'modernist' response to social and political life. Alienated by the horrors of the First World War (which such writers as Ernest Hemingway, e. e. cummings, John Dos Passos and Malcolm Cowley had witnessed as ambulance drivers), and aesthetically numbed by the first real consumer boom and its accompanying middle-brow culture (symbolized by *The Saturday Evening Post* and *The Reader's Digest*), intellectuals with a less secure grasp of cultural politics than Bourne preferred to turn their backs.

Whether in bohemian enclaves in New York and Chicago or expatriated on the Left Bank in *the* centre of culture, Paris, these intellectuals cultivated a distanced sensibility and a religion of art. But the 'lost generation', as Gertrude Stein called them, rarely plumbed the depths of European modernism or fully explored what a modernist critique of society might be, as a Bertolt Brecht or a Walter Benjamin were doing. In *Exile's Return* (1934), an autobiographical account of American artists in Paris, Malcolm Cowley reports that he and his companions on the Left Bank were disquieted by the absolute dedication of a James Joyce or a Marcel Proust, while Dada, far from awakening and redirecting political energies, mostly aroused in them the kind of anti-intellectualism from which they had themselves suffered in the United States. Returning home – to the US, but also to a more explicit social and political outlook than modernism permits – was less difficult than for the more alienated European thinkers and writers whom the Americans had uneasily admired.

American novelists also maintained a commitment to Realism, in spite of their new interest in modernist aesthetics. Hemingway's sentences still refer to people, places and events in more straightforward ways than do the sentences of Virginia Woolf or Stein – an American who stayed too long in Paris. Thus, when the economic boom that permitted expatriation or a comfortable life in Greenwich Village collapsed, American writers and critics turned quite easily to a politically direct art. Hemingway's 'proletarian' novel, *To Have and Have Not* (1937), is one example. Another is John Steinbeck's *The Grapes of Wrath* (1939), though Steinbeck was never a modernist or an expatriate. The failings of this 'committed' art – which had a relatively short life-span – seem not to have arisen from the changes in form, style or content that stemmed from the economic realities of the Depression and the spectacle of capitalism in disarray. Rather, it was the politics underlying the Realist aesthetic that came to provoke doubts. Here, the best illustration is the 'career' of the journal *Partisan Review*.

Refounded in 1937 after three years as a Communist Party cultural organ, *Partisan Review* took issue with the Stalinist-inspired Popular Front against fascism that had been inaugurated by the Comintern in 1935. The acceptance of this policy by the American Communist Party and many fellow-travellers was, in part, politically determined: a recognition of the dire threat of fascism (particularly to the USSR, the ideal against which the failings of American capitalism could be set) and an acknowledg-

ment of the poor electoral performance of the CPUSA and the Socialist Party in spite of the visible collapse of capitalism. Alliances had to be made with other left-wing groupings and even with liberals supporting Roosevelt's New Deal. In part, though, the policy of the Popular Front merged with a rapprochement with what was perceived as the 'real' America. American writers, painters and photographers left their educational and publishing institutions and bohemian 'villages' to travel west and south. The greatest works of the 1930s are those that evoke the economic and social disasters of the decade while respecting the differences among those written about, painted or photographed. In the narrative and photographs that constitute a book like James Agee and Walker Evans's *Let Us Now Praise Famous Men* (1941) there is also a painful acknowledgment of the differences between the observing artists and the observed share-crop farmers (see Figs. 4, 5). This distance is largely missing in the sentimentalized realism of Hollywood's response to the Depression: notably in the populist films of a director such as Frank Capra, in which a folksy togetherness, underpinned by a strong nationalist message, triumphs over adversity. In a more calculated manner the Popular Front also sought to tap the enduring, if politically ambiguous, tradition of American populism. Symbols had to be mobilized (the farmer rather than the urban worker, who might too easily be confused with a European proletarian; the small town community; and even 'The Star-Spangled Banner'); prejudices had to be exploited (against élitist modernists as well as city bankers); and communications had to be opened through literature, the visual arts and especially folk music. The sphere of culture became central, rather than peripheral. Culture also became political, rather than merely aesthetic; but the *Partisan Review* intellectuals argued that it was losing its critical edge.

Clement Greenberg, later to champion the Abstract Expressionists, took up the theme of mass culture in his essay 'Avant-Garde and Kitsch', published in *Partisan Review* in 1939. He attacks a cosy, representationalist art that could all too easily be co-opted by both the Soviet and the American versions of mass culture. Also in the pages of *Partisan Review* in the late 1930s and the 1940s we find parallels to Greenberg's argument in essays on literature and cinema by Philip Rahv (one of the editors), Dwight Macdonald, Lionel Trilling, Fred Dupee and others. Their 'heroes' are not the ordinary people who populate the novels of Steinbeck, but the artist, and often the most unlikely artist – the cosmopolitan Henry James or T. S. Eliot, writers with conservative political views. These writers took on a heroic and a politically radical character precisely because – according to the *Partisan Review* critics – the difficulty of their work resisted the incorporating logic of capitalism and communism. It would be hard to turn 'late' James or the austere Eliot into the man in the street so central to Popular Front thinking. Although we can glimpse here the reasoning that was to permit many American intellectuals to abandon politics and become entangled with the High Art apostles disdainful of mass culture who dominated the 1950s, it is important to note that for Greenberg, who was trying to define what a socialist art could be, it was the kind of policy espoused by the Popular Front that represented an abandonment of political radicalism. Similarly, Dwight Macdonald cited the films of the Soviet director Sergei Eisenstein as political cinema that was true to the specificity of its medium. Montage, Mcdonald explained, drew attention to the constructedness of a film and so was quite different from the seamless product perfected by the Hollywood studio system in the 1930s. Thus, the *Partisan Review* editors and contributors – later more generally known as the New York Intellectuals – had their Left credentials *enhanced* by their anti-Stalinism. It was in 1938 that *Partisan Review* courted and defended Leon Trotsky for his opposition to Stalin and for his advocacy of an art that was revolutionary by being experimental and avant-garde rather than by toeing the Party line.

The events of the late 1930s help us to understand how the relationship between culture, politics and society changed for American intellectuals. The Spanish Civil War was *the* cause of the decade, yet it ended in defeat and with suspicions aroused at the role the Communists had played. Meanwhile, news of the Moscow Trials – those 'ferocious surprises', according to Philip Rahv – led to painful divisions. Dwight

Figs. 4, 5 Walker Evans, cotton farmers in
Alabama, 1941

Macdonald and Malcolm Cowley fell out sharply, the latter offering only expedience
(the USSR had to be defended against the threat of Hitler) as an explanation for not
abandoning the Party over the executions and imprisonments ordered by Stalin. But
this argument was undercut in 1939 with the Nazi-Soviet Non-Aggression Pact, and
the disillusion completed by subsequent revelations about the Soviet labour camps.
The Second World War – at least after Pearl Harbor in 1941 and the first reports of
the Holocaust in 1942 – did not divide intellectuals as the first had, though Macdon-
ald maintained the tradition of independent thinking associated with Bourne and
Thoreau in his 1939 essay 'War and the Intellectuals: Act II', published in *Partisan
Review*.

The Post-War Years: Pluralism, Consensus and Critique

The intellectual inheritance of the 1930s was, then, twofold. First, left-wing thinkers
felt a strong sense of betrayal. In the subsequent reaction against extremism, com-
munism seemed the other end of the spectrum from fascism, while Hegelian Marx-
ism, according to another radical about to turn away – James Burnham – was
'totalitarianism in philosophy'. The shocks of the 1930s sent American intellectuals
in a determined search for centrist positions, a toughened liberalism which, for Burn-
ham, Irving Kristol and Sydney Hook, modulated towards an even tougher neo-
conservatism. The other leitmotiv to resurface from the 1930s was modernism itself,
in a variety of guises, but usually crisis versions that signalled the end, or loss, of long-
standing narrative and aesthetic forms. By tracing the conjunction of these two
themes, we can better grasp the tension between American intellectuals and capital-
ist society. There was also a geography to this tension. While the strongest case can
be made for the diversity of mid-century intellectual life, it had become concentrated
in New York at a time when the fabric of everyday life was being woven in many dif-
ferent places, mostly new suburbs and expanding Western and Southwestern cities.

In *The End of Ideology* (1960), a collection of essays written during the 1950s, the
sociologist Daniel Bell documents the loss of faith in grand designs, Marxism being
the closest to his own personal history and to that of his contemporaries and Old Left

mentors among the New York Intellectuals. These 'twice-born' intellectuals (born into communism and born again out of it) were not simply in reaction. They were also asking what would replace absolute historical explanations. The glib answer is 'America' or 'Americanism': Dwight Macdonald's remark that, 'Reluctantly, I chose America' is usually interpreted as the final proof of de-radicalization and of acquiescence. But this is too simple an answer (as is the parallel explanation, by Serge Guilbaut, in *How New York Stole the Idea of Modern Art*, 1983, for the triumph of Abstract Expressionism as a CIA-funded symbol of American freedom). It underplays both the betrayals of the 1930s – intellectuals with the benefit of hindsight really ought to ask what they would have done if faced with a similar switchback of events and choices – and the difficulty then – and perhaps even now – of locating 'actually existing socialism', let alone communism. This is not to say that some intellectuals did not embrace centrist and even neo-conservative positions with unseemly haste, giving credence to McCarthyism and attending government-sponsored congresses and symposia on cultural freedom. Ex-radicals made some of the most rigorous Cold Warriors in the 1950s. But, for others, the rethinking that went on between the mid-1930s and the late 1950s was not just painful but thoughtful and offered important non-Marxist redefinitions of politics and culture, as well as ways out of the consensus politics of the 1950s.

In *The Lonely Crowd* (1950) David Riesman shares, with Daniel Bell, the conviction that only a structured political pluralism could keep at bay the feared messianic drive towards total power. Post-war intellectuals looked back to Alexis de Tocqueville's American primer on the coming of mass society, the two-volume *Democracy in America* (1835 and 1840), for the value of free associations or, as they came to be called, interest or veto groups. These created a shifting set of alliances rather than ideological blocks, encouraged the dispersal of power into issue-based groups and therefore functioned as a bulwark against a homogenized and manipulatable mass society. Nevertheless, *The Lonely Crowd* hardly reads like a celebration of America as the ideal society and Tocqueville's fears about mass society are translated into cultural terms. As Riesman's title suggests, the amorphousness that made American politics infertile ground for totalitarianism also resulted in uncertainties and a loss of direction. Sociologically, there is an anxiety about personal identity in an 'other-directed' society, allied to a superficiality that was all too plain in the world of advertising, which Riesman describes in certain sections of his book.

Riesman's misgivings about mass culture appear fully formed in the essays of Dwight Macdonald and other New Yorkers. This suggests that cultural anxieties about the pre-digested products of the media industry were the residue of radicalism left over after these intellectuals' political reconciliation with American society. The link between politics and culture that had been so productive in their 1930s work became side-tracked into a stale élitism. Macdonald's best-known essay, 'Masscult and Midcult' (1962), could well be his least perceptive. However, the gulf between the New Yorkers and American culture was never so wide as in the work of exiled Frankfurt School theorists. For Theodor W. Adorno and Max Horkheimer, Hollywood exerted a quasi-totalitarian control over American society. Marxists with little confidence in the working classes as an agent of change, Adorno and Horkheimer dissected a 'culture industry' that disseminated its message of democracy and abundance so effectively that even resistance could be accommodated in the typical Hollywood or soap opera ending. If the New York Intellectuals were in danger of losing their *political* critique of mass culture, this being the legacy of Bourne and *Partisan Review* in the 1930s, the problem with the Frankfurt School was that they interpreted American society through the lens of their experiences with German totalitarianism.

We can observe in other key post-war American books a tension comparable to that in Riesman's *The Lonely Crowd*. On the one hand, a celebration of political pluralism and lack of apparent ideological strife; on the other, a recognition of certain shortcomings in American society and history. In *The American Political Tradition and the Men Who Made It* (1948) Richard Hofstadter observes how, underlying an often tempestuous political history, there is a reassuring commonality of vision across the

political spectrum. Ever since the constitutional debates of the 1780s there has been an unquestioning acceptance of the value of private property, economic individualism and competition. With another leading historian, Daniel Boorstin, the tension appears in between two of his books. In *The Genius of American Politics* (1953) anti-intellectualism in the United States is almost lauded because, in Boorstin's reasoning, the more acute and wide-ranging the political analysis (the more Marx, the more Rousseau, and so forth), the more unhealthy the political climate. Fortunately, in *The Image* (1962) Boorstin ignores his own injunctions and analyses the American media's power to create news and spread self-deception – an approach that undermines the complacent nationalism of his earlier study.

As already remarked, a characteristic of post-war thinking was the surprising coalescence in the social sciences of theorizing about what a non-totalitarian society should be and a modernist sensibility. Where the former was cautiously optimistic in outlook, the latter, if not pessimistic, was at least beset by (in Daniel Bell's words) 'irony, paradox, ambiguity, and complexity'. Perhaps more accurately, these former radicals were drawn to a *late* modernist outlook because – despite certain traits familiar from the 'classic' modernism of the 1880s to the 1920s (alienation; fear of, and fascination with, the new; antipathy towards mass culture) – this was an outlook revived by the double shock of the collapse of capitalism and the failures of socialism. Often, when reading the canonical political, historical, social and economic works of mid-century America, we are brought up short by the language of aesthetics and a sometimes weary, yet always experienced, voice warning against the tragic limitations of rationality, while asserting that some progress could come out of the tension between possibilities and realities. The voice is that of Arthur Schlesinger Jr., who, in *The Vital Center* (1949), wrote: 'By making choices, man makes himself: creates or destroys his own moral personality. This is a brave and bleak dilemma. But such a philosophy imposes an unendurable burden on most men. The eternal awareness of choice can drive the weak to the point where the simplest decision becomes a nightmare. Most men prefer to flee choice, to flee anxiety, to flee freedom.'

Schlesinger's modernism has a decidedly Existentialist feel. At times, the philosophical rhetoric seems intended to give a tautness to a position – liberalism – that has not generally been associated with risks or commitments. Moreover, the Existentialist idea of the freedom to make oneself could, and did, become merely a gloss for a self-interested choice in favour of American individualism. A more generous interpretation of Schlesinger's rhetoric, however, is that it reflected the pervasive anxiety of the post-Second World War years (Riesman's image of a lonely crowd has a real resonance for the period), together with the need to define a position without the props of established ideologies. With no credible templates to place upon existence, the modernist indeterminacy of meaning became an available mode of thought to intellectuals. In *Irrational Man: A Study in Existentialist Philosophy* (1958) William Barrett, a post-war editor of *Partisan Review*, acknowledges a certain sombre quality 'which went against the grain of our native youthfulness and optimism'. Nevertheless, Barrett sees in Existentialism both a necessary check upon that optimism, which had been powerless to prevent totalitarianism, and an encouragement to those who had come through the illusions of the 1930s, reborn on the dangerous 'tightrope of American liberalism', as Schlesinger puts it. Hemingway is the only American writer discussed by Barrett in *Irrational Man*, though there was an Existentialist strain in post-war American literature, notably in *Dangling Man* (1944) and *Seize the Day* (1956) by Saul Bellow, himself a contributor to *Partisan Review*, and in 'The White Negro' (1957) by Norman Mailer, though Mailer eschews European social types in favour of 'the American existentialist – the hipster'.

Although social and political scientists may be bemused, one way to distinguish between the important non-aesthetic texts under discussion is to look at the versions of modernism to which they directly or indirectly refer. Appropriately, we are helped here by the art critic Harold Rosenberg. He also came out of the 1930s, but was less drawn to the reconciliatory, tragic modernism that had attracted many post-war intellectuals because it seemed sufficiently comprehensive to contain all points of

view, yet experienced enough to recognize the dangers of totalizing ideologies. Instead, Rosenberg, while sharing his contemporaries' acute sense of historical crisis, found in his contact with those he calls the 'American action painters' the impetus to break out of the enclosed consensual spaces of post-war thought. Where Riesman and Bell, writing about mid-century interest-group politics, recommended negotiated responses (progress 'on the diagonal', Bell called it), Rosenberg, writing about the Abstract Expressionists, evokes a radical, participatory politics which would not (re)appear until the street protests of the 1960s: 'At a certain moment the canvas began to appear to one American painter after another as an arena in which to act – rather than as a space in which to re-produce, re-design, analyze or "express" an object, actual or imagined. What was to go on the canvas was not a picture but an event.' Where Clement Greenberg, the other great critic of Abstract Expressionism, defined an avant-garde according to the degree of attention to the form and medium, Rosenberg's experiential, phenomenological modernism was more dynamic, 'an event' potentially capable of being activated by events other than those contained within art history.

Up from the 1950s

To appreciate the social and political importance of Harold Rosenberg's notion of 'action' we may turn to the exiled German thinker Hannah Arendt (Fig. 6) and to a text of hers that probably did most to confirm American intellectuals in their commitment to non-ideological politics. Yet Arendt, in *The Origins of Totalitarianism* (1951), amazingly, did not allow her experiences of totalitarianism to create blanket judgments on the value of mass movements. For her, the genealogy of totalitarianism included, crucially, the loss of public political space in the nineteenth century. That empty arena had then been filled by ideology and terror and by masses of people, whether victimizers or victims. Those post-war American intellectuals who, understandably, saw totalitarianism as the antithesis of private life and who latched on to only the consequences of 'massification' found themselves intellectually caged – unable to interpret political participation other than in the shadow of totalitarian regimes. It was hardly surprising that many of the New Yorkers found it hard to support whole-heartedly the kinds of political action that became widespread with the Civil Rights Movement, the new Women's Movement, the Counter-Culture and the protest marches against the Vietnam War. To propose a generation gap is to miss the intellectual explanation for their suspicion of public action.

However, a few post-Second World War intellectuals can be singled out because they continued to ask the difficult questions: Paul Goodman in *Growing up Absurd* (1960), Dwight Macdonald in his editorship of *Politics* between 1944 and 1949, Michael Harrington in *The Other America* (1962) and C. Wright Mills. Replying to David Riesman's sympathetic account of interest-group politics, Mills raises, in *The Power Elite* (1956), the old questions of power. Who decides on the limits of political action and under what circumstances (asking this during the Cold War echoed Bourne's statement that 'war is the health of the State')? Why should politics not coalesce along ideological lines, since it clearly did within the power élite? Much of Mills's book is devoted to arguing that, in spite of the busyness of day-to-day politics, the lobbying and shifting alliances, power has continued to be concentrated at the top, with an illusion of democratic decision-making at intermediate levels, and a growing underclass at the bottom – Harrington's 'other America'. Against what he sees as a structural, rather than personal, conspiracy in American society Mills opts for the participatory politics advocated by Arendt in *The Human Condition* (1958). In his 'Letter to the New Left' (1960) Mills also revives the idea of utopianism, which had seemed so dead in the post-war years. Thinking other than responsibly and realistically could be emancipatory.

Having claimed much for the intellectual life of the 1950s, it is worth briefly outlining some of its legacies. The 'break-out' of the 1960s and 1970s, although often

Fig. 6 Hannah Arendt

attributed to demographic and sociological factors and sometimes dismissed as anti-intellectual in its drug and generational dimensions, was at least informed by critiques of consensus politics by Mills, Arendt, Goodman, Macdonald and Harrington. However, the subsequent disappointments and defeats experienced by 1960s radicalism (which actually date back to 1968, but gathered pace in the 1980s) have, as in the 1950s, produced a certain amorphousness in contemporary political culture. This has worked to the advantage of those in power. Since 1979 and Christopher Lasch's *The Culture of Narcissism* there have been a series of cultural jeremiads, the most recent being J. K. Galbraith's despairing *The Culture of Contentment* (1992). It is true that the idea of micro-politics has energized many marginal groups, and while radicals would not acknowledge the link, there are some similarities to the more positive aspects of 1950s interest-group politics, with its notion of incremental gain. But talk of 'the end of history' (to some extent Francis Fukuyama is recapitulating Daniel Bell) has once again made the big questions about power difficult to ask. Intellectuals have reduced ambitions and mostly seek productive ways to inhabit and (another 1950s echo) negotiate the institutions of a post-modern society. That many intellectuals are now academics, with their own battles over curricula and funding to fight, has accentuated this turning inwards. However, since the mid-1980s there has been a renewed interest in broader, ethical questions concerning rights and the motivation of political action. After the shift of intellectual authority to Europe, it is noticeable that American intellectuals have been looking for productive ways to link their own concerns with those of Jacques Derrida, Michel Foucault, Jean-François Lyotard and others. The philosopher Richard Bernstein has given an important lead. And it is significant that in his most recent book, *The New Constellation* (1991), he chooses to explain what is at stake by summarizing an important lesson taught by Hannah Arendt in the 1950s: 'It is action which is exhibited in the public space of political debate, action that presupposes the human condition of plurality and natality that is the highest form of the *vita activa*....We have become blind and forgetful of what is distinctive about action, and are on the verge of becoming a "laboring society." But [Arendt's] analysis of action is intended as an act of retrieval, to reveal a possibility that can never be completely obliterated.'

Bibliographical Note

The last part of this essay owes a great deal to Richard King's advice and to two essays by him in particular: 'Endings and Beginnings: Politics in Arendt's Early Thought', *Political Theory*, vol. 12 (1984), pp. 235–51, and 'The Rosenberg Case', *Over Here: Reviews in American Studies*, vol. 11, no. 2 (Winter 1991), pp. 85–103. For more general accounts of America and American intellectual life at mid-century, readers may consult the following: Paul A. Carter, *Another Part of the Fifties*, New York, 1983; Carl N. Degler, *Affluence and Anxiety: American Society Since 1945*, Glenview, IL, 1968; John P. Diggins, *The Proud Decades: America in War and Peace, 1941–1960*, New York, 1988; Rochelle Gatlin, *American Women Since 1945*, London, 1987; Geoffrey Hodgson, *America in Our Time From World War II to Nixon: What Happened and Why*, London, 1976; William E. Leuchtenberg, *A Troubled Feast: American Society Since 1945*, Glenview, IL, 1979; Douglas T. Miller and Marion Novak, *The Fifties: The Way We Really Were*, Garden City, NY, 1977; Richard H. Pells, *The Liberal Mind in a Conservative Age: American Intellectuals in the 1940s and 1950s*, New York, 1985; Michael Paul Rogin, *The Intellectuals and McCarthy: The Radical Spectre*, Cambridge, MA, 1977; Andrew Ross, *No Respect: Intellectuals and Popular Culture*, London, 1989; Douglas Tallack, *Twentieth Century America*, London, 1991; Alan M. Wald, *The New York Intellectuals: The Rise and Decline of the Anti-Stalinist Left from the 1930s to the 1980s*, Chapel Hill, NC, 1987.

Abraham A. Davidson

The Armory Show and Early Modernism in America

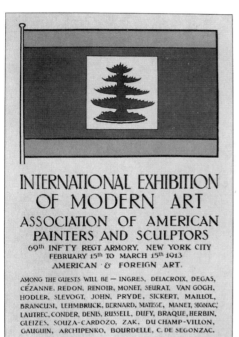

Fig. 1 Poster for the Armory Show, New York, 1913. Hirshhorn Museum and Sculpture Garden, Smithsonian Institution, Washington, DC

The International Exhibition of Modern Art of 1913, popularly known as the Armory Show because it was held from 17 February to 15 March at the 69th Infantry Regiment Armory in New York,[1] was far-reaching in its impact. Between 62,102 and 75,620 people[2] paid to see some 1,300 European and American works, beginning chronologically with a miniature by Goya and extending to the present. Thus, the Show was an extravaganza (see Figs. 1, 2). Although there were large gaps – the Futurists as a group excluded themselves – the Show represented many of the major artists and most adventurous positions from the end of the nineteenth century up to 1913. Of the Europeans, for example, there were fourteen Cézannes; nine Henri Rousseaus; eighteen Van Goghs; eight Picassos, including three drawings or paintings from 1910 to 1912 (and a 1909 bronze head), all in the 'analytical' Cubist style; a non-objective *Improvisation* by Wassily Kandinsky; and four Marcel Duchamps, including *Nude Descending a Staircase* (Fig. 3), which became the most censured of all the pieces. Of the late-nineteenth and twentieth-century Americans, there were many works by the Ashcan group; and of the modernists, there were ten watercolours by John Marin, four of them showing the newly erected Woolworth Building; three pieces, including two Fauve landscapes, by Alfred Maurer (who was still in France); three oils and a plaster by Andrew Dasburg; eight landscapes and an interior in a very free-flowing manner by the Philadelphian Arthur B. Carles; four still-lifes by Patrick Henry Bruce; five watercolours by Stuart Davis, still painting in an Ashcan mode; and a nearly non-objective piece by the Chicagoan Manierre Dawson, added to the Show when it was held in Chicago from 24 March to 16 April. Other American modernists, or modernists-to-be, included Marsden Hartley, Joseph Stella, Albert Ryder, Oscar Bluemner, Morton L. Schamberg, Charles R. Sheeler, and William and Marguerite Zorach.

The Show was also important for the purchases made by private collectors, which would later pass into the public domain and form the beginnings of prominent museum collections of modernist art. These collectors included Dr. Albert C. Barnes; Lillie P. Bliss, who bought works by Cézanne, Gauguin, Redon, Renoir, and Vuillard;

Fig. 2 View of the Armory Show, New York, 1913

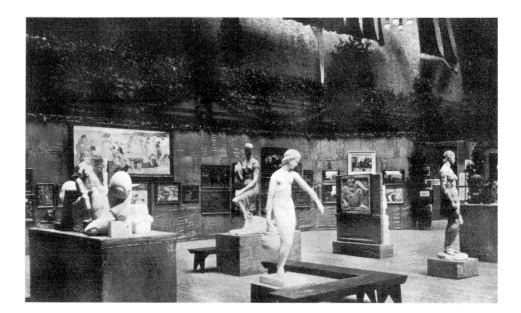

1. The most complete account, by far, of the exhibition is Milton W. Brown, *The Story of the Armory Show*, Greenwich, CT, 1963.
2. Ibid., p. 95. As Brown points out, complicating factors, such as free admissions, make it impossible to determine the exact figure.

John Quinn and Arthur J. Eddy, who acquired, respectively, thirty-one and twenty-three pieces; and Walter C. Arensberg. (The American modernists or modernists-to-be were not then considered purchase-worthy, and only a 1912 landscape by Schamberg was sold.) Finally, the Show converted two American painters – Stuart Davis and Henry Fitch Taylor – to modernism. It is instructive, in this regard, to compare a picture such as Davis's 1913 saloon scene *The Back Room* (Whitney Museum of American Art, New York), in a dark Ashcan style in which the atmosphere of the time and place is wonderfully evoked, with his 1917 *The President* (Fig. 4), which is in an 'analytical' Cubist style, although without the subtle oscillation, merged planes and triangular scaffolding found in the corresponding work of Picasso and Georges Braque.

There were some three dozen American modernists, painters and sculptors working in the second decade of the century, and each has his, or her, own story. But, so far as is known, Davis and Taylor were the only ones who converted expressly as a result of the Show. We do not know for sure which of the modernists actually walked through the aisles and/or read some of the many reports on the Show, but we may surmise that all those in or near New York, or Boston or Chicago, when the exhibition was held there, did one of the two. Some of the modernists were in France at the time, such as Bruce (who lived there continuously from 1903 to 1936 except for a visit to America in 1905), John Covert, Maurer and H. Lyman Sayen, while Hartley was in Munich and Berlin; they, of course, could not attend. Yet even in Europe, American painters would have known something of the Show. Generally, either experience or even merely knowledge of the Armory Show would have encouraged and assured those artists in Europe and America who had already committed themselves to avant-gardism that they had not embarked on some solitary venture.

Pre-dating the Armory Show, the earliest American modernists included the Synchromists-to-be, then in Paris: Stanton Macdonald-Wright, from Charlottesville, Virginia, and Morgan Russell from New York. Having worked his way through

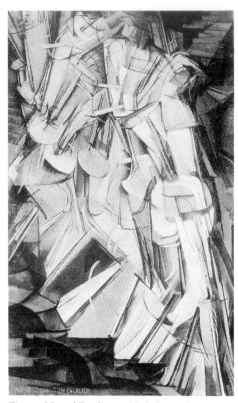

Fig. 3 Marcel Duchamp, *Nude Descending a Staircase*, 1912. Philadelphia Museum of Art; The Louise and Walter Arensberg Collection

Fig. 4 Stuart Davis, *The President*, 1917. Munson-Williams-Proctor Institute, Utica, NY

3. Gail Levin, *Synchromism and American Color Abstraction 1910–1925*, New York, 1978, pp. 10–27. Also Marilyn S. Kushner, *Morgan Russell*, Montclair, NJ, 1990.
4. Levin, op. cit., p. 43, suggests Kandinsky's influence.
5. See Anne Lee Morgan, *Arthur Dove: Life and Work, With a Catalogue Raisonné*, Newark, NJ, n.d., pp. 40–3.
6. See Mary Gedo, *Manierre Dawson*, exhibition catalogue, Chicago, Museum of Contemporary Art, 1976.
7. In 1908, because of a rise in the rent, Stieglitz moved from 291 Fifth Avenue across the hall to 293. The wall was removed, and one elevator was used for the two buildings. Stieglitz, though, continued to use the name '291', which he found more euphonious.
8. William I. Homer, *Alfred Stieglitz and the American Avant-Garde*, New York, 1977, p. 165.
9. See Brown, op. cit., p. 268.
10. See Dorothy Norman, 'An American Place', in Waldo D. Frank et al., eds., *America and Alfred Stieglitz: A Collective Portrait*, Garden City, NY, 1934, pp. 126–7.
11. Quoted ibid., p. 137.

a dependence on Cézanne and declaring that 'light is projection and depth – not a balance of forms around a center as sculpture', Russell, as Gail Levin and others have shown,[3] was by 1912 basing his painting on sculptures, specifically on plaster casts of Michelangelo's Pietàs and Slaves, which he broke up into a series of flattened, abstracted areas, making the sources virtually unrecognizable (see Fig. 5). In 1912, probably in New York, Max Weber painted a pastel consisting of brown, blue, green and yellow swirling shapes which he called *Music*.[4] Nor was this the first non-objective painting by an American. Two years earlier, Arthur Garfield Dove, from rural upstate New York, produced a number of non-objective pieces meant to be seen as parts of a series.[5] In paintings of the next year, going back to childhood memories, he used biomorphic shapes vaguely suggestive of horses, of leaves and of trees in a meadow. In 1910, too, Manierre Dawson, a designer and architectural draughtsman in Chicago, probably derived the arcs, squares and protruding hill forms in his non-objective *Prognostic* (Fig. 6) from devices used in his profession.[6] Thus, a great deal was going on even before the Armory Show.

Contributing more directly than the Armory Show to the unfolding work of certain American modernists were two New York 'salons': Alfred Stieglitz's gallery 291 at 293 Fifth Avenue[7] and Walter C. Arensberg's apartment at 33 West 67th Street, in which he settled in early 1914, having moved from Boston. Arensberg wished to be near the artists and ideas that had stimulated him when he visited the Armory Show on its last day in New York.

Stieglitz, a leading photographer, at first devoted his efforts to his own work and to the promotion of other photographers. By 1907, however, six years before the Armory Show, he had also begun to show paintings and drawings by European and American modernists. Noteworthy exhibitions of the former included those of Rodin's drawings in 1908 and his drawings and watercolours in 1910; Cézanne's watercolours and Picasso's first one-man show in 1911; and Henri Rousseau's paintings and drawings in 1910. Among the American modernists to whom he gave one-man shows were Hartley in 1909; Marin in 1910; Weber in 1911; and Carles, Abraham Walkowitz and Dove in 1912.

Stieglitz was not invited to help with the organization of the Armory Show, as William Homer has pointed out,[8] although he lent three pieces to it – the Picasso bronze, a charcoal drawing of 1910 by the same artist and a Matisse drawing (he may have lent six drawings by Matisse, only one of which was hung)[9] – and purchased five items from it. Also, some of the artists he was promoting were presented in it. He did not, of course, oppose the Show – he knew that it vindicated what he had been doing – but temperamentally he was not comfortable with its size and its appeal (accompanied by a great deal of ballyhoo) to a mass, largely uninformed public. Rather than 'push' modernism, Stieglitz often held back, presuming that not everyone was capable or even worthy of absorbing the wonderful secrets it had to impart. He gave 291 the air of a mystical shrine. He did not have his gallery listed in the telephone directory, and would tell those he did not favour that he had nothing for sale.[10] Neither did he ask for a standard commission, and even helped support his artists with his own funds or with funds that he solicited.

Though Stieglitz did not proscribe specific styles, he was clear in insisting that the artist's authentic personality be revealed through his work. One artist's work, then, should not be like another's. He opposed classifications of art, scoffing at those who would set up stylistic categories: 'It is as if there were a great Noah's ark in which every species must be separated from every other species, so that finally… they would fall upon one another and kill each other.'[11] Hence, the goal of 291, the enhancement and promotion of individualism, was diametrically opposed to that of the Armory Show, which was to trace the overall development of European and American art over a span of about one hundred and ten years.

Yet varied as the styles of Stieglitz's American modernists were, certain general approaches were approved. These included biomorphic stylizations of landscape motifs (Dove, Georgia O'Keeffe), Cubist passages within city scenes (Marin, Walkowitz, Weber), Fauve-like landscapes (Maurer), still-lifes in a 'synthetic' Cubist man-

Fig. 5 Morgan Russell, *Study after Michelangelo's 'Pietà'*, 1912. Montclair Art Museum, Morgan Russell Archives

Fig. 6 Manierre Dawson, *Prognostic*, 1910. Milwaukee Art Museum

Fig. 7 Max Weber, *Chinese Restaurant*, 1915.
Whitney Museum of American Art, New York

ner (Hartley) and non-objective configurations evoking landscapes (O'Keeffe), music in general (Dove, O'Keeffe) or specific musical compositions (Dove; see Cat. 34). Stieglitz, in the main, favoured work which was lyrical, expressive and responsive to the throbbing activity of the city as well as to the fecundity and expansiveness of nature. What was not tolerated were the strictly conceptual approaches nurtured in the Arensberg circle.

In a small format, O'Keeffe, through mere curves and arcs, could suggest a vast terrain, something in the order of the seemingly endless plains she must have known around the place of her birth in Sun Prairie, Wisconsin (for example, *Light Coming on the Plains No. II*, 1917; Amon Carter Museum, Fort Worth). Later, she would push flowers to the frontal plane and, by eliminating their landscape context, present them as a looming presence. Yet the flowing curves, as in *Black Iris III* (1926; Fig. 1, p. 47), make for distinct allusions to female sexual organs, allusions that O'Keeffe herself adamantly denied. Marin moved from his tiltings of structures early in the second decade of the century to tiltings *plus* Cubist-like interpenetrations of buildings to capture the excitement and, perhaps, the vertigo one would then have felt among, or even above, the skyscrapers being erected in New York (see *Lower Manhattan [Composing Derived from Top of Woolworth]*, 1922; Museum of Modern Art, New York). Weber depicted the interiors as well as the exteriors of buildings, as in his 1915 *Chinese Restaurant* (Fig. 7), by using kaleidoscopic arrangements of flattened planes that represent parts of the architecture, and pressed together figures or fragments of figures in a manner suggesting the influence of Italian Futurism. However, as L. D. Henderson has convincingly argued, Weber was here responding to the then widespread theoretical discourse about the fourth dimension.[12] Hartley, interested in the mystical significance of numbers, used numerals in his *Portrait of a German Officer* (Cat. 1), a painting of flags, epaulets and other accoutrements of a Junker officer. The objects alluded to the heroic German aviator and Hartley's probable lover, Karl von Freyburg, whose initials are displayed at the lower left. Levin discovered that the numbers and the triangular form at the top relate to the friendship of the two men with Arnold Ronnebeck, who also served in the German military forces.[13]

Arensberg, who graduated from Harvard in 1900, was interested in the hidden meanings of Dante's *Divine Comedy*, and in mental games, puzzles and esoteric matters in general. It was not surprising, then, that Duchamp – one of the most cerebral of artists, who wanted to 'put painting at the service of mind' – and that French adventurer, the iconoclastic Francis Picabia (who had four oils in the Armory Show and whose sixteen *New York* studies were shown by Stieglitz immediately afterwards, from 17 March to 15 April 1913), became, in effect, the 'high priests' of his salon. They directed their American followers to new departures in art.

12. Linda Dalrymple Henderson, *The Fourth Dimension and Non-Euclidean Geometry in Modern Art*, Princeton, 1983, pp. 175–8.
13. Gail Levin, 'Hidden Symbolism in Marsden Hartley's Military Pictures', *Arts Magazine*, vol. 54, no. 2, 1979, pp. 154–8.
14. See William A. Camfield, 'The Machinist Style of Francis Picabia', *Art Bulletin*, vol. 48, nos. 3/4, 1966, p. 314.
15. See Michael Klein, *John Covert, 1882–1960*, Washington, DC, 1976.

Fig. 8 Man Ray, *Marcel Duchamp's Studio, 33 West 67th Street, c.* 1917–18

Fig. 9 Francis Picabia, *Ici, c'est ici Stieglitz*, 1915. The Metropolitan Museum of Art, New York; Alfred Stieglitz Collection

Both Duchamp and Picabia passed from Cubist styles to a vision which, by 1915, had become clearly Dadaist in flavour. That year Picabia did a series of 'machine portraits', in which fantastic or real machines (a portable lamp, a sparking plug, and so forth) alluded to specific people through the appropriateness of the machine to their personality or vocation. In one of these (Fig. 9) he 'portrayed' Stieglitz as a camera-automobile, in which the twisted bellows was flaccid and the gear-lever and brake were in the parked position, an indication that the proprietor of 291 had come to a standstill as a leader of the avant-garde.[14] By 1915 Duchamp had entirely given up painting for the production of ready-mades, unaltered factory-made products – a urinal (Cat. 22), a bicycle wheel, a hat-rack (see Fig. 8) – that shocked by being presented as art objects, and of various assemblages, the most ambitious of which was the so-called *Large Glass* (see Fig. 2, p. 27). This consisted of two very large panes of glass split by a horizontal sash; between them were mechanomorphic collages, with those below the sash comprising the animus frustrated in its attempt to impregnate the anima above it.

It should be kept in mind that the American followers of Duchamp and Picabia comprised a small contingent within the much larger assembly of American modernists. And some of them created only a few pieces that were truly conceptual in approach. Early in the decade Schamberg painted bright, Fauve-like landscapes, then icy, flattened, abstracted machine parts, which eschewed the animistic overtones of Duchamp. But his plumbing trap in a mitre box, entitled *God*, made *circa* 1918, just before his death in the influenza epidemic in Philadelphia, was surely inspired by Duchamp's ready-mades. John Covert, a cousin of Arensberg, took over certain stylistic aspects of Duchamp's work while avoiding its deeper meaning. In *Brass Band* of 1919 (Cat. 32) he derived the patterning, the outward thrust of circular forms and the idea for the use of applied string from Duchamp's *Chocolate Grinder*, a version of which was incorporated within *The Large Glass*. But in place of a psychosexual drama, Covert substituted as his subject the outward thrust of such brass instruments as trumpets and trombones.[15] The disturbing aspects of Duchamp's erotically charged art were thus eliminated. Compared to the work of Duchamp and certain other Europeans, there was often an innocence to American modernism before the Depression. It was of a kind perhaps most typically associated with a newly assimilated stylistic and ideological discourse.

The most consistent Dadaist America produced was Man Ray (see Cat. 4–18), who based some of his paintings, ready-mades and assemblages on Duchamp's prototypes. The tiny multiple figure (multiple to convey movement) of the performer at the top of Man Ray's 1916 oil *The Rope Dancer Accompanies Herself with Her Shadows* (Fig. 10), for instance, probably derived from Duchamp's by then infamous *Nude Descending a*

Fig. 10 Man Ray, *The Rope Dancer Accompanies Herself with Her Shadows*, 1916. The Museum of Modern Art, New York

Staircase. A few of the assemblages have an implicitly pernicious quality, as does the ironically titled *Gift* (Fig. 6, p. 199), a flat-iron with protruding carpenter's nails attached at the bottom. Man Ray also made camera-less photographs, placing various objects in a darkroom on the light-sensitive surface of photographic paper.

Duchamp was especially fond of America because it seemed to him to value tradition less than any other country (he observed admiringly that buildings were torn down every generation) and because it venerated machines. The latter became central to his art, but he saw them not as things of power and smooth functioning, but as objects denoting frustration and scepticism. By making the figure in *Nude Descending a Staircase* appear partially as a machine, rather like a Slinky toy, he questioned the free will of human beings by suggesting that their movements were programmed and circumscribed. This work in a Cubist style was maligned not only by the general public, but also by the French Cubists themselves, who were not prepared to adopt a Dadaist stance. Duchamp was eager to produce images that conflated sexual and

Fig. 11 Francis Picabia, *I See Again in Memory My Dear Udnie*, 1914. The Museum of Modern Art, New York

Fig. 12 Man Ray, *Object to be Destroyed*, 1923.
Original lost; photograph by the artist

mechanical energy. In *The Large Glass* – the full title of which is *The Bride Stripped Bare by Her Bachelors, Even* – the nine bachelors at the lower left appear simply as metallic receptacles of their masculinity, while the bride, in the upper half, is a kind of engine.

As indicated, Duchamp's friend Picabia and Man Ray also turned to the machine in the realization of their subjects; but they used it somewhat differently. Duchamp's work was more hermetic than that of the rather reckless Picabia, who managed to incorporate something of his own experience in his art. In *I See Again in Memory My Dear Udnie* (Fig. 11), created a year before his 'machine portraits' and still in a Cubist idiom, he drew on memories of an exotic dancer he had met on a boat trip. The petal shapes call to mind uplifted skirts, the forms like sparking plugs, erect phalluses. Man Ray, the American who, on occasion, came closest to nihilism, lent some of his apparatuses a malicious quality. His *Object to be Destroyed* (Fig. 12) consisted of a metronome with a paper eye attached to its arm; the viewer, following its swinging motion, could conceivably go mad.

The importance of Duchamp's arrival in New York in June 1915 for the subsequent history of twentieth-century American art cannot be overestimated. He left his mark not only on a coterie of early modernists; the whole tenor of art from 1960 to 1980, including Pop, Minimal and Earth art, Post-Painterly Abstraction, Photo-Realism and much else, issued from his dictum of 'putting art at the service of the mind'. By insisting on the primacy of the idea over the image – or at least on an equal emphasis between the two – he became the godfather of everything conceptual in American art.

Some artists – Dove, for example – felt no compunction about being exhibited at 291 and also attending Arensberg's salon. Dove's art, accordingly, had its 'Stieglitz' side and its 'Arensberg' side. The latter featured collages wherein specific individuals or types of individual were 'portrayed' by objects suggesting their character. *Grandmother* (Fig. 13) consisted of weather-beaten shingles, pressed leaves, embroidery and a page from a Bible concordance to denote a grandmother's fragility and religious scrupulousness.

Another salon promoting modernism during the second decade of the century was held at the apartment of Mabel Dodge at 23 Fifth Avenue from 1912 until her departure for New Mexico in 1917. She helped with preparations for the Armory Show. Although she did not exhibit art or publish, as did Stieglitz, with his periodical *Camera Work*, and Arensberg, who financed such little magazines as *Others*, *The Blind Man* and *Rongwrong*, her 'evenings' brought together many members of the intelligentsia and such painters as Marin, Hartley, Dasburg, Picabia and Maurice Sterne.

Fig. 13 Arthur Dove, *Grandmother*, 1925.
The Museum of Modern Art, New York; Gift of
Philip L. Goodwin, 1939

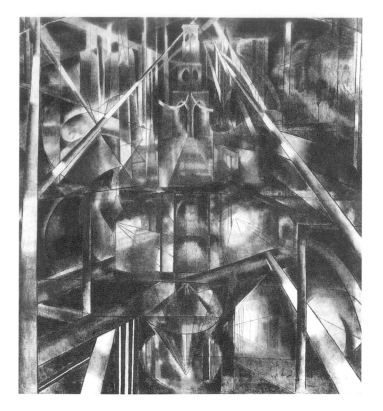

Fig. 14 Joseph Stella, *Brooklyn Bridge*, c. 1919.
Yale University Art Gallery, New Haven,
Connecticut; Collection Société Anonyme

Many of the modernist artists had no association with the salons. One such was Stuart Davis. Another was the Italian-born Joseph Stella (see Cat. 55, 56), who was brought to New York in his late teens, and returned to Italy in 1909 to become the only American intimately acquainted with, and profoundly influenced by, Italian Futurism, especially by the work of Gino Severini.[16] His *Coney Island* series of 1913–14 featured interfused swirls of surging crowds and sections of Ferris wheels. More than any other American painter he rhapsodized over the engineering marvels of New York, declaring, as he stood on the Brooklyn Bridge, that he 'felt … as if on the threshold of a new religion or in the presence of a new DIVINITY'.[17] In his paintings of that structure (see Fig. 14) the spectator looks into the maw-like opening of the spanning cables, the careful draughtsmanship somewhat obscured by the quivering play of violet blues, blacks, yellows and startling oranges. This mingling of urban forces, exhilaration and a certain dark undercurrent captures the inner tensions of America in its First Machine Age.

There were other modernists working in America during the second decade of the century. In the last twenty years no other area of American art has received more attention than early modernism in terms of exhibitions presented, articles and books written, artists rediscovered. And for all its impact, the Armory Show was but one event in a decade of great venturesomeness and accomplishment in American modernist experimentation.

16. See Irma B. Jaffe, *Joseph Stella*, Cambridge, MA, 1970, p. 40.
17. Ibid., p. 58.

Wieland Schmied

Precisionist View and American Scene: The 1920s

No one who approaches the American realists of the 1920s from a European point of view coloured by knowledge of *Neue Sachlichkeit* can help but realize that the American artists set their accents in a quite different way. 'We painted from the outside in', said Ernst Thoms of Hanover, and this was true of almost all realist painters of the Weimar period, whether Magic Realists or protagonists of *Neue Sachlichkeit*, as it was of the related movements that emerged in Italy, France, Switzerland and The Netherlands. The one great exception was the George Grosz of the aggressive, politically committed years.

'We painted from the outside in.' Can one imagine an American realist, a painter of the American Scene or a Precisionist, uttering these words? Hardly, and certainly not in such categorical terms. In the period following the First World War, the Americans evidently concentrated more exclusively than their European counterparts on the 'outside' of things, because it was this 'outside' – the modern metropolis – that made them contemporaries, gave them self-confidence as *Americans* and helped them cut free of the overpowering influence of European tradition. Although the realm of the spirit was not ideologically suspect to them, as it was to Grosz, they largely avoided introspection. In Charles Demuth's work we observe a reticence towards revealing anything of himself; the constructions of Gerald Murphy seem those of a shy man who considered his emotional life to be none of our business; and the stylization to which Charles Sheeler subjected the facades of industrial plants and the surfaces of interiors was probably as much the result of existential insecurity as of artistic choice.

Edward Hopper was an exception. He was never associated with the Precisionists, and among the depictors of the American Scene his rank was absolutely unchallenged. While he was just as retiring as Sheeler, Hopper shared none of the latter's timidity in artistic matters. 'To me, form, color, and design are merely…the tools I work with, and they do not interest me greatly for their own sake', declared Hopper. 'I am interested primarily in the vast field of experience and sensation.'[1] Hopper looked from the outside of things inwards. His seemingly matter-of-fact depictions of a pedestrian silently walking down the street, a man glancing out of the window of an elevated train, a lonely customer sitting in the corner of a diner or a guest hurrying through a hotel lobby (see Cat. 57–63) were actually the result of an aesthetic strategy in which a view into an unfamiliar interior brought insight into the private life of the person who inhabited it. As observers, we have the sense of being caught looking at something not meant for our eyes, something intimate, no matter how mundane, trivial or unimportant the gesture, pose or act of the person depicted.

Yet Hopper was not the only exception among American artists in this respect. Georgia O'Keeffe, too, can be said to have painted 'from the outside in'. During the 1920s she was preoccupied with two subjects: skyscrapers and flowers. Her discovery of New Mexico – its landscape, its adobe buildings and animal skulls – had yet to come (see Cat. 41). O'Keeffe's depictions of flowers, isolated, in strict frontality and enlarged to giant scale, were entirely original in character (see Fig. 1). What surprised her contemporaries about them was not so much the point of view, inspired by close-up photography, as their luminous, 'emotional' colours – yellows, pinks, light blues. However naturalistically precise the renderings of lilies, narcissi, petunias, camelias, zinnias, orchids and so on, the view into the open blossoms evoked an image of the female psyche and invited erotic associations. O'Keeffe herself always denied superficial interpretations of this kind. Nevertheless, her flower imagery conveys some-

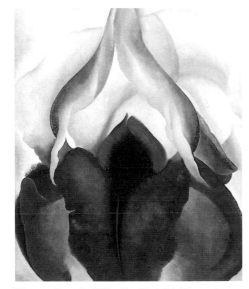

Fig. 1 Georgia O'Keeffe, *Black Iris III*, 1926. The Metropolitan Museum of Art, New York; Alfred Stieglitz Collection, 1969

1 Hopper, letter of 23 October 1939 to Charles Spencer, quoted in Lloyd Goodrich, *Edward Hopper*, New York, 1976, p. 152.

thing of the mysteriously tempting magic of the forms of nature, unfolding in accordance with vital drives – a magic that admittedly vanishes with any attempt to describe its metaphorical essence in concrete terms.

It should be noted that images of flowers and skyscrapers were of equal importance to other artists as well. Joseph Stella and Charles Sheeler also frequently depicted flowers, and floral subjects in watercolour occupied a key position in the oeuvre of Charles Demuth. Even Gerald Murphy, shortly before he gave up painting altogether, devoted himself to flowers, their forms, structure and growth, in numerous written notes for projected works. How American realists and Precisionists of the 1920s viewed and rendered flowers, and what these meant to them, is a topic worthy of an essay in its own right. This subject-matter seems to have provided them with an opportunity of relaxing the rigorous, self-imposed discipline of their approach to reality in order to express more intimate sensations. It is no coincidence that critics, as with O'Keeffe, have detected barely concealed erotic allusions in the floral watercolours of Demuth.

Interestingly, apart from Max Beckmann, very few German artists of the period attached more than marginal importance to flowers. Indeed, the basic difference between German and American realists of the 1920s is that the great German painters of the period – Beckmann, Otto Dix, Grosz, Christian Schad, Rudolf Schlichter and, in a special sense, Oskar Schlemmer – were all consummate observers of the human form and features. In people they found, as nowhere else, the expression of their era. In general, the rest of the world receded, providing no more than a background or an accessory.

With the Americans the situation was exactly the reverse. The human image dominated the work of no more than two artists of significance, Ben Shahn and the eccentric Ivan LeLorraine Albright. Others who depicted the American Scene of the 1920s were more interested in the hustle and bustle of the New York streets, its amusement parks, restaurants, bars and cafés, in people in the mass rather than as individuals. In terms of artistic rank, a Kenneth Hayes Miller, a Reginald Marsh (see Fig. 3, p. 174), a George Bellows, were no more than visual journalists, reporters with the brush. They illustrated rather than shaped their times.

The American artists who today are considered representative of the period, in contrast, were primarily painters of the metropolitan architectural scene. To them, the masterworks of modern civil engineering – skyscrapers, gasometers, power plants, water towers – constituted the physiognomy of the age. These were the subjects that fascinated them. When Sheeler gave canvases titles such as *American Landscape* or *Classic Landscape* (Cat. 54), he was referring to the chimneys, freight wagons, cranes, sidings and canals of the Ford Motor Company's River Rouge Plant. When Joseph Stella called a painting *American Landscape* (Cat. 56), he meant his favourite motif, the Brooklyn Bridge. A similarly motivated title would seem to be Demuth's *My Egypt* (Fig. 2), a rigorously frontal depiction of a grain silo. Such titles have something programmatical, confessional about them. They reflect the consciousness not only of having discovered a new, unique subject for painting, but of having developed a visual idiom adequate to its representation.

This new idiom was America's original contribution to the art of the 1920s. It came to be known as 'Precisionism', a term that was not coined until 1947.[2] Equally widespread is the designation 'Cubo-Realism'.[3] The artists' contemporaries referred to them more frequently as 'New Classicists', or even as 'Immaculates', an ironic allusion to the purity of their style.[4] The term 'Precisionism' is certainly preferable to 'Cubo-Realism'. The painters it is used to describe were realists who had overcome Cubism. While Cubism may have been the point of departure for many of them, by the 1920s traces of it had all but disappeared from their work. With Sheeler, as with most of the others, visible reality was simplified, rendered geometrical and closely cropped, yet it still dominated – even determined – the resulting pictures. In the case of Demuth, who took Precisionism furthest, this image of reality appeared in the form of a crystalline style, originally derived from Cubism, which in Europe was paralleled in the cathedrals painted by Lyonel Feininger (who, incidentally, was born

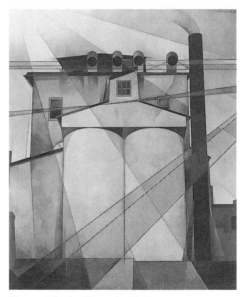

Fig. 2 Charles Demuth, *My Egypt*, 1927. Whitney Museum of American Art, New York; Purchased with Funds from Gertrud Vanderbilt Whitney, 31.172

2 By Wolfgang Born, in his *Still-Life Painting in America*, New York, 1947, p. 44 ff. See also the same author's *American Landscape Painting: An Interpretation*, New Haven, 1948, p. 196 ff.

3 See Milton W. Brown, *American Painting: From the Armory Show to the Depression*, Princeton, 1955, p. 114.

4 See Barbara Haskell, *Charles Demuth*, New York, 1987, p. 135.

5 Sheeler, 'A Brief Note on the Exhibition', in *Charles Sheeler*, exhibition catalogue, New York, Museum of Modern Art, p. 10.

6 Williams, 'Introduction', ibid., p. 8.

in New York). Another parallel is found in Paris, in the Purism of Amédée Ozenfant. Yet despite its high degree of abstraction, Demuth's approach remained far more object-orientated than Ozenfant's. Like all the Precisionists, Demuth never entirely renounced the descriptive function of painting. His aim was apparently to develop the image far enough beyond its source in reality for it to be capable of existing in its own right – but no further.

Seen in this light, 'precision' refers less to verisimilitude of depiction than to the finely tuned organization of the image as a geometrically exact, coherent structure. On the whole, this approach is closer to the principles of constructivist art than to Cubism. Indeed, Sheeler once spoke of the 'architectonic' or 'abstract' structure that ought to underlie every picture, no matter what its subject.[5] Preconceived pictorial structures affected, in turn, subject-matter itself: the envisaged structure focused the artists' gaze on those aspects of reality best suited to its realization. When an adept of the Precisionist view such as Grant Wood attempted to apply it to other subjects – in his case the Midwestern agricultural scene – the results sometimes bordered on the unintentionally comic.

No manifesto, platform or organization linked the Precisionist artists. It was less a style that they shared than a view, a gaze directed at the environment of the modern metropolis, at the reality of daily life in America, which more than anywhere else in the world was dominated in the early 1920s by advanced technologies. There was a special reason for this fascination with the buildings and machinery of the city, with skyscrapers, factories, harbours and bridges. In them the artists recognized something of themselves, of their own character, their identity as Americans. With these structures they had jumped ahead of Europe, surpassed their European models. The products of modern technology thus seemed not only to open up new artistic territory, but also to offer a chance of being creative in a truly American way.

The idea of a genuinely American art was a dream, and a trauma, that did not wait until the Armory Show of 1913 to take shape. Early in the century Robert Henri had proclaimed the unity of art and life, and attempted to draw artists' attention to everyday life in the big city. Yet while the painters of the Ashcan School, especially in their choice of subject-matter, formed an independent, American movement, they were not entirely free of provincialism, even in their finest work. More progressive spirits thus turned to the modern movement in Europe and attempted, like the photographer Alfred Stieglitz in his 291 gallery, to bring examples of it to New York. Such activities were by no means an end in themselves. They were directed less at collectors (still a rare breed in New York) than at artists. The real point was to set standards for art in America and provide new impulses – to stimulate and inspire.

That was also the intention behind the Armory Show, a good two-thirds of which was devoted to the contemporary American art for which it had originally been planned. No acute observer could help but notice the superiority of the canvases by Cézanne and Matisse, Picasso and Braque, Duchamp and Picabia. A few understanding voices corroborated this, yet in general the response indicated that many Americans felt overtaxed, even repelled, by the innovations of these artists.

Years were to pass before an audience receptive to everything new developed in the United States. That this audience began to emerge in the 1920s was not least due to the fact that, by then, much of what was being discussed as modern art was no longer imported from Europe but was entirely indigenous. 'The local is the universal', the poet William Carlos Williams stated in 1939 in the catalogue of a Sheeler exhibition at New York's Museum of Modern Art, and those words soon became a creed for many American arists.[6]

Alfred Stieglitz's later activities reflected this increase in American self-confidence. After having to close his 291 gallery on Fifth Avenue in 1917, Stieglitz reinaugurated it in 1925 as the Intimate Gallery (at 389 Park Avenue), and again in 1929 as An American Place (at 509 Madison Avenue). While 291 had been marked by advocacy of European modernism, Stieglitz now concentrated on the work of contemporary American painters – Marsden Hartley, Arthur Dove, John Marin, Demuth and O'Keeffe, whom he had married in 1924. All these artists, with the exception of

O'Keeffe, had trained in Europe. But they had returned to the United States, had emancipated themselves and found their own styles. The isolation of the war years – in effect, an incubation period – was over, and it was time to make the results of their work public. Stieglitz was convinced that, in their individuality, the works of 'his' artists were equal to those of the greatest Europeans, and he set out to spread this faith as far as he could.

It is really not ironic at all that the task of making Americans aware of the unique aspects of their existence as a subject for art should have fallen to two avant-garde Europeans, Francis Picabia and Marcel Duchamp. Picabia had come to New York as early as 1913, for the opening of the Armory Show. What struck him about the city was not its picturesque atmosphere but the mechanized rhythm of life there, which, to him, signalled the birth of a new aesthetic. 'Your New York is the cubist, the futurist city,' Picabia declared. 'It expresses in its architecture its life, its spirit, the modern thought....I see much, much more perhaps, than you who are used to seeing it.'[7] When he returned to New York two years later, Picabia not only found his first impression confirmed; he also saw a way of translating his experience into art: 'Almost immediately upon coming to America it flashed on me that the genius of the modern world is machinery....In seeking forms through which to interpret ideas or by which to expose human characteristics....I have enlisted the machinery of the modern world and introduced it into my studio.'[8]

Duchamp, in New York since 1915, expressed similar feelings, if far more concisely. He praised America as the land of new technologies and New York as the city of skyscrapers. In an interview given shortly after his arrival, Duchamp described New York as 'a complete work of art'. In his eyes, the city was a perfect ready-made. Nor was this contradicted by a statement, markedly more detached in tone, that he made in 1917: 'The only works of art America has produced are its plumbing and its bridges.'[9] This was the year in which the urinal he had given the title *Fountain*, signed 'R. Mutt' and submitted to the Exhibition of the Society of Independent Artists (Cat. 22) was not displayed but hidden behind a curtain, where it remained undetected until the show closed. The right moment had come, Duchamp thought, to force unseeing Americans to recognize their plumbers' artistry.[10]

At this time American artists, too, were discovering the new aspects of their city, letting themselves be inspired to stylistic experiment by the spirit of its engineering (more as embodied in skyscrapers and bridges than in lavatory fittings à la Duchamp). They celebrated the discovery far more rapturously than Picabia or Duchamp – as if it amounted to an initiation – and were often to describe it later, almost in terms of a religious experience, as an act of self-discovery.

As early as 1913 John Marin wrote in an exhibition catalogue: 'Shall we consider the life of a great city as confined simply to the people and the animals on its streets and in its buildings? Are the buildings in themselves dead? We have been told somewhere that a work of art is a thing alive. You cannot create a work of art unless the things you behold respond to something within you. Therefore if these new buildings move me, they must have life.'[11] The same enthusiastic feelings overcame Joseph Stella when he returned to New York from Europe in late 1912. In his *Autobiographical Notes* he declared: 'Steel and electricity had created a new world. A new drama had surged...a new polyphony was ringing all around with the scintillating, highly coloured lights. The steel had leaped to hyperbolic altitudes and expanded to vast latitudes with the skyscrapers and with bridges made for the conjunction of worlds.'[12]

Marin's words sound more Expressionist in tone, and Stella's more Futurist, than the sober language of Precisionism, and indeed Marin cannot be associated with the Precisionists at all, and Stella only in the widest sense. Yet their experience of the modern metropolis helped pave the way for the Precisionist approach. Marin's statement marked a break with the Ashcan School, and Stella's recollection testified to a focus on the technical, machine-related aspects of the big city (see Fig. 3). Stella had become acquainted with Futurism in Paris, and its pulsating rhythms soon captivated him. The pictures of New York's Coney Island that he did between 1913 and 1918 dissolved its milling crowds and glittering attractions into waves of light or refracted the

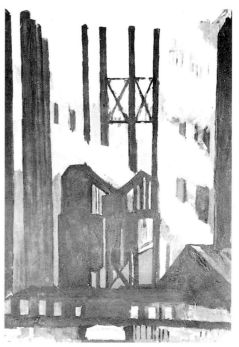

Fig. 3 Joseph Stella, *Steel Mill*, c. 1920. Downtown Gallery, New York

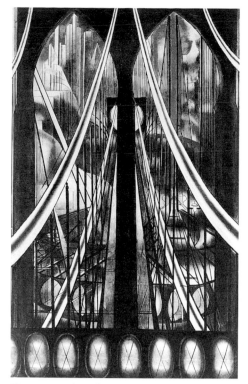

Fig. 4 Joseph Stella, *The Bridge* from *The Voice of the City of New York Interpreted*, 1920–22. Newark Museum, New Jersey

scene in a kaleidoscope of coloured fragments. In 1918 Stella found the subject that was to occupy him more than any other for over two decades: Brooklyn Bridge. Soon he had expunged all Futurist unrest from the motif and developed an individual style which, if it did not sound like a contradiction in terms, one would be tempted to call 'emotional precisionism'.

Many of Stella's canvases of Brooklyn Bridge have the appearance of altar paintings (once he even included the bridge as a side panel in a polyptych entitled *The Voice of the City of New York Interpreted*; Fig. 4). Frequently he added a 'predella' showing a cross-section of underground tunnels through which trains race towards the viewer with blazing headlights (see Fig. 14, p. 46). Through the narrow neo-Gothic arches from which the steel cables of the bridge radiate, we gaze at the illuminated city as if through the stained-glass windows of a cathedral. Brooklyn Bridge is thus transmuted into a gateway leading to a New Jerusalem, the promised city of the future, built with iron, steel and electricity above an underground flickering with the fires of Hell. Stella, by his own testimony, experienced the bridge in just these terms. When he approached it he felt as if he were stepping over 'the threshold of a new religion', as if he were in 'the presence of a new DIVINITY'.[13] And when he painted Brooklyn Bridge he thought of the 'fulgency of a cathedral', of a 'shrine containing all the efforts of the new civilization of America'.[14]

There is less pathos of this kind in Demuth's and Sheeler's work, but the religious overtones of technology are present nevertheless. When Demuth enveloped an industrial plant and its forest of chimneys in clouds of smoke and called the image *Incense of a New Church* (Fig. 5), he was certainly being ironic. Yet the vertical orientation of the architectural elements and the rigorous concentration on blue, black and greyish-white suggest sacred dignity rather than malicious irony, though it might be doubted whether the diagonally rising fumes do, in fact, smell of incense. By the same token, *My Egypt* of 1927 underscores the similarities of grain silos with the great architecture of the past rather than emphasizing the differences. It was far more in keeping with Demuth's character to invest factories, chimneys, water towers and

Fig. 5 Charles Demuth, *Incense of a New Church*, 1921. Columbus Museum of Art, Ohio; Gift of Ferdinand Howald

7 Quoted in Karen Lucic, 'Varieties of Urban Experience', in *The 1920s: Age of Metropolis*, exhibition catalogue, Montreal Museum of Fine Arts, 1991, p. 454.
8 Quoted in Haskell, op. cit., pp. 131–2.
9 Duchamp, in *The Blind Man*, no. 2, May 1917.
10 At Duchamp's instigation, Beatrice Wood (together with H.-P. Roché) issued a periodical entitled *The Blind Man* in New York in 1917. Only two numbers appeared.
11 Quoted in Werner Haftmann, *Painting in the Twentieth Century*, vol. 1, London, 1961, p. 160.
12 Quoted ibid., p. 162.
13 Quoted in Irma B. Jaffe, *Joseph Stella*, Cambridge, MA, 1970, p. 58.
14 Quoted, respectively, in John I. H. Baur, *Joseph Stella*, New York, 1971, p. 36, and Jaffe, op. cit., p. 49.

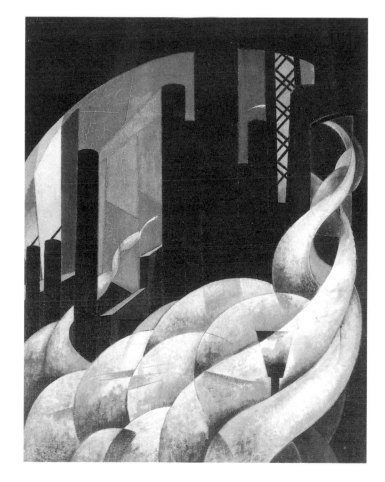

other structures of the Industrial Age with the solemnity of temples or the aura of pyramids, and thus to place his home town of Lancaster, Pennsylvania – a cradle of American industry – in the context of a global creative tradition, than to denigrate or deride the modern environment in which he felt at home. Both ancient Egyptian architecture and the association between factory and church were very much in the air at the time. Le Corbusier and Ozenfant had noted the parallels between grain silos and Egyptian pyramids – a comparison from which the silos by no means emerged the losers. Also, the connection between religion and work was deeply rooted in American thought. Calvin Coolidge, president of the United States from 1923 to 1929, put it with characteristic terseness: 'The man who builds a factory builds a temple. The man who works there, worships there.'[15]

Charles Sheeler thought similarly. One of his photographs of the River Rouge Plant, which preceded the paintings, was interpreted by the critics as 'a cathedral of industry'.[16] For an exhibition at The Museum of Modern Art in the early 1930s Sheeler arranged enlargements of his photographs of the plant in the form of a triptych – in perfect correspondence to the fact that Henry Ford had had the windows of the Rouge powerhouse fitted with lead glazing to invoke the atmosphere of a church. Sheeler himself spoke of factories as 'our substitute for religious expression'.[17] And the foreword to the catalogue of the 'Machine Art Exposition', held in 1927 in New York and organized by Sheeler in conjunction with Demuth, Duchamp, Louis Lozowick and other artists, proclaimed the machine to be 'the religious expression of today'.[18]

The link between factory and church, machinery and religion, had become a cliché. Yet to Sheeler it signified more, despite his reluctance to broadcast his conviction in the manner of, say, Stella. In his view, ethics and aesthetics were inextricably linked. The matter-of-factness of his idiom was the visual equivalent of the strict, Puritan approach to work, in which honesty and responsibility were precepts of the highest order. Through his origins in Pennsylvania, Sheeler had been acquainted with the philosophy of the Shakers from an early age. The connection was noted by William Carlos Williams in his catalogue essay of 1939.[19] For Williams, Sheeler's art had its roots in the same sensibility that informed Shaker furniture, furniture that Sheeler collected and lived with. These pieces appeared again and again in his interior views, their form reflecting the dignity that attaches to genuine craftsmanship. In the straightforward work ethic of the Shakers, its emphasis on utility and truth to materials and its rejection of ornament and high style, Sheeler detected the presence of a cosmic order. In it he was able to rediscover himself. What he attempted to do in the industrial scenes he painted from 1930 onwards was to transpose the God-fearing spirit of the Shakers to the depiction of modern manufacturing plants and their production methods. If for the Shakers daily labour amounted to serving the Lord, why should a faith that drew sustenance from the craft of human hands not extend to the machines and assembly lines that men had created?

This reverent exaltation of the world of machinery, so widespread among American artists of the day, was entirely alien to the representatives of *Neue Sachlichkeit*. The Americans depicted the machine as a symbol of creative force. If machinery interested German painters at all, then only because it was exempt from pain. Their view of the world was marked by profound mistrust, and that goes a long way towards explaining their radical turn to the things in their daily environment, as a last residue that could be depended on. This sensibility reflected more than a reaction to the modern metropolis and to a civilization increasingly dominated by technology. It resulted just as much from an experience that had largely been spared their American counterparts – the experience of the First World War. The war fundamentally transformed the art of Beckmann and Dix, and it shaped that of Grosz and Schlichter. It even exerted a definite, if indirect, influence on the work of those artists who, like Schad, managed to avoid it by crossing the border to neutral Switzerland, where they came under the spell of Dada.

It may be that the experience of war and the attempt to digest its horror had something to do with the odd nervousness with which many German artists embraced stylistic influences – from Expressionism, Futurism, Dada, Metaphysical Paint-

15 Quoted in Haskell, op. cit., p. 136.
16 See Mary Jane Jacob, 'The Rouge in 1927: Photographs and Paintings by Charles Sheeler', in *The Rouge: The Image of Industry in the Art of Charles Sheeler and Diego Rivera*, exhibition catalogue, Detroit Institute of Arts, 1978, pp. 10–18, and Martin Friedman, 'The Art of Charles Sheeler: Americana in a Vacuum', in *Charles Sheeler*, exhibition catalogue, Washington, Smithsonian Institution, 1968, pp. 33–57.
17 Quoted in Haskell, op. cit., p. 135.
18 Quoted ibid., p. 134.
19 Williams, op. cit., p. 8.
20 Andrew Causey, 'Formalism and Figurative Tradition in British Painting', in *British Art in the 20th Century*, Munich, 1987, p. 21.

ing – and then dropped them again to develop *Neue Sachlichkeit* or Magic Realism. And even these styles were subject to relatively rapid change: German paintings of the early 1920s looked different from those of the middle years of the decade, and by its end they had changed yet again. Initially reflecting the disquiet and revolt of an atomized world, they soon exuded the calm of crystal-clear, hard-edged forms, which only a short time later were already becoming less sharply focused. Thus *Neue Sachlichkeit* – to an extent comparable perhaps only with Dada – proves to have been the quintessential expression of a certain epoch. It is as though its artists existed in a particular state of tension that could be sustained only temporarily. The years preceding the demise of the Weimar Republic seem to have sapped the strength of most of them, and the onset of Nazi tyranny in January 1933 merely sealed the fate of the brief period that had given sustenance to their art.

In contrast, the work of the American artists developed with far greater continuity; deep caesuras, as in Stella's case, were the exception. It seems to have been granted to more or less all of them to think in terms of longer periods. Even the greatest crisis in contemporary American history, the Wall Street Crash of October 1929 and the ensuing Depression, while it shook Americans' ingrained optimism and their faith in the smooth functioning of an economy based on modern technology, did not leave a deep impression on the work of Demuth, Sheeler, Davis, Hopper and O'Keeffe. What the period did bring was a changed awareness, in which pride in being American shifted from identification with the achievements of the Machine Age to reappraisal of the rural regions of the Midwest, where traditional agriculture seemed to exist in harmony with industrial methods. Yet while this shift encouraged the emergence of what became known as Regionalism and brought a brief heyday for the work of Thomas Hart Benton (see Fig. 3, p. 63), John Steuart Curry and Grant Wood (see Fig. 2, p. 62), it lent no significant impulse to the Precisionists or to an artist of the rank of Hopper.

Broadening the comparison to include Britain shows that, in general, the British painters who concerned themselves with modern life, particularly the world of the big city, occupy an intermediary position between the artists of *Neue Sachlichkeit* in Germany and the painters of the American Scene on the other side of the Atlantic. Edward Burra is a case in point. Comparable to Grosz and Dix in terms of subject-matter, his images of the bustle of daily life on the street record poverty and social injustice precisely, and repeatedly exhibit a vein of robust satire. Yet Burra observes these things without the political aggressiveness of Grosz, and the mercilessly penetrating gaze of Dix is not his. On the other hand, his good-natured irony is far removed from the almost sentimental concern with the fate of the poor and unemployed, the old and handicapped, evinced by the pictures of a Ben Shahn or a Raphael Soyer.

William Roberts's images of modern life – scenes in cinemas, cafés and cabarets – are more thoroughly stylized than those of his German confrères. With Hopper, however, Roberts shared an interest in depictions of the cinema and, like Hopper, he painted cyclists resting between races. Yet he remains as different from the Americans as he does from the artists of *Neue Sachlichkeit*. Even where crowds congregate – in cinemas and theatres, stadiums, cafés and hotel lobbies – Hopper draws attention to the isolation and loneliness of the individual in the modern world, whereas for Roberts these are places of human communication and conviviality.

Stanley Spencer, too, occupies middle ground between the Germans and the Americans. Andrew Causey has written of Spencer's self-portraits with nudes: 'No privacy is permitted in these pictures, which are painted as if under floodlights. They have been compared with the paintings of the *Neue Sachlichkeit* in Germany, but they are more bitter and confrontational than the stylish double nude portraits of Christian Schad, for example, in Germany, or Edward Hopper's voyeuristic canvases in the United States.'[20]

Of all British artists of this period Christopher Nevinson is closest to the Americans. Whereas Burra did not visit the United States until 1933 (when he was fascinated, above all, by Harlem), Nevinson stayed for some time in New York in 1919 and

again the following year. In his paintings and etchings of 1919 to 1922 the city appeared to him like a vision, thrusting his gaze upwards or plunging it down from the skyscrapers. 'Although Nevinson's claim to be the first painter of New York can be discounted, he did produce some of the most startling images of the Metropolis', as one critic has noted. '[He] was ambivalent in his attitutde towards the city, but he embraces its modernity as a worthy subject of art.'[21] This can be seen in *Looking Through Brooklyn Bridge* (1920–22), which seems to have been conceived as a riposte to Stella's view of that structure as a cathedral of progress. The bridge's piers, braces and cables form a network of bars in which the individual is imprisoned hopelessly. This alarm at the other, inhuman side of modern technology places Nevinson in far greater proximity to Germany's *Neue Sachlichkeit* painters than to the Precisionists of America.

What, then, was new about the new image of reality that we think we perceive in the Precisionist View and the depiction of the American Scene in the 1920s?

It was Georgia O'Keeffe's achievement to have transposed the Precisionist approach, so eminently suited to depicting the well-oiled machine, to the organic realm – to the monumental scale of her flowers. This imagery was accompanied by paintings of skyscrapers, most of them nocturnal views of New York done from the window of her apartment on the thirtieth floor of the Shelton Hotel on Lexington Avenue (see Cat. 36) and often centring on the American Radiator Building, erected opposite in 1924 (see Figs. 6, 7). O'Keeffe's approach in these pictures appears fundamentally different from that embodied in her flower imagery. It was romantic rather than objective. While the flowers were observed with cool detachment, the nocturnal skyscrapers metamorphosed under her brush into a mysterious fairy-tale realm, a midsummer night's dream populated by primeval monsters and illuminated by a rain of dancing lights. In the floral compositions she attentively studied reality; in the cityscapes she recounted a modern legend. Here, O'Keeffe came very close to realizing the vision of buildings infused with life that Marin, in his 1913 essay, had described as an aim of art.

Fig. 6　Georgia O'Keeffe, *The American Radiator Building*, 1929. Alfred Stieglitz Collection for Fisk University, Nashville, Tennessee

Fig. 7　Alfred Stieglitz, *Evening, New York from the Shelton*, 1931; photograph. The Museum of Modern Art, New York; Gift of David McAlpine

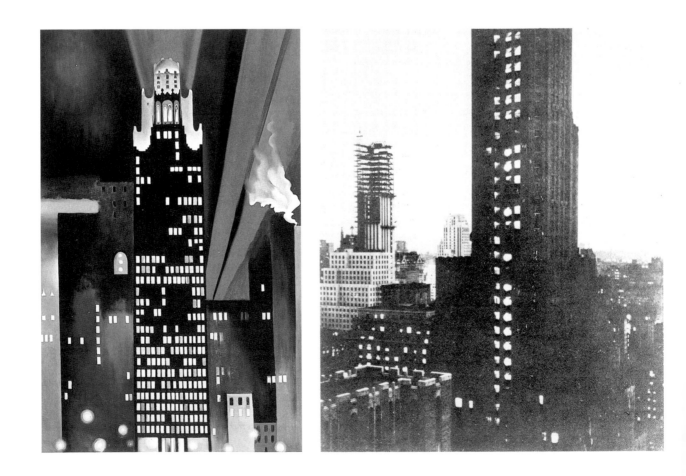

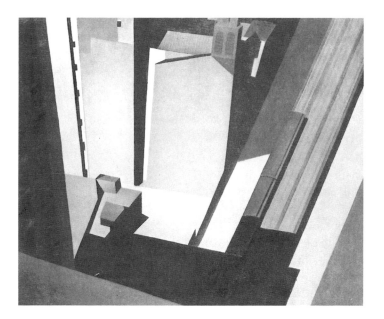

Fig. 8 Charles Sheeler, *Church Street El*, 1920. Cleveland Museum of Art; Purchase, Mr & Mrs William H. Marlatt Fund

Fig. 9 Still from Charles Sheeler and Paul Strand's film *Manhatta*, 1920

Charles Sheeler was the prototype of a Precisionist artist. The term might have been coined for him alone; certainly, his is the only oeuvre to which it applies without qualification. More than any of his contemporaries Sheeeler attempted to produce complete congruity between a slice of visible reality and a tectonically structured composition. That is why he favoured geometrically defined forms, such as the facades of buildings – initially silos seen straight on, then factories too – pieces of Shaker furniture and machines (see Cat. 51–4). Sheeler, who earned his living for a long time as a photographer, collaborated in 1920 with Paul Strand on the film *Manhatta* – named after Walt Whitman's poem *Mannahatta* – in which city buildings were frequently seen from extreme angles, diagonally from above or below. These were perspectives he subsequently employed in his painting as well (cf. Figs. 8, 9).

Sheeler's depictions of the River Rouge Plant caused him to be dubbed the 'Raphael of the Fords'.[22] He gave us the facade of a world cleansed of accidentals (see Fig. 10). Not only did he simplify; he eliminated every element that might have

Fig. 10 Charles Sheeler, *American Landscape*, 1930. The Museum of Modern Art, New York; Gift of Abby Aldrich Rockefeller, 1934

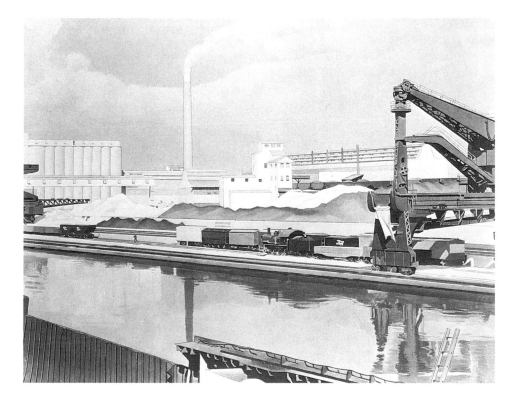

21 Jeremy Lewison, 'English Painting and the Metropolis in the Twenties', in *The 1920s*, op. cit., p. 424.
22 Quoted in Friedman, op. cit., p. 57.

proved irritating. Sheeler's factories function without human beings. Freight waggons, cranes, conveyor belts move as if propelled by a ghostly hand. These are factories without smoke, dust or dirt, factories built for hygienically approved robots. Absolute order reigns in the realm of the machine – just as it does in the realm of Raphael's Madonnas. Sheeler later said of these paintings: 'Yes. Depopulated landscape. Well, it's my illustration of what a beautiful world it would be if there were no people in it.'[23] This is a strangely misanthropic statement on the part of an artist who was imbued with the Protestant ethic. And it contains a fundamental contradiction, for Sheeler's depopulated world was one made, down to the last detail, by human beings. His 'classic landscape' is the landscape of industry, totally bereft of natural features. Also absent is any trace of individual touch. Using his hands in the tradition of that craftsmanship which meant so much to him, Sheeler imitated the perfection of the machine. Many of his paintings, early examples of American Photo-Realism, have a vacuum-sealed look. That is why Williams, who, despite his great sympathy for Sheeler's work, ultimately remained ambivalent towards it, spoke of the danger of 'empty realism'.[24]

The absolute opposite of Sheeler was his younger contemporary, Ben Shahn, probably the only outstanding representative of Social Realism in the United States. Shahn depicted everything Sheeler left out – the human beings, the dust and the dirt, the mundane things of everyday life, and all without the slightest tendency to stylization, streamlining or what is known as 'beautiful form'. In Shahn's world nothing functions as it should. His people are the suffering victims of the judiciary (see Fig. 11) or hang around on street corners, out of work; they limp past on crutches or go in search of cheap thrills. Significantly, Shahn, too, was an assiduous photographer, and based most of his paintings on photographs. Yet unlike Sheeler's, his compositions evince a highly personal touch. Shahn's graphic abbreviations lend his figures life and express his message most succinctly. This is not Precisionism, but it goes to the heart of the matter. Shahn is the American counterpart of the Grosz of the Berlin years, except that his imagery is less suffused with bitterness. His pictures are less accusations of injustice than appeals for compassion.

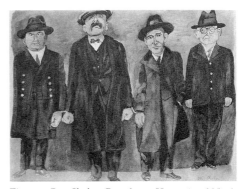

Fig. 11 Ben Shahn, *Bartolomeo Vanzetti and Nicolo Sacco and their Guards*, 1932. Collection of Mrs Patricia Healey

The most significant artist associated with Precisionism, and for the greater part of his career at that, was Charles Demuth. Apart from Davis and Murphy, who were also Precisionists only in a qualified sense, he was certainly the most original and modern. The type of composition he developed in his depictions of factories, water towers, blast furnaces, chimneys and grain silos was unprecedented (see Cat. 44–7). Like Sheeler, Demuth wished to keep evidence of his personality to a minimum, and this no doubt influenced his choice of architectural motifs as subject-matter. But unlike Sheeler's compositions, the form and structure of Demuth's were emancipated from their point of departure in reality and existed in their own right. The geometrically simplified forms of objects were tied together by a system of 'ray-lines' that lent the image a kaleidoscopic, crystalline structure. In a manner similar to Feininger's pictures of German cathedrals in his Bauhaus period, this articulation established an equilibrium between the architectural volumes and the surrounding space. Demuth's 'transcendental' approach lent the subject a significance that went beyond the mere fact of its existence – a significance, though, about which little more can be said than the visual evidence provided by the imagery itself.

A special chapter in Demuth's oeuvre is formed by his poster portraits, which perfectly reflect the retiring personality of this dandy-like man whose life was so clouded by tragedy. In them Demuth set out to characterize people without psychological revelation, simply by means of their name in large letters combined with some of the things associated with them. Demuth portrayed O'Keeffe (Fig. 12), Dove, Marin (the painters of the Stieglitz circle) and a few other friends in this manner. Some of the portraits are so cryptic that one cannot be entirely sure to whom they refer. The initial stimulus for this approach doubtless came from the caricatures of Stieglitz done by Marius De Zayas and Francis Picabia, the former in terms of abstract symbols, written characters and numerals, the latter in terms of camera components (see Fig. 9, p. 43).

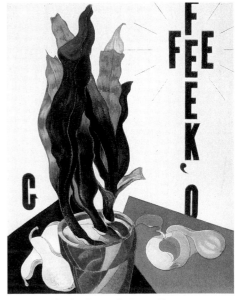

Fig. 12 Charles Demuth, *Poster Portrait: O'Keeffe*, 1923–24. Collection of American Literature, Beinecke Rare Book and Manuscript Library, Yale University, New Haven

Fig. 13 Stuart Davis, *Garage Lights*, 1931.
Memorial Gallery of the University of Rochester,
NY

The most remarkable of these portraits is called *I Saw the Figure 5 in Gold* (Cat. 45)
and is based on a poem by Williams, 'The Great Figure'. The poem describes an
experience one evening in New York, when a red fire engine with the figure 5 on its
side rushed past the poet, leaving an indelible impression on his mind.[25] The painting
is dominated by this numeral; detaching itself from the red of the vehicle, it shoots
out at the viewer. The poet is invoked by the initials W.C.W. below and by the names
'Bill' and 'Carlos' above, rendered like neon signs. Beyond being a portrait of a par-
ticular contemporary, the image combines seductive glamour and cool objectivity to
capture something of the spirit of the age itself.

Joseph Stella caught the religious overtones of the Machine Age better than any
other American artist. In contrast to the Puritan understatement of Sheeler, he sang
a hymn to technology in compositions of baroque fervour (Cat. 55, 56). To this Cath-
olic artist, born near Naples, the monuments of the modern metropolis revealed
themselves like the omens of a pre-ordained destiny. The colour harmonies of the
individual panels of *The Voice of the City of New York Interpreted* are accentuated by a
pathos-filled contrast between dark hues and brilliant sprays of light. These pan-
els – *The Port, The Skyscrapers, The White Ways I* and *II, The Bridge* – amount to the
movements of a richly orchestrated metropolitan symphony. They resound with the
enthusiasm of a man who felt himself poised on the verge of a New Age.

Stuart Davis made of simple things, commonplace consumer products such as cig-
arettes, light bulbs and mouthwashes, objects worthy of painting (see Cat. 48–50)
and, in doing so, created the incunabula of a new visual culture which found signifi-
cance not in the aura of subjects ennobled by tradition but in originality of vision and
freshness of depiction. Davis lent the Odol bottle dignity in the way that Cézanne had
the apple. After experimenting for a time with the contrast between the facades of
Parisian and New York buildings, Davis developed out of his forthright, manifesto-
like objects a pictorial scaffolding like a wide-meshed net, in which fragments of re-
ality or calligraphic arabesques were held (see Fig. 13). As the shapes grew ever more
hard-edged and the colours increasingly brilliant, his compositions took on a staccato
rhythm that reminded critics of the harsh syncopations of the Jazz Age. Comparisons
with the late work of Henri Matisse and Fernand Léger suggest themselves.

Gerald Murphy was the great outsider among American artists of the 1920s. Before
the imminent collapse of the family business forced him home to New York in 1929,
he had lived in Paris and Antibes, where he rented a house he called Villa America

23 Sheeler, interview with Martin Friedman, 18
June 1959, pt. 1, p. 31; Archives of American
Art, Smithsonian Institution, Washington.

24 Quoted by Dickran Tashjian, in *William Carlos
Williams and the American Scene*, exhibition
catalogue, New York, Whitney Museum of
Art, 1978, p. 81.

25 'Among the rain / and lights / I saw the
figure 5 / in gold / on a red / firetruck /
moving / with weight and urgency / tense /
unheeded / to gong clangs / siren howls / and
wheels rumbling / through the dark city.' 'The
Great Figure' (1921), in *William Carlos
Williams: Selected Poems*, ed. Charles
Tomlinson, New York, 1985, p. 36.

Fig. 14 Gerald Murphy, *Watch*, 1924–25.
Dallas Museum of Art; Foundation for the
Arts Collection, Gift of Gerald Murphy

(see Cat. 42).[26] Many of his friends were writers of what Gertrude Stein called the 'lost generation', especially F. Scott Fitzgerald, who was as close to him as Williams was to Demuth. Murphy's style shared a number of features with Precisionism, but it would be mistaken to place his work under this heading, even as a special variant. Comparison can reasonably be made only with the work of Léger (with whom Murphy was also friends). Murphy's painting can perhaps best be characterized as an American version of the 'conceptual realism' that Léger developed in the 1920s. Yet unlike Léger, the largely self-taught Murphy worked very slowly. His oeuvre is not extensive; of the perhaps fourteen paintings he executed between 1921 and 1929, only about half have survived, while some of the others have at least come down to us in the form of photographs.

The original feature of Murphy's approach is its treatment of reality. Choosing a group of objects or particles of reality associated in his mind, Murphy rendered them flatly by tipping them up into the picture plane (see Cat. 43). Many of these things are depicted in cross-section, and occasionally they would seem to have been dissected for display in a glass case. Carefully analysed details of reality are thus spread out over the surface of the canvas; together, as parts of a composition, they appear to function almost like a machine (see Fig. 14).

Edward Hopper, finally, was a painter of the American Scene, even though this term is generally associated with the visual journalists of the 1920s and the Regionalists of the New Deal era. The houses he depicted are American houses, their interiors are American and the people who move through them or remain in imperturbable immobility are Americans – in their unrest, their inability to communicate with one another, their loneliness (see Fig. 15). Hopper made this America timeless, yet it is a quite specific America – that of the 1920s and 1930s. He cleaved to it to the last, changing nothing in the furnishings of his offices or cafeterias, nothing in the facades of his country houses or in the appearance of his gas stations.

Reflected in Hopper's world is the America of the Great Depression of the 1930s, a sense of which seems presaged in certain canvases of the 1920s. Yet Hopper depicted far more than people under the enervating influence of economic crisis. He depicted the crisis of an alienated world, the loneliness of men and women in the twentieth century. And it was the fact that he did so in terms of his concrete experience of the contemporary American environment that makes his image of the human condition so authentic.

26 See Calvin Tomkins, *Living Well is the Best Revenge: Two Americans in Paris 1921–1933*, London and New York, 1962.
27 Quoted in Brian O'Doherty, 'Portrait: Edward Hopper', *Art in America*, vol. 52, 1964, p. 73.

Fig. 15 Edward Hopper, *Room in Brooklyn*, 1932.
Museum of Fine Arts, Boston; Hayden Collection

Seeking to discover what was new in Hopper's image of reality, we are again confronted with the specifically American nature of his art. And this is by no means solely a matter of his subjects. After his initial studies with Robert Henri, Hopper spent long periods in Paris between 1906 and 1910, where the art of Degas and Cézanne provided a stimulus that was to shape his work for a long time to come. The motifs he depicted in Paris were to occupy him throughout his life – houses, streets, bridges, rivers, trees, parks, pedestrians – but they were not yet rendered with the focus and concision of his later work. For the man who had come to enjoy the mild Paris air, the final return to New York was a shock: 'It seemed awfully crude and raw when I got back. It took me ten years to get over Europe.'[27]

Hopper developed into a genuinely American artist between 1910 and 1920. The salient feature of this was a reduction in the dominance of the painterly touch. Although separate brushstrokes remained visible, they were increasingly subordinated to the overall effect of the composition. This change in Hopper's touch may be a matter of nuances, but it altered the character of his pictures fundamentally. The accent shifted from virtuosity to a more iconic effect, from brilliant painting to the communication of a certain point of view. This point of view was lucidly objective, and for that very reason was capable of engendering a wide range of emotions.

Hopper's work on his style after his return from Paris through to the early 1920s can be compared to that of the American writers of the day who, like Hemingway, systematically expunged brilliant formulations from their texts in favour of precise expression, who tried to keep their sentences short and their adjectives few, as Ezra Pound had advocated. Cut out the deadwood – that was their chief maxim, precisely because they had so much to say. Concision heightened effect, and Hopper knew that too. His paintings stand for American reality as it was then, its fears and dreams, its limitations and its grandeur.

Francis V. O'Connor

The 1930s: Notes on the Transition from Social to Individual Scale in the Art of the Depression Era

The era of the 1930s – a 'decade' that began with the Wall Street Crash and vanished during the Second World War – saw a wider scale of reference manifest in the arts in America than can be found earlier in the century, or perhaps even subsequently. After the 1913 Armory Show modernism was one of many competing aesthetics. It tended to constrict rather than expand the artist's subjects, replacing historical and ideological narration with the rootless individual's solipsism – while inhibiting his or her integration. In the context of modernist aesthetics, then, the '1930s' is anomalous. Influenced by populist and Marxist artists and critics, art became more communal and democratic. The stylistic innovations of European modernism were creatively misread and employed as tools for expanding traditional themes, before they came to serve the purely subjective agenda of Abstract Expressionism after 1945. Further, art forms such as the mural and photography pre-empted the conventions of the closet art which the ur-modernists promoted. In sum, the fledgling modernist tradition, barely underway in the USA during the 1920s, found its penchant for abstraction and individual expression adopted for social purposes during the 1930s.

In the period from the Wall Street Crash to the inauguration of Franklin Delano Roosevelt as president in March 1933, with his 'New Deal' for the American people, many artists began to concentrate on finding ways to image, the better to alleviate, the tragedy they faced. Their initial reaction was to idealize what they believed lost while decrying the causes of their troubles.

Normally, one associates the 1930s with an art of social activism or 'realism', not modernism and abstraction. Yet stark depictions of deprivation and atrocity were comparatively infrequent. Rather, social commentary often bordered on the ironic, as in O. Louis Guglielmi's *Phoenix* of 1935 (Fig. 1). Indeed, the Communist Diego Rivera's *Detroit Industry* murals were calmly painted while Ford Motor Company guards shot striking car workers. Most FSA (Farm Security Administration) photographs, although they captured rural reality, stressed the indomitable (if harried) nature of the people, not their abject condition – as did John Steinbeck's novel *The Grapes of Wrath* (1939), itself strongly influenced by FSA images. Of the art illustrated in *Art Front*, the most radical such publication of the era, only about twenty-five per cent can be construed in any way as 'protest' art. In fact, artists (of whatever ideological persuasion), surrounded by the effects of the Depression, chose to paint either what was imagined to have been or what ought to be. This social idealism makes sense when one also considers that the major art form of the era was permanent; it does not take an irate patron to tell a sensitive muralist that depicting the cure is better than making a lasting monument to the disease. Those who see this as complicity with the oppressor might try to imagine the era's social reality as it was – for both the artist and the depressed citizen trying to survive.

Here it is worth remembering that the artists, government officials and general public in the 1930s did not view the world through the same ideological and psychological lenses as those through which we perceive public and artistic reality today. They pre-dated the Second World War, the Holocaust, the Cold War – with its political witch-hunts and its threat of nuclear annihilation – the Civil Rights movement, the international counter-culture of the late 1960s and, perhaps most important, the progressive politicizing and psychologizing of our culture. This last tendency has sensitized us to the ethical dimensions of politics, the complicity of interpreters in the cultural situation – and the capacity of art to abstract and symbolize universal experience rather than just narrate events. Life and art were seen more literally during the

Fig. 1 O. Louis Guglielmi, *Phoenix*, 1935. Nebraska Art Association, Lincoln

1930s, 'ordinary people' were valued and there was a basic bond of trust between them and the government that no longer prevails. What 'Art' meant then – especially government-sponsored art – and what it might signify some sixty years later can be quite different things. In considering that art, we ought to be aware of this cultural difference.

The first four years of the era – 1930 to 1933 – saw two key developments. On the artistic level, the significant event was the mural's revival as a popular idiom after it had been the preserve of academic allegorists and commercial decorators since the mid-nineteenth century. The exploitation of the formal conventions of Cubism also came to expand art's capacity to convey legibly a complex didactic message. This was the result of the simultaneous growth and promotion of Regionalism, led by the fledgling muralist and vociferous anti-modernist, Thomas Hart Benton, and the incursion into America of the two most prominent Mexican muralists, Rivera and José Clemente Orozco. On the political level, the development of activist artists' organizations and the start of the New Deal's art projects were crucial.

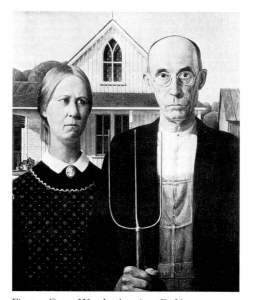

Fig. 2 Grant Wood, *American Gothic*, 1930. Art Institute of Chicago

The Regionalists were liberal populists, not the fascistic nationalists that radicals accused them of being. They and their followers attempted to find what came to be called a 'usable past' in the history and local traditions of the nation. They sought to define and idealize that past the better to give a riven nation a sense of roots. Benton practised the literal narration of a historical mythology. His two most famous colleagues in the movement, Grant Wood and John Steuart Curry, were also adept at painting a past with which the country might identify – as the former's notorious easel painting, *American Gothic* (Fig. 2), and the latter's mural *John Brown* in the Kansas Statehouse attest.

The Mexicans, eloquent if not activist Marxists, sought to dramatize the historical origins of social forces. Famous for their proletarian works in Mexico since the mid-1920s, they brought to the US an established social iconography and sense of indigenous roots that had great artistic influence.

Benton's 1930 *America Today* murals in the New School for Social Research, New York, became the first wall-paintings of the new era. Painted in a small boardroom, and based on the sketches Benton had made while travelling around the country during the 1920s, they expanded the room's horizons with dynamic montage views, divided by elegant silver mouldings that became part of the composition, of mid-western and east coast scenes of agricultural and industrial enterprise and contemporary urban activities. Benton, like Rivera, had studied in Paris during the century's early years, and understood Cubist formal methods despite his loud condemnations of pure abstraction. He copied what Rivera had achieved, using the latter's space-compressing devices in his murals. In 1932 he did a similar series of wall panels for the library of The Whitney Museum of American Art, New York, on the theme 'The Arts of Life in America'. These ranged from Native American times to the present. Here he discarded the mouldings for more fluid spatial transitions. In 1933, his style established, he left New York to execute a mural entitled *The Social History of the State of Indiana* for that state's pavilion in the Century of Progress International Exposition at Chicago. From 1934 to 1936 he painted his masterpiece, *The Social History of the State of Missouri*, in the State Capitol at Jefferson City.

All Benton's murals, while displaying an impressive stylistic development, are intent on glorifying the expansionism, and the common people, of the country. His Missouri mural (Fig. 3) combines a panoramic history of the state from Indian days to the infamous Boss Prendergast (the early political patron of Harry Truman), with scenes from American folk legends such as Jesse James and Huckleberry Finn. The whole is presented in a complex continuity derived from Cubist and Surrealist spatial devices accommodated to the architecture of the room. It stands as the best, and most advanced, mural in the country by an American.

Parallel with Benton's efforts, Diego Rivera established himself in America – first with a group of murals in San Francisco dating from 1930–31, then a series of fresco panels done for an exhibition of his work at The Museum of Modern Art, New York, in 1931–32, followed from 1932 to 1934 by highly influential walls at the Detroit Insti-

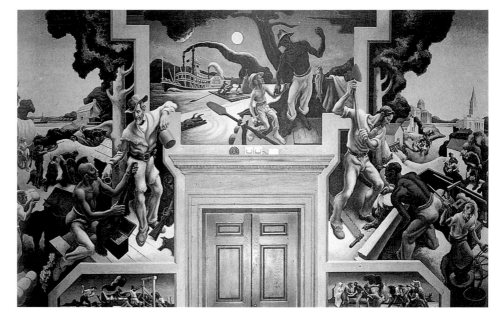

Fig. 3 Thomas Hart Benton, *Pioneer Days and Settlers* and *Huckleberry Finn* (over the door), from *A Social History of the State of Missouri*, 1936. House Lounge, Missouri State Capitol, Jefferson City

Fig. 4 Diego Rivera, *Detroit Industry* (north wall), 1932–33. Detroit Institute of Arts

tute of Arts and at the Rockefeller Center and the New Workers school in New York. Of these, the *Detroit Industry* cycle is certainly his American masterpiece (Fig. 4). Here the central panels abstract the famous Ford Motor Company's River Rouge automobile assembly line, the huge stamping presses are derived from Aztec sculpture, and the rhythms of the workers follow an underlying composition based on dynamic symmetry. Surrounding this, the subsidiary panels contain an intricate allegory of the racial groups and natural materials that contributed to a car's manufacture. Taken as a whole, these walls display Rivera's highly influential style derived from his direct experience of Cubism and the *Section d'Or*, as well as traditional aca-

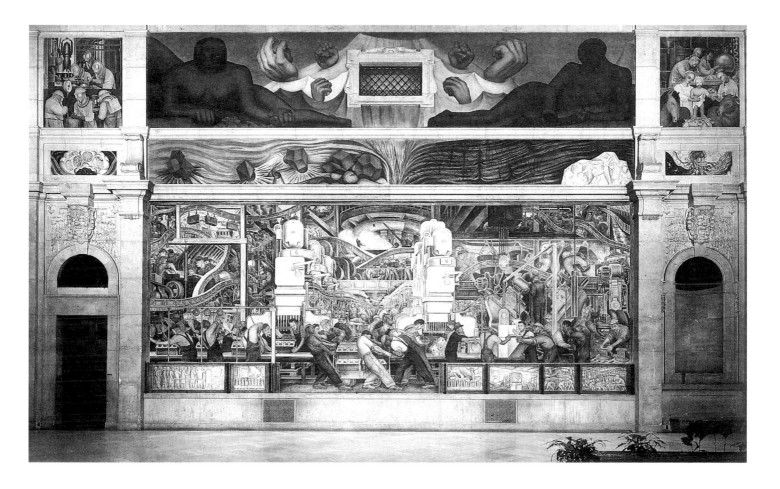

demic allegory, his knowledge of Italian Renaissance murals and the iconography of Mexican indigenous art.

While Rivera was busy with his walls, another Mexican, José Clemente Orozco, painted three major American murals. The first was *Prometheus* at Pomona College (1930), followed by a series on revolution and universal brotherhood for the New School for Social Research (1930–31), and a masterly depiction of civilization's progress and decline in the Baker Library at Dartmouth College in Hanover, New Hampshire.

Unlike Rivera, Orozco was more expressionist in style and allegorical in content. For him, Prometheus was the archetype of social concern: the god who stole fire for the masses. His murals at Dartmouth (1932–34) evoke the consequences of the intrusion of industrialized civilization into the Western hemisphere, as symbolized by the first and last panels of the sequence: the *Ancient Human Migration* of people down its continents and the *Modern Migration of the Spirit* (Fig. 5), with its devastating portrait of Christ – enraged at humanity's moral condition – cutting down his own Cross.

By the time the New Deal 'Projects' got under way in December 1933, the Regionalists and the Mexicans had already set the agenda for an aesthetic of social idealism and ideological activism. The artists, in New York and such other major cities as Chicago and San Francisco, had organized themselves during the first Depression years. In 1930 the John Reed clubs were established. In 1933 the Artists' Union developed out of the New York Club, and its publication, *Art Front*, articulated demands for an art of social concern and government assistance. This first appeared in November 1934; Stuart Davis edited its early issues. Many distinguished artists were active in the Artists' Union – as well as in the two Artists Congresses it sponsored in 1936 and 1937 – and they helped to define the policies of the New Deal Art Projects.

These began in December 1933 with the Public Works of Art Project (to 1934; hereafter PWAP). It became a pilot project, assisting unemployed artists through the winter and spring while giving the government time to establish more comprehensive patronage policies. This resulted in the Treasury Department's Section of Paint-

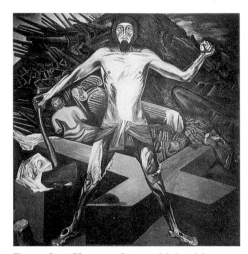

Fig. 5 José Clemente Orozco, *Modern Migration of the Spirit* from *The Epic of American Civilization*, 1932–34. Baker Library, Dartmouth College, Hanover, New Hampshire

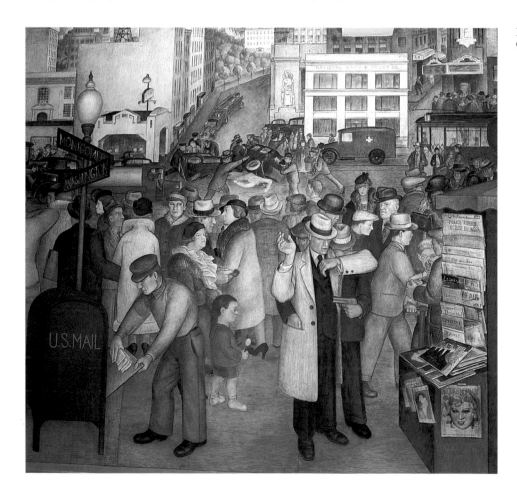

Fig. 6 Victor Arnautoff, *City Life*, 1934 (detail). Coit Tower, San Francisco

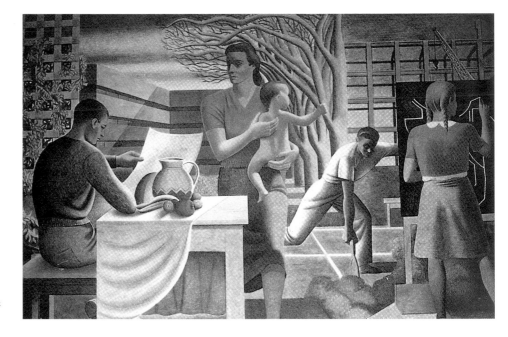

Fig. 7 Seymour Fogel, *Security of the People*, 1942
(detail). Security Building, Washington, DC

ing and Sculpture (1934–43; hereafter 'Section') and the controversial Works
Progress Administration Federal Art Project (WPA/FAP, 1935–43). The Section
commissioned through competition the best art it could acquire for federal buildings
such as post offices and court houses. Regionalist in orientation, it established 'The
American Scene' as its overriding theme and local history as its favoured subject. Its
murals constituted a symphony of variations on that 'usable past' of events and fables
which Benton had so successfully exploited in his work. The WPA/FAP, in contrast to
the cautious Section, became a vast relief project for indigent artists in all media.
While this preserved the skills and kept alive future greats such as Jackson Pollock, it
produced, along with the usual traditionalist output, work that actively encouraged
modernist tendencies. Three murals, on urban rather than rural themes, illustrate the
idealizing of everyday life and the pre-empting of advanced Mexican and European
styles characteristic of the era.

The murals in Coit Tower, San Francisco, are certainly the masterpiece of the
PWAP's short existence during 1934. Painted by a squad of twenty-six artists led by
several associates of Rivera, they were strongly influenced by his style. Victor
Arnautoff's mural *City Life*, Bernard Zacheim's *Library* (stocked with a controversial
shelf of Marxist books) in the lower rotunda of the monument and Lucien Labaudt's
facing murals of San Francisco's precipitous *Powell Street*, in the curved stairwell, are
the most striking and original of these very early New Deal walls. Arnautoff's teem-
ing view of the city beyond the tower (Fig. 6) typifies how Rivera taught an entire
generation of American artists to paint a modern mural. His method included devices
such as maintaining the wall plane by suspending the pictorial complex between a
clearly defined foreground and a continuous sky; strongly modelling figures in uni-
fying earth colours while overlapping them and massing their heads into a frieze;
using slogans and words to emphasize ideological themes; and relating the content
of the mural to its environment by means of the symbolism of compass directions or
what actually was beyond the walls painted.

The Section's taste for Regionalist themes in its approximately 1,100 murals,
mostly in post offices, resulted in competent but tedious walls depicting rural life and
local history. Of greater interest are those it commissioned for federal buildings in
Washington. Among these, two panels for the new Social Security Building by Sey-
mour Fogel stand out both thematically and stylistically. Completed in 1942, they
represent *Security of the People* (Fig. 7) and *Wealth of the Nation*, and were intended to
symbolize the goals of the New Deal's major legislative victory, the establishment of
the Social Security system. Fogel had worked with Rivera in the early 1930s, and was
also attracted to the geometric style of the American Abstract Artists group. He com-

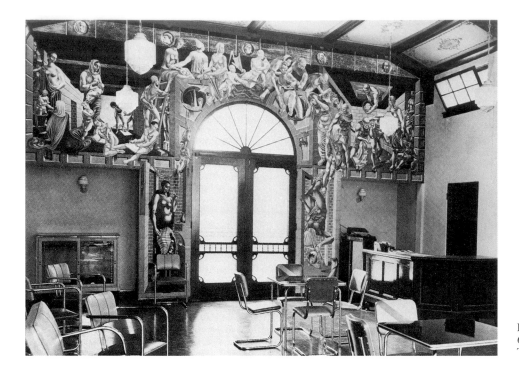

Fig. 8 Philip Guston and Reuben Kadish, *The Cycle of the Artist's Life*, 1935–36. Los Angeles Tubercular Sanatorium, Duarte, California

bined these styles in effective, decorative compositions, idealizing family and industrial life. He had painted a similar mural, as had Philip Guston, in 1939 for the WPA Building at the New York World's Fair. Between them, they invented the perfect 'New Deal Style' – but the Projects collapsed during the war, and its potential was never realized.

Of the WPA/FAP's more than 2,500 murals, one of the most thematically far-reaching was painted in the library of the Los Angeles Tubercular Sanitarium (today the City of Hope National Medical Center) at Duarte, California, by the future Abstract Expressionist Philip Guston in collaboration with Reuben Kadish (Fig. 8). The masterpiece of the 'Post-Surrealist' movement in Los Angeles, which was led by Lorser Feitelson and his wife, Helen Lundeberg, the mural depicted the life cycle of the artist from birth to death. Stylistically, it combined the spatial devices and symbolic juxtapositions of such veristic Surrealists as René Magritte and Paul Delvaux with motifs from Renaissance artists – which these young muralists would have known only from books – whose portraits are placed in roundels along the top of the wall. Iconographically, it directly transcribed the 'steps of life', mounting and descending over an arch, that can be found in European hortatory literature from the sixteenth century onwards. Technically, it is one of the most sophisticated of New Deal frescos, with the architectural details painted on rough, and the figures on smooth, plaster – thus creating an elegant relief across its surface.

Along with murals, the WPA/FAP encouraged other art forms, such as serigraphed prints and posters, which could reach a wide audience, as well as easel painting and pedestal sculpture, the best of which it allocated to schools and hospitals. It undertook a massive archaeological project, the Index of American Design, which preserved the images of perishable American folk art and crafts in thousands of meticulous watercolour renderings, now preserved in the National Gallery of Art, Washington. Its art education programmes were among the first in many school systems, and its Federal Art Centers and Galleries (a number became the foundation for regional museums), together with its sponsorship of national Art Weeks, greatly influenced the development of an audience for the arts after 1945.

Of all the new artistic initiatives encouraged by the Projects, it was certainly photography that had the greatest impact in terms of understanding the nature of the national crisis, and the role of the New Deal in coming to the rescue. Between 1935 and 1943 the Historical Section of the Resettlement Administration, known from 1937 onwards as the Farm Security Administration (FSA), produced over a quarter of

a million photographs, most showing a devastated rural America. A few of these images have become trenchant icons of 1930s visual culture – such as Dorothea Lange's *Migrant Mother* of 1936 (Fig. 9). Other notable FSA photographers were Walker Evans, Russell Lee, Arthur Rothstein and Ben Shahn – the latter using his FSA photographs as the basis for two major Section murals, those in Washington's Social Security Building and the Bronx's Central Post Office. Mention must also be made of Pare Lorentz's two films for the FSA – virtually 'cinematic murals' – *The Plow That Broke the Plains* (1936) and *The River* (1937).

The power of these photographs stemmed from their stylistic integrity, clarity and forthrightness. The camera technique was simple and direct, without eccentric viewpoints or dark-room gimmicks. Everything was kept in the sharpest focus and seen in natural light. Furthermore, the subject was almost always addressed head on, and this frontality gave the best of these images their moral authority: they confronted the viewer with an undeniable situation that required a response both emotional and political.

Of greater variety were the photography projects of the WPA/FAP, the most important being Berenice Abbott's *Changing New York* series, taken between 1935 and their publication in 1939. The WPA/FAP also experimented with photo-murals, the most original being designed by Wyatt Davis (the brother of Stuart) – but the limitations of the medium at the time, and the lack of colour photography, inhibited their development.

Although the New Deal projects were the primary focus of attention for both artists and their public during the 1930s, international and local fairs also served to promote artistic activity. Benton's mural for Chicago's 1933 Century of Progress fair has been mentioned. The fair also sponsored walls by other 1930s figures, such as George Biddle in the Agricultural Building and Pierre Bourdelle in the Hall of Science. The latter, the son of the French sculptor, found a more ample space at the Texas Centennial Exposition in 1936, where he created a suite of elegant Art Deco exterior murals for the fair's pavilions, along with Carlo Ciampaglia's similar group for the Hall of Transportation and two vast panoramas of Texas past and present, by Eugene Savage, in the main hall of the State of Texas Building. This fair site, the only one to be preserved intact, sums up the achievements of the Art Deco style that was still prevalent during the 1930s – especially at the Rockefeller Center in New York.

The years 1939–40 saw two great fairs at either end of the country. In San Francisco the Golden Gate International Exposition sponsored Rivera's last mural in the US. But the New York World's Fair was the most famous and influential. It promoted a 'usable future' based on American technology, such as 'cities of tomorrow' and highway systems dependent on automobile rather than public transportation, and introduced television. Centred on the huge geometric mass of the Trylon and Perisphere, designed by Wallace Harrison and J. A. Fouilhoux, the fair was a showcase of modernist art. It was also the last hurrah of almost every other style of the century – for

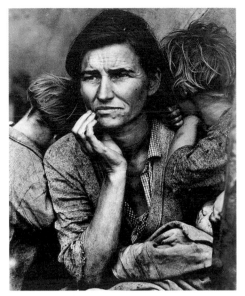

Fig. 9 Dorothea Lange, *Migrant Mother*, 1936

Fig. 10 Stuart Davis, Sketch for *The History of Communications*, a mural (now destroyed) in the Hall of Communications at the New York World's Fair, 1939. Minnesota Museum of Art, Saint Paul

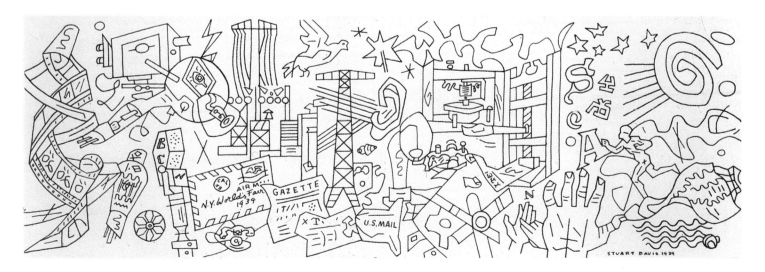

which the exhibitions held in the Contemporary American Art Building provided important summations.

Among the major modernist murals were those by Guston and Fogel (as well as Anton Refregier) for the WPA Building; Stuart Davis's huge wall in the Communications Building (see Fig. 10); Willem de Kooning's exterior mural for the Hall of Pharmacy; and interior panels by Ilya Bolotowsky, Louis Schanker, Balcomb Greene and Byron Browne in the Medicine and Public Health Building. With the exception of the latter group, which represented the non-objective style of the American Abstract Artists organization, founded in 1936 to promote pure abstraction, these murals were all semi-abstract. Davis fought hard to justify abstraction against charges of social irrelevance by his fellow Communists, claiming it to be revolutionary in the face of the 'domestic naturalism' that prevailed, but his arguments were thin, and he eventually resigned from the Artists' Union, as the outcome of the Spanish Civil War and the Hitler-Stalin pact made Marxist ideology untenable – especially in art.

The 1930s in America saw diverse styles competing for artistic and public acceptance – abstraction among them. The resultant transition consisted in a sudden, optimistic expansion – and just as sudden a contraction – of a sense of the scale of human experience. This was understood first as what communal action and national solidarity required to survive the devastating effect of the Depression. As the era ended, however, ideological disillusion was paramount, and the scale of artistic vision was soon reduced to individual experience couched in the vocabularies of Surrealism and abstraction. Indeed, the prophecy implied in Guglielmi's *Phoenix* was fulfilled, and, by the end of the 1930s, using 'art as a weapon' had come to seem as futile as leaning Lenin's portrait against a capitalist's oil derrick to alleviate the nation's condition.

This devolvement from communal to personal vision within the short span of the 1930s is best symbolized by the bustling historical surveys to be found in the murals of Benton and Rivera – which depicted, respectively, the full sweep of regional icons and revolutionary ideals – and, retroactively, Pollock's 1943 *Mural* (Cat. 86), a large-scale, non-objective easel painting done for the lobby of his dealer's town house. Pollock and most of his fellow Abstract Expressionists learned Cubist formal dynamics from 1930s murals – not from the generation of the Armory Show.

In these typical works, then, born of populism and Marxism on the one hand, and a new creative solipsism on the other, can be found the essence of the profound cultural transition that occurred during the 1930s. Modernism triumphed in reaction to the psychological untenability of Marxism's goal of a social utopia. The scale of visual experience and artistic enterprise contracted from an idealist's fantasy, whose primary art form was the public mural, to that of the studio-bound introspective painting easel work. Surrealism, as the channel for unconscious symbolism, won out over the 'American Scene' and geometric abstraction, since the post-war taste for Existentialism and mythology required a process for finding a private rather than a public subject. Ironically, the physical size of post-war art increased despite the limitation of its scale of reference. The mural's capacity during the 1930s to capture the sweep of history and human enterprise had opened up the potential of large-scale easel painting for abstract allegories of personality rather than literal narrations of social idealism.

Bibliographical Note

For the Regionalists, see Agnes Halsey Jones, 'The Search for a Usable Past in the New Deal Era', *American Quarterly*, vol. 23, no. 5, 1971, pp. 710–24; Matthew Baigell, *The American Scene: American Painting of the 1930s*, New York, 1974; and Henry Adams, *Thomas Hart Benton: American Original*, New York, 1989. For the Mexicans, see Francis V. O'Connor, 'The Influence of Diego Rivera on the Art of the United States during the 1930s and After', in *Diego Rivera: A Retrospective*, exhibition catalogue, Detroit Institute of Arts, 1986, pp. 157–83, and Laurence Hurlburt, *The Mexican Muralists in the United States*, Albuquerque, 1989. For the New Deal Art Projects, see Francis V. O'Connor, ed., *Art for the Millions: Essays from the 1930s by Artists and Administrators of the WPA Federal Art Project*, Greenwich, CT, 1973; Karal Ann Marling, 'A Note on New Deal Iconography: Futurology and the Historical Myth', *Prospects*, vol. 4, 1979, pp. 421–40; and Marlene Parks and Gerald Markowitz, *Democratic Vistas: Post Offices and Public Art in the New Deal*, Philadelphia, 1984. For artists' organizations and social protest, see David Shapiro, ed., *Social Realism: Art as a Weapon*, New York, 1973, and Matthew Baigell and Julia Williams, eds., *Artists against War and Fascism: Papers of the First American Artists' Congress*, New Brunswick, 1986. For Post-Surrealism, see Jeffrey Wechsler, *Surrealism in American Art: 1931–1947*, New Brunswick, 1977, and Francis V. O'Connor, 'Philip Guston and Political Humanism', in Henry Millon and Linda Nochlin, eds., *Art and Politics in the Service of Politics*, Cambridge, MA, 1978, pp. 342–55. For New Deal photography, see Roy Stryker and Nancy Wood, *In This Proud Land: America 1935–1943 as Seen in the FSA Photographs*, Greenwich, CT, 1973, and Pete Daniel et al., *Official Images: New Deal Photography*, Washington, 1987. For 1930s World's Fairs and the transition to the 1940s, see Olive L. Gavert, 'The WPA Federal Art Project and the New York World's Fair, 1939–1940', in O'Connor, 1973, pp. 247–67, and Erika Doss, *Benton, Pollock and the Politics of Modernism: From Regionalism to Abstract Expressionism*, Chicago, 1991. Specific material about the murals discussed in this essay is derived from the author's forthcoming *The Mural in America: A History of Wall Painting from Native American Times to the Present*.

Stephen Polcari

Modernist History and Surrealist Imagination: American Art in the 1940s

Mitchell Siporin was a mainstream American artist in the 1930s. A true believer in the social purposes of art, he established himself as a painter of the 'people'. With paintings of the American scene, of the Haymarket workers' riots in Chicago, images of the homeless and subjects derived from social history, Siporin joined others in defining the imaginative space of the 1930s as pride in, and protest against, American life.

By 1951 that imaginative space had gone. In its stead was an art of inwardness – virtually abstract canvases of dreamy, moody ambiguity and complexity (see Fig. 1).

In the 1930s Benton Murdoch Spruance, a Philadelphia print-maker, also devoted himself to mainstream portrayals of the American spectacle. Football players, big-city traffic, American locales and people at work at different times of the day were Spruance's images of the era. But, by the end of the 1940s, a taste for the fantastic had overtaken his work as well. A mythical and biblical concept of time and space, and a sense of the eternally human, informed his expressive graphics. Such subjects as Lazarus, lamentations, the stars, the mythical labyrinth, Odysseus' journey, ritual offerings and the return of the hero now defined his world. Morning was no longer part of the cycle of labour, but part of Christ's Passion.

Spruance had become a fantastic artist of pain and joy by 1950. In so doing, he joined the subjectivist Siporin and many others in demonstrating what seemed to be the new centre of American art.

Neither Siporin nor Spruance is a seminal figure. Nevertheless, they seemed to illuminate the tide that was defined by greater names – those of the Abstract Expressionists, whose work is the highest achievement in American art of the 1940s and 1950s. Initially, the Abstract Expressionists' imaginative, dramatic and fantastic art revealed a strong swing away from the prose representationalism of the 1930s and towards the contemporary European modernism of Surrealism. From this swing a new American modernism emerged in the major abstractions of Jackson Pollock, Mark Rothko and Adolph Gottlieb, and the sculpture of David Smith, Isamu Noguchi and Seymour Lipton, among others. The 1940s was the decade in which American art both decisively absorbed the European modern tradition and added to it in an original way. In the process, New York (as the cliché has it) became a major centre of modern art, and America had its first style of international renown.

Fig. 1 Mitchell Siporin, *Interior*, 1951. Babcock Gallery, New York

Fig. 2 Mitchell Siporin, *Winter Soldiers*, 1946. Babcock Gallery, New York

So decisive a transformation occurred in the 1940s that the question arises as to what led to the turn towards modernism and Surrealism at that time. How did an art of the inward, the fantastic and the mortal become part of the mainstream artistic imagination? How did it become so central that it attracted those, like Siporin and Spruance, whose heritage was so different?

The answers lie in the experiences of history. In the 1940s history and imagination were dominated by a single human event, the Second World War and its aftermath, the result of which was the transformation of self-contained American thought into a more modern, wider reality. And modern reality led to the metaphysical art of modernism, for the change in imagination that the openness to the fantastic and deadly indicated arose partly out of the nightmare of the war and directly affected artistic forms. What seemed merely imaginary in earlier modernism now appeared to fit reality. American art in the early 1940s thus defines a reality that was not only different from the previous decade, but that was already shaping the popular imagination. In other words, American artists were articulating a new, emerging vision that was being accepted as the 'truth' about the world. Human strife and suffering were the agents of the change. To understand how this came about, we must return to the transformations of Siporin and Spruance.

Siporin had spent the years 1942 to 1945 in North Africa and Italy as a war artist. Under the impact of that experience his art was never the same again. Works such as *Winter Soldiers* of 1946 (Fig. 2) and *Ghost Harbor* of 1947 (Babcock Gallery, New York), with their jagged planes, jumbled spaces and labyrinthine or wasteland vistas, record not only the transition from a 1930s realist to a 1940s fantastic artist, but also the emergence of the expressive, surreal psychological space and reality out of which Abstract Expressionism was to grow.

Spruance suggests, with his 1943 lithograph *Fathers and Sons*, in which succeeding generations of soldiers are interlocked in an underground labyrinth, that an inescapable maze characterizes the history of the human race.[1] His lithograph *Souvenir of Lidice* (1942), with its timeless mytho-ritualistic imagery of the three crucifixions, transforms the site of a Nazi massacre into the stage of a contemporary Calvary. For Spruance, conflict and war are best rendered in a new variant of the eternal Western archetype of suffering, the crucifixion.

Perhaps the sea change in art and thought is best summarized by another artist, Hananiah Harari. Harari was a founding member of the Abstract Artists Association in the 1930s who, nevertheless, treated socially relevant themes such as transport and flight. By the 1940s a new element had entered his work, before he went off to war.

1. Unlike Siporin, Spruance did not directly participate in the war. But like many in the past, such as Homer, Tolstoy and Meissonier, he observed and commented upon it.
2. Samuel Hynes, *A War Imagined: The First World War and English Culture*, New York, 1991, p. xi.

His large gouache *Flight* (Fig. 3) – exhibited in 1945 at the National Gallery of Art, Washington, in one of many exhibitions of war art – condenses the journey of American art of the 1930s to the 1940s. From the left of the canvas, in nebulous space, arises Icarus, embodying in his desire to fly as high as he can all the ancient myths and legends of flight. The middle section describes the technical history and progress of flight and the great period when humans conquered the air before they came crashing down to earth, a fall represented by an image in the bottom right-hand corner. There, stands a blood-stained, tusked monster who bestrides a landscape of the dead. This new protagonist sports a German helmet, spectacles caricaturing those of the Japanese war-lord, Hideki Tojo, and a rising sun emblem on its brow, indicating that the monster is the Axis war machine ('death machine' in the painted text), which has transformed the progressive ideal of flight into a vicious beast. Harari, however, does not allow the historic human journey to end in death and defeat. He inserts in the top of the right-hand section an abstract evocation of the future peaceful world after the war, where an abstract, Miróesque-coloured symbol of flight (a delta) offers the triumph of the human spirit in the brightness of a new dawn after the storm. *Flight*, then, distills the historical transformation of the American imagination that occurred *circa* 1940. It is in this development of the fantastic from the historical that a truly innovative American art emerges, for a new reality requires new expressive forms.

From its inception, Renaissance artistic rhetoric – on which much 1930s American art was based – had given individual human life order, dignity and greatness. But the novel experiences of total, global, ferocious war did the opposite. Soldiers' experiences and tales, familiar from newsreels, magazines, photographs, posters, radio and film, and recounted among friends, family and loved ones, impressed on the mind and heart brutality, cruelty and violence on a previously unknown scale. A radical evil – impossible to ignore – permeated the 1940s. As Samuel Hynes has written of the First World War, the second conflict was such a great *imaginative* event that 'no one after the war – no thinker or planner, no politician or labour leader, no writer or painter – could ignore its historical importance or frame his thought as though the war had not occurred.... Even as it was being fought the war was perceived as a force of radical change in society and in consciousness.'[2] This change inspired a language and style that were fantastic by the standards of just the day before. Ultimately, the change demanded a new kind of moral expression. The modern artist wanted to know how he was 'to paint pictures that would be entirely strange, and yet would express

Fig. 3 Hananiah Harari, *Flight*, 1943. Collection of the artist

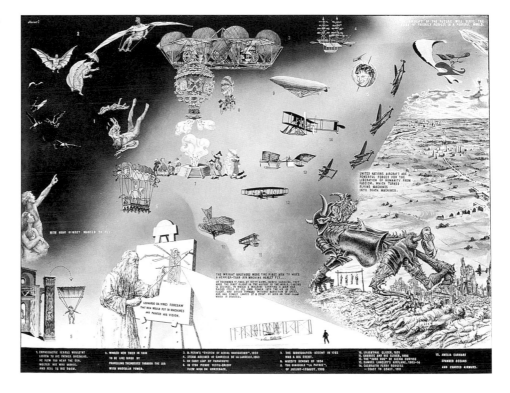

moral judgments'.[3] How could he protest about the waste, cruelty and savagery of the war while representing it? A new form of truth was needed.

Significantly, a similar need had occurred during the First World War. In England, for example, pre-war Cubism suddenly became a means of symbolizing the war as a vast, cruel mechanism:

> [The *Times*] critic Clutton Brock…acknowledged…[its] authority and power: '…Mr. [C.R.W.] Nevinson…does it by a method which has become a commonplace of modern painting, the sharp distinction of planes. He is half a cubist; but his cubism is justified by what he has to say. It expresses a certain emotion…and…a certain protest.…In these pictures [reality] is represented as a process to which personality is utterly subject, showing itself only in energy or pain; and the result is a nightmare of insistent reality, untrue yet actual, something that certainly happens and yet to which our reason will not consent.…The pictures are…efforts to show us something novel and strange….'
>
> These…critics agreed on one essential point: that the war was Modernist. They saw that the violence and the…[form] of pre-war experimental art had been validated as perceptions of reality by the War itself. Not only validated, but made necessary; for if war was a nightmare in reality, then only a distorting, defamiliarizing technique could render it truthfully.…Nevinson's Futurist war paintings provided the visual terms for imagining war in a new, unheroic, anti-romantic way.[4]

For many, then, the world wars were recognized as modernist. For the First World War, that meant Cubism and Expressionism. For the Second, it meant a Surrealist imagination of nightmare, of the terrifying, the brutal, the fantastic and the irrational yet real.[5]

Soldiers took the lead in describing the new imaginative reality. The marine and war novelist James Jones, for example, noted of Anzio 'one long hellish nightmare…a pocked, surreal, destroyed…landscape'.[6] Another soldier declared: 'For me it's B.W. and A.W. – before…and after the war.…I get this strange feeling of living through a world drama…you look forward to the glamour and have no idea of the horror.…You saw those things in the movies, you saw the newsreels.…It seemed unreal. All of a sudden, there you were.…I was acutely aware, being a rifleman, the odds were high that I would be killed. At one level, animal fear.…I was schizophrenic all

Fig. 4 Federico Castellon, *Untitled (No. 15)*, 1934

Fig. 5 Adolph Gottlieb, *Eyes of Oedipus*, 1943. Private collection, New York

Fig. 6 Standing, from left to right: Bernard Reis, Irene Francis, Esteban Francis, Elena Calas, Arshile Gorky, Enrico Donati, Nicolas Calas; seated, clockwise: Steffi Kiesler, André Breton, Agnes Gorky, Max Ernst, Becky Reis, Elisa Breton, Patricia Matta, Frederick Kiesler, Nina Lebel, Roberto Matta, Marcel Duhamp. New York, 1945

3. Ibid., p. 161.
4. Ibid., pp. 164–5.
5. The representation of the fantastic and cruel as the real was discussed in the 1940s as psychological realism. As Gottlieb declared shortly after the war in 'The Ides of War', *The Tiger's Eye* 1, December 1947, p. 43: 'Today when our aspirations have been reduced to a desperate attempt to escape from evil, and times are out of joint, our obsessive, subterranean and pictographic images are the expression of the neurosis which is our reality. To my mind certain so-called abstraction is no abstraction at all. On the contrary, it is the realism of our time.'
6. James Jones, *World War II*, New York, 1975, p. 135.
7. Robert Rasmus, quoted in Studs Terkel, '*The Good War*', New York, 1984, pp. 36–9.

through this period. … But I was acutely aware of how really theatrical and surreal it was.'[7]

In these descriptions the soldiers defined the fundamental transformation of the imagination that was taking place. Reality had become surreal. A surrealist aesthetic was, then, necessary to articulate it. American artists thus turned to the modernist art of nightmare and conflict as a starting point.

To be sure, there had been Surrealist art in America in the 1930s. It had been exhibited since the early years of the decade at New York galleries such as Julien Levy and Pierre Matisse and in exhibitions at the Wadsworth Atheneum in Hartford in 1931 and The Museum of Modern Art in New York in 1936. A small number of American artists had engaged this new art of irrationality before the war and had developed a home-grown art of ambiguous spaces, unknown narratives, irrational associations, lurking shadows, and enigmatic objects and configurations. Before the war, Federico Castellon (see Fig. 4), Kay Sage and Bruno Margo, among others, had created an imaginary world rather like that of Giorgio de Chirico or Salvador Dalí. Indeed, this enigmatic art was even practised by youthful Abstract Expressionists: by Gottlieb in his 'tablet' and 'box' paintings of the late 1930s and 1940s and his first Pictograph series (for example, *Eyes of Oedipus*; Fig. 5), by Rothko in his first mythical paintings on Aeschylean themes and by William Baziotes in his more veiled, abstract mirror paintings, such as *The Mirror at Midnight I* (1942; private collection) or *The Balcony* (1944; private collection, Santa Barbara).

As critics have long argued, the arrival of the Surrealist artists in America in 1940 as they fled the Nazis proved to be an altogether decisive influence on struggling American artists. Arshile Gorky, for example, first taught himself Surrealism in the 1930s and then met, and was profoundly influenced by, the Chilean Surrealist Roberto Matta in the early 1940s. Gorky associated with the Surrealist émigré group, and André Breton called him one of them (see Fig. 6). Gorky's was among the first American surrealizing art to be semi-abstract, a fusion of Matta and Joan Miró. His important style combined Matta's futuristic imaginary landscapes and psychological morphologies with his own personal dreams and Armenian memories. To this complex he added Wassily Kandinsky's painterliness, as in *One Year the Milkweed* (1944; Cat. 80). In 1942 Matta met with Robert Motherwell, Baziotes, Jackson Pollock, Gerome Kamrowski and Peter Busa to discuss Surrealism and to experiment with Surrealist automatism, a technique (involving improvisatory paint handling) that was meant to tap the unconscious as the initial stage of inspiration. Other Surrealists, such as Wolfgang Paalen, Gordon Onslow-Ford and Kurt Seligmann, befriended and socialized with Motherwell, perhaps Pollock, and others. The Surrealists' actual presence was undoubtedly a major factor in the Americans' absorption of the movement itself.

But European artists' emigration to American shores was not the only reason. Despite these Americans' contact with the younger Surrealists, the major figures kept aloof or never came. Miró, the favourite, stayed in Europe. André Masson and Yves Tanguy settled in Connecticut. Breton never learned English, and Max Ernst left New York after a short period. Others, such as Marc Chagall, Fernand Léger and Piet Mondrian, also arrived in America but had limited impact.

The decisive factor was the wartime validation of the Surrealist vision. In other words, Surrealism was perceived as a catalyst for imagining and representing the new world of the 1940s. This was evident in the rationale for the shows of Dalí and Miró in 1941 at The Museum of Modern Art. Both artists were described as offering signs of the nature of contemporary civilization, of man and of the character of his soul. According to the catalogue of Dalí's exhibition, his work 'is in itself a significant happening in history: a sudden and perhaps unconscious revelation of the spirit of the day and age'.[8] In his introduction Monroe Wheeler also declared that Dalí had been prescient about the calamities of his time, which were comparable to those in the era between Bosch and Callot, in which Rome had been sacked, Vienna besieged by Turks, Jews herded from one country to another and The Netherlands savaged by the Spanish. In the same catalogue Dalí was described as painting his birthright – high-pitched Spanish emotion and an 'Inquisitional heritage of cruelty and pain, the Catalan love of fantasy, and sanctification of instinct'.[9] Dalí's Surrealist art was thus taken to be an omen of the nightmare of history.

The Miró catalogue has similar notes. James Johnson Sweeney saw Miró as fore-seeing the temper of the era. According to Sweeney, his artistic vitality pointed the way out of the current crisis, for it was 'a persistent and constructive effort to achieve a sound balance of the spiritual with the material in painting, an aesthetic paradigm of a fuller, richer life in other fields.... Miró's vitality ... native lyricism, and love of life are ... auguries of the new painting in the new period which is to come.'[10]

In short, Surrealism articulated a modern need and reality quite different from the pre-war quest for economic transformation. In differed, too, from the official war rhetoric of sacrifice, nobility and goodness, and from artist-correspondents' graphic depiction of battle. Neither of these two war arts presented the unconventional and

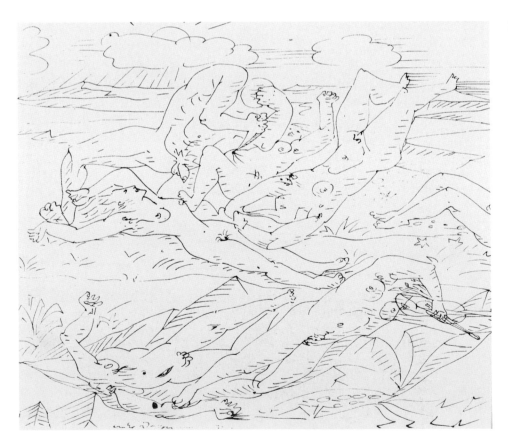

Fig. 7 André Masson, *Massacre*, 1934

8. Monroe Wheeler, Foreword to James Thrall Soby, *Salvador Dali*, exhibition catalogue, New York, Museum of Modern Art, 1941, p. 7.
9. James Thrall Soby, ibid., p. 9.
10. James Johnson Sweeney, *Joan Miro*, exhibition catalogue, New York, Museum of Modern Art, 1941, p. 78.
11. Sidra Stich, *Anxious Visions/Surrealist Art*, exhibition catalogue, Berkeley, University Art Museum, 1990, p. 137.
12. See ibid., passim.

Fig. 8 Roberto Matta, Cover of *VVV*, February 1944

Fig. 9 Isamu Noguchi, *This Tortured Earth*, 1943. The Isami Noguchi Foundation, Inc., Long Island, NY

Fig. 10 Adolph Gottlieb, *Conflict*, 1966. Flint Institute of Arts, De Waters Art Center, Flint, Michigan

the strange. Only what seemed bizarre and monstrous, yet real, was now directly relevant to many.

It is appropriate that the Surrealist, modernist version of reality was taken as true in America in the 1940s, for it had itself developed from the effects of the First World War. Surrealism is today understood not simply as revealing the personal unconscious, as dream space and automatism, but as a comment on the ruin and loss of civilization, and it contains innumerable themes that give visual form to the ideas of creation and destruction, the intellectual counterparts of war and peace. Surrealism attacks official civilization and redefines the life-process and human nature. In Surrealist thought and art, a world of endless and uncontrollable violence is portrayed. As Sidra Stich writes, with images of brutality, massacre, torture and aggression, the Surrealists record 'the transformation of a human into a voracious, bestial creature'.[11] Works such as Masson's *Massacre* (Fig. 7) and *Horses Attacked by Fish* (Centre Pompidou, Paris) describe a nature both human and animal that is dominated by overwhelming instinctual violence. Admittedly deeply influenced by the war, Matta emblematized the Surrealist imagining of war in his cover for *VVV*, the American Surrealist magazine, in 1943 (Fig. 8). Brute force, the baseness of human beings, their animal nature, violent deliriums, attacks on reason and restraint, on wholeness and unity, dynamic theatres of biomorphic (human/flora/fauna) strife, the endless conjunction of death and life, ecstasy and release, the struggle for renewal – these and many other themes form the basis of Surrealist art.[12] Surrealism and modernism thus overtook American art in the 1940s not only because of the proximity of the Surrealists themselves or because it was innovative art, but because it expressed the current condition and experience of the world.

America both absorbed and added to Surrealism. Fusing it with their own views of the mytho-ritualistic periods and processes of history and human life, American artists created an anthropologically ritualistic yet surrealist psychological art. These were now conjoined. Suffering, death and bestial cruelty, for example, form the basis not only of the new work of Siporin, Spruance and Harari, but also of that of the Abstract Expressionists. From David Smith's *Medals for Dishonor* (see Fig. 5, p. 88) to Seymour Lipton's *Moloch* and *Moby Dick* series, from Theodore Roszak's tusked birds to Gottlieb's beasts, American art in the 1940s imagined a cruel and nightmarish world as the most psychologically true. Death and destruction form the basis of early

works by Noguchi, such as *This Tortured Earth* (Fig. 9). Lamentations and ritual process dominate Rothko's work, while Bradley Walker Tomlin and Barnett Newman, like so many at the end of the 1940s, memorialize the dead in iconic yet naturalistic terms. History blasted and broken, yet elevated to myth, underlies Gottlieb's painting (see Fig. 10), and the cosmic struggle for new life and regeneration is fundamental to all Abstract Expressionist art. These themes are imagined in semi-abstract and then abstract form. For many, the conflictive unconscious, that is, inner man, became the site and rationalization of this modern reality.

The 1940s stood as a visionary, apocalyptic world. By their fusion of modern reality with modernism, American artists made formerly abstruse-seeming artistic methods and ideas (that had little native impact in the 1930s) express new truths. As America had ended its isolationism at the beginning of the decade and joined the world, so American artists stepped forward into modern imagining. The result was a new and powerful art – Abstract Expressionism – which was to be the crest of the historical wave and the pride of America.

Irving Sandler

Abstract Expressionism: The Noise of Traffic on the Way to Walden Pond

As the avant-garde of the 1940s, the Abstract Expressionists were spurned not only by the general public, but by the art-conscious audience as well. The artists were condemned to poverty and alienation. They were willing to suffer because they had a calling – to be the standard-bearers of the avant-garde, of all that was adventurous and provocative in the visual arts. Their collective sense of neglect and mission brought them together for mutual solace and support – at openings and other social events; at meetings; and notably at protests, the most notorious of which led to a photograph (Fig. 1) of some fifteen artists in *Life* magazine in 1951, the group portrait that has helped to determine our image of the Abstract Expressionists. In the face of a hostile public, the vanguard presented a common front.

However, there was no commonality in their styles. In fact, their work is distinguished by its individuality. No label can encompass a group as diverse as Jackson Pollock, Willem de Kooning, Mark Rothko, Franz Kline, Clyfford Still and Ad Reinhardt. Yet it is in the nature of art critics and historians to search for affinities – and if possible to categorize their subjects. Like many names applied to modern art move-

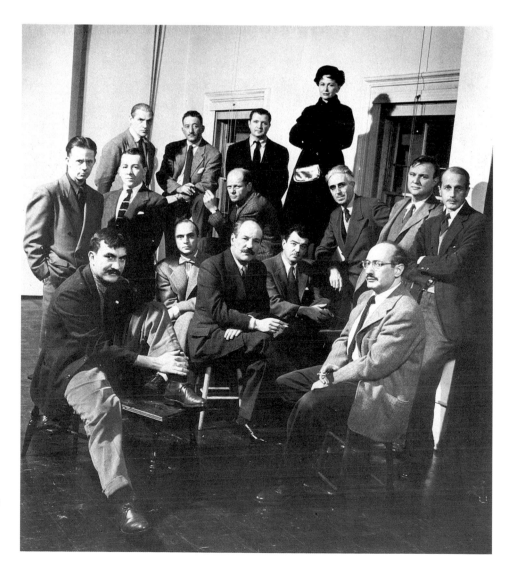

Fig. 1 'The Irascibles', photograph published in *Life*, 15 January 1951. From left to right: (back row) Willem de Kooning, Adolph Gottlieb, Ad Reinhardt, Hedda Sterne; (middle row) Richard Pousette-Dart, William Baziotes, Jackson Pollock, Clyfford Still, Robert Motherwell, Bradley Walker Tomlin; (front row) Theodoros Stamos, Jimmy Ernst, Barnett Newman, James Brooks, Mark Rothko

ments – Cubism, for example, or Fauvism – Abstract Expressionism does not define the art subsumed under the label. The paintings of Pollock, Rothko, Still, Reinhardt and Barnett Newman are abstract but not expressionist. The name fits the style of de Kooning better, but much of his work is figurative. Perhaps Abstract Expressionism can best be defined negatively, by what it was not, that is, by styles the artists rejected as outworn: Regionalism and Social Realism, popular in the economically depressed 1930s; Abstract Cubism, or geometric abstraction, the dominant avant-garde art of the 1930s; and Surrealism in its near-abstract manifestations, the advanced style of the early 1940s.

Above all, the Abstract Expressionists rejected the relational design of Cubism, whether of a Picasso or a Mondrian, that is, the tightly knit composition of varied, clearly defined, flat shapes contained within the picture limits. Instead, beginning in 1947, Pollock and Still, soon joined by Rothko and Newman, formulated a radically new conception of the picture – as an all-over, open field: an expansive linear mesh, as in Pollock's poured canvases, or an equally expansive field of colour areas, as in Still's, Rothko's and Newman's abstractions. Both kinds of field organization engaged the viewer with immediacy: suddenly, all at once, in a way very unlike Cubist compositional techniques, which induced the viewer to experience a picture from part to part to whole. It is significant that this innovative abstract image – the most radical formal invention of Abstract Expressionism – involved a total rejection of the Cubist-inspired composition that had been absolutely central to modern art of the earlier twentieth century.

But Field painting was only one tendency within Abstract Expressionism, a major one to be sure. Another, variously labelled Gesture or Action or Painterly painting, was equally important. In fact, it numbered far more artists, foremost among them de Kooning and Kline. They continued to use Cubist composition as a stable infrastructure for their improvisational configurations of open brush-marks, but their images were too explosive or implosive to be characterized as Cubist. Indeed, their painting is marked by its gestural quality.

Recognizing that the labels Field and Gesture painting are more specific than Abstract Expressionism, art critics and historians have usually treated the new American painting as two tendencies rather than as an entity. Even so, both tendencies have been linked so repeatedly that the differences between them are often minimized. They should not be. Not only did Field and Gesture painting differ formally, but the artists had different aesthetic and metaphysical outlooks, moved in different social circles, had different life-styles and were even separated geographically, most Gesture painters living in down-town Manhattan, most Field painters up-town.

De Kooning stressed the differences between himself and Still and Pollock. He recognized that they were the primary innovators of the new painting and the most radical of his colleagues. As he said of Pollock: 'Every so often, a painter has to destroy painting. Cézanne did it. Picasso did it with Cubism. Then Pollock did it. He busted our idea of a picture all to hell. Then there could be *new* paintings again.'[1] De Kooning believed that compared to Pollock's and Still's work, his own was traditional. In interviews I had with him in 1957 and 1959 he characterized Still's and Pollock's abstraction as 'American', embodying the image of the solitary pioneer who opened up the wild frontier to agrarian enterprise.[2] De Kooning neglected to mention that his own painting embodied the equally vital American urban experience. Nevertheless, his insight is crucial to the understanding of Pollock's and Still's work.

Still openly proclaimed that his art represented the New World, but he wanted his message recognized globally. So did Pollock, who also acknowledged the Americanness of his work, if less stridently. De Kooning, Kline and most of the Gesture painters rarely referred to nationality, and for good reason. During the 1930s, at the beginning of their careers, all the future Abstract Expressionists recognized that their art was derivative and provincial. They knew that it was not as provincial as the backward-looking, Marxist-orientated Social Protest and nationalistic Regionalist styles that they reviled as retrogressive and just plain bad, and this provided a solace of sorts. However, American avant-garde artists knew their work was not as original, vital and

1. Quoted in Rudi Blesh, *Modern Art USA*, New York, 1956, pp. 253–4.
2. See Irving Sandler, 'Conversations with de Kooning', *Art Journal*, vol. 48, no. 3, 1989, pp. 216–17.
3. Isaiah Berlin, 'Nationalism,' in idem, *Against the Current: Essays in the History of Ideas*, New York, 1980, pp. 333–55.
4. Adolph Gottlieb and Mark Rothko, *The Portrait and the Modern Artist*, mimeographed script of a radio broadcast, New York, 13 October 1943, n. p.
5. Jackson Pollock, 'Jackson Pollock', *Arts and Architecture*, February 1944, p. 14.
6. Barnett Newman, *Northwest Coast Indian Painting*, exhibition catalogue, New York, Betty Parsons Gallery, 1946, n. p.

masterly, and thus major, as that being created in Paris, the city they acknowledged as the hub of world art.

At an ocean's remove from the centre, the best that vanguard artists could do was to emulate those modernist masters whom they admired, notably Picasso, Mondrian and Miró. The Americans set out to master modern art, and by the outbreak of the Second World War they had. Their outlook had been anti-provincial and internationalist, and it would remain anti-provincial and internationalist; they would measure themselves by the highest and most advanced of global standards – such was the scope of their ambition – and this would lead them in time to achieve recognition abroad as well as at home.

Their internationalism was abetted by a fierce hatred of racist and xenophobic aesthetics, then promulgated most loathsomely in Hitler's Germany, which was growing in power and preparing for war. The vanguard paired Nazi blood-and-soil myths with the nationalistic rationale of the Regionalist painters. Thus, Regionalism was rejected not only because it was retrograde, but also for being chauvinistic. The Abstract Expressionists might not have been so reluctant to invoke the American dimension to their painting had they been able to distinguish between nationalism and national identity, the first a malevolent force that leads one people to hate and subjugate another, the second a people's positive awareness of shared qualities and aspirations. But no such frame of reference existed, as Isaiah Berlin has pointed out. Nationalism had dominated much of nineteenth-century Europe, and it continues to be a powerful political force in the world today, perhaps the most powerful force of all. Yet, as Berlin observed, no significant thinker, certainly none of the stature of a Freud or a Marx, has given it the attention it deserves.[3] It is telling that both Freud and Marx played down the importance of both nationalism and national identity in human affairs, and their thinking was the most influential in the Abstract Expressionist era.

In the early 1940s Pollock, Rothko and other Abstract Expressionists turned to archaic myths and 'primitive' art for inspiration. They used the Surrealist technique of automatism to recollect man's primordial past and reveal the archetypal symbols that 'lived' in the collective unconscious, an approach influenced by C. G. Jung. These 'Mythmakers', as Rothko called them in 1943, professed that their interest in primitive man was prompted by the Second World War. Rothko said that archaic art and mythology contained 'eternal symbols ... of man's primitive fears and motivations And our modern psychology finds them persisting still in our dreams, our vernacular and our art, for all the changes in the outward conditions of life.'[4]

In their statements the Mythmakers emphasized mythic and primitivistic content. It allowed them to repudiate geometric abstraction for what they considered its lack of content, while continuing to use abstract forms identified both with modernist art and much of 'primitive' art. They also claimed that their content, because it was universal, was more relevant than the Marxist class struggle of Social Realism or Regionalist nationalism; supra-national content, moreover, emphatically opposed the xenophobia of Nazi aesthetics.

The Mythmakers were attracted to all 'primitive' art, but they preferred its native American variants, notably Northwest Coast Indian, Eskimo and Pre-Columbian. Much of this indigenous art was available in New York, for example, at the Museum of the American Indian. In 1940 The Museum of Modern Art mounted 'Twenty Centuries of Mexican Art' and, in the following year, the largest and most far-ranging show in its history, 'Indian Art of the United States'. The museum stressed the universal aesthetic and human values of native American art. So did Rothko, Gottlieb, Newman and Pollock, who said, for example, that it possessed 'the basic universality of all real art'.[5]

The focus on Indian art was an early sign of American identity in the painting of the Mythmakers and their rejection of European culture. Later, in 1946, Newman claimed that the Mythmakers prized 'the many primitive traditions' because they stood apart 'as authentic aesthetic accomplishments that flourished without benefit of European history'.[6] By identifying their modernist art with the indigenous art of the

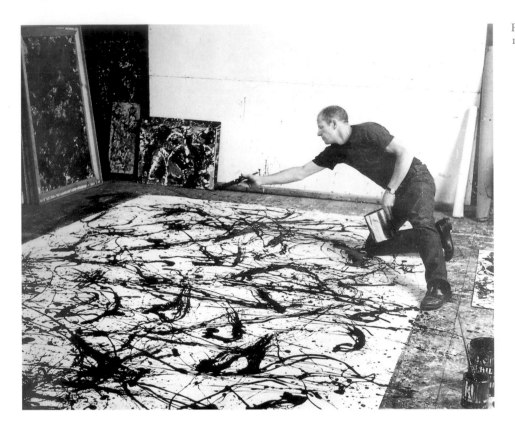

Fig. 2 Jackson Pollock at work on *Number 32*, 1950

Americas, the Mythmakers were able to differentiate their painting from European art. The idea of creating a major American art of global stature was to grow even stronger in time.

The so-called mythic period in Abstract Expressionism lasted from roughly 1942 to 1947. Pollock improvised impulsive images that allude to mythic animal sexuality, Indian totems, primitive rites and Graeco-Roman legends – violent themes rendered tempestuously. Still juxtaposed horizontal, female, dark earth with vertical, male, light suns. Rothko employed automatism to invent human, animal, bird, fish, insect and plant hybrids engaged in cryptic re-enactments of ancient myths.

From the first, the Mythmakers sought to express a universal 'Spirit of Myth, which is generic to all myths of all times', as Rothko wrote.[7] Around 1946 they found that their quasi-figurative imagery had become too commonplace to evoke visions of what Newman had begun to term 'the sublime', Rothko 'transcendental experience' and Still 'exaltation'. Mythmaking was transformed into a quest for 'the Abstract Sublime', in Robert Rosenblum's words, and in Lawrence Alloway's, 'the American Sublime'.[8] This search for a timeless and universal imagery was to lead the Mythmakers into non-objectivity.

Pollock carried automatism into abstraction so extreme that it could no longer be categorized as Surrealist (see Cat. 86–94). He placed outsize canvases on the floor, and, moving around and at times on them, poured, dribbled and flung paint instead of applying it with the brush (see Fig. 2). The technique was derived from the divergent sources of Surrealist automatism and the sand painting rituals of Southwestern American Indians. The synthesis was unusual – a process that was identified, on the one hand, with an international modernist movement and, on the other, with a 'primitive' art that was also American. Pouring pigment enabled Pollock to register his creative experience more directly than he could with the brush. His bodily movements needed scope, encouraging him to work on a large scale, to 'literally be in the painting'.[9] Sweeping, arm-long skeins of paint traject freely, like traces of energy, across the canvas. Interlaced in an all-over configuration, lacking focal points, the painting generates even more energy, a continuum so charged that it seems to expand beyond the picture limits, evoking an immediate sensation of boundlessness, a sensation intensified by the large size of the canvases.

7. Mark Rothko, Statement, 1943, in Sidney Janis, *Abstract and Surrealist Art in America*, New York, 1944, p. 118.
8. See Robert Rosenblum, 'The Abstract Sublime', *Artnews*, vol. 59, no. 10, February 1961, pp. 38–41, 56, 58, and Lawrence Alloway, 'The American Sublime', *Living Arts*, June 1963, pp. 11–12.
9. Jackson Pollock, 'My Painting', *Possibilities I*, Winter 1947/48, p. 79.
10. Leo Marx, 'American Ideology of Space', lecture at The Museum of Modern Art, New York, 21 October 1988.
11. Gertrude Stein, *The Geographical History of America*, New York, 1973, pp. 53–4.
12. Barbara Novak, 'Grand Opera and the Small Still Voice', *Art in America*, vol. 59, no. 2, 1971, p. 67.
13. Marx, op. cit. It is noteworthy that Rothko had emigrated to the United States as a boy and had crossed the country to Portland, Oregon.
14. Clyfford Still, Letter to Gordon M. Smith, 1 January 1959, in *Paintings by Clyfford Still*, exhibition catalogue, Buffalo, Albright Art Gallery, 1959, n. p.

Still, Rothko and Newman evolved styles as radical as Pollock's but focused on expression through colour. To maximize the visual – and emotional – impact of colour, they eliminated figuration and symbolism, simplified drawing and gesture, suppressed the contrast of light and dark values, painted chromatic expanses that saturate the eye and enlarged the size of the canvas. Aiming for the visionary, they strove literally to engulf the viewer by creating a total chromatic environment.

Still painted open and expansive abstract fields composed of vertical paint-encrusted areas whose contours were organic and flame-like, acting to unlock the picture space, causing it to expand up and outwards, conveying an immediate sensation of upward aspiration and boundlessness (see Cat. 103–6). Newman formulated an equally radical colour-field abstraction consisting of a single, almost matt colour cut by one or more narrow vertical bands of contrasting hues. No horizontals knit the verticals into a Cubist-like structure that might break the continuous field. Instead, the vertical stripes function as accents energizing the entire colour field, preventing it from becoming amorphous and inert (see Cat. 107–12). Rothko eliminated discrete contour lines, making the atmospheric surfaces of his abstractions continuous. His mature abstractions consist of a few softly painted and edged rectangles of luminous, airy colour, floated symmetrically one above the other on somewhat more opaque vertical fields (see Cat. 113, 116). His aim was to release viewers from their everyday existence, causing them to rise above the self's habitual experience into a state of transcendence, a frame of mind in which spiritual awareness might occur.

It should be stressed that the ambition of the Mythmakers was to be universal, modernist, internationalist and original. But equally important, their work was informed by a national consciousness. The United States is distinguished by the diversity of its people, regions, economic classes, life-styles and so forth. And yet, despite this heterogeneity, there exists a common culture, the product of geography, language, laws, institutions, historical memories and beliefs, real and imagined, which generates a commitment to certain values, such as individualism and openness. Leo Marx succinctly characterized two main forces that shaped the consciousness of Americans in the title of his book *The Machine in the Garden: Technology and the Pastoral Ideal in America*, and I would add to technology the urbanization that accompanied it. The Field painters tended to evoke the rural experience, the Gesture painters the urban.

Marx said that all self-aware peoples possess a mental map and a national myth of origin.[10] The most important attribute of the mental map of Americans is boundlessness, the United States as a limitless expanse in which, as Gertrude Stein wrote, 'there is more space where nobody is than where anybody is. This is what makes America what it is.'[11] This vast landscape, stretching some three thousand miles from the Atlantic to the Pacific oceans, is not merely a physical phenomenon but, as Barbara Novak pointed out, 'a repository of national pride … even … a religious alternative'.[12] The American national myth of origin, as Marx observed, is the transatlantic voyage of immigrants and, by extension, the journey into the uncharted West. In short, the myth is that of new beginnings, the escape from the Old World into a New World.[13] The outsize abstractions of Still, Pollock, Newman and Rothko appear to be shaped by the continental geography of the United States – not only its vast terrain, but also the stance of the people who tamed it. Still's work conveys a boundlessness and openness that calls to mind panoramic American prairies and plateaux – awesome crags and fissures. Equally American were Still's statements presenting himself as a latter-day pioneer who discovered a New World in art – the mythic terrain of art replacing the mythic American West as the open frontier, a frontier in which a heroic Individual could achieve absolute liberation. 'It was as a journey that one must make, walking straight and alone…. Until one had crossed the darkened and wasted valleys and come at last into clear air and could stand on a high and limitless plain.'[14]

Still's and Pollock's abstractions call to mind the American wilderness in its sublime vastness. But they also suggest the rural scene. Leo Marx has pointed out that the 'line between the two is not sharp. Both the wild and the cultivated versions of the garden image embody something of that timeless impulse to cut loose from the constraints

of a complex society.'[15] Much as they seem to evoke nature as untamed, Pollock's and Still's abstractions also look agrarian, Pollock's reminiscent of grasslands, Still's of farmlands. Both Pollock and Still grew up on small Western farms. Still proudly recalled his farming experiences when 'my arms have been bloody to the elbow shocking wheat'.[16] His coarse, heavy pigment, trowelled on with palette knives, calls to mind earth. Pollock had also been a farm worker in his youth. His friend Tony Smith said: 'I think that his feeling for the land had something to do with his painting canvases on the floor'[17] – the floor as a kind of surrogate earth. In an interview of 1944 Pollock said: 'I have a definite feeling for the West: the vast horizontality of the land.' After he moved East to Long Island, New York, he substituted the Atlantic Ocean for the Western plains of his youth.[18] Pollock's and Still's boyhood in the West shaped their spatial imagination. Moving to New York, they carried their landscapes with them. But immersing themselves in modern art and culture, they created bold new abstract images of American space, in which there is an utterly convincing fit of form and content.

Rothko's abstractions are distinguished by their light, which becomes a metaphor for spiritual essence. Robert Rosenblum related Rothko's work to the landscapes that Martin J. Heade, John Kensett and other Luminists painted in the nineteenth century:

> Typically, a Luminist painting confronts us with an empty vista of nature (often a view of sea and sky from the shore's edge) that is more coloured light and atmosphere than terrestrial soil. [The] power of light slowly but inevitably … pulverize[s] all of matter, as if the entire world would eventually be disintegrated by and absorbed in this primal source of energy and life. A surrogate religion is clearly a force here, too. [This] natural American light … can slowly lead us to the supernatural and the transcendental thought of [Ralph Waldo] Emerson and [Henry David] Thoreau, who also sought a mystic immersion in the powers of nature.

Rosenblum suggested that Luminism was of central importance in American visual and cultural traditions and that Rothko's art could 'be seen as resurrecting, in an abstract mode, the Luminist tradition'.[19] It is significant that Rothko's close friend, Newman, venerated the Transcendentalists, even choosing to spend his honeymoon on Walden Pond, where Thoreau had lived.

To sum up, the Field painters distilled American nature as they imagined it, abstracting its essential American quality and transforming it into mythic imagery. In a sense, they *reinvented* Regionalist painting, not as illustration but in the abstract forms of their own historical moment.[20] At the same time, their art commanded global attention, indeed it dominated avant-garde art in the post-war West. Or, as Pollock put it: 'The important thing is that Cliff Still … and Rothko, and I – we've changed the nature of painting.'[21]

In a real sense, the idea of an American wilderness, in which humankind creates a garden, turned out to be a myth. And the myth was long outdated. After all, the frontier had vanished by 1890. Nevertheless, its image lived on in the American imagination: a symbolic terrain, it evoked emotions, ideas and associations in the American psyche and continued to shape the very being of Americans – their psychology, thinking, behaviour and even hopes. The Field painters invested the myth with new vitality.

Leo Marx posited a powerful counter-force in the American consciousness to the pastoral ideal, namely industrial power – the accompaniment of which was the city, a 'man-made wilderness'.[22] And in the twentieth century, the United States had become predominantly industrial and urban. De Kooning, quintessentially urban, was the most influential avant-garde artist in the 1950s (see Cat. 95–102). His work appealed to his colleagues because it was rooted in tradition, referring to human anatomy, Cubist design, drawings by Rembrandt and Rubens, and graffiti on tenement walls. It also appeared to be based on what Wassily Kandinsky called 'inner necessity'. Moreover, it seemed existential – the improvisational painterly images looked as if they were encountered in the anxious struggle of creation and thus embodied the artist's authentic being – at a time when Existentialist philosophy was in vogue. Much

15. Leo Marx, *The Machine in the Garden: Technology and the Pastoral Ideal in America*, London, 1964, pp. 42–3.
16. Quoted in Dore Ashton, *The New York School: A Cultural Reckoning*, New York, 1972, p. 34.
17. Tony Smith, interviewed by Francine du Plessix and Cleve Gray, in 'Who Was Jackson Pollock?', *Art in America*, vol. 55, no. 3, May/June 1967, p. 52.
18. Jackson Pollock, 'Responses to a Questionnaire', *Arts and Architecture*, February 1944, p. 14.
19. Robert Rosenblum, 'Notes on Rothko and Tradition', in *Mark Rothko*, exhibition catalogue, London, Tate Gallery, 1987, pp. 26–7.
20. Pollock had studied under Thomas Hart Benton, a leading Regionalist painter, and had begun his artistic career as a painter of American scenes. Although Pollock rejected his teacher's tame realism, he retained the spirit of Regionalism.
21. Quoted in Selden Rodman, *Conversations with Artists*, New York, 1957, p. 84.
22. Marx, 1964, p. 358.
23. Quoted in Sandler, op. cit., p. 216.
24. Quoted in Frank O'Hara, 'Franz Kline Talking', *Evergreen Review*, Autumn 1958, reprinted in Frank O'Hara, *Standing Still and Walking in New York*, Bolinas, CA, 1975, p. 94.

as de Kooning acknowledged his debt to the European 'fathers' of modernism, as he said, '[I was] grappling for a way to say something new ... I have this point of reference – my environment – that I have to do something about I change the past.'[23] And that environment was the city. In its restlessness, claustrophobia, density, rawness, violence and ambiguity, de Kooning's painting of the late 1940s and 1950s felt like a walk down a Manhattan street.

Franz Kline's thrusting black-and-white swaths also allude to the ever-changing city – to massive sections of partly demolished or constructed skyscrapers and bridges (see Cat. 119, 120). But unlike de Kooning's images, which are compacted, ambiguous and anxious, Kline's are expansive, bold and exuberant. He once said: 'Hell, half the world wants to be like Thoreau at Walden worrying about the noise of traffic on the way to Boston; the other half use up their lives being part of that noise. I like the second half. Right?'[24]

David Anfam

Beginning at the End:
The Extremes of Abstract Expressionism

Origins, beginnings, ends, go to the end and beyond the end
<div align="right">Ad Reinhardt, undated notes</div>

Painting is a clock that sees both ends of the street as the end
of the world Philip Guston, Statement, 1958

Abstract Expressionism runs its course between a play of extremes. They stamp certain clear features upon what is otherwise perhaps the most sprawling artistic landscape in the twentieth century. At first glance, indeed, it is the opposing patterns on any map of this heterogeneous 'movement' that catch the eye. Superficially, these are the co-ordinates to the almost Manichaean drive behind Abstract Expressionism's dramatic, if now familiar, highlights. Cutting across formalist and existential dogmas in the 1950s, the left-wing critic Meyer Schapiro drove that basic point home by noting how the 'restless complexity' of Jackson Pollock or Willem de Kooning found a polar counterpart in Mark Rothko's 'all-pervading, as if internalized, sensation of a dominant colour'.[1] Such confrontations still appear insistent enough to resemble some binary system, the blueprint to attitudes remote from a more deconstructive, post-modern present.

Thus, Robert Motherwell's entire aesthetic outlook was keyed to dialectics: initially, during the 1940s, it involved what he saw as conscious elements (straight lines, weighted colours, abstraction) and unconscious equivalents (soft lines, obscured shapes, automatism); then mortality and existence itself in the grand *Elegies to the Spanish Republic* series (see Fig. 1) that followed; and finally, freedom versus con-

Fig. 1 Robert Motherwell, *Elegy to the Spanish Republic No. 34*, 1953–54. Albright-Knox Art Gallery, Buffalo; Gift of Seymour H. Knox, 1957

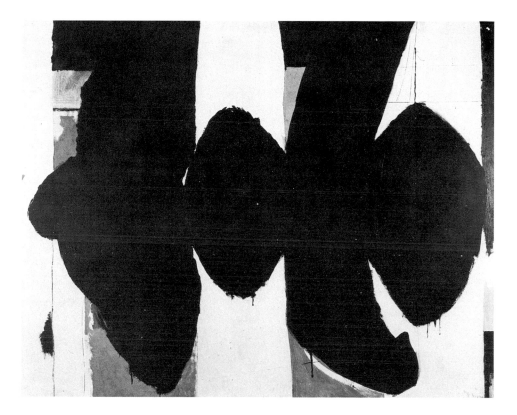

1. Maurice Tuchman, *New York School: The First Generation*, Greenwich, CT, 1971, p. 20.

straint in a path that led from *The Little Spanish Prison* (1941–44; Museum of Modern Art, New York) to the *Open* canvases of over twenty years later. For Franz Kline, the thesis and antithesis meant pitting black against white to create vectors that clash together in raw grids (see Cat. 119, 120). Hans Hofmann went further and viewed reality in terms of a dualism that was supposedly conveyed through the well-known 'push-and-pull' principles of his technique.[2] Elsewhere, dichotomies reach into other spheres. To sexuality, for example (signalled by Pollock's emblematic early 1940s title *Male and Female*), which occasions Abstract Expressionism's renderings of Woman as a combative Other, which, in turn, presuppose a male sensibility. Or the divisions encompass the counterpoint between the urban themes that motivated Kline, de Kooning and the photographer Aaron Siskind, on the one hand, and the pastoral vision of Arshile Gorky and, sometimes, Pollock on the other. Lastly, there are the epic limits of the human journey, as when Clyfford Still spoke of his work's 'power for life … or for death', while Rothko included 'tragedy, ecstasy, doom' among his goals.[3]

If such extremes contributed much to Abstract Expressionism's promotion or status in the past, they now look overtly romantic and more a part of its *Sturm und Drang*, legacies from a late-eighteenth or nineteenth-century world-view.[4] Delving beyond them, however, uncovers a finer text. It was crafted into how the various artists handled their media. Extreme magnitude or aggressiveness, for instance, typify the movement in the popular view, wherein they have mingled with pre-existent American notions about rawness, power and 'machismo'. *Time* magazine's epithet for Pollock, 'Jack the Dripper', lent this assumption a derogatory wit, whereas Harold Rosenberg's 'Action Painting' ideas gave a philosophical rationale to somewhat analogous underlying stereotypes.[5]

Whether faced with the largest Abstract Expressionist icons, such as Pollock's 1943 *Mural* (Cat. 86) and Barnett Newman's *Vir Heroicus Sublimis* (1950–51; Museum of Modern Art, New York), with de Kooning's violent painterliness (see Cat. 95–102), Still's chiaroscuro (Cat. 103–6) or the rivets, welding, found objects, spikiness and bulk that impart a sheer physical presence to David Smith's sculpture (Cat. 126, 127), it remains impossible to deny that this is art of spectacle, extravagance and force. Yet repeatedly those factors are also held in check, deferred and given correctives.

Just as Pollock's huge *Mural* probably grew from a compact kernel – Picasso's 1932 *Girl in Front of a Mirror* (Fig. 2), whose intertwined spheroids multiply across its length – so his 'classic' drip paintings mediate far-flung options. On the one hand, their microstructure tends towards either chaos or barely readable flux. On the other, they have at best an often-remarked overall unity. Hence two ways of seeing – a restless glance and a totalizing gaze – are suspended.[6] *Vir Heroicus Sublimis* exemplifies how Newman controlled colour, here an immense redness, not only through the rhythm of its five vertical 'zips', but also by predicating everything around a central observer whose attention unites them to complete the field. This explains why Newman, who painted some of the century's more awesome chromatic statements, could claim that his primary contribution lay in 'drawing', the structuring of his work.[7] Likewise, from the later 1940s onwards, Still and Rothko exploit pictorial signs that subvert their monolithic images. Rothko will undercut a vibrant orange or blue with edges and glazes hinting at tonalities hidden below; Still may use a tiny dissonant stroke to arrest a six-foot-high black expanse. Again, one is made aware of an utmost stress upon vision and its purviews. The same applies to the surprises that unfold when Smith's sculptures are seen from different viewpoints, their apparent frontal mass yielding to voids and planes. This climaxes in the *Cubi* (see Cat. 129), whose steel blocks are dematerialized by dazzling burnished surfaces. It is as though sight and touch challenged each other.[8]

Given the artists' personae, their endeavours might be expected to involve maximum contrasts. Still recalled his intellectual mentor, Nietzsche, with such remarks as 'I revel in the ultra-complex' and had no trouble combining a taste for car mechanics, Beethoven, baseball and Plato.[9] A similarly rich mix defined the secular Judaic cosmopolitanism of Newman, Rothko and Philip Guston, wherein little distance might separate Mozart and Brooklyn, Krazy Kat cartoons and the Kabbalah. With Smith,

Fig. 2 Pablo Picasso, *Girl in Front of a Mirror*, 1932. The Museum of Modern Art, New York; Gift of Mrs Simon Guggenheim

2. See Irving Sandler, 'Hans Hofmann: The Dialectical Master', in *Hans Hofmann*, exhibition catalogue, New York, Whitney Museum of American Art, 1990, pp. 77–97.
3. Clyfford Still, Letter to Gordon M. Smith, 1 January 1959, in *Paintings by Clyfford Still*, exhibition catalogue, Buffalo, Albright Art Gallery, 1959, n. p.; Rothko, quoted in Selden Rodman, *Conversations with Artists*, New York, 1957, pp. 93–4.
4. The most persuasive updating of this standpoint is Robert Rosenblum, *Modern Painting and the Northern Romantic Tradition: Friedrich to Rothko*, New York, 1975.
5. On Rosenberg's politics, see Fred Orton, 'Action, Revolution and Painting', *The Oxford Art Journal*, vol. 14, no. 2, 1991, pp. 3–17.
6. The distinction is Norman Bryson's, in his *Vision and Painting: The Logic of the Gaze*, London, 1983. See also David Anfam, *Abstract Expressionism*, London, 1990, p. 130.
7. John O'Neill, ed., *Barnett Newman: Selected Writings and Interviews*, New York, 1990, p. 251.
8. See Rosalind Krauss, *Terminal Iron Works: The Sculpture of David Smith*, Cambridge, MA, 1971.
9. See David Anfam, 'Clyfford Still', unpublished Ph.D. thesis, University of London, 1984, © David Anfam 1993, p. 16 and pp. 15, 53, 116, 271.
10. *U.S.A. Artists: Barnett Newman*, National Education Television programme, broadcast 12 July 1966.
11. See, for example, Stephen Polcari, *Abstract Expressionism and the Modern Experience*, Cambridge, 1991.
12. See the Newman-Rothko correspondence, Barnett Newman Papers, Archives of American Art, Smithsonian Institution, Washington, DC.
13. Jeffrey Wechsler and Greta Berman, *Realism and Realities: The Other Side of American Painting, 1940–1960*, New Brunswick, 1981, pp. 49–61.

Fig. 3 Gorgon; Greece, late 7th century BC.
Museo Nazionale, Syracuse

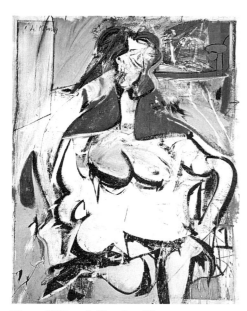

Fig. 4 Willem de Kooning, *Woman*, 1949.
Mr and Mrs Boris Leavitt, Hanover,
Pennsylvania; on loan to the National Gallery of
Art, Washington, DC

14. Rosenblum, op. cit., Part III; Frederick
 Levine, *The Apocalyptic Vision*, New York, n. d.
 (*c.* 1979); and William Graebner, *The Age of
 Doubt*, Boston, 1991.
15. Frank Kermode, *The Sense of an Ending*,
 London, 1981 (first published 1966).
16. See Clifford Ross, ed., *Abstract Expressionism:
 Creators and Critics*, New York, 1990,
 pp. 193–6. Hence Still's frequent use of quest
 or journey imagery in his written statements
 and earlier art.
17. Ibid., pp. 127–30, 167–70. Garnett McCoy,
 ed., *David Smith*, London, 1973, p. 66.
18. See Anfam, 1990, fig. 10, for a reproduction
 of the Still.

too, presenting himself as, for example, an upstate New York outdoors type attuned, nevertheless, to Bartók and Schoenberg, the polarities were doubtless again a device to contradict Establishment values. But essentially they transcend mere biographical matter and point towards strategies that spur perhaps Abstract Expressionism's widest leap – between earlier darkly narrative trends and the subsequent iconic abstractions, and from pictorial closures to manifold renovations. As the extremes are taken apart, patterns of apocalypse and eschatology emerge.

'In my own case, the feeling I had at the time, around '41, was that the world was coming to an end. And if the world was coming to an end, the whole issue of painting … was over', Newman recollected a quarter of a century later.[10] Of course, neither the world, nor art, ended. Quite the reverse, in fact, because eschatologies are fictions, ways of organizing reality. And of making art. That Newman soon did both attests to this; that one of his ensuing paintings was titled *The Beginning* (1946) indicates the design associated with the apocalyptic imagination.

The years that Abstract Expressionism spans, encompassing a world war, genocide and the prospect of nuclear annihilation, obviously did not lack cataclysms, fictive or actual. Scholarship has examined their impact at length, tracing cycles of crisis, death, violence and spiritual rebirth within Abstract Expressionism.[11] But wartime conflict, Jungian psychology, existentialism or mythology – important as they are for the art's context and content – do not exhaust its resources. As it happens, Newman considered Jung a Nazi, de Kooning had scant interest in myth, Still formulated a personal proto-existentialism early on (and apparent in his 1935 Master's thesis on Cézanne) and Rothko wrote breezy letters from the seaside in the grim post-war years.[12] Moreover, devastation and atomic outbursts are subordinate themes in American painting throughout the 1940s.[13] History, biography and artistic motives need not move in step. Deeper structures may operate.

From German Expressionism, via Futurism, to the conflagrations that close Nathanael West's novella *The Day of the Locust* (1939) and Raoul Walsh's film *White Heat* (1949), apocalyptism has an extensive lineage within modernism and demotic culture alike.[14] Among the most trenchant analyses of its inner mechanisms, and one that cuts closest to Abstract Expressionism's, is Frank Kermode's literary study *The Sense of an Ending*.[15]

Ends, beginnings and a pivotal in-between stage (caught by Horace's phrase *in medias res* and Sir Philip Sidney's memorable translation, 'in the middest') are the contours that Kermode discerns to the apocalyptic framework. They order chaos and crisis, as already shown by Newman's canny switch between the first two states. Whether these extremes 'really' marked American history from the late 1930s to the 1950s proves inconsequential in so far as its culture was preoccupied by them. Alongside ideas of time and transition – which cement the terms in the apocalyptic equation – they are keys to a great deal that is otherwise locked into Abstract Expressionism.

The sense of being at some pregnant historical crisis or juncture seemed to obsess each artist differently. Cultural pessimism influenced this. If you suppose, as Still's diatribes insist, that past and present are moribund, you will always be urged to new beginnings.[16] Seminal late 1940s writings, such as Newman's 'The Sublime is Now' and Rothko's 'The Romantics were Prompted', vary this scenario. Smith rephrased it, providentially, by saying that his was 'the greatest time in the history of man to make art'.[17]

With modernism's more pertinent chapters – Post-Impressionism, Expressionism, Cubism and Surrealism – already behind, the artists might start anew while, paradoxically, fraught with aesthetic self-consciousness. Hence, despite Still's iconoclasm, his 1940 *Self-Portrait* echoes Delacroix's of *c.* 1837 (Louvre, Paris).[18] Temporal overlays were fundamental to Gorky's search for a modern identity. Around 1927 he could paint a *Self-Portrait at the Age of Nine*. By extension, his mature style, as represented by *Waterfall* (Cat. 81) and *The Betrothal II* (Whitney Museum of American Art, New York), telescopes allusions to nature, Uccello, Duchamp, medieval Armenia and autobiography. Remote references also haunt de Kooning's contemporaneous figures. If

the archaic Greek Gorgon sculpture (Fig. 3) did advise his 1949 *Woman* (Fig. 4), they further act to petrify the present.[19]

Time's weight also impelled Ad Reinhardt's work (and figured often in his writings), though towards altogether different conclusions. His gradual elimination of every extraneous visual element can be read as a process of negating the past to achieve abstractions that stand 'outside' time. In them, colour, light and composition are taken to an end-game (see Cat. 123–5) and it cannot be coincidental that Reinhardt's notes mention the '"Sense of an ending," paradigm of apocalypse'.[20]

Awareness of time had undergone abrupt changes in American thought by the late 1930s. Previously, such critics as Van Wyck Brooks and Waldo Frank had rediscovered earlier native traditions in order to service a felicitous present. When asked in 1929 'What do you look forward to?', Charles Demuth answered, 'The Past'.[21] But catastrophic events during the next two decades made the past more often seem treacherous or irrelevant than benign. Once the Cold War and Korea had succeeded the Second World War, even putative new beginnings looked doubtful.

Fig. 5 David Smith, *Medal for Dishonor: Death by Bacteria*, 1939. Collection of Candida and Rebecca Smith

A disjunct present therefore underpinned the temporal concerns so evident in both Abstract Expressionism and its wider matrix. One 1946 hit song, 'A Rainbow at Midnight', for instance, symbolized an alternative future within a current dystopia, while a new cinematic genre, *film noir*, used flashbacks and voice-overs to evoke disparate temporal threads.[22] The films' titles themselves conjure up time lost, distant or seen down long vistas: *Out of the Past*, *Till the End of Time*, *The Dark Past* and *Deadline at Dawn*, each from the late 1940s. In like spirit must be reckoned such titles from the same era as *Fantasy at Dawn* (Rothko), *Genesis – The Break* (Newman), *Something of the Past* (Pollock) and *The Mirror at Midnight* (William Baziotes).

In Kermode's analysis, new perspectives are preceded by the sense of endings, the so-called 'terror of the last days' when anxiety mounts and things fall apart. This was indeed the tone of emergent Abstract Expressionism. There, strong narrative impulses (flowing from Regionalism, American Scene painting and 1930s murals) were short-circuited. The results are oddly *fabulated* pictures. In Pollock's *Going West* (*c.* 1934–38; National Museum of American Art, Washington) Thomas Hart Benton's frontier journey has fallen into gothic gloom; Smith's *Medals for Dishonor* (*c.* 1936–40) concoct apocalyptic ruin from graphic fragments (see Fig. 5); and the early figures of Gorky and de Kooning resemble wide-eyed mannequins. Locale and

Fig. 6 Willem de Kooning, *Excavation*, 1950. The Art Institute of Chicago; Mr and Mrs Frank G. Logan Purchase Prize, Gift of Mr and Mrs Noah Goldowsky and Edgar Kaufmann, Jr., 1952.1

Fig. 7 Pablo Picasso, *Orpheus Killed by the Maenads*, 1930. Etching, first state

19. Though the sculpture has entered the de Kooning literature, to my knowledge this specific connection has not. Key resemblances are the out-thrust arm, leg and tongue.
20. Quoted in Barbara Rose, ed., *Art-as-Art: The Selected Writings of Ad Reinhardt*, New York, 1975, p. 107.
21. Quoted in Michael Kammen, *Meadows of Memory*, Austin, 1992, p. xx.
22. George Lipsitz, *Culture and Class in Cold War America*, New York, 1981, p. 2, and Graebner, op. cit., ch. 3. On *film noir*, see J. P. Telotte, *Voices in the Dark*, Urbana, 1989, and Dana Polan, *Power and Paranoia*, New York, 1986. This essay is indebted to both books, and Graebner's. Several Abstract Expressionists were known cinema-goers.
23. And also in the writings of another apocalyptic theorist who influenced Newman: Wilhelm Worringer. See Tuchman, op. cit., pp. 67, 105, 139.
24. Cornell Woolrich's novel *Deadline at Dawn*, quoted in Polan, op. cit., p. 223; *Lady from Shanghai* quoted in Telotte, op. cit., p. 60.
25. Steven Naifeh and Gregory White Smith, *Jackson Pollock*, New York, 1989, p. 663.
26. Ibid., p. 540.
27. George Scrivani, ed., *The Collected Writings of Willem de Kooning*, Madras, 1988, p. 23. Revealingly, Kermode discusses Sartre's *La Nausée* among apocalyptic fictions.

animation recede from Siskind's 1930s New York photographs, from Still's twilit daemonic imagery of the period and from Rothko's Brooklyn subway scenes (*c.* 1935–40), where blank areas and columns, menacing the bystanders, fissure an erstwhile social space.

By the early 1940s motifs redolent of myth or primitivism, such as the totemic presences that flank Pollock's *Guardians of the Secret* (Cat. 87), were announcing 'deep' strata of the mind, implying the co-existence of the past or the distant unconscious in the strife-ridden present. It was a Jungian commonplace that the archetypes bridged unknowable depths. As the 1940s progressed, chaotic and mysterious spaces – alongside enframing effects and nascent thresholds – were foregrounded, as if to signify a world swinging between extremes of present and past, conscious and secret levels. Adolph Gottlieb's pictographs impose one cognitive pattern (a grid) upon unknown symbols; Rothko's surreal protagonists gyrate 'at the edge of the sea' (that is, on the fringe of consciousness); and Gorky evolved a biomorphic idiom to suggest nature seen at close enough range for interiors and outside to merge, as they also do in Guston's X-ray-like *Tormentors* (1947–48; San Francisco Museum of Modern Art) and Siskind's almost microscopic photographic textures.

This was, then, the moment of being plunged 'in the middest', as Kermode argues, the crisis point 'twixt ends and their opposites. Terror and pressures both real and imaginary become the operative forces here and were prominent in statements by Newman, Rothko and Gottlieb.[23] Harold Rosenberg added, in the 1947/48 issue of *Possibilities*, how 'the very extremity of their isolation [creates] an impulse to … dissociate some personal essence of their experience and rescue it as the beginning of a new world'.

In fact, the 1940s had either flung together, or lost sight of, first and last things. As a 1944 popular novel observed, 'Each hour, each minute can hold all Heaven or Hell in it' – against which sound the initial words from Orson Welles's 1947 film *Lady from Shanghai*: 'If I'd known where it would end, I'd never have let anything start.'[24] Perhaps the most extraordinary visual responses to such contesting ideological spaces were those by Pollock and de Kooning. Pollock himself saw his images of 1947 to 1950 as having 'no beginning and no end'.[25] In short, time here acquires a spatial form. Thus, although the standard cliché about *One (Number 31), 1950* (Museum of Modern Art, New York) and similar canvases (see Cat. 88,89) conveying boundless energies is valid, it misses their double-edged impact. To be sure, the eye races around the vortices. In that sense they are Bergson's *durée* as never quite visualized before. Equally certain, though, is how they contain so much incident that we seem to be looking on from some omniscient viewpoint, witnesses to a cosmos and hence outside time. Pollock's words, 'energy and motion made visible … memories arrested in space', epitomize this collapse of temporality into a single, resonant field.[26]

Without its Olympian aspect Pollock's 'classic' phase would reflect, rather than seek to transcend, the introverted predicaments of the decade. Popular discourse again voices the mood, in films whose very titles intimate life drawn into snarled cross-currents: *Whirlpool, Whiplash, Detour, Crossfire, Boomerang*. Nothing translates the impulses behind the *film noir* into a 'high' art context more perfectly than de Kooning's monochrome paintings from 1946 to 1950. Both explore the apocalyptic years when predatory powers were, or were thought to be, abroad. Other versions of this paranoia are Smith's monstrous avian creatures (*Australia*, 1951; Museum of Modern Art, New York) and Still's fields with their earthen claustrophobia.

Like the *film noir*, de Kooning used familiar elements – abstracted from domestic interiors, urban glimpses and anatomy – in the series that climaxed in *Excavation*. Each renders the known unrecognizable, hostile, prone to abrupt reversals. Anxieties about women – then construed by male America as destructive, erotic and incarnating the Id – coalesce here with another eschatological issue, the body. Any outlook that entails being thrust *in medias res* must view the body as a site of ultimate crisis. De Kooning thought 'flesh was the reason why oil paint was invented' and his black-and-white abstractions have a corporeal space whose planes slither, cave inward, protrude and appear, in turn, viciously torn and compressed.[27] *Excavation* (Fig. 6) – a

landmark among modern paintings – makes the connection explicit. One possible and hitherto unrecognized catalyst for it, a Picasso etching (Fig. 7) whose organization and dynamics seem strikingly comparable, depicts flesh about to be rent asunder.[28] Even without that potential buried content, *Excavation* articulates an apocalyptic process, its details endlessly consumed and regurgitated within the labyrinth.

Fragments presuppose wholeness, as submergence does revelation, the root meaning of 'apocalypse'. Both qualities – wholeness and revelation – pervade the pictorial expanses formulated by Newman, Still and Rothko. They were the alternative retort to crisis. Each artist invoked new beginnings, renovation, immediacy. Newman's 'The Sublime is Now' text was explicit on that score: 'We are freeing ourselves of the impediments of memory, association, nostalgia, legend, myth …. The image we produce is the self-evident one of revelation.'[29] The deliverance from history into absolute consciousness represents another potent fiction. As Walter Benjamin argued, the illusion of timelessness in the present may 'blast open the continuum of history'.[30]

Fields embody colour in a revelatory manner and so fulfil a subtle apocalyptism. Keyed around a single hue (red, blue or black/white), Newman's *Onement* series (see Fig. 8) unifies the central vertical and ambient field. 'The beginning and the end', said Newman, 'are there at once.'[31] Consequently, all conventional detailing is stripped away as colour fills the eye and mind, especially by means of the large formats prevalent during the 1950s. To isolate the beholder in the perceptual act had the greatest significance for Newman. He related it to both the 'sensation of time' and the 'fullness that comes from emotion'.[32] This encounter is none other than the heightened moment – not clock time (*chronos*) but a charged self-awareness (*kairos*) – of extremes distilled to a totality, to concord.[33]

Although the Abstract Expressionist 'sublime' can be paraphrased, to talk even figuratively about atmospheric voids or lightning-like bolts and crags misrepresents its abstract attack. A former antinomy, between time past and current, metamorphoses into effects of obscurity (Rothko's enigmatic hues, Still's marginal incidents, Newman's hidden symmetries) that balance urgent surfaces. The paradox here is crucial: whatever feels metaphysical about the paintings depends upon a precise physical form.

Meanings were generated around that fact. The solid, saturated reds of Newman's *Eve* (Cat. 108) and the deepest ultramarine of his *Cathedra* (1951; Stedelijk Museum, Amsterdam) answer the occult white-on-whites in *The Voice* (1950; Museum of Modern Art, New York) and *The Name II* (Cat. 109). A composition such as *Concord* (1949; Metropolitan Museum of Art, New York), whose two symmetrical 'zips' exhale poise, complements the towering *Prometheus Bound* and *Ulysses* (both 1952; Museum Folkwang, Essen, and Menil Collection, Houston), which contain asymmetrical forces intruding from outside the picture. Still manipulated texture, edges and the palette knife's pressure so acutely that surfaces possess their own life: sometimes charred to a light-absorbent blackness, at other moments erupting as bare canvas, acid ochres or cobalts and alizarin crimson luminous with oil medium. For Rothko, expressive irony was more poignant. Brilliant or penumbral hues are soaked into the canvas and therefore become impalpable, metaphors of sensuousness as at once intense and transient. The archetypal Rothko composition (see Cat. 113, 116) seemingly wells up from nowhere, facing us with its forthright design yet, like the 'facades' that the artist said his creations were, a means to conceal as much as to reveal. A single line by Wallace Stevens captures their essence: 'There seemed to be an apostrophe that was not spoken.'[34]

Common to the Abstract Expressionists was a belief that authenticity rests upon unique, immediate experience. As consumerism, technocracy and impersonal vision homogenized America (by 1950 the Xerox copier, cybernetics and Muzak's sudden popularity had all become portents), Abstract Expressionism instead stressed the sentient individual, bound neither by words nor consensus. 'A painting', Rothko wrote, 'lives by companionship, expanding and quickening in the eyes of the sensitive observer.'[35]

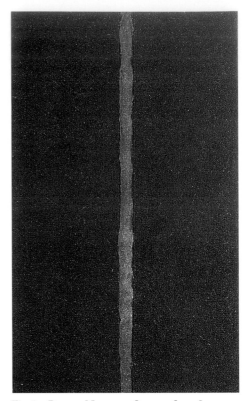

Fig. 8 Barnett Newman, *Onement I*, 1948. The Museum of Modern Art, New York; Gift of Annalee Newman

28. First reproduced in Bernhard Geiser, *Picasso: Peintre-graveur*, Berne, 1933, no. 173. Note especially the widely splayed lines radiating from the upper edge, the vortex motion, the paw-like detail in the lower right corner and the toothy head at left of centre corresponding to a similarly placed maenad. And cf. Telotte, op. cit., p. 8: '*Savage Night*'s narrator describes his reactions as his girl hacks him to death with an axe.' Also, de Kooning's *The Marshes* (c. 1946; University Art Museum, Berkeley) seems related to Picasso's drawing *The Murder* (1934; Musée Picasso, Paris), another scene of female terminative destructiveness.

29. O'Neill, op. cit., p. 173.

30. Quoted in Leo Bersani, *The Culture of Redemption*, Cambridge, MA, 1991, p. 61.

31. O'Neill, op. cit., p. 306.

32. Ibid., pp. 175, 248.

33. See Kermode, op. cit., ch. II. Newman's 'fullness' is Kermode's Biblical *pleroma*.

34. Wallace Stevens, *Collected Poems*, London, 1984, p. 424.

35. Quoted in Tuchman, op. cit., p. 140.

36. This is Kermode's last facet of apocalypse: ironic disconfirmation.

37. Quoted in Ross, op. cit., p. 43.

38. Kermode, op. cit., p. 3.

39. George Steiner, *Real Presences*, Chicago, 1989, p. 232. Robert Storr, *Philip Guston in the Collection of the Museum of Modern Art*, New York, 1992, p. 23, notes how *East Coker T.S.E.* translates a terminal situation: the painter/ poet grins, wide-eyed, into the void. Art/ speech forestalls ends by facing and representing them. Cf. Michel Foucault, quoted in Telotte, op. cit., p. 198: 'Writing so as not to die … or perhaps even speaking so as not to die is a task undoubtedly as old as the world.'

Fig. 9 Philip Guston, *East Coker T.S.E.*, 1979.
The Museum of Modern Art, New York; Gift of
Musa Guston

In retrospect, this rhetoric of active vision may sound wishful since culture and language always modify perception. Nevertheless, it nurtured vivid and complex art, as banality in the Truman and Eisenhower epochs could not. Furthermore, if immediacy is another fable of the time-struck mind, some subsequent developments in Abstract Expressionism show that outlook itself under scrutiny. Apocalypse was, somehow or other, delayed.[36]

De Kooning's 1950s *Woman* paintings (see Cat. 97, 98) confound previous terrors with humour. Simultaneously, figure and surroundings blur: extremes can no longer remain intact. Though *Woman II* (1952; Museum of Modern Art, New York) looks feline, with something of Blake's Tyger about her, she is comic rather than sublime. During the 1950s his brushstroke swells to erase boundaries. Often unremarked is how the titles also blend Culture's traces and Nature: *Door to the River* (Cat. 101), *Rosy-Fingered Dawn at Louse Point* (note the Homeric epithet) and … *Whose Name was Writ in Water*. To be a 'slipping glimpser' – as de Kooning saw himself and as his mercurial paintwork still confirms – thwarts finalities.[37]

Others went on to reprise old themes. Yet the outcome could be fresh. Pollock's *Portrait and a Dream* (Cat. 92) straddles this ambivalence. Now divided are antipodes that Pollock had once sought to unite: image and abstraction, unconscious tumult and the self. The pairings evoke, as it were, 'the shape of life in relation to the perspectives of time'.[38] Parallels exist with Rothko's 1969–70 'black and greys' (see Cat. 118). Nothing quite anticipates them. Despite the darkness Rothko favoured after 1957 (see Cat. 114, 115), those preceding works still beckon the viewer. An alienating device, white borders, instead keeps these apart. Far from melodrama, they make closure and finalities their subject. That ultimately engaged Guston, too. Returning to a virulent representationalism around 1967, he scattered emblems of time and termination everywhere in his paintings. Clocks, stark walls, lights soon to go out, horseshoes parodying the final Greek letter 'omega' and even, *in extremis*, T.S. Eliot (Fig. 9), whose poetry was a long meditation on apocalypse and temporality. Guston's parable here may then pinpoint Abstract Expressionism's broadest design: to reconfigure the 'brute enigma of ending'.[39]

Mary Emma Harris

Black Mountain College:
European Modernism, the Experimental Spirit
and the American Avant-Garde

The summer of 1952 was not unlike previous summers at Black Mountain College. The guest faculty was exceptional, although, at that time, without critical recognition. Painting was taught by Jack Tworkov in July and Franz Kline in August, music by John Cage and dance by Merce Cunningham. Karen Karnes and David Weinrib came from Alfred University to teach ceramics. Of the regular faculty, Charles Olson taught literature, Stefan Wolpe music, Katherine Litz dance and Hazel Larsen Archer photography. The composer Lou Harrison, who had resigned in the spring, remained to work on his opera *Rapunzel*, and David Tudor, accompanied by M. C. Richards, came to give a concert of the music of Pierre Boulez, Morton Feldman, Henry Cowell, Cage and Wolpe. Among the forty-three students were Nick Cernovich, Fielding Dawson, Viola Farber, Harvey Lichtenstein, Joel Oppenheimer, Robert Rauschenberg, Dorothea Rockburne and Cy Twombly.

Besides the Tudor concert, scheduled events included lectures on 'Philosophical Foundations of India' by Nataraj Vashi, on the world hunger problem by Edgar Taschdjian and on contemporary music by Wolpe, as well as dance concerts by Jean Erdman and Litz. Yet, as was often the case at Black Mountain, the most significant events were spontaneous, an outgrowth of the atmosphere of intensive intellectual interaction. Mealtime conversations would undoubtedly have included discussion of the writings of Carl Sauer, Gestalt theory, Dada, the *I Ching*, Zen Buddhism, pre-Columbian carvings, Abstract Expressionism, jazz, Noh theatre, Antonin Artaud, projective verse and the prevailing conservative political climate. Cage read *The Huang Po Doctrine of Universal Mind* from beginning to end, including notes, in a single sitting, and a theatrical farce, *Occupe-toi de Brunhilde!*, was written and staged by the community. On one afternoon Cage organized a performance, given that same evening, that was later designated the first 'Happening'. Since teaching at the college in the summer of 1948, Cage had begun to use chance procedures and indeterminacy as a way of divorcing his own taste and ego from his work, and for this event chance procedures were employed to create time brackets for the performers.

Fig. 1 Black Mountain College, dining hall and theatre on Lake Eden

Fig. 2 Robert Rauschenberg, *Untitled* (self-portrait at Black Mountain College), *c.* 1952

The performance took place in the dining hall, which also served as a theatre and concert hall (Fig. 1). Chairs were placed in four quadrants around a square, and there were ladders from which speakers read, as well as other props. A large Kline painting was hung from the rafters, as was a white one by Rauschenberg. Although Cage knew that a person might read from a ladder within an assigned time bracket, he did not know what would be read.

For Cage and Rauschenberg, who had met previously in New York, the summer represented recognition between kindred spirits (see Figs. 2, 3). Rauschenberg, who had studied at Black Mountain in 1948–49, had returned in 1951 with Twombly as a 'resident student' (Fig. 4). In the interim in New York, in an effort to come to terms with Abstract Expressionism, Rauschenberg had made a group of monochromatic paintings exploring the picture plane, figure/background relationships and the painting process itself. On his return to Black Mountain, this exploration culminated in a group of black paintings in which newspaper was used for textural effect and in a series of white paintings – canvas stretched and painted white. He wrote to the gallery

Fig. 3 Robert Rauschenberg, *John Cage, Black Mountain*, 1952. Collection of the artist

Fig. 4 Robert Rauschenberg, *Cy, Black Mountain*, 1952. Collection of the artist

owner Betty Parsons that the white paintings were 'almost an emergency.... [d]ealing with the suspense, excitement and body of an organic silence, the restriction and freedom of absence, the plastic fullness of nothing, the point a circle begins and ends.... a natural response to the current pressures of the faithless and a promoter of intuitional optimism.'[1] Later that summer Cage, taking courage from Rauschenberg's silent paintings, wrote *4'33"*, a silent composition in three movements, each of which was indicated by the opening and closing of the keyboard cover of the piano. For Cage, the time frame of the composition – like the picture frame around a painting – distinguished it as art. Cage selected *4'33"* as his favourite composition because he was 'free of [his] own likes and dislikes',[2] and Rauschenberg has written of his paintings: 'It is completely irrelevant that I am making them.'[3] Each recognized that, in fact, true silence did not exist and that the sounds of nature and human activity filled the composition, just as shadows and light constantly changed the white paintings. Despite the apparent irreverence of these works, for Cage and Rauschenberg, both quintessential American inventors, the spirit in which they were created was one of affirmation and high seriousness.

Black Mountain College in 1952 had changed radically since its founding in the mountains of North Carolina in 1933 by John Andrew Rice and a group of dissident, progressive academicians. At Black Mountain learning and experience were to be closely bound, and emotional maturity and the ability to think were to be as much the goal of education as the assimilation of information and ideas. The study and practice of the arts were to be the centre of the educational programme. The college was run by the faculty, and there was no outside control. As it took shape, the college became a unique combination of liberal arts school, summer camp, farm school, pioneering village, refugee centre and religious retreat. Fewer than twelve hundred students attended in twenty-four years, with the largest group (about one hundred) coming in the post-war period. There was little money and the facilities were simple. The farm, run by the faculty and students, supplied milk, eggs and some meat and vegetables, and, when the college moved to its own property in 1941, the faculty and students constructed buildings and remodelled existing structures. Crucial to the founders' vision was that the college remain open to new ideas in a truly experimental spirit: the community changed from year to year, driven by the ideas and personalities of its faculty and students. Despite perennial financial problems and

Fig. 5 The design class of Josef Albers at Black Mountain College

1. Quoted in Walter Hopps, *Robert Rauschenberg: The Early 1950s*, Houston, 1991, p. 230.
2. Richard Kostelanetz, ed., *Conversing with Cage*, New York, 1988, p. 65.
3. Quoted in Hopps, op. cit., p. 230.

Fig. 6 The Summer Art Institute faculty at Black Mountain College, 1946. From left to right: Leo Amino, Jacob Lawrence, Leo Lionni, Theodore Dreier, Nora Lionni, Beaumont Newhall, Gwendolyn Lawrence, Ise Gropius, Jean Varda (in the tree), Nancy Newhall (behind the tree), Walter Gropius, Mary Gregory, Josef Albers, Anni Albers

frequent schisms, Black Mountain College survived for twenty-four years, closing in the spring of 1957.

The college's history and influence were inevitably marked by the many European refugees who taught there and by the special summer sessions in the arts. Only two months after its founding, Anni and Josef Albers (see Fig. 5) arrived from Germany to teach art and weaving, and they remained for sixteen years. Through their teaching, Black Mountain proved an important centre for the transmission of Bauhaus theory and ideas in America, and the college was from its beginnings identified with abstract art and a modern, experimental spirit. For Josef Albers, the spirit of modernism meant a 'significant contemporaneousness',[4] a way of seeing that was neither retrospective nor fixed, but responsive to contemporary possibilities and needs. At Black Mountain he adapted the curriculum of the Bauhaus to general education, emphasizing the education of the students' visual perception and basic skills in drawing, colour theory and design concepts. He challenged the American idealization of, and subservience to, the cultures of Europe and Classical Greece, and instead turned the attention of his students to their own culture – to advertisements, to architecture and engineering, to the natural world and to New World cultures. Xanti Schawinsky, a former Bauhaus student and collaborator with Oskar Schlemmer, taught for two years at Black Mountain, where he staged the first performance of his abstract production *Spectodrama: Play, Life, Illusion*; Trude Guermonprez Elsesser, who had been in hiding in Holland during the war, taught weaving. Music was taught by Frederick Cohen, a composer and co-founder of the Jooss Ballet; Heinrich Jalowetz, one of Arnold Schoenberg's first students and a conductor of modern music; Edward Lowinsky, the eminent historian of Renaissance music; and Wolpe, a composer. Leaders in their fields in Europe, these illustrious refugees gave the college an exceptional faculty.

The special summer sessions in the arts, the first of which was held in 1944, brought refugee artists and musicians together with young American faculty members and students for several weeks of concerts, lectures, panel discussions, classes and continual conversation. The atmosphere was informal and camp-like, and the isolation in the mountains, far from any distractions, only added to its intensity. Among the Europeans were Lyonel Feininger, Walter Gropius and Bernard Rudofsky;

Americans included Mary Callery, R. Buckminster Fuller, Paul Goodman, Clement Greenberg, Kline, Jacob Lawrence, Richard Lippold, Robert Motherwell and Jack Tworkov (see Fig. 6). In 1944 a celebration of Schoenberg's seventieth birthday brought together a distinguished group of musicians for concerts and lectures. Fuller attempted to raise his first dome at the college in 1948, and that same summer Cage sponsored a festival of the music of Erik Satie, which culminated in a production of *Le Piège de Méduse* with Fuller, Elaine de Kooning and Merce Cunningham (Fig. 7). In 1953 the Merce Cunningham Dance Company was founded at the college. Many of these artists, especially the young Americans, were, like Elaine and Willem de Kooning, 'penniless with no prospects'[5] and eager to get away from the city for the summer.

Among the students to emerge as significant figures in the second generation of post-war American artists were John Chamberlain, Ray Johnson, Kenneth Noland, Rauschenberg, Dorothea Rockburne, Kenneth Snelson and Twombly. For all, the experience of being in the community was profound – a rebirth and cleansing, compared by a former student, Sewell Sillman, to 'a snake that loses its skin'.[6] Although Black Mountain produced no distinct 'style', for each of these students the experience at the college represented the crucial catalyst for their mature work.

Like all young artists at the time, the Black Mountain students had to come to terms with the overwhelming presence of Abstract Expressionism, either by rejecting it as an influence or by translating and assimilating its tenets into their own work. The latter approach is most evident in the work of Chamberlain and Twombly. Chamberlain's sculptures of twisted, crumpled and welded automobile parts (see Cat. 159–61) are the most powerful sculptural interpretation of the aesthetic of energy and process inherent in Abstract Expressionism. Similarly, Peter Voulkos, a production potter who came to Black Mountain to teach, realized the creative potential of clay after his experience of the community and his contact with Abstract Expressionism. Twombly's enigmatic paintings of cryptic scribbles and symbols (see Cat. 142–5) are a highly personal translation of the automatism of that style. Noland (see Fig. 8, p. 111) was introduced to Geometric Abstraction through both Albers and Ilya Bolotowsky. His association with Clement Greenberg, whom he met at the college in 1950 and who became his critic and mentor, and with Helen Frankenthaler, who visited Greenberg there for a few days, was to be crucial to his work as a Colour-Field painter. Both Snelson and Rockburne have worked in the Constructivist tradi-

Fig. 7 Robert Rauschenberg, *Merce*, 1952. Collection of the artist

Fig. 8 Robert Rauschenberg and unicorn costume, worn by Ingeborg Lauterstein, 1949

4. Josef Albers, Address at the Black Mountain College Meeting at The Museum of Modern Art, New York, 9 January 1940; The Josef Albers Papers, Yale University Library, New Haven.

5. Elaine de Kooning, 'Elaine de Kooning's Memories: Starting Out in the 1940's – A Personal Account', *Vogue*, vol. 173, no. 12, 1983, p. 352.

6. Interview with Sewell Sillman, 7 March 1971.

tion. For Snelson, Fuller's experiments with structure were the catalyst for his abstract sculptures, in which tension and compression are discontinuous. His analytical approach to structure has extended to his work with photography and computer images and to his sculptures interpreting atomic structure and theory. Rockburne's studies with the refugee geometer Max Wilhelm Dehn, as well as her association with dancers, painters and musicians, were a catalyst for her work which, though cerebral and complex in conception, is in effect both classical and sensuous. Ray Johnson, the 'father of mail art', whose work has been associated with Surrealism, Conceptual Art and neo-Dada, was one of Albers's most attentive students. His habit of sending collages, drawings and messages through the post grew into a large network of correspondents later identified as the 'New York Correspondence School'. A well-read artist with a remarkable capacity for perceiving associations, Johnson built his collages and his mail art on an elaborate and sophisticated system of references and correspondences which, as mail art, literally took the form of correspondence. For Rauschenberg, the studies with both Albers and Archer, as well as his association with Cage, were crucial to his later development. His fascination with materials and found images and objects (see Fig. 8), which was to find its most innovative expression in his combines and sculptural assemblages (see Fig. 3, p. 167), was evident in his formative work of blueprint images, collages, paintings and sculpture from 1948 to 1955 (see Cat. 135, 136). The use of found objects, commercial images and discarded junk by Johnson, Rauschenberg and Chamberlain represents both an affirmation of the visual viability of American culture and environment and a practical solution to the artists' inability to afford traditional art materials. In contrast to Pop Art, however, the found materials were incorporated into their work without reference to, or employment of, the techniques of commercial art, such as enlarged scale and flatness.

The influence of Black Mountain College on the arts in America has been pervasive. For the twenty-four years of its existence, the college played a significant role in the reinterpretation and assimilation of European modernist thought into American culture, and it was an environment for the generation and realization of experimental activities and events in all areas of the arts. As an outspoken advocate of Geometric Abstraction, Albers was instrumental in creating in America an atmosphere receptive to experimental art forms, and the college was a catalyst for the emergence of the American avant-garde after the Second World War.

During the 1960s the college came to be associated primarily with two groups, the Black Mountain poets and the circle of artists, dancers, performers and musicians associated with Cage and Cunningham. The Black Mountain poets, including Robert Creeley, Fielding Dawson, Edward Dorn, Robert Duncan, Charles Olson, Joel Oppenheimer, Michael Rumaker and Jonathan Williams, who taught and studied at the college, as well as Paul Blackburn and Denise Levertov, who were never there but who published in the *Black Mountain Review*, had a decisive influence on literature during the 1960s and 1970s. In 1954 Cage, Karen Karnes, Richards, Tudor, David Weinrib and Stan Vanderbeek, the experimental film-maker and former Black Mountain student, and others formed a community north of New York City which was in essence a Black Mountain without students. Both as history and as myth Black Mountain College has entered the consciousness of the American art community as a symbol of academic freedom and the experimental spirit. Cage's observation that 'you were just as much in [Black Mountain] when you left as when you were there'[7] is testimony to the enduring influence that it had on those who came under its spell.

7. Kostelanetz, op. cit., p. 249.

Barbara Moore

New York Intermedia: Happenings and Fluxus in the 1960s

It is fitting that I write this shortly after the death of John Cage (Fig 1),[1] whose influence has permeated virtually every avant-garde movement of the last forty years. Cage was a paradigm of the late twentieth-century experimental artist: trained as a composer, he transcended categories to delve beyond the limits of his chosen discipline into theatre, poetry, multi-media work, visual art, philosophy, the study of mushrooms and myriad combinations of all these.

Cage was influential not just through his compositions, but also as a teacher. He began to reach his largest audience in the late 1950s. One of the most important cultural events of 1958 was his twenty-five-year retrospective concert at New York's Town Hall. That year his class in experimental music composition at the New School was attended by Dick Higgins, George Brecht, Allan Kaprow, Al Hansen and Jackson Mac Low, all of whom were themselves to become seminal figures in the nascent avant-garde.

Giving a hint of what was to come, this formative class was 'open to those with or without previous training'. The prospectus promised 'problems and solutions in the field of composition based on…duration, timbre, amplitude and morphology' rather than on such conventional musical criteria as pitch and frequency. 'The course also encourages inventiveness.'[2]

Cage considered the composer an 'organizer of sound',[3] *any* sound, a theory that achieved some notoriety with the first performance of *4'33"* in 1952. In this composition the pianist opens the keyboard but strikes no notes for the full duration given in the title, allowing ambient noise to become part of the piece.

In addition to sound, Cage's primary composing tools were time and the use of chance operations, which determined parameters for each score yet allowed performers great latitude in execution. His acceptance of extra-musical elements in performance dissolved the boundaries of music. 'Where do we go from here?', he asked, answering, 'Towards theatre.'[4]

These theatrical inclinations were evident in an event organized by Cage in 1952 at Black Mountain College, in which Merce Cunningham danced while, simultaneously, Cage, M. C. Richards and Charles Olson read texts from ladders and David Tudor played the piano. In this proto-Happening Cage pioneered the cross-disciplinary form known as intermedia. As defined by Dick Higgins in 1966, intermedia is hybrid art that lies between media, in which 'each work determines its own medium and form according to its needs'.[5] Arbitrary boundaries are abolished: painting can join with sculpture, as in Robert Rauschenberg's combines; visual art can appropriate life, as with Marcel Duchamp's ready-mades. One of the most radical intermedial art-forms that developed at the end of the 1950s was the Happening, which Higgins called 'an uncharted land that lies between collage, music and the theater'.[6]

At a time when many younger artists recoiled from the emotionally and visually overpowering hegemony of Abstract Expressionism, Cage's ideas were a breath of fresh air. They filtered into the vital, rebellious subculture that existed, in which numerous small cliques, evanescent movements and underground publications shared an overlapping personnel, individuals often linked more by what they were against than what they were for.

It was an artistic community that transcended geographical as well as categorical boundaries, bypassing America's Cold War isolation in favour of increased internationalism. Pop Art had parallels with France's Nouveau Réalisme. Happenings took

Fig. 1 John Cage (right) and David Tudor in the 1960s

1. 12 August 1992.
2. *New School Bulletin*, vol. 15, no. 33, 7 April 1958, p. 31; reproduced in *George Brecht: Notebooks*, vol. 1, Cologne, 1991, n.p. (endnote section).
3. John Cage, 'The Future of Music: Credo', in idem, *Silence*, Middletown, CT, 1961, p. 5.
4. Cage, 'Experimental Music', ibid., p. 12.
5. Dick Higgins, 'Intermedia', *The Something Else Newsletter*, vol. 1, no. 1, 1966, n.p.
6. Ibid.

place throughout Europe. Japanese music changed irrevocably when David Tudor toured that country in 1962, introducing Cage's work. The cultural interchange went in all directions. Japan's Gutai Group of abstract painters-turned-performance artists drew inspiration from the French action painter Georges Mathieu, who 'recreated' battles by dressing in full regalia and slashing at the canvas with the paintbrush during the same hours of the day as the original event (see Fig. 1, p. 189). Among works described in a *New York Times* article on Gutai were ones in which performers threw colourful paint-dipped paper balls at a white wall, splashed coloured water on cellophane scrims or caused a row of red sticks to fall forward, one by one and sometimes in groups, to the mounting beat of a temple drum.[7] This 1957 article was a stimulus to Happenings' first practitioner and theoretician, Allan Kaprow, and to others.

Like Gutai, Kaprow and most of his American Happenings colleagues – in particular Red Grooms, Claes Oldenburg, Jim Dine, Al Hansen, Carolee Schneemann and Robert Whitman – began as conventional abstract artists and, without totally abandoning the language of Abstract Expressionism, activated painted forms and collage-like elements with live figures, extending them into the fourth dimension of time. It is no accident that early Happenings abound in references to painting. In Grooms's first performance work (1958) he simply painted a canvas in front of the audience for a half-hour or so. Dine's *The Smiling Workman* (Fig. 2) presented him drinking jars of paint and pouring them over himself, then diving through a canvas. For Kaprow's *18 Happenings in 6 Parts* (1959) the programme notes list as participants the artists Sam Francis, Grooms, Lester Johnson, Alfred Leslie, Jay Milder, George Segal and Robert Thompson, 'each of whom paints' as part of the performance.

In the most general sense, Happenings were a non-literary artists' theatre, representing the auteurist visions of a single individual rather than the compartmentalized talents – separate costume, stage and lighting designers – of conventional theatre.

Fig. 2 Jim Dine, *The Smiling Workman*, 1960, at the Judson Gallery, Judson Memorial Church, New York. Photo © Robert McElroy

Fig. 3 Allan Kaprow, *Calling*, 1965, at Grand Central Station, New York. Photo © Peter Moore

Although Happenings were popularly viewed as improvisatory, among the major figures only Al Hansen worked exclusively in this way. Hansen would loose his performers, armed with cans of spray paint and whatever materials, such as toilet paper, might be available, into a designated area hung with yards of transparent plastic sheeting. They would layer the space with colour and collaged junk until, by the end of the evening, what had been a bare gymnasium or a platform in a café was transformed into a dense room-size assemblage of overpainted scrims and dangling detritus.

The Happenings of Oldenburg, Kaprow, Dine, Grooms, Whitman, Schneemann and Ken Dewey, on the other hand, while diverse in style, were more structured. Oldenburg, Dine and Kaprow created feverish spectacles in expressionistic, assemblaged urban environments; Grooms cavorted in free-wheeling, carnival-like playlets; Whitman designed short, linked surreal sequences; Schneemann organized performers in sensual, collective group movement pieces. Dewey, the product of a theatrical background and therefore the notable exception to the visual-art orientation of Happenings, produced works combining movement, music and language. (Although Dewey was American, he created his best-known works in Europe, with only one major Happening in New York, *Without and Within* of 1965.)

These performances usually followed scenarios (as distinct from scripts with specific dialogue) which, depending on the artist, contained varying degrees of detail – from the briefest notes to fully-fledged descriptions including stage directions and sketches. The most evocative of these descriptive notations were by Oldenburg. He presented simple tasks poetically, to full visual and auditory effect, as in this scene from a draft of his *Store Days I*, in which a woman cuts her toenails:

1. Sits on couch
 Gets up walks
 Walks in a circle fast on
 hard floor clicking

2. Still walking
 Sits down curls up slowly
 Looks at body, turns legs
 looks at legs drops off shoes

3. Still looking
 Abruptly rolls down stockings &
 off drops
 Begins cutting toenails with
 great care and pleasure[8]

This excerpt hints at the disjointed performance style of Happenings, in which gestures were derived from tasks rather than emotion. Characters and actions were not linked narratively and, in the most elaborate pieces, several events might happen simultaneously in different parts of one performance space or even in different locations. Many of Oldenburg's early pieces were created for his small storefront on New York's Lower East Side, with brief episodic actions in different rooms and the audience crammed together claustrophobically in the midst of the activity.

Kaprow, who alone among the artists mentioned here kept working in the Happenings form throughout the 1960s, progressed from the intimate ambience typical of early Happenings to events spread over a wide geographical area, sometimes with different segments on different days. On the first day of *Calling*, for example, several far-flung participants were wrapped sequentially in various materials (cloth, aluminium foil, and so forth) and then, for the finale, carried to the information booth at the mammoth Grand Central railway station (Fig. 3). A second day had other participants hanging upside down from trees in the New Jersey woods.

As these descriptions suggest, a Happening's relationship to its space and to its audience differed from that in conventional theatre. Although proscenium stages were occasionally used, traditional theatre settings were generally shunned in favour

7. Ray Falk, 'Japanese Innovators', *New York Times*, 8 December 1957; reprinted in Barbara Bertozzi and Klaus Wolbert, *Gutai: Japanese Avant-Garde 1954–1965*, Darmstadt, 1991, p. 445.
8. Claes Oldenburg, *Store Days*, New York, 1967, p. 103.

Fig. 4 Claes Oldenburg, *Injun I*, 1962, at The Store, New York. Photo © Robert McElroy

of unconventional lofts, small cafés and individualized spaces such as Oldenburg's Store (Fig. 4). A few took place in larger, sometimes public, areas or outdoors. Whatever the location, audiences could not avoid feeling like part of the action even when not actively participating. Kaprow, in particular, worked steadily to break down the separation between spectator and performer, usually requiring everyone in attendance to participate. Eventually, he discarded the designation 'Happenings' in favour of 'activities', task-orientated pieces for non-public performance by small groups of invited people.

Kaprow's evolution in this respect was significant. As a genre, the Happening was short-lived, dying out by the end of the 1960s (although something of the auteurist vision that Happenings embodied went into what later became known as Performance Art). Dine, Grooms and Oldenburg had ceased doing performances years before. Whitman, who had always preferred to call his works theatre pieces, did infrequent productions that tended more and more to precise, exquisite, multi-media tableaux. Schneemann became an influential, highly politicized, solo performance artist. Hansen eventually moved to Europe and was rarely seen in the States again. Dewey turned his attention to multi-media work, the layering-on of technological media such as film and video, itself another intermedial form.

In the meantime, in a startling role reversal, Fluxus, whose brief, quirky performances were at first erroneously considered a decidedly minor subdivision of Happenings, became ascendant. From the beginning, Happenings were viewed as serious and significant, like the visual art whence they sprang. In contrast, Fluxus, under its eccentric leader/publisher George Maciunas (see Fig. 5), was derided by many, both in experimental circles and in the artistic establishment, as trivial, representing, in

9. 'Happenings and Events', a radio discussion between Brecht and Kaprow, WBAI, New York, May 1964. Quoted in *V TRE / fluxus cc fiVe ThReE* (Fluxus Newspaper no. 4), June 1964, p. 1.

Fig. 5 George Maciunas, *Piano Piece*, New York, 1964. Photo © Peter Moore

Fig. 6 Dick Higgins with scores from *1000 Symphonies*, 1968. Photo © Das Anudas

Fig. 7 Dick Higgins and a rifleman creating the scores of *1000 Symphonies*, New Jersey, 1968. Photo © Das Anudas

Kaprow's words, irresponsible people who saw themselves as 'more important doing unimportant things'.[9]

Fluxus was a loose coalition of visual artists, poets and musician/composers who created publications, objects and performances that were explicitly anti-expressionistic and strongly conceptual, yet grounded in the concrete. It grew out of the New York avant-garde in the early 1960s but, through its participants' extensive travels and enthusiastic dissemination of printed matter, became truly international in scope.

Although interdisciplinary, Fluxus was philosophically rooted in music, in large part owing to Cage's influence. Three important early figures – George Brecht, Dick Higgins (see Figs. 6, 7) and Jackson Mac Low – attended his class at the New School, and many other early participants were either musicians or serious students of music.

But Fluxus went beyond Cage in stating what could be designated as music. In addition to, and often in lieu of, sound, it stressed musical terminology and such abstract musical concepts as duration, rhythm, tempo and dynamics. Fluxus pieces

Fig. 8 George Brecht performing his *Solo for Violin, Viola, Cello, or Contrabass* (1962) at Fluxhall, New York, 1964. Photo © Peter Moore

are called compositions, their notations are termed scores; performances are concerts containing solos, quartets, octets or the full Fluxorchestra, usually in formal concert dress.

Musical instruments were treated as objects, not just sound-producing vehicles. Brecht's *Solo for Violin, Viola, Cello, or Contrabass* (Fig. 8) is a typical Fluxus composition in its literal action and concrete treatment of the music-object. Using any one of the instruments named in the title, the performer simply follows the single-word score, 'polishing'. As Fluxus artist Ben Patterson replied when asked whether such works were indeed music: 'What do you mean, is it music? Of course it's music. It's performed on a musical instrument, it's taking place in a concert hall, and I'm a composer and trained musician.'[10]

The form taken by Brecht's *Solo for Violin ...*, a word score, is an important Fluxus innovation. These scores may give explicit instructions, as in Emmett Williams's *Voice Piece for La Monte Young* (1962) – 'Ask if La Monte Young is in the audience, then exit'[11] – or be intentionally open to interpretation. Takehisa Kosugi's *Theatre Music* (Fig. 9), for which the score is 'keep walking intently', was once performed by placing an ink-saturated foam-rubber pad across the threshold of the Fluxhall and having the 'audience' walk over coloured papers spread on the floor. But that was only one possible realization.

Fig. 9 Takehisa Kosugi, *Theatre Music* (1964) at Fluxhall, New York, 1964. Photo © Peter Moore

Fluxus publications, objects and performances have a seamless interrelation that takes the concept of intermedia to its most radical extreme. One example is another Brecht score, *Word Event* (Fig. 11), whose text is 'Exit'. The score exists in its published state, printed on a small white card, in the seminal Fluxus boxed edition of Brecht scores, *Water Yam* (Fig. 10). This version can be considered complete in itself, a conceptual experience for private contemplation. The work has also appeared in exhibitions as a found object: the existing 'Exit' sign over a door, for example, or one that has been placed nearby for the duration of the show. In its third incarnation *Word Event* has been performed by Brecht as the action of writing 'Exit' in large letters on the wall, indicating that a concert is over.

Fluxus was unique in transposing such ephemeral gestures and small mundane items from everyday life into thought-provoking, often whimsical, performances and art. The most famous Fluxus statement is Maciunas's manifesto that Fluxus is 'art-amusement ... a fusion of Spike Jones, gags, games, vaudeville, Cage and Duchamp'.[12] But humour was the means, and not the only means, that Fluxus called on to undermine traditional forms of art. If in its performances it carried Cage's theories to their

10. Quoted in Emmett Williams, 'Way Way Way Out', *The Stars and Stripes*, 22 August 1962; reprinted in idem, *My Life in Flux – and Vice Versa*, Stuttgart and London, 1991, p. 23.

11. Ibid., p. 48.

12. One of several versions of this statement published by Maciunas, beginning in 1965. As printed here, it appears on a card, the size of a visiting card, first circulated in 1966.

Fig. 11 George Brecht performing his *Word Event* (1961) at Fluxhall, New York, 1964. Photo © Peter Moore

Fig. 10 *Water Yam*, edition of George Brecht's scores published by Fluxus in 1963. Photo © Peter Moore

logical conclusion, incorporating gestures as well as sound, in its objects it went one better than Duchamp's ready-mades. As revolutionary as they were for their time, Duchamp's objects were *signed*, and thereby singled out for reverent art-attention. Maciunas published hundreds of, at the time, bargain-priced multiples (in addition to collections of word scores, such as *Water Yam*) composed of found oddities, household junk and industrial bits and pieces from the bins of Canal Street, which he neatly but cheaply packaged in commercial plastic boxes. Not one of these carried a signature or an edition numbering.

Brooks Adams

The 1960s: Notes on Camelot

> All hail, Pop Art, the first lively thing that's happened in painting since Jackson Pollock tripped over his bucket of despair in East Hampton. (You can stop trying to like Kline, Rothko and de Kooning and breathe easy; it's over at last. The Museum of Modern Art will soon be fun enough to hang around in for more than a movie, a fast cruise, and tea with your friends on the staff.) Intelligence is a popular commodity. The apparently American is respectable in the arts....If Europe today is economically self-sufficient, it isn't spiritually self-sufficient; its dynamism comes from us.
>
> Alfred Chester, 'Mailer in Search of His Hero', 1964[1]

A new medievalism pervaded the landscape of late 1950s and early 1960s America. In Philadelphia, for instance, Louis Kahn's Richards Building cast its San Gimignanesque towers up against the sky, while in New York Frank Stella's striped 'Black' paintings of 1959–60 proposed a glowering eurhythmy, inspired perhaps by the Hiberno-Saxon illuminations the artist had just studied while at Princeton. By this time several generations of fledgling artists and critics had listened to Meyer Schapiro's lectures on Romanesque art at Columbia University, and Johan Huizinga's magisterial study *The Waning of the Middle Ages* was timely enough to be cited in Susan Sontag's intellectually bumptious 'Notes on "Camp"'(1964).[2] Roy Lichtenstein, who had painted a 'Knight' series as early as 1950–51, was making comic-book 'illuminations' based on the chivalric themes of War and Romance. Furthermore, a whole new kind of soft heraldry emerged: in Jasper Johns's 'Flags' and 'Targets', in Kenneth Noland's stained 'Targets' and in the covertly Pop abstractions of the British expatriate Richard Smith, which were painted puns on lipstick colours and corporate logos.[3] Morris Louis's late 'Unfurleds' suggested banners at a medieval tournament. Robert Rauschenberg's Dante illustrations recast the *Inferno* in terms of appropriated magazine imagery. Agnes Martin's elongated, arced grid drawings and canvases of 1960 to 1962 recalled Gothic fenestration. Even Andy Warhol's iconic movie star portraits could be read as expressions of courtly love. To top it all, Lerner and Loewe's musical *Camelot* opened on Broadway at the Majestic Theater on 3 December 1960, the month before John F. Kennedy's inauguration as President. And, indeed, 'for one brief shining moment' the Kennedy White House was itself called 'Camelot'.

Pop Art and its non-objective analogue, Post-Painterly Abstraction, were both upstarts and inheritors of the old order of Abstract Expressionism. While Willem de Kooning and company gathered at their round table at the Cedar Tavern in Greenwich Village and went questing after their artistic Grail, a younger generation was champing at the bit. The young knights wanted some action. Soon enough they revolutionized the palace with their garbage, pulp magazines and the long-vilified imagery of nineteenth-century academic history painting and *pompier* art. Yet the so-called radical plots of the Pop artists and Post-Painterly Abstractionists also depended on the pictorial innovations of their elders.

Lichtenstein's 'Brushstroke' paintings (see Fig. 1), for instance, with their blow-up simplifications of painterly calligraphy, mock the cult of the hand and the myth of the spontaneous mark that so thoroughly absorbed the Abstract Expressionists. Warhol's large repeating images, whether Elvis Presley or S & H Green Stamps laid out in grid formation, transformed Jackson Pollock's famous 'all-over' approach into a bold new

1. Alfred Chester, *Looking for Genet: Literary Essays and Reviews*, Santa Rosa, CA, 1992, p. 157.
2. Susan Sontag, *Against Interpretation and Other Essays*, New York, 1979, p. 276.
3. On Richard Smith, see Brooks Adams, 'Cosmetic Abstractions', *Art in America*, vol. 80, no. 10, October 1992, pp. 118–21.

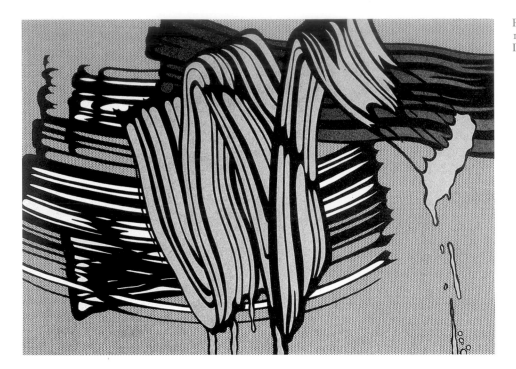

Fig. 1 Roy Lichtenstein, *Big Painting No. 6*, 1965. Kunstsammlung Nordrhein-Westfalen, Düsseldorf

supermarket aesthetic. James Rosenquist's billboard-scaled paintings (see Cat. 175, 176) took the monumental sweep of Abstract Expressionist painting into a vast realm of popular imagery, where close-ups of spaghetti might suddenly recall Pollock's dense webs of paint, and the frontal aspect of an automobile could even refer to that artist's death in a car accident, in 1956. These are just a few examples of what could be called the parodistic nature of Pop Art, a new species of genre painting which subverted the old epic aspirations of Abstract Expressionism.

By about 1962 Pop artists were also punning on novel, reductive idioms of abstraction. The empty fields of pure colour that Warhol often laid down against his serial images of car crashes even recall Ellsworth Kelly (cf. Cat. 189 and 130–4). It is as if Warhol were contemplating the delirious vastness of space and choice confronting artists in the early 1960s, from Dada and Suprematism to the *tabula rasa* of Barnett Newman and Neo-Dada in America. The famous tilt of the letter 'O' in Robert Indiana's *Love* of 1966 (Fig. 2) was also based on Kelly's bright colour abstractions. And by 1968 Tom Wesselmann was painting gigantic red lips and phallic cigarettes (see Fig. 3) that recast the suggestive contours of Stella's abstract 'Protractors' as explicit emblems of the 1960s sexual liberation movement.

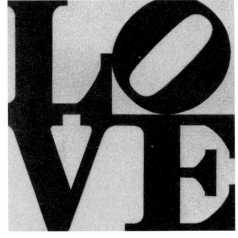

Fig. 2 Robert Indiana, *Love*, 1966. Private collection

Pop Art was a global, interactive phenomenon. The Japanese performance artist Yayoi Kusama made collage accumulations of Air Mail stickers in New York that probably influenced Warhol's early serial imagery. Uncanny affinities arise between Vija Celmins's 1960s grisaille fighter planes painted in California and Gerhard Richter's contemporaneous images of bombers executed in Germany. We may now more fully appreciate such regional responses to Pop as Ed Paschke's images of tattooed and hirsute shoes and, also in Chicago, funk figuration by the 1960s artists' collective The Hairy Who. In San Francisco there were Peter Saul's blisteringly satirical 'Vietnam' paintings, R. Crumb's radical 'comix' (that also proved influential for the later works of Philip Guston; see Cat. 227) and other manifestations of the Bay Area Acid Rock scene. Even a seemingly non-Pop expatriate such as Cy Twombly (see Cat. 142–5) was recently included in the exhibition 'Hand-Painted Pop' on the grounds that his late 1950s deflations of Abstract Expressionist brushwork, and his preoccupation with mythological subject-matter, do have much in common with contemporaneous work by Johns, Rauschenberg and Warhol.[4]

In the thirty years since Pop was named, social and political upheavals, and resulting shifts in public consciousness, have brought to light previously latent, coded, hidden or simply unnoticed content in Pop Art. An autobiographical, and possibly

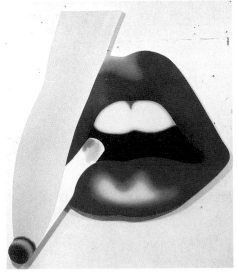

Fig. 3 Tom Wesselmann, *Mouth No. 18 (Smoker No. 4)*, 1968. The Museum of Modern Art, New York

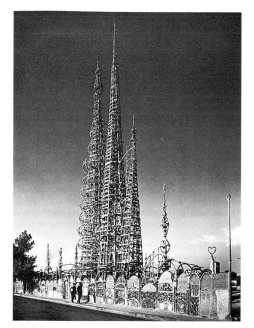

Fig. 4 Simon Rodia, Watts Towers, Los Angeles,
1921–54

homo-erotic subtext in Johns's early flags and targets – the plaster casts of body parts, for instance – is now an academic consideration. Even the geometric abstractions of Stella now seem a bit Pop-ish. Important figures on Pop's periphery, such as John Chamberlain, Jim Dine, Alex Katz and Larry Rivers, are also becoming increasingly relevant to art historians searching for a broader context in which to examine the period's revival of such devalued genres as history, portrait, still-life and flower painting, and various forays into fashion and commercial work.

When Warhol apotheosized bottles of Coca-Cola in seemingly flat, yet subtly modulated rows of serial imagery (see Cat. 186), he was in fact reacting to a rich tradition of native assemblage, one whose most spectacular embodiment was perhaps Simon Rodia's Watts Towers in Los Angeles (Fig. 4), completed in 1954 and consisting, among other things, of Seven Up bottles. Included in the catalogue of 'The Art of Assemblage' show at The Museum of Modern Art, New York, in 1961, and celebrated in an early issue of *Artforum* – founded in San Francisco in 1962 and designed by Ed Ruscha – the Watts Towers were a world-class monument to many hip young artists in 1962.[5] This was the very year in which Warhol showed his Campbell Soup Cans (see Cat. 185) at the Ferus Gallery in Los Angeles (where Ruscha also worked). When race riots erupted in Watts in 1965, Rodia's Towers provided a symbolic backdrop for what was one of many epic public dramas that Warhol documented in the 1960s. These included the 'Race Riot' series (1963–64), based on photographs of the riots in Birmingham, Alabama, and the 'Disaster' series (1962–67), of electric chairs and car accidents (see Cat. 187–9).[6]

Here again, the contrast between Abstract Expressionist sculpture and Pop monuments could not be more marked. Where Newman's sculpture *Broken Obelisk* (Fig. 5), later consecrated as a memorial to Martin Luther King, was emphatically abstract, Claes Oldenburg's obelisk, *Lipstick, Ascending, on Caterpillar Tracks* (Fig. 6), took the form of a gigantic lingam on a tank and became a rallying point for the student protests at Yale against the Vietnam War. When Rosenquist's *F-111* (1965; private collection, New York), with its image of the controversial bomber plane, was exhibited at The Metropolitan Museum of Art, New York, in a show called 'History Painting – Various Aspects' in 1968, this marked an early highwater mark of Pop's public acceptance.

The distinction between so-called 'pure' abstraction and works informed by popular culture no longer seems ironclad. But it did to many critics and artists at the time.

Fig. 5 Barnett Newman, *Broken Obelisk*,
1963–67. Institute of Religion and Human
Development, Houston

4. See Linda Norden, 'Not Necessarily Pop: Cy Twombly and America', in *Hand-Painted Pop: American Art in Transition, 1955–62*, exhibition catalogue, Los Angeles, Museum of Contemporary Art, 1992, pp. 147–61.
5. For the Watts Towers in *Artforum*, see Amy Baker Sandbaker, ed., *Looking Critically: 21 Years of Artforum Magazine*, Ann Arbor, 1984, p. 2.
6. For the iconography of death in Pop Art, see Sidra Stich, *Made in U.S.A.: An Americanization in Modern Art, the '50s and '60s*, exhibition catalogue, Berkeley, University Art Museum, University of California, 1987, p. 172.

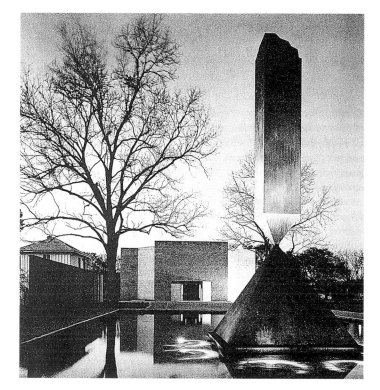

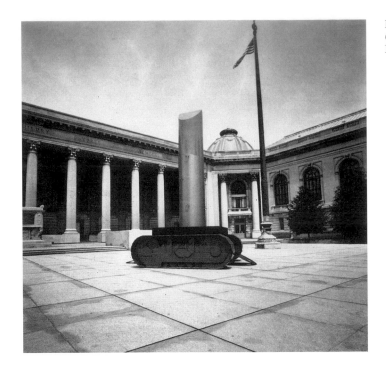

Fig. 6 Claes Oldenburg, *Lipstick, Ascending, on Caterpillar Tracks*, 1969. Yale University, New Haven, Connecticut

As early as 1964, however, Robert Rosenblum observed that – quite like Pop Art – Post-Painterly Abstraction was a cool, even-handed, deliberate reaction to Abstract Expressionism.[7] Where the Pop artists replaced an emotional subtext with bluntly consumerist imagery, abstract painters of the 1960s drained the angst out of Abstract Expressionism. Post-Painterly works have, furthermore, come to be read as reactions to Pop, even abstractions of it.

The term 'Post-Painterly Abstraction' – a broad rubric that encompasses such variations as 'Colour Field' and 'Hard Edge' – was coined by the critic Clement Greenberg to describe serious painting that came after Abstract Expressionism (which he preferred to call 'Painterly Abstraction'). The major figures of the movement were Louis, Noland and Jules Olitski, although abstract painters as diverse as Friedel Dzubas, Paul Feeley, Sam Francis, Helen Frankenthaler, Al Held, Kelly and Stella were included in Greenberg's exhibition of the same name held at the Los Angeles County Museum of Art in 1964. Post-Painterly Abstraction was never meant to be *fun*. Indeed, wrote Greenberg in the Los Angeles catalogue: 'As diverting as Pop Art is, I happen not to find it really fresh. Nor does it really challenge taste on more than a superficial level. So far (aside, perhaps, from Jasper Johns) it amounts to a new episode in the history of taste, but not to an authentically new episode in the evolution of contemporary art. A new episode in that evolution is what I have tried to document here.'[8]

According to Greenbergian orthodoxy, the first monument of Post-Painterly Abstraction was Frankenthaler's *Mountains and Sea* (1952; National Gallery of Art, Washington). In Frankenthaler's large stain painting the critic found the rigours of Pollock's 1950–51 stained works, but now in an idiom that suggested giant watercolours. Despite Frankenthaler's breakthrough painting, however, and despite some promising experimental collaboration and 'jamming' between Noland and Louis in the early 1950s, when both artists were working in Washington, Greenberg's movement did not really gather momentum until 1958 and the first of Noland's 'Target' stain paintings. It seems clear that Noland was by then aware of Johns's 'Target' paintings (see Cat. 147) – seminal, too, for Pop. But unlike Johns's almost hermetically sealed, encaustic works, Noland's heraldic abstractions, with their sherbet and earth tones, also incorporated raw canvas as an active part of their compositions.

So did Louis's 'Veils' and, in turn, his 'Unfurleds' (see Fig. 7) and 'Stripes'. These series of raw canvas-and-stain paintings, cut short by the artist's untimely death in 1962, further suggest the mystery and ambiguity of late nineteenth-century Symbolism. Louis's 'Unfurleds' (1960–61) were, for instance, compared at the time by

7. Robert Rosenblum, 'Pop Art and Non-Pop Art', in John Russell and Suzy Gablik, *Pop Art Redefined*, New York, 1969, pp. 53–6.

8. Clement Greenberg, Introduction, in *Post-Painterly Abstraction*, exhibition catalogue, Los Angeles County Museum of Art, 1964, n. p.

9. Rosenblum's review is quoted in Irving Sandler, *American Art of the 1960s*, New York, 1988, p. 30.

10. Tony Smith's stained paintings were shown for the first time at the Paula Cooper Gallery, New York, in November 1992.

Fig. 7 Morris Louis, *Gamma Delta*, 1959–60.
Whitney Museum of American Art, New York

Rosenblum to Art Nouveau gardens, and with hindsight seem to have presaged the enormous revival of interest, during the 1960s, in everything Jugendstil, from Gallé glass to Mucha posters and Beardsley prints – all manifestations of an earlier medieval revival.[9] To many viewers today, Louis's paintings seem no more and no less than lyrical and decorative abstractions. They were nevertheless praised by the inconceivably influential Greenberg for having taken Pollock's idea of flatness a crucial, and possibly spiritual, step further into a dazzling near-emptiness: Louis's emptying the centre of the canvas of all incident still evokes a Zen-like spirit of renunciation.

Yet Post-Painterly works also addressed some of the same raunchy culture as did Pop. Olitski's early 1960s pictures may be characterized by large, stained circular shapes floating in seas of unprimed canvas, but a number of them have Pop titles – *Flaming Romance of Beverly Torrid* of 1964 is just one example. In the same year, Olitski began spray-painting, an industrial technique that reflects Warhol's stated desire to be a machine. (Tony Smith, it should be noted, made spray-painted canvases as early as 1956.)[10] By the mid-1960s Noland was highly successful and also producing quasi-mechanistic pictures by means of taped edges and working with assistants in a 'factory' situation far more similar to Warhol's than one might assume. Noland sometimes had help making 'editorial' decisions on how to crop his unstretched stripe paintings, just as Warhol had collaborators in order to decide on colours for his 'Flowers' paintings. But unlike Warhol's Factory output, Noland's production immediately entered the ivory tower.

Fig. 8 Kenneth Noland, *New Day*, 1967.
Whitney Museum of American Art, New York

Today, Noland's series 'Crosses', 'Cat's Eyes', 'Chevrons' and 'Stripes' all suggest the cool emblems of Pop as well as many corporate logos of the period – for instance, those of CBS or Chevrolet. His stained and taped, horizontal stripe paintings of 1967 to 1971 (see Fig. 8) underscore the deliberate air of affectlessness that so frequently characterizes the decade. Their insistent road-like flatness seems part of the spirit of the times that also gave rise to Robert Smithson's pictographic earthworks (see Fig. 3, p. 127) or a movie such as *Easy Rider* (1969), with its laconic bikers' paean to a lost America.

If Pop was the major brat who succeeded in upstaging everything around it, abstraction was the cerebral sibling that quietly held its own. Greenbergian formalism may have found its Valhalla by the mid-1960s at Bennington College, then still a girls' school, in the Green Mountains of Vermont. Although neither critic nor artist ever formally taught at the school, Noland lived nearby in South Shaftsbury, and both presences were powerfully felt. Their power there may owe something to the fact that Greenberg and Noland, along with Olitski and Larry Poons, were all involved in Sullivanian analysis, which was enjoying a considerable vogue on university campuses, as well as in bohemian circles in New York and, during the summers, in Amagansett on Long Island. (The so-called Sullivanians, named after Harry Stack Sullivan, a progressive Baltimore-area psychoanalyst, espoused communal living, believed in confrontational dialogue and, beginning in the late 1970s, were widely decried as a noxious subcult.)[11]

Like Abstract Expressionism – against which it rebelled – Post-Painterly Abstraction itself became an authoritarian symbol to later generations. Indeed, a rather perverse fascination exists among younger artists and critics with the restrictive precepts of Greenbergian formalism – its insistence on the 'essential' flatness of painting, its theoretical proscriptions against figurative allusions, however oblique. A recent essay by Robert Storr, a curator at The Museum of Modern Art, on the Greenbergian legacy was, for example, entitled 'No Joy in Mudville'.[12] Post-Painterly Abstraction, if less catchy than Pop, had significant repercussions on abstract art of the late 1980s, such as the geometrically patterned paintings of Philip Taaffe or the 'optical' and striped abstractions of Ross Bleckner.

Although Greenberg never entirely approved of him, the young Stella was at once pivotal and a figure apart vis-à-vis Post-Painterly Abstraction. From his first 'Black' paintings onwards (see Cat. 153–5), Stella remained consciously open to forbidden forms and content, alluding to everything from Beat nihilism to Nazi slogans and black-American jazz in his titles. Indeed, Stella set standards of cool that would only

Fig. 9 Frank Stella, *Darabjerd III*, 1967.
Joseph Hirshhorn Collection, New York

Fig. 10 Louis Kahn, National Assembly Building (detail), Dacca, Bangladesh, 1962–83

11. Sullivan published his theories of interpersonal growth in the 1940s. The Sullivanians were a splinter group (under the leadership of Jane Pearce and Saul Newton) of the established William Alanson White Institute in New York. See Steven Naifeh and Gregory White Smith, *Jackson Pollock: An American Saga*, New York, 1991, p. 768.

12. Robert Storr, 'No Joy in Mudville: Greenberg's Modernism Then and Now', in *Modern Art and Popular Culture: Readings in High and Low*, New York, 1990, pp. 160–90.

13. For the 1960s context of Kahn's work, see Brooks Adams, 'What Does the Building Want to Be?', *Art in America*, vol. 80, no. 7, July 1992, pp. 67–75.

14. Sontag, op. cit., p. 290.

15. Kenneth E. Silver, 'Modes of Disclosure: The Construction of Gay Identity and The Rise of Pop Art', in *Hand-Painted Pop*, op. cit., pp. 179–203.

16. The Saint Phalle is reproduced in Marco Livingstone, ed., *Pop Art: An International Perspective*, exhibition catalogue, London, Royal Academy of Arts, 1991, p. 232.

17. See Roni Feinstein, *Robert Rauschenberg: The Silkscreen Paintings, 1962–64*, exhibition catalogue, New York, Whitney Museum of American Art, 1990.

18. See Laurie J. Monahan, 'Cultural Cartography: American Designs at the 1964 Venice Biennale', in Serge Guilbaut, ed., *Reconstructing Modernism: Art in New York, Paris, and Montreal 1945–1964*, Cambridge, MA, 1991, pp. 369–416.

later be equalled, and perhaps surpassed, by Warhol and Lichtenstein. It is, for instance, entirely possible that the famous 'Torpedo … Los!', the phrase-in-a-bubble of Lichtenstein's 1963 'War' painting, is an 'Allied' response to Stella's *Arbeit Macht Frei* (1958; Mr & Mrs Graham Gund, New York) and '*Die Fahne Hoch!*' (Cat. 153). Stella's many subsequent series of shaped canvases wreaked havoc with Greenbergian notions of flatness. By 1967, and the 'Protractor' series (see Fig. 9), he was devising orientalist fantasias as strict in their geometries as the Islamic art he admired, and as immediate in their gestalt as the NBC peacock logo. The ripples of Stella's abstract orientalism reached as far as Dacca in Bangladesh, where Louis Kahn's monumental government buildings for the new capital rose, between 1962 and 1983, with *brise-soleil* walls structured by gigantic, open, geometric orders (see Fig. 10).[13]

During Pop's late 1950s prelude, other maverick figures emerged as important precursors, among them John Chamberlain, best known for his abstract sculptures made of welded car parts (see Cat. 159–61). Chamberlain formed a crucial bridge between the lush painterly effects of de Kooning (see Cat. 95–102), which he evoked in three dimensions, and early Warhol who, perhaps coincidentally, made car-crash paintings, and who in any case owned a Chamberlain car-part sculpture called *Jackpot* (1961; Whitney Museum of American Art, New York). Larry Rivers, too, prefigured a Pop revival of history painting, with his *Washington Crossing the Delaware* of 1953 (Museum of Modern Art, New York) – a subject, also, for pre-Pop Lichtenstein in 1951. Rivers also beat Warhol to the punch with his depictions of automobiles, of US and French currency, as well as charged political allegories, such as *Friendship of America and France (Kennedy and de Gaulle)* of 1961–62 (Mrak and Livia Strauss Collection), with its binational array of cigarette-packet logos. Rivers's rendition of Jacques-Louis David's portrait of Napoleon in his study, *The Greatest Homosexual* (1964; Hirshhorn Museum and Sculpture Garden, Washington), further reveals High Camp content in the very year that Sontag's famous essay (much influenced by her friend Alfred Chester) appeared. 'Jews and homosexuals', Sontag proclaimed, 'are the outstanding creative minorities in contemporary urban culture.…The two pioneering forces of modern sensibility are Jewish moral seriousness and homosexual aestheticism and irony.'[14]

When Johns painted his first flags, he was not making a patriotic gesture, nor an unpatriotic one either. He was trying to empty the emblem of symbolic value. To depoliticize the American flag was a political act during the McCarthy era, with its witch-hunts and charades of 'loyalty'. When Johns first put plaster casts of body parts above his painted targets, he put forth in the most cryptic fashion the notion of being targeted himself. It has recently been suggested by Kenneth Silver that Johns's compartmentalized body parts may allude to the compartmentalization of his own sexuality during the 1950s, and to what Eve Kosofsky Sedgwick has called 'The Epistemology of the Closet'.[15] Silver notes Johns's affinity with the iconography of such poets and artists as Hart Crane, Charles Demuth, Frank O'Hara – and others whose homosexuality has been revealed, or celebrated, by scholars in the last twenty years. Silver sees the 'Targets' as belonging to martyrology, specifically to the iconography of Saint Sebastian pierced with arrows – long a gay emblem. All such understandings of Johns's work would have been strictly covert when the artist was just emerging as a major force in the late 1950s and early 1960s. Yet Niki de Saint Phalle's *Saint-Sebastian or the Portrait of My Love* (1960; collection of the artist), with its target head studded with darts, suggests that these subliminal Johnsian elements were understood at least by some at the time.[16]

By the early 1960s Rauschenberg had already become an Establishment figure within the avant-garde. Many of his silk-screened paintings of 1962 to 1964, with their repeated use of the image of John F. Kennedy as a Christ-like new world leader, in fact, seem self-consciously important (see Cat. 141).[17] When Rauschenberg won the Grand Prize at the Venice Biennale in 1964, the first such award to be granted to an American, there were cries of US cultural imperialism.[18] This dubious charge may have gone to his head, for Rauschenberg has since become a sort of one-man institute of multiculturalism, whose grandiose, ecumenical collaborative projects have

been carried out all over the world, from Russia to Ecuador. In many of his ground-breaking works of the early 1950s, however, which prefigure both Minimalism and Pop, as well as his later fusions of performance, politics, painting, sculpture, film and mechanical technology, Rauschenberg has provided a truly protean model.[19]

The images of Warhol and Lichtenstein have turned out to contain more coded autobiographical references than we ever guessed. Full of private meanings, campy in-jokes and art-world digs, Pop sometimes seems to be anything *but* popular in its appeal. Lichtenstein's 'War' paintings (see Cat. 179) may be cartoon re-enactments of the traumas he endured as a GI during the Second World War. In fact, much of Lichtenstein's Pop production can be read as a reworking in hieroglyphic terms of his own earlier and more hesitant styles. He had, after all, addressed Rococo art and Cubism, as well as Abstract Expressionism, in one way or another well before 1962. His subsequent series 'Masterpieces' after those of famous artists – his 'Women' after Picasso (1963), his 'Rouen Cathedrals' after Monet (1969) – are replays both of art-historical high points *and* of his own apprenticeship at the altar of High Modernism. Lichtenstein's work seems suffused with memories even of his student years under Hoyt Sherman at Ohio State University in Columbus. Sherman was given to the eccentric practice of super-fast slide presentations whereby images were flashed at students in a darkened auditorium. Thus did Lichtenstein learn to draw.[20]

Lichtenstein's recent paintings of interiors are blatantly personal allegories. These Pop-ishly generic living-rooms and bedrooms represent veritable inventories of the artist's taste in objects and of his long-standing friendships in art – recent works by Johns are 'Lichtensteinized' in many of these images. The artist continues to parody Abstract Expressionism in a composition such as *Interior with Exterior (Still Waters)* of 1991, which alludes to Clyfford Still.[21] Lichtenstein seems never to abandon any of his themes for long: the 1992 poster and Democratic Party button he designed feature the White House's Oval Office as a stage set – the stage for historical events of the future. Here Lichtenstein reveals himself as a politically engaged painter in the tradition of David.

Warhol's guises and reincarnations are more various. From the outset, he was a master of innuendo and subterfuge. The different versions of *Before and After* (1960–62) from the early Pop canon should not be taken as just impersonal appropriations of an advert for 'nose jobs', but also as oblique references to the fact that Warhol himself had cosmetic surgery on his nose in 1957. Similarly, his ladies' wigs paintings (1960) allude, circuitously, to his own well-documented experiments with hair-pieces. Kenneth Silver sees the artist implicitly imaging himself as a female con-

Fig. 11 Harold Stevenson, *The New Adam*, 1962. Collection of the artist. Shown here in an installation at the Richard Feigen Gallery, New York, 1963

19. For Rauschenberg and collage, see Brooks Adams, 'Salmigondis a la Rauschenberg', *Artstudio*, no. 23, Winter 1991, pp. 56–67.
20. See David Deitcher, 'Unsentimental Education: The Professionalization of the American Artist', in *Hand-Painted Pop*, op. cit., pp. 95–118.

21. For Lichtenstein's 'Interiors', see Brooks Adams, 'New Pop Reflections', *Art in America*, vol. 80, no. 7, July 1992, pp. 88–91.
22. Silver, op. cit., p. 201.
23. Stevenson's *The New Adam* was exhibited at the Mitchell Algus Gallery in New York in November/December 1992.
24. Illustrated in *Andy Warhol: Heaven and Hell Are Just One Breath Away! Late Paintings and Related Works, 1984–1986*, New York, 1992, pp. 53–4.
25. Richardson's eulogy is reprinted ibid., pp. 140–1.
26. See *Newsweek*, 30 November 1992.

sumer, and has interpreted Warhol's famous cow wallpaper of 1966 as being emblematic of that consumer – the exact opposite of Picasso's bull.[22]

Warhol's homo-erotic art demands continual reinterpretation. With the rediscovery of early works by perpetual outsiders, such as Harold Stevenson, whose *The New Adam* (Fig. 11) – a colossal multi-panel painting of the actor Sal Mineo's nude body – was first exhibited at Iris Clert's Parisian gallery in 1963, Warhol's gay imagery no longer seems to have come out of a void. Stevenson was an early member of Warhol's entourage and the subject of an early Warhol film called *Harold* (1964); and *The New Adam* is a premonition of Warholian homo-eroticism and Rosenquist's billboard scale.[23]

Religious content for Warhol also carries an increasingly personal charge. His *Hospital* (1963; Dia Art Foundation, New York), with its repeating image of a nun assisting at a birth, alerts us to the issue of Christian iconography even in the coolest period of early Pop. The last works, of 1984 to 1986, in which Raphael's *Sistine Madonna* and Leonardo's *Last Supper* are appropriated, begin to take on new meaning as soon as we learn about the artist's continuing adherence to the Catholic faith, or his charity work in soup kitchens at the end of his life. Using blown-up headlines from *The New York Post*, Warhol also made explicit reference to AIDS in at least one large hand-painted and silk-screened work, *AIDS/Jeep/Bicycle* (c. 1985; Estate of Andy Warhol), that brings the tradition of on-the-spot history painting fully up to the minute.[24]

Warhol may have seemed a Baudelairean dandy in the 1960s, or a Boldiniesque society portraitist in the 1970s, but by the end he had become a father figure to, and collaborator with, younger artists such as Jean-Michel Basquiat (see Cat. 233, 234) and Francesco Clemente. At Warhol's funeral the artist was eulogized by John Richardson as a *yurodstvo*, the saintly simpleton of Russian literature and Slavic folklore.[25] (Today a display of Warhol prints, on loan from the artist's foundation, may be viewed at the Museum of Modern Arts in the Medzilaborce region of the Slovak Republic, where his parents were born.) In 1992 Cady Noland commanded attention with her car-crash installation at the Kassel 'documenta IX' and Jeff Koons stole the show with a gigantic topiary dog placed outside an eighteenth-century *Schloss* on the outskirts of the town. And lawyers continued to wrangle over the Warhol estate. Now the Holy Fool casts his aura over Britain and a reunified Germany, as well as a United States in which President Bill Clinton appears on a cover of *Newsweek* as a boyish Saint George about to slay the dragon: Camelot revisited.[26]

Neal Benezra

'To Speak Another Language':
The Critique of Painting and the Beginnings
of Minimal and Conceptual Art

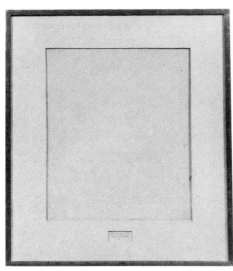

Fig. 1 Robert Rauschenberg, *Erased de Kooning Drawing*, 1953. Collection of the artist

Fig. 2 Jasper Johns, *Target (Do It Yourself)*, 1960. Collection of Ileana Sonnabend, New York

With the passage of time, the 1960s have emerged as among the most rich and complex decades in the history of twentieth-century American art. This was a decade of emphatic and productive artistic questioning, a period in which all manner of conventional wisdom concerning the nature, form and content of art was reconsidered. Reflecting, perhaps, the social and cultural upheaval in American society during these years, artists of every progressive stripe assumed the will to challenge to be a necessity.

For the first time in several decades, American artists possessed a vivid home-grown model to which to respond. In the post-Second World War period Abstract Expressionism dominated American art, and Willem de Kooning, Arshile Gorky, Franz Kline, Barnett Newman, Jackson Pollock, Mark Rothko and Clyfford Still formed a powerful, if loosely constituted, group. Although remarkably diverse personalities and intellects, these artists shared an approach in which largeness of scale, bold composition and colour, and a commitment to the process of painting all came to evoke the individualistic, humanist tradition. In addition to producing works of an extraordinary formal presence, they often expressed ambitions for their painting that could only be termed profound. Having survived the exceptional travails of economic depression, the Works Progress Administration and the Second World War, the Abstract Expressionists viewed themselves as pioneers in the creation of a new art which, in Still's eloquent and romantic phrase, 'was as a journey that one must make, walking straight and alone'.[1] While Still, in particular, personified the individualism and integrity of the Abstract Expressionist pursuit, his was a path so separate and so personal that it could neither provide guidance nor generate adherents. More influential for the future were the words of Barnett Newman, as they appeared in the pages of *Tiger's Eye* magazine in 1948: 'We are freeing ourselves of the impediments of memory, association, nostalgia, legend, myth, or what have you, that have been the devices of Western European painting.'[2] For a younger generation, Newman's words offered the possibility of a new approach and granted them permission to look outside tradition for sustenance.

In the 1950s artists such as Robert Rauschenberg and Jasper Johns had already begun to challenge what they considered the overwhelming self-consciousness and pictorial ambition underlying Abstract Expressionism. In 1953 the insouciant Rauschenberg approached de Kooning and obtained a drawing with the express purpose of erasing it. A Duchampian gesture of the first order, Rauschenberg's *Erased de Kooning Drawing* (Fig. 1) explicitly challenged the intrinsic value placed on marks made by the artist as conveyors of quality and meaning. It was no accident that Rauschenberg sought out de Kooning for this purpose; of all the New York School painters, de Kooning most clearly personified the humanist values associated with the history of painting. In subsequent years Rauschenberg pressed his critique even further: in 1958 he produced the twin paintings *Factum I* (Museum of Contemporary Art, Los Angeles) and *Factum II* (Morton Neumann Family Collection, Chicago), works bearing virtually identical markings and collaged elements which, by virtue of their sameness, constituted another assault on the notion that individual inspiration resides in the traces of the painter's hand.

In 1960 Johns made *Target (Do It Yourself)* (Fig. 2), a funny yet altogether meaningful reprise of his *Target with Plaster Casts* (1955; Collection of Leo Castelli, New York). Whereas the original juxtaposed the target with fragmented and closetted body parts, in the later work Johns created the painting only in outline form, offer-

1. Still, Letter to Gordon Smith, 1 January 1959, in *Paintings by Clyfford Still*, exhibition catalogue, Buffalo, Albright Art Gallery, 1959, n. p.
2. Newman, 'The Sublime is Now', *Tiger's Eye*, December 1948, p. 53.

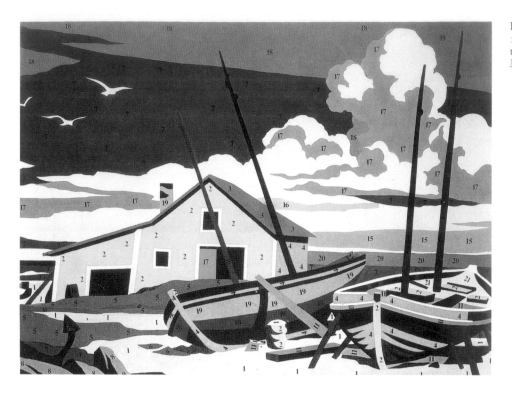

Fig. 3 Andy Warhol, *Do It Yourself (Seascape)*, 1962. Marx Collection, Berlin; on permanent loan to the Städtisches Museum Abteiberg, Mönchengladbach

ing the viewer the opportunity not merely to fill in the picture, but even to claim co-authorship by signing it beside Johns's own name.

If Rauschenberg and Johns challenged long-standing notions equating painterly virtuosity with assessments of quality and humanistic value, they were far from alone. For example, Andy Warhol followed Johns's model rather directly, making numerous 'do it yourself' drawings and paintings in 1962–63. Landmarks of early Pop Art, works such as *Do It Yourself (Seascape)* (Fig. 3), find Warhol transforming the delineation of an already debased pictorial subject into a 'how to' lesson, complete with silhouette drawings and keyed colour, the result being a biting parody of painting.

Equally penetrating and persuasive were the works and the words of Ad Reinhardt. In a rhetorical attempt to make paintings that could not be exploited, Reinhardt began to paint 'black square' paintings (see Cat. 125): works measuring five feet square in which the dense black hue nevertheless yielded a variety of subtle cruciform shapes. If Reinhardt intended the pictorial difficulty of the 'black square' paintings to place them outside the processes of the art world – processes that Reinhardt utterly detested – implicit in these works was a challenge to the further viability of painting. As Reinhardt noted in 1966, he was making 'the last painting which anyone can make'.[3]

The examples established by artists such as these were crucial to a younger generation. The romantic notion of the painter pouring out his or her soul on to the canvas came to be considered a humanist cliché. Remarkably, throughout the 1960s certain painters were themselves in the forefront of this movement to undermine the traditional values attached to the medium. Frank Stella made successive series of shaped canvases that were defiantly non-allusive and non-expressive (see Fig. 4). Stella's words were as prosaic as his paintings: 'I always get into arguments with people who want to retain the old values in painting – the humanistic values that they always find on the canvas. If you pin them down, they always end up asserting that there is something there besides the paint on the canvas. My painting is based on the fact that only what can be seen there is there.'[4]

Stella's decidedly anti-romantic stance was shared by Robert Ryman who, in the early 1960s, reduced his palette to white, limited his paint application to certain carefully controlled brushstrokes and found new ways of attaching his works to the wall – all in an attempt to rid his paintings of any trace of illusionism (see Cat. 195-7). In an ongoing series of 'date paintings', On Kawara similarly reduced his

3. Quoted in Bruce Glaser, 'An Interview with Ad Reinhardt', *Art International*, vol. 10, December 1966, p. 18.
4. Quoted in Bruce Glaser, 'Questions to Stella and Judd', in Gregory Battock, ed., *Minimal Art: A Critical Anthology*, New York, 1968, pp. 157–8.
5. Judd, 'Specific Objects', in idem, *Complete Writings: 1959–1975*, Halifax, Canada, 1975, p. 181.

Fig. 4 Frank Stella, *Sanbornville II*, 1960. Westfälisches Landesmuseum für Kunst und Kulturgeschichte, Münster

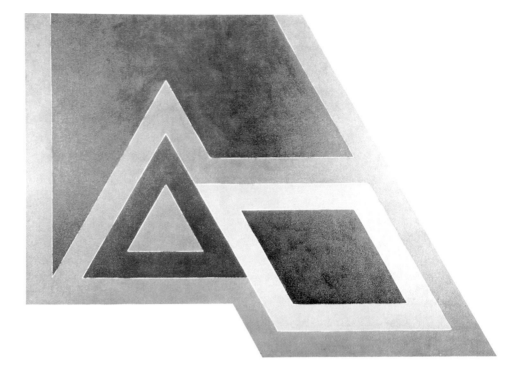

means – simply recording the work's date in white characters on a dark grey field – in effect making paintings with the sole purpose of recording his own activity as a person and as an artist, an idea that, after 1965, reverberated in the works of many of Kawara's contemporaries.

While painters such as Stella, Ryman and Kawara redefined the terms of the medium, others assumed a more radical stance. Some, like Donald Judd, challenged the medium from a formal standpoint. Although Judd's first paintings were made under the respected influence of Newman, he soon came to challenge the traditional separation of painting and sculpture. A prolific writer and critic, in his most influential essay, 'Specific Objects' (1965), Judd outlined his position: 'Half or more of the best new work of the last few years has been neither painting nor sculpture.... The main thing wrong with painting is that it is a rectangular plane placed flat against the wall. A rectangle is a shape itself; it determines and limits the arrangement of whatever is inside of it.... The composition must react to the edges and the rectangle must be unified, but the shape of the rectangle is not stressed; the parts are more important, and the relationships of colour and form occur among them.'[5]

Fig. 5 Donald Judd, *Untitled (91.29)*, 1963. Hirshhorn Museum and Sculpture Garden, Smithsonian Institution, Washington, DC; Mueseum Purchase, 1991

Judd sought an art that would operate between painting and sculpture, work composed of wholes and not parts, in which colour and shape would be inseparable. In the early 1960s he produced works such as *Untitled* (Fig. 5), a wooden, box-shaped form painted bright cadmium red. But Judd became dissatisfied with the imprecision of wood, and he also stopped constructing the sculptures himself, preferring to design for precise industrial fabrication. He found that aluminium, stainless steel and plexiglass could achieve his desire for clarity far more consistently, and these remained his preferred materials. Beyond establishing formal control, industrial fabrication allowed Judd to work serially, and by 1965 he was creating 'stacks', wall-mounted series of disconnected, cantilevered boxes mounted at equal intervals in vertical arrangements (see Cat. 203).

Fig. 6 Carl Andre, *Lever*, 1966. National Gallery of Canada, Ottawa

While Judd's methods were new and, for many, shockingly extreme, both his approach and the look of his sculpture – uninflected geometric forms, serially arranged with colour inseparable from shape – were shared by a number of other artists identified with Minimalism. An unfortunate term, one which has long been considered wholly inappropriate by those whom it has come to designate, 'Minimalism' today refers principally to the work of Judd, Carl Andre and Dan Flavin, the paintings of Stella and Ryman, as well as moments in the careers of Sol LeWitt and Robert Morris, among many others.

If Judd reconsidered traditional media in order to arrive at new definitions of sculptural form, he has been possibly the most formal of the Minimalists. In comparison with this approach, Andre, for example, redefined sculpture in a more radical way. Initially a poet, by 1958 he was working with wood, drilling, incising and then building his sculptures (see Cat. 206). Andre's early work reflects his friend Stella's similar desire to equate compositional elements with the shape of the whole. Constantin Brancusi was Andre's other decisive early influence, as the young American almost immediately rid his work of any distinction between sculpture and base while retaining an essentially vertical format.

Andre has described his experience of working on the trains of the Pennsylvania Railroad as seminal: 'It is an enormous plain with the long lines of freight cars lined up in the freight yard and the flat, vast swampy meadows. It just became a strong influence upon my work.'[6] While Andre continued to stack and assemble wood and fire-bricks, around 1965 he began to deploy his forms horizontally. The determination to compose work that would hug the floor was a major breakthrough, and two important sculptures resulted immediately: *Equivalents* (1966), eight rectangular forms each consisting of 120 bricks stacked two high but arranged in different configurations; and *Lever* (Fig. 6), a long line of 137 bricks placed on the floor of the Jewish Museum in New York. Andre's 'signature work', however, is perhaps *37 Pieces of Work* of 1969 (Hallen für neue Kunst, Schaffhausen). Created for the artist's exhibition the following year at the Guggenheim Museum, it is composed of 1,296 units – 216 each of aluminium, copper, steel, magnesium, lead and zinc. These metal plates composed an enormous square in the Guggenheim lobby which was meant to be seen from the upper levels of the spiral ramp. The '37' of the title refers to the series of thirty-six parts, each of which measured six feet square (and together utilized all the metals); the thirty-seventh was the sum of the parts.

Flavin pursued a different and, perhaps, more radical course. While Judd combined the formal values of contemporary painting and sculpture, and Andre made sculptures which denied mass and volume, both were ultimately devising new approaches to formal expression. By contrast, Flavin was possibly the first to abandon objects in favour of formless environments. Like Judd, Flavin left painting behind at an early stage of his career, finding himself 'in opposition to the loose, vacant and overwrought tactile fantasies spread over yards of cotton duck'.[7] He achieved a more literal, object-free exhibition environment with fluorescent light. While a number of artists were turning to light as a medium in the early 1960s, most (for example, Chryssa, James Rosenquist and Robert Watts) employed neon to emphasize an object or as a method of reference. Flavin, however, concerned himself with the articulation of space. As he noted in 1965: 'Now the entire interior spatial container and its

6. Andre, quoted in Diane Waldman, 'Holding the Floor', *Artnews*, vol. 69, no. 6, October 1970, p. 76.
7. Flavin, '…In Daylight or Cool White', *Artforum*, vol. 4, no. 4, December 1965, p. 24.
8. Ibid.
9. LeWitt, 'Sentences on Conceptual Art', in *Sol LeWitt*, exhibition catalogue, New York, Museum of Modern Art, 1978, p. 168.
10. LeWitt, 'Paragraphs on Conceptual Art', ibid., p. 166.
11. Ibid.

parts – wall, floor, and ceilings – could support this strip of light but would not restrict its act of light except to enfold it.... The actual space as a room could be broken down and played with by planting illusions of real light (electric light) at crucial junctures in the room's composition.'[8]

Beginning around 1964, Flavin deployed fluorescent tubes on the wall, ceiling or floor. He termed them 'pseudo-monuments', as if to stress their often architectonic composition while playing down any public implications. Unlike Judd or Andre, Flavin employed referential titles; these included allusions to friends and colleagues past and present: Josef Albers, Alexander Calder, Donald Judd, Sol LeWitt, Barnett Newman, Barbara Rose and Robert Rosenblum (see Cat. 209, 210). Perhaps Flavin's most compelling reference is found in his series of spare, architectonic pieces devoted to the Russian Constructivist artist and designer Vladimir Tatlin (see Fig. 7). The allusion to Tatlin is of interest, because Tatlin (who, significantly, drew on the skills of the engineer) was himself the creator of a most untraditional 'monument', the *Monument to the Third International* (1919).

If this paradoxical combination – the redefinition of an architectural space without resort to objects – marks Flavin's achievement, it is an accomplishment that he shares with LeWitt. With Flavin and LeWitt one moves beyond the stereotypical public perception of Minimalism as consisting merely of ponderous geometric forms imposed on an often unwilling public. Though LeWitt has made many white, open-cube structures based on serially realized, mathematical permutations (see Cat. 208), his most important contributions may be his writings and his 'wall drawings', first exhibited at the Paula Cooper Gallery, New York, in 1968.

LeWitt's statements are crucial because they expound the evolution among progressive artists away from the necessity of the object and towards a more conceptual approach. Like Judd, LeWitt inveighs against formalist notions governing painting and sculpture: 'When words such as painting and sculpture are used, they connote a whole tradition and imply a consequent acceptance of this tradition thus placing limitations on the artist who would be reluctant to make art that goes beyond the limitations.'[9] LeWitt has consistently described his own activity as 'conceptual art', in which 'the idea or concept is the most important aspect of the work'.[10] This did not mean, however, that he denied the value of the created object.

Whereas Judd and Andre rethought traditional sculptural form in order to create new types of perceptual experiences, LeWitt values the idea and the process of conception first and foremost. 'When an artist uses a conceptual form of art, it means that all of the planning and decisions are made beforehand and the execution becomes a perfunctory affair.... This kind of art is not theoretical or illustrative of theories; it is intuitive, it is involved with all types of mental processes and it is purposeless.'[11]

Whereas LeWitt's cubic sculptures are often considered his 'signature works', the wall drawings, begun in 1968, may be his most important and influential formal contributions. LeWitt had been making sculpture for several years when, around 1967, he became preoccupied with drawing. Rather than present works on paper framed and mounted in traditional fashion, he decided to work directly on the wall. Initially the drawings were modest linear configurations executed with graphite and drawn by the artist himself, but soon LeWitt was incorporating colour and dynamic compositions, extending from floor to ceiling and around corners, and was employing trained assistants to realize them (see Fig. 8).

Some observers have dismissed the wall drawings as mere decoration, yet they are arguably among the most conceptually advanced works of the 1960s. Like Flavin's light, LeWitt's wall drawings de-objectify creativity while upholding the bases of art as residing in the artist's mind and the viewer's senses. Though each is originally site-specific, LeWitt arranges for them to be privately owned and even 'portable'. When a drawing is purchased, the buyer is provided with a certificate of authenticity, which effectively grants ownership. If ownership changes or circumstances require reinstallation, the new owner commisions one of the artist's trained assistants to reinstall the piece. Eminently practical, this arrangement also ensures that the wall drawings will continue to exist as long as trained draughtsmen are available. Ultimately, the wall

Fig. 7 Dan Flavin, *Monument 7 for V. Tatlin*, 1964. Museum Ludwig, Cologne

Fig. 8 Sol LeWitt, *Continuous Forms*. Installation in the Wiener Secession building, Vienna, 1988

drawings are the best evidence of LeWitt's dictum that 'the idea is the machine that makes the art'.[12]

As noted above, LeWitt has insisted that the designation 'conceptual' be applied to his work, and it is a small step from the assumptions underlying his wall drawings to the work of such Conceptual artists as Joseph Kosuth and Lawrence Weiner. Rather than analyse the tradition of painting and sculpture in order to achieve advances in terms of form or presentation, these slightly younger figures challenged established media as part of a more sweeping critique of art as based in aesthetics. For Kosuth, historical guidance was provided by Marcel Duchamp. In his breakthrough article, 'Art After Philosophy' (1969), Kosuth described Duchamp as raising the issue of 'the function of art' for the first time. 'The event that made conceivable the realisation that it was possible to "speak another language" and still make sense in art was Marcel Duchamp's first unassisted readymade. With the unassisted readymade, art changed its focus from the form of the language to what was being said.'[13] If Duchamp's example was potent, it was also somewhat distant and historical; Kosuth has acknowledged his debt to Ad Reinhardt, whom he met and befriended in 1964, in more compelling and personal terms: 'Ad Reinhardt's paintings, for many of us, were a kind of passage. His contradictions were the contradictions of modernism being made visible to itself. After Reinhardt, the tradition of painting seemed to be in the process of completion, while the tradition of art, now unfettered, had to be redefined…. That tradition of art as painting that Reinhardt spoke of, had to negate painting in order to proceed.'[14] Clearly, such thinking marked a fundamental shift. Although intellectual concerns have seldom, if ever, been absent from art, Conceptualism's elevation of ideas largely unburdened by aesthetics was a historic development. In attempting to overturn formalism, Conceptualists introduced language as their principal medium. Characteristic of this reliance upon language was Kosuth's *One and Three Chairs* (Fig. 9). An unstated homage to the philosopher Ludwig Wittgenstein's ideas concerning the function of language as analytic proposition, the piece consists of a chair, a printed dictionary definition thereof and a photograph of the object.

If Kosuth tended towards incisive juxtapositions of language, image and object, he obviously remained reliant on the presentation of form. By contrast, Weiner pressed even further, initially ridding his work of all visual references and employing language as the sole vehicle of his ideas: that is, while Kosuth continued to create and present objects, Weiner, beginning in 1967, eliminated the need for physical presence in any form (see Cat. 221, 222). As he was to note in an often-quoted statement of 1969: '1. The artist may construct the piece 2. The work may be fabricated 3. The piece need not be built.'[15] For example, Weiner's *Statements*, exhibited by Seth Siegelaub in 1967, consisted of a series of phrases printed quite simply on consecutive pages of a book (Fig. 10). In presenting his ideas thus, Weiner asserted that art differed little from other forms of knowledge in daily life. The fact that one need only read Weiner's

12. Ibid.
13. Kosuth, 'Art After Philosophy', in Gabriele Guercio, ed., *Joseph Kosuth: Art After Philosophy and After – Collected Writings 1960–1990*, Cambridge, MA, 1991, p. 18.
14. Kosuth, 'On Ad Reinhardt', ibid., p. 192.
15. Weiner, 'January 5–31, 1969', in *L'Art Conceptuel: Une Perspective*, exhibition catalogue, Paris, Musée d'Art Moderne de la Ville de Paris, 1989, p. 229.
16. Weiner, quoted in Colin Gardner, 'The Space Between Words: Lawrence Weiner', *Artforum*, vol. 29, no. 3, November 1990, p. 158.
17. Siegelaub, 'Some Remarks on So-Called "Conceptual Art" …', in *L'Art Conceptuel: Une Perspective*, p. 92.

Fig. 9 Joseph Kosuth, *One and Three Chairs*, 1965.
The Museum of Modern Art, New York

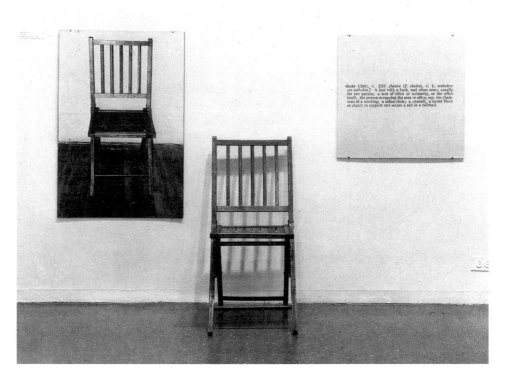

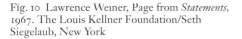

One sheet of plywood secured to the
floor or wall

Fig. 10 Lawrence Weiner, Page from *Statements*,
1967. The Louis Kellner Foundation/Seth
Siegelaub, New York

words to possess his work had additional implications. As he noted, collectors were
no different from other viewers: 'They don't have to buy it to have it – they can have
it just by knowing it.'[16] This marked a clear departure from convention; by introduc-
ing an unsaleable form of expression, Conceptual artists sought, and largely achieved,
independence from the traditional market-based practice of the art world. As Siege-
laub, the individual most responsible for presenting the early work of Kosuth, Weiner
and their colleagues Robert Barry and Douglas Huebler, has noted: 'Behind the so-
called "dematerialization" there was an attitude of general mistrust toward the object,
seen as a necessary finalization of the art work, and consequently towards its physical
existence and its market value.'[17]

Particularly in their early phase, Conceptual artists emphasized the sitelessness of
their art, and exhibitions could take place without galleries or dealers in the tradi-
tional sense. Catalogues often sufficed in presenting new formulations, and when
actual exhibitions did take place these often consisted of photographs, diagrams,
words and books, as well as other forms of documentation relevant to a given idea.
Perhaps the most important and, in the long run, the most influential form of Con-
ceptual Art assumed photographic form. Indeed, the recent explosion of interest in
non-traditional photography dates to the advent of Conceptualism, with artists such
as John Baldessari, Dan Graham, Bruce Nauman and Ed Ruscha all employing the
camera, not in the production of refined aesthetic objects, but rather as a means of
documenting their activities and their ideas.

This last point is a rather important one. With the critique of the formalist tradi-
tion, many artists have come to defy characterization according to style or medium.
Beginning in the late 1960s, artists found that they need not master a single formal
approach; if a particular idea merited or required realization in a particular form,
they obtained the means to that end. As a result, determinations of quality are today
increasingly based not on stylistic grounds, but rather on the quality of an artist's ideas
as expressed in a variety of media. In part, this is testimony to the richness of Ameri-
can creative culture in the 1960s, with a remarkable cross-fertilization occurring in all
the arts, including music, dance, video, literature and film. While an artist such as
Baldessari began by working with strongly conceptual content, he has since evolved
into a leading figure in the manipulation of pre-existing photographic images.
Graham's work hovers, tantalizingly, between architecture, Minimalism and Concep-

tualism (see Cat. 223). Ruscha has imbued his paintings (see Cat. 190) with a particularly witty form of conceptual and pictorial content. Nauman has used photography, film, video, dance, performance, neon and sculpture – everything, seemingly, except painting – in his reconsideration of the meaning of art in contemporary society (see Cat. 214–17). For them and numerous others maturing in the 1960s, the advances made by Minimal and Conceptual artists throughout the decade proved both fertile and decisive.

Richard Armstrong

Antiform: 1965–1970

After lecturing on the idea during the summer of 1966, the critic Lucy Lippard assembled a group exhibition that autumn which she called 'Eccentric Abstraction'. She used the same title for an article published in *Art International* describing the show's contents. A wide-ranging selection, the exhibition featured ten artists.[1] Lippard ascribed to their work a non-sculptural impulse that freely adapted aspects of painting to three dimensions, joining Surrealist ploys with the more formal strategies of so-called 'primary structures'. With characteristic prescience, she identified as a crucial factor Pop Art's legacy of accepting materials and attitudes previously deemed too vulgar or ugly to serve aesthetic ends. Lippard singled out Claes Oldenburg's work, with its penchant for manipulated shapes and surfaces and its celebration of physical metamorphosis, as an influence. The show included recent work by Louise Bourgeois, Eva Hesse, Bruce Nauman and Keith Sonnier, and marked the first attempt at analysing a new attitude that was shortly to be dubbed 'process art', 'post-Minimalism' and 'antiform'. Its characteristics were a taste for new media, a valuing of the horizontal as well as the vertical and a sense of scale closely related to the human body. While at least some of these traits were shared by the Minimalist sculptors, the generally younger artists represented in 'Eccentric Abstraction' infused their eccentrically fashioned pieces with telling signs of the creative process. They revived credibility in facture, which had been largely ignored by the Pop artists and deliberately eschewed by the Minimalists.

In 1966 Minimalism was itself a recent arrival: Donald Judd had begun his fabricated metal and plastic forms in the summer of 1964; Dan Flavin's first one-man show of fluorescent lights had been held later that year; Carl Andre's stacked Styrofoam oblongs had first been seen in 1965. Judd's call for 'specific objects' in the 1965 *Arts*

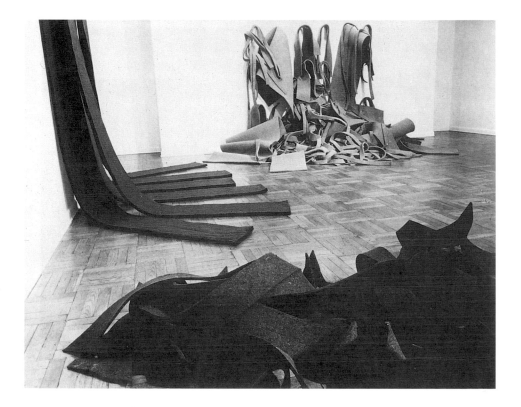

Fig. 1 Felt pieces by Robert Morris on show in his exhibition at the Leo Castelli Gallery, New York, 1968

1. 'Eccentric Abstraction' was seen at the Fischbach Gallery, New York, from 20 September to 8 October 1966. It included work by Alice Adams, Louise Bourgeois, Eva Hesse, Gary Kuehn, Bruce Nauman, Don Potts, Keith Sonnier and Frank Lincoln Viner. Lippard's 'Eccentric Abstraction' article was published in *Art International*, vol. 10, no. 9, November 1966, pp. 28–40.

Yearbook defined the painting/sculpture hybridization which he saw taking place: 'In the new work … the shape, image, color, and surface are single and not partial or scattered. There aren't any central or moderate areas of parts, any connections or transitional areas.'[2] Robert Morris's 'unitary objects', shown as an ensemble at the Green Gallery in 1963, were prime examples of Judd's dicta and represented the apogee of Morris's reductivism. Involved in performances by way of his contacts with young choreographers and dancers throughout the early 1960s, Morris was temperamentally attuned to the emerging interest in process, as is evidenced by his work of the second half of the decade. Certainly, by the time he published a series of articles in *Artforum* during 1966–67, Morris's position had evolved into a revisionist one. Codifying practices of the previous few years, he mentioned investigations of tools and materials, noting the frequent absence of the figure in favour of a focus upon the force of gravity. 'Random piling, loose stacking, hanging, give passing form to material. Chance is accepted and indeterminacy is implied since replacing will result in another configuration.'[3] Compositional attributes of this kind had become an integral part of Morris's own work by this time (see Fig. 1), and were almost ubiquitous in that of such younger artists as Nauman, Richard Tuttle and Barry Le Va. Lippard's 'Eccentric Abstraction' had included pieces of cut burlap by Nauman that were meant to be seen either hung on the wall or tossed into a corner. One critic characterized the result as 'not-work.…It has no formal character and yet no particular content either.…The idea of working something really inconsequential seems to have possibilities.'[4] Nauman consciously embraced this nascent anti-monumental concept. Speaking of another fibreglass piece of about the same time, he said that his work 'has to do with trying to make a less important thing to look at'.[5]

A parallel motive lay behind Richard Tuttle's work from the moment of its earliest appearance, in 1965. Convinced of the irrefutable logic of Minimalist sculpture, Tuttle addressed the larger context of site in quirky presentations of modestly scaled, imperfectly made and evocatively coloured objects (see Fig. 2). Seen variously on the floor or the wall (and there at unexpected heights), his pieces embodied a personal allusiveness that further contravened the deliberate impersonality of the typical Minimalist object. Formal playfulness of conception and casual composition continue to distinguish his oeuvre, as does an essential pictorialness: always modest, Tuttle's painted objects or relief paintings insist on a symbiosis between two and three dimensions.

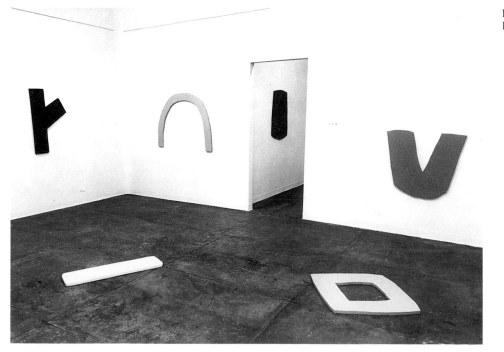

Fig. 2 View of the exhibition 'Richard Tuttle', Betty Parsons Gallery, New York, 1965

Fig. 3 Robert Smithson's *Mirror Displacement: Cayuga Salt Mine Project* (1968–69) on show in the exhibition 'Earth Art' at the Andrew Dickson White Art Museum, Cornell University, Ithaca, NY, 1969

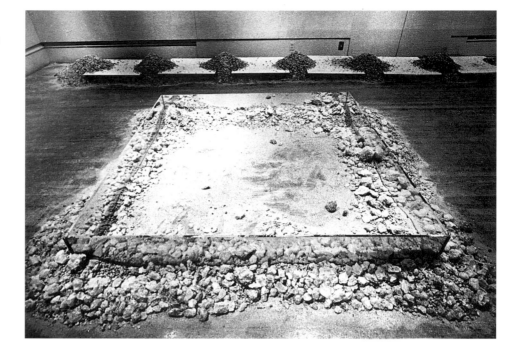

The anti-art inferences common to both Nauman and Tuttle were more fully articulated in Robert Smithson's mature work, dating from the six years preceding his death in an accident in 1975. Smithson invented the category 'non-sites' for much of what he did, arbitrarily reconstituting landscape – most often industrial rather than natural – indoors. His preoccupation with developing social and aesthetic theories to support such activities underscores his crucial position as a link between Conceptual Art and the new sculptors. His fascination with the industrially disfigured no man's land of suburban New Jersey indicates that his was a pioneering role in the development of environmental ethics. With Gordon Matta-Clark, he was the first to interpret the post-modern landscape. Beginning with the Cayuga salt mine non-sites that he made for the exhibition 'Earth Art' at Cornell University in 1969 (see Fig. 3), Smithson elaborated on a series of displaced earthworks that embodied entropy.

Smithson's recreation of a controlled field was but one manifestation of the gravity-bound nature of much post-Minimal production. No one more insistently explored process-derived field situations than Barry Le Va, who had worked alone with these ideas since 1966 while still attending graduate school in Los Angeles. During the next four years he produced a series of complex 'scatter' pieces. Their critical influence and visibility increased after one of them appeared on the cover of the November 1968 issue of *Artforum*, which contained an article on Le Va's work. The artist himself played down the material manifestations of his work, focusing instead on its internal chronology. As he explained, his work was 'not so much indication of a specific process, of what had been done to the material, as of marking off stages in time'.[6] Although his large-scale accumulations of felt, glass, wood and metal appeared to be at the outer limits of anti-formalism, they were organized by a determinist logic that allied Le Va with his Conceptualist peers. All the same, La Va's distinctive philosophy is evident in his willing incorporation in a work of the random disintegration of its component parts, their physically altered nature functioning as a record of his actual activity.

Another, more metaphysical, exemplar of aleatoric composition was Alan Saret, whose conglomerations of wire mesh and rubber were meant as carriers of poetic meaning. Saret's abiding interest in spiritual quests, often announced in the titles he chose, prompted his move to India in 1969.

That year, two young curators at the Whitney Museum of American Art, Jim Monte and Marcia Tucker, organized an exhibition surveying the rapid evolution of the new aesthetic. Entitled 'Anti-Illusion: Procedures/Materials', it featured paintings, sculpture and performances by twenty-one artists, including Hesse, Le Va, Mor-

2. Donald Judd, 'Specific Objects', *Arts Yearbook*, vol. 8, 1965, reprinted in *Donald Judd: Complete Writings 1959–1975*, New York, 1975, pp. 181–9.
3. Robert Morris, 'Antiform', *Artforum*, vol. 6, no. 8, April 1968, p. 35. The title was the editor's, not the author's. See also Morris's three-part 'Notes on Sculptures', published in *Artforum* in February and October 1966, and Summer 1967.
4. Mel Bochner, 'Eccentric Abstraction', *Arts Magazine*, vol. 41, no. 1, November 1966, p. 58. Bochner's own work was initially allied with 'process' art, but soon assumed an empirical, investigative form that located it within Conceptualism.
5. Quoted in *American Sculpture of the Sixties*, exhibition catalogue, Los Angeles County Museum of Art, 1967, p. 49.
6. Willoughby Sharp and Liza Bear, 'Interview with Barry Le Va', *Avalanche*, no. 3, Autumn 1974, p. 66. This short-lived underground tabloid was the house organ of various downtown avant-gardes and therefore reflects the concerns of the moment.

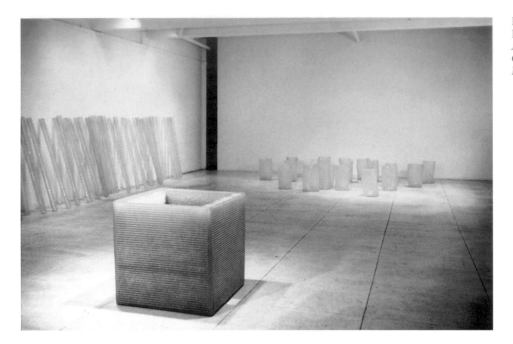

Fig. 4 View of the exhibition 'Eva Hesse: Chain Polymers', Fischbach Gallery, New York, 1966. *Accretion* (1968; Rijksmuseum Kröller-Müller, Otterlo) is on the left, *Repetition Nineteen III* (1968; Museum of Modern Art, New York) at the rear

ris, Nauman, Sonnier, Tuttle and Richard Serra (Saret withdrew at the last moment). In her catalogue text, Tucker proposed that the things on view were 'not attempts to use new materials to express old ideas or evoke old emotional associations, but to express a new content that is totally integrated with material'.[7]

Hesse's contributions to the 1969 show, including *Expanded Expansion* (at ten by thirty feet, the largest resin piece she had created) and *Untitled (Ice Piece)*, underscored her central position within this group of artists who, though intellectually unallied, were on friendly terms with each other. Hesse's work had become more ambitious after she turned to fibreglass as her principal medium earlier that year. Since its first showing in Lippard's exhibition three years before, her sculpture had gone through three stages: Surrealist wall-reliefs occupied her for rather more than a year, beginning in early 1965; there followed a body of work comprised of anthropomorphic features on a grid structure (an unusually gestural example, *Metronomic Irregularity II* [Cat. 212], was included in 'Eccentric Abstraction'); and, lastly, the culminating phase came with the fibreglass and/or polyester resin works that she started producing in the summer of 1968. In such serialized works as *Accretion* and *Repetition Nineteen III* (see Fig. 4) Hesse successfully embodied her ideas about new formal values. In notes to herself written that summer she stated: 'It is my main concern to go beyond what I know and what I can know....It is the unknown quantity from which and where I want to go.'[8] Her adaption of gesture in such hanging works as *Right After* (Fig. 5) and

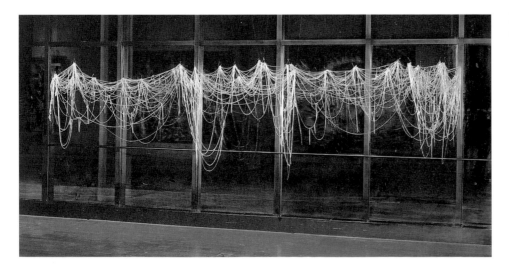

Fig. 5 Eva Hesse, *Right After*, 1969. Milwaukee Art Museum; Gift of the Friends of Art

7. Marcia Tucker, in *Anti-Illusion: Procedures/Materials*, exhibition catalogue, New York, Whitney Museum of American Art, 1969, p. 30. The show also included works or performances by Carl Andre, Michael Asher, Bill Bollinger, John Duff, Rafael Ferrer, Robert Fiore, Philip Glass, Neil Jenney, Robert Lobe, Robert Morris, Steve Reich, Robert Rohm, Robert Ryman, Joel Shapiro and Michael Snow. Lynda Benglis's work could not be accommodated physically, though it is discussed in the catalogue.
8. Quoted in *Eva Hesse: A Retrospective*, exhibition catalogue, New Haven, Yale University Art Gallery, 1992, p. 45.

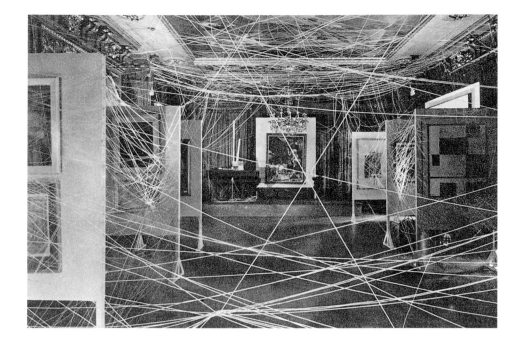

Fig. 6 'First Papers of Surrealism', exhibition organized by André Breton and Marcel Duchamp – whose string 'labyrinth' invaded the entire space – at the Whitelaw Reid Mansion, New York, 1942

Untitled (*Rope Piece*) (1970; Whitney Museum of American Art, New York) evinces a profound link with the freedoms of Abstract Expressionism as negotiated via Surrealism (see Fig. 6). Her ability, late in life, to accommodate both rational structure and irrational fluidity elevated her work to its present status as a well-spring. The only woman to be included in a variety of group shows, including '9 at Leo Castelli' (Castelli Warehouse, New York, 1968) and 'When Attitude Becomes Form' (Kunsthalle, Berne, 1969), Hesse was admitted at an early date to the male bastion of sculpture – a signal event, the consequences of which were cut short by her untimely death.

The Whitney and Castelli shows underscored the forcefulness of Richard Serra's new metal work; his acclaimed 'process' piece *Splashing*, done at the Castelli Warehouse, involved the repeated tossing of molten lead into a floor/wall joint. The hardened free-form castings attest both to the defining role of site and to the irrefutable dominance of gravity. In turning to lead and then steel, as in *One Ton Prop (House of Cards)* (Cat. 220), Serra deliberately overthrew the compositional primacy of pre-welded Constructivist-derived sculpture in favour of leaning or balancing structures. His *Prop* series (see Fig. 7), by dint of the works' implied instability, insisted on the role of process – in effect incorporating the viewer in an ongoing phenomenological drama. Serra's earliest pieces (see Cat. 218), had employed rubber,

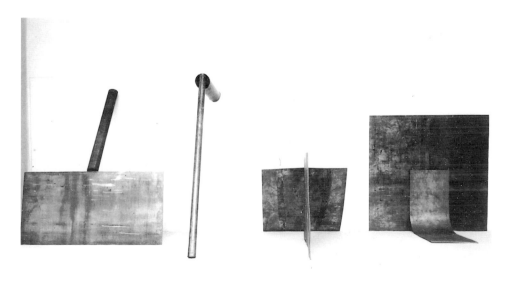

Fig. 7 Works by Richard Serra on show in the exhibition 'Theodoran Awards: Nine Young Artists' at the Solomon R. Guggenheim Museum, New York, 1969. From left to right: *Shovel Plate Prop, Clothes Pin Prop, Wall Plate Prop, Right Angle Prop* (all 1969)

fibreglass and neon as he defined for himself the significance of composition to meaning. His famous 'verb list' of 1967–68 became a projection of his actions *vis-à-vis* his materials, from 'to roll, to crease, to fold' to the concluding 'to continue'.[9] Although they are among the largest examples of the process genre, Serra's works nevertheless retain a structural clarity that elucidates his intentions. Form is simplified and mass exaggerated in a reprise of the elemental, carved and cast shapes of Constantin Brancusi. Serra's sculptures became an icon of the era, and have retained that status throughout the succeeding quarter of a century.

Even among so heterogeneous a group of artists as this, Bruce Nauman was an anomaly. He was, for one thing, the only one not to live in New York. In its variety and profound indebtedness to Marcel Duchamp, his work (see Cat. 214–17) astonished from the beginning. While living in California, Nauman produced an eclectic group of works that gave various forms both to his abiding interest in the human body as the gauge of measurement and to negative space. Such pieces as *Collection of Various Flexible Materials Separated by Layers of Grease with Holes the Size of My Waist and Wrists* and *Platform Made Up of the Space Between Two Rectilinear Boxes on the Floor* (both 1966; Collection of Linda and Henry Macklowe, and Rijksmuseum Kröller-Müller, Otterlo, respectively), the former a 'soft sculpture' structured on a roll of felt, the latter one of his many plastic casts, were indicative of concerns that were to occupy Nauman for another fifteen years. The long titles reveal the Duchampian-Dadaist strain underlying his creative impulse as well as a preoccupation with language. Nauman's numerous videotapes and films of the late 1960s show him exploring perception as generated by speech and action, most often in sequences that confound narrative expectations. Video has remained a favoured medium for the artist. Similarly, his work with neon has been a constant and constantly evolving concern, beginning with the disarming spiral *Window or Wall Sign* (1967; Leo Castelli Gallery, New York), which reads 'The true artist helps the world by revealing mystic truths'. Characteristically, this and subsequent neon pieces, such as *My Last Name Exaggerated Fourteen Times Vertically*, evince an exaggerated self-awareness. With such anatomical casts as the punning *From Hand to Mouth* (see Fig. 8) Nauman demonstrated the protean magnitude of his imagination. From 1969 on, he presented recent work regularly at European galleries and museums, and in 1972 the Whitney Museum of American Art and the Los Angeles County Museum of Art co-organized a large retrospective; his influence was thus widely felt almost from the outset.[10]

As a new, inexpensive and flexible medium, video offered these artists a way of recording their activities and of structuring both behaviour and space. Narcissistic self-depictions predominated in the tapes produced by two young Louisiana artists, Lynda Benglis and Keith Sonnier. With their flamboyant sensibilities, they explored the possibilities of 'process' art. Benglis's large-scale poured pigment and latex pieces were deliberate efforts to monumentalize the sacred gesture of 1950s American painting. Studio photographs of her echo shots of Jackson Pollock in action, and it was typical of Benglis that she should have confronted the heroics of Abstract Expressionism. Both wall and floor-bound, her enormous plastic works and their cast metal successors exchanged malleability for arrested fluidity, inventing new configurations of mass. With her later adoption of such materials as beeswax and plaster, Benglis emphasized tactility and finish in a consciously feminist manner, an attitude even more dominant in her many videotapes.

Sonnier, no less experimental with his materials, sought to incorporate the audience in his work, often by physical evocations of a stage-like space. After 1967 his constructions of neon and incandescent light, latex, rags and an additive, synthetic texture called 'flocking', which he mixed with liquid medium, became overtly painterly. Colour seemed more important to him than to most of his fellow sculptors, while his use of both audio and video tape enabled him to create free adaptions of theatrical environments.

The last of the artists to be considered here, Joel Shapiro, is a case study in the weakening of the process ethos after 1970. The tangled nylon filament reliefs of his that were presented in 'Anti-Illusion' at the Whitney Museum were typical of the

9. Quoted in *Richard Serra: Interviews, Etc. 1970–80*, exhibition catalogue, Yonkers, NY, Hudson River Museum, 1980, pp. 10–11.

10. See Jane Livingston and Marcia Tucker, *Bruce Nauman: Works from 1965 to 1972*, exhibition catalogue, Los Angeles County Museum of Art, 1972.

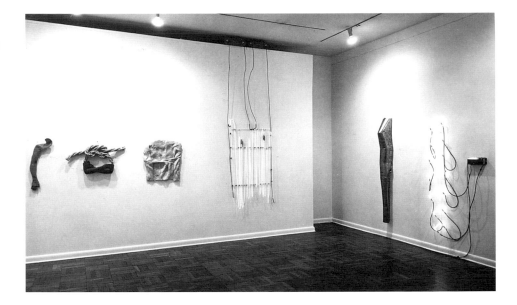

underlying pictorialism evident in much of that exhibition's contents. Shapiro's rapid development, via a sequence of autodidactic, hand-shaped works around 1970, led him to a group of 'signature pieces', including the bird, bridge and coffin shapes that were first shown at New York's Clocktower in 1973. Small in scale (the bird, for example, was roughly two by four by three inches) and simply rendered, these pieces marked a turning away from the generally abstract forms preferred by his peers. These miniatures were harbingers of a new representationalism that was about to manifest itself in the work of such American painters as Elizabeth Murray and Susan Rothenberg, as well as in that of a host of Europeans still unknown in the US at the time. Shapiro's tentativeness hardened – metaphorically and physically – as he began casting simplified 'houses' in 1973. In pursuing such quasi-architectural and, later, figural forms, he embraced subjects that superseded post-Minimalism. The reintroduction of recognizable subject-matter in much painting of the early 1970s was but the opening volley in that medium's successful bid for supremacy over sculpture, and marked a gradual shift in interest that reached its apex ten years later in the worldwide flowering of Neo-Expressionism. In a way that recalled the ossification of Abstract Expressionism in the second half of the 1950s, 'process' art had become all too familiar and lost the potency of genuine spontaneity. Its original practitioners moved on, adapting to the exigencies of careers and to their new roles as established artists. Eva Hesse died in 1970; Robert Smithson was killed in a plane crash three years later. With their loss, 'process' art entered another, secondary phase.

The artistic and social legacy of the late 1960s is rich and far from exhausted. Its most salient feature is the greatly expanded sense of the permissible, which prompted so much of the era's disruption and exhilaration, and which remains capable of unleashing comparable forces today.

John Beardsley

Land Art

Americans live on hallowed ground: consecrated to equality and freedom, and witness, so many have held, to a special covenant between a people and their Creator. 'God has promised us a renowned existence, if we will but deserve it', the writer James Brooks proclaimed in *The Knickerbocker Magazine* in 1835. 'He speaks this promise in the sublimity of Nature. It resounds all along the crags of the Alleghanies. It is uttered in the roar of Niagara.... The august TEMPLE in which we dwell was built for lofty purposes.'[1] Beyond that, the land has been sanctified by sacrifice: steeped in the blood of fratricidal war; etched with the trails of dispossessed Native Americans; and shadowed with the figures of runaway slaves, following the pole star north. The tropes of landscape still resound. They were heard in one of Martin Luther King's most eloquent exhortations, delivered during the 1963 March on Washington, which pressed the cause of equality and justice for all in a racially segregated America: 'Let freedom ring from the prodigious hilltops of New Hamsphire.... Let freedom ring from the snow-capped Rockies of Colorado.... But not only that, let freedom ring from Stone Mountain of Georgia. Let freedom ring from Lookout Mountain of Tennessee. Let freedom ring from every hill and every molehill of Mississippi. From every mountainside, let freedom ring.'

It is little wonder, then, that the landscape has been one of the most vivid and persistent metaphors in American art; and little wonder that, after decades of eclipse, it emerged in the late 1960s and early 1970s as a focus of some of the most compelling American art of the late twentieth century. It was then that artists such as Michael Heizer, Walter De Maria, Robert Smithson, Robert Morris, Christo, Nancy Holt, James Turrell, Charles Simonds, Ana Mendieta and literally dozens of others began making art of the landscape itself, using it both as the source of material and of meaning for their work. With hindsight, it does not seem coincidental that Land Art (or Earth Art, as it is now most commonly known) emerged at the same time as the ecology movement; indeed, notions of environmental stewardship have played an ever-increasing role in recent American culture, as they have in global politics. At the time, however, the motivations for Earth Art were somewhat more parochial: many artists of the late 1960s, joining in a wider revolt against convention, were alienated from the network of museums and galleries with their ties to money and social status. They were also dissatisfied with what they perceived to be the limited concerns of traditional – read formalist – art. As Heizer told it: 'The intrusive, opaque object

1. James Brooks, quoted in Perry Miller, 'Nature and the National Ego', in *Errand into the Wilderness*, New York, 1964 (first published 1956), p. 210.

Figs. 1, 2 Michael Heizer, *Double Negative*, 1969–70. Mormon Mesa, near Overton, Nevada. Photos © Gianfranco Gorgoni

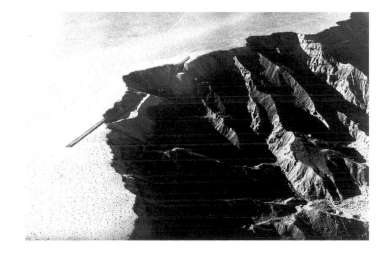

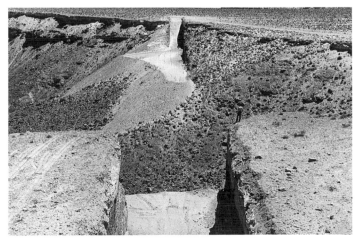

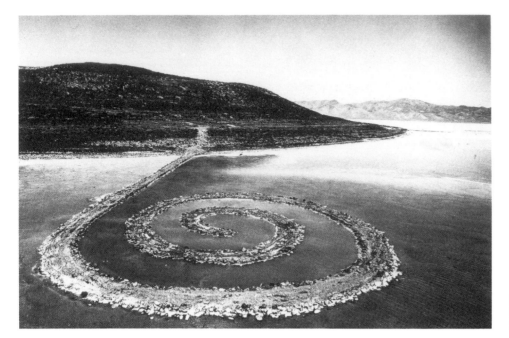

Fig. 3 Robert Smithson, *The Spiral Jetty*, 1970.
Great Salt Lake, Utah. Photo © Gianfranco
Gorgoni

refers to itself....It is rigid and blocks space. It is a target. An incorporative work is aerated, part of the material of its place and refers beyond itself.'[2]

Heizer's 'incorporative' art – which he began making in 1967 and which is most familiar from his *Double Negative* (Figs. 1,2) – would be composed of space itself, carved out of the material of its place. *Double Negative* is formed of two cuts, each thirty feet wide and fifty feet deep; it reaches across a scallop in the escarpment of the Mormon Mesa in southern Nevada and measures over a quarter of a mile in length. It affirmed numerous new possibilities for sculpture: not only is it a form determined by space rather than by surface and volume, an environment rather than a monolith, a horizontal rather than a vertical; but it is also a phenomenon to be experienced in time rather than apprehended in an instant.

Heizer was less successful at having his work refer beyond itself: *Double Negative* is curiously self-contained, a space into which to withdraw in solitary contemplation. Others who followed him into the western deserts were to make more of the connection with place: Walter De Maria, who executed his first landscape work in Heizer's company in the spring of 1968, and Robert Smithson and Nancy Holt, who joined Heizer that summer in Nevada, where he was working on a series of small excavations called *Nine Nevada Depressions*. Smithson's *The Spiral Jetty* (1,500 x 15 feet; Fig. 3), as told by the artist in an essay of the same name, was generated by his reactions to the landscape on the edge of the Great Salt Lake in Utah, where the curving shore is ringed by distant mountains: 'As I looked at the site, it reverberated out to the horizons only to suggest an immobile cyclone....The shore of the lake became the edge of the sun, a boiling curve, an explosion rising into fiery prominence.' If *The Spiral Jetty* was thus a reaction to the macrocosmic landscape, then it was also linked to the microcosmic: the salt crystals that grew on the jetty were formed in the shape of a spiral. 'The Spiral Jetty could be considered one layer within the spiraling crystal lattice, magnified trillions of times', Smithson observed. 'So it is that one ceases to consider art in terms of an "object".'[3]

The references to place at De Maria's *The Lightning Field* (Figs. 4, 5) are likewise multiple. Formed of a grid of 400 stainless steel poles spaced 220 feet apart, *The Lightning Field* stretches out a mile on an east-west axis, and nearly a kilometre on a north-south one, in an isolated area of west-central New Mexico. The poles are arrayed in such a way that their tips form a level plane at an average height of just under twenty-one feet. The allusions at *The Lightning Field* are to measurement and to mapping, especially to the way the bulk of the nation was divided into an orthogonal grid of mile-square sections by the so-called Northwest Ordinance of 1787.

2. Michael Heizer, 'The Art of Michael Heizer', *Artforum*, vol. 8, no. 4, December 1969, p. 37.
3. Robert Smithson, 'The Spiral Jetty', in *The Writings of Robert Smithson*, ed. Nancy Holt, New York, 1979, pp. 111, 112.
4. Walter De Maria, 'The Lightning Field', *Artforum*, vol. 18, no. 8, April 1980, p. 52.
5. Nancy Holt, 'Sun Tunnels', *Artforum*, vol. 15, no. 8, April 1977, p. 36.

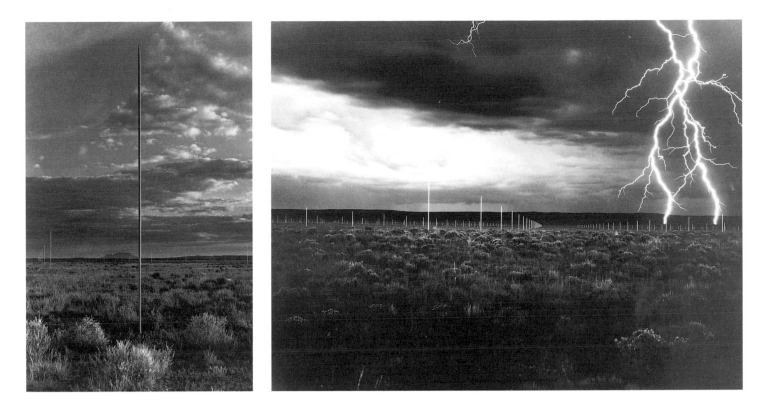

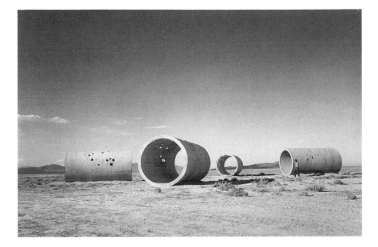

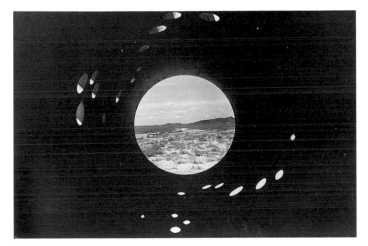

Figs. 4, 5 Walter De Maria, *The Lightning Field*, 1974–77. Near Quemado, New Mexico. © Dia Center for the Arts

Most explicitly, however, De Maria's work makes reference to the awesome power of lightning, which occurs with relative frequency in this high-altitude region of the southwest. As De Maria insists, however, 'the light is as important as the lightning': the piece is a perceptual puzzle, virtually disappearing in the brilliant midday sun and only becoming fully visible in the raking light of dawn and dusk.[4]

Nancy Holt executed her first major work of Land Art during these years. Her *Sun Tunnels* (Figs. 6, 7), four concrete cylinders eighteen feet long and nine feet in diameter, were set out in the Utah desert in the shape of an X, with each cylinder orientated to the position of the rising or the setting sun at the summer or winter solstice. The upper surface of each cylinder is cut with holes in the configurations of various constellations; these star patterns are cast by day on to the lower inside surfaces of the tunnels. 'Day is turned into night, and an inversion of the sky takes place', as Holt nicely tells it. 'Stars are cast down to earth, spots of warmth in cool tunnels.'[5] While *Sun Tunnels* might thus be seen as an exercise in astronomical orientation, it also functions as something of an earthly camera, framing views into a disturbingly vast landscape.

James Turrell, an artist known for manipulating light in such a way that it becomes almost palpable (see Cat. 224), is also intent upon framing views – in his case, into

Figs. 6, 7 Nancy Holt, *Sun Tunnels*, 1973–76. Near Lucin, Utah

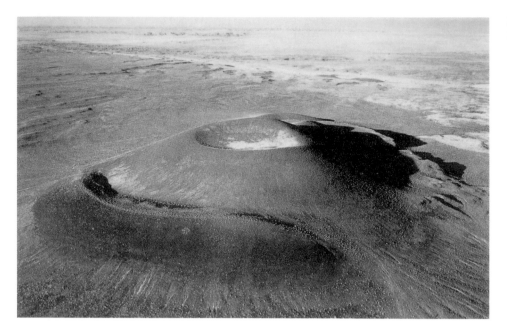

Fig. 8 James Turrell, *Roden Crater Project*, begun 1974. San Francisco Peaks, near Flagstaff, Arizona

infinity. Turrell began work in the mid-1970s on an undertaking known as the *Roden Crater Project* (Fig. 8), so ambitious and so expensive that it is as yet unfinished. In and around the tawny-red cinder cone of a dormant volcano in northern Arizona he is fashioning a series of spaces that will function as observatories for various celestial lighting events: the yearly, northernmost rising of the sun, for example, or the southernmost rising of the moon, which occurs just over every eighteen-and-a-half years. The main incident will be the experience of a phenomenon known as celestial vaulting: from the bottom of the interior of the cone one will look up beyond the perfectly recontoured, elliptical rim of the volcano to see the sky like an arcing roof, composed of light but implausibly solid.

Although grand, Turrell's work should fit with some subtlety into its environment; it may thus escape the criticism that has been levelled at other monumental interventions in the landscape. By the mid-1970s the critique of Earth Art was increasingly being framed in ecological terms, with Heizer taking the most serious blows. A writer in *Artforum* complained of *Double Negative* that 'it proceeds by marring the very land, which is what we have just learned to stop doing'; another critic, referring to Heizer's

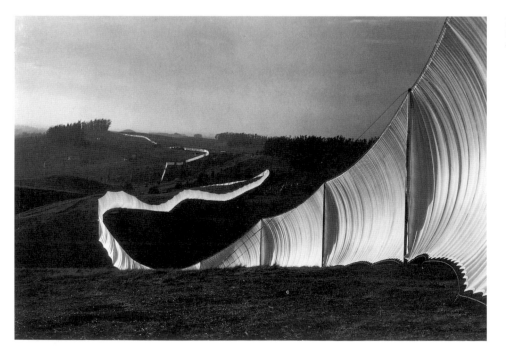

Fig. 9 Christo, *Running Fence, Sonoma and Marin Counties, California*, 1972–76 (removed after two weeks)

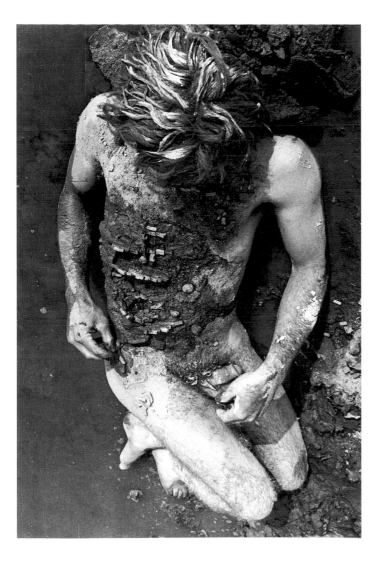

Fig. 10 Charles Simonds,
Landscape↔Body↔Dwelling, 1970

Fig. 11 Ana Mendieta, *Untitled* (*Fetish* series),
1977; Old Man's Creek, Iowa City. Photograph,
Collection of Raquel Mendieta

6. Joseph Masheck, 'The Panama Canal and
Some Other Works of Work', *Artforum*, vol. 9,
no. 9, May 1971, p. 41; Michael Auping,
'Michael Heizer: The Ecology and Economics
of "Earth Art"', *Artweek*, vol. 8, 18 June 1977,
p. 1.

7. See Alfred Frankenstein, 'Christo's "Fence":
Beauty or Betrayal?', *Art in America*, vol. 64,
no. 6, November/December 1976, pp. 58–61.

work in *Artweek*, insisted that 'earth art, with very few exceptions, not only doesn't improve upon its natural environment, it destroys it'.[6] By then, in a spirit akin to this criticism, alternatives to the monumental western works of Land Art had already emerged, both in Europe and in the United States. In Europe the countervailing sensibility was typified by the work of Richard Long and Hamish Fulton; in the United States by such artists as Dennis Oppenheim, Michael Singer and Alan Sonfist. In the late 1960s Oppenheim opted for impermanent projects – drawings in snow or wheat – while Singer made permanent but very modest works in wood and stone and Sonfist worked with growing plants. Christo, meanwhile, continued his series, begun in 1961, of flamboyant, theatrical projects, such as the 24-mile-long, 18-foot-high *Running Fence* (Fig. 9), which, though temporary, elicited criticism on the grounds that it disrupted an ecologically sensitive stretch of California coastline.[7]

Among the most abiding images of the less monumental sort from the 1970s were those that explored the connection between body and landscape. Artists such as Charles Simonds and Ana Mendieta, from very different points of view, managed to convey an awareness of landscape as a system we inhabit, rather than as a surface upon which we act. In 1970, in a private ritual called *Birth*, Simonds buried himself in a clay pit in New Jersey and was filmed enacting his metaphorical creation from the earth. He followed this with a series called *Landscape↔Body↔Dwelling* (Fig. 10), in which he lay naked in the clay, fashioned a landscape upon himself, then constructed upon that the dwellings of an imaginary civilization of little people. Simonds was suggesting not only comparisons between the body and earth, but between body/earth and architecture as well: all are different forms of dwellings. He developed a language of architecture by natural analogy, in which forms emerged like growing plants, then faulted

and crumbled like earth. At the same time, his landscapes – replete with sexual characteristics – were like flesh that withered and cracked with age. The little people subsequently left the body of their creator and appeared on the walls of buildings in inner cities around the world, a potent reminder of the alienation of most urban dwellers from natural cycles and systems.

Ana Mendieta's work had at once a more personal and a more political cast to it. In a series of temporary, ritualistic pieces from the middle of the 1970s variously titled *Fetish* (see Fig. 11), *Tree of Life* or *Silhouette*, she inscribed the life-size image of her own body on the ground. Sometimes it was built out of mud, sometimes etched in rock, sometimes delineated in gunpowder and set on fire; all these pieces survive only as photographs. There is a sense of longing in these works: Mendieta was sent alone at the age of thirteen from Cuba to the United States, where she was brought up in orphanages and foster homes in Iowa. Some of the first of these sculptures were executed on tree trunks and river-banks in Iowa, as if to assuage her feelings of exile. At the same time, there is a feeling of anger to them: variously scorched, pierced with sticks or spattered with blood, they seem to decry the violence done to women and to the landscape, while provoking meditation on numerous typically hierarchical oppositions – male and female, mind and body, culture and nature.

In some important ways the dichotomy between the monumental works of Earth Art and the more restrained, ecologically determined works is a false one: there is much common ground. Smithson, for example, came to see his work as 'a resource that mediates between the ecologist and the industrialist', and proposed, just before his death in 1973, several projects that would use art to reclaim surface mines in Ohio and Colorado.[8] Heizer was recently involved in such a project, incorporating five *Effigy Tumuli Sculptures* – the huge abstracted shapes of a frog, a water-strider, a snake, a turtle and a catfish – into the reclamation of a two-hundred-acre surface coal mine in Illinois. Regardless of the ecological stance of the various artists, Earth Art has helped define landscape as one of the chief cultural battlegrounds of our time, in which we are beginning to address the future health of our species and our planet, while still struggling to enact the promises of the past.

8. Smithson, op. cit., 'Untitled, 1971', p. 220.

Wolfgang Max Faust

Shattered Orthodoxy:
The Energy of Transformation

Fig. 1 Philip Guston, *Talking*, 1979.
Edward R. Broida Trust, Los Angeles

Fig. 2 Jonathan Borofsky, *Running Man*, 1982.
Painted on the Berlin Wall on the occasion of the
exhibition 'Zeitgeist' at the Martin-Gropius-Bau,
Berlin

Fig. 3 Julian Schnabel, *Olatz mira*, 1991.
Pace Gallery, New York

At present, with the twentieth century drawing to a close and a new millenium about to dawn, the very idea of 'national' art appears mildly absurd. Modern economic conditions and the technical possibilities offered by the mass media have long since created a global civilization in which the national is accorded – at best – a peripheral status.

Nevertheless, the present is marked by catastrophes arising from national, ethnic and religious conflict. These are signs of the panic which typically emerges in times of radical change and innovation. Before the new can institute its own set of stable conventions, long-established patterns of thought and behaviour which oppose the dynamic of change are given a fresh, radical emphasis. There are, however, two aspects to this. The past is endowed with an illusory grandeur, but at the same time those elements are revealed within it which engendered the new and will continue to do so in future.

We are currently living at a historical watershed, in a state where the new has not yet emerged but the old no longer holds good – ours is an age of transition in which the parameters of the future are perceptible only as dim outlines. That the new will suddenly reveal itself at a single dramatic stroke is a vain hope. History does not merely happen: it is made by men and women. It is a process involving conflicting fields of force, with points of condensation and concentration, moments of regression and moments of transformation. A part of the new element infiltrating into the making of history consists in the disturbing realization that the future can only be planned in bare outline. The more detailed our blueprints and predictions for the future are, the wider they fall of the mark. Historical projections have to be open, leaving space for the unpredictable, for things that shape themselves of their own accord. This means that the present is not to be taken as a given fact but seen, instead, as a dynamic whole whose primary quality is energy. It is only by looking at the present from this angle that we are able to discern its contradictions and conflicts, its retrospective and prospective elements, its moments of conservation and transformation. This calls for an open form of thinking that does not seek to preserve the status quo but willingly accepts insecurity – placing its trust in the configuration of the quest.

An interpretation of American art since the end of the 1970s as a field of energy throws all the parameters of this subject into sharp relief. 'American' art, here, means the art of the USA, and this fact has historical, political and cultural implications that are closely connected with the issues of nationality and power. The simplifying label 'American' refers back to a traditional self-image based on a loose geographical concept that was redefined by narrowing it down into national terms. Underlying this there is a hankering for identity which is rooted in the modern Western tradition of thinking in the categories shaped by the nation-state. In the USA this concept was burdened from the outset with irreconcilable internal contradictions. The USA is a European invention, created through the displacement of Europe's geopolitical dominion. Identity could only develop via negation. Whereas in Europe the relative congruence of geographical configuration, ethnic distribution and national boundaries could be taken for granted, the USA had to manufacture a sense of nationhood and justify it in missionary terms. The attempted extermination of the Indians and the brutal denial of their rights form the background on which this desire for identity inscribes itself. As every remnant of contact with the aboriginal population was severed, the quest for identity created a *tabula rasa*, the illusion of an entirely new beginning, the dream of innocence in the midst of guilt. Thus, the visions of paradise

that continue to surface in American society are not only designs for the future; they are also directed towards the past, which they strive to repress. The identity of the USA evolved, in relation to the nation's history, by thinking in the subjunctive terms of the phrase 'as if' : 'as if' the region had had no history of its own before the Europeans conquered it, 'as if' this were a divinely ordained path to world salvation, 'as if' the new nation were the true chosen people. In this view of history two perspectives converge: the one referring to a geographical space and its historical prefiguration (the country itself, as the 'ground' of the USA), and the other to an imaginary space, the severing of the umbilical cord linking America with Europe. Identity via negation is based on the fantasy of otherness. One of the convictions fundamental to US culture is the notion that Europe rediscovered itself through contact with an alien world, thereby forging a new identity and leaving the past behind.

This also applies to 'American' art. The pathos of independence that it continually parades is closely connected with the yearning for identity, in the latent awareness that all its paradigms derive from European tradition. Its singularity consists, rather, in its capacity for assimilation and transformation, in curiosity and open-mindedness, in the experimental redrawing of the parameters defined by Europe and, to a lesser extent, by 'world art'. If one wishes to probe further, refusing to content oneself with identifying variants, extensions and reinterpretations, one has to seek out the meta- and substructures of American art, the specific element in which the radicalization of European attitudes generates a new kind of energy. There are numerous aspects to which one might point: the experiences of space, of the frontier, of unity in diversity; the national sense of missionary purpose; the periodic disillusionment induced by the failure of the American dream. Although this essay singles out the element of 'as-if-ness' in American art, this is intrinsically bound up with the other aspects: it constitutes the very basis of America's identity. By accepting the condition of 'as-ifness', identity departs from the 'nature' by which tradition sets such store, and takes on an artificial character, as a complex tissue of desires and longings which is essentially dynamic rather than fixed.

Looking at American art from this angle, it is possible to identify a number of significant characteristics that diverge from the European model. In an endless series of variations on the same theme, American art has called attention to the artificiality of art, to the fabricated character of its products, to the significance bestowed on the work of art by the context in which it appears. Artists themselves are regarded as human 'makers' rather than natural 'creators': there is an emphasis on craftsmanship, on the actual process of execution, which is seen as having its own specific dignity. The fact of 'making' is inscribed directly in the work, as a meaning in its own right. The greatness of American art consists in its facility for making things visible. Striving for immediate effect, it forces meaning to surface and reveal itself.

The reasons for this lie in American society. American artists have to cater for a relatively mixed audience whose constituent sections have their own traditions of perception. In order to address the public as a whole, the artist has to step outside the framework of expectations shaped by conditions in Europe, where the art world is comparatively homogeneous. As well as the question of how the work is perceived, there is also the issue of the socio-economic conditions under which it is produced. To a greater extent than in Europe, art in the USA has always been bound up with commerce. The work of art is a commodity that is expected to prove its worth in the market-place. Commercial success not only confers economic status; it is also a sign of cultural legitimation.

The international art scene of the 1980s and 1990s is characterized by the interplay of conflicting – European and American – mentalities. At the end of the 1970s Minimalism and Conceptualism, the innovative movements of the previous two decades, were largely played out. Especially in the USA art was in the doldrums and showing definite signs of lethargy. However, the vacuum was promptly filled by new trends in European painting, whose impact was tremendous. The return to painting began in Italy, with artists such as Sandro Chia, Francesco Clemente, Enzo Cucchi and Mimmo Paladino, who were followed by a large group, spanning two generations, of

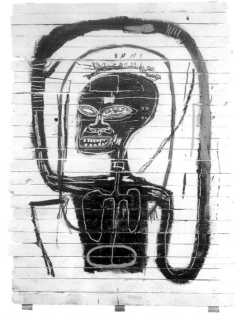

Fig. 4 Jean-Michel Basquiat, *Flexible*, 1984.
Estate of Jean-Michel Basquiat

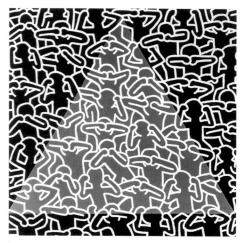

Fig. 5 Keith Haring, *Silence = Death*, 1989.
Private collection

Fig. 6 Robert Gober, *Untitled, Candle*, 1991.
Paula Cooper Gallery, New York



Fig. 7 Jeff Koons, *Saint John the Baptist*, 1988. Collection of the artist

Fig. 8 David Hammons, *Cold Shoulders*, 1990. Jack Tilton Gallery, New York

Fig. 9 Mike Kelley, *Almost White*, 1990. Galerie Jablonka, Cologne

West German painters, including Sigmar Polke, Gerhard Richter, Georg Baselitz, Anselm Kiefer, Markus Lüpertz, Jörg Immendorf, A. R. Penck, Walter Dahn, Georg Jiri Dokoupil, Rainer Fetting and Salomé. Both these European movements were eagerly hailed in the USA, where their sensational success, coupled with the general financial euphoria of the Reagan era, led the art market to boom: the link between art and commerce grew closer than ever before. With the work of Philip Guston, Jonathan Borofsky, David Salle, Julian Schnabel, Jean-Michel Basquiat and Keith Haring (see Figs. 1–5), the American school of 'New Image' painting followed a similar pattern, adding a certain national touch but refusing to deny its European origins. These new developments in art were promoted with the aid of industrial marketing strategies, using public relations techniques to present artists as 'stars'. Based as it was on the reinterpretation of tradition – re-establishing a medium formerly regarded as dead and taking its bearings from the conventions of Expressionism – the New Figuration served as the model for a concept of art that was no longer directed towards innovation in the traditional avant-garde sense. The idea of linear progress, as a continual path of discovery, was replaced by an emphasis on reshaping the past, as seen in the various 'neo', 'retro', 'appropriation' and 'recycling' approaches.

Within the framework defined by post-avant-garde and post-modern attitudes, a situation therefore arose which allowed artists to exploit the entire range of modernist inventions for their own ends, in order to make an immediate contemporary statement. In response to the pre-eminence of Europe in painting, American art began to develop forms of its own, combining the appropriation of history with specifically American characteristics. Object art, rather than painting, became the dominant medium, highlighting the manufactured quality of art and its proximity to the world of commodities. A disparate assortment of historical traditions – ranging from Marcel Duchamp's ready-mades (see Cat. 19–23) and Surrealist assemblages to the aesthetics of Andy Warhol (Cat. 183–9) and the work of Joseph Cornell (Cat. 64–71) – was brought together and blended. At the same time, ideas shaped by the experience of the 1960s and 1970s were taken up again and re-explored. With the realization that the significance of the work of art derives from the context in which it stands, it became necessary to see the strategies employed in selling art, in positioning it on the market, as an integral part of the work itself.

The illusory boom created by Ronald Reagan in the early 1980s was followed in the latter part of the decade by political decline and economic slump, which dramatically accelerated the breakup of American society. Spectacular events in foreign policy, such as the Gulf War set in train by George Bush, were no more than interim disguises for inner weakness: the fictional character of such displays of greatness was all too evident. The continual talk of a new 'world order', to be set up and administered by the USA, was pure fantasy. Even the upheavals in eastern Europe and the breakup of the Soviet bloc failed to stimulate the forces that might have brought about a regeneration of the USA. With figures such as Robert Gober and Jeff Koons (see Figs. 6, 7), American art of the early 1980s had focused on 'internal' issues, looking at the relationship between the work of art and the world of consumer capitalism and investigating the appropriation and reworking of tradition. Under the pressure of circumstances, however, there has latterly been a renewal of emphasis on the political and social implications of art: David Hammons and Mike Kelley (see Figs. 8, 9) are two of the names that spring to mind. The collapse of the art market means that economic success can no longer serve as a yardstick of artistic value. Nowadays, the way to succeed is by systematically resisting success. It would be impossible, however, to recreate the state of innocence towards which contemporary art aspires. There is no going back on the experience accumulated in and through art over the last two decades.

At present, it is difficult to say exactly what constitutes the energies fuelling the art of the 1980s and 1990s. To identify those energies more clearly, one has to abandon the internal viewpoint of the art world and turn to society as a whole. Here, one finds a series of paradoxes. In the 1980s art was hugely successful, adapting itself to fit in with social and economic strategies and commanding an enormous amount of atten-

tion as a social phenomenon. Yet instead of ensuring the preservation of art, these signs of success were harbingers of its extinction. The canons of modernism are exhausted: all that remains of them in the various reworkings of tradition is their outermost shell. In its newly revised form, art is virtually incapable of speaking in utopian terms; at most, it is 'atopian', scattering its potential in the present. For the art of today, modernity is a thing of the past. An era is drawing to its close. Repetition, appropriation, variation: these ideas suggest that the traditional verities are still flourishing, but their legitimacy appears more problematical than ever before. The question now is no longer how to make art, but whether it should be made at all, at least in the form familiar to us since the emergence of modernism. It is not enough to say that works of art still exist and artists still carry on working. These days, the age-old problem 'Why bother with art?' is no longer a rhetorical question that has already been answered before it is even posed; instead, the veil is being lifted from its radical implications as a question of fundamental principle.

Fig. 10 Jenny Holzer, Installation from the series 'Truisms', Times Square, New York, 1982

The mixture of opulence and misery which passes for democracy in the prosperous societies of Europe and North America, the massacres in the former states of Yugoslavia and the USSR, the pauperization of the Third World and the ecological catastrophe facing the world as a whole – all these things add up to a global crisis that cannot be resolved by conventional means: the established categories of action and thought are inadequate to cope with it. The crisis has such an immediate, tangible quality that nothing – not even art – can blot it out. Seen as a social phenomenon in which certain forms of experience are inscribed, art has to relate to the things that enable it to maintain its presence in society. The greatness of modernist art consisted in its energy as – to quote Theodor W. Adorno – 'a social antithesis to society'. Art was a form of ersatz authenticity, a surface on to which the failures of the inert 'unlived' life could be projected. With the end of modernism, the fictitious character of art has become so obvious that the insistence on maintaining the pretence is anachronistic and wholly inappropriate. Drained of the energy supplied by tradition, art has been reduced to a set of bare functions, a commodity neatly integrated into the commercial strategies devised by the sponsors, the PR managers of local and national authorities and the entertainment industry. The ritual invocation of its original impetus is no more than a game. Even critics and art historians present modern art – and contemporary art, too – in 'as-if' terms, 'as if' modernism still existed. Thus, it becomes an empty phrase, an ornamental fiction which attempts to shore up the status quo.

Fig. 11 Cindy Sherman, *No. 225*, 1990; from the series 'History Portraits'. Monika Sprüth Galerie, Cologne

Since the early 1980s art has finally broken loose from the ideas that shaped modernism. The orthodoxies of the modern have been shattered. By embracing the doctrine 'anything goes', seen as a message with a positive emphasis, art has gained a new freedom. However, since it merely dissipates the past, this freedom remains tied to tradition. Up to now there has been no evidence of an impending quantum leap which would bring about a radical change. Art continues to shuffle around on the same old paths that link it to the prevailing system. The question 'Why bother with art?' is still being steadfastly evaded.

However, this question is now integral to art. Its explosive potential as an underlying theme has been revealed, above all, by American art, whose characteristic features – the emphasis on 'making', on fabrication and artificiality – have introduced the stimuli that are necessary if contemporary art is to transcend 'art' in the guise familiar to us since the inception of modernism. The idea of art as pure artifice is directly connected with the habit of thinking in 'as-if' terms, which is a constitutive element in the identity of the USA. On this basis, art acquires the status of a possibility rather than a 'natural' fact; thus, its continued existence in the future is by no means assured. The issue now is whether art itself is remotely capable of engendering anything new. With the global networking of every domain of experience, this appears increasingly improbable. That is why artists have been searching for new areas of reference: politics and communication in the case of Jenny Holzer (see Fig. 10), eroticism and the body with Cindy Sherman (Fig. 11), and, for Gary Hill and Bill Viola (Figs. 12, 13), reality and the media.

Fig. 12 Gary Hill, Still from the video *Incidence of Catastrophe*, 1987–88

Fig. 13 Bill Viola, *Heaven and Earth*, 1992.
Donald Young Gallery, Seattle

Today, the real focus of art lies in reception. Its significance is determined by the ways in which it is perceived, experienced and appropriated. The artist and the viewer are equal partners. What we are currently witnessing is the liberation of the beholder and, with it, the end of Joseph Beuys's dream of transforming society through art and the artist. Instead, the artist is merely one among many participants in the enterprise of building the future. This is a challenge he has to accept if he is to avoid being left behind. Looking at society as a whole, the impression is beginning to emerge – now that the orthodoxies of modernism have collapsed – that the former avant-gardes have long since become *derrière-gardes*.

A new art which seriously engages with our present age of transition can only develop through dialogue, by interacting with everyday life, with science, with politics and the mass media. The terms on which this dialogue might be conducted were set out by the poet Novalis at the beginning of the nineteenth century, when he wrote: 'Becoming human is an art in itself.'

Donald Kuspit

Critics, Primary and Secondary

> Instead of seeking to forge new cults of believers, criticism might dedicate itself to bringing into being a consciousness of those factors of experience that are related to style – for example, the liberation of individuals from dead forms in expression and social behaviour.
>
> Harold Rosenberg, 'Spectators and Recruiters'[1]

Fig. 1 Clement Greenberg.
Photo © Hans Namuth

Fig. 2 Harold Rosenberg

It may be heresy to suggest that Clement Greenberg (Fig. 1) and Harold Rosenberg (Fig. 2) have something in common, but in fact they share the same conception of the Abstract Expressionist artist. For both, he is the tragic Jew of American art, establishing a complex cosmopolitan identity in an aesthetically simple-minded, provincial society. Everything in their criticism follows from this view of the authentic American artist – or 'Coonskinner', as Rosenberg wittily called him[2] – as suffering the same problems of identity and adaptation as the Jew, who is always regarded as an outsider or stranger wherever he lives. This idea of the artist's fundamentally alienated place in America, and of America's inherent suspicion of the 'misfit' artist (however much it may officially sanction creativity), is implicit in Greenberg's 1965 essay 'Kafka's Jewishness' and explicit in Rosenberg's 1966 essay 'Is There a Jewish Art?'

No doubt the idea of the artist's insecure place in a hostile America seems dated. It may have served to acknowledge the resentment and resistance Abstract Expressionism encountered before being appropriated by American society as a 'triumph' that proved America's greatness.[3] But even as socially and economically successful an artist as David Salle declares that 'to be a serious artist in America is always to be marginal and alienated'.[4] And US Senator Jesse Helms's persecution of Andreas Serrano and Robert Mapplethorpe suggests that the public understanding of serious art has not changed much since Congressman George Dondero's day.[5]

According to Greenberg and Rosenberg, American society tests the serious artist by promising to reward him for becoming less serious. America makes it difficult to create an art of aesthetic depth – let alone of profound human insight – by suggesting that there is a socially more appropriate, shallow path. Thus, for Rosenberg, the American artist always faces a choice between being a True or a False Self.[6] For Greenberg, it is between being an avant-garde or a kitsch artist.[7] The essence of the choice is the same: to maintain one's sacred integrity or comply with society's profane demands. The American artist is always in a Jewish situation, trapped between autonomy and assimilation. (In conceptualizing the avant-garde American artist as a Jew, Rosenberg and Greenberg put into positive use an idea that supposedly negates him or her, which demonstrates their intellectual sophistication. They in effect stand the Nazi cliché of avant-garde art as a 'Jewish-Bolshevik' conspiracy on its head: the defamatory charge of 'Jewish revolution' becomes the basis for its fame. As always, the best way to disarm an enemy is to embrace him dialectically.)

Neither the movements that followed Abstract Expressionism in negative reaction to it, nor the critics who followed Greenberg and Rosenberg in negative reaction to them, questioned their sense of the fundamental dilemma that the serious American artist faced: to endorse American society, however ironically (as Pop Art did); or to withdraw from it into a new fundamentalism, whether involving a return to the basics of art or of nature (often a combination of both, as in the convergence of Minimalism and Earth Art). It was only a matter of which side the post-Greenberg/Rosenberg critics favoured, and how they reinterpreted that side to show it in the best intellectual light: the alienated True Self avant-garde side, celebrated by Greenberg's dis-

ciples Michael Fried and Rosalind Krauss, in whatever attenuated form; and the 'with it' False Self kitsch side, welcomed by Lawrence Alloway and Lucy Lippard in very different ways. These critics buttressed their beliefs by fleshing them out with new ideas that, though perhaps more trendy than those of Rosenberg and Greenberg, were not basically different.

Rosenberg writes:

> In the chaos of the 20th century, the metaphysical theme of identity has entered into art, and most strongly since the war. It is from this point that the activity of Jewish artists has risen to a new level. Instead of continuing in the masquerade of conforming to the model of the American painter by acquiring the mannerisms of European art, American Jewish artists, together with artists of other immigrant backgrounds – Dutchmen, Armenians, Italians, Greeks – began to assert their individual relation to art in an independent and personal way. Artists such as Rothko, Newman, Gottlieb, Nevelson, Guston, Lassaw, Rivers, Steinberg, and many others helped to inaugurate a genuine American art by creating as individuals.[8]

For Rosenberg, 'the most serious theme in Jewish life is the problem of identity'.[9] Abstract Expressionism was also 'inspired by the will to identity…the aesthetics of self'.[10] It 'enacted' a sense of unique identity through a 'specific encounter' with an unprecedented 'situation'.[11] Similarly, immigrant Jews had to enact their uniqueness in order to maintain faith in themselves. Indeed, for Rosenberg, Abstract Expressionism was not only a peculiarly Jewish achievement, but also the art of immigrants.

Arshile Gorky, about whom Rosenberg wrote so movingly, was an immigrant from Armenia, and Willem de Kooning, to whom Rosenberg had the most sustained commitment, was an immigrant from Holland. Jackson Pollock was also an immigrant – from Wyoming. They all came to New York City, an essentially immigrant city (and still one), and faced the immigrant problem of having 'to begin anew'.[12] They were all strangers in the strange land of avant-garde art as well. It had immigrated to New York to escape Nazi persecution and devaluation. Theirs was a double encounter: with a new kind of world and a new kind of art. As Rosenberg points out, neither the immigrant artists nor the immigrant art found it easy to start anew in New York. Not only was it simpler to imitate the old, as the Dutch did in 'New' Amsterdam and the Pilgrims in 'New' England, but, having achieved some measure of genuine newness, it was simpler 'to settle into a self-repeating [and self-congratulatory] pattern', as Rosenberg thinks happened with so many Abstract Expressionists, who complacently began to manufacture so-called signature art.[13] Nevertheless, in Abstract Expressionism's heyday the synergistic interaction of the chaotic monumentality of New York and the imported Tradition of the New was remarkably catalytic. Correlatively – and no doubt ironically, considering that it was an immigrant achievement – Abstract Expressionism came to symbolize the energetic, authentically American self, as the 1958–59 Museum of Modern Art show 'The New American Painting', exported to Europe, indicated. This was all the more peculiar in that Abstract Expressionist painting was 'un-American' in its rejection of Regionalist, American Scene painting, with its overt social interest, and of American popular culture, with its facile reification of the life-world and general lack of expressive depth. Both were illustrational, making them especially irrelevant.

In general, the 'massive trajectories which speed across the canvas field', as in Franz Kline's paintings, not only 'captured the [disruptive] energy of the urban experience',[14] but expressed the ruptured psyche of the immigrant artist. The conflict-ridden city and the emotional conflicts of the artists correlate abstractly in their art. Abstract Expressionist gestures are simultaneously mnemonic traces of the Jewish dilemma and of the puzzling dynamics of New York. Ambiguously compulsive and spontaneous, the gestures reflect the dynamic new American situation alongside the artist's resistance to it. Thus, through one and the same gesture, Abstract Expressionist painting at its best conveys a sense of separate identity and apparent assimilation – a cosmopolitan Jewish achievement. It signifies irreconcilability and adversarial individualism, but also a certain communal spirit.

1. Harold Rosenberg, *Discovering the Present*, Chicago, 1973, p. 132.
2. Harold Rosenberg, *Tradition of the New*, New York, 1965, pp. 13–22. Rosenberg distinguishes between 'Redcoat' artists in stylistic uniforms and 'Coonskinner' artists making a 'non-style' or 'nonlook' in response to a specific situation. Ironically, the original non-style inevitably becomes codified as a habitual style.
3. I am alluding to Irving Sandler's *The Triumph of American Art: A History of Abstract Expressionism*, New York, 1970, and Serge Guilbaut's account of *How New York Stole the Idea of Modern Art: Abstract Expressionism, Freedom, and the Cold War*, Chicago, 1983, as well as to Max Kozloff's 'American Painting during the Cold War', *Artforum*, vol. 13, no. 9, 1973, pp. 43–54.
4. Quoted in Dodie Kazanjian, 'Salle Days', *Vogue*, vol. 182, no. 5, May 1992, p. 303.
5. See Herschel B. Chipp, ed., *Theories of Modern Art*, Berkeley, 1968, pp. 496–7, for excerpts from Dondero's speech on 16 August 1949 in the United States House of Representatives about the 'horde of germ-carrying art vermin' who had been 'let into our homeland … to aid in the destruction of our standards and traditions.'
6. Rosenberg's distinction between the pioneer and the conformist artist is essentially that which D. W. Winnicott makes between the True and the False Self. In 'Ego Distortion in Terms of True and False Self', in his *The Maturational Processes and the Facilitating Environment*, New York, 1965, p. 146, Winnicott associates the True Self with 'the spontaneous gesture and the personal idea'. In contrast, 'the False Self results in feeling unreal or in a sense of futility'. Where the True Self brings together experiences of aliveness, the False Self represents 'the whole organization of the polite and mannered social attitude' (p. 143). The split, yet ironical relationship between the two haunts modern art. In American art it is represented by the irreconcilability of Jackson Pollock and Andy Warhol.
7. The difference between avant-garde and kitsch as well as between Redcoat and Coonskinner art is the difference between the True and the False Self. As Greenberg, *Art and Culture*, Boston, 1965, pp. 14–15, writes, where avant-garde works through vital 'plastic values' that make the work 'breathe', kitsch works by creating an effect of social identification.
8. Rosenberg, 1973, pp. 230–1.
9. Ibid., p. 230.
10. Ibid., p. 231.
11. Rosenberg, 1965, p. 19.
12. Ibid., p. 17.
13. Ibid., p. 18.
14. Barbara Rose, *American Art Since 1900*, New York, 1967, p. 204.

Greenberg's emphasis on aesthetic purity and the critical character of immanent form[15] seems remote from Rosenberg's argument that 'act-painting is of the same metaphysical substance as the artist's existence'.[16] However, immanent form also entails immanent identity for Greenberg, as his discussion of Kafka – the exemplary modern artist for him – indicates. The Jew Kafka has the same identity dilemma – the same existential uncertainty and critical relationship to both art and life – as the American Coonskinner. The dilemma underlines the difference between sacred avant-garde abstract art and profane rear-guard representational kitsch art. Indeed, 'Kafka's Jewishness' supplies the theoretical underpinning of the practice advocated in 'Avant-garde and Kitsch'. They are the alpha and omega of his criticism, whatever the order of their writing.

> Kafka wanted more than anything else to be an artist, a writer of fiction not of oracles.... But might not all art ... begin to appear falsifying to the Jew who looked closely enough? And when did a Jew ever come to terms with art without falsifying himself somehow? Does not art always make one forget what is literally happening to oneself as a certain person in a certain world? And might not the investigation of what is literally happening to oneself remain the most human, therefore, the most serious... of all possible activities? Kafka's Jewish self asks this question, and in asking it, tests the limits of art.[17]

Kafka's conflict bespeaks the contradiction at the heart of modern art. On the one hand, it transcends life by its tendency to purity and abstractness. It emphasizes the 'discontinuity between art and life'.[18] On the other hand, this same abstractness serves the self by encapsulating the unconscious dominant feeling, or *Zeitgeist*, of a life-world, freeing us from it by bringing it to aesthetic consciousness. 'The genuine artist starts from a personal, particular experience' of a certain world,[19] but invents valid 'abstract equivalents' for that experience.[20] Fernand Léger did this when he conveyed the 'mood of secular optimism' with which the twentieth century opened,[21] and so did the Abstract Expressionists when they made daringly explicit the 'existential pessimism' that underlay American existence.[22] Greenberg cuts Kafka's Gordian knot by arguing that art's self-critical 'reduction' of form is simultaneously a critical reduction of the self to its emotional fundament. 'Dissolving emotion into the abstract elements of style'[23] does not falsify experience, but shows that art alone is true to what is most immanent – deepest – in the world in which it occurs. As Greenberg says, 'extremes meet': a 'radically transcendental' approach to art and a 'radically positivist' approach to life can dialectically converge.[24] Art 'removed from history, behind the "fence" of abstraction, can indirectly acknowledge – which does not mean become completely reconciled to – profane history' without losing its sacredness.[25]

Fried seems to advocate a similarly ultra-radical art, reconciling the sacred and profane. But the opposition he posits between art and theatre separates what Greenberg subtly unites through emotion. For Fried, 'presentness is grace', but the sacred 'presentness and instantaneousness' of modernist style 'defeat theater'[26] rather than bespeak, however covertly, the emotion generated by it. Labelling works that 'establish ... a *theatrical* relation to the beholder' as 'ingratiating and mediocre'[27] – he seems to have Robert Morris and Tony Smith most in mind[28] – he celebrates 'the paintings of Louis, Noland, Olitski, and Stella, and the sculptures of Smith and Caro' as 'in essence *anti*-theatrical, which is to say that they treated the beholder as if he were not there'.[29] But for Greenberg, in contrast to Fried, such art – however 're-strained'[30] – must be true to feeling, and this would make it subliminally theatrical. It invites the spectator to project his feelings into it, or, as we say, evokes them, thus making him, to his own surprise, true to himself.[31] A 'theatrical' effect is only superficially the result of the work's seeming to invite the spectator to enter it literally. More crucially, it results from the subliminal emotional relationship established between the spectator and the work. What Fried calls theatrical art makes this relationship explicit. Fried does not address the issue of the different ways in which theatrical and anti-theatrical art are true to feeling – indeed, of truth to feeling in general. In any case, he de-dialectizes what Greenberg dialectizes, suggesting that his analysis of 1960s art in terms of the theatrical and anti-theatrical is inadequate.

15. Greenberg, 'Modernist Painting', in Gregory Battcock, ed., *The New Art*, New York, 1966, p. 101.
16. Rosenberg, 1965, p. 28.
17. Greenberg, 1965, p. 273.
18. Ibid., p. 14.
19. Greenberg, 'Koestler's New Novel', *Partisan Review*, vol. 13, November/December 1946, p. 580.
20. Rose, op.cit., p. 204.
21. Greenberg, 1965, p. 97.
22. 'Positivism, materialism, when they become pessimistic, usually turn into hedonism', as in post-First World War Paris, writes Greenberg (1965), p. 121. But in post-Second World War New York they turned into seemingly 'ungoverned spontaneity and haphazard effects' (p. 210), which can be read as signs of revolt.
23. Greenberg, 'Art', *Nation*, no. 164, 8 March 1947, p. 284.
24. Greenberg, 1965, p. 170. See also Donald Kuspit, *Clement Greenberg, Art Critic*, Madison, WI, 1979, pp. 20–9, for a discussion of Greenberg's sense of 'dialectical conversion' as the basic mechanism of artistic advance.
25. Greenberg, 1965, p. 268. I am using the terms of Greenberg's discussion of Halachah.
26. Michael Fried, 'Art and Objecthood', in Gregory Battcock, ed., *Minimal Art*, New York, 1968, pp. 146–7. As Fried says (p. 139), 'the success, even the survival, of the arts has come increasingly to depend on their ability to defeat theater'.
27. Fried, *Absorption and Theatricality*, Berkeley, 1980, p. 5.
28. Fried, 1968, pp. 128, 130.
29. Fried, 1980, p. 5.
30. Fried, 1968, p. 130.
31. Greenberg, 1965, p. 15, suggests as much when he says that kitsch 'predigests art for the spectator and spares him effort', affording 'unreflective enjoyment' rather than 'reflection' on 'the effect' art has 'upon himself'.

What Fried calls 'the primacy of absorption'[32] is really Greenberg's primacy of abstraction in fancy new intellectual dress. Krauss also advocates and justifies abstraction, in different, if equally fashionable, intellectual terms: 'the sculpture of our time continues this project of decentering through a vocabulary of form that is radically abstract.'[33] Just as the art of Rodin and Brancusi, by 'representing a relocation of the point of origin of the body's meaning – from its inner core to its surface – [is] a radical act of decentering',[34] and Michael Heizer's *Double Negative* (Figs. 1, 2; p. 133) forces us into an 'eccentric position relative to the center of the work',[35] so the copy implies that the original is a false centre.[36] Moving from phenomenology through semiotics to deconstruction, Krauss always affirms the primacy of abstraction, with no awareness that the issue of truth to feeling is as central here as its 'self-critical' character.[37] Unlike Greenberg, she and Fried eschew art's expressive aspect – the 'identification of form and feeling', as Greenberg puts it[38] – which no doubt reflects the apparently 'cool' appearance of post-Abstract Expressionist art, but misses the emotional significance of this inexpressivity. Emotion, the *via media* between the theatre of life and abstract purity, is sold short by Fried and Krauss, while being secretly central for Greenberg.

The repudiation of Abstract Expressionism in the 1960s was correlative with the repudiation of the concepts used to comprehend it. While the repudiation is only partial for Fried and Krauss – presentness and absorption are purity in disguise, much as decentring extends Greenberg's idea of 'the all-over, "decentralized"... picture'[39] and 'expendable conventions'[40] almost to a *reductio ad absurdum* – it seems complete in the cases of Alloway and Lippard. Thus, while Fried and Krauss do not quite achieve their own identities as critics (for they build on one aspect of Greenberg's identity), Alloway and Lippard seem to come into their own by explicitly rejecting Greenberg: for them, art is a reflection of profane history. But Greenberg also thinks it is. Like Fried and Krauss, Alloway and Lippard deny the dialectical conversion of profane history into sacred art – the inner relation of feeling and form – so crucial for Greenberg. And thus, like Fried and Krauss, they miss the point that art is at bottom a matter of 'self-identification' for him.

Alloway – credited with inventing the term 'Pop Art' – emphasizes the 'connections' and 'reconciliations of fine and popular art, of elite and public taste'.[41] For him, the artwork is a 'conglomerate' or 'cluster': 'a rendezvous of objects and images from disparate sources, rather than ... an inevitably aligned setup.'[42] According to Alloway, Greenberg and Rosenberg 'are interested only in art's unique identity'; the former locates it 'in the end product', the latter 'in the process of work'.[43] But Pop Art is about the work of art's 'translatability' rather than its uniqueness. Alloway elevates the 'endless reproduction' of the cliché into 'the authorized expression of mankind, a kind of common property that especially binds us together', over the uniqueness that separates us and asserts the self's authority.[44] In contrast to Greenberg and Rosenberg, he views art as a means of socialization rather than individuation.

Similarly, Lippard's criticism originates in 'revolt against Clement Greenberg's patronization of artists, against the imposition of the taste of one class on everybody, against the notion that if you don't like so-and-so's work for the "right" reasons, you can't like it at all, as well as against the "masterpiece" syndrome, the "three great artists" syndrome.... I was opposed to all these male authority figures not because they were male, however, but because they were authorities.'[45]

Lippard even asserts that the first artists she supported 'differed not only in aesthetic but also in political attitudes from the Greenberg artists ... some of whom ... were in favor of the war in Vietnam',[46] as though this 'politically incorrect' position necessarily made their art bad. Lippard came into her own as a critic by 'identifying with female underdogs',[47] becoming interested in art's 'communicative effectiveness' rather than 'esthetic effect',[48] and turning 'a temperamental consciousness into a cultural consciousness'.[49] This led her to a variety of culturally 'communicative' arts, including feminist, ecological and multi-cultural production.[50] Unlike Lippard, Alloway does not completely reduce art to an ideological instrument. His ideological axe attacks certain kinds of art and art criticism rather than

32. This is the title of the first chapter of *Absorption and Theatricality*.
33. Rosalind E. Krauss, *Passages in Modern Sculpture*, New York, 1977, p. 279.
34. Ibid.
35. Ibid., p. 280.
36. I am interpreting Krauss's discussion of the 'discourse of the copy' in Sherrie Levine's art in *The Originality of the Avant-Garde and Other Modernist Myths*, Cambridge, MA, 1985, p. 170.
37. Krauss, 1977, p. 78. Greenberg, 1966, writes '"purity" means self-definition, and the enterprise of self-criticism in the arts became one of self-definition with a vengeance'.
38. Greenberg, 1965, p. 153.
39. Ibid., p. 155.
40. Ibid., p. 209. 'It seems to be a law of modernism', Greenberg writes (p. 208), 'that the conventions not essential to the vitality of a medium be discarded as soon as they are recognized.'
41. Lawrence Alloway, *American Pop Art*, exhibition catalogue, New York, Whitney Museum of American Art, 1974, p. 3. See also Alloway, 'Pop Art: The Words', in idem, *Topics in American Art Since 1945*, New York, 1975, pp. 119–22.
42. Alloway, 1974, p. 5.
43. Ibid., p. 9.
44. Ibid.
45. Lucy R. Lippard, *From the Center*, New York, 1976, p. 3.
46. Ibid.
47. Ibid.
48. Ibid., p. 10.
49. Ibid., p. 11.
50. She has written about politically orientated art in *Get The Message?*, New York, 1984, ecologically orientated art in *Overlay: Contemporary Art and the Art of Prehistory*, New York, 1983, and *Mixed Blessings: New Art in a Multicultural America*, New York, 1990.

51. Lippard, 1976, p. 9.
52. Alloway, 1974, pp. 5, 7.
53. Leo Steinberg, *Other Criteria*, New York, 1972, pp. 67–8. Steinberg points out that the opposition Greenberg posits between modernism and the Old Masters is inherently 'unstable'. It is not self-evident that they have different goals, especially in view of the fact that 'all major painting, at least of the last six hundred years, has assiduously "called attention to art"' (p. 71).
54. Robert Pincus-Witten, *Postminimalism*, New York, 1977, pp. 13–14.
55. Douglas Davis, *Art and the Future*, New York, 1973, p. 169.
56. Nicolas Calas, *Art in the Age of Risk*, New York, 1968, p. 140. Calas also thinks that Greenberg confuses 'standards used for eliminating outside interference' in order to achieve purity 'with standards used to determine inherent qualities of objects' (p. 141).
57. Rose, *Autocritique: Essays on Art and Anti-Art 1963–1967*, New York, 1988, pp. xiv–xv. Rose notes that Greenberg's objection that Pop Art is 'formally inadequate' may not be valid, because the 'criteria of evaluation' of abstract art and Pop Art may not be the same (p. 47).
58. Joseph Masheck, *Historical Present: Essays of the 1970s*, Ann Arbor, 1984, pp. 133–69.
59. Max Kozloff, 'Critical Schizophrenia and the Intentionalist Method', in Battock, 1966, p. 131, describes Warholism as 'the sensibility ... in which nothing has to be proved or justified, and which is designed to invalidate criticism. It is an anti-humanist development.'
60. Alloway, 'Statement', David W. Ecker, Jerome J. Hausman and Irving Sandler, eds., *Conference on Art Criticism and Art Education*, New York, 1970, pp. 7–9.
61. Rose, 'Statement', ibid., p. 13.
62. Kozloff, 'Statement', ibid., p. 69.

society as such. He remains firmly in the art world. In contrast, Lippard says feminism is her 'sole remaining excuse' for remaining in the art world, there being 'so few feminists in the establishment'.[51] Nevertheless, like Lippard, Alloway conceives of art as a democratic communication of signs held in common, and tends to favour the underdog.[52]

While there are many other critics, the six I have chosen to discuss here are those whose conception of the art they advocate has had a lasting effect on our understanding of it. Of the six, Greenberg and Rosenberg remain the greater and lesser touchstone critics, in that subsequent criticism is a reaction, negative or positive, to their ideas. Whether it be Leo Steinberg arguing against Greenberg's 'construction' of modernism;[53] or Robert Pincus-Witten rebelling against 'the mandarin tone ... of critical writing' and the 'closed formalist machine of judgment' – the 'apersonal, hermetic value system' – in favour of criticism 'stressing autobiography, the artistic persona and psyche';[54] or Douglas Davis's criticism of Greenberg for neither defining 'quality' nor directly stating 'the premise underlying [his] value judgments';[55] or Nicolas Calas's argument that Greenberg's idea of purity implies that art cannot 'point beyond itself to the spirit';[56] or Barbara Rose's criticism of the authoritarian character of Greenberg's notion of 'modernist reduction';[57] or Joseph Masheck's essays on 'cruciformality' and 'hard-core painting', which rethink Greenberg's idea of form in art historical terms,[58] Greenberg remains the seminal figure of American art criticism. Similarly, Max Kozloff's attack on 'Warholism'[59] echoes Rosenberg's moral attitude, suggesting the latter's ongoing subliminal importance. Certainly this is the case when, as with Lippard and, more obliquely, Alloway, art is conceived of more in social and moral than aesthetic terms (although both separate the psychological from the social, as Rosenberg never does, and from the formal, as Greenberg never does).

At a 1970 'Conference on Art Criticism and Art Education' Alloway yet again attacked 'elite criticism',[60] implicitly Greenberg's, and Rose described criticism as 'a self-challenging humanistic discipline',[61] like Rosenberg's. Similarly, Kozloff called for an 'open, informal' criticism uncompromised by 'mandarin instincts or commercial functions',[62] like Rosenberg's and unlike Greenberg's. Almost two decades after the reign of Greenberg and Rosenberg art criticism was still haunted by their shadows, for better or worse.

Gail Stavitsky

The Museum and the Collector

> Private collectors usually acquire work before museums. They account for the earliest and greatest number of acquisitions in the contemporary field – probably not because of greater appreciation or astuteness, but because one mind decides.... Whatever economic hope we have lies with state sponsorship or the private collector, especially the younger collector who is usually of the professional class.
>
> David Smith, 1947[1]

The astonishing growth of American art museums since 1870 is due to the unique generosity of private collectors functioning within a capitalist, free-enterprise system. Unlike Europe, America had neither royalty nor aristocracy, papacy nor civic organizations to develop collections that would eventually form the basis of publicly administered, government-funded museums during the eighteenth and nineteenth centuries. Large-scale collecting in America was not possible until the period of economic recovery and industrialization after the Civil War. Thus, America's first major collectors were mostly self-made businessmen. They included the founders of the country's great art museums in 1870, particularly New York's Metropolitan Museum of Art. Behind this pattern of individual philanthropy, private control and local initiative lies a complex variety of motivations, including art as social prestige and profitable investment, connoisseurship and aesthetic pleasure, as well as populist ideals of civic duty, public education and the encouragement of creativity.

At the turn of the century, J. Pierpont Morgan and other men of fortune amassed prestigious, blue chip collections of historical European art which continued to set the standards for American museums and private collectors (see Fig. 1). Their indifference to the work of living artists was challenged by a small group of pioneers who were to transform the nature of art collecting in America through their missionary efforts.

None of these zealous collectors commanded vast financial or industrial empires. Their varied enterprises or inheritances afforded them the opportunities to develop their intellectual concerns, befriend living artists and spread the new modernist faith. The most influential pioneers were the expatriate Stein family – Leo, Gertrude (Fig.

1. David Smith, 'The Sculptor's Relationship to the Museum, Dealer, and Public', quoted in Garnett McCoy, ed., *David Smith*, New York, 1973, pp. 57–8.

Fig. 1 J. Schuerle, *The French and the American Napoleons of Art, c.* 1913

2), Michael and Sarah – who had become prescient patrons of Cézanne, Matisse and Picasso by 1905. Among the many visitors to their legendary, art-filled Parisian apartments were Claribel and Etta Cone, who eventually acquired over forty Matisses, bequeathed in 1950 to the Baltimore Museum of Art. Another important guest was the photographer, dealer and collector Alfred Stieglitz, who in 1911 tried to sell a group of works on paper by Picasso to The Metropolitan Museum of Art. The museum's curator Bryson Burroughs 'vouched that such mad pictures would never mean anything to America'.[2]

The Metropolitan's most modern purchase at that time was Cézanne's *La Colline des Pauvres* (1888–90) – in 1913 the first Post-Impressionist painting to enter an American museum collection. It had been acquired from the Armory Show, an event that provided the major stimulus for collecting modern art in America. This landmark exhibition was spearheaded by the painter Arthur B. Davies, art adviser to Lillie P. Bliss and Mary Quinn Sullivan, who would later be among the founders of New York's Museum of Modern Art.

The New York lawyer John Quinn, the Show's main patron, conducted a successful legal crusade to eliminate the import duty on all works of art less than twenty years old, thus facilitating the rapid expansion of the New York art market. At his death in 1924, Quinn had amassed the most important collection of avant-garde literature and art, with a perspicacious emphasis on Constantin Brancusi. Another collector galvanized by the Armory Show was the Chicago lawyer Arthur Jerome Eddy, who became a pioneering patron of Wassily Kandinsky and wrote one of the first books on modern art to appear in America, *Cubists and Post-Impressionism* (1914). Walter and Louise Arensberg (Fig. 3) launched their avant-garde collection of Marcel Duchamp, Dada, Cubist and Surrealist art with the purchase of a painting by Jacques Villon at the Show.

Fig. 2 Gertrude Stein, *c.* 1906

Serving as the catalyst for the Arensbergs' collection and New York salon from 1915 to 1920, Duchamp also influenced his other major patron, the painter Katherine Dreier (Fig. 4). Along with Man Ray, Dreier and Duchamp founded the *Société Anonyme* as the first American museum of modern art in 1920 in New York, although it functioned primarily as a gallery. Managed by Dreier, the *Société Anonyme* organized landmark exhibitions of international modern art in 1921 at the Worcester Museum and in 1926 at the Brooklyn Museum, introducing Dada, Surrealism, De Stijl and Constructivism to American museum visitors. In a review of the Brooklyn Museum show, Henry McBride articulated the imperative need for a museum to house modern art permanently. Unable to achieve this goal, Dreier bequeathed the *Société*'s collection to Yale University in 1941.

The first permanent showcase for modern art was founded by the relatively conservative Duncan Phillips, who opened his home in Washington to the public in 1921 with works by European and American Impressionists and the Ashcan School, alongside the Old Master ancestor El Greco. Soon afterwards, two other institutions of modern art opened which, like the Phillips Memorial Art Gallery, were one-man operations. Amassing a diverse collection of work by Cézanne, Matisse and others that was rejected as 'degenerate' when exhibited at the Pennsylvania Academy of Fine Arts in 1921, Dr Albert C. Barnes greatly restricted access to his Foundation after it opened in a Philadelphia suburb in 1925. Two years later, the critic and connoisseur Albert Eugene Gallatin inaugurated his more influential Gallery of Living Art as America's first museum devoted exclusively to contemporary art and located in the country's premier art centre, New York.

Fig. 3 Marcel Duchamp (right) with Walter and Louise Arensberg, Hollywood, 1936

Influenced by the considerable publicity lamenting the dispersal of Quinn's art estate at auction in 1926, Gallatin installed his collection as a small, informal museum in the South Study Hall of New York University from 1927 to 1943. Opening with a relatively precocious selection of Cubist paintings, Gallatin subsequently (1928–33) acquired the first works by Jean Arp, Robert Delaunay, Joan Miró, Piet Mondrian and his own adviser, Jean Hélion, to enter an American museum collection. Few museums could challenge the Gallery's primacy as a showcase of living art, although the Art Institute of Chicago established the Birch-Bartlett Collection in May 1926 as the first

Fig. 4 Katherine S. Dreier and Marcel
Duchamp in Dreier's home at West Redding,
Connecticut, 1936. Duchamp's *The Large Glass* is
on the right, his painting *Tu m'* above the
bookshelves

public display in America of Post-Impressionists and pioneer modernists, including
Picasso. On the West Coast, the Los Angeles County Museum displayed the collec-
tion, promised to the museum, of contemporary American and European art that had
been assembled by William Preston Harrison. Guided by its director, William
R. Valentiner, the Detroit Institute of Arts had made the unusual purchase of a group
of important German Expressionist works as early as 1921 and, in 1922, also acquired
La Fenêtre (1916), one of the first works by Matisse to enter an American public col-
lection.

Gallatin's Museum of Living Art (renamed thus in 1936) was overshadowed by the
development of a larger institution in New York. Founded in 1929 by a genteel com-
mittee of collectors and connoisseurs, The Museum of Modern Art (MoMA) was
modelled on such European precedents as London's Tate Gallery and the Palais de
Luxembourg in Paris. At this time, modern art museums were located in fourteen
European cities. Sixty European museums, the majority of them in Germany, had
galleries of modern art, whereas in America they totalled a mere twelve.[3] Among
these was Hartford's Wadsworth Atheneum, which was to organize America's first
museum exhibition of Surrealism in 1931 and its first Picasso retrospective in 1934.

Under the shrewd leadership of director Alfred H. Barr, Jr., the museum soon out-
stripped its European sources to become the world's leading arbiter of taste, an insti-
tution that established the legitimacy of modernist art and theory through definitive,
historicizing exhibitions and publications.[4] Functioning initially as an experimental
temporary exhibition space, the museum did not set out on the road to becoming a
permanent collection until the development of an endowment was stipulated by the
1931 bequest of one of its founder-trustees, Lillie P. Bliss. The museum received her
collection of French modern art in 1934 and established its first purchase fund with a
donation by another founder, Abby Aldrich Rockefeller, in 1935. Bliss also presented
a large collection of American modernist paintings and works on paper. Rockefeller's
pioneering commitment to native contemporary art, by Charles Demuth, Edward
Hopper and others, was not shared by most of the museum's staff and benefactors.
One of MoMA's first exhibitions, 'Painting in Paris From American Collections'
(1930), revealed collectors' preferences for the critically acclaimed, increasingly val-
uable French modernist masters.

The outstanding exception to this pattern was the sculptor Gertrude Vanderbilt

2. Dorothy Norman, *Alfred Stieglitz: An American
Seer*, New York, 1973, p. 108, quoting a letter
of 19 December 1939 from Stieglitz to Edward
Alden Jewell.

3. See Appendices A and B in *An Effort to Secure
$3,250,000 for The Museum of Modern Art*,
New York, 1931, pp. 35–9.

4. For an account of MoMA's history, see Russell
Lynes, *Good Old Modern: An Intimate Portrait of
the Museum of Modern Art*, New York, 1973.

Whitney, who purchased works by Robert Henri, Ernest Lawson, George Luks and Everett Shinn from the pioneering exhibition of The Eight in 1908. Founding the Whitney Studio Club in 1918, she provided gallery space for progressive artists, assembling the largest collection of contemporary American art from each show. After unsuccessfully offering her varied collection of five hundred works by Stuart Davis, Hopper and others to the Metropolitan Museum, Whitney founded her own New York museum, the Whitney Museum of American Art, in 1931. In the same year, another major collector of American modernism, Ferdinand Howald, bequeathed his large collection of work by Demuth, Arthur Dove, Marsden Hartley, Man Ray and others to the Columbus Gallery of Fine Arts in his home town of Columbus, Ohio. Duncan Phillips also emerged as a prescient supporter of such American modernists as Dove, John Graham, John Marin, Georgia O'Keeffe and Augustus Vincent Tack.

By the 1940s European and native pioneers of modernism were increasingly represented in American museum collections. In 1943 Gallatin bequeathed his collection to the Philadelphia Museum of Art. He encouraged the director, Fiske Kimball, to pursue the Arensbergs, who had tried to establish a museum in Los Angeles. In 1950 their bequeathed collection of modern and 'primitive' art joined that of Gallatin to establish the Philadelphia museum as a national centre. Another important bequest of this period was that of Alfred Stieglitz, encompassing major works by Dove, Hartley and O'Keeffe, to the Metropolitan Museum in 1949, even though it did not form a separate department of twentieth-century art until 1967. The pervasive taste for historical French modernism continued to influence many collectors, including Stephen C. Clark, Sam Lewisohn, John Hay Whitney and especially Chester and Maud Dale. The Dales' 1963 bequest launched the modern art collection of the National Gallery of Art in Washington, which has since been greatly augmented by Paul Mellon's donations. Possibly the largest collection of European modernist painting by 1940 was that of Walter Chrysler, who opened his own museums at Provincetown, Massachusetts (1958), and Norfolk, Virginia (1971).

Between 1942 and 1946 America's war-induced prosperity generated a 'boom' in sales of contemporary art – which was relatively inexpensive and available through an increasing number of outlets. A new group of adventurous upper-middle-class collectors, such as the Philadelphia Museum of Art's long-time trustee Eleanor Gates Lloyd and the painters Muriel Kallis Newman, Fred Olson and Alfonso Ossorio, were among the first to acquire Abstract Expressionist works. The pioneer of these patrons was Peggy Guggenheim (Fig. 5), whose uncle Solomon had founded New York's Museum of Non-Objective Art in 1939, highlighting the work of Kandinsky. From 1942 to 1947 Peggy Guggenheim presented her collection of European abstract and Surrealist work at her New York gallery-cum-museum, Art of This Century, alongside changing shows devoted to new American artists whose work she purchased and sold. In 1944, guided by curator-collector James Thrall Soby, MoMA acquired Jackson Pollock's *The She-Wolf* (Fig. 1, p. 14) from her – the first work by him to enter a public collection. Guggenheim was also an active donor of modern art to regional institutions, including the Seattle Art Museum and the San Francisco Museum of Modern Art (the latter gave Pollock and Mark Rothko their first one-man museum shows, in 1945 and 1946 respectively).

Often criticized for having neglected the American avant-garde, MoMA encouraged patronage of native artists by establishing an Art Lending Library in the 1950s and by presenting various group exhibitions of local private collections in 1946, 1948, 1951 and 1955. Although the majority of works on view were by European modernists, the 1948 show featured paintings by William Baziotes, Theodoros Stamos and Mark Tobey. These were lent by the pioneering collector of American modernism, Edward W. Root, an art professor and critic who donated his eclectic collection, formed since the 1920s, to the Munson-Williams-Proctor Institute in Utica, New York, in 1956.

During the 1950s MoMA's long-time trustee Nelson Rockefeller emerged as a leading collector of Abstract Expressionism. Inspired by MoMA's 'Americans' exhibition series, organized by curator Dorothy Miller, Rockefeller also developed a large

Fig. 5 Peggy Guggenheim and Herbert Read in front of a painting by Yves Tanguy, 1939

collection of modern European, Latin American and 'primitive' art. Indeed, Rockefeller's patronage – in tandem with MoMA's international travelling shows – has even been viewed as an aesthetic symbol of American imperialist aspirations. Another major Abstract Expressionist patron was Seymour H. Knox who, from the 1950s onwards, donated seminal works by Arshile Gorky, Pollock, Rothko and others to the Albright-Knox Art Gallery in Buffalo, New York. Ben Heller's group of monumental canvases by Barnett Newman, Pollock, Rothko, Clyfford Still and others was applauded as New York's best private collection of American action paintings when it was exhibited at MoMA in 1961. Heller also became actively involved with the Friends of the Whitney Museum, lending works by Joseph Cornell, Philip Guston, Franz Kline, Joan Mitchell and Robert Rauschenberg in 1958 and 1964 to the Friends' series of exhibitions promoting the private collecting of contemporary American art.

The Whitney Museum presented the private collections of such Friends as Edith and Milton Lowenthal in 1952, with important works by Stuart Davis, and Roy R. Neuberger in 1956, with work by Milton Avery, Baziotes, Adolph Gottlieb, Hans Hofmann and Pollock. Inspired by Duncan Phillips, Neuberger founded his own museum in 1974 at the State University of New York in Purchase.

Another Whitney Friend, museum founder and collector of American (as well as European) art was the uranium magnate Joseph P. Hirshhorn. His acquisition of works by Gorky and David Smith was notably precocious. The Hirshhorn Museum and Sculpture Garden, conceived as a modern complement to the Smithsonian's National Gallery of Art (founded in 1941), opened in Washington in 1974 with the unsurpassed donation of over twelve thousand art objects, including a celebrated collection of work by Willem de Kooning.

Other major gifts during the 1960s and 1970s were presented by Howard (a former sculptor) and Jean Lipman to the Whitney Museum as the fruits of a long-term collaboration on the development both of a representative group of works by Alexander Calder and of a major travelling collection of contemporary American sculpture. By 1969 the first two exhibited selections had included sculpture by John Chamberlain, Dan Flavin, Don Judd, Ellsworth Kelly, Sol LeWitt, Robert Morris, Claes Oldenburg and Robert Smithson. Many of these artists also benefited from the patronage of MoMA's prominent trustee-architect Phillip Johnson, who presented works by them to this institution in the 1970s. With a collection ranging from Abstract Expressionism to Pop Art, Minimalism and Conceptual Art, Johnson could often be relied upon to acquire, and subsequently donate, challenging work that had not been approved by the Collections Committee. From 1959 to 1970 a special fund established by Larry Aldrich, the founder of the Aldrich Museum of Contemporary Art in Ridgefield, Connecticut, in 1964, enabled MoMA to acquire work by such

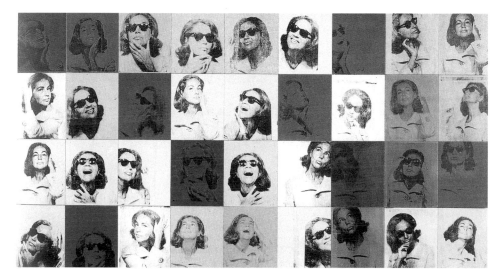

Fig. 6 Andy Warhol, *Ethel Scull Thirty-six Times*, 1963. Whitney Museum of American Art, New York; Gift of Ethel Redner Scull

Americans not already in the collection as Joseph Kosuth, Brice Marden, Agnes Martin and Frank Stella.

The first pieces by Chamberlain and Jasper Johns to enter MoMA's collection were donated by Robert and Ethel Scull in 1958 and 1961. Renowned as the 'mom and pop of Pop Art' and 'the Medici of the Minimals', the taxi-cab tycoon and his modish wife (see Fig. 6) also owned Abstract Expressionist work. Their reputation as daring celebrity-collectors was based, however, on their canny purchases of Flavin, Johns (acquired in depth during 1959–60), Roy Lichtenstein, Morris, Bruce Nauman, Oldenburg, Rauschenberg, Stella, Cy Twombly and Andy Warhol. Ardently committed to the direct patronage of lesser-known artists, Bob Scull also financed the construction of sculpture and earthworks by Walter De Maria and Michael Heizer. The Sculls' greatest competitors were Burton and Emily Tremaine, among the first to buy the work of the Abstract Expressionists, Johns, Rauschenberg and the major Pop artists. In 1965 Pop Art was designated 'a collector's movement', thus acknowledging the prominent role played by the Sculls, Richard Brown Baker and others in the phenomenal emergence of a critically condemned style.[5]

Robert Scull's 1973 sale of fifty works in a record-breaking auction at Sotheby's in New York reflected the rapid expansion and commodification of the contemporary art world since 1960. Recently choosing the more venerable American tradition of museum patronage, another collector-couple, the postal clerk Herbert and the librarian Dorothy Vogel (Fig. 7), presented their ever-growing, premier collection of Minimal and Conceptual art to the National Gallery of Art. By 1966 they were already collecting many of the artists featured that year in the landmark exhibitions 'Primary Structures' at the Jewish Museum and 'Systemic Painting' at the Guggenheim. Known as the 'unlikely Medici', the Vogels have filled their tiny New York apartment mostly with graphic work by their friends Carl Andre, Chamberlain, Eva Hesse, Judd, Kosuth, LeWitt, Robert Ryman, Smithson, Richard Tuttle and Lawrence Weiner.

Art collecting in America originated with the patronage of an 'old money', mostly patrician generation of WASP, East Coast businessmen acquiring historical European masters. Their indifference towards modern art was challenged by a more cosmopolitan group of collectors with increasingly diverse social backgrounds and sources of income. By the time MoMA was founded in 1929, modern art in America had evolved from the esoteric mission of a small network of artists, avant-garde collectors, dealers and critics to a widespread phenomenon. With this ratification, more 'on-guard' collectors and museums began to acquire acknowledged art by modern masters, whereas a smaller avant-garde risked the purchase of unaccredited contemporaries. While few early collectors were devoted to American modernism, the ranks of avid patrons swelled during the prosperous post-war years when New York replaced Paris as the capital of the art world. Throughout the century, some collectors have focused on certain stylistic tendencies, while many more have intuitively developed an eclectic connoisseurship approach, suggesting affinities between modern, historical, non-Western and 'primitive' art. Exemplary of this development is the vast Menil Collection, opened in 1987 in Houston to house the diverse collection of prehistoric, 'primitive', Surrealist and American post-war art assembled since 1942 by Dominique de Menil and her late husband, John. Many other collectors, including Hirshhorn, Phillips and Whitney, have also chosen to establish new museums, acts that reflect the quintessential American conception of entrepreneurial largesse – whereby private collections eventually metamorphose into public show-places.

Formed during the 1920s by private collectors, America's first museums of modern art were small, experimental galleries, organized in contrast to the exclusionary policies of established institutions. Through the unparalleled contributions of collectors, America's public and private modern art collections now rival, or even excel, those of Europe.

5. See John Rublowsky, *Pop Art*, New York, 1965, p. 159.

Fig. 7 Dorothy and Herbert Vogel, 1986

I should like to acknowledge the help of Naomi Sawelson-Gorse and Deidre Robson in the preparation of this essay.

Bibliography

Julia Brown, ed., *The First Show: Painting and Sculpture from Eight Collections, 1940–1960*, exhibition catalogue, Los Angeles, Museum of Contemporary Art, 1983; Laurence Vail Coleman, *The Museum in America*, Washington, DC, 1939; W. G. Constable, *Art Collecting in the United States of America*, London, 1964; Diana Crane, *The Transformation of the Avant-Garde: The New York Art World, 1940–1985*, Chicago, 1987; Martin Feldstein, ed., *The Economics of Art Museums*, Chicago, 1991; Paul Garner, 'An extraordinary gift of art …', *Smithsonian*, October 1992, pp. 124–32; Jean Lipman, ed., et al., *The Collector in America*, New York, 1971; Karl E. Meyer, *The Art Museum: Power, Money, Ethics*, New York, 1979; Deidre Robson, 'The Avant-Garde and the On-Guard: Some Influences on the Potential Market for the First Generation Abstract Expressionists', *Art Journal*, vol. 47, Autumn 1988, pp. 215–21; Aline B. Saarinen, *The Proud Possessors*, New York, 1958; Judith Zilczer et al., *The Advent of Modernism*, exhibition catalogue, Atlanta, High Museum of Art, 1986.

Mary Lublin

American Galleries in the Twentieth Century: From Stieglitz to Castelli

With one important difference, the modern art gallery emerged in the United States in ways that were strikingly similar to its advent in Europe. Within a short period of time, the focus of art moved from the academy and official salon to various secessionist forums organized by independent artists. By 1863, in France, the secessionist impulse had led to the first *salon des refusés*. The first modern gallery owner, Paul Durand-Ruel, followed soon after, developing a market for avant-garde art that fed on the staleness of salon art.

The significant difference in the American scene was that the impetus for a new kind of art and a new kind of gallery came from American artists and dealers of a thoroughly European inspiration, not from home-grown artists, most of whom remained in a French academic orbit until the early twentieth century. Robert Henri was a lone exception, although his defiance of academic tradition was felt less in his style than in the way he challenged the powerful National Academy of Design (founded in 1825), which sponsored annual shows that were vital to most artists' survival. After attempting to reform the Academy from within, Henri and other members of the Ashcan School held a show at the Macbeth Galleries in New York in 1908. Their naturalism was a response to new urban realities, but their stylistic indebtedness to Manet and Thomas Eakins was so strong as to identify them with an earlier generation of artists rather than with the vanguard that was surfacing in Europe.

By introducing innovative art and changing the nature of its patronage, Alfred Stieglitz (1864–1946; Fig. 1) did more than anyone in America to transform this state of affairs. Almost single-handedly, he turned the gallery of contemporary art – of which there were a considerable number in Boston, New York and Philadelphia – into a gallery of *modern* art. A photographer and gallery director, Stieglitz launched his first vanguard project, the magazine *Camera Work*, in 1903. Naturalism served Stieglitz, as it had the Ashcan artists, as a way of breaking clear of the Beaux-Arts style. But within a few years, after making contact with Leo and Gertrude Stein in Paris and taking advice from the photographer Edward Steichen, Stieglitz was fired with a passion that gave a new direction to the little gallery he had opened in 1905 on 291 Fifth Avenue, which would soon be known simply as '291'. A show of Rodin drawings was followed by Cézanne watercolours and works by Matisse and Picasso, and opened up a novel world of European art to many Americans (see Fig. 2).

Fig. 1 Alfred Stieglitz in his 291 gallery, New York. Photograph, Philadelphia Museum of Art; Dorothy Norman Collection

Both Stieglitz's artists and patrons had this European, avant-garde bias. Arthur Dove had been to Paris in 1908, John Marin and Max Weber were both there in 1905 and Marsden Hartley lived as a virtual émigré in Europe. Francis Picabia and his wife, Gabrielle, played an important role in bringing the latest art and ideas to New York, while the French-born collector Paul Haviland, the Mexican Marius De Zayas, the American collector Agnes Meyer and the socialite Mabel Dodge Luhan all supported Stieglitz's endeavours.

The vocation of 291 was soon vindicated by the famous Armory Show of 1913.[1] It was typical of Stieglitz, however, to turn away from the European vanguard and promote the unrecognized American avant-garde. Stieglitz began to add the epithet 'American' to everything he did. He billed his wife's 1923 show as 'Georgia O'Keeffe American', and called the large exhibition that he curated two years later at the Anderson Galleries 'Seven Americans'. His Intimate Gallery, a successor to 291, was inaugurated in 1925 as an 'American Room' and featured the work of O'Keeffe, Dove, Hartley, Stieglitz himself and other Americans. When the Anderson Galleries

1. Although examples of American art outnumbered European by more than two to one at the Armory Show, the foreign works sold best. One hundred and seventy-four works, or roughly ten per cent of what was shown, were sold.

Fig. 2 Exhibition including work by Georges Braque and Pablo Picasso at Alfred Stieglitz's 291 gallery, New York, 1915

building closed four years later, Stieglitz and several friends opened a new space, An American Place, on Madison Avenue, and he continued to show the American artists in whom he had the most faith.

New dealers quickly stepped in to develop what Stieglitz had initiated. Charles Daniel (1878–1968), a former bar owner, opened his gallery in 1912 to support struggling, progressive artists, including Charles Demuth and Man Ray. By 1920 the Daniel Gallery had emerged at the forefront of modernism. Although he lacked the polish and magnetism of Stieglitz, Daniel became a rival in promoting the American avant-garde, backing many of Stieglitz's artists in the period between the close of 291 in 1917 and the opening of the Intimate Gallery. He was most closely associated with Precisionism in the 1920s and the urban-industrial themes of artists such as Demuth, Charles Sheeler and Preston Dickinson.

One of the great landmarks of the New York art world, the Downtown Gallery, was founded by Edith Gregor Halpert (1900–1970) in 1926 and specialized in contemporary realists, such as Stuart Davis and Yasuo Kuniyoshi. Halpert remained loyal to American art throughout the gallery's forty-four-year history, and was widely considered the doyenne of the American art market. Much of the art that emerged in the years following the stock market crash of 1929 was concerned with a need to define the national identity and had been prefigured, for example, by Halpert's fascination with folk art and by the remarkable success of Edward Hopper's watercolours of small-town views at the Rehn Gallery in 1924.

Artists responded to the Great Depression in a variety of ways. Regionalists such as Thomas Hart Benton glorified traditional values, while urban realists such as Reginald Marsh depicted the harsh truths of city life and the need for social change. During this period the US government itself came to play a major role in art. From 1932 to 1943 the Federal Art Project of the Works Progress Administration (WPA) functioned as the country's largest art patron by subsidizing thousands of artists and beginning a programme of federal art patronage.[2] The WPA defined official policy towards the arts by insisting on American subject-matter, yet the liberal interpretation of this policy allowed for great stylistic diversity. Artists with visions as varied as those of Stuart Davis, Jack Levine, Jackson Pollock and Philip Guston were all nourished by the WPA.

Despite the WPA's vast patronage, the American art scene during the 1930s was still, at some deeper level, dominated by Paris. Julien Levy (1906–1981) opened his gallery in 1931, to bring what he called the 'discrete discontinuity' of Surrealism to the 'country of pragmatism'.[3] The Harvard-educated Levy began his lifelong fascination with the art of the new in 1927, when he accompanied Marcel Duchamp to Paris

2. See Richard D. McKinzie, *The New Deal for Artists*, Princeton, 1973, p. 11, and Francis V. O'Connor's essay in the present volume. The Federal Art Project was responsible for well over 2,500 murals, 17,000 sculptures, 108,000 easel paintings and 11,000 designs.
3. Julien Levy, *Memoirs of an Art Gallery*, New York, 1977, pp. 12–13.

Fig. 3 Peggy Guggenheim with the revolving presentation of objects from Marcel Duchamp's *Boîte-en-Valise* in her Art of This Century Gallery, New York, 1942

to make an experimental film with Man Ray. With his sensitivity to European culture and his constant travels, Levy ran what became an international centre for the latest advances in painting, sculpture and photography. He first recognized the eccentric genius of Joseph Cornell in 1932, and throughout the 1930s showed such Europeans as Max Ernst, Salvador Dalí and Giorgio de Chirico, as well as the Americans Arshile Gorky and David Hare. Photographs by Paul Strand, Walker Evans (see Figs. 4, 5; p. 33) and Eugène Atget were all brought to the attention of the American public on the curved walls of the gallery. For a time, Levy offered a weekly programme of experimental films, screening Buñuel and Dalí's *Un Chien andalou*. Shocked by the suicide of his close friend Gorky and offended by the chauvinism of Abstract Expressionism, Levy closed America's first truly multi-media gallery in 1949.

Levy was a sophisticate with a taste for the sublime. The other great force in bringing Surrealism to America, Peggy Guggenheim (1898–1976; Fig. 3), was both fantastically rich (she was the niece of the industrialist Solomon Guggenheim) and hell-bent on hedonism. She opened Art of This Century in 1942, wearing a tiny pink landscape by Yves Tanguy on one ear-lobe and a metal and wire mobile by Alexander Calder on the other in an attempt to demonstrate equal respect for Surrealist and abstract art. The gallery was both an exhibition space for young artists and a place to display Guggenheim's growing private collection. With Duchamp as her adviser, she presented the most radical works by André Breton, Wassily Kandinsky, Piet Mondrian, Giacomo Balla and Fernand Léger. Designed by the Austrian-born architect Frederick Kiesler, the gallery boasted curved walls covered in ultramarine canvas sails, turquoise floors, unframed pictures mounted on baseball bats or suspended from ropes, paintings revolving on a Ferris wheel or seen through peep-holes and a variety of flickering lights (Fig. 4). Guggenheim's frenzied whirl of parties and openings also set the New York art world spinning, offering young American artists the chance to associate with the European avant-garde. Her support of Pollock and encouragement of Robert Motherwell, Hans Hofmann, Clyfford Still, Mark Rothko and Adolph Gottlieb made her the chief patron of the New York School in its infancy.

When Guggenheim left for Venice in 1947, only the well-born and well-connected Betty Parsons (1900–1982) was bold enough to take on the difficult Pollock – as well as Still and Rothko, who were soon joined by her friend Barnett Newman. From 1947 until 1951 these key Abstract Expressionists formed the core of Parson's gallery, hanging shows and writing catalogue introductions for each other, and advising Parsons on prospective additions to her roster. With its bare wooden floors and windowless white walls, the pared-down gallery provided a suitable environment for the kind of large-format works that became a quintessential element of post-war American

Fig. 4 The Abstract Gallery in Peggy Guggenheim's Art of This Century Gallery, New York

painting. As such, the Parsons gallery prefigured various later commercial spaces whose asceticism interacted subtly with the art displayed in them.[4]

Many of the Abstract Expressionists left Parsons for Sidney Janis in an attempt to find a more commercial manager of their increasing fame and fortune. But Parsons (who was herself an artist) pursued her love for undiscovered talent, supporting Robert Rauschenberg and other young artists. By the time the gallery closed in 1977, she had presented most of the major artists of the previous three decades, especially such 'Colour-Field' and Minimal painters as Ellsworth Kelly, Richard Tuttle and Agnes Martin.

In 1945 the curator and critic Samuel Kootz (1898–1982) began to show European and American abstractionists, taking on William Baziotes and Motherwell when Guggenheim closed. Perhaps his most noteworthy exhibition occurred in 1949. It featured Willem de Kooning, Gorky, Gottlieb, Hofmann, Motherwell, Pollock, Ad Reinhardt and Rothko – artists whom he associated with a world of 'inward emotions and pain'.[5] During the 1950s Franz Kline, Helen Frankenthaler, Morris Louis and Kenneth Noland had shows in his gallery. Unlike the refined Parsons, Kootz kept his eye on commerce. He scored a coup in 1947 when he returned from Paris with nine recent works by Picasso, going on to support the gallery for many years by selling the Spanish master from his back room. It was also in 1947 that Kootz presented the first Paris show of American moderns at the Galerie Maeght, a commercially unsuccessful but ground-breaking attempt to develop a market for this work in post-war Europe.

However, American art was beginning to take its place on the world stage, and for the first time in history a large international market developed. European classics remained, nevertheless, the commercial salvation for many an American gallery, including those best known for American art. What is striking about Sidney Janis and Leo Castelli – the two gallery directors most instrumental in the rise of successive generations of the New York School – is the degree to which both belonged to an archetypal European mould.

By the 1940s Janis (1896–1989) had initiated a career as a curator, private dealer and art critic, publishing with his wife, Harriet, a study of Picasso and *Abstract and Surrealist Art*. Janis's gallery opened in 1948 on 57th Street, occupying the space vacated by Kootz. There he embarked on an ambitious series of museum-like shows such as 'Les Fauves' and 'Futurism'. By 1949 he had begun to exhibit art that made the gallery a focus of Abstract Expressionism. With the exhibition 'American Vanguard Art' of 1952–53, Janis became identified with figures such as Baziotes, de Kooning, Pollock, Gottlieb, Kline, Rothko and Motherwell. The gallery never had more than nine American artists at one time, since Janis, like Kootz, needed to sell classic European art in order to survive. But things had begun to change by 1953, when de Kooning's show of aggressive paintings of women sold out, netting about $14,000. Canvases by Pollock were selling for $5,000 to $8,000 just before his death in 1956. (The national mean income at the time was about $2,800 per year.)[6]

After the Second World War the Italian-born Leo Castelli (*b.* 1907) started his career as perhaps the most influential art dealer of the twentieth century, his nascent interest in contemporary art guided by his Rumanian wife, Ileana (*b.* 1914). When the couple finally settled in New York in the late 1940s, Castelli sold European modernist works acquired largely through contacts formed during a brief involvement with a Paris gallery in the 1930s. Finding this market dominated by such more established galleries as Curt Valentin, Pierre Matisse and Valentine Dudensing, Castelli turned his eye to American art. In 1950 he and Janis assembled an exhibition pairing the Abstract Expressionists de Kooning, Pollock, Gorky and Rothko with such post-war French artists as Jean Dubuffet and Pierre Soulanges.

This desire to place American contemporary art on a par with the European avant-garde also inspired the first exhibition Castelli held when he opened a gallery in the living room of his East 77th Street house in 1957. The strengths of de Kooning, Pollock and David Smith were demonstrated when their work was placed alongside paintings by artists such as Léger, Mondrian and Picabia. It was, however, the final exhibition of that first year which established the direction Castelli was to take: 'New

4. On Betty Parsons, see Lee Hall, *Betty Parsons: Artist, Dealer, Collector*, New York, 1991. On the aesthetics of the gallery environment, see Brian O'Doherty, *Inside the White Cube*, Santa Monica, 1986.

5. See Grace Glueck, 'Samuel M. Kootz Dead at 83: An Activist for American Art', *New York Times*, 9 August 1982.

6. See Diana Crane, *The Transformation of the Avant-Garde: The New York Art World, 1940–85*, Chicago, n. d. (*c.* 1987).

7. Quoted in Laura de Coppet and Alan Jones, *The Art Dealers*, New York, 1984, p. 142.

8. Quoted in Calvin Tomkins, 'Profiles: A Good Eye and a Good Ear', *New Yorker*, 26 May 1980, p. 41.

Fig. 5 Jasper Johns's first exhibition, at the Leo
Castelli Gallery, New York, 1958

Work' included Jasper Johns and Robert Rauschenberg, the two artists with whom
his career is most closely identified, and announced Castelli's unfailing sympathy with
what was soon to emerge as Pop Art. Earlier that year, an encaustic painting by Johns
included in a show assembled by the art historian Meyer Schapiro at the Jewish
Museum had caught the dealer's attention. Johns's first one-man show, held at
Castelli's in January 1958 (Fig. 5), instantly catapulted the artist to fame. It was also,
in Castelli's own words, 'probably *the* crucial event in my career as an art dealer,
and … an even more crucial one for art history'.[7] Johns's *Target with Four Faces*
appeared on the cover of *Artnews* and Alfred Barr purchased four paintings for The
Museum of Modern Art, *Target with Four Faces* among them.

Castelli had been familiar with Rauschenberg's work well before his involvement
with Johns. Betty Parsons's exhibition of Rauschenberg's now famous white paintings
in 1951 had prompted Castelli to include the young artist in the 'Ninth Street Show'
that he helped to organize later that year. Rauschenberg's series of red paintings
shown at Charles Egan's Gallery in 1954 (see Cat. 135) served only to confirm Cas-
telli in his opinion of the artist's originality. However, the Pop artist's first show at
Castelli, mounted just two months after Johns's, only managed to provoke visitors.
Yet by the following year, Castelli had succeeded in placing a work by Rauschenberg
in a public collection, selling *Migration* to the museum at Cornell University.

Castelli's talent lay in his ability to grasp the significance of the historical moment.
He has defined his purpose simply, stating 'you spot movements emerging and try to
pick the best practitioners'.[8] The reputations of most of the major artists of the 1960s
were made under Castelli's guidance. He established the careers of Cy Twombly,
Frank Stella and Roy Lichtenstein, before enhancing the standing of Andy Warhol,
who had turned to Elinor Ward at the Stable Gallery following a rejection from Cas-
telli in 1964, and James Rosenquist, when the latter left the Green Gallery in 1965.
With his first exhibition of Claes Oldenburg in 1974, Castelli completed his group of
Pop celebrities. Ellsworth Kelly, whom he took on from Janis at the same time as
Oldenburg, was something of an anomaly in the gallery's circle, for painters con-
cerned primarily with colour – Morris Louis, Kenneth Noland, Helen Frankenthaler
and others – showed up-town with Andre Emmerich.

Castelli has always professed to have no interest in the business of art, and indeed,
his willingness to help other dealers, artists, critics and curators is legendary. In the
early years he helped to change the American gallery system by introducing a

European-type retainer (monthly wages advanced against royalties from future sales), enabling his artists to concentrate exclusively on their art. Often, Castelli's seeming innocence has revealed what can only be considered a canny sense of the interplay between the art market and the museum. When Alfred Barr wished to acquire Stella's large black painting *The Marriage of Reason and Squalor* (Cat. 155) for The Museum of Modern Art in 1959, Castelli lowered the price from $ 1,200 to $ 700, enabling Barr to circumvent the disapproval of the museum's trustees and purchase the work without the consent of the board.

This generosity has frequently worked to Castelli's advantage. He has been extremely shrewd in his development of a network of contemporary dealers, increasing the status of his artists by providing accessibility to collectors outside the New York area. Although earlier dealers such as Kootz had tried to develop a European market for American Abstract Expressionists, it was Castelli, in partnership with his former wife, Ileana Sonnabend, who successfully broke through the barrier of Eurocentrism. When Sonnabend opened her gallery in Paris in 1962, she showed mostly Castelli artists. This exposure to European museum directors, curators, journalists and collectors proved immensely important, placing Pop Art at the centre of the international scene.

Other talents have been instrumental in Castelli's rise to the top. Ivan Karp (*b.* 1926) and Richard Bellamy (*b.* 1924) helped secure the gallery's position at the forefront of the art market. By 1958 Karp, who started out as an art critic for the *Village Voice*, had established his place in the avant-garde art world by presenting the sculpture of John Chamberlain and the Happenings of Allan Kaprow in the elegant, uptown gallery of Martha Jackson. He went on to become Castelli's gallery director, a position he held during the momentous years of 1959 to 1969. Karp's outspoken, aggressive personality offset Castelli's more elegant, European charm, and the New Yorker's enormous skill at generating press commentary proved decisive to the successful manipulation of critical opinion regarding the gallery's artists. Eventually, Karp assumed responsibility for the important and often daunting task of viewing the work of idealistic young painters for his employer, who preferred to advise collectors and curators. This commitment to up-and-coming artists became the focus of the eclectic O.K. Harris Gallery, which Karp opened in October 1969.

After five years as director of the Hansa Gallery, an artists' co-operative, Bellamy opened the loosely run Green Gallery in 1960 with funding from the taxi magnate and collector Robert Scull. Unlike Castelli, Bellamy selected his artists by personal preference and in recognition of their pressing need for exhibition space. The plaster cast figures of George Segal, the multi-media creations of Lucas Samaras, the billboards of James Rosenquist, the constructions of Mark di Suvero and the Minimalist works of Donald Judd, Dan Flavin and Robert Morris were all presented at the Green Gallery before it succumbed to financial difficulties in 1965. Bellamy had continued to work closely with Castelli, drawing the older dealer's attention to, for example, Richard Serra, Bruce Nauman and Keith Sonnier.

Many dealers who later became prominent worked for established galleries before finding their own place in the art world. John Weber (*b.* 1932) offered Jim Dine and Robert Indiana their first one-man shows when he took over from Karp at the Martha Jackson Gallery in 1960. But it was Weber's association with the Virginia Dwan Gallery, whose director he was from 1967, when it moved from Los Angeles to New York, until its closure four years later, that fostered his close identification with the Earthwork artists Walter De Maria, Michael Heizer and Robert Smithson, as well as the Minimalists Sol LeWitt and Robert Ryman.

In 1971 Weber opened his own exhibition space at 420 West Broadway in SoHo, the building in which the more renowned Castelli and Sonnabend galleries were also located. Paula Cooper, whose artists included Jonathan Borofsky and Joel Shapiro, had opened her gallery in this former industrial area of lower Manhattan by 1968, but it was with the inauguration of the 420 building that the contemporary art scene moved from up-town to down-town. Soon after, SoHo emerged as the centre of the international art world.

The young dealer Mary Boone (*b.* 1951) began her rise to a position of power when she took a space at the 420 building in 1977. Perhaps reacting against the reification she found in the Minimalist painters Brice Marden and Dorothea Rockburne, with whom she had worked at Klaus Kertess's Bykert Gallery, Boone turned towards representing art that was more emotional and painterly. She soon emerged as the key dealer for Neo-Expressionism. While promoting her male-dominated stable of art stars, who included Ross Bleckner, Eric Fischl, David Salle and Julian Schnabel, Boone became part of the media-orientated art boom of the 1980s. She assumed the role of reigning queen of SoHo, inspiring endless interviews and press coverage. In 1981 she combined forces with the still-dominant Castelli to show the works of Schnabel, a joint effort that furthered Boone's ascendancy while confirming Castelli's standing as a leading force in the market.

Part of the reason for the power of the art dealer in the decades following 1960 may have been a lack of direction in New York's museums. With the exception of several ground-breaking exhibitions, The Museum of Modern Art, the Guggenheim Museum and the Whitney Museum of American Art failed to focus consistently on developing trends and new talents, leaving responsibility for this to galleries and alternative spaces. Perhaps this has been the case ever since Durand-Ruel supported the French Impressionists in the late nineteenth century. The American dealer's place in the art world can best be summed up by recalling a comment made by that most famous of Americans in Paris, Gertrude Stein. When Picasso boasted to her about a forthcoming exhibition of his work at The Museum of Modern Art, Stein retorted with a devastating 'no museum can be modern'. This certainly applies to the fortunes of avant-garde art in New York, where it was left to a select group of knowledgeable and perceptive dealers to shape the development of American art in the twentieth century.

Carter Ratcliff

'The Body Electric': The Erotic Dimension in American Art

In November 1974 *Artforum* magazine published a colour photograph of the sculptor Lynda Benglis in the nude. Her skin looks well tanned and liberally oiled. Slim yet decidedly feminine, the artist's body is arranged in a hip-slung pose, with back arched – a sexy contrapposto. She has cut her hair short and greased it back. The expression on her lips hovers part-way between a pout and a sneer, and there is an allusion to Lolita in the white-rimmed sun glasses that hide her eyes. From Benglis's crotch extends a long and meticulously detailed dildo, held in place by her right hand.

Intended to illustrate an essay on her sculpture, this portrait of the artist with a synthetic phallus so scandalized the editors of *Artforum* that they banished it to the advertising pages.[1] Nowadays, Benglis's flirtation with pornography is remembered as a short and quirky interlude in a long and successful career, yet it was more than that. With her precedent-setting dildo, she prepared the American art world for sexually explicit images by artists who flourished in the 1980s – Eric Fischl, Jeff Koons and Cindy Sherman. Pictures of Koons assuming self-consciously erotic poses with the Italian porn star Cicciolina show an obvious debt to Benglis. More subtly, Benglis's hermaphroditic charade of 1974 illuminates the sexuality lurking in the art of certain predecessors – Jackson Pollock, in particular.

In an art world scaled to the swagger of figures such as Pollock and Willem de Kooning, said Benglis, art is 'all about territory', and there is only one pertinent question: 'How big?' How big is the zone you capture and occupy with your painting, your floor sculpture, video piece, your public persona? How powerful is the image that establishes your presence? As Benglis saw it, American art was a 'heroic, Abstract Expressionist, macho, sexist game'.[2] Her male colleagues tended to see it the same way, though they shrugged off her accusatory tone. Taking it as axiomatic that serious art is a product of a 'tough' sensibility, they expected the serious artist to show masculine aptitudes, temperamentally and even physically.

Painting from the shoulder, not the wrist, de Kooning gigantified the pictorial architecture that he had inherited from the School of Paris. Undeniably, there is athletic bravura in the brushwork that churns over the surfaces of the *Woman* pictures (see Cat. 97, 98) he painted in the early 1950s. Evoking demonically powerful females, the artist put all his strength on display. Yet his colours learned from his subject how to be lush and, as his career lengthened into the 1960s and beyond, de Kooning often flirted with prettiness. Still, the image of the New York painter as a two-fisted tough guy persists. Many commentators, the artist among them, have compared the trajectory of Pollock's flung paint to the arc of a male's urine.[3] He could just as well have noted that his method mimics ejaculation too.

Introduced by this metaphor, a Pollock drip painting looks like the product of explosively masculine energies – a seminal image (see Fig. 2, p. 80). With her dildo, Benglis mocked the figure of the toweringly phallic artist, and with her naked femininity she suggested that we are too quick to assign a male nature to art made with vigorous gestures. After all, it was with gestures more sweeping than Pollock's that she made her far from macho floor sculptures – puddles and heaps of hot pink and green latex. Approached from the direction of these flamingly sensuous objects, his poured paintings seem vigorous but not slashingly aggressive. Look past the image of Pollock as the he-man artist and you see that certain passages in his work are gorgeous, if brash. He was capable of preciosity, even, as were all the heroes of the so-called New York School's founding generation – de Kooning, Franz Kline, Robert Motherwell. Like Benglis's dildo, the hyper-masculinity of American art and artists is

1. Robert Pincus-Witten, 'Lynda Benglis: The Frozen Gesture' (1974), in *The New Sculpture 1965–1975: Between Geometry and Gesture*, exhibition catalogue, New York, Whitney Museum of American Art, 1990, pp. 310–13. Benglis's portrait appeared on p. 7 of *Artforum's* November 1974 issue.
2. Lynda Benglis, quoted in Pincus-Witten, op. cit., p. 312.
3. Patsy Southgate, quoting Jackson Pollock, in Jeffrey Potter, *To A Violent Grave: An Oral Biography of Jackson Pollock*, New York, 1985, p. 88.

fake, a product of make-believe. At their strongest, works of American art aspire to a sensuality prior to the social construction of gender.

Among the milling crowd of Pollock's sculptural descendants is Richard Van Buren, who achieved flashy, theatrical effects by covering walls with poured and spangled bits of fibreglass. Rafael Ferrer smeared walls with wide swaths of grease, as an adhesive for handfuls of hay, and Barry Le Va scattered all manner of mundane materials on gallery floors, guided only by the most flexible protocols. On occasion, materials touched by an expansive impulse evanesce, as when Alan Saret's seemingly casual tangles of wire dissolve into clouds of light.[4] This art surges and flows and at times writhes with a manifestly physical pleasure. It symbolizes the happily polymorphous body, at once enveloped and enveloping. Though it feigns mindlessness on occasion, art of this sort can betray something like wit.

Until the waters of Utah's Great Salt Lake submerged it, Robert Smithson's *The Spiral Jetty* (Fig. 3, p. 134) made a Pollock-style gesture at the scale of the far western desert. Built in 1972, this rock and gravel earthwork coiled over the lake's surface to a length of 1,500 feet. Turning in on itself, it was a vortex designed to engulf the landscape. With its direction reversed, Smithson's *Jetty* became a projectile ready to penetrate the same immensity. At once vaginal and phallic, this large sculpture made a small joke about the mutability of gender. Beyond the joke is the sculptor's faith that, in making *The Spiral Jetty*, he found unity with matter, space and light on an American scale.[5]

To identify oneself with the immensity of America is a grandiose and sexually ambiguous sort of nationalism. In consummating the union, who or what plays which role? No artist has spoken directly of the experience. To hear it discussed, we need to attend to Walt Whitman, whose blending with America began with a happy image of himself as 'a kosmos, of Manhattan the son, / Turbulent, fleshy, sensual, eating, drinking and breeding.' To extend this self-regarding pleasure, he turns to others as to further elaborations of his own being. 'In all people I see myself', he announces, 'And the good or bad I say of myself I say of them.' Feeling that he simply is the American people, Whitman embraces the land in its vastness: 'my elbows rest in seagaps, / I skirt sierras, my palms cover continents.'[6]

This feeling of orgasmic oneness with the New World recurs in the art of Marsden Hartley, Arthur Dove and Georgia O'Keeffe, painters whom we meet on the way back from Whitman's century to our own. Granted, O'Keeffe insisted on not drawing equations between female anatomy and natural things, especially flowers. Yet in her pictures of irises and other, less easily identified varieties, petals are voluptuously labial (see Fig. 1, p. 47). By irresistible implication, the unseen interior of an O'Keeffe blossom is vaginal. Her flower pictures had a scandalous allure in the 1920s and, half a century later, made her a feminist hero. Since the 1970s her stature as a political figure-head has grown so steadily that it is difficult to see how much she has in common with male contemporaries such as Dove and Hartley.

Though alert to Cubist and Expressionist innovations in Europe, these American modernists never tried to maintain properly avant-garde allegiances to one style or another. Remaking and mingling the shapes of observed things, Dove arrived at abstraction (see Cat. 33, 34). Instead of detailing a place, he evoked its weather, drawing no distinction between external conditions of sun or rain and the inward climate of his feelings. In his late, schematic manner Hartley frequently painted homages to the fishermen of Maine. Alternating these expressions of homosexual love with pictures of the Maine coast, he gave to rocks and clouds the same rapturous, brooding care that he lavished on flesh. Each object of his affection was the momentary occasion for a persistent, pan-sexual yearning. His art is a promiscuous grappling with the presence traditionally called 'Nature'. The struggle is friendly, yet there is always a victor: the artist, who imprints his presence on the American landscape and thus indexes it to the passionate body.

You see this wide, urgent embrace in the art of O'Keeffe and Dove and other American painters of their time, among them Charles Burchfield and John Marin. Because Whitman and Pollock and so many of their descendants also display this exu-

4. For a survey of these episodes, see Marcia Tucker and James Monte, *Anti-Illusion: Procedures/Materials*, exhibition catalogue, New York, Whitney Museum of American Art, 1969.

5. Robert Smithson, 'The Spiral Jetty' (1972), in *The Writings of Robert Smithson*, ed. Nancy Holt, New York, 1979, pp. 109–16.

6. Walt Whitman, 'Song of Myself' (1855, 1891–92), in Justin Kaplan, ed., *Walt Whitman: Complete Poetry and Collected Prose*, New York, 1982, pp. 206, 210, 219. The quotation in the title of the present essay is taken from Whitman's poem 'I Sing The Body Electric' (1855); ibid., p. 127.

7. Ralph Waldo Emerson, 'Nature' (1849), in Joel Porte, ed., *Emerson: Essays and Lectures*, New York, 1983, pp. 10, 14.

8. Barnett Newman, respectively 'The First Man Was an Artist' (1947) and 'The Sublime is Now' (1948), in John P. O'Neill, ed., *Barnett Newman: Selected Writings and Interviews*, New York, 1990, pp. 158, 173.

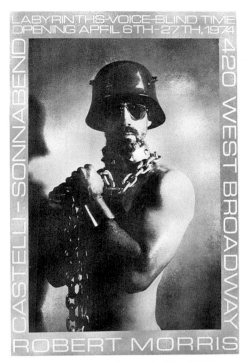

Fig. 2 Robert Morris, Poster for his exhibition at the Castelli-Sonnabend Gallery, New York, 1974

berant pan-sexuality, it begins to look like the essentially American trait. However, we should not overlook the American inclination to be chaste. This is another facet of the same pervasive awareness of the body.

In a carnal spirit Whitman embraced an infinitely large idea of America. Though Ralph Waldo Emerson's idea of his nation was as grand as Whitman's, and his embrace as wide, he favoured vision over touch. With his sensual urges spiritualized, Emerson described himself as a 'transparent eyeball' adrift above the American landscape. As 'the currents of the Universal Being' flow through him, he becomes 'the lover of uncontained and immortal beauty'. Sustaining his love through vision, Emerson became exceedingly sensitive to light, which he called 'the first of painters'.[7]

Declaring a century later that 'the first man was an artist', Barnett Newman cast himself as a master of the American light, the spiritual illumination that removes from our eyes 'the nostalgic glasses of history' and reveals 'our relationship to the absolute emotions'.[8] His wide fields of luminous colour (see Cat. 107–12) promulgate the faith that, in the New World, art and the artist are renewed. For Newman, a successful painting is less an image than a presence that reveals truths too elemental for language to enunciate. A melancholy variant of the same American light fills the canvases of Mark Rothko (see Cat. 113–18). Under Clyfford Still's agitated touch, such radiance turns melodramatic and the New York School sublime shows its Gothic shadows (see Cat. 103–6).

Though he was ethereal in comparison to Whitman, Emerson looks sybaritic beside the nineteenth-century sectarians called 'Shakers'. Strictly celibate, these rural utopians practised a severe style of carpentry that has attracted many admirers among contemporary American artists. Donald Judd, in particular, has cited the plain, practical forms of Shaker furniture as a precedent for his Minimalist boxes (see Cat. 202, 204). Though he often covers these metal objects with coats of lush colour, their prim forms give them an aura of simple American virtue. There are variants of that primness, that earnest clarity, in Minimalist sculpture by Carl Andre, Sol LeWitt and Robert Morris, though the grey boxes Morris made in the mid-1960s stand apart. Vaguely coffin-like, the largest of them seem less chaste than numb.

Doting on death, Morris does not deny sensuality so much as inflict it with a chill. Particularly cold seasons freeze his images in sexually violent postures. In 1974, the year of Benglis's portrait with dildo, Morris appeared on an exhibition poster naked and statuesque in a helmet, dark glasses, a spiked metal collar and chains (Fig. 2). His apocalyptic pictures of the next decade prophesy universal violence. This is American pan-sexuality in a sado-masochistic mood. In Morris's apocalypse Newman's revelatory light turns cruel and Pollock's unbounded energies become destructive.

Fig. 3 Robert Rauschenberg, *Monogram*, 1955–59. Moderna Museet, Stockholm

The American taste for absolutes is strong but never absolute. Early in the 1950s Robert Rauschenberg made all-black and all-white paintings. Soon, though, he was loading his canvases with pictorial incident and found objects: de Kooning-style brush-marks, scraps of newsprint and lumber, fragments of furniture, and what not. Splashing the quilts and sheets of *Bed* (Museum of Modern Art, New York) with shrieking colour, Rauschenberg evoked much, from nightmares to sexual assault. In *Monogram* (Fig. 3) with its billy goat stuffed through the tight ring of a car tyre, there is a rebus of penetration to be read.

The commercial technique of photographic silk-screening encouraged Rauschenberg to flood his canvases with pictures gathered from art books and magazines, from the television screen and through the viewfinder of his camera. In *Barge* (1962–63; National Gallery of Art, Washington) the curves of a super-highway mimic the haunches of Velázquez's *Rokeby Venus*. All across this 32-foot-long canvas bits of images mirror, jostle and infiltrate one another, churning up a field that feels, like a big Pollock canvas, potentially infinite.

Ecstatically splashing in the image-currents of ordinary life, Rauschenberg drew attention to subjects that had gone unseen by ambitious artists. Coolly, Jasper Johns did the same, and soon the Pop artists had appeared. In 1961 Tom Wesselmann launched his series *Great American Nudes* (see Fig. 4) – anonymous female sex objects on display in tableaux accented by images of consumer products. These paintings and wall sculptures are as bluntly erotic as skin-magazine centrefolds, almost. Claes Oldenburg's soft sculptures are more allusive (see Cat. 170–2). Like household objects in form, they have the weight of flesh. Sometimes engorged but usually flaccid, these appliances and plumbing fixtures appear to be caught in an endless round of sexual excitement and exhaustion. Oldenburg gets at the obsessions and disappointments that drive consumerism.

In Oldenburg's version of Pop Art lurks a quirky impulse towards satire. There is no satire, only obsession, in the peculiarly chaste art of Andy Warhol. His flat, repetitive pictures of stars such as Marilyn Monroe, Elvis Presley and Jackie Kennedy promulgate an aesthetic of the crush – the adolescent infatuation with some untouchably glamorous presence (see Cat. 183, 184). These stars included Campbell's soup cans and Brillo soap pads, for Warhol had a crush not merely on famous people, but also on the supermarket's plenitude of brand-name goods (see Cat. 185, 186). Desire has materialized into commodities. In imagination Whitman embraced the American people and blended with them. Pollock's gestures gave him an imaginary oneness

Fig. 4 Tom Wesselmann, *Great American Nude No. 57*, 1964. Whitney Museum of American Art, New York

Fig. 5 Eric Fischl, *Bad Boy*, 1981. Saatchi
Collection, London

with unbounded American space. Warhol, too, identified himself with America, let-
ting all his attention be absorbed by the endless field of American stars. As he found
a place in the array of celebrities he so promiscuously adored, Warhol's art defined
sexuality as narcissism unalloyed.

In obscure corners of Warhol's oeuvre are a few explicitly sexual images. Most are
homosexual, though several show a naked man and woman in a casual embrace. None
offers the affront of Benglis's portrait with dildo or of Morris's rough-trade beefcake.
That sort of aggression was rare in American art until the 1980s, when a period of
uninhibited sexual illustration began. In Eric Fischl's pictures (see Fig. 5) the un-
expected nakedness of certain figures introduces sexual tensions into otherwise unex-
ceptionable scenes of suburban family life. The effect is always mysterious. Fischl is
given to theatrical lighting effects and subtly skewed perspectives, and he likes to load
his pictorial narratives with insoluble clues. Still, he conveys a sharp and uneasy
nostalgia for the onset of adolescent sexuality.

Fig. 6 Jeff Koons, *Position Three*, 1991. Galerie
Max Hetzler, Cologne

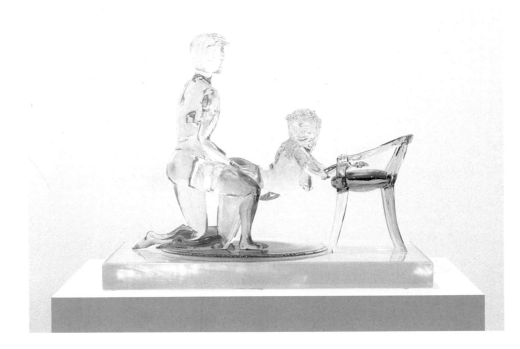

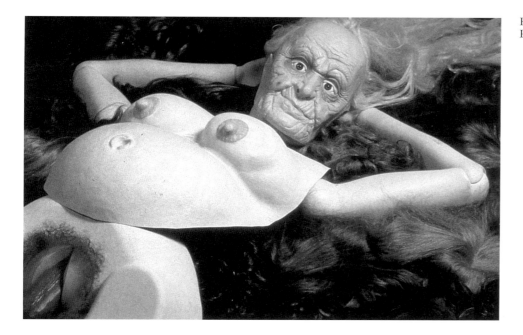

Fig. 7 Cindy Sherman, *Untitled*, 1992. Metro Pictures, New York

Nothing mars the happiness of Keith Haring's universe (see Cat. 235, 236). As spaceships hover and dogs bark, androgynous babies multiply by some method other than the usual one. Arranging his creatures in narrative patterns, Haring often told sexual stories. Sometimes a drawing's copulating figures proliferate until it is impossible to distinguish one body from another. Line itself becomes orgasmic, as in the dripped, poured and splashed canvases of Pollock. In Haring's hands, Pollock's subtly ordered intimations of the infinite become images of exuberant disorder, as on a down-town Manhattan dance-floor.

All is carefully controlled in the sugary world where Jeff Koons executes sexual manoeuvers with Cicciolina (see Fig. 6). His fanatically detailed pictures and statues of their couplings illustrate an idea of utopia. If we attend carefully, he promises, we will be the better for it. Talking of a film he planned to make with Cicciolina, the artist said that 'Jeff Koons is there for people to become who they are. And after someone views the film, they are … going to have the impression that "I can be this, I am this, I am becoming this." … The public will only have an impression of what they can become.'[9] The promise is that sex, or the spectacle of Koons having it, is good for you. Remarkably, he gives signs of being convinced by his own moralizing. Cindy Sherman's kind is more convincing, or at least more unsettling.

For more than a decade Sherman has taken photographs of herself in assumed roles (see Cat. 242–5). At first, these were familiar stereotypes from B-movies – the quietly sexy librarian, the would-be career woman freshly arrived in Manhattan. Slowly, her self-images became more bizarre. She impersonated a coven of grotesque hags in one series of photos. Another showed her as a corpse half silted over by waves. Sherman has vanished from her most recent works, as masks, false breasts and bellies, and bits of mannequins arrange themselves in allegorical figures of sexual horror. All are contorted, some are mutilated. The most dreadful one (Fig. 7) leers at us as she gives birth to something unidentifiable. These figures preach caution. Of the dangers conjured up, AIDS is only the most obvious.

Reaching back to her earlier work, the calm and ghastly light of her new pictures casts shadows over the very notion of gender. Sherman's illustrations of sexual trauma are persuasive at present. Yet the most abidingly powerful images are not illustrative. In American art, anyway, the images that remain strong over the seasons are enacted by exemplary gestures. And the strongest of these gestures are charged, like Pollock's, with a sensuality that sweeps aside all limiting notions of gender.

9. Quoted in Andrew Renton, 'Jeff Koons', *Flash Art*, vol. 23, no. 153, Summer 1990, p. 112.

Karal Ann Marling

The Media in America: But is it Art?

A selection of incidents from the media during 1992:

• George Holliday, the bystander who videotaped the beating of Rodney King by Los Angeles police officers on 3 March 1991, sues film-maker Spike Lee for infringement of copyright, charging that the footage Lee has incorporated into his upcoming movie, *Malcolm X*, was illegally obtained. The discrepancy between Holliday's tape of King being brutalized by the cops (Fig. 1) and the verdict of a jury that concluded they didn't do it sparked off the L. A. riots. A second video, showing lorry driver Reggie Denny hauled from the cab of his vehicle and beaten by rioters, is expected to figure in their trial.

• Bill McKibben, a writer for the *New Yorker*, watches cable television in a Washington suburb for twenty-four hours straight off. He sees some amazing stuff – yowling televangelists, obscure sporting events, infomercials for products almost too bizarre for the normal retail trade and endless re-runs of sitcoms. Then he spends a day alone on a mountain. The conclusion: TV sucks. It flattens out the specificity and pungency of life into one vast, undifferentiated, placeless, timeless package of spiritual snack food for nineteen-year-olds. If this is the global village Marshall McLuhan prophesied in the 1960s, McKibben wants no part of it. He'd rather be Thoreau jun., playing at hermithood somewhere in the Adirondacks.[1]

• On the tenth anniversary of its first release, Ridley Scott presents a new version of his sci-fi thriller *Blade Runner* – a so-called 'director's cut'. Perhaps the original film looks a little too much like Rodney King's Los Angeles for comfort. But Scott claims he has re-edited the story to highlight a romantic sub-plot. In one of the most famous passages in American literature, the narrator of F. Scott Fitzgerald's *The Great Gatsby* gently tells the hero that he can't alter the past to suit his fancies. 'Can't repeat the past?' Gatsby cries. 'Why of course you can.'[2] Well, Jay Gatsby was apparently right all along. The new, hearts-and-flowers *Blade Runner* proves his point.

• In an impassioned Op-Ed piece for the *Los Angeles Times* Emmy-winning producer Steven Bochco (of *L. A. Law* and *Hill Street Blues*) complains about too much

Fig. 1 Still from George Holliday's video of Rodney King being attacked by Los Angeles police officers, 3 March 1991

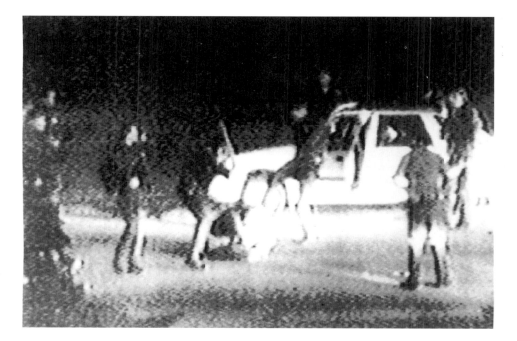

1. Bill McKibbon, *The Age of Missing Information*, New York, 1992, pp. 52–3.
2. F. Scott Fitzgerald, *The Great Gatsby*, in Arthur Mizener, ed., *The Fitzgerald Reader*, New York, 1963, pp. 185–6.

market research and too many commercials on network TV. 'I'd acknowledge television as an art form', he concludes, 'and challenge those working in the medium to redefine their standards of excellence accordingly.'[3]

• The largest indoor shopping mall in the world opens in suburban Minneapolis/St. Paul, a few miles from the first indoor mall ever built (in 1954–56). This new mega-mall, the Mall of America, consists of more than three hundred stores centred on an amusement park replicating the adventures of Charles Schulz's cartoon beagle, 'Snoopy', from the *Peanuts* comic strip. Two years earlier, the French Minister of Culture Jack Lang had named Schulz 'Commandeur des Arts et Lettres' in recognition of his contribution to world art. For the opening of the *Peanuts* retrospective at the Musée des Arts Décoratifs in Paris, Snoopy appeared in a suit designed by couturier Christian Lacroix.

Oh – and one more thing.

• In *Home Fires*, a book that follows a middle-class family from the Second World War to 1990 using techniques of documentary film or home video, Donald Katz finds his subjects in 1948 gathered around a ten-inch TV set bought on the weekly payment plan. The neighbours are there, too, three dozen strong. TV sets are still novelty items. Owners are trend-setters, electronic pioneers. A professor looking into the phenomenon finds that watching TV stifles conversation, except during the commercials, when everybody talks as quickly as possible in 'a new kind of rapid discourse'. In 1948 people who have sets spend an average of three-and-a-half hours a day in front of them.[4]

So what, if anything, do these assorted incidents have in common? Urban riots. Books based on TV. Film *auteurs* adding moustaches to their own *Mona Lisa*s. Cartoon critters in the round. California culture ascendant or in flames. Bred-in-the-bone contempt for the media coexisting with the wistful notion that television might still aspire to the condition of fine art? Factoids. Fragments. Marshall McLuhan, the Canadian professor of literature who became America's best-known media theorist of the television age, treated argumentation as a discontinuous process. In the old-fashioned print media, for which he had increasingly little use, things moved from left to right in a logical lock-step. In the electronic age of pixels, everything was up there on the screen, all over, simultaneously. So McLuhan tried to write in a mosaic format, juxtaposing suggestive observations without 'proving' that one fact influenced another in any particular way. Hey, 'the *medium* is the message'.[5]

Form and content were both at issue in his work. His many professional critics, and they were legion, hated what McLuhan analysed: ads, comics and Charles Van Doren, the promising academic turned notorious prime-time game-show cheat. The anti-McLuhanites also despised the way he did it, in aphorisms and ellipses that look, in retrospect, like an afternoon of MTV translated into type.[6] That wasn't exactly McLuhan's point, but it was close enough. Television was a 'cool' medium, involving the viewer in a direct, sensory way, as s/he reconstructed images from scattered motes of light on the picture tube. Reality, in other words, was the responsibility of the guy in the La-Z-Boy chair with the cold beer. Although McLuhan harboured the odd belief that vision was not the primary sense engaged when families gathered before the tube, there was nothing passive about the collective, neo-tribal ritual being enacted around his electronic hearth. The mosaic made sense because the audience actively thought it did.

This attitude contrasts markedly with the stance of many of his peers, who looked hard at the subject-matter of popular art and despaired. It was purest kitsch, wrote Clement Greenberg in his famous essay in praise of the avant-garde, 'ersatz culture … the epitome of all that is spurious in the life of our times.'[7] And kitsch – whether in the form of dancing Alka-Seltzer bottles, moronic radio soap operas or 'adult' Westerns on television – was a conspiracy on the part of capitalist overlords variously to subdue, to arouse or to narcotize an audience of nitwits, according to its evil whims.[8] The spurious media culture was nothing more than a commodity, an instrument of oppression.[9] Ad men ruled the media and the media ruled the supine masses. *O tempora! O mores!* Alvin Toffler counted the number of dramatized classics

3. 'Here's what's wrong with TV!' *Minneapolis Star Tribune*, 8 September 1992, 7E.
4. Donald Katz, *Home Fires*, New York, 1992, pp. 36–7.
5. Marshall McLuhan, *Understanding Media: The Extensions of Man*, New York, 1964, pp. 7–8.
6. See, for example, Raymond Rosenthal, ed., *McLuhan: Pro and Con*, New York, 1968.
7. Clement Greenberg, 'Avant-Garde and Kitsch' (1939), in Francis Frascina, ed., *Pollock and After: The Critical Debate*, New York, 1985, p. 25.
8. Herbert J. Gans explains and disputes this reasoning in *Popular Culture and High Culture: An Analysis and Evaluation of Taste*, New York, 1974, p. viii.
9. See, for example, Max Horkheimer and Theodor W. Adorno, 'The Culture Industry: Enlightenment as Mass Deception', in *The Dialectic of Enlightenment*, trans. John Cumming, New York, 1972, for the best-known formulation of a thesis latent in many American texts of the 1950s, including John Kenneth Galbraith's *The Affluent Society* (1958) and Vance Packard's *The Hidden Persuaders* (1957).

and symphonies broadcast by the networks in a given year in a valiant effort to prove that mindless trash and the TV set were not always synonymous.[10] But Newton Minow, Chairman of the Federal Communications Commission, in a famous 1961 speech, called the broadcast industry 'a vast wasteland' of tasteless, debasing dreck.[11]

The distrust of media-made 'art' or popular culture in the 1950s and early 1960s had something to do with the exalted status of high art. Beginning with Abstract Expressionism, American art was one of the major ideological weapons of the Cold War era. Its gestural imagery stood for freedom and its scale for American cultural aspirations: Jackson Pollock and his contemporaries proved that the United States was a leader in art as well as in the technology of consumer merchandise. And, along-side the Soviet Union and the Sputnik (1957), America could further claim a certain moral superiority from the Pop artist's critique of tail fins, ads, comics and processed food. Despite his preaching in favour of TV, McLuhan himself larded his prose with reverential twaddle about artists of the avant-garde persuasion shooting non-elec-tronic 'probes' into a future mere mortals glued to their sets could scarcely imagine. Finally, despite the fact that Pollock, Andy Warhol and the others were marketed like refrigerators or rock stars, art seemed insulated from the grubby grasp of capitalism by its own pictorial inscrutability.[12] What did these drips *mean*? These soup cans? Only the critics knew for sure.

There were movie critics, too, of course. Even the weekly *TV Guide* offered occa-sional commentary on the significance of *Bonanza* or *I Love Lucy* along with the chan-nel listings.[13] In general, however, the media confirmed the American tradition of individualism, whereas art, mediated and interpreted by 'experts', advanced the anti-democratic claims of class, meritocracy and a self-selected élite. The effect is more readily apparent in politics than in aesthetics. The Rodney King video, for instance, makes every viewer a judge, an expert, just as the daily spectacle of the Vietnam War, once broadcast in living colour during the dinner hour, let viewers judge Lyndon Johnson, William Westmoreland and the other military experts. Abraham Zapruder's home movie of the Kennedy assassination continues to challenge official accounts of what happened in Dallas in November 1963. The media level the playing field. By permitting free access to images – and to pictures that have evaded cultural censor-ship – they have always served the interests of the immigrant, the illiterate, the per-son without high standing or influence, the average American. If they are anarchistic forces as well, perhaps chaos in Los Angeles is the price of accessibility. But they are basic to the American national character.

In an ingenious essay on advertising Daniel Boorstin traces American anarchy, along with individualism, hyperbole, optimism and an obsession with novelty, to the ads that brought newcomers across the Atlantic in the first place.[14] According to his analysis, fanciful woodblock prints in exploration chronicles, illustrated handbills for the railroads, dime novels, paperback almanacs and Buffalo Bill's *Wild West* were crude versions of the modern media, spreading the news of a new land and touting its real and mythical virtues. Such 'advertising', he writes, 'has become the heart of the folk culture and even its very prototype'. And for most of the nineteenth century, folk expression and art were not altogether dissimilar: George Washington looked much the same in a Rembrandt Peale oil painting as in the bowl of a souvenir spoon from the 1893 World's Columbian Exposition.[15] The American Art Union flourished at mid-century under a lottery system whereby all members got an engraving of the genuine oil painting awarded to a single, lucky ticket-holder. The medium, not the message, was the watershed between high and low art in an emerging age of mech-anical reproduction. The media were multiples, made possible by the new technology of the industrial world.

Mass culture, media culture, begins in earnest with the Columbian Exposition and the other great American fairs of the turn of the century. In Chicago, St. Louis, Buffalo and San Francisco huge crowds, undifferentiated by income or learning, gathered to celebrate progress around giant machines that wove yard upon identical yard of carpet, printed newspapers by the bundle and cranked out thousands of souvenir handkerchiefs, each one bearing the same likeness of the Father of His

10. Alvin Toffler, *The Culture Consumers: Art and Affluence in America*, Baltimore, 1964, pp. 21–32.
11. Quoted in Lynn Spigel, *Make Room for TV: Television and the Family Ideal in Postwar America*, Chicago, 1992, p. 48.
12. See Christin J. Mamiya, *Pop Art and Consumer Culture: American Super Market*, Austin, 1992.
13. See Glenn C. Altschuler and David I. Gross-vogel, *Changing Channels: America in 'TV Guide'*, Urbana, 1992.
14. Daniel J. Boorstin, 'Advertising and American Civilization', in Yale Brozen, ed., *Advertising and Society*, New York, 1974, pp. 12. 23.
15. See Karal Ann Marling, *George Washington Slept Here: Colonial Revivals and American Culture, 1876–1986*, Cambridge, MA, 1988, pp. 160–2. For the relationship between fine and popular art in the nineteenth century, see Lawrence W. Levine, *Highbrow Lowbrow: The Emergence of Cultural Hierarchy in America*, Cambridge, MA, 1988.

Country. Often the festivities took place in buildings constructed with the latest interchangeable, factory-made parts but artistically disguised as temples of Imperial Rome. Art conferred dignity on the products of the machine. Art looked singular, stunning, unique – in marked contrast to the gewgaws *any* tourist could take home, secure in the knowledge that his pictorial handkerchief was just like all the rest.

Tradition vs. innovation. The past vs. the present. Art vs. the media. The first home-grown avant-garde movement in American painting of the twentieth century hinged on such polarities. The artists of the so-called Ashcan School assimilated media iconography into their paintings (see Fig. 2). Specifically, they represented the amusements and the vibrant street life of the urban masses – especially of children – or pictorial themes common to both craven journalism and the reformist magazine photography of Lewis Hine.[16] The transgressive element in Ashcan art – the group was called 'the black revolutionary gang' – was not its *alla prima* technique but its hard-bitten, press-room topicality. According to the experts, art in gilded frames was supposed to trade in loftier stuff altogether: sentiment, sensibility, beauty, eternal truths.

Until D. W. Griffith came to 'reform' the movies with doses of Biblical historicism and morality, the early motion picture industry also dwelt on popular Ashcan School themes.[17] As long as the films were silent and the aesthetic derived from movement, movies enjoyed some intellectual standing as a crude folk art. Charlie Chaplin was OK. So was the antic, street-wise Mickey Mouse of the 1920s. But when cinema 'artists' had the temerity to suggest that the movies might actually be a new kind of art in their own right, the distinction between mere media and real culture was swiftly reasserted (see Fig. 3). In 1912 Winsor McCay, brilliant newspaper cartoonist and father of modern animation, lamented the fact that Michelangelo never got the chance to draw for the movies. 'The coming artist', he predicted, 'will make his reputation not by pictures in still life, but by drawings that are animated.'[18] But when he tackled a serious, contemporary subject with tragic overtones in *The Sinking of the Lusitania* (1918), the artistic merits of McCay's effort were admired chiefly by other animators. When Walt Disney wedded classical music to the cartoon format in his 1940 *Fantasia*, the film was a critical disaster and a financial flop.

Yet, throughout the 1930s, détente between art and the media had seemed inevitable. Government relief programmes were bringing murals to public buildings in places where the only art was in the form of greeting cards, calendars, picture maga-

Fig. 2 John Sloan, *Picture Shop Window*, 1907. The Newark Museum, Newark, New Jersey; Gift of Mrs Felix Fuld, 1925

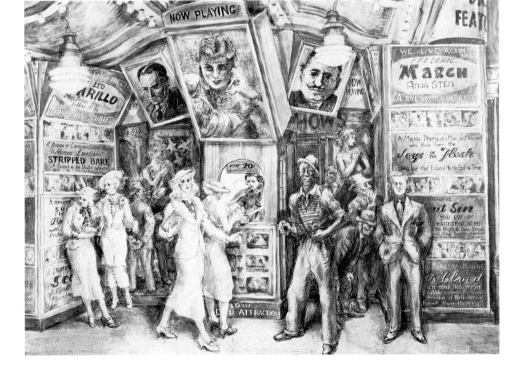

Fig. 3 Reginald Marsh, *20-Cent Movie*, 1936. Whitney Museum of American Art, New York

16. On the entertainment media of the streets, see Rob Snyder, *The Voice of the City: Vaudeville and Popular Culture in New York*, New York, 1989.
17. See Lary May, *Screening Out the Past: The Birth of Mass Culture and the Motion Picture Industry*, New York, 1980, esp. chs. 2 and 4.
18. Quoted in John Canemaker, *Winsor McCay: His Life and Work*, New York, 1987, p. 134.

Fig. 4 Thomas Hart Benton, *Hollywood*, 1937.
Nelson-Atkins Museum of Art, Kansas City;
Bequest of the artis

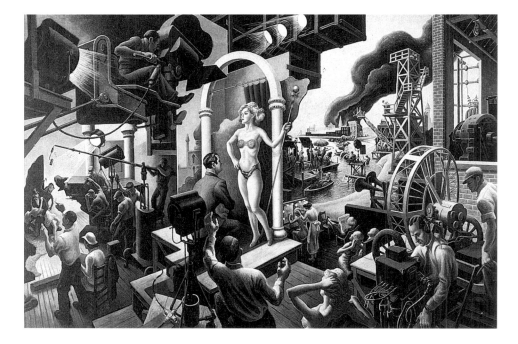

zines and movies with elevated themes.[19] Under the auspices of Associated American
Artists, a private New York firm that sold prints by established figures through a mail-
order catalogue at department store prices, a number of prominent painters, includ-
ing Grant Wood and Thomas Hart Benton (see Fig. 4), went to Hollywood to work
for the studios.[20] Benton was a Disney in reverse, peddling his painterly services to the
media as a publicist and a reporter. Thus, it is hardly surprising that Disney should
have hired Benton and the Surrealist Salvador Dalí to work on a sequel to *Fantasia*,
eventually abandoned in the fire-storm of mockery that greeted his presumptuous
foray into art.

After his brush with high art, Disney returned to the media with a vengeance,
becoming, arguably, the single most influential force in twentieth-century visual cul-
ture. First, he reconfigured the media: at Disneyland (1955) virtual reality took on
three dimensions and viewers could literally inhabit the film or TV show. He was the
first of the Hollywood moguls to cease hostilities with television and develop the syn-
ergistic relationship between one medium and the other. Home viewers could change
the channel from a Western to a cartoon; tourists at Disneyland could stroll from
Frontierland into the precincts of Fantasyland, presided over by Donald Duck and

Fig. 5 'Main Street U.S.A.', Disneyland,
Anaheim, California, 1955

19. See, for example, Karal Ann Marling, *Wall-to-
Wall America: A Social History of Post-Office
Murals in the Great Depression*, Minneapolis,
1982.
20. See Erika Doss, *Benton, Pollock, and the Politics
of Modernism*, Chicago, 1991, esp. ch. 3.

Mickey Mouse. The circular forms of Mickey's head constituted a visual esperanto, on a par with the Coca-Cola logo. In the new Disney park in Florida, opened in the 1970s, Mickey, the globe and a geodesic dome were conflated into one universal symbol of benign but omnipresent wholeness.

In the past decade Disney's corporate empire has been lauded for hiring cutting-edge architects – Michael Graves, Robert A. M. Stern, Frank Gehry – to design its theme parks and offices. In a real sense, however, post-modern architecture began with Disney, who recognized the imagistic power of the commercial vernacular and exploited it in Disneyland, almost twenty years before Robert Venturi suggested that architects might benefit from a closer look at Las Vegas.[21] The contemporary shopping mall, where 'real' post-modern architecture on the outside cloaks a vernacular interior that may include cowboy caryatids and whole amusement parks, can also be traced back to Main Street U.S.A. at the entrance to Disneyland (Fig. 5). In this rich stew of images, which is the medium and which the message? Where does the art stop and something else begin? Are malls media? Or solid, by-God things: architecture, art? Does it matter? It's everywhere, all the time, this 'whatever-it-is-ness'.

Between trips to the mall, after (or with) a daily dose of the morning funny pages, Americans now watch, on average, six hours of television every day. But it's not like the 1950s. The choices are staggering. Network. Cable: the all-Disney channel; old black-and-white movies, colorized by Ted Turner; Technicolor epics re-sized and re-edited for home use. The VCR. Video games. Grandpa's home movies translated to tape. McLuhan would be dazzled by the sheer level of potential involvement. Zapping through the channels. Sound off. Sound on. Everything green, or orange. Do-it-yourself television. Mutable. Personalized. Culture at Home. Art: where the pictures and the hot stories are – Rodney King's story, according to George Holliday's video. Pictures – movies – that are never quite the same twice: you *can* re-run the past any time, day or night, and make it better, or more colourful, or more artful. Take it or leave it. Go live on a mountain top. Or stay tuned for Eyewitness News at 11. Riots in L. A.

Fig. 6 Edward Kienholz, *Six o'Clock News*, 1964. Collection William N. Copley

21. Robert Venturi, Denise Scott Brown and Steven Izenour, *Learning From Las Vegas*, revised edn., Cambridge, MA, 1977.

Peter Selz

Americans Abroad

In 1766 John Singleton Copley, the foremost painter of the American colonial period, wrote to his compatriot Benjamin West in England, lamenting that in the American colonies not a single portrait was 'worthy to be called a Picture'.[1] Eight years later Copley went to England. There he painted his masterpiece, *Watson and the Shark* (1778; National Gallery of Art, Washington), was elected to the Royal Academy of Arts and spent the next forty years as a 'British' painter. West, who had left his native Pennsylvania for London in 1763, eventually succeeded Sir Joshua Reynolds as President of the Royal Academy.

Copley's was not the last such lament to be raised. Even a hundred years later, Thomas Cole, an artist of great spiritual aspiration, spoke regretfully of an American public that preferred 'things not thoughts'. American artists had to cope with a congeries of adversity in the nineteenth century. The work of the carpenter and the artisan was more highly valued than the rarefied pursuit of the arts; an egalitarian sensibility in the new republic found it hard to give special respect to artistic talent; and an ingrained Puritan tradition regarded the sensuous aspect of the visual arts with suspicion. In short, a fundamental anti-intellectualism, traceable at least as far back as the 1830s, the era of President Andrew Jackson, marginalized painting and sculpture. In the latter part of the century three of America's foremost artists, James McNeill Whistler, Mary Cassatt and John Singer Sargent, felt that England and France provided a more sympathetic artistic and intellectual environment, as well as better patronage, than their native country.

A generation later, Lyonel Feininger left New York for Germany, where he established himself as a painter. He was the first artist to join the faculty of the Bauhaus when it opened in Weimar in 1919, and he remained there until its closure in 1933. In America a supportive intellectual community of artists, writers and critics did not exist until the early years of this century, when Alfred Stieglitz established his gallery at 291 Fifth Avenue in New York, a place where new ideas could be exchanged. Stieglitz was a crucial cultural force in early twentieth-century America, an antidote to its inherent aesthetic provincialism. At the suggestion of his friend and fellow photographer Edward Steichen, he began in 1906 to show modern art as well as photography in the Photo-Secession Gallery at 291. He exhibited Rodin's boldly unconventional drawings of nudes, never before shown anywhere, and followed them with new drawings by Matisse. Then, in rapid succession, he introduced Toulouse-Lautrec, Cézanne, Brancusi and Picasso.

In the nineteenth century Americans who went to Europe for their training had gone to Rome, and later to the academies in Düsseldorf and Munich. But now they chose Paris. There, too, they were swept up in an atmosphere of invention. Alfred Maurer, who arrived around 1900, was the first American to be influenced by Matisse and the Fauves. Max Weber, arriving five years later, actually studied under Matisse in his famous class, which was also attended by Patrick Henry Bruce, Arthur B. Carles and Morgan Russell. Weber was in contact with Picasso during the incipient years of Cubism. He introduced the Spanish painter to his close friend Henri Rousseau and in 1910 arranged an exhibition of the *douanier*'s work at Stieglitz's 291 gallery.

Many of the Americans frequented Gertrude Stein's Saturday soirées in the rue de Fleurus. This most celebrated American expatriate and significant avant-garde writer had moved to Paris in 1903 and, together with her brother Leo, acquired key paintings by Cézanne, Matisse, Picasso and others. With extraordinary acumen the Steins selected the finest new art. For almost forty years Gertrude was an important intel-

1. John Singleton Copley, letter to Benjamin West, 12 November 1766; quoted in John McCoubrey, *American Art 1700–1960: Sources and Documents*, Englewood Cliffs, 1965, p. 14.

lectual catalyst. Stieglitz met her in 1908 and a year later published her biographical sketches of Matisse and Picasso in his journal *Camera Work*. The Italian-American painter Joseph Stella memorably described his encounter with Gertrude Stein: 'Somehow in a little side street in Montparnasse there was a family that had acquired some early work of Matisse and Picasso. The lady of the house was an immense carcass austerely dressed in black. Enthroned on a sofa in the middle of the room where the pictures were hanging, with the forceful solemnity of a priestess or Sybilla, she was examining pitilessly all newcomers, assuming a high and distant pose.'[2]

Marsden Hartley, a well-trained artist familiar with the new trends in painting, had a solo show at 291 in 1912, before sailing for Europe at the age of thirty-five. In Paris, at Gertrude Stein's salon, he met the American expatriates as well as French painters. Most important was his encounter with Wassily Kandinsky's book *On the Spiritual in Art*. At Hartley's suggestion, an excerpt from it was published in *Camera Work* in 1913. Hartley's series of abstract mystical paintings, done in Paris in 1912–13, which he called 'intuitive abstractions' and 'spiritual illuminations', conflated Henri Bergson's philosophy, Kandinsky's art theory and American Indian imagery. Hartley felt that the most significant new art was that being created in Germany by the *Blaue Reiter* group. He went to Berlin and Munich, made direct contact with Kandinsky and Franz Marc, and had five works included in Herwarth Walden's First German Autumn Salon in Berlin in 1913, the first truly international survey of avant-garde art.

During his Berlin stay, Hartley combined his response to the city's military pageantry with mystical symbolism in strangely emblematic compositions that reached their climax in *Portrait of a German Officer* (Cat. 1). Its flags and military insignia referred to an intimate friend who had been killed in action. Hartley achieved a tightly knit, Cubist-derived structure combined with the vivid, intuitive colour of German Expressionism. After the war, restless and insecure, he travelled from New York to Bermuda, to New Mexico, back to Paris and Berlin, spent several years in the south of France trying to enter the spirit of Cézanne in Aix, returned to Germany at the beginning of the Nazi period, and then went to Nova Scotia before settling in his native Maine in 1937, where, during the last six years of his life, he accomplished a powerful synthesis of his previous work.

The son and grandson of American sculptors, Alexander Calder had studied engineering before turning to art. Realizing that 'Paris seemed to be the place to go',

Fig. 1 Alexander Calder working on his Circus (1926–32)

2. Joseph Stella, 'Modern Art' (MS); quoted in John I. H. Baur, *Joseph Stella*, New York, 1971, p. 29.

he sailed for France in 1926. For the remainder of his long career, his time and energy were divided between France and America. In Paris he first made wire renditions of animals and people. These he then animated to create his famous Circus (see Fig. 1), which attracted the attention of the Parisian art world.

Calder, inspired by Joan Miró's free organic forms and Piet Mondrian's equilibratory colours, wanted to make three-dimensional versions of the latter's work. His kinetic sculptures, at first driven mechanically, then floating freely in space, were christened 'mobiles' by Marcel Duchamp. Although these works had been preceded by experiments in kinetic sculpture by Duchamp himself, Naum Gabo, Man Ray and László Moholy-Nagy, Calder introduced infinite fortuitous variations. He invented designs that move at random, stirring lightly like leaves in the wind (see Cat. 72, 77, 78). Calder changed sculpture from a static, solid art to one of movement in time. During the 1960s and 1970s he continued making mobiles as well as 'stabiles' (so named by Jean Arp), which are monumental in scale and help define the space of their urban environments (see Cat. 75). More than any other American artist of this period, 'Sandy' Calder was accepted in France, as elsewhere, as belonging among the twentieth-century masters.

Fig. 2 Isamu Noguchi, Sunken garden for the Beinecke Rare Book and Manuscript Library, Yale University, New Haven, Connecticut, 1960–64

Isamu Noguchi arrived in Paris a year after Calder and assisted him with the display of the Circus. Born in Los Angeles to a Japanese poet and an American writer, Noguchi spent much of his childhood and youth in Japan before returning to study in the US. In New York he was deeply affected by an exhibition of work by Constantin Brancusi, and in Paris the Rumanian master took him into his white studio as his assistant, initiating him into the symbolic meaning of pure, abstract form.

In 1930 Noguchi returned to the East. He studied with the celebrated Chinese painter Chi Pai-Shih in Beijing, and in Japan he learned to work in clay, largely by studying ancient *haniwa* sculptures. In Japanese sculpture, theatre and architecture he found again that 'simplicity beyond complexity' which Brancusi had first instilled in his mind. Returning to New York, he became part of the incipient New York School and also began an extended association with the choreographer Martha Graham, creating innovative stage designs. These relate to the sculptural totality of his gardens and landscapes (see Fig. 2), which later became a major aspect of his work. A restless voyager, Noguchi worked on sculptural projects in Paris, Greece, India, Japan, Israel and the marble mountains of Italy, carrying out significant civic commissions and producing many designs which, though sometimes unrealized, encapsulate his humanist and visionary thinking.

Mark Tobey, who was born in the Midwest, also achieved a personal synthesis of Eastern and Western thought. He was a wanderer as well as a mystic and, like Noguchi, acquired familiarity with foreign cultures, which he incorporated into his art. At the age of twenty-eight, living in New York, Tobey became a life-long adherent of Baha'i, a faith uniting all religions. In 1923, while residing in Seattle, he was introduced to calligraphic brush painting by the young Chinese painter Teng Kuei. With this mode he felt enabled to use his brush to open up the solid forms of Western art and penetrate the void of space.

Pursuing his search for a realm beyond the rational mind, he undertook a crucial visit to China and Japan in 1934, spent some time in a Zen monastery in Kyoto and became proficient in *sumi* painting. Tobey taught at Dartington Hall in Devon throughout the 1930s. There he exchanged ideas with writers and other intellectuals, such as Aldous Huxley, Arthur Waley, Pearl Buck and Rupi Shankar, who were also engaged in marrying Eastern and Western ideas.

In the early 1940s Tobey began his all-over abstractions, often using a mesh of white and off-white lines. In these works he rejected formal composition, activating the total surface of the painting as an energized continuum (see Fig. 3). Shown at the Willard Gallery in New York in 1944, they heralded the much larger all-over canvases of Jackson Pollock. Never fully recognized in New York, Tobey was esteemed in the Orient as well as in Paris, where he seemed closely related to *Art informel* and Tachism. In 1958 he became the first American painter since Whistler to be honoured with a gold medal at the Venice Biennale. Two years later, he settled permanently in Basle. Here again one notices an intricate pattern of acceptance and rejection associated with the phenomenon of 'fleeing America' – whether to Europe or across the Pacific.

For a time French critics did indeed suggest the term 'Ecole du Pacifique' to encompass the work of Tobey, Morris Graves and Sam Francis. Born in Oregon in 1910 and brought up in Seattle, Graves first encountered the Orient in 1928, as a seaman in the United States Merchant Marine. Returning to Seattle, he immersed himself in the Asian art collection at the Seattle Art Museum and began to study Zen philosophy and aesthetics. He worked closely with Tobey, whose calligraphic 'white writing' Graves adopted for his symbolic renderings of 'spirit birds' (see Fig. 4), sacred vessels and pine-trees. He shared involvement with Zen with his friend, the composer John Cage, who was greatly influenced by Graves's evocative and mysterious paintings and wrote a series of 'dance chants', or word portraits, of the painter. For most of his life Graves migrated from place to place, always finding spots of seclusion – a rock on Fidalgo Island in Puget Sound or a small isle in County Cork – whence he occasionally travelled to Japan and India. The emphasis on meditative stillness in Zen finds a response in Graves's use of the forms of nature.

Sam Francis went from his native California to Paris, where he became a vital link between Tachism and Abstract Expressionism. He was also drawn to the Orient, making the first of many visits to Japan in 1957. On first arriving in Tokyo, Francis experienced a sense of *déjà vu*, a 'return to the non-rational', and felt very much at home. In turn, the Japanese, with their traditional view of art as a primarily meditative experience, responded almost immediately to Francis's work (see Cat. 121, 122). The Japanese artist, like the Abstract Expressionist, sees the working process as eliciting a new consciousness that becomes the work, and Francis found himself closely attuned to Japanese aesthetics.

A sojourn in Europe – almost obligatory for American artists before the Second World War – became less imperative as their European confrères came to the United States with the rise of Nazism. By the mid-1940s the United States was providing refuge for many eminent émigré artists, including Josef Albers, Herbert Bayer, André Breton, Marc Chagall, Duchamp, Max Ernst, Lyonel Feininger, Stanley William Hayter, Richard Lindner, Jacques Lipchitz, André Masson, Roberto Matta, Miró, Moholy-Nagy, Mondrian, Gordon Onslow-Ford, Amedée Ozenfant, Kurt Seligman, Yves Tanguy and Ossip Zadkine (see Fig. 5). Some of these were to take up permanent residence.

Fig. 3 Mark Tobey, *White Night*, 1942. Seattle Art Museum; Gift of Mrs Berthe Poncy Jacobson

Fig. 4 Morris Graves, *Blind Bird*, 1940. The Museum of Modern Art, New York; Purchase

Fig. 5 Photograph taken on the occasion of the exhibition 'Artists in Exile' at the Pierre Matisse Gallery, New York, 1942. From left to right: (front row) Roberto Matta, Ossip Zadkine, Yves Tanguy, Max Ernst, Marc Chagall, Fernand Léger; (back row) André Breton, Piet Mondrian, André Masson, Amédée Ozenfant, Jacques Lipchitz, Pavel Tcheletchew, Kurt Seligman, Eugene Berman

Two German painters, Hans Hofmann and Josef Albers, became the most important art teachers in America.[3] There really seemed no longer any need for American artists to go abroad. Nevertheless, they continued to make their pilgrimages to Europe, chiefly to Paris. Second World War veterans could study there at government expense, and many enrolled at the Académie des Beaux-Arts, the Académie de la Grande Chaumière and at the *ateliers* of Fernand Léger and Zadkine. More than three hundred young American painters and sculptors went to Paris during the 1950s. Among them were a good many African Americans who, by moving to France, escaped the discrimination and racism at home while receiving more attention and

Fig. 6 Romare Bearden, *The Prevalence of Ritual: Baptism*, 1964. Hirshhorn Museum and Sculpture Garden, Smithsonian Institution, Washington, DC

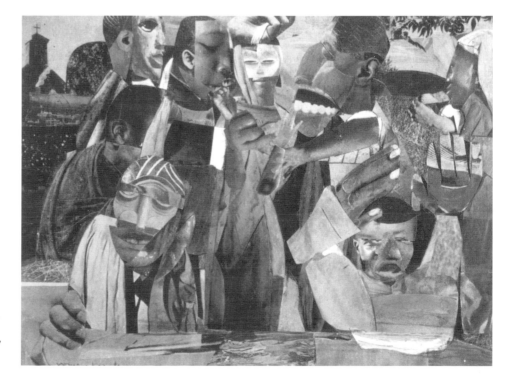

3. Hofmann taught at Berkeley in 1930 and 1932, then at his own school in New York from 1933 to 1958. Albers first taught at Black Mountain College, from 1933 to 1949, then was Chairman of the Department of Design at Yale from 1950 to 1958.

4. Romare Bearden, interview with Henry Ghent, June 1968; Archives of American Art, Smithsonian Institution, Washington, DC.

better exhibition opportunities. None, to be sure, equalled the phenomenal success and the honours accorded Henry Ossawa Tanner, who had lived as an expatriate in Paris from 1895 until his death in 1937. Between the wars a substantial 'Negro art colony' had been established in Paris, though the artists were less successful than their celebrated jazz-musician friends. Among the African American artists in Paris after the 1950s was the widely respected Beauford Delaney, who exhibited at prestigious Paris galleries. He was a close friend of the writers James Baldwin, Jean Genet and Henry Miller, as well as an older comrade to the American painters.

Romare Bearden, a vital presence in that blossoming of African American creativity between the wars known as the Harlem Renaissance, went to Paris after his discharge from the US Army in 1945. There he was befriended by Brancusi, but, like many newcomers, found the cultural richness and the diversity of Parisian life overwhelming: '[I] was so absorbed in seeing and walking in Paris from one end to the other, that I could never get around to doing any painting.'⁴ Only after returning to New York did Bearden create his distinctive, syncopating photo-collages (see Fig. 6), empathizing with Afro-American culture, and achieve widespread recognition.

The younger generation of African Americans in Paris included Bob Thompson, who did some of his finest post-Abstract Expressionist figurations during his years in the city, before moving on to Rome and an early death. Barbara Chase-Riboud was given a solo exhibition of her exquisite sculptures, which combine metal and fibre, at the Musée d'Art Moderne in 1974. The sculptor Sam Gilliam had one of his first one-man shows in Paris, at Darthea Speyer's gallery, in 1970; Howardina Pindell was introduced to the art world at the Paris Biennale of 1975; and Raymond Saunders executed many of his mysterious, paradoxical collages during extended sojourns in the French capital.

When Ellsworth Kelly (Fig. 7) was a student at the Boston Museum School (1946–48), Max Beckmann's visit had the greatest impact on him. The expressionist mode of Beckmann, Ernst Ludwig Kirchner, Alexei Jawlensky and, above all, Picasso, informed Kelly's early work.⁵ On arrival in France in 1948 he immediately travelled to Colmar to see Grünewald's *Isenheim Altarpiece*. Only when he began creating replicas of objects in his surroundings was Kelly able to break away from his Beckmannesque figurative idiom. By the late 1940s he was creating flat paintings based on road-markers, pavements, windows, ground-plans and walls. He transformed real objects – or, as he called them, 'already mades' – in a manner akin to photography; the geometric shapes were located and arranged in the artist's eye.

Fig. 7 Ellsworth Kelly in the Hôtel de Bourgogne, Paris, 1949

Kelly was in contact with the two groups of Geometric Abstractionists in Paris, *Abstraction-Création* and *Circle et Carré*, and became well acquainted with Michel Seuphor, the leading spokesman of these artists and a follower of Mondrian. He eventually wrote to Kelly, voicing his opinion that, 'amongst Mondrian's serious successors, you're going to be the best'.⁶ Kelly encountered Georges Vantongerloo and Alberto Magnelli, but more significant was his meeting with Arp in 1950. Kelly was more inclined towards Arp's investigations of the Laws of Chance than towards the rational discourse of De Stijl and neo-Constructivist art. In fact, while the foremost work he did during his Paris years, *Colours for a Large Wall* (Fig. 8), had a systemic appearance, its organization and choice of colours were entirely arbitrary. This large painting (eight-feet square) was in great contrast to the salon-size paintings done in Paris by Geometric and Tachist painters alike. At this time, Kelly was unaware of the large scale on which such Americans as Barnett Newman, Mark Rothko and Clyfford Still had been working in New York, where he went in 1954 after having seen the catalogue of an Ad Reinhardt exhibition.

Italy, which traditionally attracted American artists, continued to draw painters in the post-war period. William Congdon arrived in Venice in 1948 and spent almost his entire creative life on Italian soil. In 1952 Robert Rauschenberg and Cy Twombly, with Rome as their base, travelled throughout Italy and to North Africa. In Rome Rauschenberg continued his work in photography and collage (see Fig. 9). His visit to Alberto Burri's studio, where he saw the latter's eloquent, stained, rough burlap collages, may have confirmed him in his exploration of heavy, encrusted and ravaged

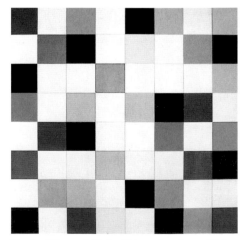

Fig. 8 Ellsworth Kelly, *Colours for a Large Wall*, 1951. The Museum of Modern Art, New York; Gift of the artist

Fig. 9 Robert Rauschenberg, Double-exposure photograph of himself and Cy Twombly with the Horses of San Marco, Venice, 1952

Fig. 10 Robert Rauschenberg working on his *Personal Fetishes*, Rome, *c.* 1953. Photograph probably taken by Cy Twombly

Fig. 11 Cy Twombly in Pompeii, 1957

5. Ellsworth Kelly, telephone conversation with the author, 20 May 1992.
6. Michel Seuphor, letter to Ellsworth Kelly, 21 October 1953; quoted in *Ellsworth Kelly: The Years in France, 1948–1954*, Washington and Munich, 1992, p. 33, n. 16.
7. Katharina Schmidt, 'The Way to Arcadia: Thoughts on Myths and Images in Cy Twombly's Paintings', in *Cy Twombly*, Houston, 1992, p. 12, recognizes that 'the entire field of Mediterranean culture – its myths, its history, its art, its poets, painters, and sculptors – acquired a constantly growing, changing and deepening, yet abiding significance in [Twombly's] life and work'.
8. Roland Barthes, 'The Wisdom of Art', in *Cy Twombly*, New York, 1979, p. 15.

surfaces. Burri arranged for Rauschenberg's exhibition at the Galleria dell'Obelisco in 1953 (see Fig. 10), where Burri himself had shown a year earlier; Burri, in turn, was given a solo show at the Stable Gallery in New York in 1954.

Having lived in Spain, North Africa and Italy, Twombly (Fig. 11) settled in Rome permanently in 1957. His paintings (see Cat. 142–5), with their scribbles and clusters, their cursive skeins, smudges and scratches, may not be immediately accessible in their evocation of ancient myths, their allusions to specific loci, their references to Italian Renaissance painters, but these concerns are fundamental.[7] The titles of the paintings evoke ancient deities and allude both to Virgil and Hesiod and to Shelley and Keats, who had also been steeped in Mediterranean culture. These titles, as Roland Barthes remarked, function like a maze in which we have to retrace our steps in order to become initiated into the work.[8] A careful reading of Twombly's images

Fig. 12 R.B. Kitaj, *The Ohio Gang*, 1964. The Museum of Modern Art, New York; Phillip Johnson Fund

permits the viewer to penetrate an apparent chaos to arrive at their inner silence and the opening of a window on to the classical past.

R. B. Kitaj, like Twombly, is a man highly cognizant of art, literature and history. His collage-like pictorial world (see Fig. 12), based on virtuoso drawing, is filled with multiple allusions, discontinuous allegories, questions and unexpected relationships, with references to Walter Benjamin, T. S. Eliot, Franz Kafka, Erwin Panofsky and Ezra Pound, as well as to mass culture. Kitaj, too, has led the life of an expatriate. Born in Cleveland, Ohio, he was adopted by a Viennese Jew, brought up in upstate New York, joined the Merchant Marine, served in the US Army, studied at Cooper Union in New York, the Akademie in Vienna, the Ruskin School of Art in Oxford and the Royal College of Art in London. He decided finally to remain as a permanent émigré in London and considers himself a member of the 'School of London', a term he invented. At the same time, he sees himself as the perpetual outsider, the Jew in the Diaspora,[9] the artist in exile.

German culture, at *Stunde Null* (zero hour) after the war, required time to recover and find a new voice. The West German government resurrected the DAAD (*Deutscher Akademischer Austauschdienst*; German Academic Exchange Service) to bring artists from abroad to the insular city of Berlin, to transform it into a cosmopolitan centre of the arts. Among American grant recipients were the poets Gregory Corso, Lawrence Ferlinghetti, Dick Higgins and Emmet Williams, the composer Morton Feldman and a great many visual artists.

In Berlin Allan Kaprow, as part of a Fluxus activity, erected *Sweet Wall* in 1970 with the help of the American 'concrete poet' Dick Higgins and the German painter K. H. Hödicke. The wall enclosed nothing and separated no one, a symbol of paradox. During the 1960s and 1970s many American artists associated with Fluxus worked in Germany (see Fig. 13), which, like the rest of Western Europe, supported such activities far more than the US. Other DAAD grant recipients were the hyperrealist sculptor Duane Hanson; Charles Simonds, the creator of miniature archaizing ensembles; and Colette, who transformed her innovative and intimate living environments into sets and costumes for the Deutsche Oper, Berlin. George Rickey

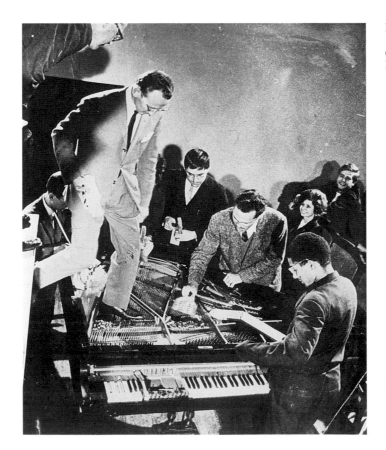

Fig. 13 Phil Corner, *Piano Activities*, Wiesbaden, 1962. From left to right: Emmett Williams, (unidentified), George Maciunas, Dick Higgins, Benjamin Patterson. Photo © H. Rekort

9. In 1989 Kitaj published the first *Diaspora Manifesto* in London, in the prologue to which he states: 'I offer this manifesto to Jews and non-Jews alike in the (fairly) sure knowledge that there be a Diasporic painting.'

Fig. 14 Edward Kienholz, *The Cage*
(*Volksempfängers* series), 1975. Private collection

accepted a DAAD stipend in 1968. His moving sculptural forms – of a great many typologies – respond to the motions of nature and are made of bright steel, engineered with mathematical precision. Rickey is both artist and engineer, the *homo faber* whose work embodies random order. Significantly, he is also a student, historian and collector of Constructivist art. In 1964 (when this writer was Commissioner for American Art for 'documenta III') Rickey was invited to install a 35-foot-high sculpture of two tapering stainless steel blades which oscillated in parallel rhythms in front of the Fridericianum in Kassel. This work confirmed his reputation in Germany. Over a period of some twenty years, Rickey spent half of every year in Berlin, enjoying its 'intelligence, attraction and energy'. Among his many German commissions for permanent installations is the precisely equiposed *Four Squares in a Square* (1969), placed in front of Mies van der Rohe's Nationalgalerie in Berlin, which it complements perfectly in its classical, balanced symmetry.

Edward Kienholz has also spent at least half of every year in Berlin since his 1973 DAAD grant. His *tableaux vivants* are biting critiques of contemporary society, and raise disturbing existential questions. Kienholz was one of the few American artists whose work commented on the disgrace of the Vietnam War; his narratives of reproach were never popular in New York. In Berlin he produced his *Volksempfängers* series (see Fig. 14), the cheap old radio receivers of the Nazi period used to listen to broadcasts of Fascist propaganda. Now, instead of emitting the voices of Hitler or Goebbels, they resound with Wagner's *Ring des Nibelungen*. The *Volksempfängers* were interventions by a foreigner in German history. Taken out of their original context in the German home, they were exhibited in Berlin's Nationalgalerie in 1977, producing both controversy and acclaim. By using history's relics as his objects, Kienholz reflects on history, but he also comments on the media in general and their control of our lives.

Kienholz, coming from a small provincial town in the American Northwest – a carpenter, a *bricoleur*, largely self-taught as an artist, a person who has never achieved full recognition in his own country – found acclaim only abroad. His life and work embody much of the enduring impetus that has directed many American artists to search in European and Asian culture for aesthetic resonances as well as for a deeper sense of artistic tradition and its ramifications.

Thomas Kellein

It's the Sheer Size:
European Responses to American Art

It was American products – 'movies, chewing gum, check jackets, Coca-Cola'[1] – that, after the Second World War, came to form a kind of cultural substitute in parts of Central Europe. In the early 1920s jazz, literary fiction and films from the United States had exerted an influence on modern art in Europe and enriched life in Paris and Berlin. American fine arts, by contrast, had remarkably little effect until 1958.

Marcel Duchamp, the French-American artist who went to New York during the First World War, established himself thereafter as an impresario for the development of an infrastructure among private collectors, gallery owners, artists and museums. After forming the *Société Anonyme* with Man Ray and Katherine Dreier in 1920 and promoting the importation of works of art from such sources as Herwarth Walden's *Der Sturm* gallery, the Bauhaus in Weimar and the studio of Kurt Schwitters, he acted in New York as a mentor to young artists, whom he encouraged to eschew the dominant art of Pablo Picasso in favour of concepts and attitudes.[2] Through him the American art world acted upon the 'old' continent. 'Ready-mades', for instance, which pre-empted object art on both sides of the Atlantic from the 1920s on, took their name not from Europe but from American linguistic usage.[3] From his arrival in New York in 1915 until his death in 1968, therefore, Duchamp personified the long and dramatic process of art-historical exchange between Europe and America, in which the tide was eventually to turn in favour of the United States.

After the Second World War the Marshall Plan, instituted in 1948, and the NATO concept of a nuclear-armed security system made it possible for the Americans to prescribe the course of development to be followed by entire national economies, especially in Europe, and to establish a world-wide political monopoly that was to their advantage commercially. It was not the culture of the United States, but its sheer economic and military strength, which initially formed the basis of its predominant status among the anti-Communist countries west of the Iron Curtain. Parallel with this, there appeared from 1948 on the broad expanses and huge, appellatory canvases of American painters. The 'big canvases' and the 'all-over' method, developed in New York between the end of the war and Spring 1949, were impressive in terms of sheer size. In devising them, a relatively small group of artists took account of recent political changes in a very personal way, but without lapsing into a national style.[4]

After 1945 most European countries quasi-automatically conformed to President Roosevelt's vaguely formulated 'one world' idea and, while retaining their respective national sovereignties, professed themselves consumer societies of a democratic complexion. Although they continued to develop their own culture and art, the dominance of the United States and its defensive alliance had repercussions on art in that only 'one art' seemed necessary in the remaining 'one world'.[5] This emerged from a kind of no man's land, since no one cared to give visual expression to the changed world situation by drawing on Eastern images or examples taken from the American or European past. American artists of this generation had no wish to suppress the cultural disappointments and horrors that had occurred between the Spanish Civil War and the dropping of the H-bomb. In 1948 a disenchanted Robert Motherwell and Harold Rosenberg debated the nature of the 'possibilities' open to them. In their view, artists lived in a 'deadly political situation', though 'a great many people...find it possible to hang around in the space between art and political action'.[6]

The art of the Bomb-protected and culturally indeterminate, abstract NATO area was to an increasing extent discovered, exhibited and marketed in New York. Within a decade, or from around 1960, the centuries-old predominance of European paint-

1 See Lucius Grisebach, 'Stationen amerikanischer Kunst in Europa nach 1945', in Dieter Honisch and Jens Christian Jensen, eds., *Amerikanische Kunst von 1945 bis heute: Kunst der USA in europäischen Sammlungen*, Cologne, 1976, p. 9.
2 See the artists' contributions in Anne d'Harnoncourt and Kynaston McShine, eds., *Marcel Duchamp*, exhibition catalogue, New York, Museum of Modern Art, and Philadelphia Museum of Art, 1973; reprinted Munich, 1989.
3 See Craig Adcock, 'Marcel Duchamp als Mittler zwischen Europa und Amerika', in *Europa/Amerika: Die Geschichte einer künstlerischen Faszination seit 1940*, exhibition catalogue, Cologne, Museum Ludwig, 1986, pp. 26–7.
4 The appellatory character of Mexican murals and of Picasso's *Guernica*, in New York since 1939, has often been stressed in connection with the large formats that appeared from 1945 onwards. Mention is seldom made, however, of the 1947 exhibition 'Large Scale Modern Paintings' at The Museum of Modern Art, which, in addition to *Guernica*, showed Jackson Pollock's *Mural* (Cat. 86), produced in 1943 for Peggy Guggenheim's Art of This Century Gallery. No iconographical study of the 'big canvas' has yet been undertaken. Accounts of the so-called New York School generally derive the 'big canvas' from a stylistic logic inherent in modern art since Monet and Mondrian or condemn it as a politico-cultural means of intimidation employed during the Cold War.
5 Wittingly or not, Ad Reinhardt absolutized this tendency with his 'art-as-art' dogma: 'The one thing to say about art is that it is one thing'; Barbara Rose, ed., *Art-as-Art: The Selected Writings of Ad Reinhardt*, New York, 1975, p. 53. In the exhibition field, the same tendency was expressed, above all, by 'Westkunst', a show subtitled 'Contemporary Art since 1939'; Laszlo Glozer, ed., *Westkunst: Zeitgenössische Kunst seit 1939*, exhibition catalogue, Cologne, 1981.
6 Robert Motherwell and Harold Rosenberg, editors' foreword, *Possibilities I*, Winter 1947/48.

ing and sculpture had been called into question. By the end of the 1960s exhibitions in Kassel, Amsterdam, Düsseldorf and, above all, Berne had brought acknowledgment of the fact that the artistic achievements of America and Europe were of equal significance.[7] From then until about the end of the 1980s large tracts of the Western world obtained their art from the new artistic metropolis, New York. Almost every country in Europe, as well as in Asia and Latin America, credited American art with trail-blazing properties and superior quality.

New York's young and highly politicized generation of artists had already, at the outbreak of the Second World War, been the world's best-informed avant-garde.[8] From 1941, when the European art trade had virtually ceased to exist, a New York market for young contemporary artists had slowly grown up at galleries such as those of Peggy Guggenheim (who was advised by Duchamp), Sidney Janis, Samuel Kootz and Betty Parsons. It was not until the late 1950s, however, that American art was acquitted of its subversive status and promoted to the rank of official representative,[9] and not until the 1960s that practitioners of Pop and Minimal art reaped the benefits of roughly ten years' work on the part of the Abstract Expressionists.[10]

Initially, the European response to American art was influenced primarily by New York's Museum of Modern Art (MoMA).[11] In 1948 MoMA erected its own pavilion on the Biennale site in Venice, and from 1952 onwards touring exhibitions of items from its collection of contemporary art were compiled by Porter A. McCray, adviser to the museum since 1946. On the European side, the French painter Georges Mathieu strove for a trial of strength with his American confrères (see Fig. 1). In 1948 he invited New York galleries to contribute pictures by Willem de Kooning, Arshile Gorky, Jackson Pollock, Reinhardt, Mark Rothko and Mark Tobey to an exhibition at the Galerie du Montparnasse in Paris, where they were confronted by paintings of his own and works by Camille Bryan, Hans Hartung, Francis Picabia, Morgan Russell and Wols.[12] In the same year Peggy Guggenheim's collection displayed examples of de Kooning, Gorky, Pollock and Rothko at the Venice Biennale. Another Venice showing of de Kooning, Gorky and Pollock followed in 1950 – the first occasion on which three of the younger representatives of New York abstraction gained access to a world public. Mathieu's contention that Paris and New York artists were on a par was mooted by a second Paris exhibition, at the Galerie Nina Dausset in 1951. 'Véhémences confrontées' was the programmatic title of this show, in which works by de Kooning and Pollock were contrasted with pictures by Hartung, Jean-Paul Riopelle, Wols and Mathieu himself. The following year saw Pollock's first European one-man show, at Paul Facchetti's gallery in Paris. Also in Paris in 1952, Mathieu distributed a 'Déclaration aux peintres américaines d'avant-garde', and early in 1953 he exhibited works by himself, Henri Michaux, Riopelle, Jaroslav Serpen, Sam Francis, Alfonso Ossorio and Pollock at London's Institute of Contemporary Arts under the title 'Opposing Forces'. For five years, therefore, isolated exhibitions provided a foretaste of American post-war art, Pollock being from the outset its most frequent representative. However, there were few outside Paris who knew how to classify American painting. Apart from the Italian collector Count Panza di Biumo, European collectors and exhibition organizers who actually set eyes on New York studios or galleries were very thin on the ground.[13] Parisian critics who reported on the New York art scene were also careful to keep their distance. Michel Seuphor, for example, wrote in 1951: 'Where the works are concerned, they will pass judgment on themselves in due course.'[14]

In April 1953 the first MoMA-compiled touring exhibition, entitled '12 American Painters and Sculptors of the Present Day', opened at the Musée d'Art Moderne in Paris before travelling to Zurich, Düsseldorf, Stockholm, Helsinki and Oslo. Gorky and Pollock were again represented, as were Edward Hopper, Ben Shahn, Alexander Calder, David Smith and others. However, it was another five years before American art made the breakthrough that this exhibition had been intended to achieve. In 1954 Werner Haftmann wrote in sibylline vein that 'the American Pollock and the German Wols exert great influence on the Ecole de Paris'.[15] Mathieu and Pierre Soulages were likewise much concerned with Pollock and Wols, whereas the Americans took

7 See *documenta IV*, exhibition catalogue, Kassel, 1968; *Op Losse Schroeven*, Amsterdam, Stedelijk Museum, 1969; *When Attitudes Become Form*, Berne, Kunsthalle, 1969; *Prospect 69*, Düsseldorf, Kunsthalle, 1969. All four exhibitions strove to achieve a discriminating balance between European and American artists of the kind that became axiomatic in the ensuing decade.

8 See Irving Sandler, *The Triumph of American Art: A History of Abstract Expressionism*, New York, 1970, p. 23.

9 The fundamental discussion of this subject is Max Kozloff, 'American Painting During the Cold War', *Artforum*, vol. 11, no. 9, May 1973, pp. 43–54.

10 Ad Reinhardt's caustic comment on this was: 'But finally it was Andy Warhol. He has become the most famous. He's a household word. He ran together all the desires of artists to become celebrities, to make money, to have a good time.' Quoted in Mary Fuller, 'An Ad Reinhardt Monologue', *Artforum*, vol. 9, no. 2, October 1970, p. 38.

11 See Grisebach, op. cit., p. 10. MoMA made regular appearances in Europe as a collecting institution as well: at Zurich's Kunsthaus in 1955; at Berne's Kunstmuseum and the Museum Ludwig, Cologne, in 1979; and at Bonn's Kunst- und Ausstellungshalle der Bundesrepublik Deutschland in 1992. It is significant that New York artists attacked and boycotted MoMA in 1947 because they wished to gain access to this major repository of modern European art. The group American Abstract Artists had contested its policy in 1940 in a leaflet entitled 'How Modern is the Museum of Modern Art?' In 1950 twenty-eight so-called 'Irascibles' (see Fig. 1, p. 77) signed a petition against The Metropolitan Museum of Art in New York because it was planning a national exhibition, selected by a panel of artists, which would, as they saw it, exclude all examples of progressive art (see *Artnews*, vol. 49, no. 4, Summer 1950).

12 See Georges Mathieu, *Au-delà du tachisme*, Paris, 1963, pp. 58–60. His interest had been aroused by the periodical *Possibilities* (see note 6). According to him, however, the exhibition was only 'partly' realized.

Fig. 1 George Mathieu painting *The Battle of Brunkeberg* in front of an audience of 200 in the courtyard of the Hallwylska Museet in Stockholm, 23 July 1958

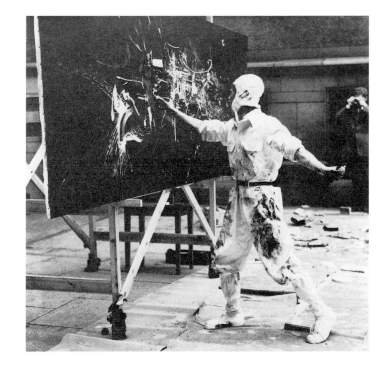

13 Eberhard Kornfeld claimed to have visited New York for the first time in 1953 (see Honisch and Jensen, op. cit., p. 117) and Count Panza di Biumo went there regularly from 1954 onwards (ibid., pp. 131–5). In *Cimaise*, no. 2, December 1958, p. 35, Count Panza stated: 'I am convinced that America has something new to impart, something quite different from that which we Europeans – constrained as we are by an excess of intellectualism – can make and feel.'

14 *Art d'aujourd'hui*, no. 6, June 1951, p. 14; special issue devoted to American art.

15 Werner Haftmann, *Malerei im 20. Jahrhundert*, Munich, 1954, p. 463.

16 Adolph Gottlieb and Mark Rothko, with Barnett Newman, 'Letter to the Editor', *New York Times*, 13 June 1943, quoted in Sandler, op. cit., p. 68. The full text is reprinted in Clifford Ross, ed., *Abstract Expressionism: Creators and Critics*, New York, 1990, pp. 205–7.

17 See Barnett Newman, 'The Ideographic Picture' (1947), in John P. O'Neill, ed., *Barnett Newman: Selected Writings and Interviews*, New York, 1990, p. 107 ff.

18 See Barnett Newman, 'The First Man Was an Artist' (1947), ibid., pp. 156–60. Robert Goldwater's 'Reflections on the New York School', *Quadrum*, vol. 8, 1960, pp. 17–36, discusses this in detail.

19 Hayden Herrera's account of this rivalry mentions an altercation between Jean Fautrier and Franz Kline in Venice in 1960 during which the American allegedly felled the Frenchman with an uppercut. See Herrara, 'Besitzergreifen und Darstellen: Amerikanische und europäische Malerei der Avantgarde 1945–60', in *Europa/Amerika*, op. cit., pp. 165–6.

20 See John Beardsley, *Art in Public Places*, Washington, 1981, pp. 14, 16, 26.

scant interest in recent European art. New York did not care to acknowledge the much-praised psychic automatism of Wols, who had died in 1951, because since the 1940s it had possessed the very latest information on Surrealist procedures thanks to the presence of artists such as Max Ernst, André Masson and Roberto Matta, and to periodicals such as *View* and *VVV*. By the end of the Second World War, William Baziotes, de Kooning, Gorky, Motherwell and Pollock had already turned their backs for good on Surrealism and developed large-scale compositions such as neither Wols nor Mathieu could offer. According to an often-quoted letter to the *New York Times* in 1943, they were interested from the outset in the 'flatness' of a picture,[16] which was to supplant Cubism, Surrealism and the universality of abstraction as presented in the work of Piet Mondrian. In the post-war years they hoped to replace autographic psychograms with directly effective 'ideographs'[17] and the ramified compositions of lyrical *Art informel* with a new primitivism seemingly devoid of precedents.[18]

While Mathieu and Soulages persevered with the Paris/New York contest until 1960,[19] a fascinated interest in the works of the young Americans directed the activities of Arnold Rüdlinger, head of the Kunsthalle in Berne (from 1947) and of that in Basle (from 1955). Rüdlinger began in 1947 with a Calder exhibition in Berne. Strongly Europe-orientated, the sculptor had paid repeated visits to Paris since 1926 and was friendly with such European artists as Joan Miró, Fernand Léger, Mondrian and Theo van Doesburg. After Berne, his wire sculptures, abstract constructions and mobiles could be seen at the Stedelijk Museum in Amsterdam. Works by Calder were shown in Hanover in 1954, again by Rüdlinger in Basle in 1957 and throughout Europe from 1959 onwards, but it was not until 1967 that Calder was able to introduce a belated 'Art in Public Places' programme in his native land with a monumental open-air work at Grand Rapids.[20] Rüdlinger's friendship with Calder brought him into contact with the young Sam Francis and his circle of American acquaintances in Paris, whom he placed on an equal footing with French artists in the third, 1955 instalment of his Berne exhibition series 'Tendances actuelles'. Soon after taking up his post at the Basle Kunsthalle he commissioned Francis to paint three monumental pictures for the staircase of the local Art Association building (Fig. 2), thereby proclaiming his aesthetic standpoint to the German-speaking art world. In March 1957, at Francis's suggestion, he travelled to America to select artists for an exhibition in Basle of contemporary New York painting. However, lack of funds compelled him to fall back on the MoMA touring exhibition put together by Porter A. McCray, 'The

Fig. 2 Sam Francis's murals in the Kunsthalle, Basle, 1956–57

New American Painting', which opened in Basle in April 1958 together with a MoMA retrospective of Jackson Pollock (Figs. 3, 4), who had died in a car accident two years previously. In 1959, since no one in Europe had yet established sufficiently close contact with the New York art world, McCray also selected the twenty-seven American artists who were included in 'documenta II', the Kassel exhibition mounted by Werner Haftmann.

These three exhibitions focused international attention on American art for the first time.[21] On account of his key position in this, McCray, who had fulfilled his informative function as a paid MoMA representative and was not obliged to explain or justify his criteria of selection to the Europeans, was classified fifteen years later as a Cold War agent. The Museum of Modern Art had been a Rockefeller organization from the outset, Eva Cockcroft wrote in 1974, and McCray's task had been to create a cultural stir wherever Rockefeller and his Chase Manhattan Bank were especially heavily committed.[22] What made McCray and Abstract Expressionism suddenly seem suspect during the 1970s was the fact that pioneering artists like Motherwell, New-

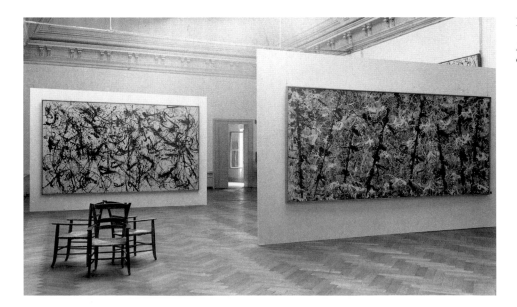

Fig. 3 View of the exhibition 'Jackson Pollock 1912–1956' at the Kunsthalle in Basle, 1958. *Number 32* is on the left, *Blue Poles: Number II* on the right

Fig. 4 Arnold Rüdlinger, US Consul General A. McQuaid and Dr Hans Theker (President of the Art Association) at the opening of the exhibitions 'The New American Painting' and 'Jackson Pollock 1912–1956' at the Kunsthalle, Basle, in 1958

21 The two Basle exhibitions toured Europe separately from 1958 onwards. Another major exhibition, mounted in London by the Institute of Contemporary Arts, was that of E.J. Powers's private collection, which included works by Franz Kline, de Kooning, Pollock, Rothko and Still.

22 Her sweeping verdict was that Rockefeller should be accounted 'a particularly powerful and effective man in the history of cultural imperialism'. See Eva Cockcroft, 'Abstract Expressionism: Weapon of the Cold War', *Artforum*, vol. 12, no. 10, June 1974, pp. 39–41.

23 Kozloff, op. cit., passim.

24 Serge Guilbaut, *How New York Stole the Idea of Modern Art: Abstract Expressionism, Freedom, and the Cold War*, Chicago and London, 1983. See, for example, p. 76: 'Newman had contacts with such apolitical avant-garde galleries as Peggy Guggenheim's and Betty Parsons's. Motherwell had connections to high society through his father.'

25 Contributions to the symposium appear in Serge Guilbaut, ed., *Reconstructing Modernism: Art in New York, Paris, and Montreal 1945–1964*, Cambridge, MA, and London, 1990.

26 T.J. Clark, 'Zur Verteidigung des Abstrakten Expressionismus', *Texte zur Kunst*, vol. 2, no. 7, October 1992, p. 51. Clark, a British art historian, considers the book by his pupil Guilbaut (see note 24) to be definitive. In 1992, when addressing the Internationaler Kongress für Kunstgeschichte in Berlin, he claimed that a 'cul-de-sac mood' prevailed among students of Abstract Expressionism.

27 Albert Schulze Vellinghausen, 'Atlantische Erneuerung: Kunst aus den Vereinigten Staaten in Brüssel und Basel', *Frankfurter Allgemeine Zeitung*, 16 May 1958. A collection of press comments translated into English can be found in Ross, op. cit., pp. 279–95.

28 Rüdlinger's inaugural address, printed in *Die Geschichte des Basler Kunstvereins und der Kunsthalle Basel, 1839–1968: 150 Jahre zwischen vaterländischer Kunstpflege und modernen Ausstellungen*, Basle, 1989, pp. 234–5.

29 Johannes Gachnang, 'From Continent to Continent', in *Europa/Amerika*, op. cit., p. 337.

30 Rexroth, 'Americans Seen Abroad', in *Artnews*, vol. 58, no. 4, Summer 1959, p. 33.

man, Pollock and Clyfford Still had bidden a disillusioned farewell to their youthful dreams of a Socialist International and expressly pronounced their work to be one of commitment in a cultural vacuum. In 1973 Max Kozloff declared that their espousal of 'the sublime', of the 'big canvas' and of 'abstraction as a world language' had indirectly supported, if not actually exemplified, American aspirations to world supremacy.[23] Ten years later, Serge Guilbaut claimed in his polemically entitled book, *How New York Stole the Idea of Modern Art*, that they had renounced their 1930s socialist ideals in order to enlist their art, their utterances and their financial interests in the service of American high finance and the Pentagon's anti-Communist propaganda. Guilbaut not only construed the achievements of the American avant-garde as a reflection of Cold War political propaganda; he also portrayed artists and gallery owners, most of whom were on a precarious financial footing, as political puppets and shrewd businessmen.[24] 'Hot Paint for Cold War' was the title of a 1986 symposium in Vancouver designed to buttress this point of view.[25] Established within the changed moral attitudes of the 1970s, the notion that Abstract Expressionism may no longer be extolled as an art-historical triumph because it embodies 'a style marked by a kind of *petit bourgeois* aspiration to aristocracy, to totalizing cultural power' has endured to this day.[26]

The first press appraisals of Abstract Expressionism on the occasion of the Basle exhibition in 1958 welcomed an 'Atlantic renewal' in the realm of art. Albert Schulze Vellinghausen declared that 'The New American Painting' had redefined 'the category "size".' The concurrent exhibition of paintings by Pollock, in particular, affected him 'not only as *quantitas*... but as a stunning, exciting, seductive precondition of action'. Pollock's paintings were permeated by 'reality', he went on, and the 'diminishing [effect of] likeness' had been abolished. Visitors to both exhibitions had perceived not only a 'signal', but also an 'alarm call'.[27] For the first time, the Parisian art that was still so highly esteemed in Central Europe seemed outmoded and its informal principles of composition merely illustrative – not that anyone admitted as much. Rüdlinger, who still had a long way to go in Basle before he convinced his French-schooled public and local artists of the merits of 'the Americans', extolled New York painting's 'gestural' capacity and its 'unprecedented grandeur and freedom of manner'. 'Where Pollock, Kline, Still, Rothko and a few others are concerned, it is almost a rule of thumb that the larger the canvas, the stronger the picture.'[28] He expressly felt 'prompted to remark – heretically – that there is at least as much happening today in New York as in Paris, if not more, and that it may even be more interesting'. He drew attention to the 'sense of space' engendered by the paintings. In explaining their size he cited neither NATO nor Cold War politics, but related it to Walt Whitman and America's proverbial expanses of prairie and forest. The 'sheer bareness of the huge canvas' should be construed as a trail-blazing pictorial invention that seemed at a stroke to eliminate the lingering national styles and cultural hierarchies of the 1950s.

For younger art lovers able to visit them at one or another of the stops on their European tour from June 1958 onwards, the two legendary exhibitions were a formative experience – one that seemed, all at once, to enlarge the world of art and extend it beyond the bounds of Paris-orientated Europe. Recalling them almost two decades later, Johannes Gachnang wrote: 'Baselitz saw them in Berlin, Nitsch in Vienna, I myself in Basle, and Kounellis cannot have missed them in Rome....For my generation, the one born just before the Second World War, it was our first real contact with American art; a genuine shock, but also a liberating blow that seemed to open doors in the most diverse directions.'[29]

The Americans themselves awaited Europe's initial reactions in almost hysterical suspense. Kenneth Rexroth, who evaluated a series of newspaper articles and published their headlines, stated that visitors to the exhibitions had generally reacted in a 'hostile' manner, basing their criticisms on 'anti-American arguments'.[30] On the other hand, he commented approvingly, special interest had been evinced by smaller countries not in a position to withstand American competition on a political and economic level. In Switzerland, Holland and the Federal Republic of Germany (whose

constituent federal states were culturally sovereign), but also in Italy and Great Britain, it was recognized in 1959 that the prevalent criteria of effectiveness and the actual appearance of European art should be reconsidered. As early as 1956 Hertha Wescher had observed in Paris that the rivalry between America and Europe corresponded to the contest between an 'unlimited' and a 'limited' pictorial format.[31] The question of format was closely connected with the problem of a work's 'completion'. 'I usually ask my wife', was Adolph Gottlieb's ironical comment on the latter subject during a debate on painting in New York.[32] Newman considered the idea of completion to be a fiction,[33] and Pollock's 1947 verdict on the consequences of his 'dripping' technique was as follows: 'I have no fears about making changes, destroying the image, etc., because the painting has a life of its own.'[34] His 'easy give and take' method led to stylistically determinative 'all-over' paintings, such as *One (Number 31), 1950* (Museum of Modern Art, New York), *Autumn Rhythm* (1950; Metropolitan Museum of Art, New York) and *Number 32* (1950; Kunstsammlung Nordrhein-Westfalen, Düsseldorf), which, together with large canvases by Barnett Newman – for example, *Vir Heroicus Sublimis* (1950–51; Museum of Modern Art, New York) – impressed Europe as the quintessence of new American art. Essays, monographs and doctoral theses later interpreted these pictures in terms of their formal content at such length, especially in the Federal Republic of Germany, that the 'big canvas' seemed eventually to disclose 'the beginnings of a theory of active understanding'.[35]

Fig. 5 Andy Warhol at his exhibition 'Flowers', Galerie Ileana Sonnabend, Paris

The degree to which the outsize canvases of Abstract Expressionism aimed at capturing the totality of perception by deliberately subordinating any internal, compositional structure to an impression of size and closeness had been noted by opponents of the new Americans at Basle in 1958. One Zurich paper remarked: 'Many of them could pass for a ten- to a hundredfold enlargement and a five- to a fiftyfold coarsening of an imaginary watercolour by Klee.'[36] The full extent of American 'superficiality' was not, however, manifested solely in the pictures of the Abstract Expressionists: examples of American Pop Art could be seen at Ileana Sonnabend's Paris gallery from 1963 onwards (see Fig. 5) and subsequently in many other European capitals.

Rüdlinger had 'discovered' America for Europe,[37] but his recounting of New York's art history ended with the 'Hard Edge' paintings he showed in 1965 under the title 'Signale'.[38] In the intervening seven years, European exhibitions had been governed by who of which generation was introduced by whom, and at what stage, into the New York art scene. Pontus Hultén, for example, director of Stockholm's Moderna Museet, met the engineer Billy Klüver on his first visit to the States in 1959 and, in company with him, paved the way for Jean Tinguely's *Homage to New York*. Thus it came about that, in March 1960, a vernissage audience watched with derisive amusement as a kinetic auto-destructive work by the Swiss artist failed to auto-destruct in the inner courtyard of The Museum of Modern Art[39] – an event that inspired Tinguely's *Nouveau Réaliste* confrères in Paris to emulate him by moving to New York as soon as possible. In 1961 Hultén himself organized the exhibition 'Bewogen Beweging/Rorelse i Konsten', a selection of kinetic art from Europe and the United States, at the Stedelijk Museum in Amsterdam (whence it travelled to Stockholm and the Louisiana Museum in Humlebaek). He also put together 'American Pop Art' for the same places, a first large-scale exhibition of the genre which, with an eye to the market, he did not open until 1964.[40] Edy de Wilde, the new director of the Amsterdam museum, had been particularly fascinated on a 1962 visit to New York by Ben Heller's private collection, which was then touring seven American cities as a 'young legend'.[41] Thereafter, the Stedelijk Museum acquired several major works by Newman, Pollock and Rothko, and exhibited all the new trends in American art almost as soon as they came into being.[42]

The tradition of extensive one-artist exhibitions at London's Whitechapel Art Gallery was inaugurated by Bryan Robertson in 1961 with a Rothko show. Ten years later, Rothko presented nine major works from his group of 'Seagram Murals'– originally intended for a New York restaurant – to the Tate Gallery.[43] London reactions to Pop Art, as exemplified by 'The Popular Image' at the Institute of Contemporary Arts in 1963 and 'The New Generation' at the Whitechapel Art Gallery the following year,

31 Wescher, in *Cimaise*, no. 2, November/December 1956, p. 45.

32 Gottlieb, quoted in *Gazette*, no. 1, 1961 (interview with Lawrence Alloway).

33 See ibid., p. 12.

34 Pollock, in *Possibilities 1*, Winter 1947/48, p. 79.

35 Thus the subtitle of Nicolas Hepp's dissertation, 'Das nicht-relationale Werk: Jackson Pollock, Barnett Newman – Ansätze zu einer Theorie handelnden Verstehens', Mülheim an der Ruhr, 1982.

36 'Das humanistische Basel wird tachistisch', *Die Tat*, no. 132, 16 May 1958.

37 The two exhibitions 'New York in Europe' at Berlin's Nationalgalerie and 'Amerikanische Druckgraphik aus öffentlichen Sammlungen der Bundesrepublik Deutschland' at the Kunsthalle, Kiel, in 1976, together with the concomitant publication (see note 1), were dedicated to Rüdlinger.

38 The exhibition comprised works by Al Held, Ellsworth Kelly, Kenneth Noland, Jules Olitski, Hansjörg Mattmüller, Karl Georg Pfahler, John Plumb and William Turnbull.

39 See Honisch and Jensen, op. cit., p. 119, and Pontus Hultén, *Jean Tinguely: 'Meta'*, Berlin, Frankfurt and Vienna, 1972.

40 See Hultén, in Honisch and Jensen, op. cit., p. 121.

41 Ibid., p. 122. See also Henry Geldzahler, 'Heller: New American-type Collector', *Artnews*, vol. 60, no. 5, September 1961, pp. 28–32, 58.

42 An exhibition chronology can be found in the exhibition catalogue '60'80: Attitudes/Concepts/Images*, Amsterdam, Stedelijk Museum, 1982.

Fig. 6 Paintings by Robert Rauschenberg being transported to the US Pavilion at the Venice Biennale in 1964

were rather cool: decisive contributions to the subjects of popular culture and visions of the future had already been made in London since the mid-1950s by Lawrence Alloway, Reyner Banham and Richard Hamilton. Nevertheless, it was London's Hayward Gallery that organized, in 1969, the first-ever comprehensive survey of Pop Art.

In 1964, when the Venice Biennale's Grand Prize was awarded to Robert Rauschenberg – over twenty works of his were included in the ninety-nine examples of Hard Edge and Pop Art selected by Alan R. Solomon (see Fig. 6)[44] – the European art world was suddenly gripped by a sense of urgency. In the eyes of many young artists, as well as critics, gallery owners, exhibition organizers and one or two museum directors, everyone had simply slept through the 1950s. Although the older generation had been cautious in its evaluation of Abstract Expressionism, prices rose, and major works by Pollock had become virtually unobtainable in Europe by the beginning of the 1960s.[45] An appreciable lack of understanding also greeted the arrival of Pop Art in 1963 and of Minimal Art thereafter, so the majority of European art experts, who rejected these movements, were ripe for a conflict between generations. American art became a topic for debate during the student revolt, and years of argument were devoted to the question of whether Andy Warhol's Pop Art was, or was not, 'affirmative'. Meanwhile, the industrialist Karl Ströher, who had first visited New York in 1966 with the Stuttgart gallery owner Hans-Jürgen Müller, acquired the complete Pop collection of the deceased insurance broker Leon Kraushar with the aid of the Munich gallery owners Heiner Friedrich and Franz Dahlem. Entitled 'Sammlung 1968 Karl Ströher', this was exhibited in Munich and travelled to Hamburg, Berlin, Düsseldorf and Berne before spending two decades in the Hessisches Landesmuseum in Darmstadt.[46] Peter Ludwig, who had witnessed the growth of a collection of *Nouveau Réalisme* and Fluxus assembled in the Rhineland by Wolfgang Hahn, chief restorer at the Wallraf-Richartz Museum – Kahn exhibited it at his own home in 1968 – also resolved to buy up Pop Art *en bloc* from 'documenta IV', thereby founding one of the world's largest collections of contemporary art.

Fig. 7 Carl Andre, *5 x 20 Altstadt Rectangle*, at the Galerie Konrad Fischer, Düsseldorf, 1967

43 See *Mark Rothko: The Seagram Mural Project*, exhibition catalogue, London, Tate Gallery, 1988, and *Mark Rothko: Kaaba in New York*, exhibition catalogue, Basle, Kunsthalle, 1989.

44 See *Catalogo della XXXII Esposizione Biennale Internazionale d'Arte*, Venice, 1964, pp. 275–80, and Umbro Apollonio, 'Die Kunst der USA auf der Biennale in Venedig', in Honisch and Jensen, op. cit., pp. 62–6.

45 According to statistics published in Honisch and Jensen, op. cit., pp. 158–9, public collections in Europe purchased only eight works by Pollock between 1960 and 1972.

46 See *Bildnerische Ausdrucksformen, 1960–1970: Sammlung Ströher*, exhibition catalogue, Darmstadt, Hessisches Landesmuseum, 1970. At the time, Ströher was promised a new building for his collection, much of which has been housed in Frankfurt am Main's Museum für Moderne Kunst since 1988.

From 1967 New York artists had more and more dealings with private collectors in Holland, the Federal Republic of Germany, Switzerland, France, Italy and Great Britain – for instance, with Mia and Martin Visser in Bergeijk or Panza di Biumo in Varese. In those countries they also found gallery owners who were often quicker than their US colleagues to exhibit and publicize examples of Minimal and Conceptual art – Konrad Fischer of Düsseldorf (see Fig. 7), Yvon Lambert of Paris and Enzo Sperone of Turin, for example. In the late 1960s the enthusiastic, if belated, acceptance of American art reached its culmination in an attempt to introduce Land Art to Central Europe: in 1968, immediately after 'documenta IV', Heiner Friedrich had invited Walter De Maria to create *Münchner Erdraum* at his gallery (Fig. 8),[47] and in 1969 Friedrich's associate, Franz Dahlem, afforded Michael Heizer an opportunity of executing his *Munich Depression* on a building site on that city's outskirts.[48] Carlo Huber, who in January 1970 made a trip to Land Art's places of origin in the wilds of Nevada, wrote in the first issue of *Kunstjahrbuch* of a 'walk to the end of the earth'.[49] Even in the case of this emphatic readiness to accept Land Art, love of American art was motivated by a quest for profound, existential experiences of a kind that seemed to have been too often lacking in the post-war culture of Europe. In addition, American art helped to overcome fears of a sneaking provincialism and, even after 1945, presented the supranational consumer society of the NATO alliance with the prospect of a sophisticated visual culture.

The art-historical divergences between America and Europe were largely assimilated during the 1970s by developments on the international market. Widespread efforts were made to lend contemporary art international impact. In time, fears of missing out became the general rule. In 1972 'documenta V', organized by Harald Szeemann as a systematic review of realism and its potential, presented a recent stylistic innovation in the shape of Photographic Realism. Its acceptance in Europe was governed by a view of it as a contribution made by a few individuals on an international level, not as a specifically American phenomenon. The 1987 exhibition 'New York Art Now', at which London's Saatchi Collection showed works by artists such as Robert Gober, Peter Halley and Jeff Koons, was a final attempt – for the time being – to assign the leading role to a younger generation from the United States. America's predominance had, however, been steadily declining since the 1970s, and the art world registered a growing equilibrium between market centres scattered world-wide. It is to be expected that the increasing decentralization that has taken place in the world since the end of the Cold War will become equally perceptible in the realm of art.

Fig. 8 Walter De Maria, *Münchner Erdraum*, at the Galerie Heiner Friedrich, Munich, 1968

47 See Thomas Kellein, 'Walter De Maria "50 qm/1600 Cubic Feet Level Dirt", München 1968', in Bernd Klüser and Katharina Hegewisch, eds., *Die Kunst der Ausstellung: Eine Dokumentation dreissig exemplarischer Kunstausstellungen dieses Jahrhunderts*, Frankfurt am Main, 1991, pp. 184–9.

48 See Julia Brown, ed., *Michael Heizer: Sculpture in Reverse*, exhibition catalogue, Los Angeles, Museum of Contemporary Art, 1984, p. 56.

49 Carlo Huber, 'Spaziergang ans Ende der Welt: zu Werken von Heizer und De Maria in Nevada', in *Kunstjahrbuch 1*, ed. Jürgen Harten, Manfred de la Motte, Karl Ruhrberg and Wieland Schmied, Hanover, 1970, pp. 129–35.

Achille Bonito Oliva

The Western Frontiers of Internationalism: Europe – America

Basically, the American artist, starting from a typically puritanical tradition, tends to resolve the conflicts within his own work, and those of art with the world, in terms of the quality of the work itself, which stems from a complete and almost fetishistic clinging to the media employed. The maximum analysis of his own linguistic tools corresponds to maximum specialization, which is assumed to guarantee a product carefully studied and executed.

The European artist, on the other hand, with the historical avant-garde tradition behind him, starts out from an awareness of the specific nature of artistic languages. Yet he tends to criticize and challenge the specialization derived from his activity, which he regards as a factor alienating and separating him from the conception of a more comprehensive and unitary work.

American artists view the market as a pragmatic determination of the standing of their work and its quality, whereas the commodification and commercialization of art constitute a definite political problem for European artists. They see the downgrading of art to the level of goods as ideological proof that the word 'avant-garde' has been robbed of its meaning through the co-opting of the work of art by the market and the whole economic system.

The American market, resting on an aggressive and imperialistic economic structure, tends to flood the entire world with its artistic merchandise. For this reason – and for this reason alone – even the average product, by virtue of its power of penetration and the backing it receives from the economic machine, acquires a higher quality status than that of the average product of European art. Quantity, the striking force of economic power, thus becomes quality, in that it compels, objectively and fetishistically, European collectors to soak up American art virtually *a priori*.

European art, buttressed by a multinational reality whose sole unity is cultural, is less optimistic in accepting the conditions of its own market. For Europe, cultural autarchy, with distinct national lives for art, is out of the question. Given their common cultural and ideological platform, artists in the various European countries must necessarily find a bond among their experiences and experiments.

European political realities do exist in a narrow sense, and so it is possible for Europe to establish a less schematic and less fragmented geography of art; however, Europe can confront American art dialectically only by broadening the scope of its own endeavours. Hence, 'Europe' is less a geographical than a cultural notion, based as it is on constants inherent in artistic procedures: the value of history and ideology. The post-war concept of 'avant-garde' in Europe emerged because artists felt a need to link up with the tradition and mentality of past avant-gardes. The latter, flourishing in Europe since the early decades of our century, had focused on the artistic concept of transforming both art and the world. That is why European artists tend to employ art for opening a discourse not only on art itself, but also on the system of art – that is, on the world.

American artists, by contrast, have used the historical European avant-gardes to plug into a discourse on experimentation with artistic language. Such investigations, conducted within the context of America's high-tech development, have led artists to be extremely specialized and yet not troubled by their specialization.

The American avant-garde engages in a discourse and an artistic practice that coincide with a search for, and analysis of, linguistic instruments. European efforts, however, are undertaken in the consciousness of having overcome the word 'avant-garde', inasmuch as not even research and experiment can save art from the

sign of negation under which history lives. Yet both neo-avant-gardes have their sources in the modernist movements that developed, chiefly in France, Germany, Italy and Switzerland, at the start of this century. The first American exhibition of these Europeans' work took place in 1913 at the Amory Show in New York, thanks to Marcel Duchamp.

Europe: The Ideological

Although the European artist starts with an awareness of working through the specific language of art, he nevertheless tries to evolve this specificity into a project for the transformation of reality by viewing art as a model of alternative conduct.

Joseph Beuys wanted art to reconstruct spiritually the unity of man, restoring energies and tensions in order to transmute his political and cultural relationship with the world (see Fig. 1). With Beuys, ideology signified a political vision, a plan for transforming the world; yet it simultaneously referred to his own cultural constants: the artist as hero and demiurge, the recovery of nature and, finally, the idea of wresting form from elementary energy in order to make of the latter a means of communication. Beuys's notion of art fulfilled a need to interrelate all living elements in mutual communication without assigning priority to any single one. If art had the alchemical capacity to modify the elements, then the dialogue with the public, as a political action carried beyond the traditional structures of art, permitted contact with human beings and extended communication along horizontal and democratic lines. Together with actions involving his own body, Beuys made plastic use of words in order to create social sculptures. Society was moulded and moulded itself in the growing consciousness acquired by the public through dialogue with the artist.

Beuys's actions and debates involved various aspects: nature, death, economics and so forth. He was the hero passing through these different levels with the goal of reunifying a culture that had been broken up into diverse specializations, just as society was divided into classes. His actions were always based on the idea that material exists initially as pure energy, an indistinct chaos beyond the grasp of the organizing force of reason. Beuys took blocks of margarine, for example, and manipulated them by imprinting on them the shape of his body. Then he would arrange this material, or others, in geometrical shapes, dictating the growth of the material and lending it a form consistent with human order. This was an expanded order that, along with the paralysing – and thoroughly Western – notion of reason, recovered the vitality of matter and nature.

In Beuys's ideology will, thought and feeling worked together as a triad. Through the practice of art, which is always communication, they constituted and established an area of counter-reality that opposed the negative reality of everyday life.

The idea that art transforms and modifies by giving shape and purpose to the energy of the world corresponds, in the history of culture, to the alchemist's process. Words have a moulding function in so far as they organize communication, as in the relationship between Beuys and his public. Beuys, à la Socrates, used words to make the collective consciousness aware of the problem of all-embracing freedom – something no longer circumscribed and pursued through specific activities in clearly demarcated sectors, which tend only to fragment man's anthropological unity.

Fig. 1 Joseph Beuys, *Sweep Up*, Karl-Marx-Platz, Berlin, 1 May 1972; organized by the Galerie René Block

America: The Statistical

American civilization has introduced a notion of consumption as cannibalism. Sustained by the insistent force of publicity, production tries to satisfy its own rhythms by creating a kind of hunger, a permanent desire for consumer objects. But now the situation is reversed: it is the object that chases the subject. Production has commenced its sadistic hunt of the individual, and man becomes the means in the inversion of roles and in the new hierarchy of positions. Thus, society is no longer an arena for relations among people; it is an exchange-place for the trading of commodities.

Fig. 2 Andy Warhol, *Mao*, 1972

Statistics, or rather the statistical imagination, is what fuelled Andy Warhol, who systematically catalogued the data of reality (see Fig. 2). American reality is based on technology and its attendant mind-set. The notion of 'load-bearing' is the module. In fact, the module is the unit of measurement, the standard, the conceptual and infinitesimal representation of geometrical infinity. And this infinity is constituted by megalopolises – urban sprawls that find their value in quantity. The skyscraper therefore becomes the module, in urban, but not human terms. Indeed, the skyscraper is designed not so much for living in as for exhibiting the public and the productive, rather than the domestic and the private; the transparency of its glazed exterior amounts to a declaration of that intent.

With his cold, detached presence, Warhol took up the module, the standard, at an anthropological level, obliterating individual psychology and snobbishly celebrating the inexpressive. Thus, he tended to transform the module into a multiple; the individual reiterated as the mass-man, the multiplied man, borne by the system of production into a stereotyped existence. The singularity and individualism characteristic of European culture were replaced by the American mentality, in which affirmation of the individual is provided by the security of an overall levelling and by the model of standardized life. Singularity – that is, the unique product – was supplanted by the repeated work, whose repetition, no longer involving existential angst, reaches a state of indifference, which was Warhol's way of looking at the world.

To display this view more effectively and to convey his own indifference to the formative process, Warhol placed the camera or cine-camera as diaphragms between himself and life. The gaze of their lenses eliminated the possibility of affirming any individuality that might smack of privacy; instead, we see a flaunting of stereotyped gestures that, as such, are already public and destined for consumption.

With Warhol any possible secrecy is totally undermined by an ostentation that promises consumption, which American society is eager not to forego. The artist's cynical eye registers the objective condition of the average American, a condition from which he himself neither flees nor countenances fleeing. After all, the models and parameters adopted here are inside and not outside American reality. A constitutive element of that reality is technology, with its neutrality – which Warhol raised to a formative process – towards artistic experience and existence itself. Warhol's statistical imagination recorded human behaviour as though it were a superstructure, the reflection of an economic totality that the artist did not seek to modify through his art. He thus confirmed this condition and, neither despairing, nor glimpsing any possible alternative, accepted the irreversible notion of man as man consumed.

Language

Experimental art, whether in Europe or America, is based on the assumption that the object of art is its language and that artistic investigation today means analysis of linguistic instruments rather than experimentation with new techniques and media.

In America the domain of art is circumscribed by the language it adopts: Ad Reinhardt's 'art-as-art'. With pragmatic faith in his use of instruments, the American artist tends to reflect not on the negative specificity of his work, but solely on the correspondence between that work and the idea of art. The maximum extension of American art is to be found in Conceptual Art, with artists such as Robert Barry (see Fig. 3), Douglas Huebler, Joseph Kosuth, On Kawara and Lawrence Weiner enlarging artistic context to include art history. This extension stems from the acquisition of language phenomenologically, as in the 'cold' trans-avant-garde represented by Ashley Bickerton, Peter Halley, Jenny Holzer, Jeff Koons, Barbara Kruger, Cindy Sherman, Haim Steinbach and Meyer Vaisman. What such artists fail to realize, however, is that Conceptualism, intent on challenging the very definition of art, is based on a tautology: the affirmation of a language that refers only to itself.

Fig. 3 Robert Barry, *Speculations*, 1973. Collection of Panza di Biumo, Varese

In Europe, on the other hand, where Conceptual Art was born of ideology, of the artist's need to ask questions about art in order to define its system, analysis of artistic language utilizes the dialectical method. In Britain, with the Art and Language group and the work of Victor Burgin, the analysis of artistic language tended to acquire and incorporate a number of concerns that lay outside the confines of specific language. In Continental Europe, in the work of Bernd and Hilla Becher, Hanne Darboven (see Fig. 4), Jan Dibbets and Emilio Prini, the study and conceptual probing of artistic language may have encompassed its own object – the notion of art – phenomenologically. Yet it also fostered an analysis that shifted the – wholly American – tautology mentioned above in the direction of ideology, to an investigation in which language is the spectrum of a reality located outside language.

We may therefore say that Europe and America, as the two poles of the experimental antithesis, are respectively ideological and pragmatic. Minimal strutures in the United States – as in the work of Carl Andre, Dan Flavin, Donald Judd, Sol LeWitt and Robert Morris – are characterized by accumulation and the concrete occupation of space and by a search for geometrical relationships and repeatable arithmetical units. Europe, by contrast, prefers the rational organization of space and its qualification; such artists as Enrico Castellani, Francesco Lo Savio, Enzo Mari and François Morellet favour reason and planning over the sheer phenomenology of the event. And in the 'Superart' of Günther Förg, Bertrand Lavier, Gerhard Merz and Reinhard Mucha the elementary use of the object involves a reference to the reality of its context.

Fig. 4 Hanne Darboven, *One Century, 00/99*, 1970–73 (detail)

Nature

Nature in its most specific meaning of 'natural element' has been incorporated into the formative processes of experimental art either as a factor in pragmatic verification or as a critical 'quotation'.

American art, accustomed to a notion of space drawn from the vast, flat landscape of prairies and deserts, employs nature both as an object of artistic intervention and, as in the work of Georgia O'Keeffe, as a reference to an uncontaminated realm. Acting on their countryside and territory, American artists have tended to measure and reduce natural space, using such tools offered by technology as tractors, planes and cars. Behind these poetics there is the anthropology of the cowboy, the man who lives in direct contact with pure, unsullied spaces, the pioneer who alters nature with his own hands. The artists that spring to mind here – Michael Heizer, Walter De Maria, Dennis Oppenheim, Robert Smithson – reveal an optimistic sense of appropriation typical of North American pragmatism and tend to value action and gesture above intention.

For them, as for the British artists Hamish Fulton and Richard Long, gesture is a scale encroachment on the landscape, a macroscopic widening for people used to microscopic places, such as museums and galleries. The initial appropriation derives from direct experience of space as a real and precise physicality and not as an entity existing prior to or outside the artistic operation. Nature becomes yet another space to occupy, a site without traumas and not involving the sociological goals of verifying alternative spaces. The marks left by art are deliberately abbreviated as primary and elementary signs, as in Heizer's deep canyons, Smithson's spiral jetty (Fig. 3, p. 134), De Maria's corridors, Oppenheim's furrows in snow and soil.

The mentality here is analytical and fundamentally geometrical. Through the grammatical use of signs, American artists appropriate a nature that strikes them as a given phenomenon outside themselves, functioning literally as a landscape, a backcloth for their artistic experience. In short, this is nature-nature, a pliable material for elaborating a gesture which, though formal in intention, is still an action, a sign of specific activity.

In European art nature exists not as an uncontaminated space, but as one already given over to the history of culture. This history, which in itself connotes all reality

Fig. 5 Marcel Duchamp, *Bottle Rack*, 1914. Original lost; photograph by Man Ray of the replica made for Duchamp's *Boîte-en-Valise* (1941)

and every entity, whether physical or abstract, finds expression in the critical use of myth and, more generally, in anthropological research. Nature is encompassed in the polarity of its physical concreteness and its 'culturalized' reality. Natural materials are presented directly or rendered in such a way as to represent the tension and energy typical of the natural state, as in the work of Giovanni Anselmo, Gilberto Zorio and others who have used nature in a Situationist manner. Or else the natural materials become a reference to, and/or proof of, a magical and legendary renewal of nature as a myth.

American art thus recognizes nature as a permanent, but not tragic, fact that can be encompassed in its transformation, while European art 'quotes' nature, transforms it and re-presents it in a broader and more complex model.

History

If we define history as the specific tension between art and external reality, not as a mere chronicle, but as a series of significant events, then this distinction forms the watershed between American and European art. For Marcel Duchamp and Man Ray (see Figs. 5, 6), this also implied a reference to a temporal depth within the history of art itself.

For American art since John Cage, all life has been a reservoir of materials, of facts and circumstances to be collected in artistic form only as general symptoms of life. This actually happens in Hyper-Realism, an 'oleograph' of recognition and acceptance of the city as the sole historical space. Such painting fixes and suspends a series of particular data that never refer to a general – that is, wider and more historical – vision of life. Thus, life is observed from a necrophilous viewpoint that emphasizes the separateness of the depicted elements, just as the artist's specialized condition is set off within a highly technologized context that permits only division, never unity. The Hyper-Realism of John de Andrea, Chuck Close, Richard Estes, Ralph Goings, Duane Hanson and Richard McLean provides objective confirmation of a culture of accumulation, constantly reducing history to the level of a chronicle.

The Happening likewise focuses on accumulation: it functions as a free assemblage of gestures and objects that find their own necessity in quantitative association. While the fantastic and useless gesture of the Happening attempts to invade the public space of the city, its action remains anchored to improvisation, which, in the work of Allan Kaprow and Robert Whitman, tries to oppose systematic and standardized living with a freedom that is only of the moment.

In European art the event is not so much an accumulation as a series of gestures and materials selected to oppose the reality in which the event takes place. With Beuys, Giuseppe Chiari, Vittore Pisani and Katharina Sieverding the event, rather than accelerating emotions, functions through them: it fosters awareness, critical behaviour.

The Fluxus group (George Brecht, Chiari, Phil Corner, Robert Filliou, Alison Knowles, Takehisa Kosugi, George Maciunas, Nam June Paik, Ben Patterson, Tomas Schmit, Gianni-Emilio Simonetti, Ben Vautier, Wolf Vostell, Robert Watts) always focused on total events. Through the linearity of gesture and the obsessive theft of every possible technique and medium, this totality was a response to violence and aggressiveness. Consistent with their backgrounds, the European artists cultivated the liberating gesture, whereas the Americans aimed at an experimental practice of interdisciplinary languages. The relationship between artists and history was viewed cynically by Duchamp, but these artists treated it dialectically and metaphysically.

Thus, history, instead of offering brutal content, is a quoting of language, which is also a spectrum of an alienating and oppressive condition – witness Piero Gilardi's renunciation of art.

Feminism has entered the field of art too, raising the matter of the objective marginalizing of women in art and its history. This is, of course, a political issue because it presupposes an analysis of the social system in which women perform artistic work.

Fig. 6 Man Ray, *Gift*, 1921. Original lost; photograph by the artist

Fig. 7 Enzo Cucchi, *The Barbarians' House*, 1982. Emilio Mazzoli, Modena; Gian Enzo Sperone, Rome

In America feminist artists tend to use art as a way of rediscovering an identity, a specific sensibility. In Europe they not only seek to uncover female subjectivity; they also pose the problem of asserting the role of women as transformers of art history and of history in general.

In the end, while history may acknowledge a condition of impossibility in art, it remains the basis for any artistic experience. European art, recognizing the need to experiment, predicates the object of its own research as language; however, it tends ideologically to present itself as the consciousness of its own production process and, through the latter, as the consciousness of history's process of production.

The post-modern culture of the 1980s and early 1990s has been dominated by the model of the trans-avant-garde, operating as 'hot' and/or 'cold' in Europe and America. This mentality is the fruit of a strategy that confronts history devoid of linear progress with cultural nomadism, stylistic eclecticism, deconstruction, reconversion and assemblage.

The 'hot' trans-avant-garde in Europe (Georg Baselitz, Jörg Immendorff, Markus Lüpertz, A. R. Penck, Sigmar Polke, Per Kirkeby, Sandro Chia, Francesco Clemente, Enzo Cucchi [see Fig. 7], Nicola De Maria, Mimmo Paladino) – and then in America (Jonathan Borofsky [see Fig. 8], David Salle, Julian Schnabel, Susan Rothenberg) has adopted the 'quoting' of styles as ready-mades. The abstract and historicized object of language replaces the everyday concrete object: in Europe with a stronger awareness of time, which, in America, is experienced with pragmatic neutrality.

Europe's 'cold' trans-avant-garde is dominated by the idea of a restrained plan as the constructive position of art facing the chaos of external reality. However, this reality is embraced by America's 'cold' trans-avant-garde (Peter Halley, Koons, Steinbach): the formalization of the work is consistent not with an ethics of intellectual resistance to chaos, but with an anthropology of the modular and the reproducible – the mark of a *fin de siècle* period such as ours.

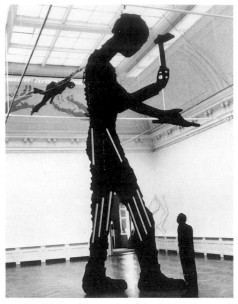

Fig. 8 Jonathan Borofsky, Installation in the Kunsthalle, Basle, 1981, with versions of *Hammering Man* and *Flying Figure*

This essay is a revised version of one published in the author's *The Different Avant-Gardes: Europe/America*, Milan, 1976.

ARTISTS IN THE EXHIBITION

CARL ANDRE (Cat. 206, 207)

RICHARD ARTSCHWAGER (Cat. 191, 192)

JEAN-MICHEL BASQUIAT (Cat. 233, 234)

JONATHAN BOROFSKY (Cat. 228–30)

JAMES LEE BYARS (Cat. 225, 226)

ALEXANDER CALDER (Cat. 72–9)

JOHN CHAMBERLAIN (Cat. 159–61)

JOSEPH CORNELL (Cat. 64–71)

JOHN COVERT (Cat. 31, 32)

STUART DAVIS (Cat. 48–50)

WILLEM DE KOONING (Cat. 95–102)

CHARLES DEMUTH (Cat. 44–7)

ARTHUR DOVE (Cat. 33–5)

MARCEL DUCHAMP (Cat. 19–30)

DAN FLAVIN (Cat. 209, 210)

SAM FRANCIS (Cat. 121, 122)

ROBERT GOBER (Cat. 251)

ARSHILE GORKY (Cat. 80–5)

DAN GRAHAM (Cat. 223)

PHILIP GUSTON (Cat. 227)

DAVID HAMMONS (Cat. 246)

KEITH HARING (Cat. 235, 236)

MARSDEN HARTLEY (Cat. 1–3)

EVA HESSE (Cat. 211–13)

GARY HILL (Cat. 247)

JENNY HOLZER (Cat. 240)

EDWARD HOPPER (Cat. 57–63)

JASPER JOHNS (Cat. 146–52)

DONALD JUDD (Cat. 201–4)

MIKE KELLEY (Cat. 252)

ELLSWORTH KELLY (Cat. 130–4)

FRANZ KLINE (Cat. 119, 120)

JEFF KOONS (Cat. 248–50)

SOL LEWITT (Cat. 208)

ROY LICHTENSTEIN (Cat. 177–82)

ROBERT MANGOLD (Cat. 198)

BRICE MARDEN (Cat. 199, 200)

AGNES MARTIN (Cat. 193, 194)

ROBERT MORRIS (Cat. 205)

GERALD MURPHY (Cat. 42, 43)

BRUCE NAUMAN (Cat. 214–17)

BARNETT NEWMAN (Cat. 107–12)

GEORGIA O'KEEFFE (Cat. 36–41)

CLAES OLDENBURG (Cat. 162–74)

JACKSON POLLOCK (Cat. 86–94)

MARTIN PURYEAR (Cat. 237–9)

ROBERT RAUSCHENBERG (Cat. 135–41)

MAN RAY (Cat. 4–18)

AD REINHARDT (Cat. 123–5)

JAMES ROSENQUIST (Cat. 175, 176)

MARK ROTHKO (Cat. 113–18)

EDWARD RUSCHA (Cat. 190)

ROBERT RYMAN (Cat. 195–7)

JULIAN SCHNABEL (Cat. 231, 232)

RICHARD SERRA (Cat. 218–20)

CHARLES SHEELER (Cat. 51–4)

CINDY SHERMAN (Cat. 242–5)

DAVID SMITH (Cat. 126–9)

FRANK STELLA (Cat. 153–8)

JOSEPH STELLA (Cat. 55, 56)

CLYFFORD STILL (Cat. 103–6)

JAMES TURRELL (Cat. 224)

CY TWOMBLY (Cat. 142–5)

BILL VIOLA (Cat. 241)

ANDY WARHOL (Cat. 183–9)

LAWRENCE WEINER (Cat. 221, 222)

Note

Cat. 25, 54, 58, 108 and 213 on show in London only.

The works illustrated as Cat. 224 and 246 are not
identical with those shown in the exhibition.
Dimensions are given in centimetres and inches,
height before width before depth.

1 MARSDEN HARTLEY, *Portrait of a German Officer*, 1914
 Oil on canvas, 173.5 x 105 cm (68¹/₄ x 41¹/₂ in.)
 The Metropolitan Museum of Art, New York; The Alfred Stieglitz Collection, 1949

2 MARSDEN HARTLEY, *Painting No. 48*, 1913
Oil on canvas, 120 x 120 cm (47¼ x 47¼ in.)
The Brooklyn Museum, New York; Dick S. Ramsay Fund

3 MARSDEN HARTLEY, *Paris Days ... Pre War*, 1914
 Oil on canvas, 105.5 x 86.5 cm (41¹/₂ x 34 in.)
 Collection of John and Barbara Landau

4 MAN RAY, *Dance*, 1915
 Oil on canvas, 91.5 x 71 cm (36 x 28 in.)
 Andrew J. Crispo Collection, New York

5 MAN RAY, *Promenade*, 1916
Oil on canvas, 100 x 81 cm (39¼ x 32 in.)
Private collection

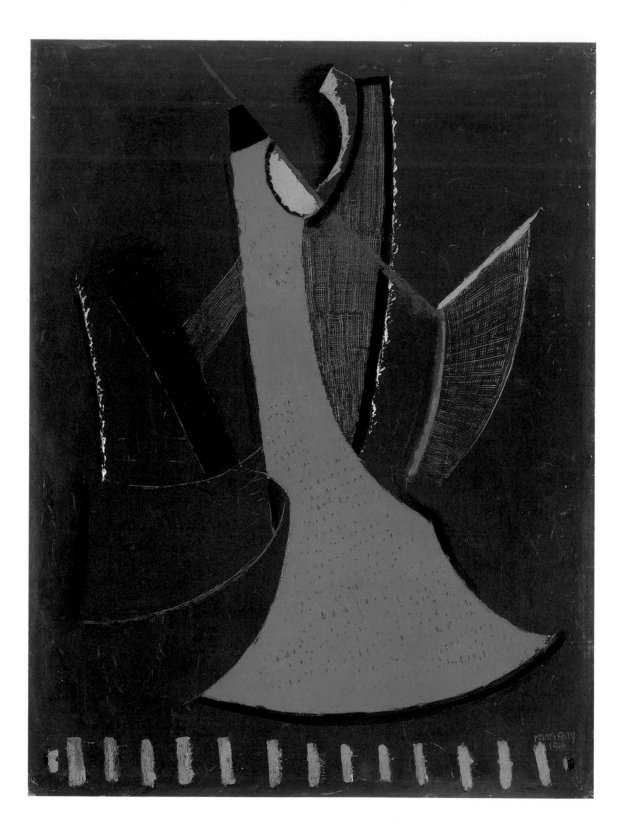

6 MAN RAY, *The Mime*, 1916
 Oil on Masonite, 61.5 x 46 cm (24¼ x 18 in.)
 The Metropolitan Museum of Art, New York; Gift of Everett B. Birch, 1982

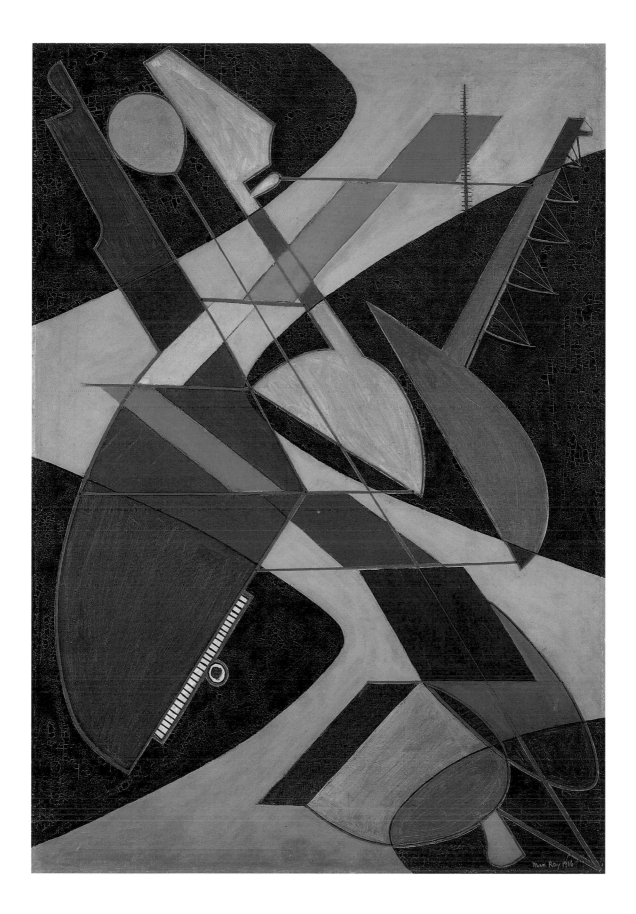

7 MAN RAY, *Symphony Orchestra*, 1916
 Oil on canvas, 132 x 91.5 cm (52 x 36 in.)
 Albright-Knox Art Gallery, Buffalo, NY; George B. and Jenny R. Mathews Fund, 1970

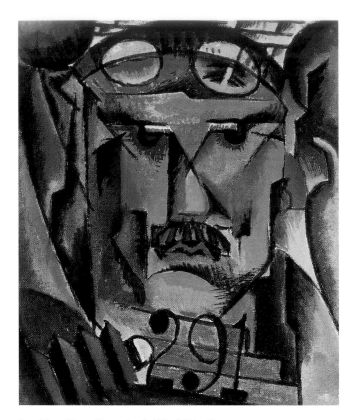

8 MAN RAY, *Portrait of Alfred Stieglitz*, 1913
Oil on canvas, 26.5 x 21.5 cm (10¹/₂ x 8¹/₂ in.)
The Yale Collection of American Literature, Beinecke Rare
Book and Manuscript Library, Yale University, New Haven

9 MAN RAY, *L'abat-jour* (Lampshade), 1919;
replica, 1959
Sheet iron, height approx. 80/90 cm (31¹/₂ / 35¹/₂ in.)
Ulmer Museum, Ulm; Gift of Inge Fried

10 MAN RAY, *New York*, 1917; replica, 1966
Silver, 42.5 x 26 cm (16³/₄ x 10¹/₄ in.)
Galerie Marion Meyer, Paris

11 MAN RAY, *L'Enigme d'Isidore Ducasse*, 1920; replica, 1971
 Various materials, 48 x 58 x 23cm (19 x 22³/₄ x 9 in.)
 Museum Boymans-van Beuningen, Rotterdam

12 MAN RAY, *Obstruction*, 1920
 65 clothes-hangers, each 42 cm (16¹/₂ in.)
 Galerie Marion Meyer, Paris

13 MAN RAY, *Marcel Duchamp & Optique de Précision*
(Marcel Duchamp & Rotary Glass), 1920
Vintage silver print, 12.5 x 9 cm (5 x 3¹/₂ in.)
Courtesy Galerie Rudolf Kicken, Cologne,
and Galerie Alain Paviot, Paris

14 MAN RAY, *Optique de Précision & en avant du bras*
(Rotary Glass & In Advance of the Broken Arm),
1920. Vintage silver print, 12.5 x 9 cm (5 x 3¹/₂ in.)
Courtesy Galerie Rudolf Kicken, Cologne,
and Galerie Alain Paviot, Paris

15 MAN RAY, *Dust Breeding*, 1920
Vintage toned gelatin silver print,
7.5 x 11 cm (3 x 4¹/₄ in.)
Jedermann Collection, N.A.

16 MAN RAY, *Marcel Duchamp (Tondu par De Zayas)*
(Marcel Duchamp [Haircut for De Zayas]), 1921
Vintage silver print, 12 x 9 cm (4³/₄ x 3¹/₂ in.)
Courtesy Galerie Rudolf Kicken, Cologne,
and Galerie Alain Paviot, Paris

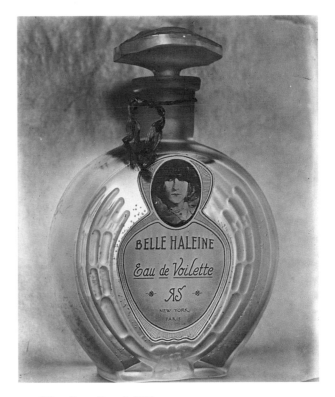

17 MAN RAY, *Eau de Voilette*, 1921
Vintage silver print, 11 x 9 cm (4¹/₂ x 3¹/₂ in.)
Courtesy Galerie Rudolf Kicken, Cologne,
and Galerie Alain Paviot, Paris

18 MAN RAY, *Marcel Duchamp as Rrose Sélavy*, 1921
14 x 10 cm (5¹/₂ x 4 in.)
Private collection

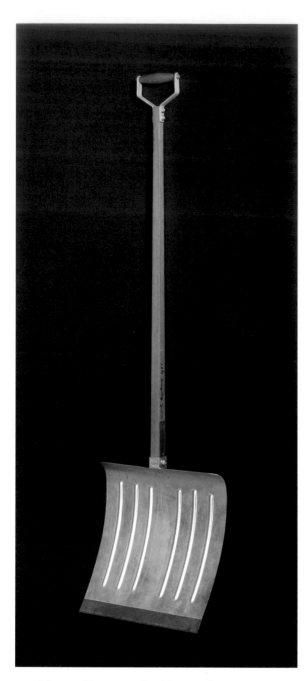

21 MARCEL DUCHAMP, *Traveller's Folding Item*, 1917;
replica, 1964
Ready-made, 24 x 42.5 x 38 cm (9¹/₂ x 16³/₄ x 15 in.)
Indiana University Art Museum, Bloomington;
Partial Gift of Mrs William Conroy

20 MARCEL DUCHAMP, *Comb*, 1916;
replica, 1964. Ready-made,
0.3 x 16.6 x 3.2 cm (¹/₈ x 6¹/₂ x 1¹/₄ in.)
Collection Ronny Van de Velde, Antwerp

19 MARCEL DUCHAMP, *In Advance of the Broken Arm*,
1915; replica, 1964
Ready-made, 121.5 x 35.5 cm (47³/₄ x 14 in.)
Indiana University Art Museum, Bloomington;
Partial Gift of Mrs William Conroy

22 MARCEL DUCHAMP, *Fountain*, 1917;
replica, 1964
Ready-made, 62.5 x 35.5 x 49 cm (24¹/₂ x 14 x 19¹/₂ in.)
Indiana University Art Museum, Bloomington;
Partial Gift of Mrs William Conroy

23 MARCEL DUCHAMP, *Trébuchet* (Trap), 1917;
replica, 1964
Ready-made, 11.5 x 100 cm (4½ x 39¼ in.)
Collection Ronny Van de Velde, Antwerp

27 MARCEL DUCHAMP, *Boite-en-Valise* (Box in a Valise), series E, *1963*
Box with 68 objects
Collection Loic Malle, Paris

Previous page

centre left:
24 MARCEL DUCHAMP, *A Bruit Secret (With Hidden Noise)*, 1916; replica, 1964
Assisted ready-made: various materials, 11.5 x 13 x 13 cm (4¹/₂ x 5 x 5 in.)
Indiana University Art Museum, Bloomington; Partial Gift of Mrs William Conroy

lower left:
25 MARCEL DUCHAMP, *Why Not Sneeze, Rose Sélavy?*, 1921; replica, 1964
V arious materials, 12.5 x 22 x 16 cm
(4³/₄ x 8³/₄ x 6¹/₄ in.)
Private collection

lower right:
26 MARCEL DUCHAMP, *Fresh Widow*, 1920; replica, 1964
Various materials,
77.5 x 45 cm (30¹/₂ x 17³/₄ in.);
base 1.5 x 53 x 10 cm (¹/₂ x 21 x 4 in.)
Collection Ronny Van de Velde, Antwerp

28 MARCEL DUCHAMP, *Objet-Dard*, 1951;
replica, 1966
Bronze cast, 20 x 7.5 x 6 cm (8 x 3 x 2¼ in.)
Private collection

29 MARCEL DUCHAMP, *Feuille de Vigne Femelle*
(Female Fig-Leaf), 1950; replica, 1961
Bronze cast, 9 x 14 x 12 cm (3½ x 5½ x 4¾ in.)
Private collection

30 MARCEL DUCHAMP, *Coin de chasteté* (Wedge of Chastity),
1954; replica, 1963
Bronze cast and dental plastic, 5.5 x 8.5 x 4 cm
(2¼ x 3¼ x 1¾ in.)
Collection Ronny Van de Velde, Antwerp

31 JOHN COVERT, *The Temptation of St. Anthony*, 1916
 Oil on canvas, 66 x 61 cm (30 x 24 in.)
 Yale University Art Gallery, New Haven;
 Société Anonyme Collection

32 JOHN COVERT, *Brass Band,* 1919
Oil and string on composition board, 66 x 61 cm (26 x 24 in.)
Yale University Art Gallery, New Haven;
Société Anonyme Collection

33 ARTHUR DOVE, *Sewing Machine*, 1927
 Oil, cut and pasted linen and graphite on aluminium, 38 x 50 cm (15 x 19¾ in.)
 The Metropolitan Museum of Art, New York; The Alfred Stieglitz Collection, 1949

34 ARTHUR DOVE, *George Gershwin – Rhapsody in Blue, Part I*, 1927. Oil and metallic
 paint on aluminium with clock spring, 30 x 25 cm (11¾ x 9¾ in.)
 Andrew J. Crispo Collection, New York

35 ARTHUR DOVE, *Goin' Fishin'*, 1925
Collage on wood panel, 49.5 x 61 cm (19¹/₂ x 24 in.)
The Phillips Collection, Washington, DC

36 GEORGIA O'KEEFFE, *Shelton Hotel, New York, NY, No. 1*, 1926
Oil on canvas, 81.5 x 43 cm (32 x 17 in.)
Regis Corporation, Minneapolis, Minnesota

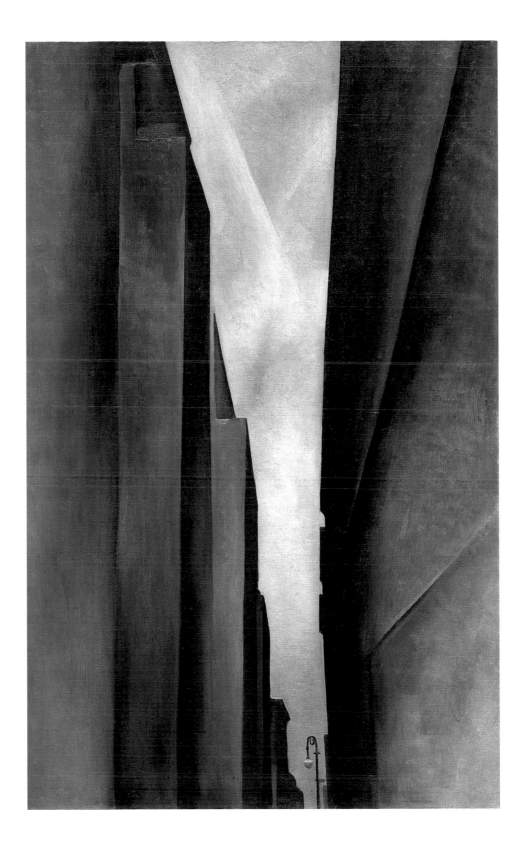

37 Georgia O'Keeffe, *Street, New York, No. 1*, 1926
Oil on canvas, 122 x 76 cm (48 x 30 in.)
Private collection

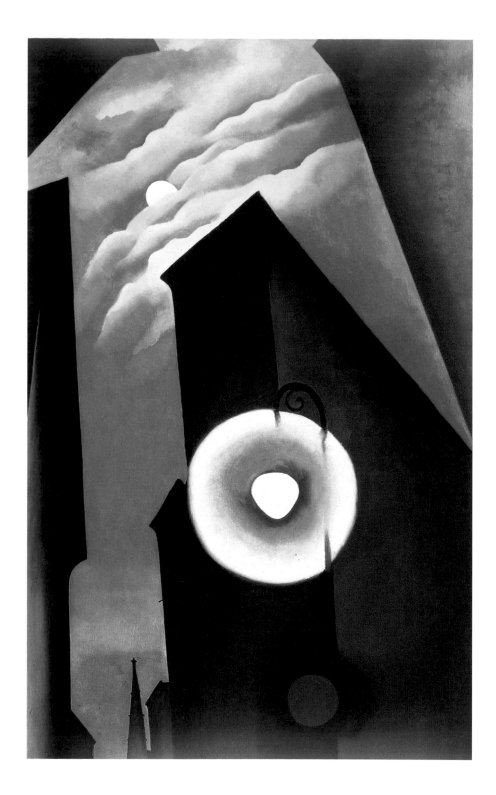

38　Georgia O'Keeffe, *New York with Moon*, 1928
　　Oil on canvas, 122 x 77 cm (48 x 30¼ in.)
　　Thyssen-Bornemisza Collection, Madrid

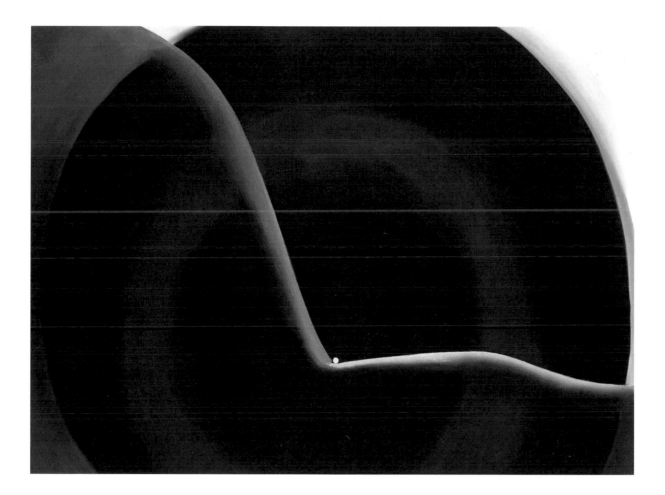

39 GEORGIA O'KEEFFE, *Black Abstraction*, 1927
 Oil on canvas, 76 x 102 cm (30 x 40¼ in.)
 The Metropolitan Museum of Art, New York; The Alfred Stieglitz Collection, 1969

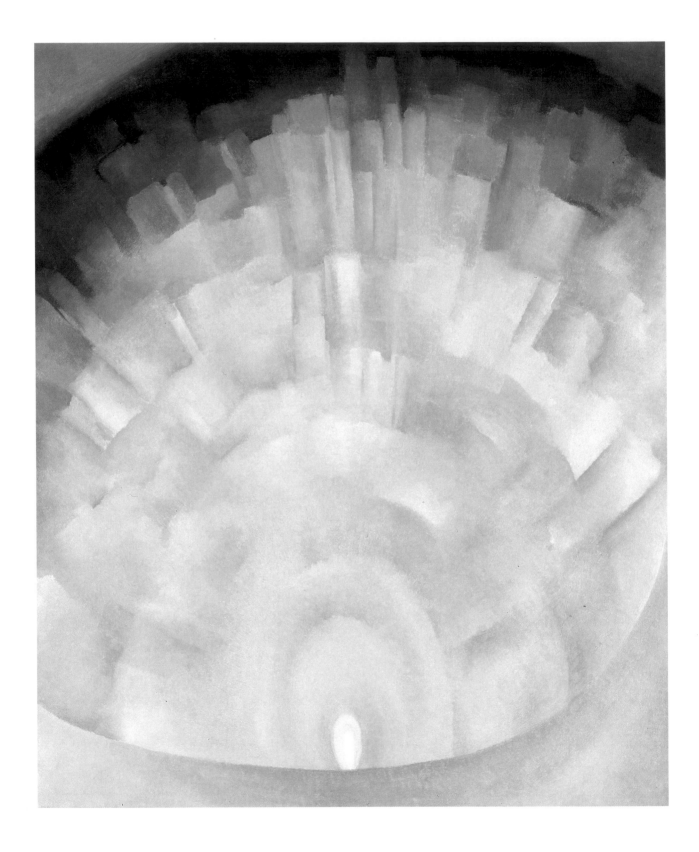

40 GEORGIA O'KEEFFE, *Abstraction – White Rose III*, 1927
 Oil on canvas, 91.5 x 91.5 cm (36 x 36 in.)
 The Art Institute of Chicago; Alfred Stieglitz Collection, bequest of Georgia O'Keeffe, 1987.250.1

41 GEORGIA O'KEEFFE, *Ranchos Church*, 1930
 Oil on canvas, 61 x 91.5 cm (24 x 36 in.)
 The Metropolitan Museum of Art, New York; The Alfred Stieglitz Collection, 1969

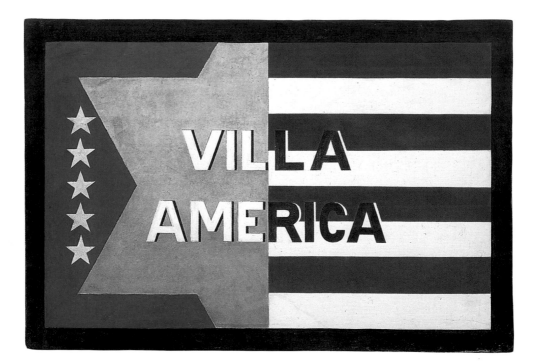

42 GERALD MURPHY, *Villa America*, 1922
 Tempera and gold leaf on board,
 37 x 54.5 cm (14¹/₂ x 21¹/₂ in.)
 Honoria Donnelly, Murphy: courtesy Salander-O'Reilly Galleries, Inc., New York

43 GERALD MURPHY, *Razor*, 1924
 Oil on canvas, 83 x 93 cm (32$\frac{1}{2}$ x 36$\frac{1}{2}$ in.)
 Dallas Museum of Art; Foundation for the Arts Collection, gift of the artist

44 CHARLES DEMUTH, *Business*, 1921
 Oil on canvas, 51 x 61.5 cm (20 x 24¼ in.)
 The Art Institute of Chicago; Alfred Stieglitz Collection, 1949.529

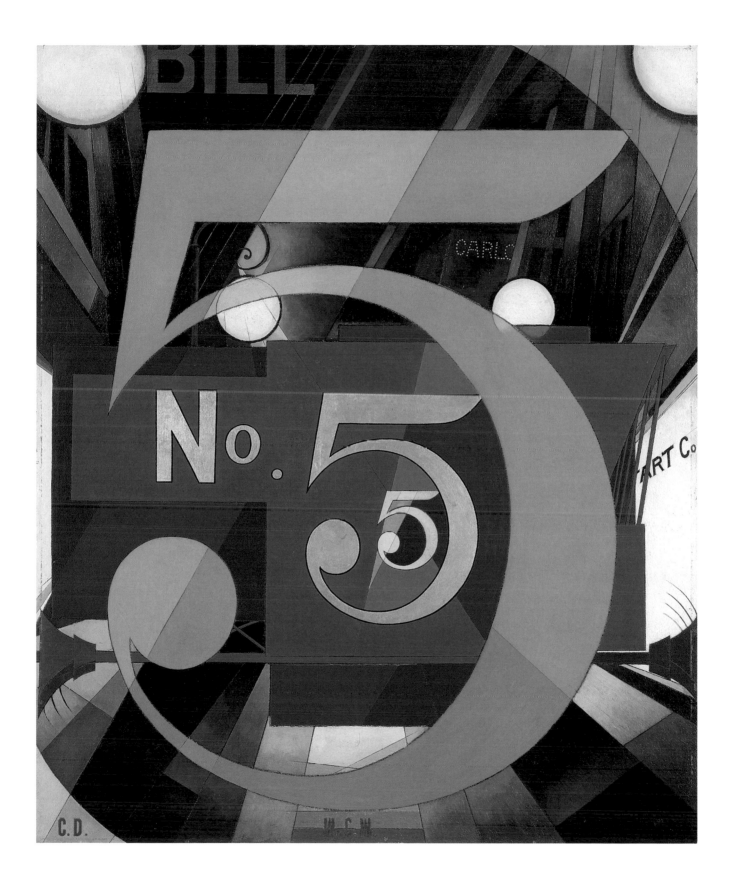

45 CHARLES DEMUTH, *I Saw the Figure 5 in Gold*, 1928
Oil on cardboard, 90 x 76 cm (35½ x 30 in.)
The Metropolitan Museum of Art, New York; The Alfred Stieglitz Collection, 1949

46 CHARLES DEMUTH, *Love, Love, Love: Homage to Gertrude Stein*, 1928
Oil on panel, 51 x 53 cm (20 x 20³/₄ in.)
Thyssen-Bornemisza Collection, Madrid

47 CHARLES DEMUTH, *Buildings, Lancaster,* 1930
 Oil on composition board, 61 x 51 cm (24 x 20 in.)
 Collection of Whitney Museum of American Art, New York; Gift of an anonymous donor

48 STUART DAVIS, *Cigarette Papers*, 1921
 Oil, bronze paint and graphite pencil on canvas,
 48.5 x 35.5 cm (19 x 14 in.)
 The Menil Collection, Houston

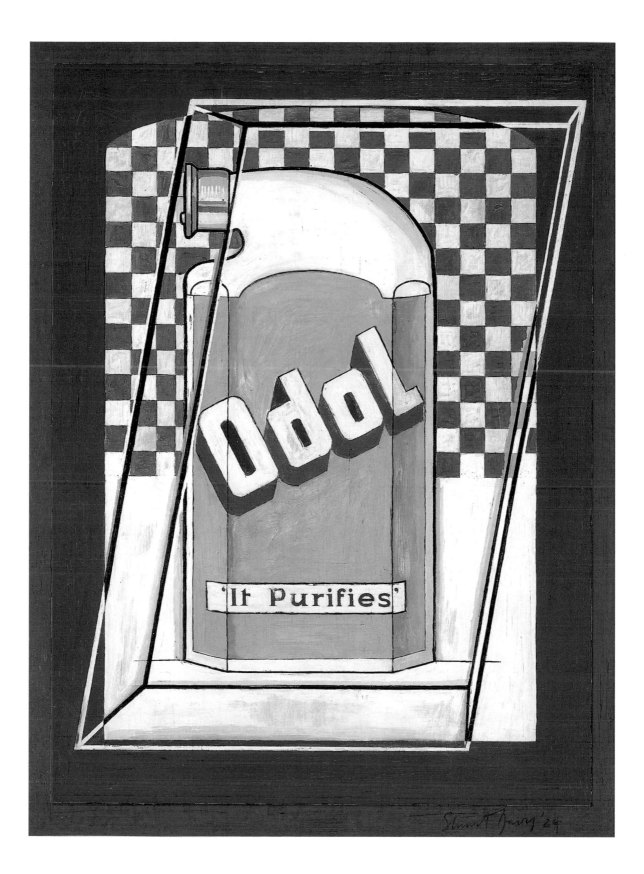

49 STUART DAVIS, *Odol*, 1924
Oil on canvas-board, 61 x 45.5 cm (24 x 18 in.)
Andrew J. Crispo Collection, New York

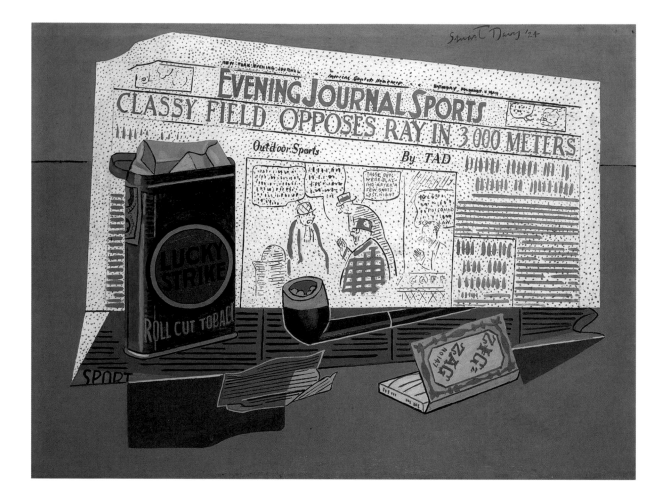

50 STUART DAVIS, *Lucky Strike*, 1924
 Oil on paper-board, 45.5 x 61 cm (18 x 24 in.)
 Hirshhorn Museum and Sculpture Garden, Smithsonian Institution,
 Washington, DC; Museum Purchase, 1974

51 CHARLES SHEELER, *Upper Deck*, 1929
 Oil on canvas, 74 x 56.5 cm (29 x 22¼ in.)
 Fogg Art Museum, Harvard University Art Museums, Cambridge, MA;
 Louise E. Bettens Fund

52 CHARLES SHEELER, *Skyscrapers (Offices)*, 1922
Oil on canvas, 51 x 33 cm (20 x 13 in.)
The Phillips Collection, Washington, DC

53 CHARLES SHEELER, *View of New York*, 1931
Oil on canvas, 121 x 92 cm (47³/₄ x 36¹/₄ in.)
Museum of Fine Arts, Boston; The Hayden Collection, 35.69

54 CHARLES SHEELER, *Classic Landscape*, 1931
Oil on canvas, 63.5 x 81.5 cm (25 x 32 in.)
Collection of the Mr and Mrs Barney A. Ebsworth Foundation, St Louis

55 JOSEPH STELLA, *Factories at Night – New Jersey*, 1929
Oil on canvas, 73.5 x 92 cm (29 x 36¼ in.)
Collection of The Newark Museum; Purchase 1936, Thomas L. Raymond Bequest Fund

56 JOSEPH STELLA, *American Landscape*, 1929
 Oil on canvas, 200.5 x 100 cm (79 x 39¼ in.)
 Collection Walker Art Center, Minneapolis; Gift of the T.B. Walker Foundation, 1957

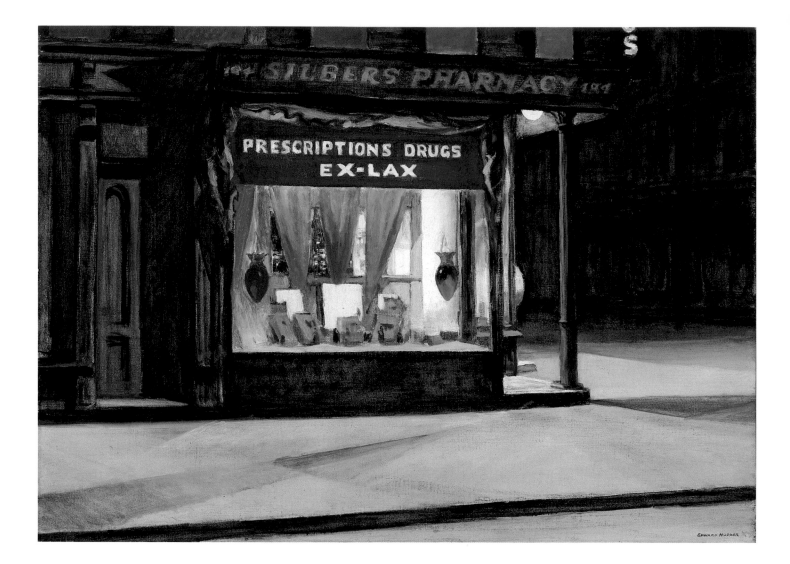

57 EDWARD HOPPER, *Drug Store*, 1927
 Oil on canvas, 73.5 x 101.5 cm (29 x 40 in.)
 Museum of Fine Arts, Boston; The Bequest of John T. Spaulding, 48.564

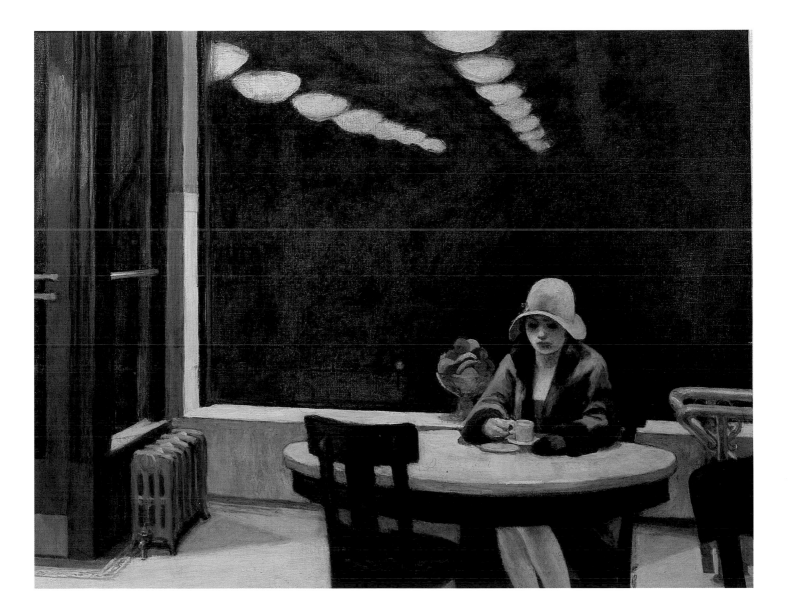

58　EDWARD HOPPER, *Automat*, 1927
Oil on canvas, 71.5 x 91.5 cm (28 x 36 in.)
Des Moines Art Center Permanent Collection, 1958.2;
Purchased with funds from the Edmundson Art Foundation, Inc.

59 EDWARD HOPPER, *From Williamsburg Bridge*, 1928
Oil on canvas, 74 x 109 cm (29 x 43 in.)
The Metropolitan Museum of Art, New York; George A. Hearn Fund, 1937

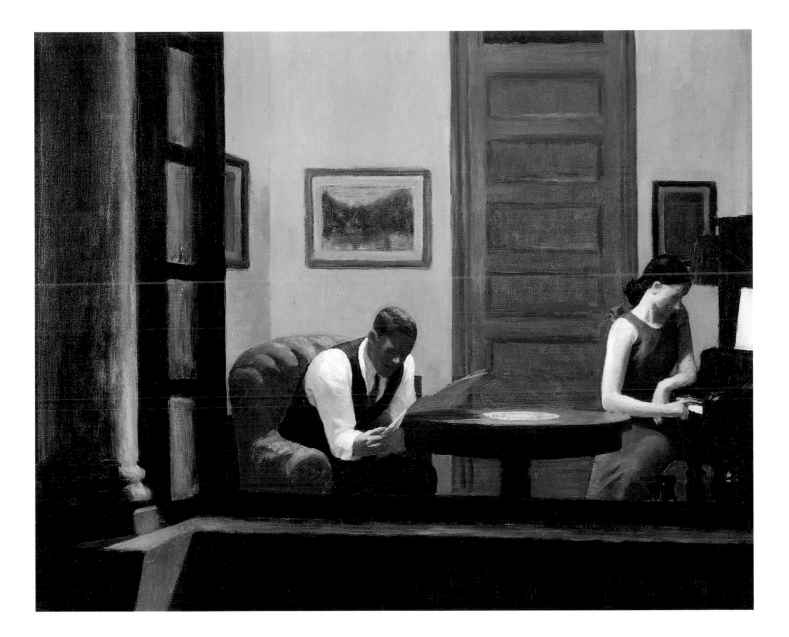

60 EDWARD HOPPER, *Room in New York*, 1932
Oil on canvas, 73.5 x 91.5 cm (29 x 36 in.)
Sheldon Memorial Art Gallery, University of Nebraska, Lincoln;
F. M. Hall Collection, 1936.H.-166

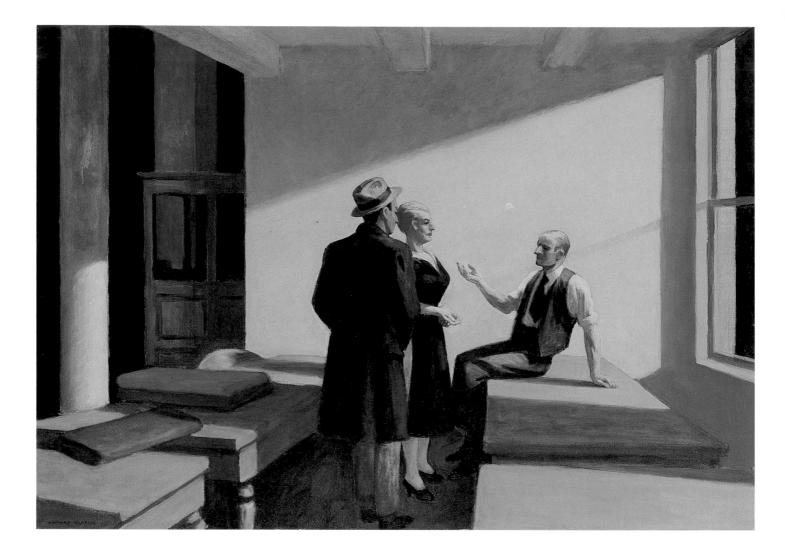

61 EDWARD HOPPER, *Conference at Night*, 1949
 Oil on canvas, 70 x 102 cm (27¹/₂ x 40 in.)
 Wichita Art Museum, Wichita, Kansas; The Roland P. Murdock Collection

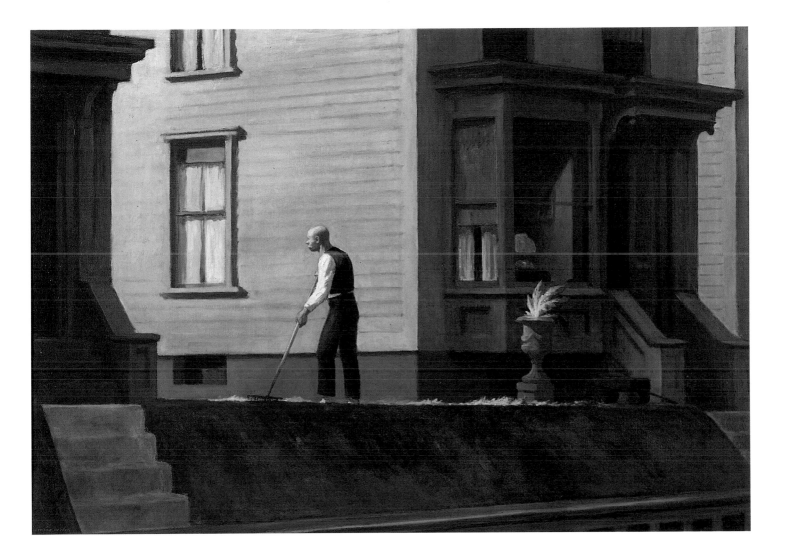

62 EDWARD HOPPER, *Pennsylvania Coal Town*, 1947
 Oil on canvas, 71 x 101.5 cm (28 x 40 in.)
 The Butler Institute of American Art, Youngstown, OH

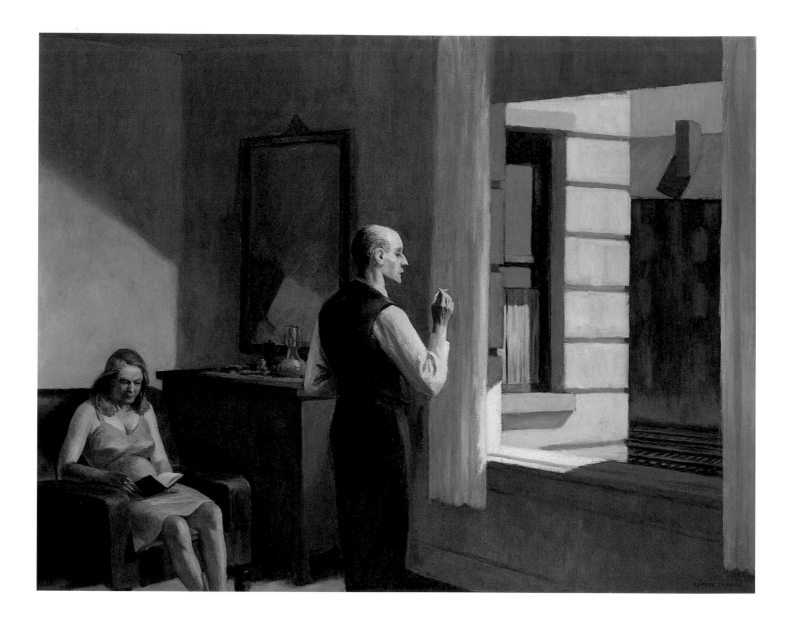

63 EDWARD HOPPER, *Hotel by a Railroad*, 1952
Oil on canvas, 79 x 102 cm (31¼ x 40¼ in.)
Hirshhorn Museum and Sculpture Garden, Smithsonian Institution, Washington, DC;
Gift of Joseph H. Hirshhorn Foundation, 1966

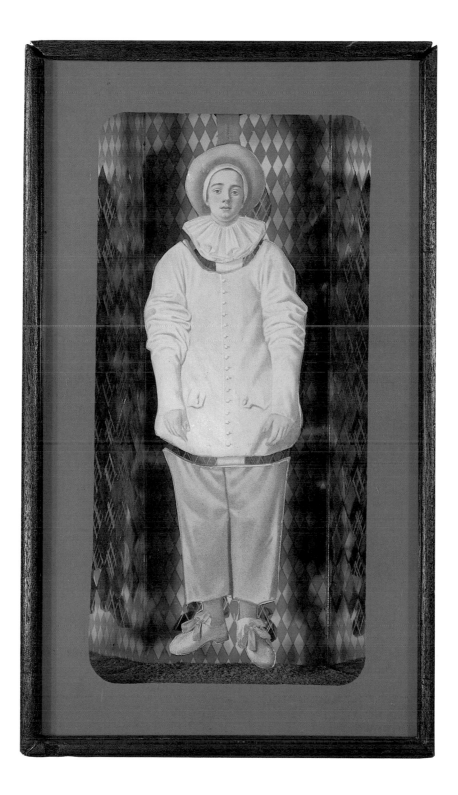

64 Joseph Cornell, *A Dressing Room for Gille*, 1939
 Mixed media box construction, 38 x 22 x 17 cm (15 x 8½ x 6¾ in.)
 Richard L. Feigen, New York

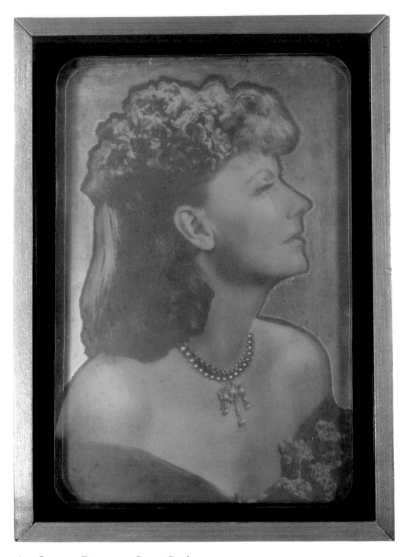

65　JOSEPH CORNELL, *Greta Garbo, c.* 1939
Mixed media box construction, 33.5 x 24 x 7.5 cm (13½ x 9½ x 3 in.)
Richard L. Feigen, New York

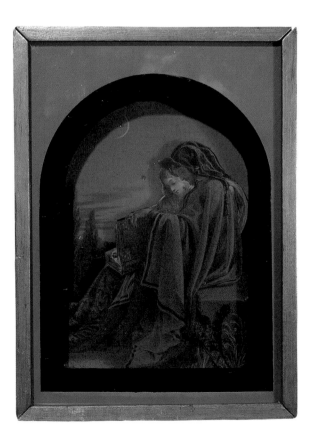

66　JOSEPH CORNELL, *Victorian Parlour Constellation
(Paolo and Francesca),* 1942
Mixed media box construction,
32 x 24 x 7.5 cm (12½ x 9⅓ x 3 in.)
Richard L. Feigen, New York

67　Joseph Cornell, *Soap Bubble Set*, 1940; replica, 1952
　　Wooden box with glass and objects, 34.5 x 48.5 cm (13½ x 19 in.)
　　The Art Institute of Chicago; Simeon B. Williams Fund, 1953.199

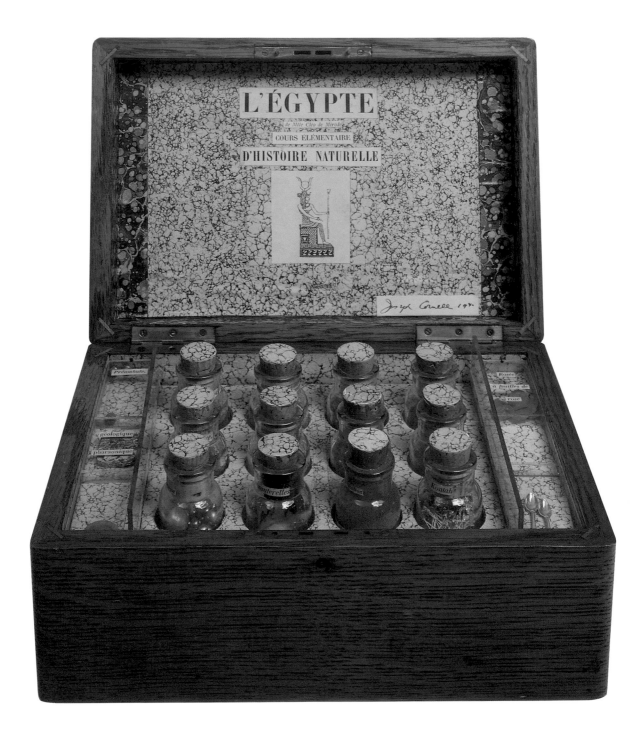

68 Joseph Cornell, *L'Egypte de Mlle Cléo de Mérode Cours Elémentaire d'Histoire naturelle*
(The Egypt of Mlle. Cléo de Mérode, Elementary Course in Natural History), 1940
Mixed media box construction, 27 x 18.5 x 12 cm (10¹/₂ x 7¹/₄ x 4³/₄ in.)
Richard L. Feigen, New York

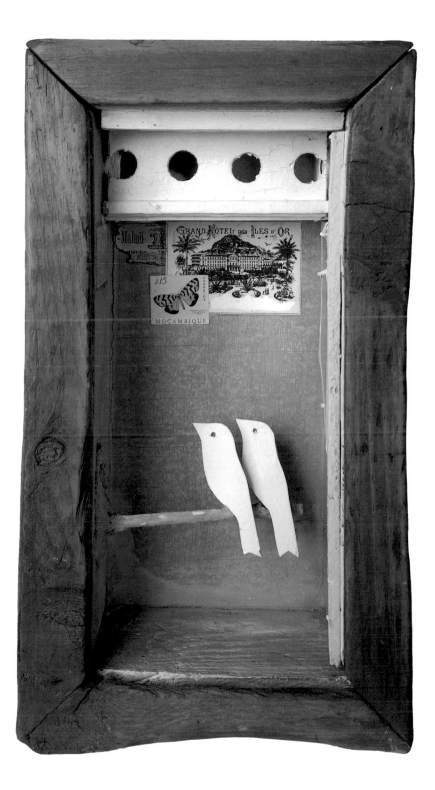

69 Joseph Cornell, *Untitled* (Grand Hôtel des Iles d'Or), 1952
Mixed media box construction, 27 x 15 x 8 cm (10¹/₂ x 6 x 3¹/₄ in.)
Galerie Karsten Greve, Cologne and Paris

70 JOSEPH CORNELL, *Untitled* (Hôtel de l'Etoile), 1953-54
Mixed media box construction, 51.5 x 36 x 12.5 cm (20¼ x 14¼ x 5 in.)
Galerie Karsten Greve, Cologne and Paris

71 JOSEPH CORNELL, *Untitled* (Dürer Boy), 1953
 Mixed media box construction, 52.5 x 34 x 12 cm
 (20³/₄ x 13¹/₂ x 4³/₄ in.)
 Private collection, Cologne

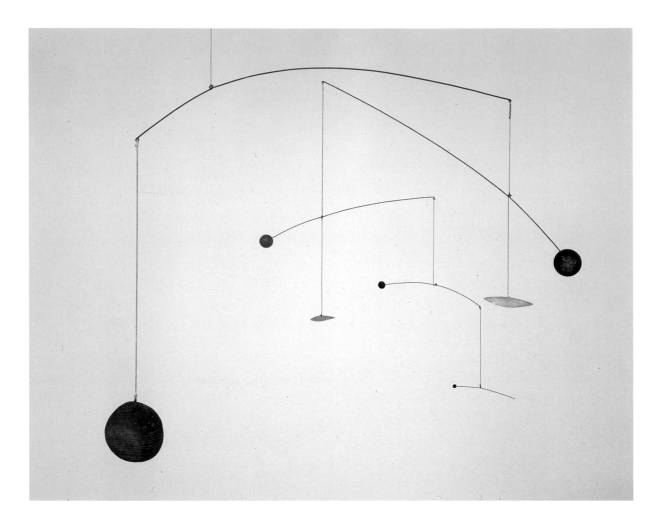

72 ALEXANDER CALDER, *Mobile*, 1932-34
Wood, 70 x 100 cm (27$^{1}/_{2}$ x 39$^{1}/_{4}$ in.)
Collection M. et Mme Adrien Maeght, Paris

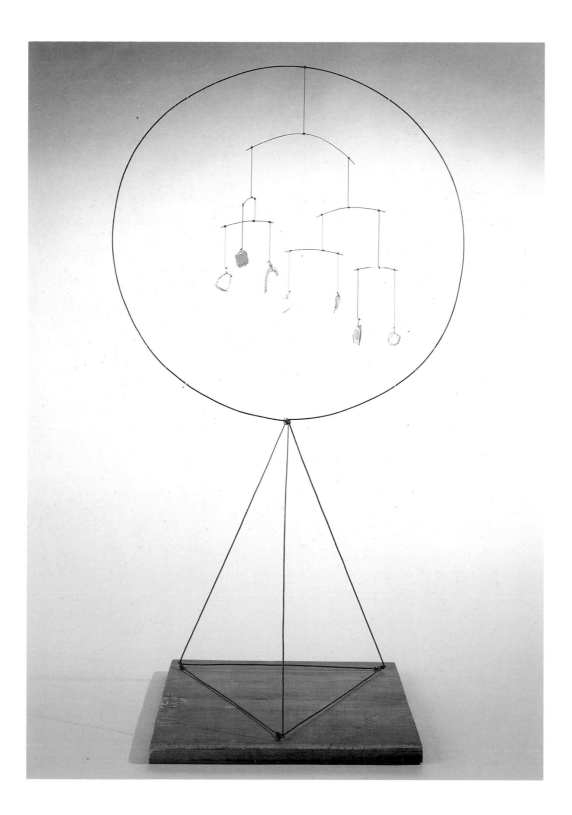

73 ALEXANDER CALDER, *Standing Mobile*, 1935
Metal, wire, broken glass, china and cord on wood base,
height 92 cm (36¼ in.)
Private collection, Paris; Courtesy Marc Blondeau, Paris

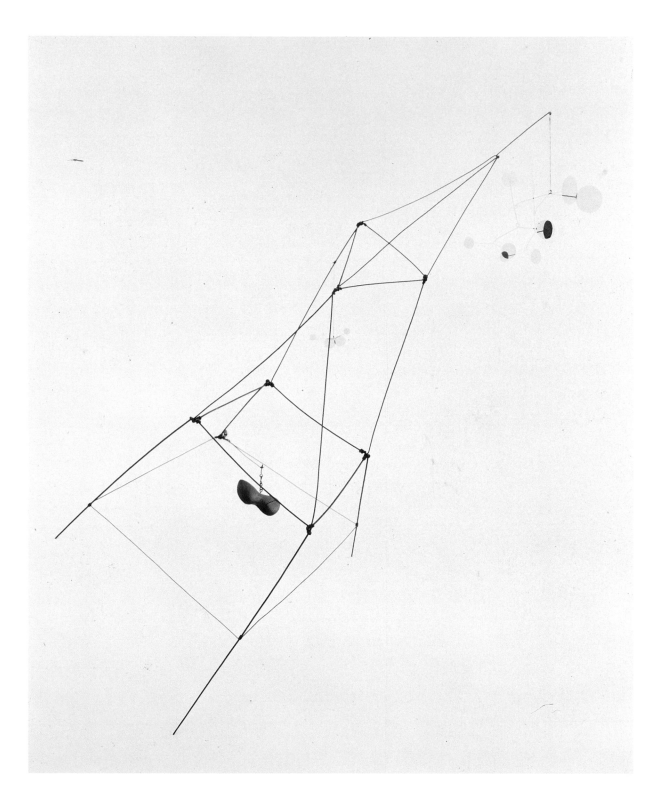

74 ALEXANDER CALDER, *Tower*, 1938
Painted metal and wood, 91.5 x 48.5 x 71 cm (36 x 19 x 28¼ in.)
Ron and Ann Pizzuti

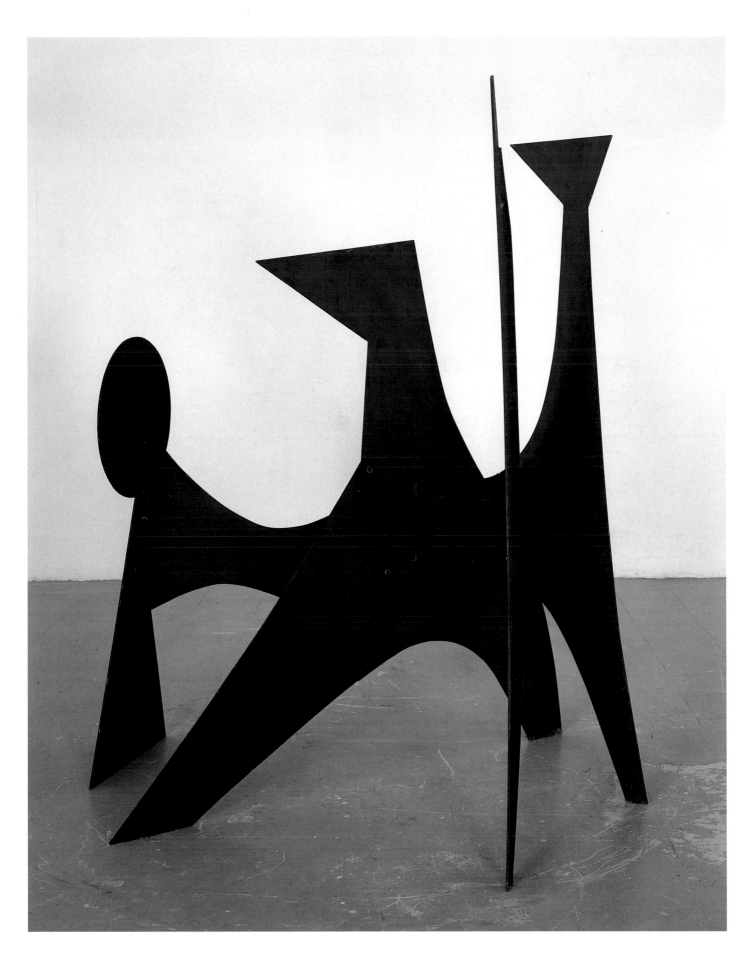

75 ALEXANDER CALDER, *Le Bougnat* (The Coalman), 1959
Stabile, iron, 205 x 170 cm (80¾ x 67 in.)
Collection M. et Mme Adrien Maeght, Paris

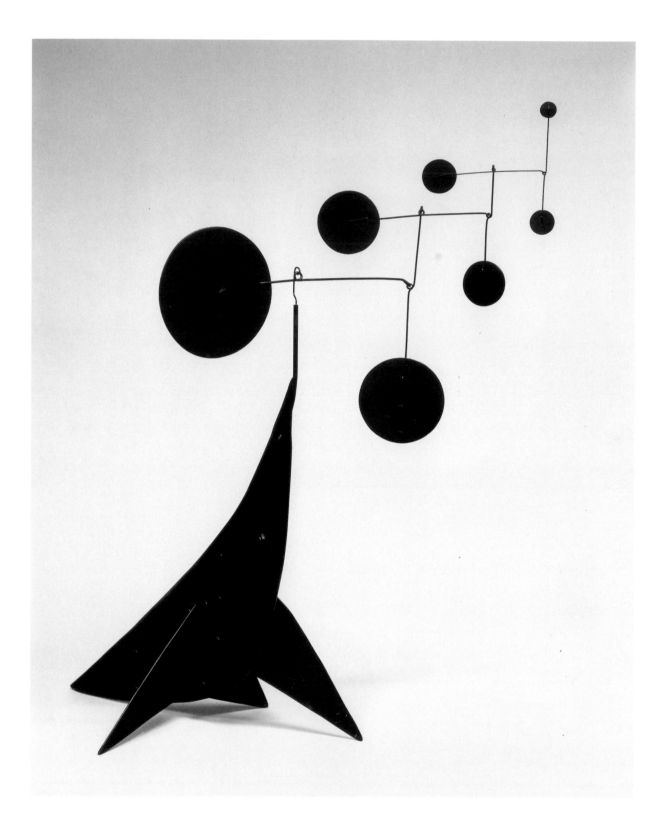

76 ALEXANDER CALDER, *Performing Seal*, 1950
 Stabile/mobile, painted sheet metal and steel wire, 84 x 58.5 x 91.5 cm (33 x 23 x 36 in.)
 Museum of Contemporary Art, Chicago; promised gift of Ruth and Leonard J. Horwich Family

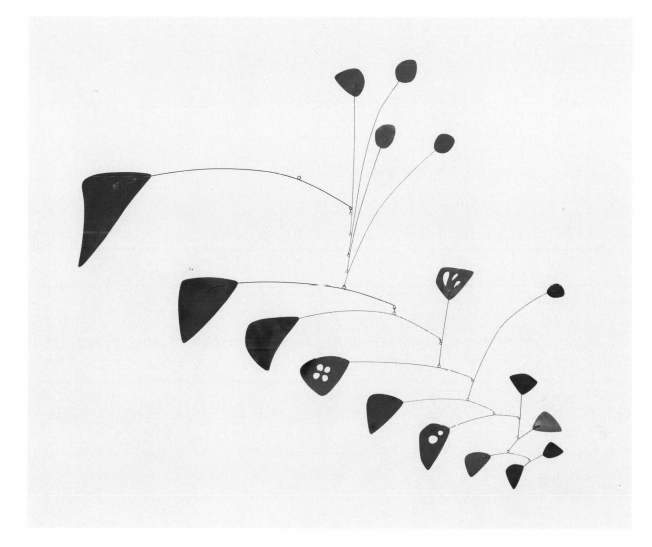

77 ALEXANDER CALDER, *All Red*, 1955
Mobile, painted metal, 140 x 145 cm (55 x 57 in.)
The Pace Gallery, New York

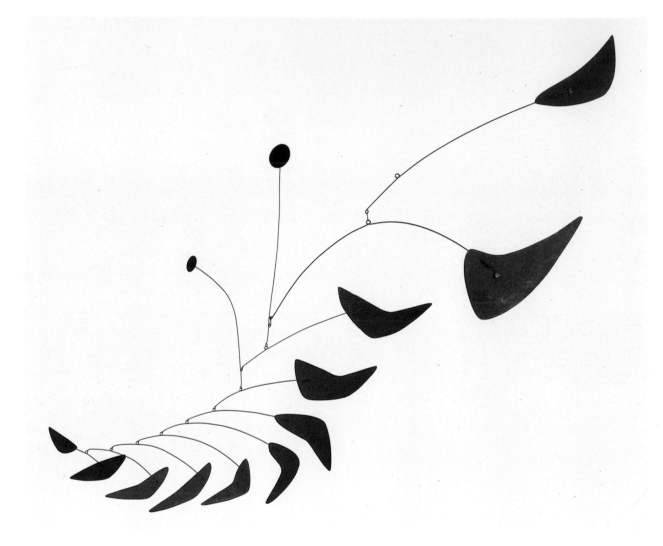

78 ALEXANDER CALDER, *Black: Two Dots and Eleven*, 1959
Mobile, painted metal and wire, 112 x 162.5 cm (44 x 64 in.)
Andy Williams

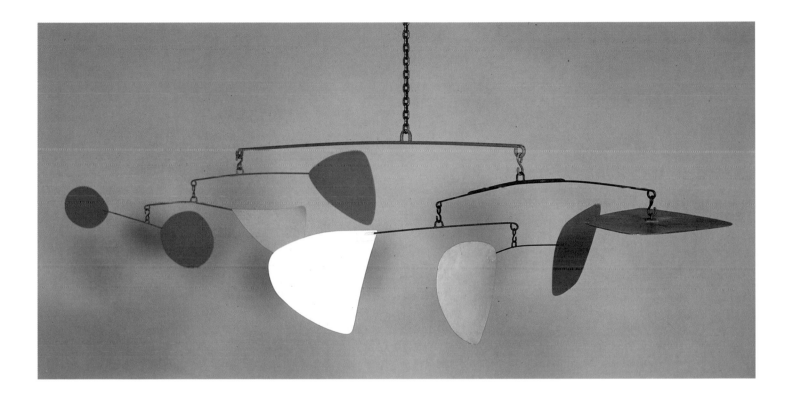

79 Alexander Calder, *Polychrome from One to Eight*, 1962
 Painted metal, 96.5 x 411.5 cm (38 x 162 in.)
 Courtesy of Marlborough Gallery, New York

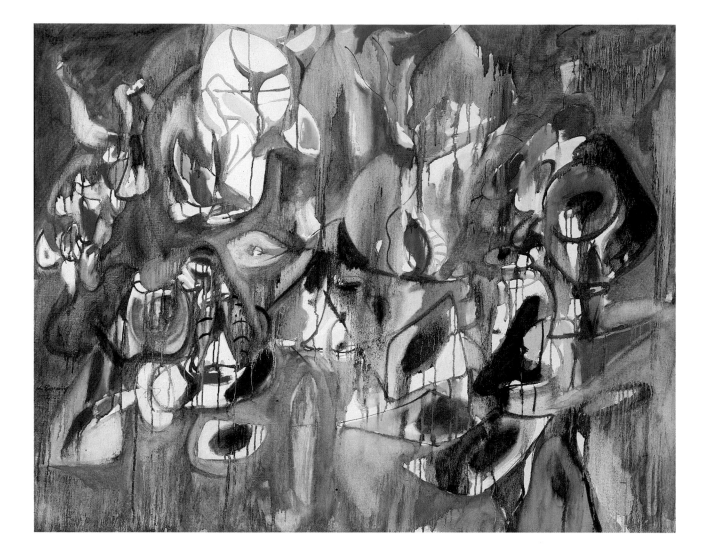

80 ARSHILE GORKY, *One Year the Milkweed*, 1944
Oil on canvas, 94 x 119 cm (37 x 47 in.)
National Gallery of Art, Washington, DC; Alisa Mellon Bruce Fund, 1979.13.2

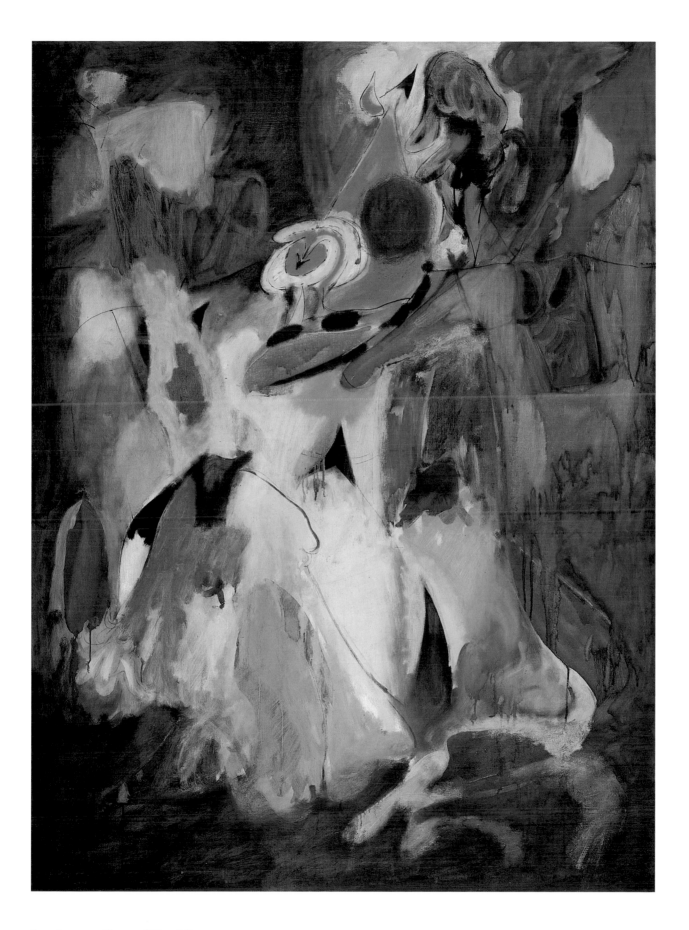

81 ARSHILE GORKY, *Waterfall*, 1943
 Oil on canvas, 153.5 x 113 cm (60½ x 44½ in.)
 Tate Gallery, London; Purchase with assistance from the Friends of the Tate Gallery, 1971

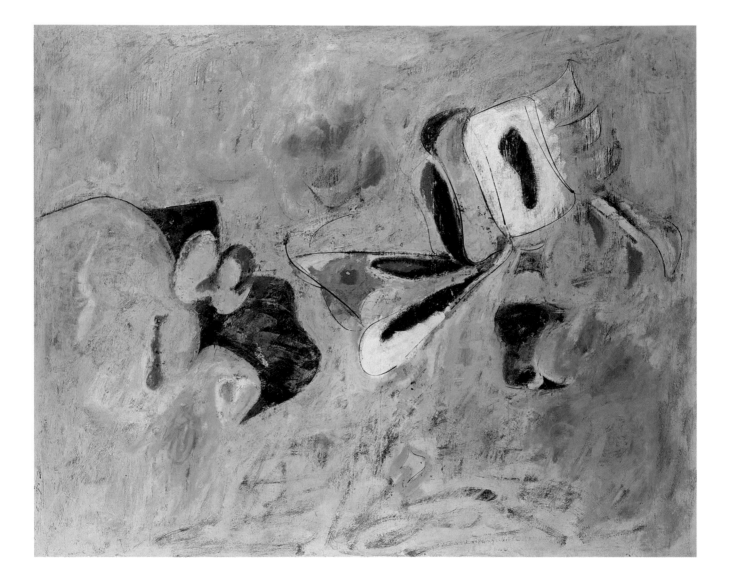

82 ARSHILE GORKY, *Apple Orchard*, 1943-46
Oil on canvas, 111 x 136 cm (43³/₄ x 53¹/₂ in.)
Private collection

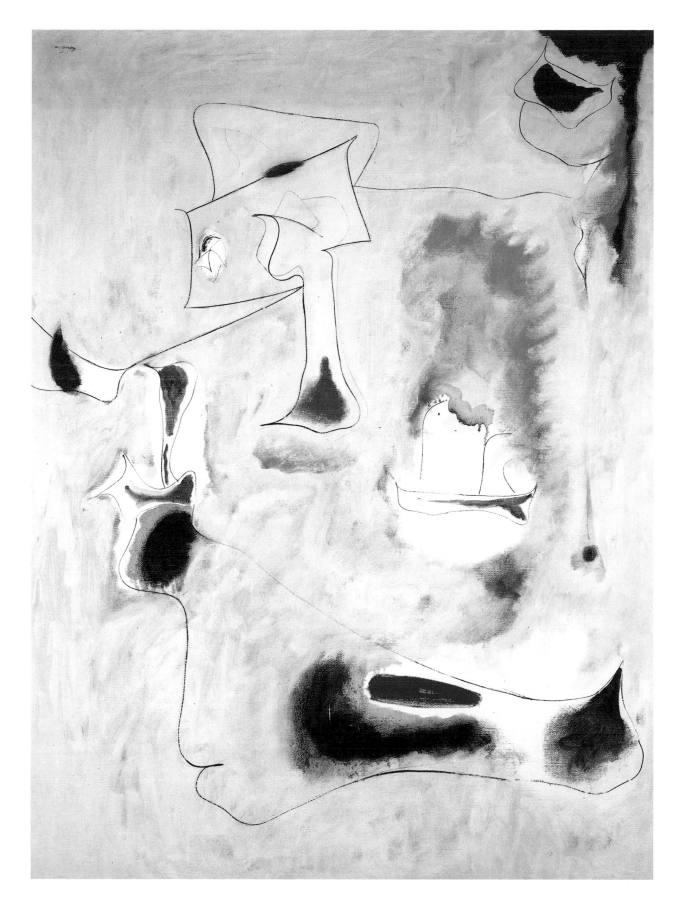

83 Arshile Gorky, *Charred Beloved I*, 1946
 Oil on canvas, 136 x 101 cm (53½ x 39¾ in.)
 Adriana and Robert Mnuchin

84 ARSHILE GORKY, *Pastorale*, 1947
Oil on canvas, 112 x 143 cm (44 x 56 in.)
Private collection

85 ARSHILE GORKY, *Making the Calendar*, 1947
 Oil on canvas, 86.5 x 104 cm (34 x 41 in.)
 Munson-Williams-Proctor Institute, Museum of Art, Utica, NY

86 JACKSON POLLOCK, *Mural*, 1943
 Oil on canvas, 247 x 605 cm (97 x 238 in.)
 The University of Iowa Museum of Art, Iowa City; Gift of Peggy Guggenheim

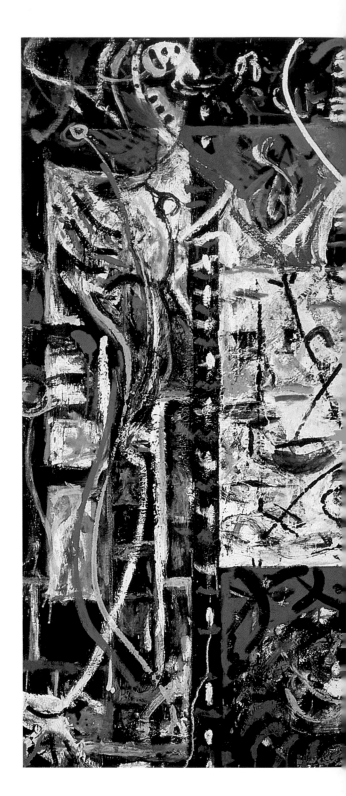

87 Jackson Pollock, *Guardians of the Secret,* 1943
Oil on canvas, 123 x 192 cm (48¹/₂ x 75¹/₄ in.)
San Francisco Museum of Modern Art;
Albert M. Bender Collection, Albert M. Bender Bequest Fund

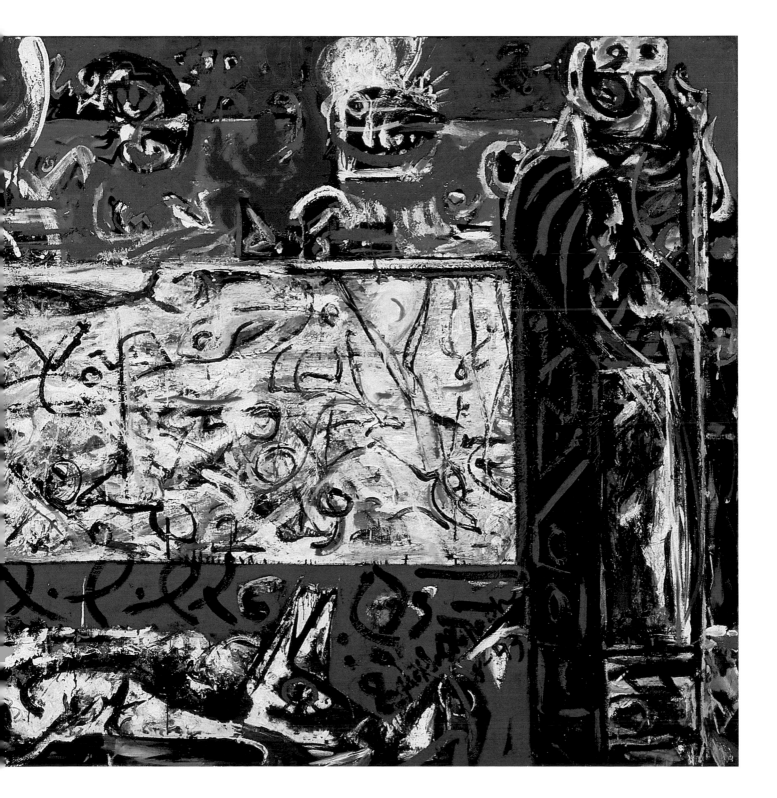

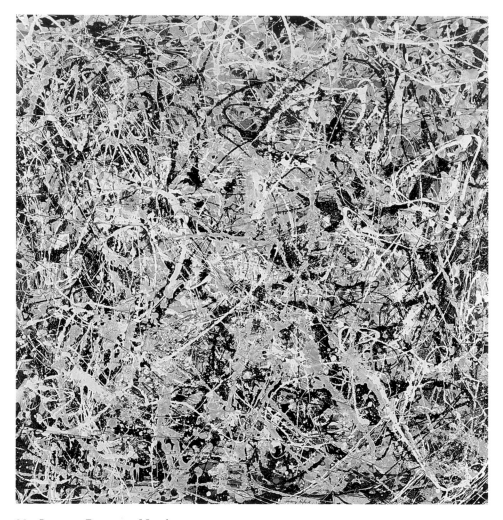

88 JACKSON POLLOCK, *Number 4*, 1949
 Oil, enamel and aluminium paint with pebbles on cut canvas, on composition board,
 90 x 87.5 cm (35½ x 34½ in.)
 Yale University Art Gallery, New Haven; The Katherine Ordway Collection

Opposite
89 JACKSON POLLOCK, *Number 2*, 1950
 Oil, lacquer, duco, silver paint and pebbles on canvas, 287 x 91.5 cm (113 x 36 in.)
 Fogg Art Museum, Harvard University Art Museums, Cambridge, MA; Gift of Mr and Mrs Reginald R. Isaacs and their fam
 and Comtemporary Art Fund

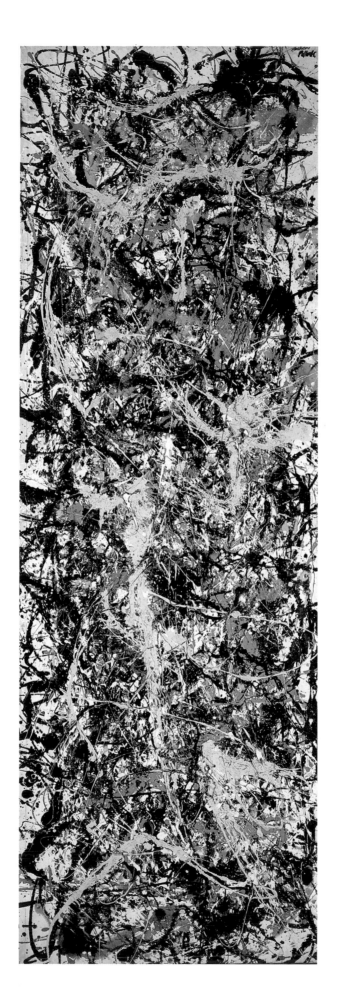

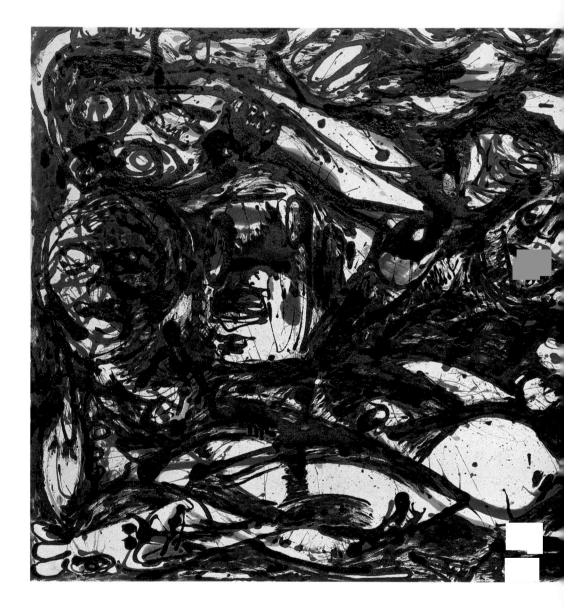

90 Jackson Pollock, *Number II*, 1951
 Enamel paint on canvas, 146 x 352 cm (57½ x 138½ in.)
 Private collection; Courtesy Thomas Ammann Fine Art, Zurich

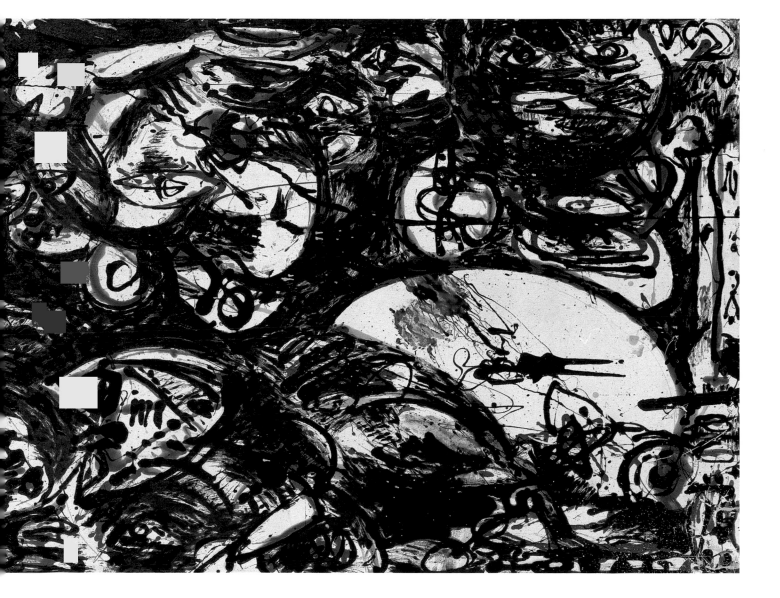

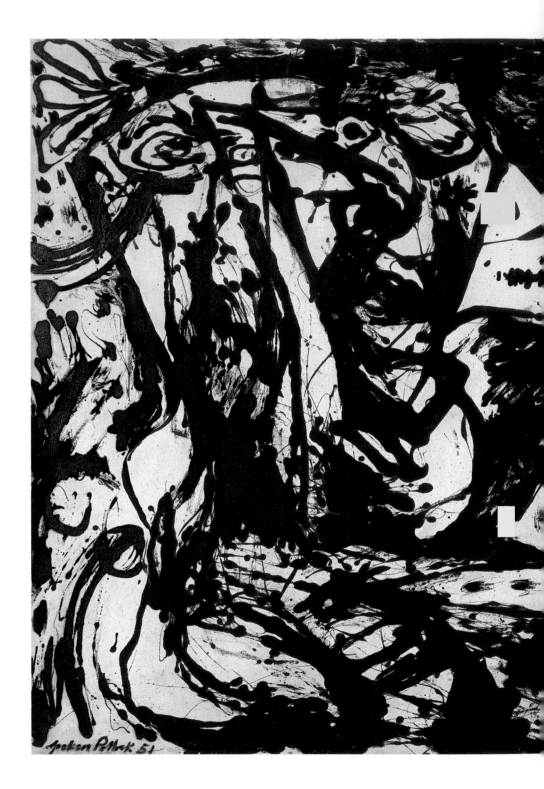

91 JACKSON POLLOCK, *Number 14*, 1952
 Enamel paint on canvas, 146.5 x 269.5 cm (57¾ x 106 in.)
 Tate Gallery, London; Purchase with assistance
 from the American Fellows of the Tate Gallery Foundation, 1988

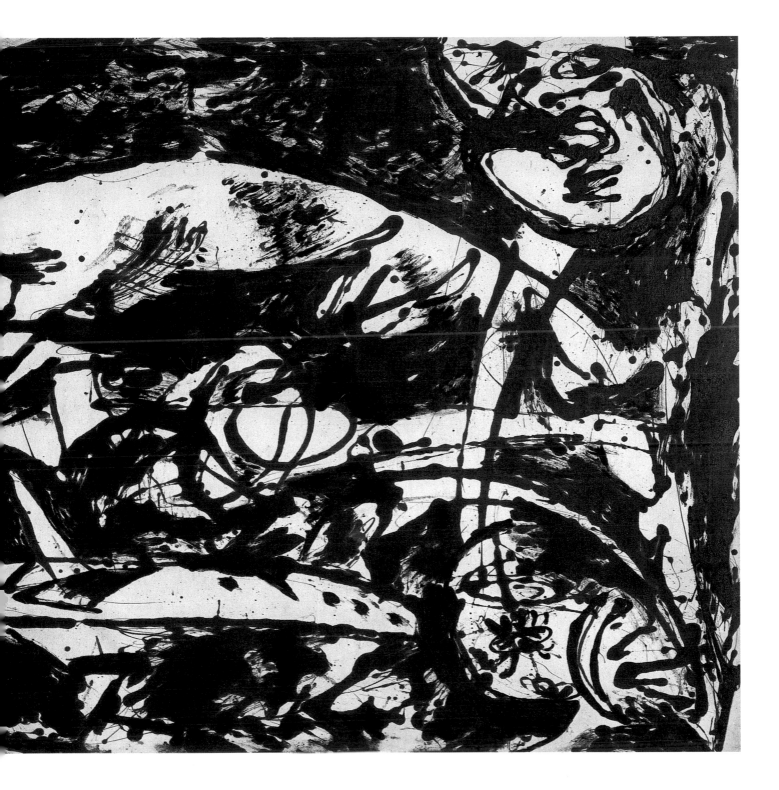

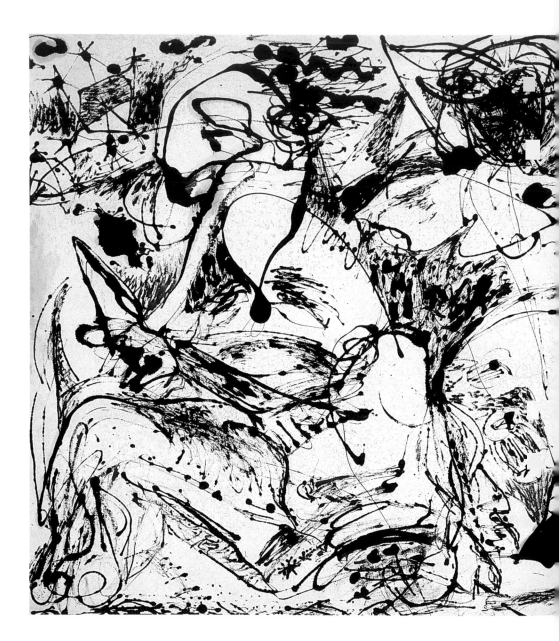

92 JACKSON POLLOCK, *Portrait and a Dream*, 1953
 Oil on canvas, 146.5 x 337 cm (57³/₄ x 132¹/₂ in.)
 Dallas Museum of Art; Gift of Mr and Mrs Algur H. Meadows
 and the Meadows Foundation Incorporated

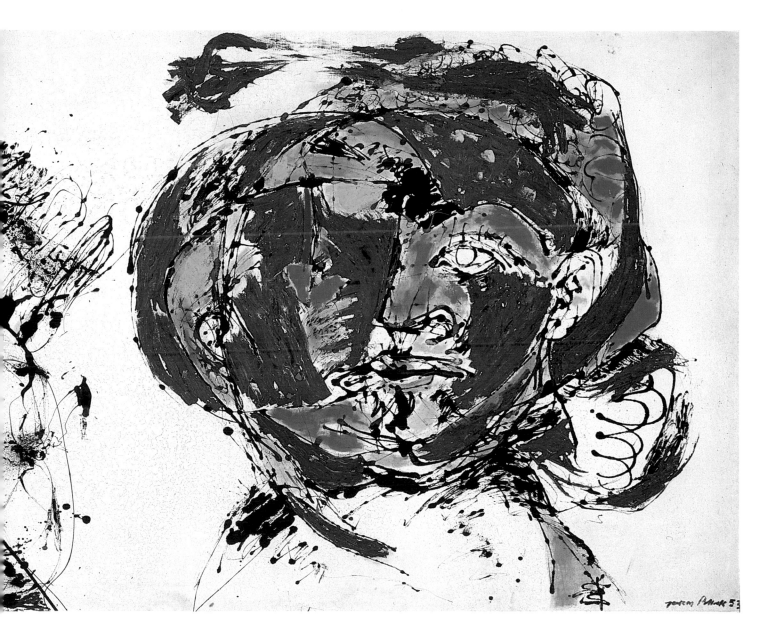

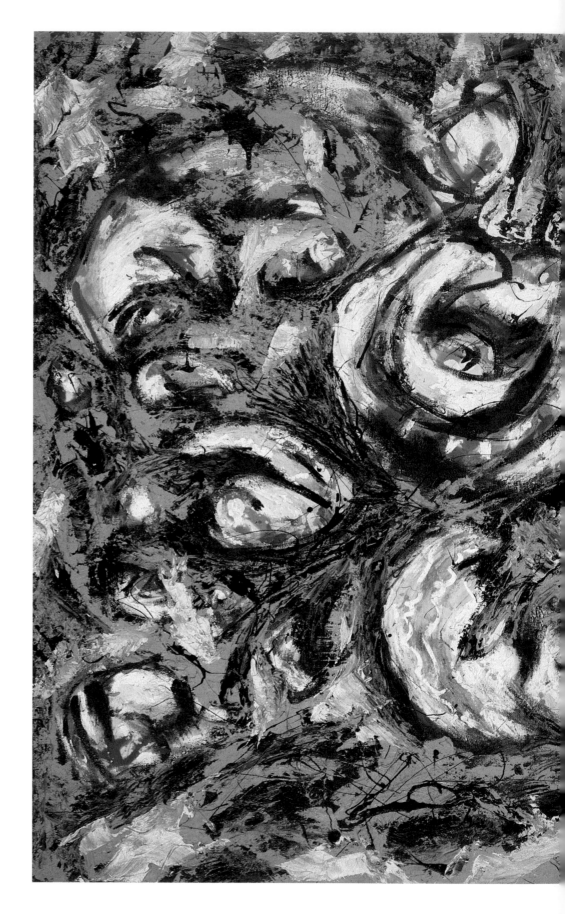

93 JACKSON POLLOCK, *Ocean Greyness*, 1953
Oil on canvas, 146.5 x 229 cm (57³/₄ x 90 in.)
Solomon R. Guggenheim Museum, New York

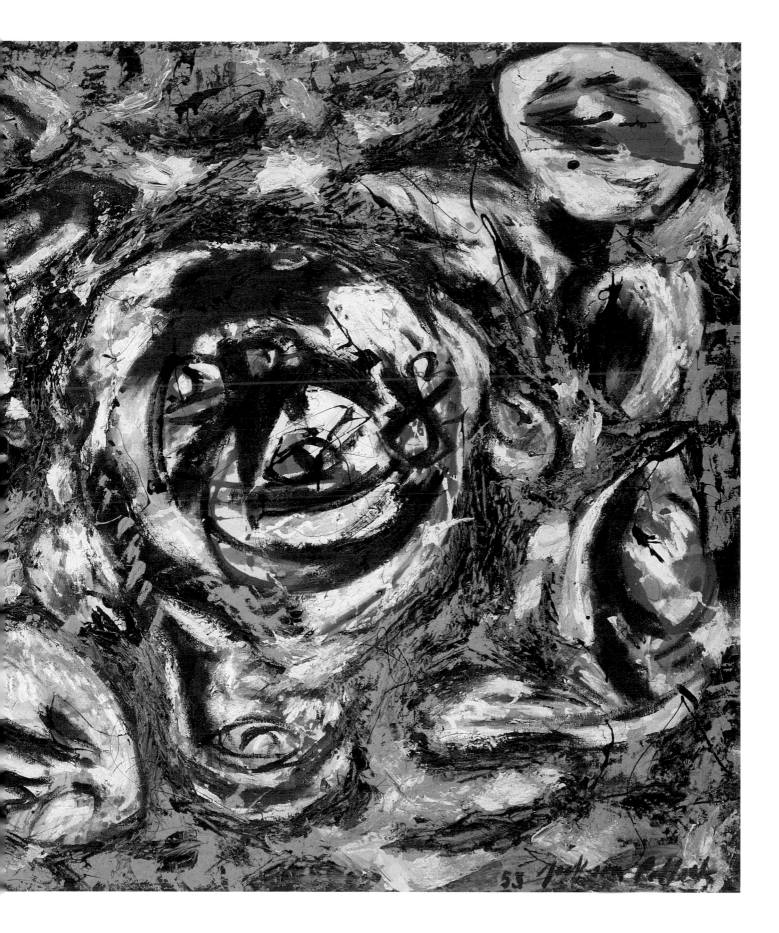

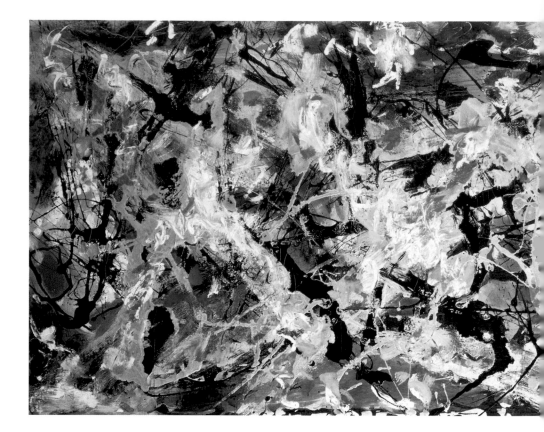

94 JACKSON POLLOCK, *Frieze*, 1953-55
Oil on canvas, 66 x 218.5 cm (26 x 86 in.)
Private collection

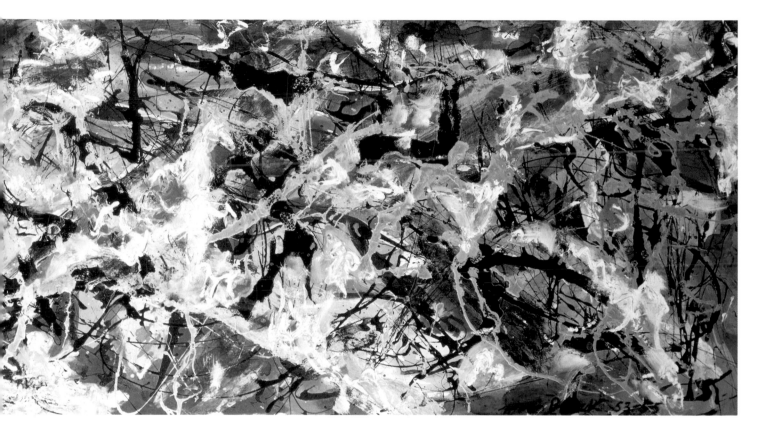

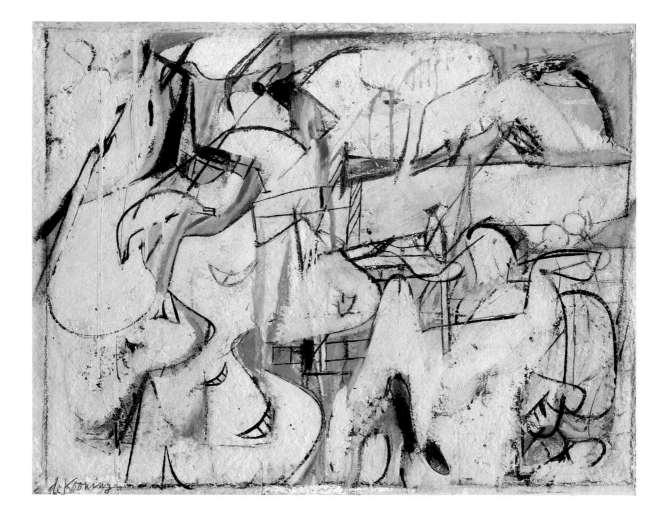

95 WILLEM DE KOONING, *Mailbox*, 1948
 Oil, enamel paint and charcoal on paper on board,
 59 x 76 cm (23¹/₄ x 30 in.)
 Private collection, Fort Worth, Texas

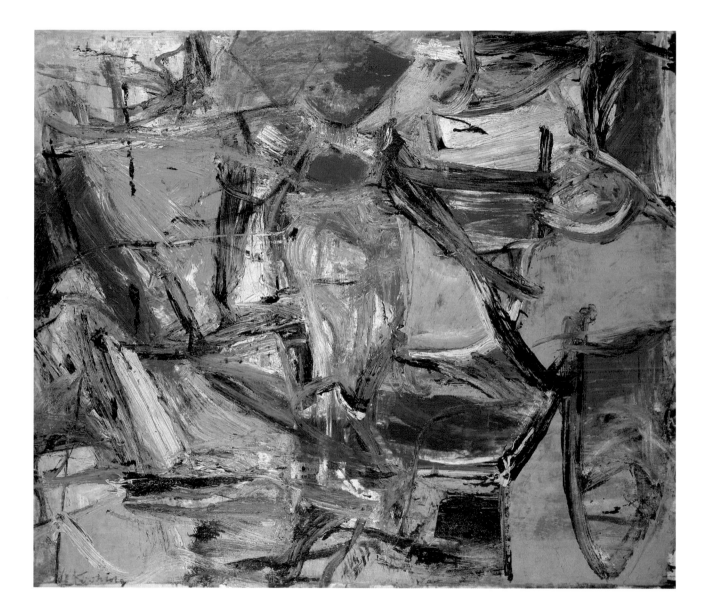

96 WILLEM DE KOONING, *Police Gazette*, 1955
Mixed media on canvas, 109 x 126 cm (43 x 49½ in.)
Private collection

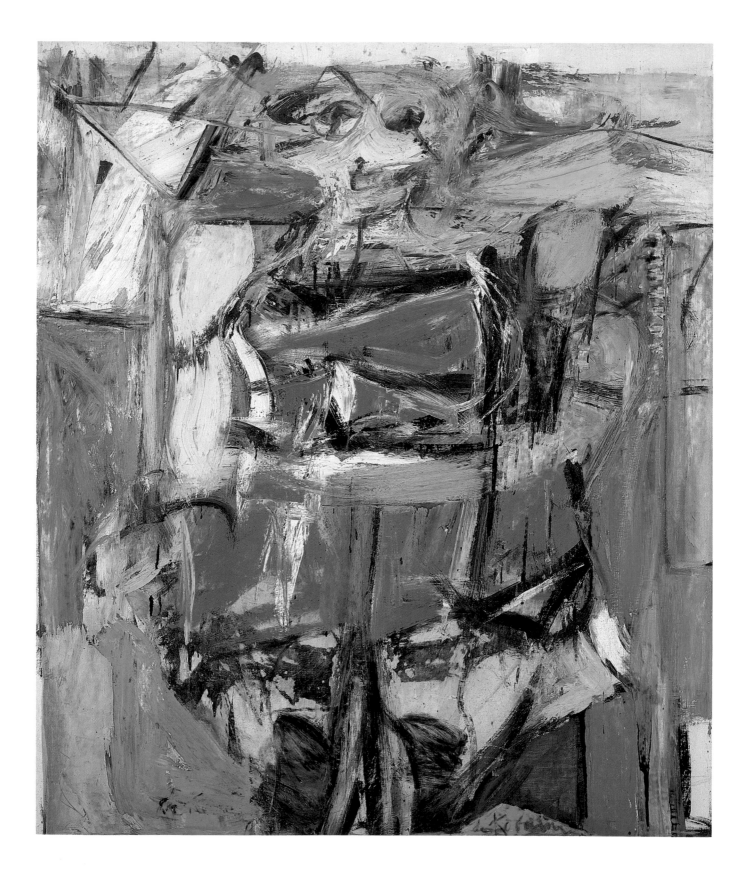

97 WILLEM DE KOONING, *Woman VI*, 1953
Oil on canvas, 174 x 148.5 cm (68$^1/_2$ x 58$^1/_2$ in.)
The Carnegie Museum of Art, Pittsburgh; Gift of G. David Thompson, 55.24.4

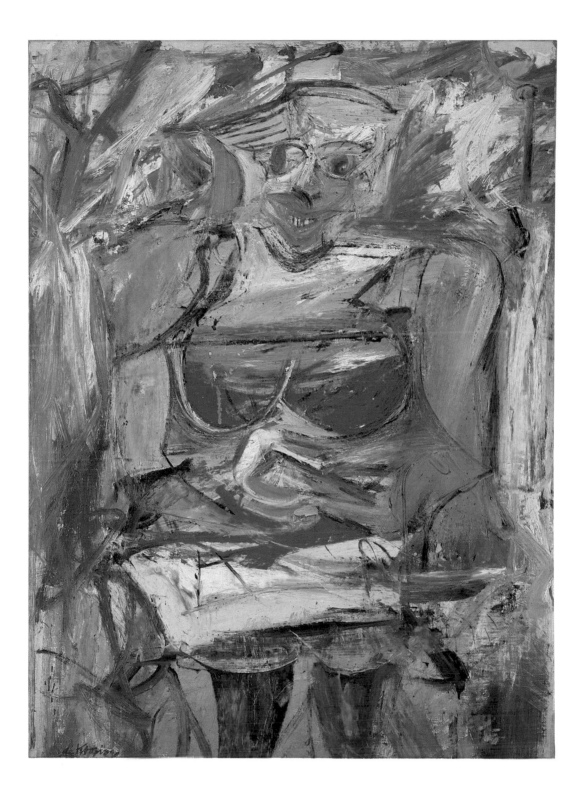

98　Willem de Kooning, *Woman V*, 1952-53
Oil on canvas, 154.5 x 114.5 cm (60³/₄ x 45 in.)
National Gallery of Australia, Canberra

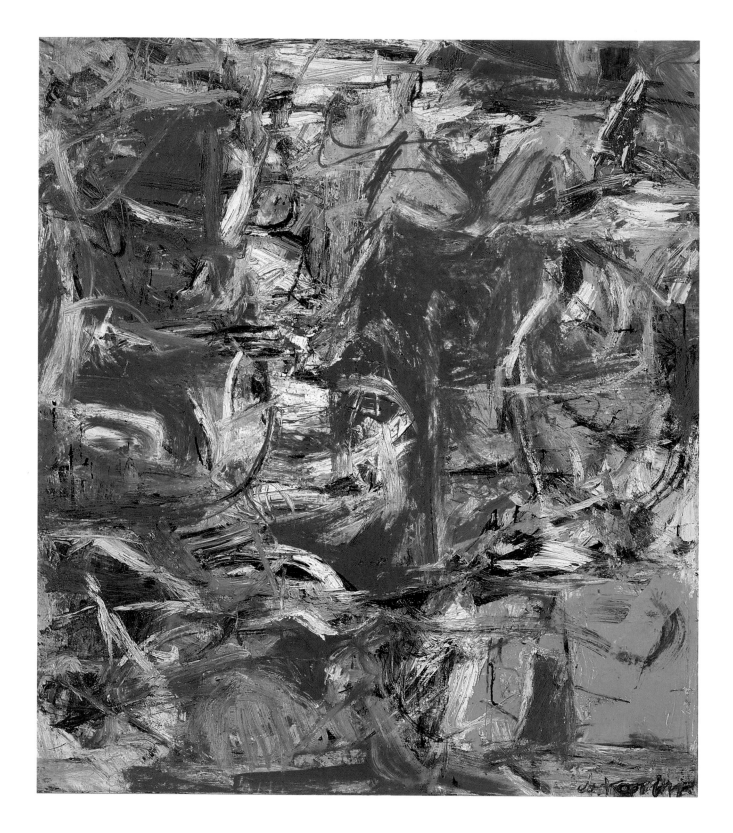

99 WILLEM DE KOONING, *Composition*, 1955
 Oil, enamel paint and charcoal on canvas, 201 x 175 cm (79 x 69 in.)
 Solomon R. Guggenheim Museum, New York

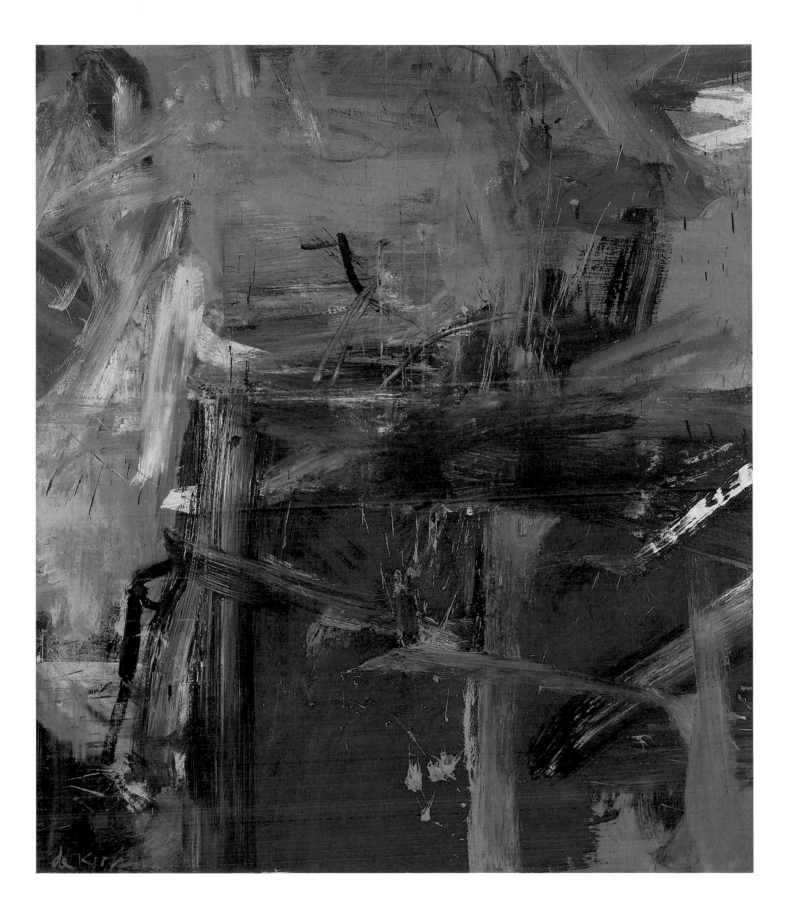

100 WILLEM DE KOONING, *Palisade*, 1957
Oil on canvas, 201 x 175 cm (79 x 69 in.)
Private collection

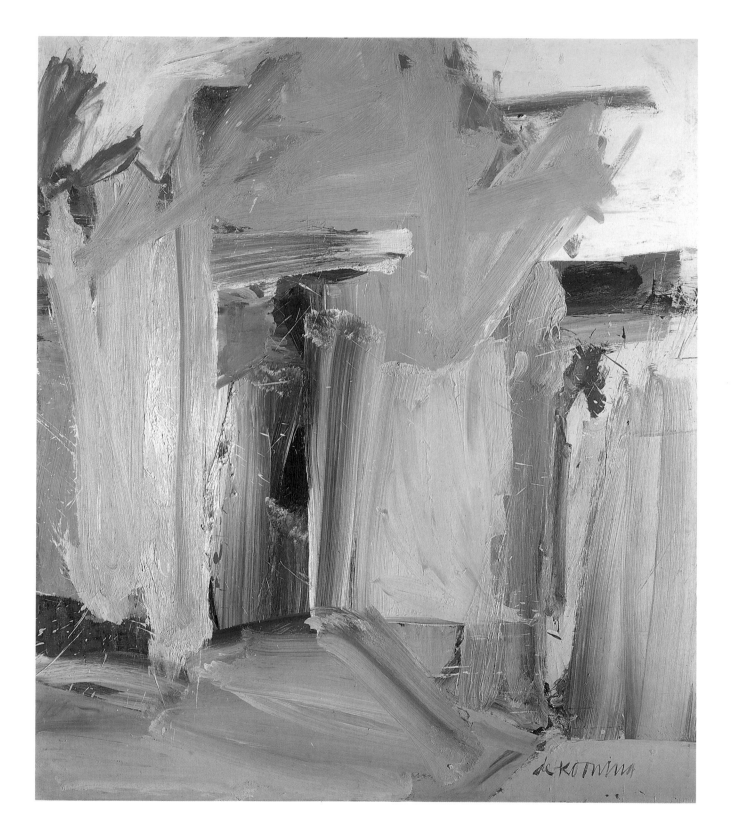

101 WILLEM DE KOONING, *Door to the River*, 1960
Oil on canvas, 203 x 178 cm (80 x 70 in.)
Collection of Whitney Museum of American Art, New York; Purchase with funds
from the Friends of the Whitney Museum of American Art

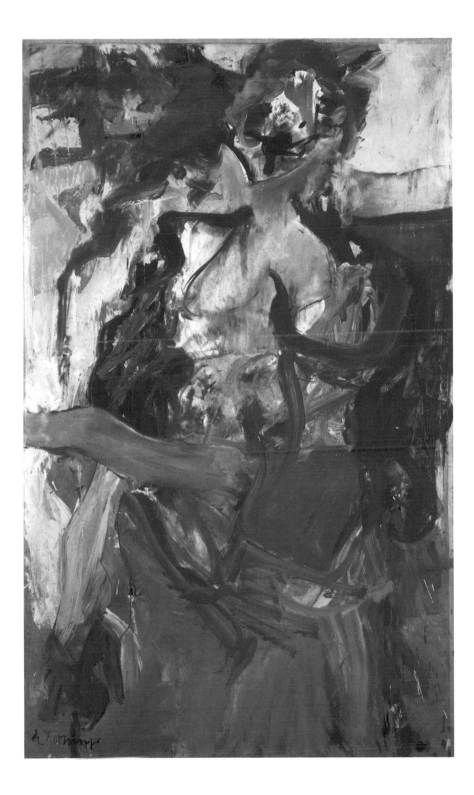

102 WILLEM DE KOONING, *Two Women*, 1964
 Oil on paper mounted on canvas, 153.5 x 94 cm (60½ x 37 in.)
 Galerie Hans Mayer, Düsseldorf

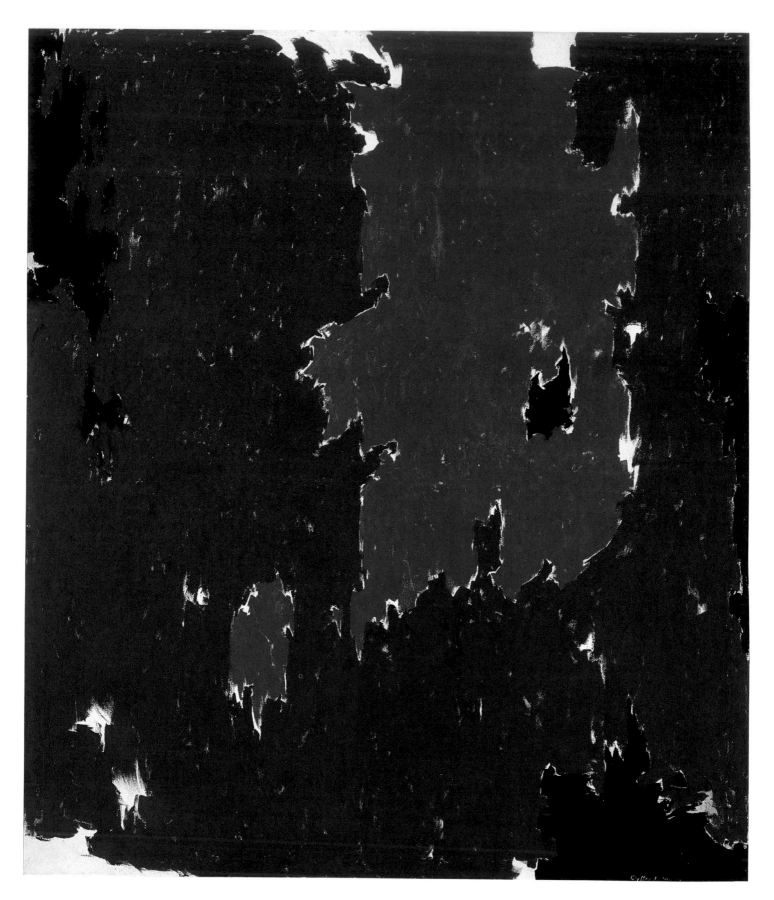

103 CLYFFORD STILL, *1950-A, No. 2*, 1950
Oil on canvas, 276 x 234 cm (108¾ x 92 in.)
Hirshhorn Museum and Sculpture Garden, Smithsonian Institution, Washington, DC;
Gift of Joseph H. Hirshhorn Foundation, 1972

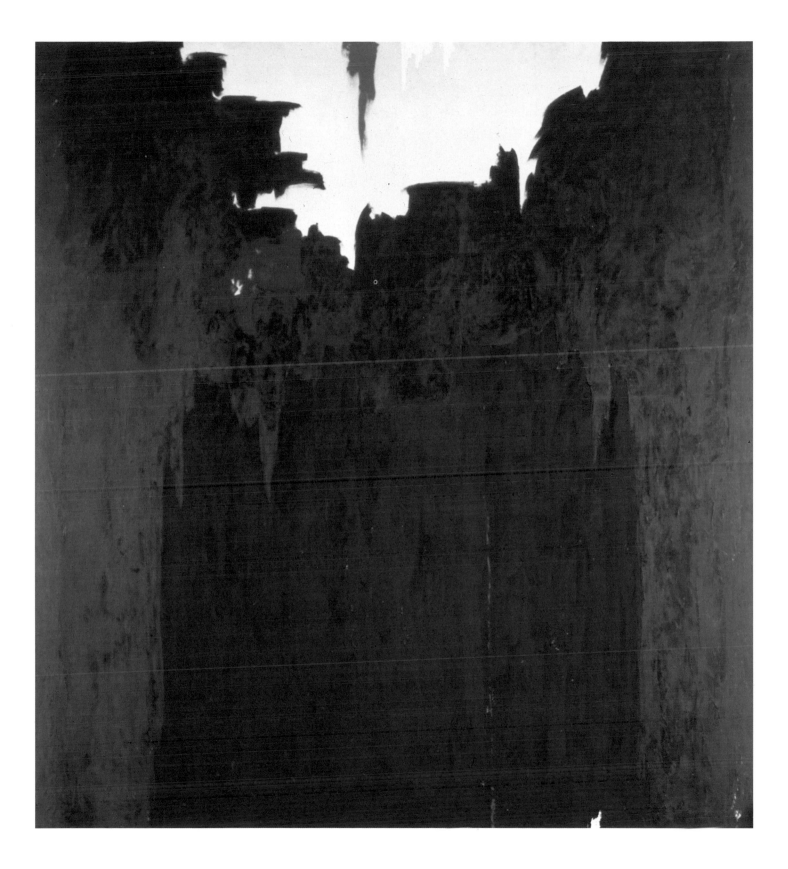

104 CLYFFORD STILL, *Untitled*, 1955-56
 Oil on canvas, 292.5 x 269 cm (115 x 106 in.)
 The Menil Collection, Houston

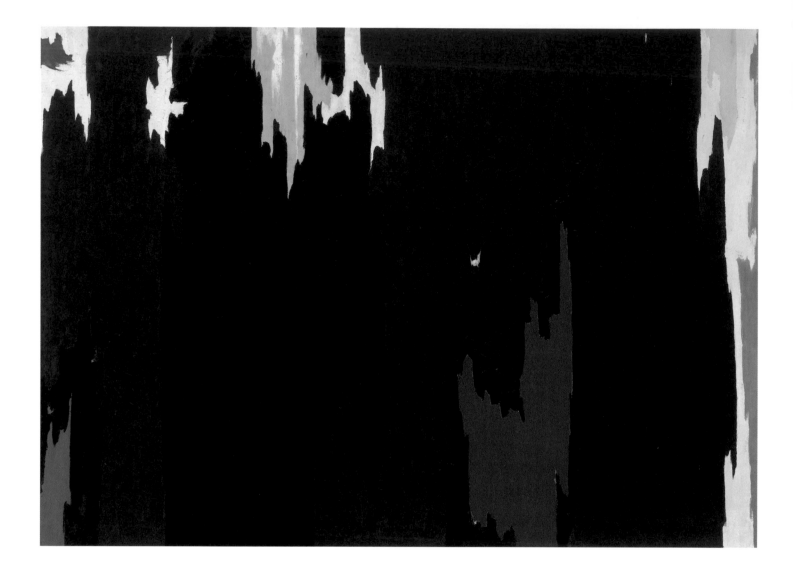

105 CLYFFORD STILL, *Untitled*, 1957
 Oil on canvas, 284.5 x 391 cm (112 x 154 in.)
 Collection of Whitney Museum of American Art, New York;
 Purchase with funds from the Friends of the Whitney Museum of American Art

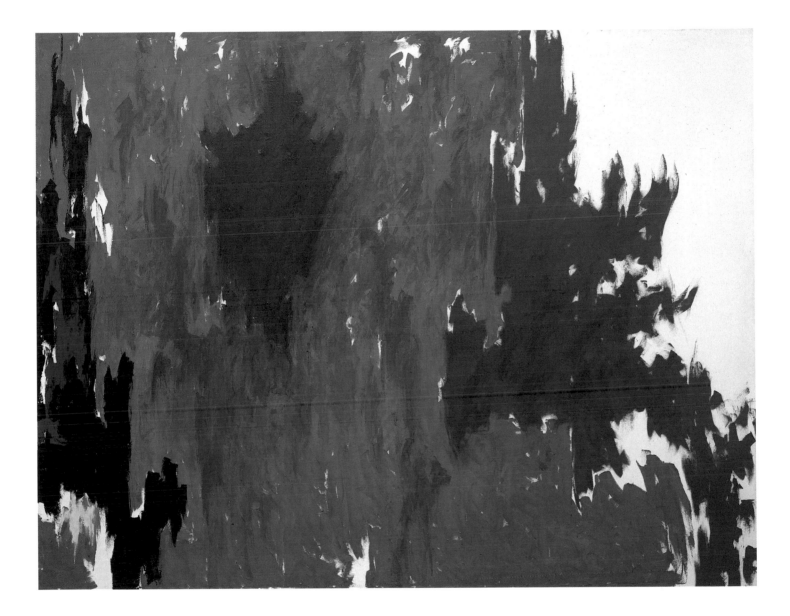

106 CLYFFORD STILL, *1960-F,* 1960
 Oil on canvas, 284 x 369 cm (112 x 145 in.)
 Onnasch Collection, Berlin

107 BARNETT NEWMAN, *Onement IV,* 1949
Oil and casein on canvas, 84 x 96.5 cm (33 x 38 in.)
Allen Memorial Art Museum, Oberlin College, Ohio; Gift of an anonymous donor,
the National Endowment for the Arts and Mrs Ruth C. Roush

108 BARNETT NEWMAN, *Eve*, 1950
 Oil on canvas, 240 x 172 cm (94¹/₂ x 67³/₄ in.)
 Tate Gallery, London; Purchase, 1980

109 BARNETT NEWMAN, *The Name II*, 1950
Oil and Magna on canvas, 264 x 240 cm
(104 x 94¹/₂ in.)
National Gallery of Art, Washington, DC; Gift of Annalee Newman
(in honour of the Fiftieth Anniversary of the National Gallery of Art)

110 BARNETT NEWMAN, *Tundra*, 1950
 Oil on canvas, 182 x 226 cm (71³/₄ x 89 in.)
 Mrs Jack M. Farris

111 BARNETT NEWMAN, *The Word II*, 1954
Oil on canvas, 228 x 178 cm (90 x 70 in.)
Onnasch Collection, Berlin

112 BARNETT NEWMAN, *The Three*, 1962
Oil on raw canvas, 193.5 x 183 cm (76¼ x 72 in.)
Mr and Mrs Bagley Wright

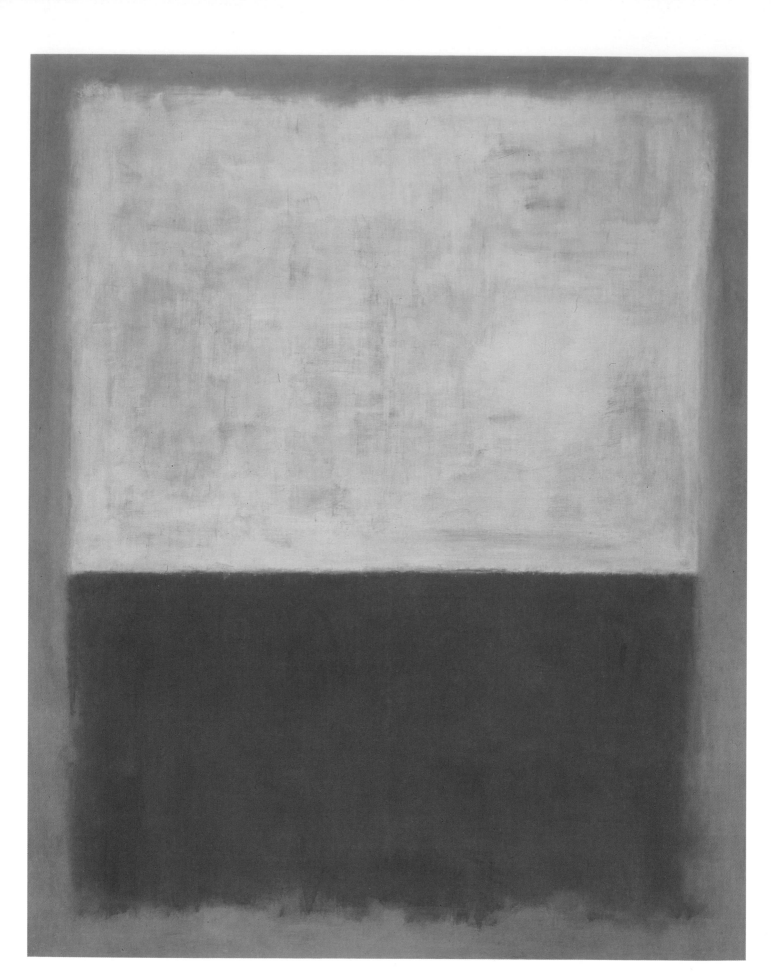

113 MARK ROTHKO, *Untitled* (Yellow, Orange, Red on Orange), 1954
Oil on canvas, 292 x 231 cm (115 x 91 in.)
Collection of Kate Rothko Prizel

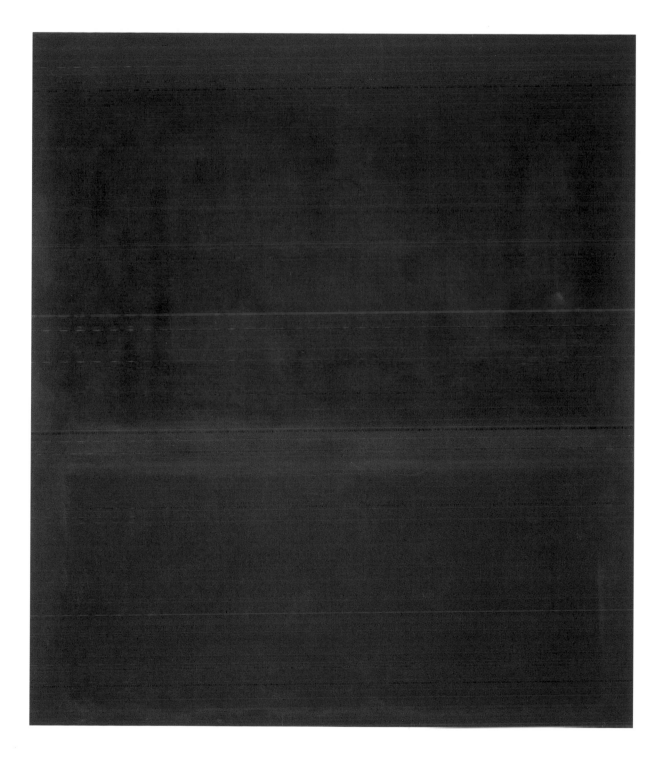

114 MARK ROTHKO, *Black on Dark Sienna on Purple*, 1960
Oil on canvas, 303 x 266.5 cm (119¼ x 105 in.)
The Museum of Contemporary Art, Los Angeles; The Panza Collection

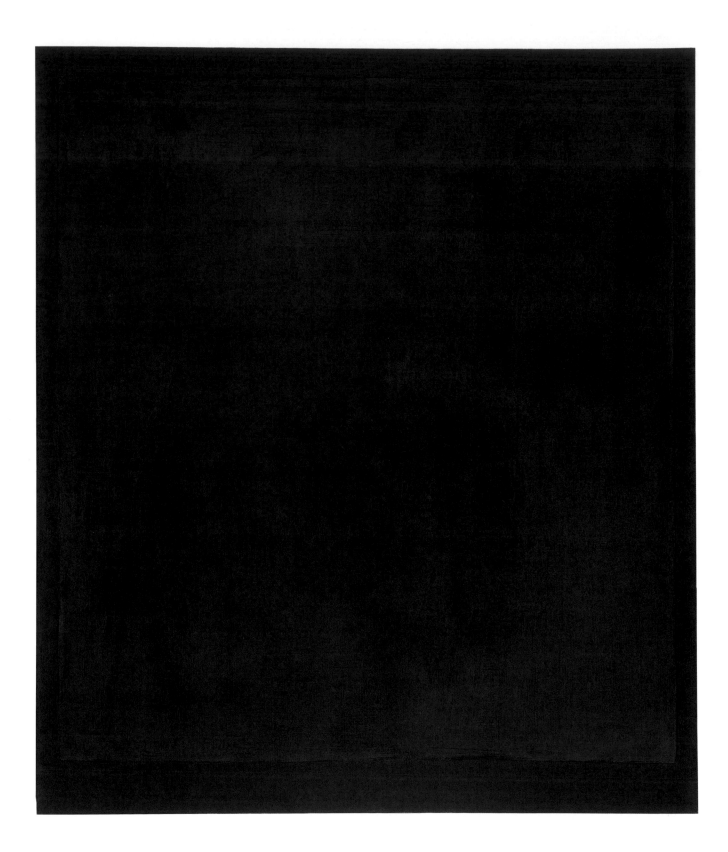

115 MARK ROTHKO, *Untitled*, 1961
Oil on canvas, 236 x 203 cm (93 x 80 in.)
Courtesy of Marlborough Gallery, New York

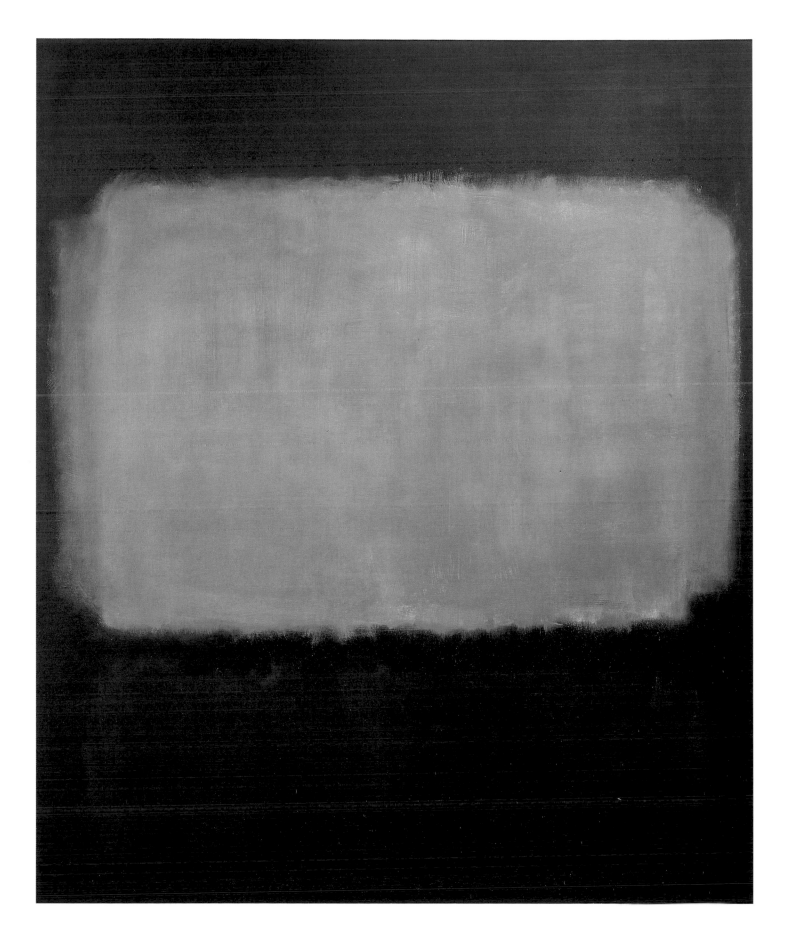

116 MARK ROTHKO, *Browns*, 1957
Oil on canvas, 233 x 194.5 cm (91³/₄ x 76¹/₂ in.)
Adriana and Robert Mnuchin

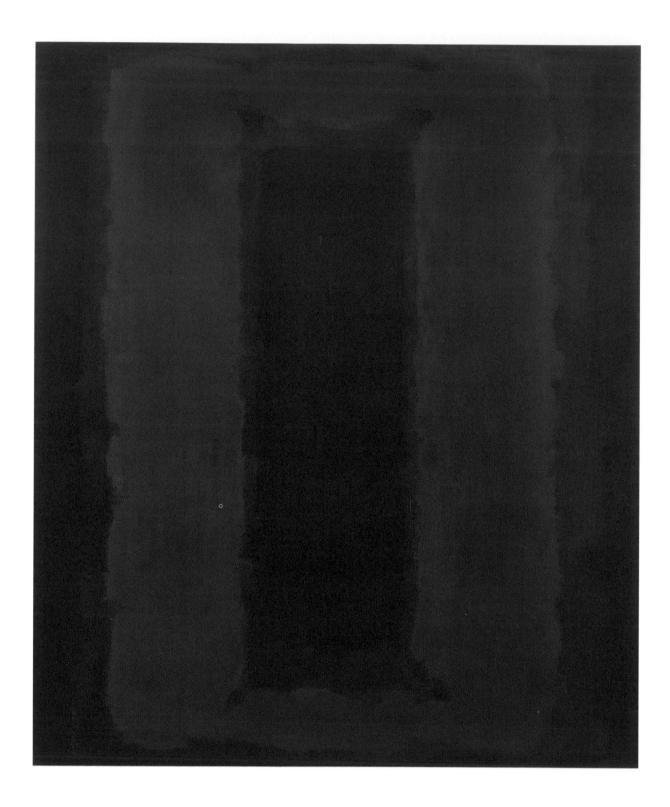

117 MARK ROTHKO, *Untitled* (Seagram Mural), 1959
 Oil and acrylic on canvas, 183 x 152.5 cm (72 x 60 in.)
 National Gallery of Art, Washington, DC; Gift of The Mark Rothko Foundation 1985.38.3

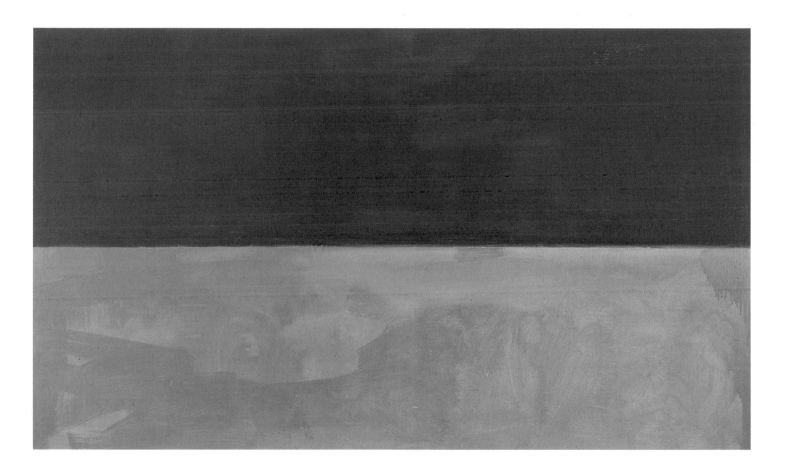

118　Mark Rothko, *Untitled*, 1969
　　Acrylic on canvas, 177 x 297 cm (69³/₄ x 117 in.)
　　Collection of Christopher Rothko

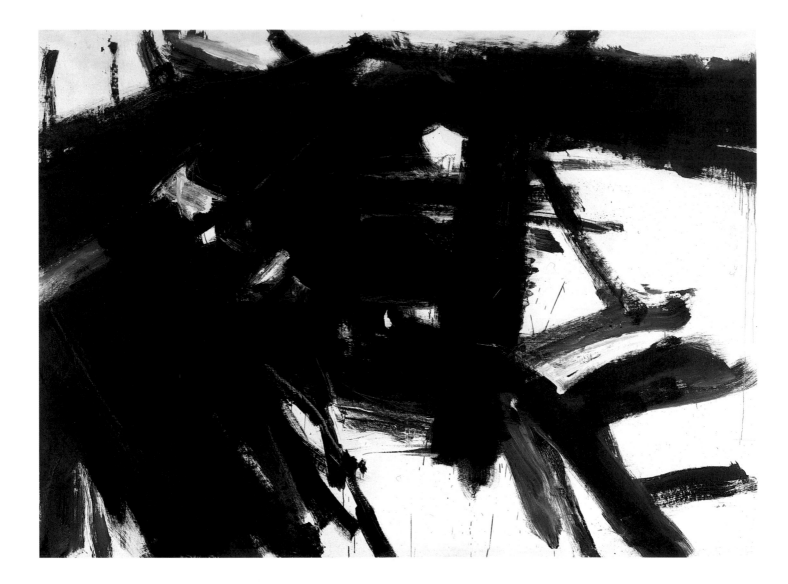

119 FRANZ KLINE, *Siskind*, 1958
Oil on canvas, 203 x 282 cm (80 x 111 in.)
The Detroit Institute of Arts; Founders Society Purchase W. Hawkins Ferry Fund

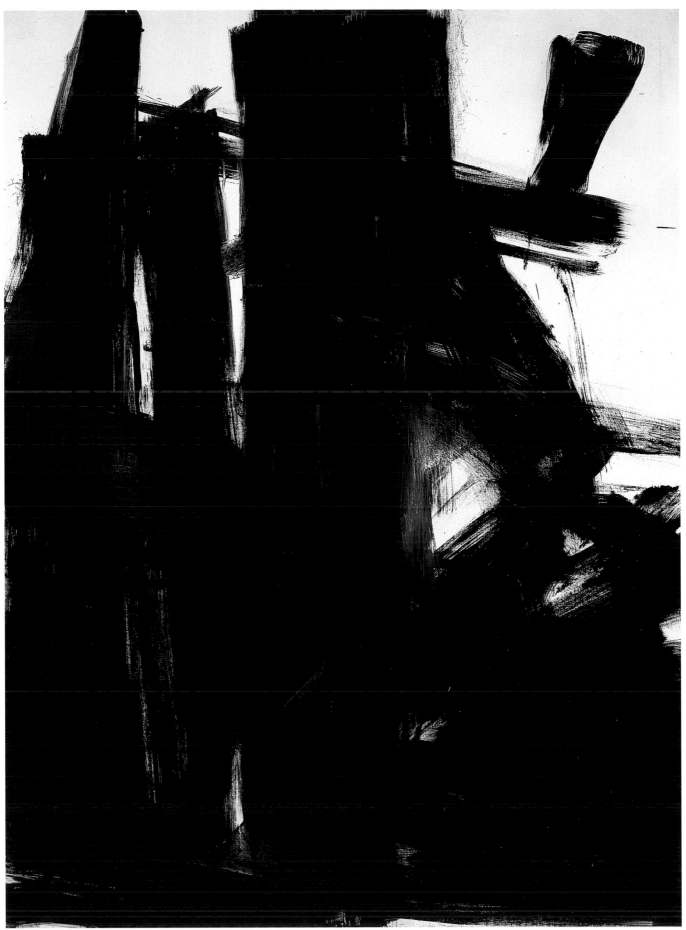

120 FRANZ KLINE, *Black Iris*, 1961
 Oil on canvas, 275 x 202 cm (108¼ x 79½ in.)
 The Museum of Contemporary Art, Los Angeles; The Panza Collection

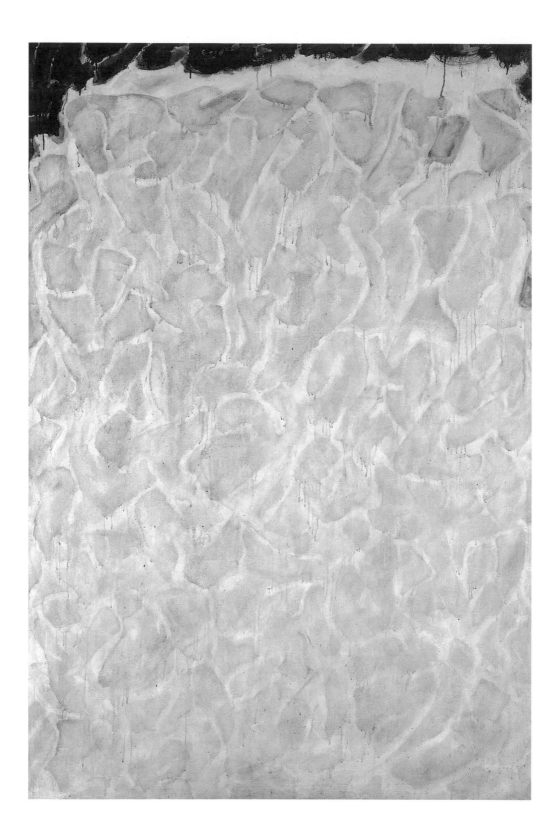

121 SAM FRANCIS, *St.-Honoré*, 1952
Oil on canvas, 201 x 134.5 cm (79¼ x 53 in.)
Kunstsammlung Nordrhein-Westfalen, Düsseldorf

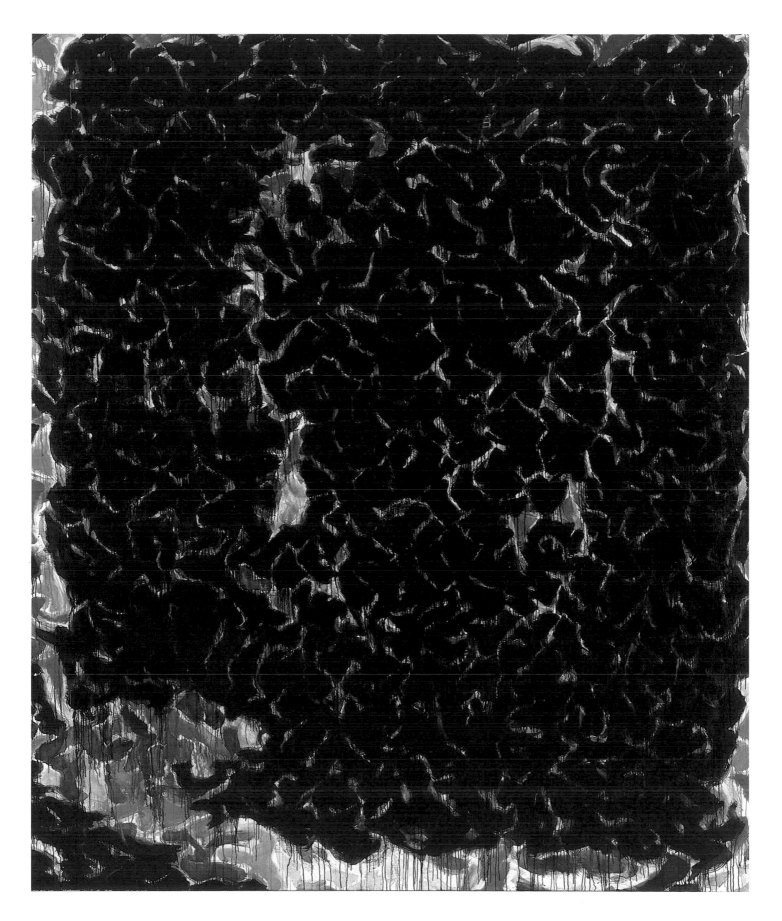

122 SAM FRANCIS, *Deep Orange and Black*, 1954-55
Oil on canvas, 371 x 312 cm (146 x 122 3/4 in.)
Öffentliche Kunstsammlung Basel, Kunstmuseum, Basle

123 AD REINHARDT, *Abstract Painting*, 1959
Oil on canvas, 274.5 x 101.5 cm (108 x 40 in.)
Marlborough International Fine Art

124 AD REINHARDT, *Painting*, 1956-60
Oil on canvas, 274.5 x 101.5 cm (108 x 40 in.)
Marlborough International Fine Art

125 AD REINHARDT, *Abstract Painting, Black*, 1954
Oil on canvas, 198 x 198 cm (78 x 78 in.)
Marlborough International Fine Art

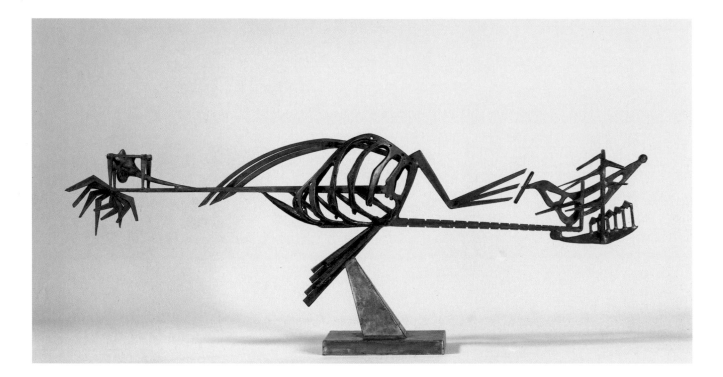

126 DAVID SMITH, *The Royal Bird*, 1947-48
Welded steel, bronze and stainless steel,
56 x 150.5 x 21.5 cm (22 x 60 x 8¹/₂ in.)
Collection Walker Art Center, Minneapolis; Gift of the T.B. Walker Foundation, 1952

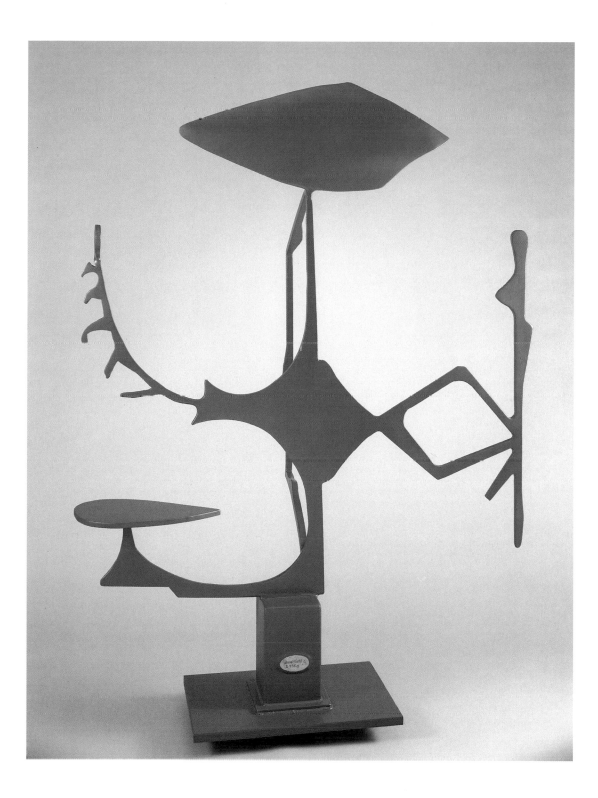

127　David Smith, *Agricola I*, 1951-52
Painted steel, 186.5 x 140.5 x 62.5 cm
(73$\frac{1}{2}$ x 55$\frac{1}{4}$ x 24$\frac{1}{2}$ in.)
Hirshhorn Museum and Sculpture Garden, Smithsonian Institution, Washington, DC;
Gift of Joseph H. Hirshhorn, 1966

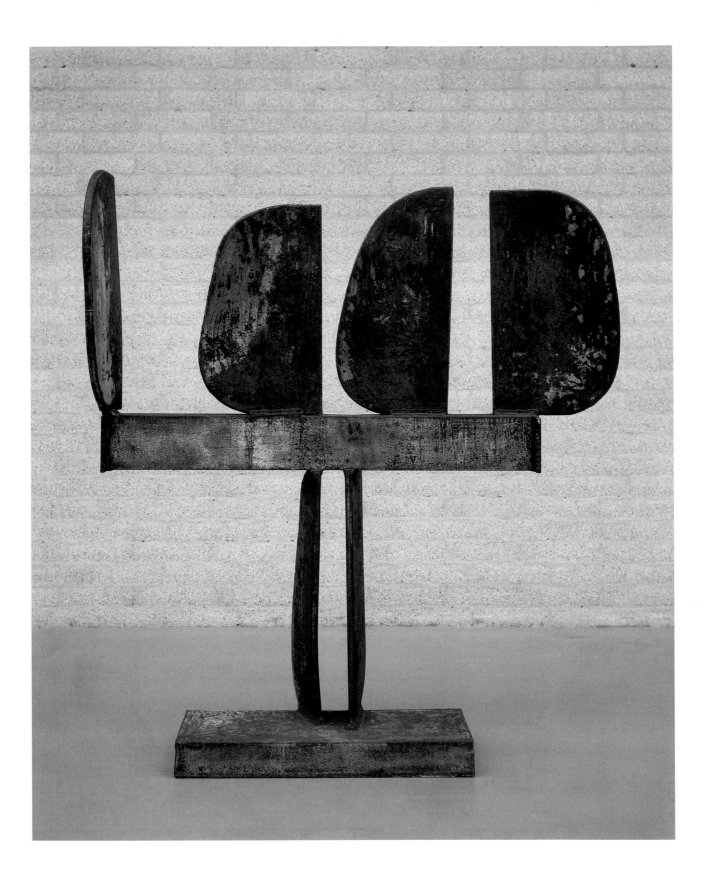

128 DAVID SMITH, *Voltri IV*, 1962
Steel, 173 x 151 x 36 cm (68 x 59¹/₂ x 14¹/₄ in.)
Rijksmuseum Kröller-Müller, Otterlo, The Netherlands

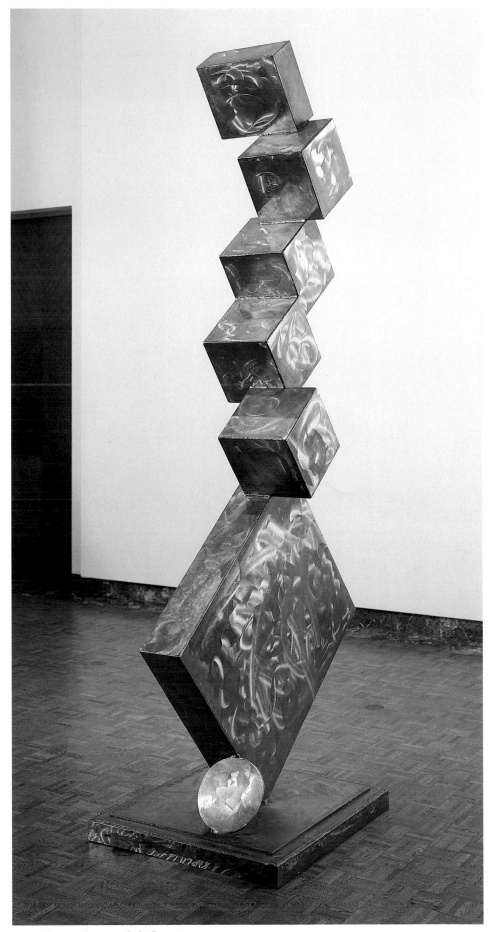

129　Davⁱd Smith, *Cubi I*, 1963
Stainless steel, height 315 cm (124 in.)
The Detroit Institute of Arts; Founders Society Purchase, Special Purchase Fund

130 ELLSWORTH KELLY, *Black, Two Whites*, 1953
 Oil on canvas (3 joined panels), 59.5 x 179.5 cm (23½ x 70¾ in.)
 Collection of the artist

131 ELLSWORTH KELLY, *White, Two Blacks*, 1953
 Oil on canvas (3 joined panels), 59.5 x 179.5 cm (23½ x 70¾ in.)
 Collection of the artist

132 Ellsworth Kelly, *Yellow Black*, 1968
 Oil on canvas, 235 x 237.5 cm (92½ x 93½ in.)
 Louisiana Museum of Modern Art, Humblebaek

 Opposite
133 Ellsworth Kelly, *Dark Blue Red*, 1965
 Oil on canvas, 244 x 185.5 cm (96 x 73 in.)
 Mr and Mrs Ronald K. Greenberg, St. Louis

134 ELLSWORTH KELLY, *Red Blue Green*, 1963
Oil on canvas, 212.5 x 345 cm (83½ x 135¾ in.)
Collection Museum of Contemporary Art, San Diego; Gift of Dr and Mrs Jack M. Farris

135 ROBERT RAUSCHENBERG, *Untitled* (Red Painting), 1953
Oil, fabric and newsprint collage on canvas,
179.5 x 122 cm (70³/₄ x 48 in.)
Eli and Edythe L. Broad Collection

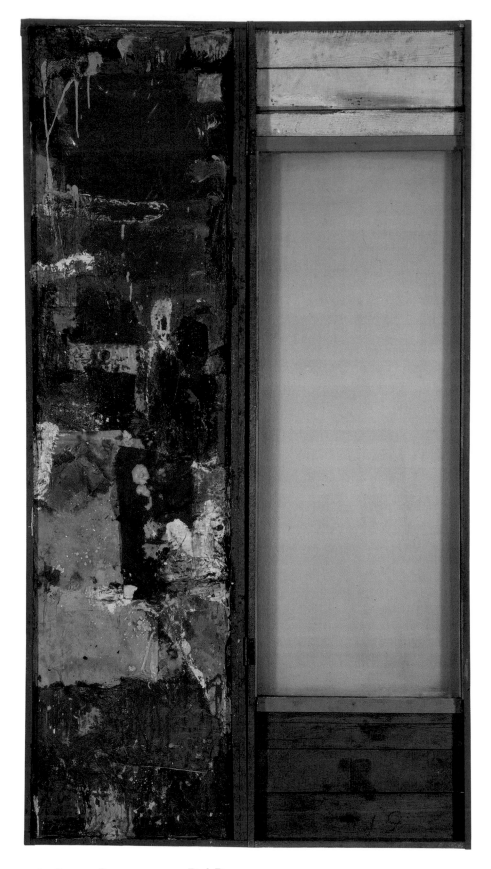

136 ROBERT RAUSCHENBERG, *Pink Door*, 1954
Combine painting: door-frame, door and mixed media,
230 x 121 cm (90¹/₂ x 47¹/₂ in.)
Marx Collection, Berlin; on loan to the
Städtisches Museum Abteiberg, Mönchengladbach

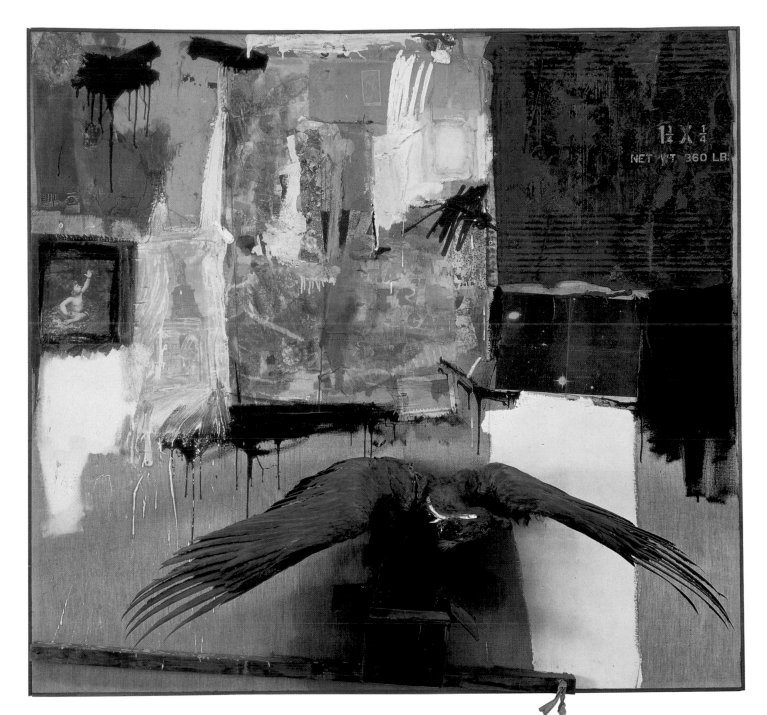

137 ROBERT RAUSCHENBERG, *Canyon*, 1959
Combine painting: mixed media on canvas with objects,
207.5 x 178 x 61 cm (81¾ x 70 x 24 in.)
Sonnabend Collection, New York

138 ROBERT RAUSCHENBERG, *First Time Painting,* 1961
Combine painting: oil and mixed media on canvas with objects,
195.5 x 130 cm (77 x 51¹/₄ in.)
Marx Collection, Berlin

139 Robert Rauschenberg, *Trophy III (for Jean Tinguely)*, 1961
Combine painting: mixed media and objects, 240 x 167 cm (96 x 65¾ in.)
The Museum of Contemporary Art, Los Angeles; The Panza Collection

140 ROBERT RAUSCHENBERG, *Manuscript*, 1963
Oil and silkscreen on canvas, 213.5 x 152.5 cm (84 x 60 in.)
Mr and Mrs Bagley Wright

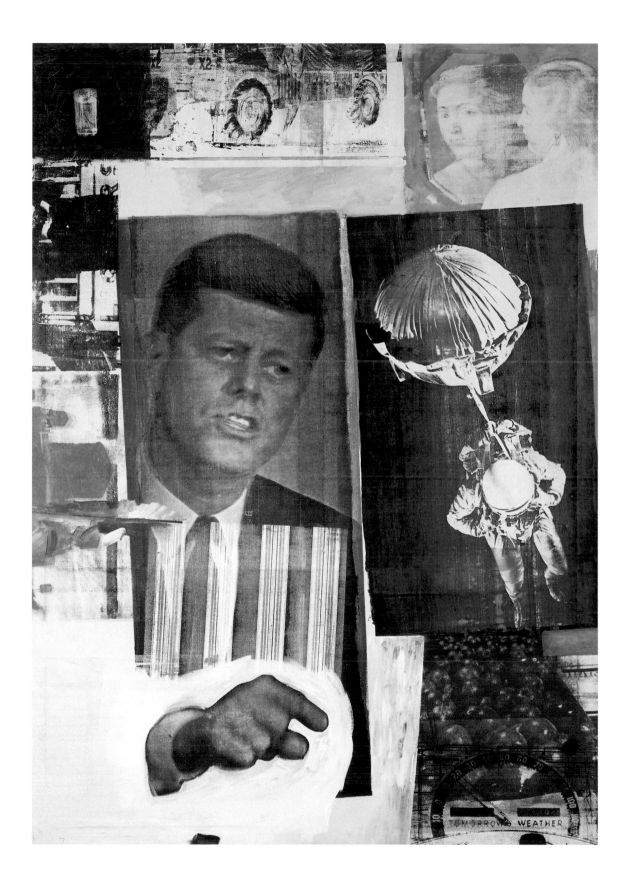

141 ROBERT RAUSCHENBERG, *Retroactive II*, 1964
 Oil and silkscreen on canvas, 213.5 x 152.5 cm (84 x 60 in.)
 Stefan T. Edlis Collection

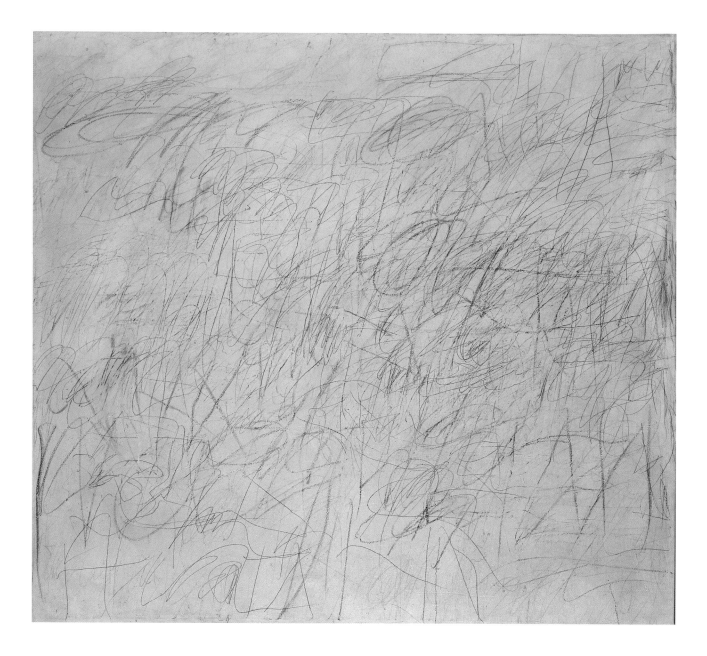

142 CY TWOMBLY, *Free Wheeler (New York City)*, 1955
Oil, crayon and pencil on canvas, 174 x 190 cm (68 x 74¾ in.)
Marx Collection, Berlin; on loan to the
Städtisches Museum Abteiberg, Mönchengladbach

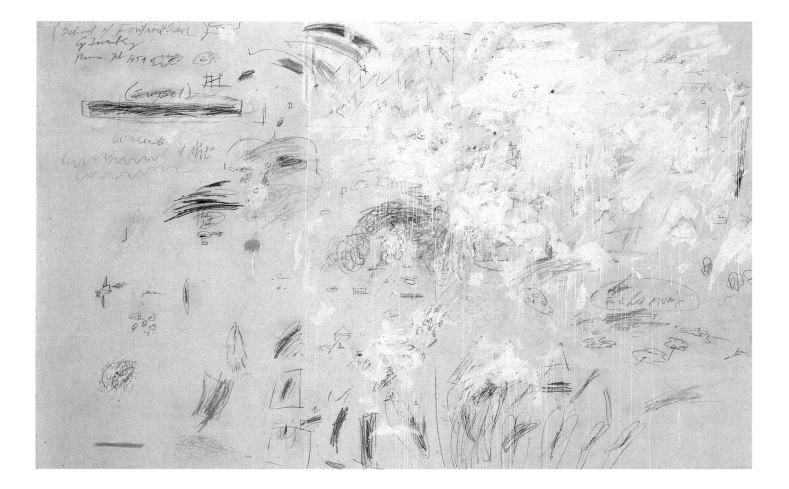

143 CY TWOMBLY, *School of Fontainebleau*, 1960
Oil, crayon and pencil on canvas, 200 x 321.5 cm (78³/₄ x 126¹/₂ in.)
Marx Collection, Berlin; on loan to the
Städtisches Museum Abteiberg, Mönchengladbach

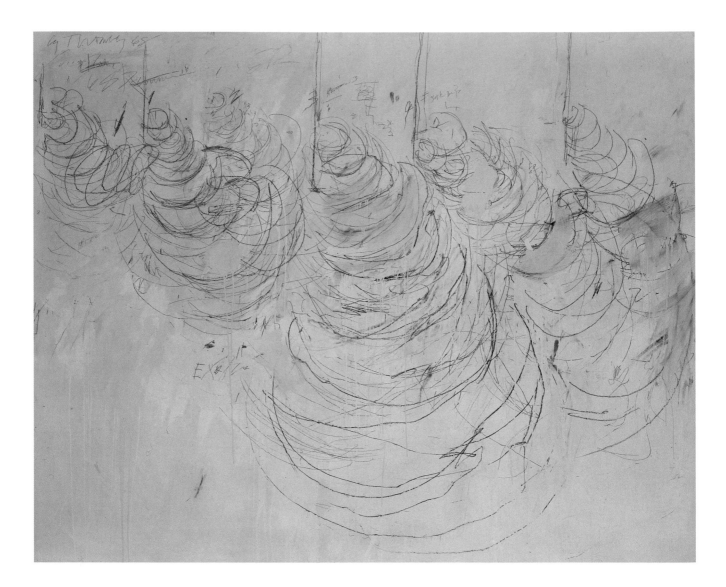

144 Cy Twombly, *Orion II*, 1968
Wall paint, crayon and pencil on canvas, 173 x 215 cm (68 x 84¾ in.)
Marx Collection, Berlin; on loan to the
Städtisches Museum Abteiberg, Mönchengladbach

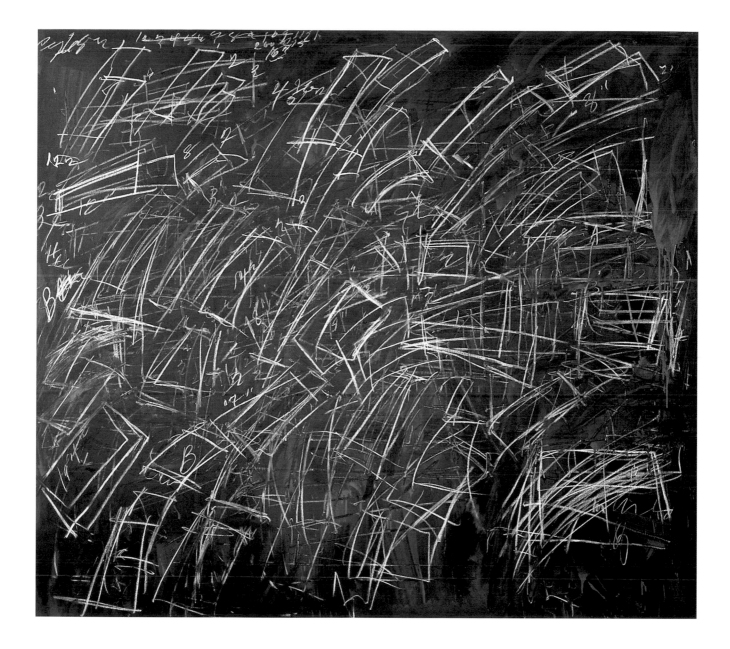

145 Cy Twombly, *Untitled*, 1968
Oil and crayon on canvas, 152.5 x 172.5 cm (60 x 68 in.)
Courtesy Thomas Ammann Fine Art, Zurich

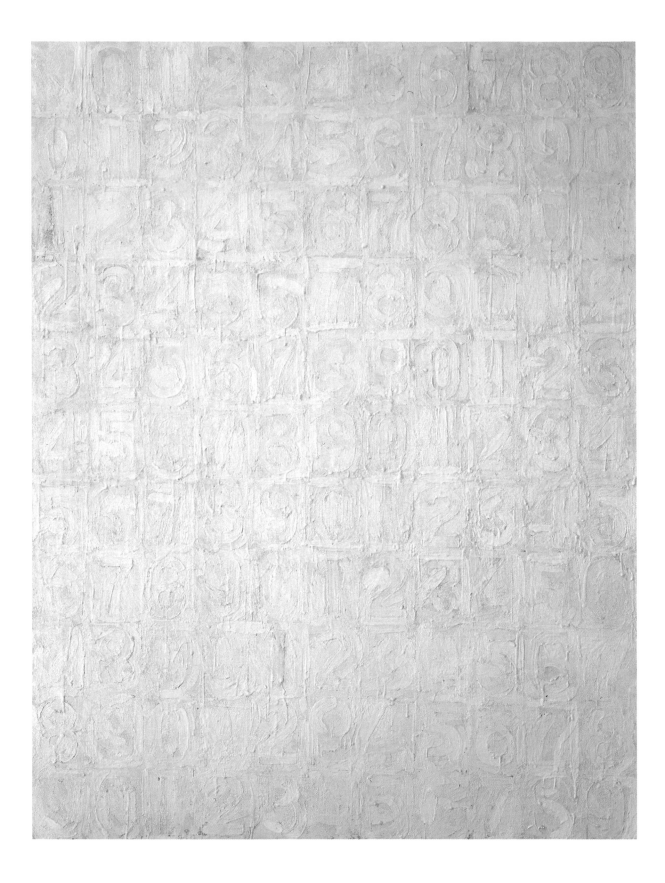

146 JASPER JOHNS, *White Numbers*, 1959
 Encaustic on canvas, 135.5 x 101.5 cm (53¼ x 40 in.)
 Collection of Mrs Victor W. Ganz

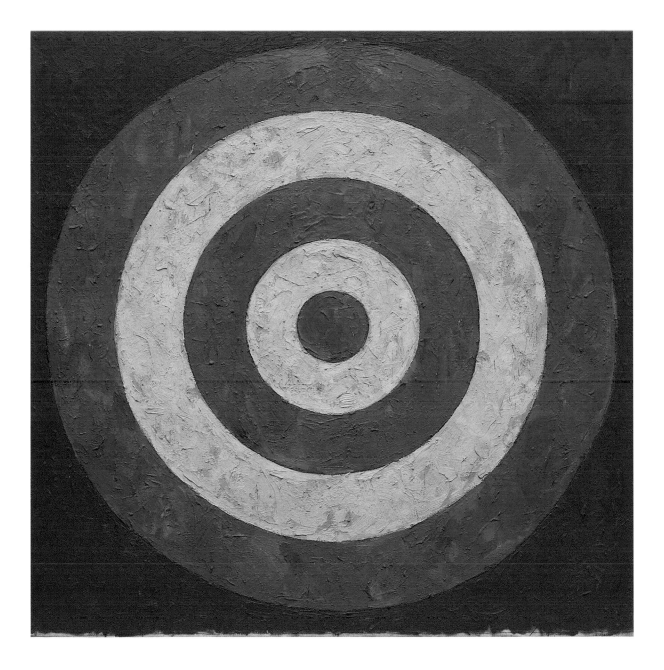

147 JASPER JOHNS, *Target*, 1958
 Oil and collage on canvas, 91.5 x 91.5 cm (36 x 36 in.)
 Collection of the artist; on loan to the National Gallery of Art, Washington, DC

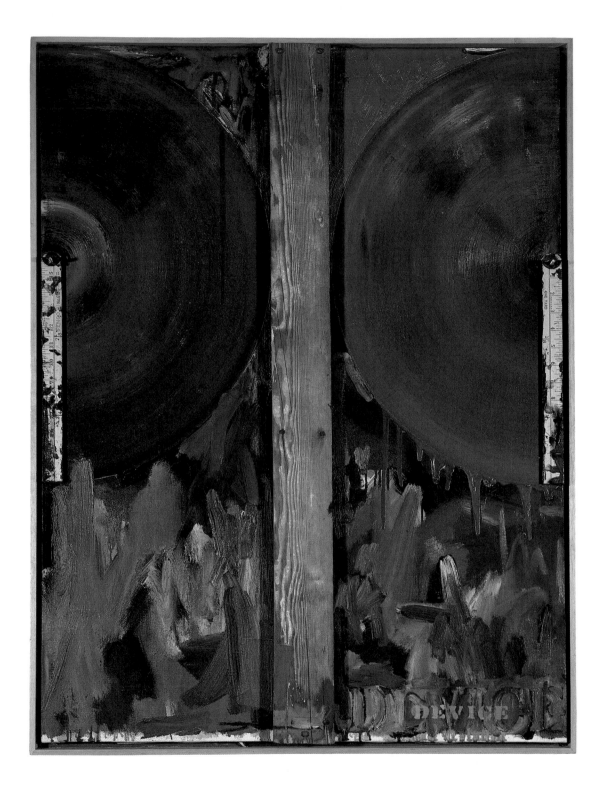

148 JASPER JOHNS, *Device*, 1962
 Oil on canvas, 101.5 x 76 cm (40 x 30 in.)
 The Baltimore Museum of Art; Purchased with funds provided by
 The Dexter M. Ferry Jr. Trustee Corporation Fund and by Edith Ferry Hooper (BMA 1976.1)

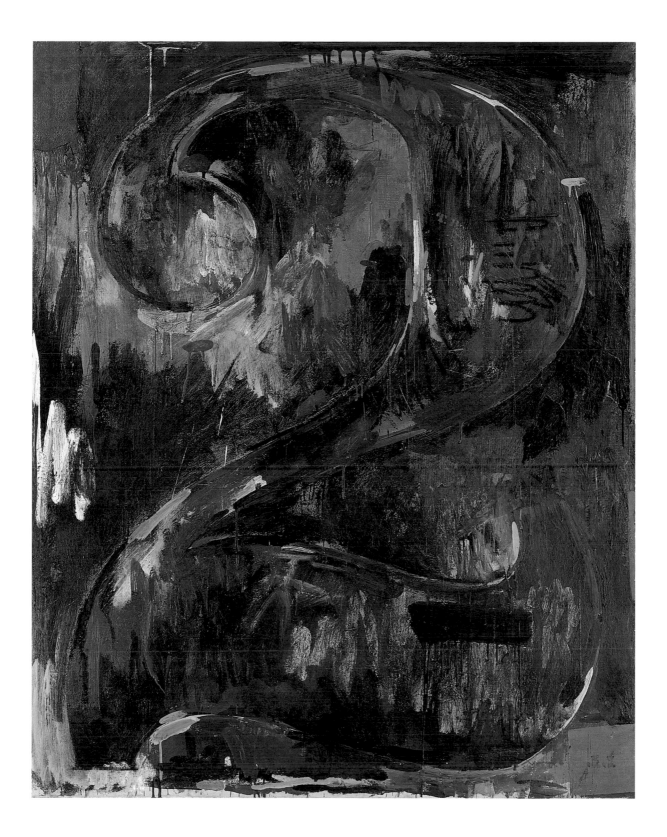

149 JASPER JOHNS, *Figure 2*, 1962
Encaustic on collage on canvas,
127.5 x 102 cm (50¹/₄ x 40¹/₄ in.)
Öffentliche Kunstsammlung Basel, Kunstmuseum, Basle

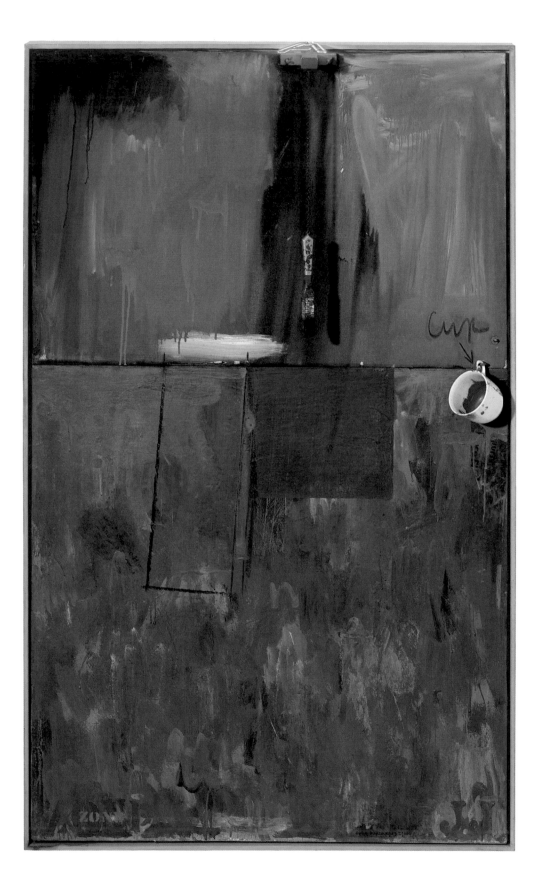

150 JASPER JOHNS, *Zone*, 1962
 Oil on canvas with objects, 153 x 91.5 cm (60¼ x 36 in.)
 Kunsthaus Zürich

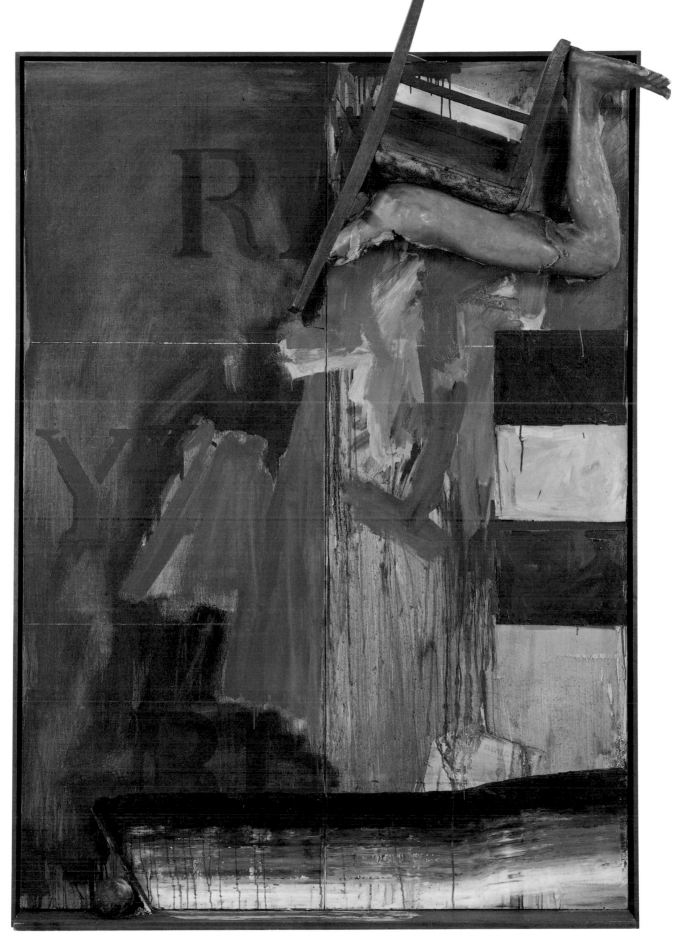

151 JASPER JOHNS, *Watchman*, 1964
Oil on canvas with objects, 216 x 153 x 24 cm (85 x 60¼ x 9½ in.)
Mr Hiroshi Teshigahara

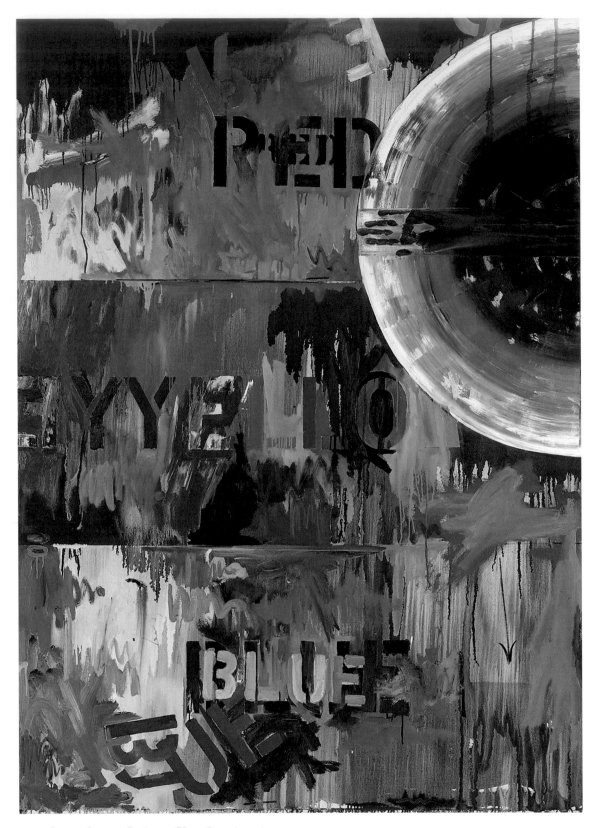

152 JASPER JOHNS, *Periscope (Hart Crane)*, 1963
Oil on canvas, 170 x 122 cm (67 x 48 in.)
Collection of the artist; courtesy of the National Museum of American Art, Smithsonian Institution, Washington, DC

Opposite

153 FRANK STELLA, *'Die Fahne Hoch!'*, 1959
Enamel paint on canvas, 308.5 x 185.5 cm (121½ x 73 in.)
Collection of Whitney Museum of American Art, New York; Gift of Mr and Mrs Eugene M. Schwartz and purchase, with funds from the John I.H. Baur Foundation; the Charles and Anita Blatt Fund, Peter M. Brant; B.H. Friedman; the Gilman Foundation, Inc.; Susan Morse Hilles; The Lauder Foundation; Frances and Sydney Lewis; the Albert A. List Fund; Philip Morris Incorporated; Sandra Payson; Mr and Mrs Albrecht Saalfield; Mrs Percy Uris; Warner Communications Inc. and the National Endowment for the Arts

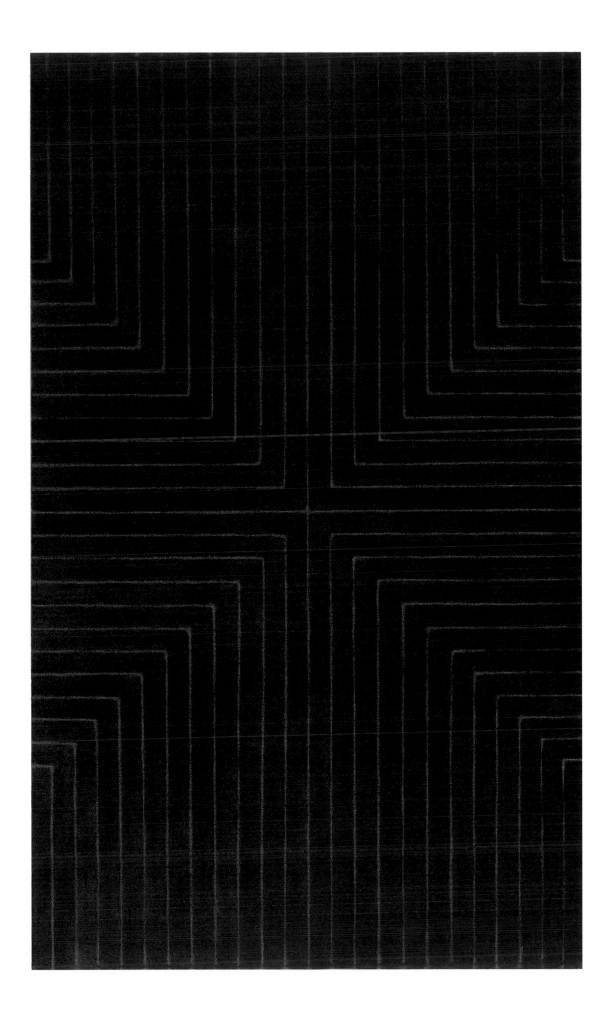

154 FRANK STELLA, *Tuxedo Park Junction*, 1960
Enamel paint on canvas, 310 x 187 cm (122 x 73½ in.)
Stedelijk Van Abbemuseum, Eindhoven, The Netherlands

155 Frank Stella, *Marriage of Reason and Squalor,* 1959
Enamel paint on canvas, 230 x 334 cm (90½ x 131½ in.)
The Saint Louis Art Museum, St. Louis; Museum Purchase and Funds given by
Mr and Mrs Joseph A. Helman, Mr and Mrs Ronald K. Greenberg

156 FRANK STELLA, *Harewa*, 1978
Mixed media on aluminium, 227.5 x 340.5 x 71 cm (89½ x 134 x 28 in.)
Gabriele Henkel Collection; courtesy Hans Strelow, Düsseldorf

157　FRANK STELLA, *Mysterious Bird of Ulieta*, 1977
Mixed media on aluminium, 300 x 360 x 46 cm
(118 x 141¾ x 18 in.)
Onnasch Collection, Berlin

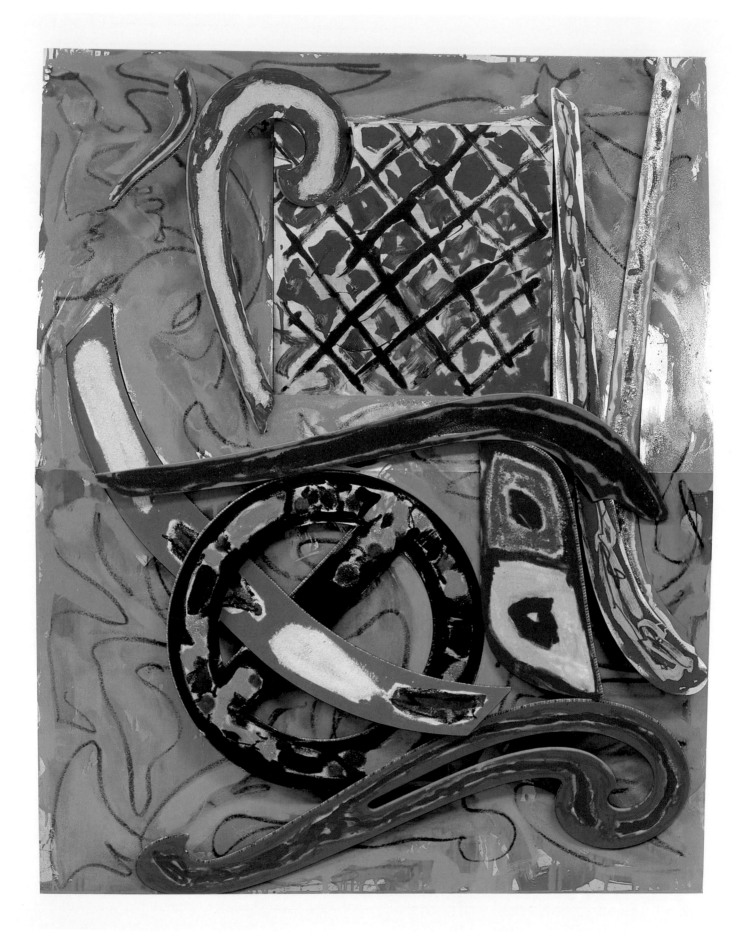

158 FRANK STELLA, *Brazilian Merganser*, 1980
Mixed media on aluminium, 305 x 213.5 cm (120 x 84 in.)
The Margulies Family Collection

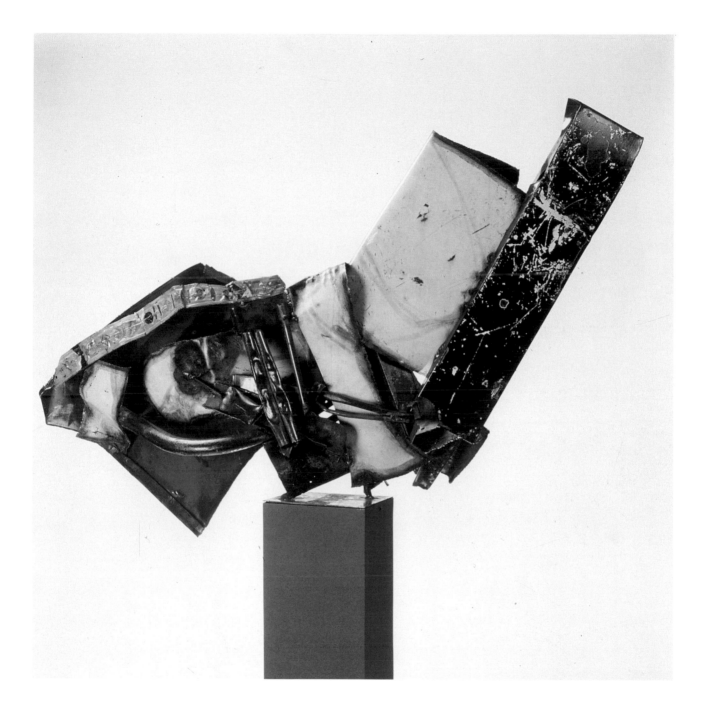

159 JOHN CHAMBERLAIN, *Zaar*, 1959
 Welded steel, painted, 130 x 173.5 x 50 cm (51¹/₄ x 68¹/₂ x 19¹/₂ in.)
 From the Patsy R. and Raymond D. Nasher Collection, Dallas

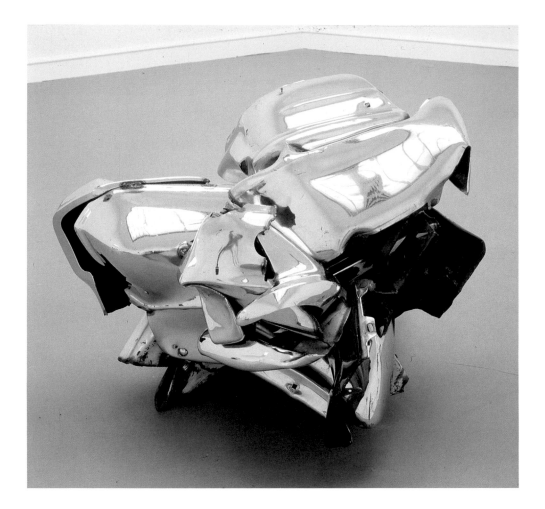

160 JOHN CHAMBERLAIN, *Iron Stone*, 1969
Painted and chromium-plated steel,
101.5 x 123 x 111.5 cm (40 x 48¹/₂ x 44 in.)
Fröhlich Collection, Stuttgart

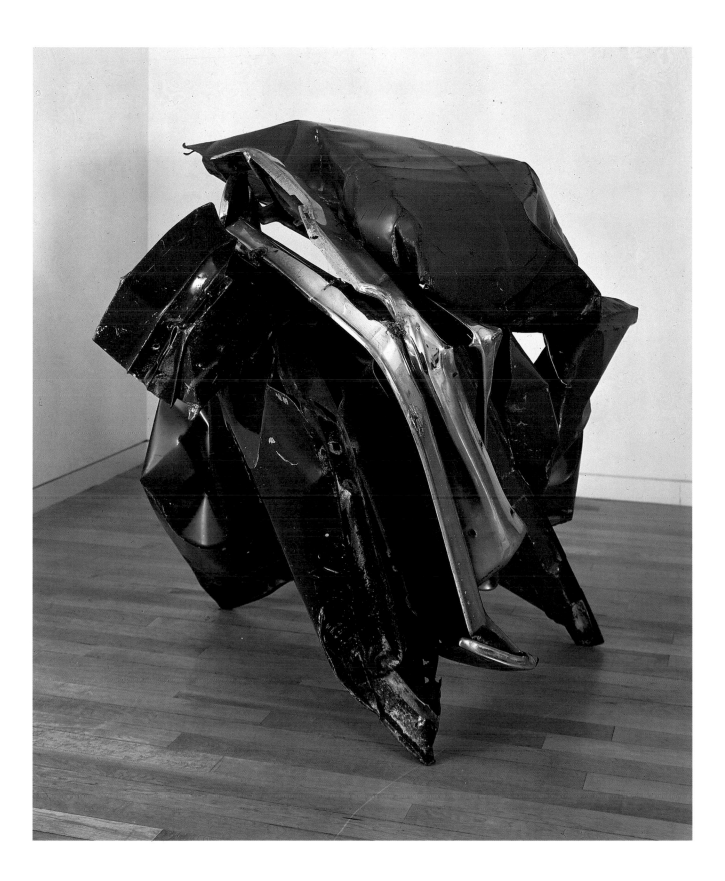

161 JOHN CHAMBERLAIN, *Hillbilly Galoot*, 1960
Steel, 152.5 x 152.5 cm (60 x 60 in.)
JW Froehlich UK, Ltd

162 CLAES OLDENBURG, *Blue Stockings*
(Blue Thighs, Yellow Garters), 1960
Tempera on plaster-soaked burlap over wire frame,
75 x 44.5 x 14 cm (29 1/2 x 17 1/2 x 5 1/2 in.)
Private collection, New York; c/o Rubin Spangle, New York

163 CLAES OLDENBURG, *Mannekin Torso:*
Two Piece Bathing Suit, 1960
Painted plaster-soaked cloth over wire frame,
83 x 37.5 x 11 cm (32 3/4 x 14 3/4 x 4 1/4 in.). From the Patsy R. and
Raymond D. Nasher Collection, Dallas

164 CLAES OLDENBURG, *The Fur Jacket*, 1961
Painted plaster-soaked muslin over wire frame,
110.5 x 98 x 15 cm (43½ x 38½ x 6 in.)
Öffentliche Kunstsammlung Basel, Kunstmuseum, Basle

165 CLAES OLDENBURG, *White Shirt on Chair*, 1962
Painted plaster-soaked muslin and wood,
101 x 76 x 63.5 cm (39¾ x 30 x 25 in.)
The Museum of Contemporary Art, Los Angeles;
The Panza Collection

166 CLAES OLDENBURG, *Lunch-box*, 1961
Painted fabric, 70 x 45 cm (27½ x 17¾ in.)
Louisiana Museum of Modern Art, Humlebaek

167 CLAES OLDENBURG, *Birthday Cake*, 1963
Board and fabric, 60 x 44 x 21.5 cm
(23½ x 17½ x 8½ in.)
Galerie 1900 △ 2000, Paris

168 CLAES OLDENBURG, *Meats*, 1964
Plaster, clay and marble, painted,
57 x 96 x 96 cm (22½ x 37¾ x 37¾ in.)
Private collection; on loan to the Museum Boymans-van Beuningen, Rotterdam

169 CLAES OLDENBURG, *Ice Cream Cone*, 1962
Plaster and metal painted with enamel,
35 x 95 x 34 cm (13¾ x 37½ x 13½ in.)
Sonnabend Collection, New York

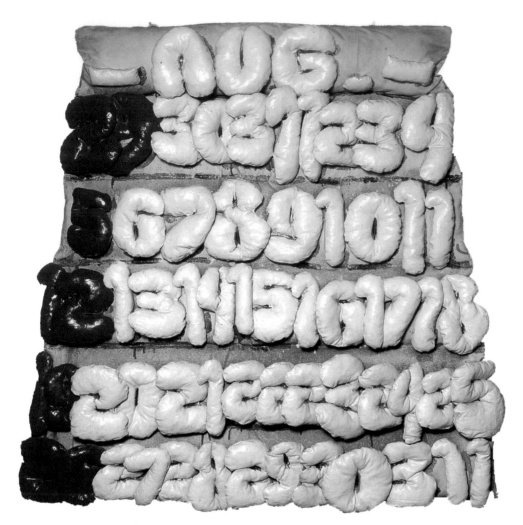

170 **Claes Oldenburg**, *Soft Calendar for the Month of August*, 1962
Canvas filled with foam rubber painted with Liquitex and enamel,
110 x 107.5 x 14 cm (43¼ x 42¼ x 5½ in.)
Muriel Kallis Newman

171 **Claes Oldenburg**, *Soft Typewriter*, 1963
Vinyl filled with kapok, wood and Plexiglas,
22.5 x 68.5 x 65 cm (9 x 27 x 25½ in.)
Private collection

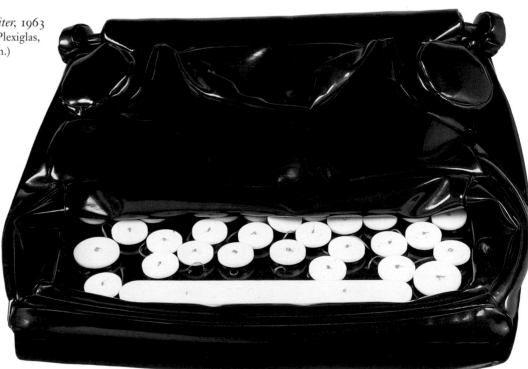

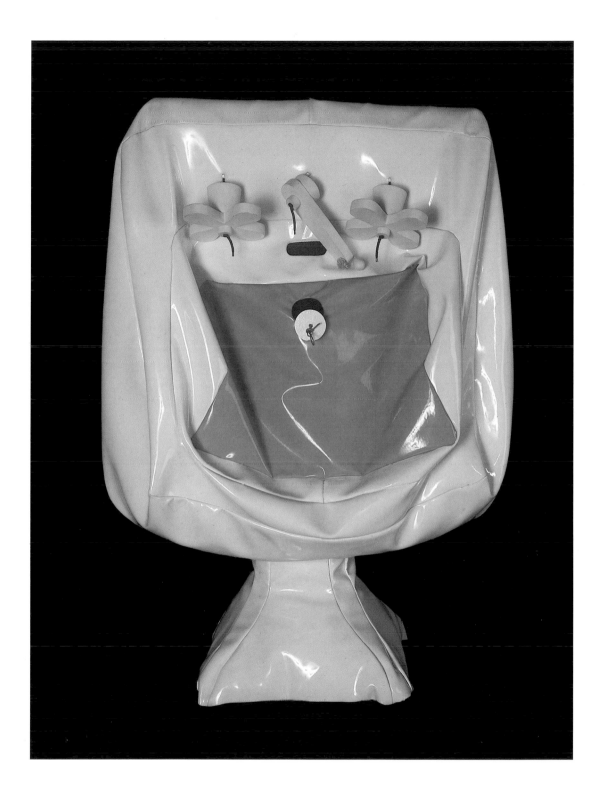

172　CLAES OLDENBURG, *Soft Washstand*, 1965
Vinyl, stuffed, 143 x 80 x 50 cm (56¼ x 31½ x 19¾ in.)
Private collection; on loan to the Museum Boymans-van Beuningen, Rotterdam

173 CLAES OLDENBURG, *Lightswitch*, 1964
Spray-paint on cardboard,
98.5 x 84 x 30 cm (38³⁄₄ x 33 x 11³⁄₄ in.)
Onnasch Collection, Berlin

174 CLAES OLDENBURG, *Three Way Plug, Model*, 1969
Wood and Masonite,
150 x 99 x 72.5 cm (59 x 39 x 28¹/₂ in.)
Onnasch Collection, Berlin

175 JAMES ROSENQUIST, *In the Red*, 1962
 Oil on canvas, 168 x 198.5 cm (66 x 78 in.)
 Stefan T. Edlis Collection

176 JAMES ROSENQUIST, *The Light that won't fail I*, 1961
 Oil on canvas, 182 x 244.5 cm (71¾ x 96¼ in.)
 Hirshhorn Museum and Sculpture Garden, Smithsonian Institution, Washington, DC;
 Gift of Joseph H. Hirshhorn Foundation, 1966

177 Roy Lichtenstein, *Live Ammo – Ha Ha Ha*, 1962
Oil on canvas, 172.5 x 172.5 cm (68 x 68 in.)
The Chrysler Museum, Norfolk, VA; Gift of Walter P. Chrysler, Jr. 71.676

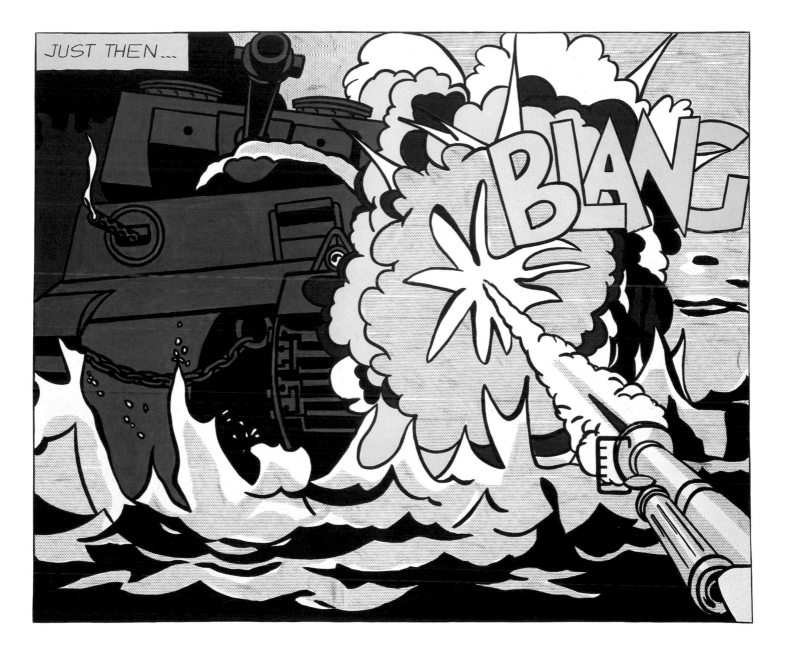

178 Roy Lichtenstein, *Blang*, 1962
Oil on canvas, 174 x 150 cm (68 x 59 in.)
Seibu Department Stores, Ltd, Tokyo

179 Roy Lichtenstein, *Fastest Gun*, 1963
Magna on canvas, 91.5 x 172.5 cm (36 x 68 in.)
Douglas S. Cramer

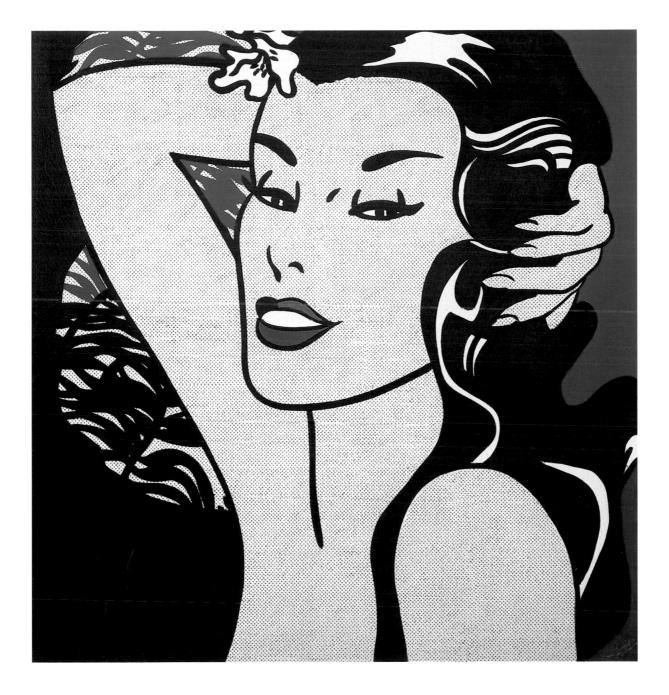

180 ROY LICHTENSTEIN, *Little Aloha*, 1962
Magna on canvas, 112 x 107 cm (44 x 42 in.)
Sonnabend Collection, New York

181 ROY LICHTENSTEIN, *Yellow Sky*, 1966
Magna on canvas, 91.5 x 172.5 cm (36 x 68 in.)
Ulmer Museum, Ulm; Collection Kurt Fried Donation

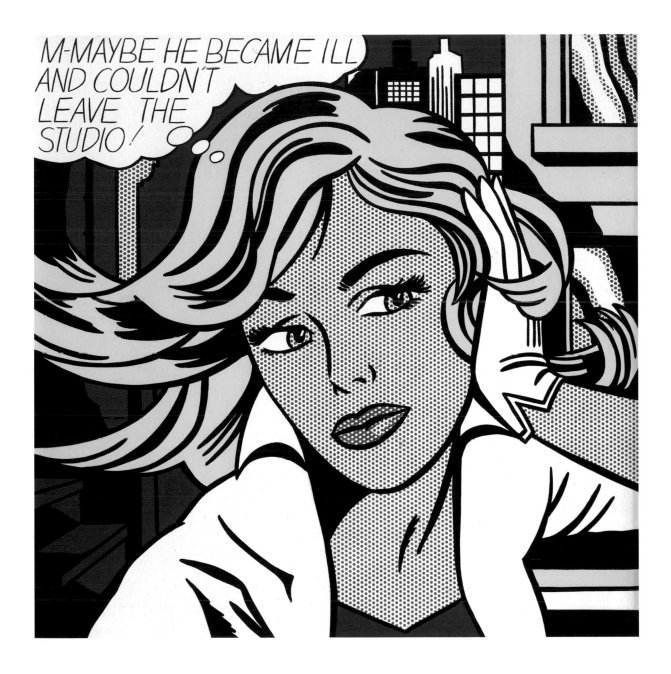

182 ROY LICHTENSTEIN, *M-Maybe (A Girl's Picture)*, 1965
 Magna on canvas, 152 x 152 cm (59¾ x 59¾ in.)
 Museum Ludwig (Ludwig Donation), Cologne

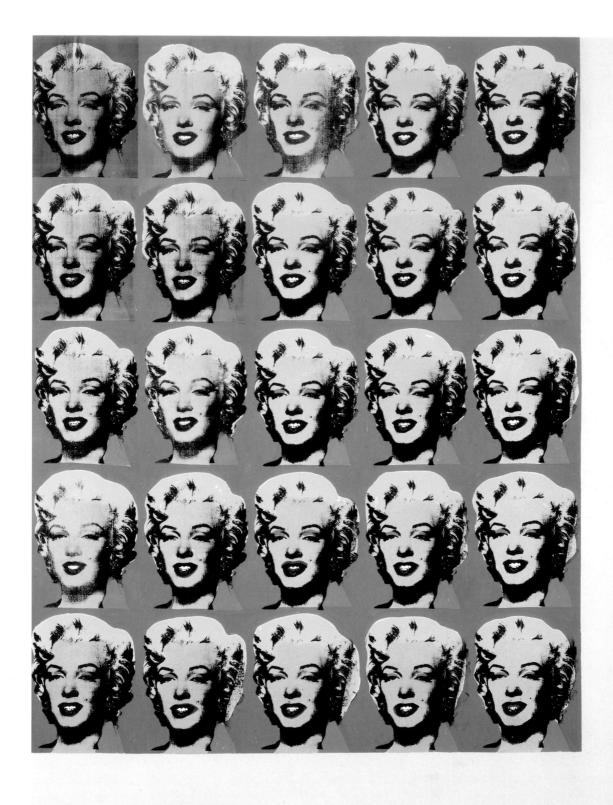

183 ANDY WARHOL, *Twenty-Five Colored Marilyns,* 1962
Acrylic on canvas, 209 x 169.5 cm (82¼ x 66¾ in.)
Collection of the Modern Art Museum of Fort Worth, Texas;
The Benjamin J. Tillar Trust, Acquired from the Collection of Vernon Nikkel,
Clovis, New Mexico, 1983

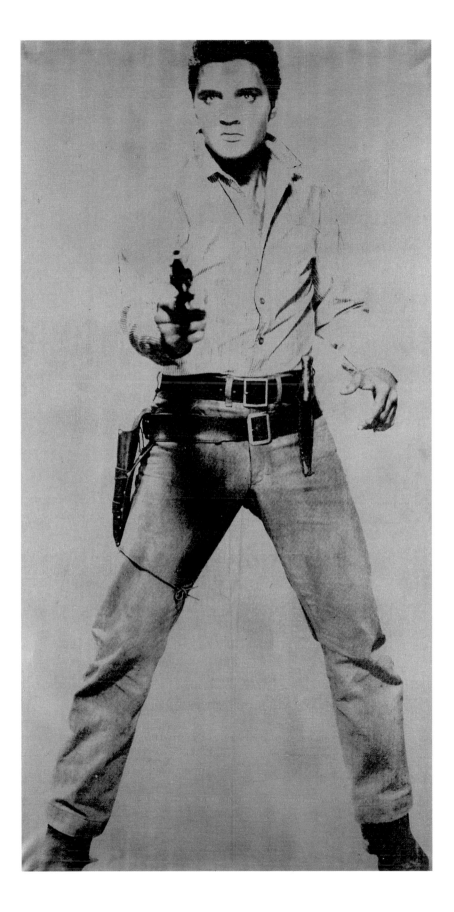

184 ANDY WARHOL, *Single Elvis*, 1963
 Acrylic and silkscreen on canvas, 210 x 107 cm (82³/₄ x 42¹/₄ in.)
 Ludwig Múzeum, Budapest

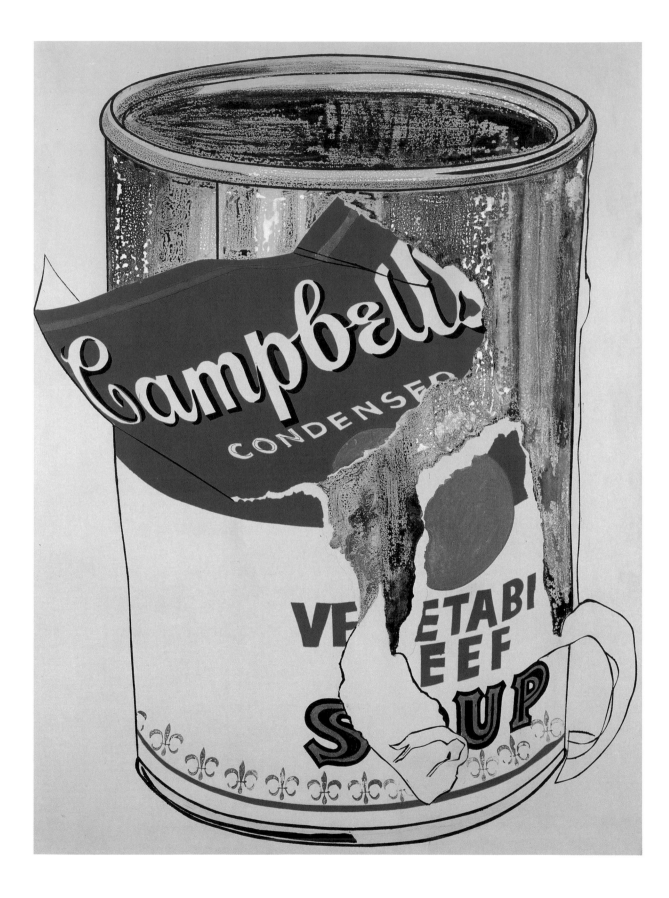

185 ANDY WARHOL, *Big Torn Campbell's Soup Can (Vegetable Beef)*, 1962
Acrylic on canvas, 183 x 137 cm (72 x 54 in.)
Kunsthaus Zürich

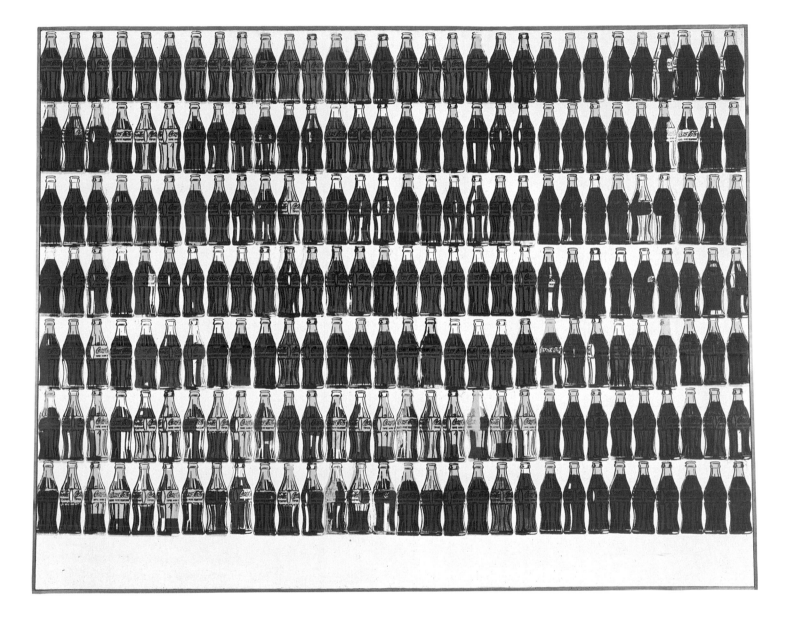

186 ANDY WARHOL, *210 Coca-Cola Bottles*, 1962
Silkscreen ink, acrylic and pencil on canvas,
209.5 x 266.5 cm (82½ x 105 in.)
Courtesy Thomas Ammann Fine Art, Zurich

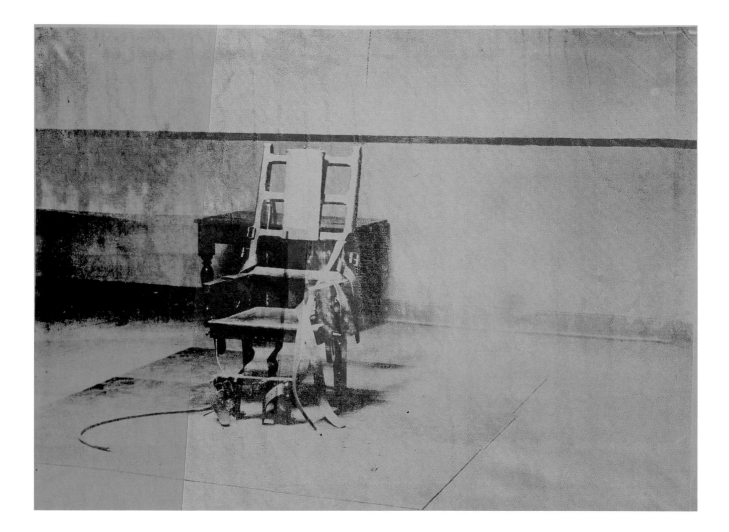

187 ANDY WARHOL, *Big Electric Chair*, 1967
 Acrylic and silkscreen ink on canvas, 137 x 185 cm (54 x 72¾ in.)
 Fröhlich Collection, Stuttgart

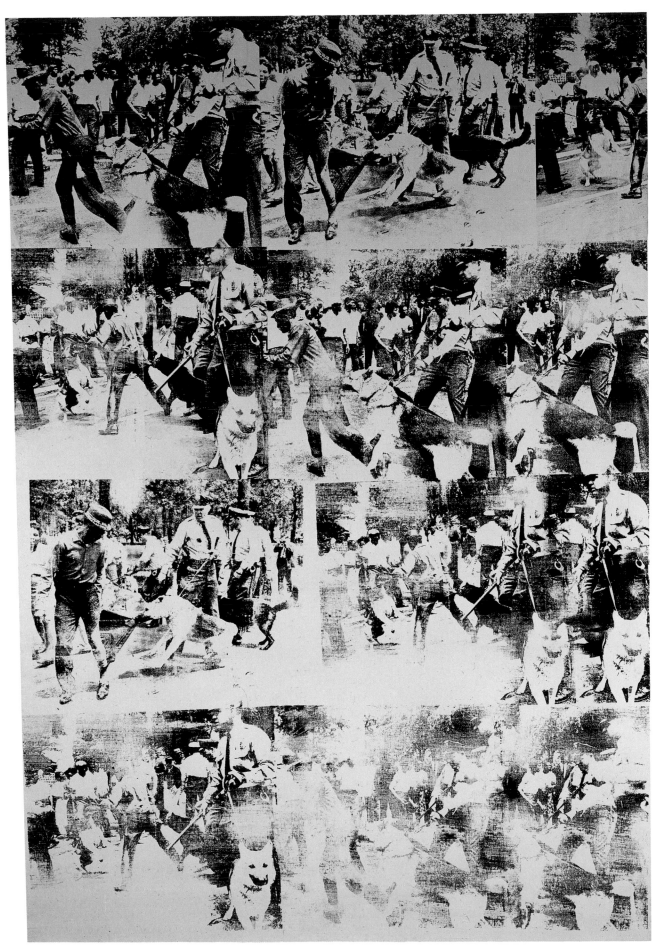

188 ANDY WARHOL, *Race Riot*, 1963
Acrylic and silkscreen ink on canvas, 307 x 210 cm (120³/₄ x 82³/₄ in.). Courtesy Thomas Ammann Fine Art, Zurich

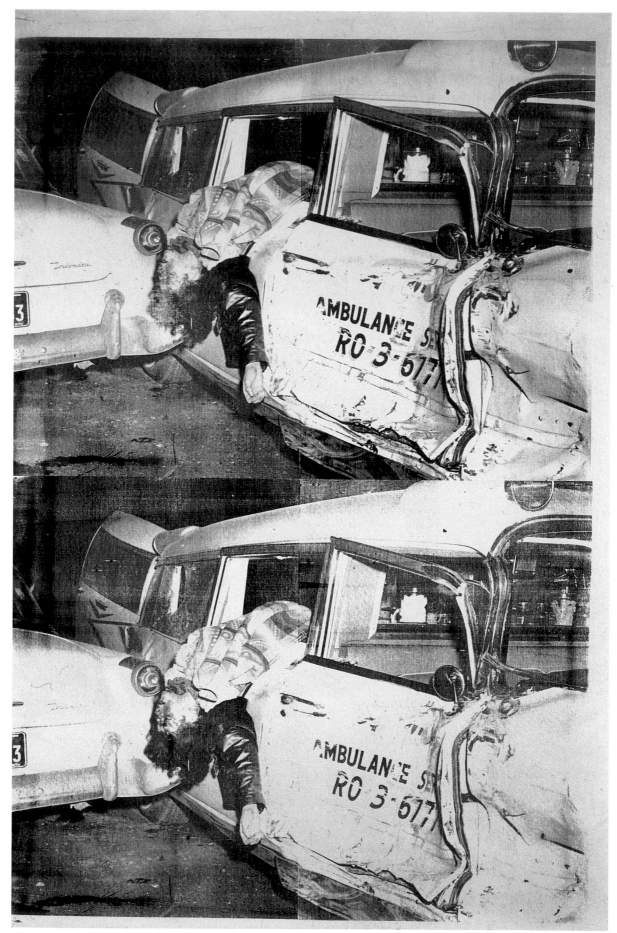

189 ANDY WARHOL, *Ambulance Disaster*, 1963
Acrylic and silkscreen ink on canvas, 315 x 203 cm (124 x 80 in.)
Marx Collection, Berlin; on loan to the Städtisches Museum Abteiberg, Mönchengladbach

190 Edward Ruscha, *Large Trademark with Eight Spotlights*, 1962
Oil on canvas, 169.5 x 338.5 cm (66³/₄ x 133¹/₄ in.)
Collection of Whitney Museum of Americam Art, New York;
Purchase, with funds from the Mrs Percy Uris Purchase Fund

191 RICHARD ARTSCHWAGER, *Piano*, 1965
 Formica on wood, 81.5 x 122 x 48.5 cm (32 x 48 x 19 in.)
 Castelli Collection, New York

192 RICHARD ARTSCHWAGER, *Lefrak City*, 1962
 Acrylic/celotex with Formica, 113 x 247.5 cm (44¹/₂ x 97¹/₂ in.)
 Collection Irma and Norman Braman

193　Agnes Martin, *Leaf,* 1965
　　　Acrylic and graphite on canvas, 183 x 183 cm (72 x 72 in.)
　　　Collection of the Modern Art Museum of Fort Worth, Texas;
　　　Museum Purchase, Sid W. Richardson Foundation Endowment Fund

194 AGNES MARTIN, *Happy Valley*, 1967
Acrylic, pencil and ink on canvas, 183 x 183 cm (72 x 72 in.)
Onnasch Collection, Berlin

195 ROBERT RYMAN, *Untitled*, 1960
Oil on cotton, 109 x 109 cm (43 x 43 in.)
Hallen für neue Kunst, Schaffhausen

196 ROBERT RYMAN, *Untitled*, 1960
 Oil on linen, 149 x 149 cm (58¾ x 58¾ in.)
 Hallen für neue Kunst, Schaffhausen

197 ROBERT RYMAN, *Delta I*, 1966
Oil on cotton, 267 x 267 cm (105 x 105 in.)
Hallen für neue Kunst, Schaffhausen

198 ROBERT MANGOLD, *Brown Wall*, 1964
Oil on plywood and metal (2 parts), 244 x 244 cm (96 x 96 in.)
Hallen für neue Kunst, Schaffhausen

199 Brice Marden, *Blunder,* 1969
 Oil and beeswax on canvas, 183 x 183 cm (72 x 72 in.)
 Galerie Karsten Greve, Cologne and Paris

200 BRICE MARDEN, *Nebraska,* 1966
Oil and beeswax on canvas, 147 x 183 cm (58 x 72 in.)
Collection of the artist

201 DONALD JUDD, *Untitled*, 1965
Red lacquer on galvanized iron, 12.5 x 175.5 x 21.5 cm (5 x 69 x 8½ in.)
Fröhlich Collection, Stuttgart

202 DONALD JUDD, *Untitled*, 1966
Plexiglas and stainless steel, 51 x 122 x 86.5 cm (20 x 48 x 34 in.)
Fröhlich Collection, Stuttgart

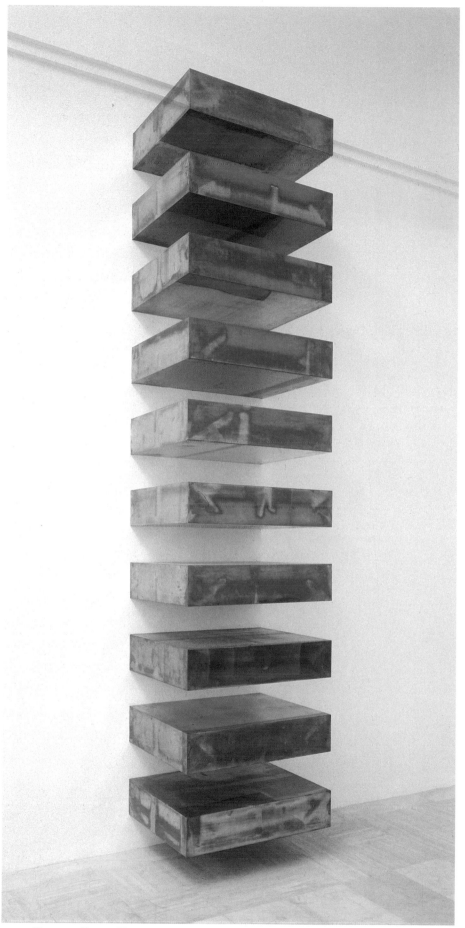

203 Donald Judd, *Untitled*, 1969
Copper, mirror finish (ten units), 23 x 102 x 292 cm (9 x 40½ x 115 in.) (each), total height 292 cm (115 in.)
Solomon R. Guggenheim Museum, New York; The Panza Collection, 1991

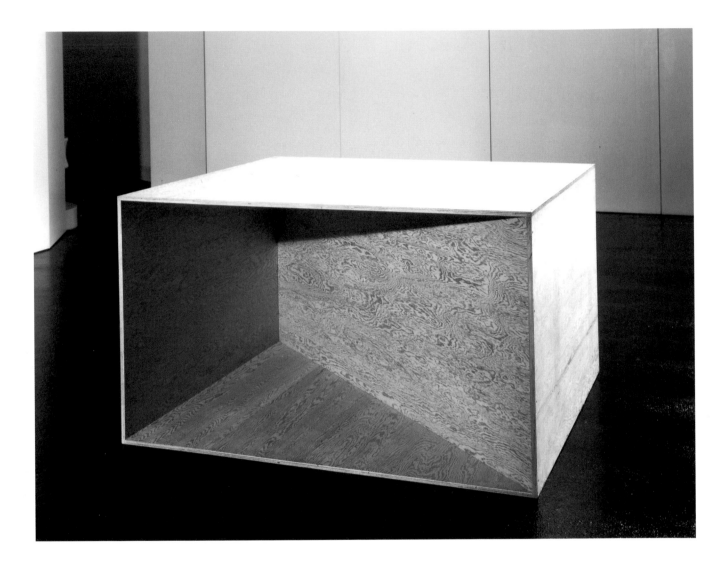

204　Donald Judd, *Untitled*, 1974/76/77
　　Wood, 91,5 x 152.5 x 152.5 cm (36 x 60 x 60 in.)
　　Kunstmuseum, Berne; Hermann and Margrit Rupf Donation

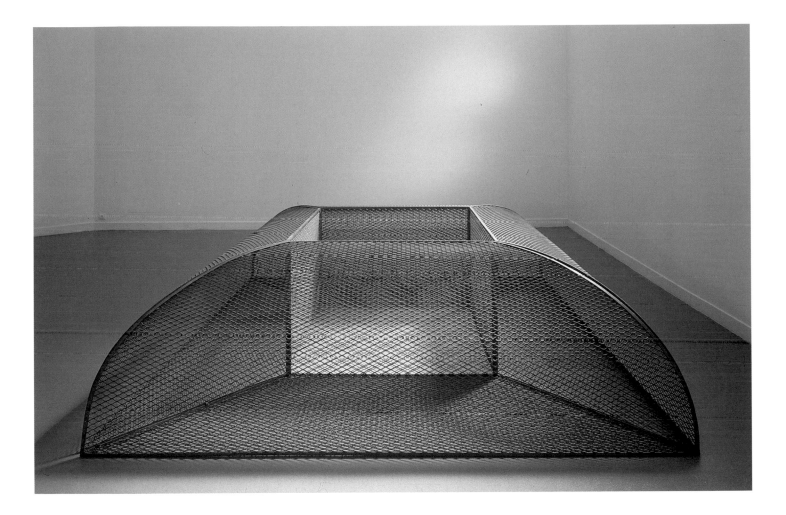

205 ROBERT MORRIS, *Untitled*, 1967
Steel grating, 78.5 x 277 x 277 cm (31 x 109 x 109 in.)
Solomon R. Guggenheim Museum, New York; The Panza Collection, 1991

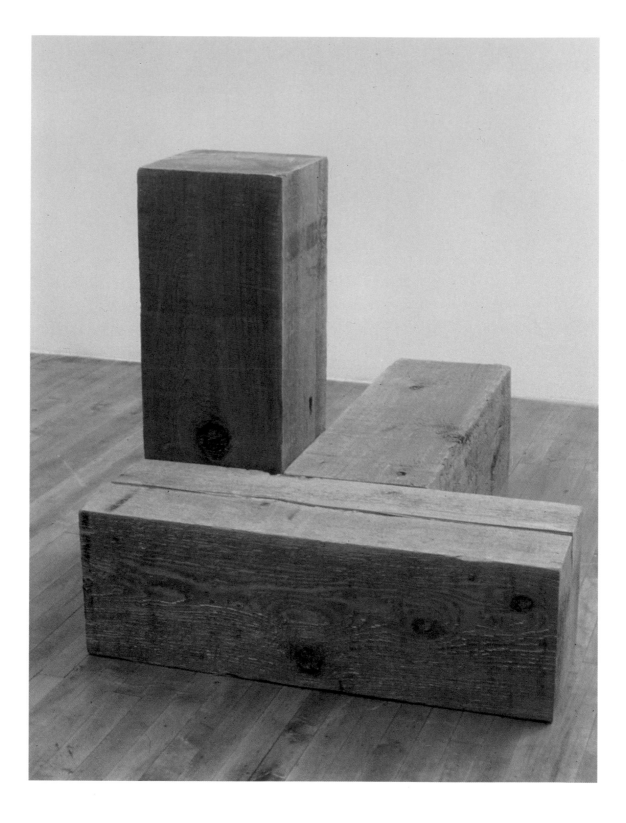

206 CARL ANDRE, *The Way North and East (Uncarved Blocks), Vancouver,* 1975
Western red cedar (3 units), 30.5 x 30.5 x 91.5 cm (12 x 12 x 36 in.) (each),
91.5 x 91.5 x 122 cm (36 x 36 x 48 in.) (overall)
Paula Cooper, New York

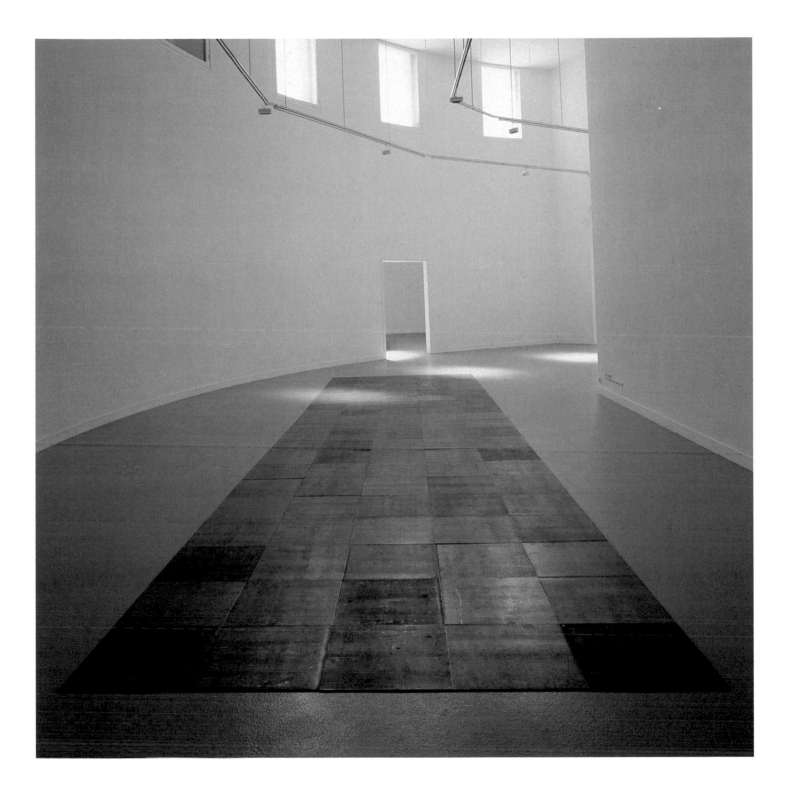

207　Carl Andre, *5 x 20 Altstadt Rectangle*, 1967
　　100 hot-rolled steel plates, 0.5 x 50 x 50 cm (1/4 x 19³/₄ x 19³/₄ in.) (each),
　　250 x 1000 cm (98¹/₂ x 394 in.) (overall)
　　Solomon R. Guggenheim Museum, New York;
　　The Panza Collection, 1991

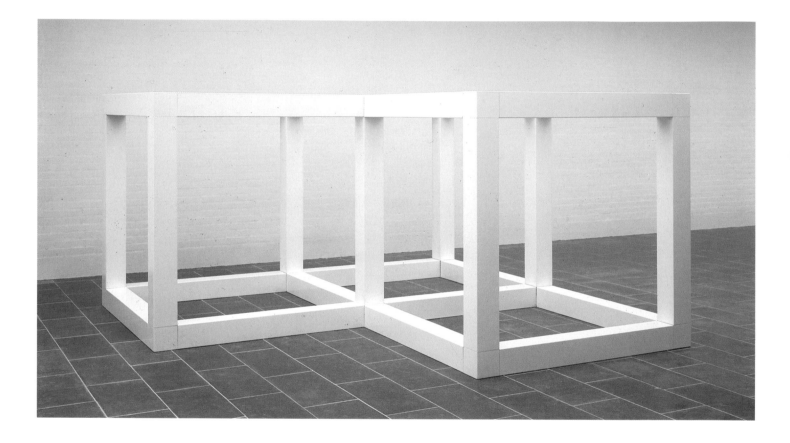

208　Sol LeWitt, *Three Cubes with One Half - Off*, 1969
Painted steel, 160 x 305 x 305 cm (63 x 120 x 120 in.)
Louisiana Museum of Modern Art, Humlebaek

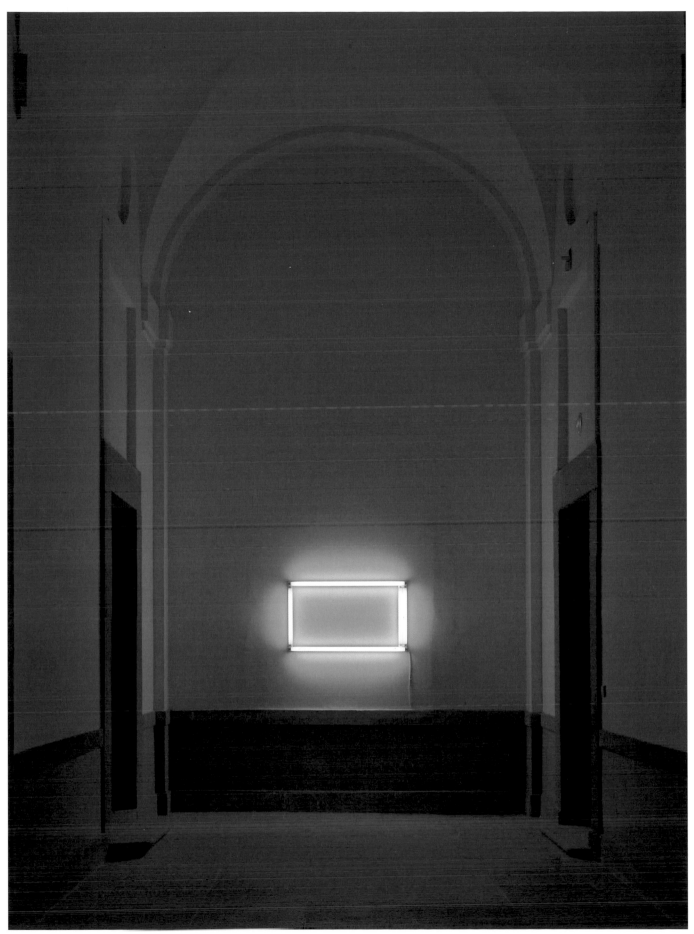

209 DAN FLAVIN, *Ursula's One and Two Picture* 1/3, 1964
Ultraviolet fluorescent light, 81 x 126 x 16 cm (32 x 49½ x 6¼ in.)
Solomon R. Guggenheim Museum, New York; The Panza Collection, Gift 1992

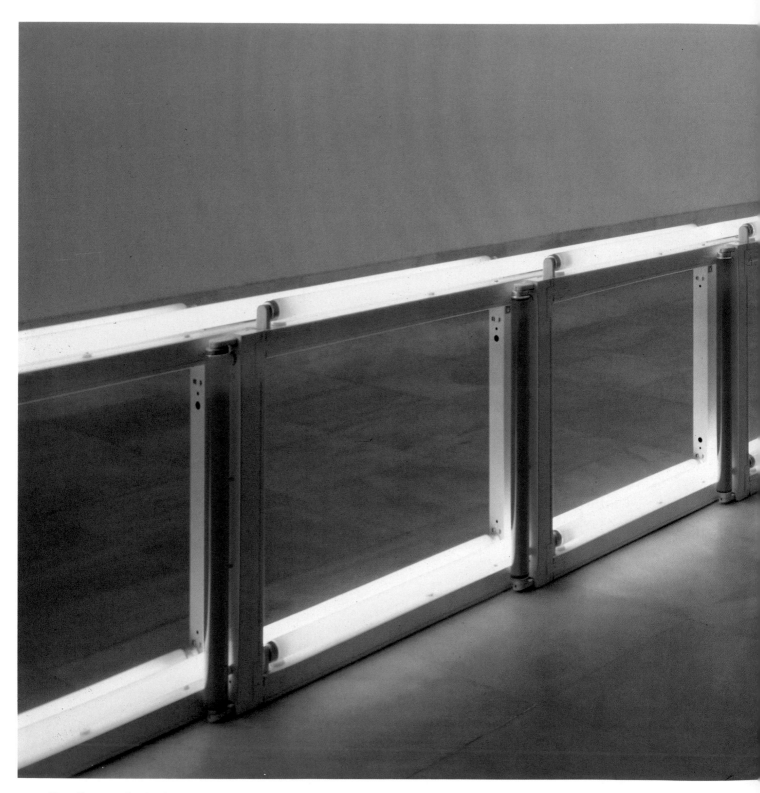

210 DAN FLAVIN, *An Artificial Barrier of Blue, Red and Blue Fluorescent Light
 (to Flavin Starbuck Judd)*, 1968
 Fluorescent light, length approx. 1700 cm (670 in.)
 Solomon R. Guggenheim Museum, New York; The Panza Collection, 1991

211 Eva Hesse, *Cool Zone*, July 1965
 Aluminium and painted cloth-bound cord, diameter of stand 38 cm (15 in.),
 length of cord 114.5 cm (45 in.), depth 25.5 cm (10 in.)
 Audrey and Sidney Irmas, Los Angeles

212 EVA HESSE, *Metronomic Irregularity II*, 1966; reconstruction, 1993
Painted wood and cotton-covered wire (3 panels),
122 x 122 cm (48 x 48 in.) (each),
122 x 610 cm (48 x 240 in.) (overall)
The Estate of Eva Hesse and courtesy Robert Miller Gallery, New York

213　EVA HESSE, *Untitled* (Three Nets), 1966
Painted papier mâché and nets, 108 x 29 x 15 cm (42 1/2 x 11 1/2 x 6 in.)
Private collection

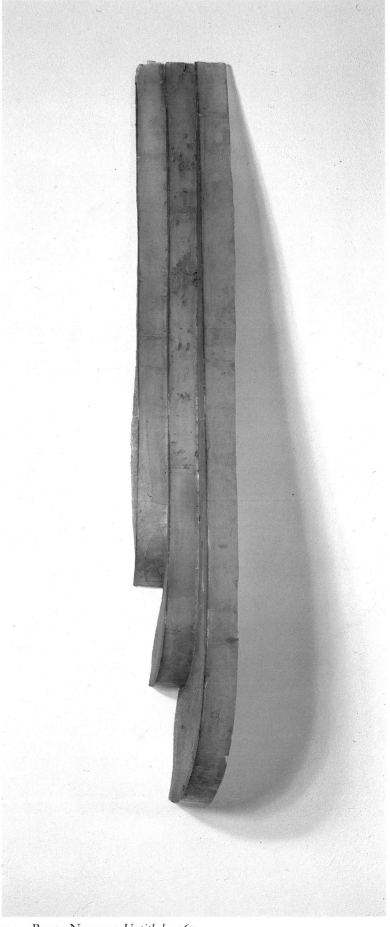

214 Bruce Nauman, *Untitled*, 1965
Fibreglass, 237 x 47 x 29 cm (93 x 18 1/2 x 11 1/2 in.)
Hallen für neue Kunst, Schaffhausen

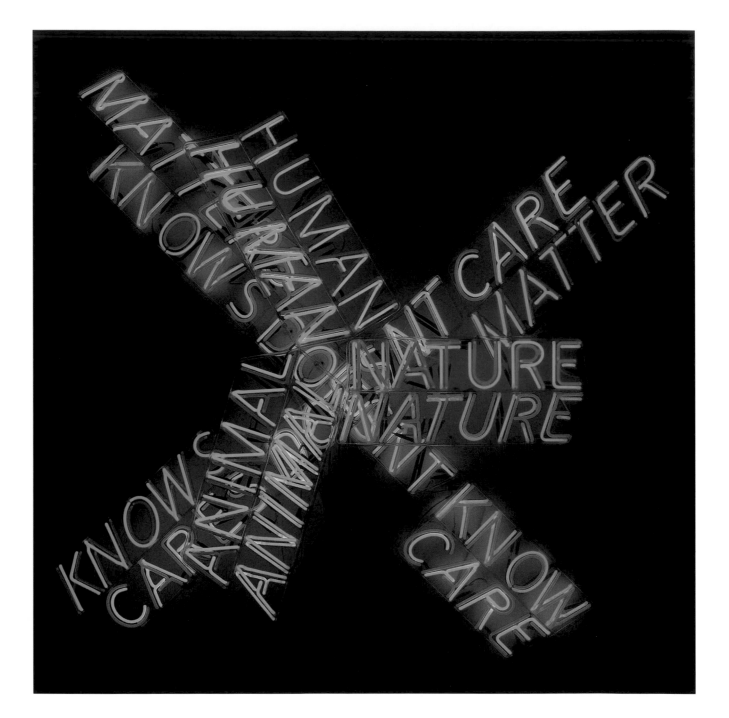

215 Bruce Nauman, *Human Nature/Knows Doesn't Know*, 1983-86
Neon tubing, 230 x 230 x 35.5 cm (90^1/$_2$ x 90^1/$_2$ x 14 in.)
Fröhlich Collection, Stuttgart

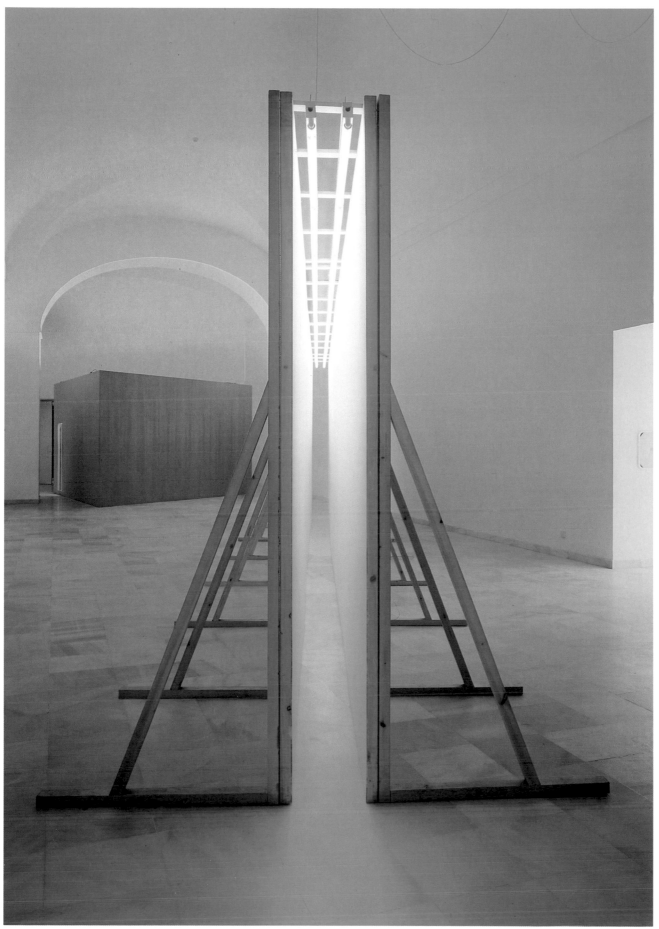

216 BRUCE NAUMAN, *Green Light Corridor*, 197-71
Wall-board and fluorescent light, 304.8 x 1219.2 x 30.5 cm (120 x 480 x 12 in.)
Solomon R. Guggenheim Museum, New York; The Panza Collection, Gift 1992

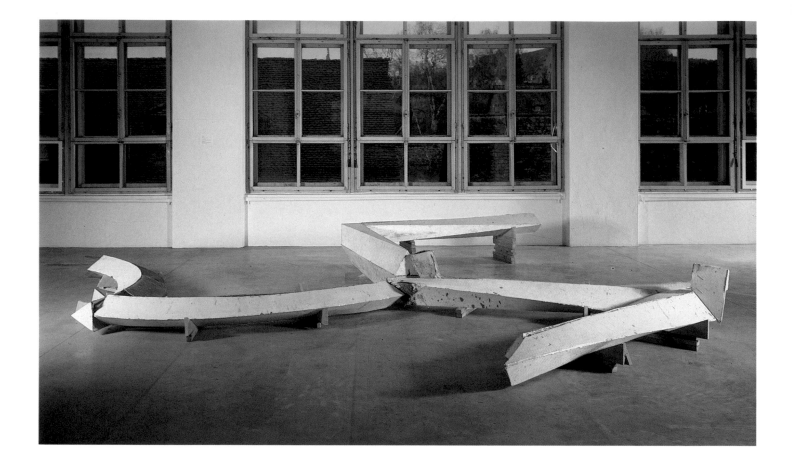

217 BRUCE NAUMAN, *Model for Tunnel Made up of Leftover Parts of Other Projects*, 1979-80
Fibreglass, plaster and wood, 56 x 700 x 650 cm (22 x 275 x 256 in.)
Hallen für neue Kunst, Schaffhausen

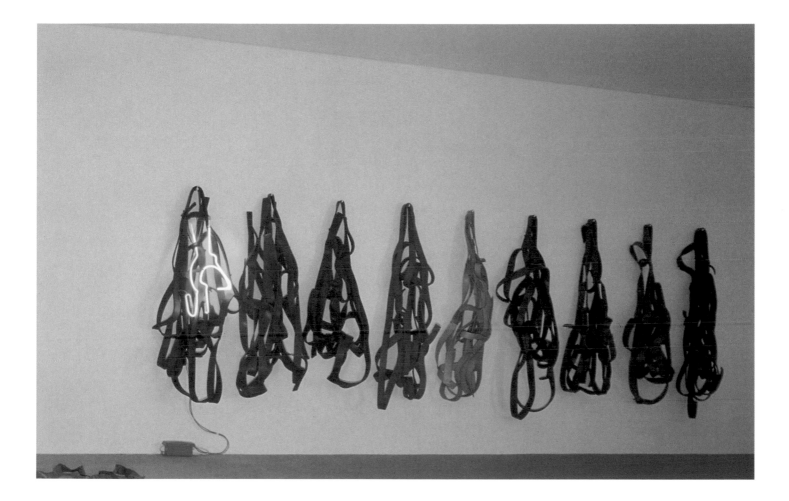

218 RICHARD SERRA, *Belts*, 1966-67
 Vulcanized rubber and neon tubing, 214 x 732 x 51 cm (84 x 288 x 20 in.)
 Solomon R. Guggenheim Museum, New York; The Panza Collection, 1991

219 Richard Serra, *Floor Pole Prop*, 1969
Antimony lead, 250 x 250 x 95 cm
(98¹/₂ x 98¹/₂ x 37¹/₂ in.)
Onnasch Collection, Berlin

220 RICHARD SERRA, *One Ton Prop (House of Cards)*, 1969-81
4 sheets of lead, 165 x 165 cm (65 x 65 in.) (each)
Galerie m, Bochum, and the artist

TO SEE AND BE SEEN

SEHEN UND GESEHEN WERDEN

221 Lawrence Weiner, *No. 278,* 1972
Language and the materials referred to, dimensions variable
Solomon R. Guggenheim Museum, New York; The Panza Collection, Gift 1992

1000 GERMAN MARKS WORTH

MATERIAL MITTLEREN UMFANGES IM WERT

MEDIUM BULK MATERIAL

VON 1000 DEUTSCHEN MARK

TRANSFERRED FROM ONE COUNTRY

VON EINEM LAND

TO ANOTHER

IN EIN ANDERES GEBRACHT

222 LAWRENCE WEINER, *No. 051*, 1969
Language and the materials referred to, dimensions variable
Solomon R. Guggenheim Museum, New York; The Panza Collection, extended loan

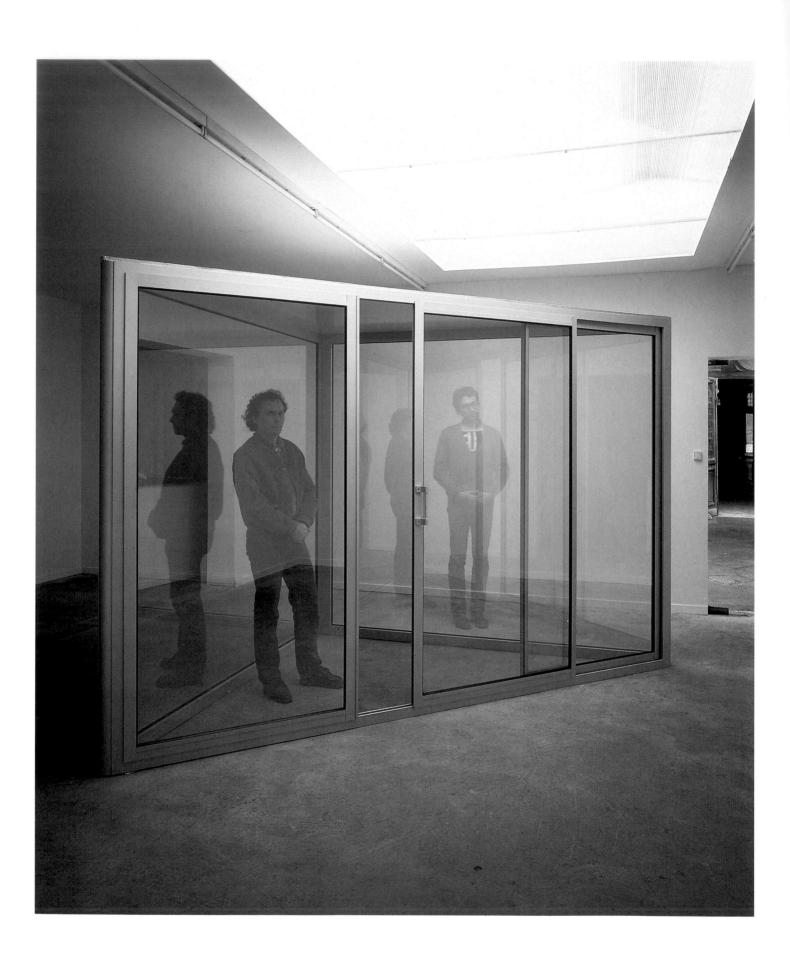

223 Dan Graham, *Triangular Solid: Right Angles*, 1987
Glass and metal, 225 x 225 x 225 cm
(88¹/₂ x 88¹/₂ x 88¹/₂ in.)
Collection FRAC de Bourgogne, Dijon

224 JAMES TURRELL, *Decker*, 1967
Light projection, dimensions variable
Courtesy Anthony d'Offay Gallery, London

225 JAMES LEE BYARS, *Untitled* (Perfect Painting), 1962-63
 Ink on paper, 30 x 300 x 30 cm (11³/₄ x 118 x 11³/₄ in.)
 Private collection

226 JAMES LEE BYARS, *The Book of the 100 Perfects*, 1985
4 chaises longues and book (velvet, paper), chaises longues 66.5 x 182 x 75 cm (26 x 71¹/₂ x 29¹/₂ in.) (each),
book 35 x 35 x 35 cm (13³/₄ x 13³/₄ x 13³/₄ in.)
Galerie Michael Werner, Cologne and New York

227 PHILIP GUSTON, *The Painter,* 1976
Oil on canvas, 188 x 295 cm (74 x 116 in.)
Collection of Richard E. Lang, Jane M. Davis, Medina, WA

228 JONATHAN BOROFSKY, *Prisoner at 3,000,426,* 1986
Acrylic on canvas, 244.5 x 194.5 cm (96¼ x 76½ in.)
Eli Broad Family Foundation, Santa Monica, California

229 JONATHAN BOROFSKY, *Running Man at 2,550,116*, 1978-79
Acrylic on plywood, 227.5 x 280 cm (89¹/₂ x 110¹/₄ in.)
From the Patsy R. and Raymond D. Nasher Collection, Dallas, Texas

230 JONATHAN BOROFSKY, *Split Head at* 2,673,047, 1980
Oil on canvas, approx. 300 x 250 cm (120 x 100 in.)
Richard and Lois Plehn, New York

231 JULIAN SCHNABEL, *Hospital Patio – Baboon in Summer,* 1979
 Oil and wax on canvas (2 pieces), 229 x 366 cm (90 x 144 in.)
 Courtesy Galerie Bruno Bischofberger, Zurich

232 JULIAN SCHNABEL, *Circum-Navigating the Sea of Shit*, 1979
Plates, oil and wax on wood, 244 x 244 cm (96 x 96 in.)
Courtesy Galerie Bruno Bischofberger, Zurich

233 JEAN-MICHEL BASQUIAT, *Man from Naples*, 1982
Acrylic, oil stick and collage on canvas, 124 x 265 cm (49 x 104 in.)
Galerie Bruno Bischofberger, Zurich

234 Jean-Michel Basquiat, *K*, 1982
Acrylic on canvas, 183 x 102 cm (72 x 40 in.)
Courtesy Galerie Bruno Bischofberger, Zurich

235 KEITH HARING, *Untitled*, 1985
Acrylic and oil on canvas, 295 x 457 cm (116 x 180 in.)
FAE Musée d'art contemporain, Pully/Lausanne

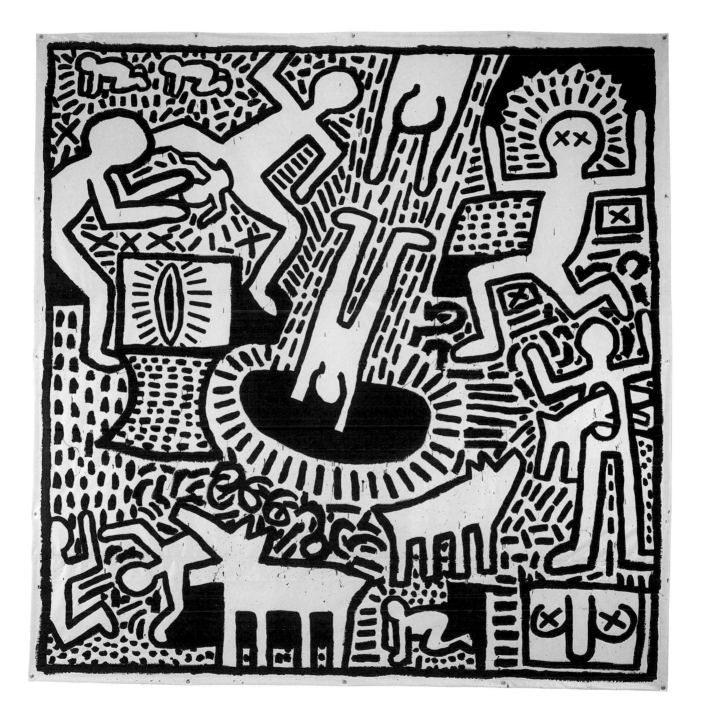

236 KEITH HARING, *Untitled*, 1981
Vinyl ink on tarpaulin, 366 x 366 cm (144 x 144 in.)
Courtesy Galerie Bruno Bischofberger, Zurich

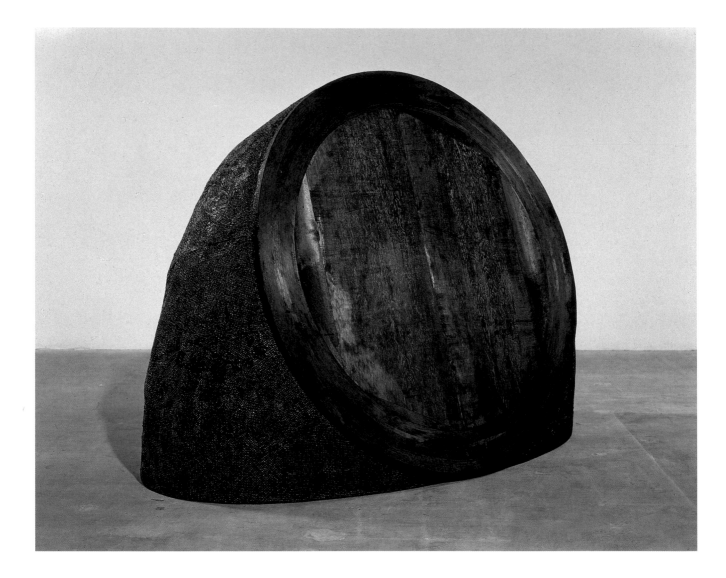

237 MARTIN PURYEAR, *Vault*, 1984
Wood, wire mesh and tar, 167.5 x 246.5 x 122 cm (66 x 97 x 48 in.)
Collection Museum of Contemporary Art, San Diego

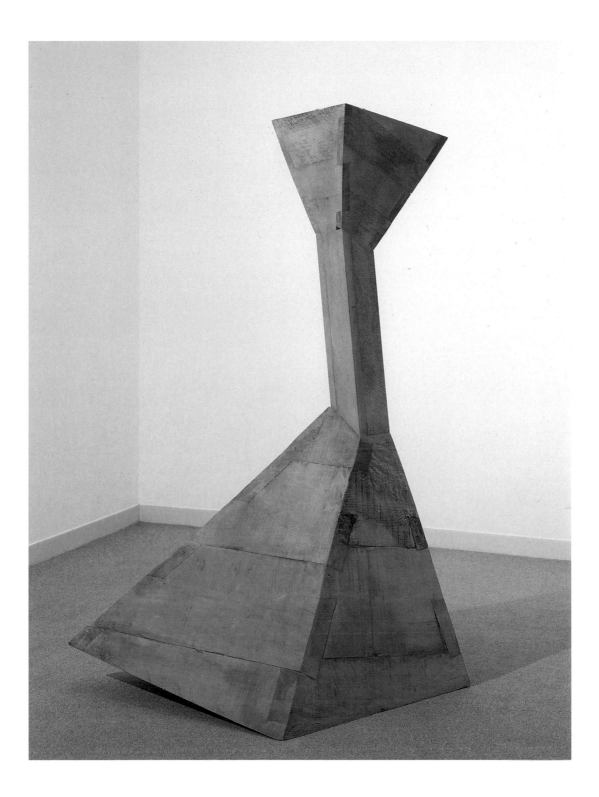

238 MARTIN PURYEAR, *Timber's Turn*, 1987
Wood, 219.5 x 118.5 x 87.5 cm (86½ x 46¾ x 34½ in.)
Hirshhorn Museum and Sculpture Garden, Smithsonian Institution,
Washington, DC; Museum Purchase, 1987

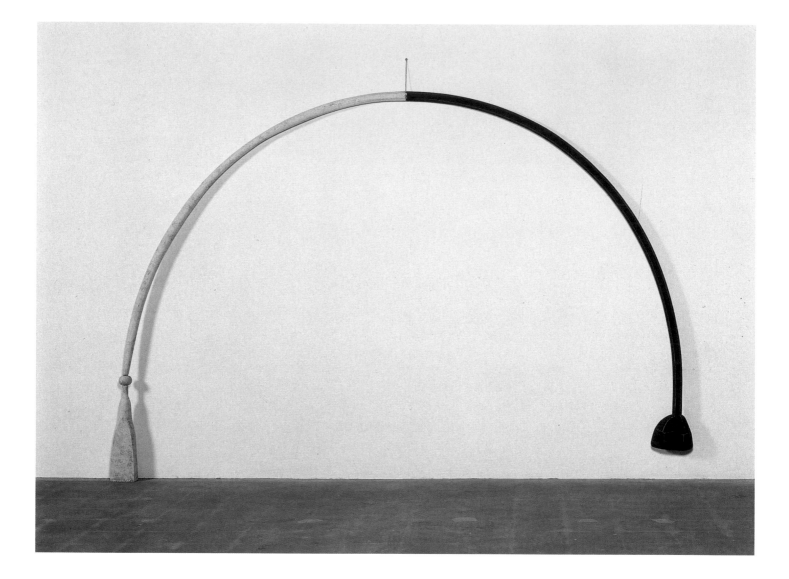

239 MARTIN PURYEAR, *Night and Day*, 1984
Painted wood and wire, 212 x 301 x 12.5 cm (83$\frac{1}{2}$ x 118$\frac{1}{2}$ x 5 in.)
From the Patsy R. and Raymond D. Nasher Collection, Dallas

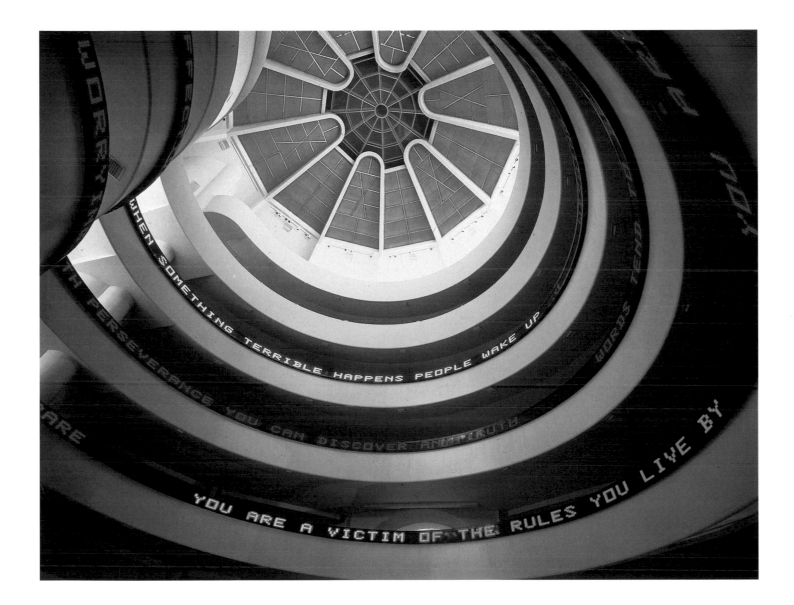

240 JENNY HOLZER, Selection from *Truism: Inflammatory Essays,*
The Living Series, The Survival Series,
Under a Rock, Laments and new writing
Extended helical LED electronic signboard,
35.5 x 1616 x 10 cm (14 x 636 x 4 in.)
Installation in the Solomon R. Guggenheim Museum, New York, 1989;
courtesy Barbara Gladstone Gallery, New York

241 Bill Viola, *Room for St. John of the Cross*, 1983
Video/sound installation
The Museum of Contemporary Art, Los Angeles;
The El Paso Natural Gas Company Fund for California Art

242　Cindy Sherman, *Untitled no. 70*, 1980
　　Colour photograph, 51 x 61 cm (20 x 24 in.)
　　Saatchi Collection, London

243 Cindy Sherman, *Untitled no. 96*, 1981
 Colour photograph, 61 x 122 cm (24 x 48 in.)
 Saatchi Collection, London

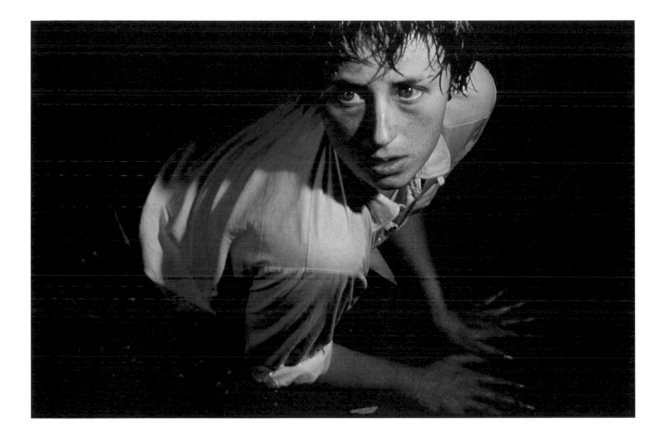

244 Cindy Sherman, *Untitled no. 92*, 1981
 Colour photograph, 61 x 122 cm (24 x 48 in.)
 Saatchi Collection, London

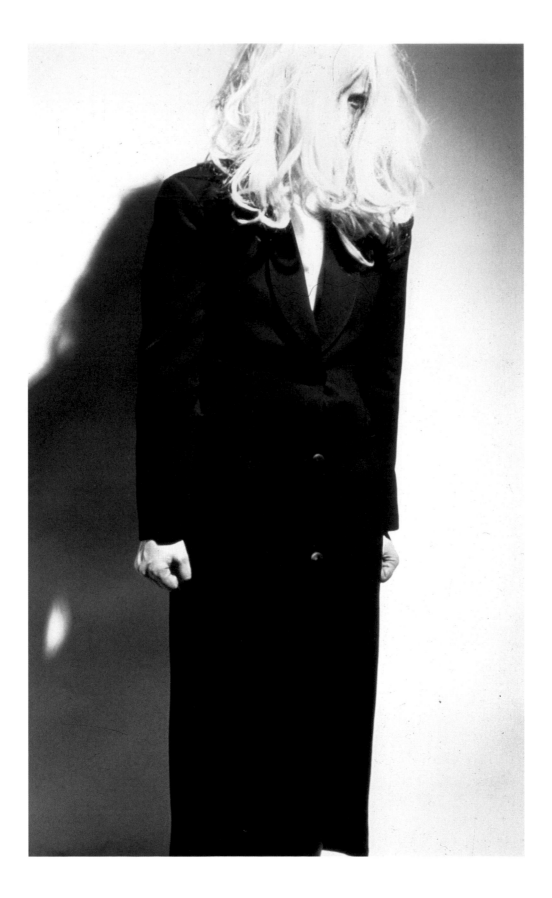

245 CINDY SHERMAN, *Untitled no. 122*, 1983
Colour photograph, 220 x 146.5 cm (86½ x 57¾ in.)
Saatchi Collection, London

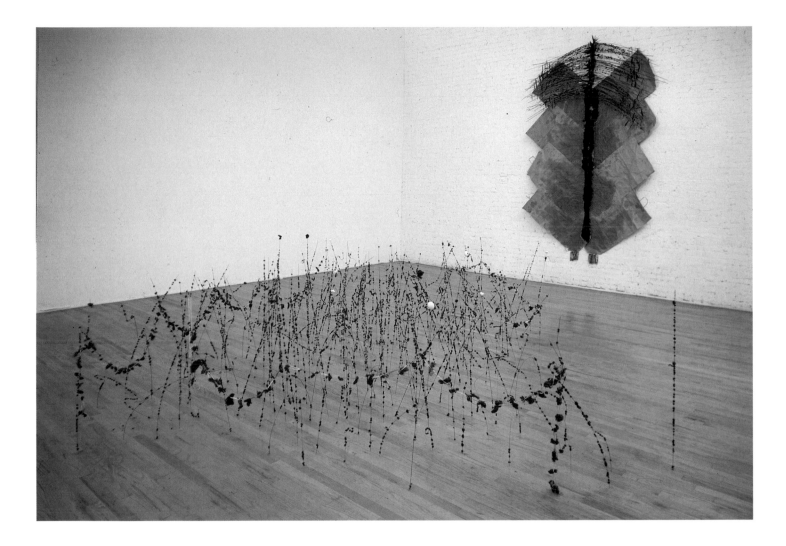

246 DAVID HAMMONS, *Flight Fantasy* and *Lady with Bones*, 1983
Various materials
Installation at P.S.1, New York, 1990

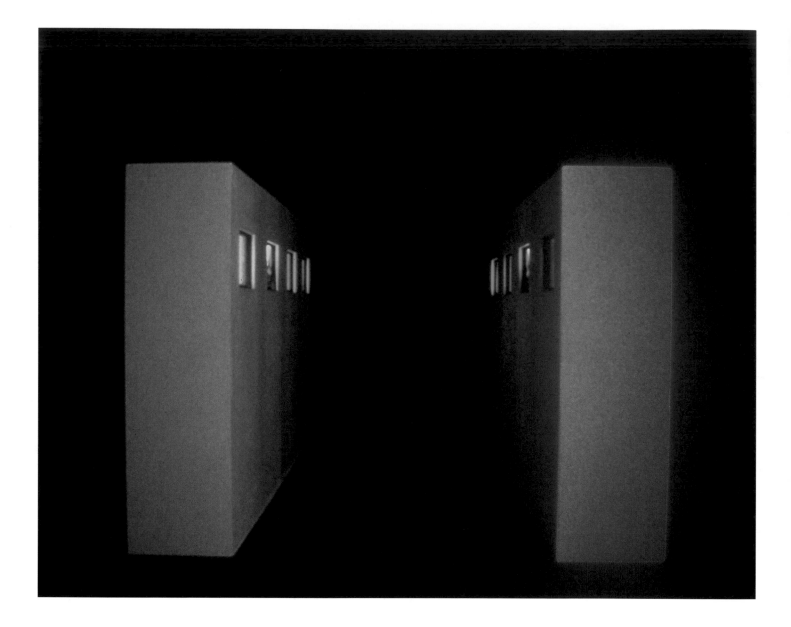

247 GARY HILL, *Primarily Speaking*, 1981-83
Video/sound installation
Donald Young Gallery, Seattle

248 JEFF KOONS, *New Hoover Quadraflex, New Hoover Convertible, New Hoover Dimension 900,*
 New Hoover Dimension 1000, 1981-86. New Hoovers, acrylic glass and fluorescent light,
 251.5 x 136 x 71 cm (99 x 53¹/₂ x 28 in.). Lewis and Susan Manilow

249 JEFF KOONS, *Total Equilibrium Ball*, 1985
 Glass, iron, water and basketball, 164 x 77.5 x 33.5 cm (64¹/₂ x 30¹/₂ x 13¹/₄ in.)
 Dakis Joannou, Athens

250 JEFF KOONS, *Jim Beam J.B. Turner Train*, 1986
 Stainless steel, 25 x 294.5 x 17 cm
 (9³/₄ x 116 x 6³/₄ in.)
 Dakis Joannou, Athens

251 ROBERT GOBER, *Untitled, Closet*, 1989
Wood, plaster and enamel paint, 213.5 x 132 x 71 cm
(84 x 52 x 28 in.)
S. and J. Vandermolen, Ghent

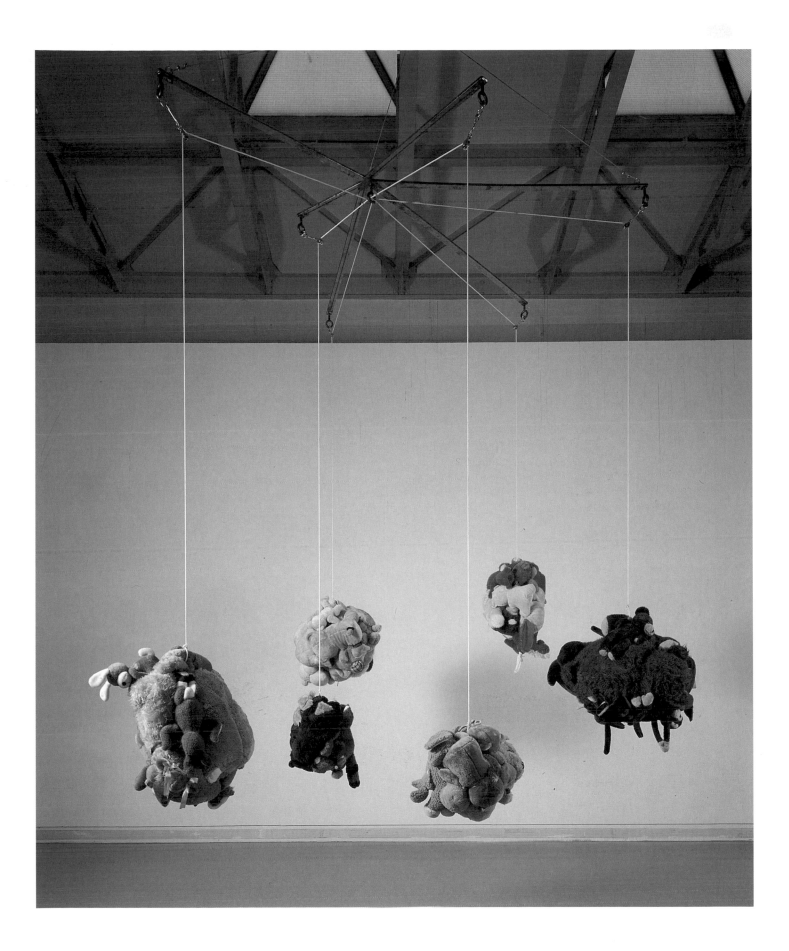

252 Mike Kelley, *Brown Star*, 1991/92
Stuffed animals and steel, 257 x 185 cm (101 x 73 in.)
Dakis Joannou, Athens

Biographies of the Artists

Compiled by David Anfam (D.A.), Anna Brooke (A.B.), Isabelle Dervaux (I.D.),
Lorraine Karafel (L.K.), Gail Stavitsky (G.S.) and Jeffrey Weiss (J.W.)

Carl Andre

was born on 16 September 1935 in Quincy, Massachussetts. From 1951 to 1953 he attended the Phillips Academy in Andover. On a 1954 European trip he visited Stonehenge and other neolithic sites, finding in them a sense of order that was later to influence his sculpture. In the late 1950s Andre shared a New York flat with the poet and film-maker Hollis Frampton, who introduced him to Frank Stella. It was in Stella's studio that Andre created his first large sculptures. Made of carved timbers, they gave expression to an interest in Constantin Brancusi, both in the direct carving of the wood and through the relationship of the sculpture to the floor. Furthermore, they related to Stella's 'Black Paintings' in their systematic accumulation of identical units. Unable to make a living as an artist, Andre worked from 1960 to 1964 as a train driver and guard on the Pennsylvania Railroad, a seminal experience that was to inform his conception of sculpture, which stressed horizontality and modular composition. During those years Andre made few sculptures, mostly of scavenged material, and these were later destroyed. In 1964 he participated in a group exhibition with other sculptors who shared a reductive aesthetic, soon to be called 'Minimalist'. His first one-man show was held at the Tibor de Nagy Gallery, New York, in 1965.

Andre has described his contribution to sculpture in terms of the transformation from 'form' and 'structure' to 'place'. Conceived as repetitive modules in varied configurations, his sculptures are often created for a specific setting and tend to control how the viewer uses and perceives the space. Although some of the early works were vertical, Andre came to favour horizontality in order to avoid anthropomorphic associations and in order to give equal value, in terms of gravity, to each component. Andre's first metal pieces were made in 1967 from plates of aluminium, copper and other metals arranged flat on the floor and meant to be walked on. Hence, the artwork was wedded to the environment. It could be seen from any point of view and included a temporal experience. Using raw material from the building industry – Styrofoam beams, timbers, bricks and metal – Andre investigated the inherent properties of materials so as to derive his compositions from the volume and weight of their components. Each was made of free separate units, generally small enough to be handled by one person.

Andre became known in Europe as early as 1968 through his inclusion in 'Minimal Art' at the Gemeentemuseum, The Hague, and in 'documenta IV' in Kassel. Work by him was also shown in the epoch-making exhibition 'When Attitudes Become Form' (Berne, 1969). In 1984 he reveived a grant in connection with the Berlin Artists Programme of the Deutscher Akademischer Austauschdienst.

Owing to the ordinariness of the materials employed in his work, the limited intervention of the artist and the high prices that his sculptures soon commanded, Andre has found himself at the centre of several public controversies concerning aesthetic values and the role of institutions in their legitimation. Yet the revolutionary impact of his work is undeniable, not least since he has rethought the logic of sculptural practice. Andre lives in New York.

I.D.

David Bourdon, *Carl Andre: Sculpture 1959–1977*, New York 1978.
Carl Andre and Hollis Frampton, *12 Dialogues: 1962–1963*, Halifax, Nova Scotia, 1980.
Carl Andre, The Hague, Haags Gemeentemuseum, and Eindhoven, Stedelijk Van Abbemuseum, 1987.

Richard Artschwager

was born on 26 December 1923 in Washington to an immigrant family. His Prussian-born father, Ernst, was a botanist educated at Cornell University, Ithaca, and his Ukrainian mother, Eugenia Brodsky, had trained as an artist in New York and Washington. In 1935 his father's tuberculosis necessitated the family's move to New Mexico. There Artschwager attended the New Mexico Military Institute in Las Cruces and, on trips with his mother to the desert mesas, showed an interest in drawing. In 1941, however, he enrolled at Cornell University with the intention of becoming a scientist. He served in the US Army from 1944 to 1947 in England, France and Austria – where he met his future wife – before receiving his BA in chemistry and mathematics from Cornell in 1948.

In 1949 Artschwager moved with his wife to New York and entered the studio school of Amédée Ozenfant, the painter and theorist who, together with the architect Le Corbusier, had developed Purism, an abstract, machine-orientated style, about 1919. Although gestural painting was coming to the fore in New York at this time, Artschwager preferred the stark, geometrical forms espoused by Ozenfant, which were to influence his work strongly.

In 1953 Artschwager began to support himself by manufacturing finely crafted furniture; examples were included in an exhibition at New York's Museum of Contemporary Crafts. A fire destroyed his workshop in 1958, and Artschwager retreated to New Mexico, where he reactivated his interest in painting. A commission in 1960 from the Catholic church to make altars for ships led him to discover the possibilities of producing functional objects that, unlike the furniture he had been creating, transcended pure utilitarianism.

At this time, the use of everyday and found objects – a feature of recent exhibitions of work by Jasper Johns, Robert Rauschenberg and Mark di Suvero – prompted Artschwager to produce the first of his 'pseudo-paintings', which were constructed of wood and Formica, a material he characterized as 'the great ugly material, the horror of the age'.

Artschwager introduced other commercial materials into his work, including the paper composite Celotex, which he first used in 1962, and played with the visual perception of mundane objects. His Formica-covered cube in imitation of a covered table, *Table with Pink Tablecloth* (1964), was included in the artist's first one-man show at the Leo Castelli gallery (1965). Artschwager continued to construct seemingly ordinary objects that made use of his skills as a craftsman yet which, as the critic Barbara Rose wrote in 1965, 'raise questions about the utility of art and its ambiguous role in our culture'. In 1965 Artschwager discovered architectural imagery, borrowed from sources such as the property section of the *New York Post*, as a means of providing a context for his constructed environments.

Combining sculpture and painting, Artschwager has continued to experiment with space, and with how it is perceived, by creating entire modern habitats. Indeed, he has created an outdoor 'living room' for a park project at New York's Battery Park City (1985). In 1975 Artschwager described his goal as 'to force the issue of context … to make art that has no boundaries'. The artist lives in Rhinebeck, New York, and also has a studio in Brooklyn.

L. K.

Primary Structures, New York, The Jewish Museum, 1966.
Richard Artschwager, Basle, Kunsthalle, 1985.
Richard Armstrong, *Artschwager, Richard*, New York, Whitney Museum of American Art, 1988.

Jean-Michel Basquiat

was born on 22 December 1960 in Brooklyn, New York, to a Haitian accountant and a Puerto Rican mother, who separated when he was seven. Hoping to become a writer and a cartoonist, he drew and occasionally visited museums with his mother. He left home at fifteen for eight months, and two years later, during one of his several absences from school, began collaborating with Al Diaz. They painted graffiti slogans and symbols with a Magic Marker on walls in lower Manhattan, using the signature 'SAMO ©', which referred to 'same old shit', rather like a corporate logo.

Inspired by John Cage, Basquiat played the guitar (with a file) and the synthesizer in a band called Gray, worked at odd jobs, sold 'junk' jewellery, crashed parties, painted on clothing, and frequented the punk hang-out, the Mudd Club, and the new wave Club 57. The collaboration with Diaz ended when the latter became a musician, and Basquiat began working alone with found materials. In 1979 graffiti appeared in the Bowery and in SoHo stating 'SAMO © is dead'.

Basquiat – a self-taught artist – painted on paper, doors, a refrigerator and scrap metal, and made assemblages out of junk. In the summer of 1980 his spray-paint and brushwork wall in the 'Times Square Show' was described by a critic as combining Willem de Kooning's Abstract Expressionism with Subway spray art. In 1981 his work was seen in a group exhibition, 'New York/New Wave', at the P.S.1 gallery in Long Island City; he travelled to Europe for his first one-man show, in Modena, and received an initial US solo exhibition at the Annina Nosei Gallery in New York (where he was given a studio in the basement store-room). Further recognition came with his inclusion in 'documenta VII' at Kassel (1983) and the Whitney Biennial (1983). The critic John Russell noted in a 1984 review how 'Basquiat proceeds by disjunction – that is by making marks that seem quite unrelated, but that turn out to get on very well together'. The artist himself observed: 'I get my facts from books, stuff on atomisers, the blues, ethyl alcohol, geese in Egyptian style…. I put what I like from them in my paintings.' Other influences were Picasso, African masks, children's art, 'hip-hop' and jazz. The results have been

compared to 'visual syncopation. Eye Rap.' Flat, primitive and childlike, his angry images stress schematic anatomy and contain heads, grimacing skulls, words, arrows, crowns, rockets and skyscrapers. Related to the work of the Neo-Expressionists, his prolific verbal and visual fragments are painted in a mixture of black and bold, saturated colours. Some employ mixed media. Despite a casual, graffiti-like appearance, the surface is often heavily reworked and semantically complex. Unlike the other popular New York graffiti artists of the early 1980s, such as Keith Haring and Kenny Scharf, Basquiat rapidly established an international reputation with his exhibitions in Europe, and his later work fetched high prices at auction. After meeting Andy Warhol, Basquiat painted his portrait and the two artists collaborated on a series of works. Basquiat's brief, meteoric rise to fame ended on 12 August 1988, when he died of a drug overdose in New York at the age of twenty-seven. A. B.

Jean-Michel Basquiat: Paintings 1981–1984, Edinburgh, Fruitmarket Gallery, 1984.
Jean-Michel Basquiat: Drawings, ed. John Cheim, New York, Robert Miller, 1990.
Jean-Michel Basquiat, New York, Whitney Museum of American Art, 1992.

Jonathan Borofsky

was born in Boston, Massachusetts, on 24 December 1942. The son of a music teacher and an artist, he was encouraged to study art from the age of eight in addition to pursuing his interest in singing and sport. A Fine Arts degree from the Carnegie-Mellon University in Pittsburgh (1964) was followed by an MFA from the Yale University School of Art and Architecture (1966). While still a student, he was included in a group exhibition, his first, at the Museum of Art, Carnegie Institute, Pittsburgh (1963). During the summer of 1964, Borofsky attended the Ecole des Beaux-Arts in Fontainebleau. There he moved from abstract, welded-metal sculpture to plastered forms. In

1966 he took up residence in a lower Manhattan loft and subsequently held a teaching post at the School of Visual Arts, New York (1969–77). His first one-man show came in 1973 at Artists Space in New York, and was followed by a gallery exhibition of the contents of his studio at Paula Cooper (1975).

In the early 1970s Borofsky became obsessed with counting, having begun in 1969 with '1'. 'When I started I thought it would teach me all I wanted to know about myself … - counting is an exercise in self-control.' In 1972 he made a painting based on a matchstick figure drawing to which he gave a number, combining the conceptual and representational, and he has since continued the process of numbering his paintings, drawings and sculpture. He started taking his dreams as a source of inspiration in 1973, and two years later began to create room-size installations, sharing the contents of his mind with the viewer. 'All Is One', a Persian phrase, first appeared in his work in 1976; it expressed his view of universality in the individual life. After ten years in New York, Borofsky went to teach at the California Institute of the Arts, Valencia (1977–80). In the 1979 Whitney Biennial he included one of the series 'I Dreamed …'. He participated in 'documenta VII' in 1982. The Philadelphia Museum of Art organized a major retrospective that travelled in the US from 1984 to 1986.

Borofsky's work owes a debt to the all-over painting technique of Jackson Pollock, the Minimalist sculpture of Carl Andre, the wall drawings of Sol LeWitt and the cerebral anti-commercialism of the Conceptualists. Associated with Neo-Expressionism, Borofsky produces multi-media carnival environments using sound, light, video and projections. Created in two and three dimensions in a style both naive and cartoon-like, his familiar serial images include the perforated 'Molecule Man', 'Running Man', 'Man with a Briefcase', 'Flying Figure', 'Hammering Man', a large ruby and a head with rabbit ears. Apart from dreams, his sources include photographs, advertisements and television. In order to reach a wider audience, Borofsky repeats his autobiographical themes in silk-screens and lithographs. An 'idea artist', he has said that 'It's all about the politics of the inner self, how your mind works, as well as the politics of the exterior world'. He lives in Venice, California, the site of one of his most famous public works, the 34-foot-high kinetic *Ballerina Clown* (1989).

A. B.

Jonathan Borofsky: Dreams 1973–81, London, Institute of Contemporary Arts, and Basle, Kunsthalle, 1981.
Jonathan Borofsky, ed. Mark Rosenthal and Richard Marshall, Philadelphia Museum of Art, 1984.
Jonathan Borofsky: Subjects, Hanover, NH, Dartmouth College, 1992.

James Lee Byars

was born in Detroit, Michigan, on 10 April 1932. He attended the Merrill Palmer School for Human Development and Wayne State University in Detroit, studying art and philosophy. By the artist's own account, the chief influences on his work have been Gertrude Stein, Albert Einstein and Ludwig Wittgenstein. For an early exhibition (1956) he displayed stone spheres in a snowy field at midnight under a full moon while members of the audience were pushed in circles in sleighs. While living in the Detroit house of a Greek patron, Mr Softi, he designed a 'tactile garden' in 1957. Neighbours then funded a trip to Japan for one year in 1958. Based in Kyoto, Byars worked as an English teacher and travelled throughout the country, studying its traditional culture, ceramics, paper-making, Noh theatre and Buddhist philosophy until 1967. In 1960 he won the William Copley Prize and the following year received his first one-man show, at the Marion Willard Gallery in New York. *A Mile Long Paper Walk* was performed by the dancer Lucinda Childs, dressed in ostrich feathers, and was included in the 1964 Pittsburgh International exhibition. A recipient of the J. Clawson Mills Grant from the Architectural League of New York, he realized *Dress for 500*, a collective performance by five hundred art students poking their heads through holes in a single piece of cloth. The Hudson Institute appointed him Artist-in-Residence in 1969. He gained international recognition at 'documenta V' in Kassel (1972) with a performance in which he stood, dressed in a white suit and hat, in the pediment on the facade of the Friedericianum. He was included in the next three 'documenta' exhibitions, as well as in the 1980 Venice Biennale.

Associated with Joseph Beuys, of whom he has said, 'I think he is a great thinker in all the things he does, whether they're musical or poetic or philosophical or political or … stones', Byars was considered, until 1980, to be a performance artist, making the individual into the content of sculpture: starting in 1975, he investigated performance as a dimension of sculpture. The 'Perfect' works, based on perfect geometrical form – for example, *Pedestal for Perfect* (1978) – and his one-word 'plays' – tiny formal pieces – evinced a simplicity and rigorous elimination of detail

characteristic of Shinto ritual and Noh theatre. Since 1980 Byars has made 'Stone Books' – stone spheres which raise questions of meaning and language. *The Path of Luck* (1989) is a series of five unique, blue African granite objects on white pedestals. *IS* (1992) includes two gold-leafed perfect spheres and the letters 'IS' in gold, presented in two black velvet and black-painted spaces. According to one critic, 'Byars has made the circle, the sphere, gold, black and the idea of perfection his own'.

Byars's materials range from bronze, granite, marble, basalt and glass (sometimes gilded) to found objects such as velvet sofas. His oeuvre is conceptual, analysing the relations between sculpture and philosophy, and the concept of sculpture itself. His installations, performances and 'actions' inhabit a realm of metaphysical questioning and remain outside traditional artistic categories. He lives in Venice, New York and Florida.

A. B.

James Lee Byars, Paris, Musée d'Art Moderne de la Ville de Paris, 1983.
James Lee Byars: The Philosophical Palace/Palast der Philosophic, ed. Jürgen Harten, Düsseldorf, Städtische Kunsthalle, 1986.
James Elliott, *The Perfect Thought: Works by James Lee Byars*, Berkeley, University Art Museum, 1990.

Alexander Calder

was born in Lawnton, Pennsylvania, on 22 July (or August) 1898, the son of the Beaux-Arts sculptor Alexander Stirling Calder and the painter Nanette Lederer. Having decided to become an engineer, Calder attended Stevens Institute of Technology in Hoboken, New Jersey (1915–19). After graduation, he studied

at the Art Students League in New York until 1926, primarily under John Sloan. While a free-lance commercial artist, Calder sketched animals at the zoo and at the Barnum & Bailey Circus, leading to an enduring fascination with this subject-matter. His deft, single-line drawings anticipated the wire sculptures that he began creating in 1952. The following year, Calder moved to Paris, where he made movable wood and wire animals as well as figures for a miniature circus. This ingenious, hand-animated ensemble soon became a favourite attraction among the Parisian avant-garde. His first Paris one-man show, at the Galerie Billiet in 1929, featured whimsical wood and wire sculptures. Their formal economy adumbrated his experiments with abstract, kinetic wire sculpture, which were inspired by a visit to Piet Mondrian's studio in 1930, where he suggested that the coloured rectangles on the wall could be made to oscillate. Subsequently, his interest in non-objective art was fostered by friendship with Joan Miró and by his involvement with the *Abstraction-Création* group, which he joined in 1931. His first motorized and hand-cranked moving sculptures were exhibited in 1932; at Marcel Duchamp's suggestion, they were called 'mobiles'. Jean Arp proposed the name 'stabile' for Calder's complementary, static constructions. Shortly after his 1932 show, Calder created wind-driven mobiles, which, by the middle of the decade, had come to dominate his output: he preferred the random movements of the mobiles, which were related to his fascination with physics, scientific models, cosmic imagery and contemporary astronomical discoveries.

After the American showing of his mobiles, at the Julien Levy Gallery, New York, in 1932, Calder settled in New York and Roxbury,

Connecticut. He was the only American sculptor to be included in the landmark exhibition 'Cubism and Abstract Art' at The Museum of Modern Art, which also gave him a major retrospective in 1943. During the mid-1930s, when Calder was receiving stage set commissions from Martha Graham and various theatre companies, Miróesque biomorphic forms, inventive and poetic, replaced geometrical shapes as the dominant elements of his increasingly refined idiom. A synthesis of Abstract Surrealism and Constructivism was the basis of Calder's mature sculptural style.

The next major development in Calder's multi-faceted career came in the 1960s and 1970s, when he produced monumental stabiles. These mostly black and red, architectural-scale steel constructions – which helped to revitalize sculpture as a public spectacle – included *Man*, made for Expo '67 in Montreal, and *Flamingo*, in Chicago's Federal Center Plaza (1974). Retrospectives were organized by the Solomon R. Guggenheim Museum, New York (1964), Chicago's Museum of Contemporary Art (1974) and the Whitney Museum of American Art, New York, in 1976. The first American of his generation to acquire an international reputation, Calder died on 11 November 1976 in New York. G.S.

James Johnson Sweeney, *Alexander Calder*, New York, Museum of Modern Art, 1951.
Jean Lipman, *Calder's Universe*, New York, Whitney Museum of American Art, 1980.
Joan M. Marter, *Alexander Calder*, New York, 1991.

John Chamberlain

was born on 16 April 1927 in Rochester, Indiana, and spent his youth in Chicago, where he lived with his grandmother from 1931 until 1943, when he joined the US Navy. After service in the Pacific and the Mediterranean, Chamberlain moved to Detroit in 1948. Returning to Chicago in 1950, he initially studied hairdressing. At the School of The Art Institute of Chicago (1951–52) his interest in sculpture grew and in 1953 he turned from carving and modelling to welding. After a brief career as a hairdresser and make-up artist, Chamberlain went to North Carolina in 1954, studying and teaching at Black Mountain College during 1955–56; he was stimulated by the college's poetry classes and by its Bauhaus-inspired sensitivity to materials. He found a New York studio in 1956.

Influenced by Abstract Expressionism, particularly Franz Kline's work and its apparent speed and power, he began using

scrap metal and crushed motor car parts in 1957. With regard to his process of compressing these materials, Chamberlain has said that 'Common material is what an artist should use because it doesn't get in the way of doing an uncommon thing'. His work was included in 'The Art of Assemblage' (1961) at The Museum of Modern Art, New York. From 1963 to 1965 he lived in Embudo, New Mexico, then alternated between New York, Santa Fe, Los Angeles and Amarillo, Texas, until 1974, when he returned to New York. Between 1974 and 1980 he kept a studio in Vestry Street in Manhattan; in 1980 he moved to Sarasota, Florida, where he has lived ever since. During 1977 Chamberlain converted a barn in Essex, Connecticut, into a residence with an outdoor studio, married Lorraine Belcher and began making photographs with a wide-lux camera. He has exhibited extensively in America and Europe since his first one-man show, at Chicago's Wells Street Gallery in 1957. Awards he has received include a John Simon Guggenheim Memorial Foundation Fellowship (1966) and a Creative Arts Award from Brandeis University in Waltham, Massachusetts (1984). Chamberlain now lives in Sarasota, Florida.

During the 1960s Chamberlain experimented with materials and processes, including metal-flake painting, a series of about fifty images in car paint on Formica, 'soft sculptures' of urethane foam, galvanized metal, aluminium foil, brown paper bags and Plexiglass, until he finally returned to his almost baroque, brightly coloured steel car body parts in 1974. The artist has continued to explore a wide variety of media and genres: collage, prints (including monotype) and photography, vertical monuments, wall reliefs, furniture and even, from 1967 to 1971, film. The reflecting surfaces of his metal sculptures were coloured and decorated with spray-paint graffiti and sand-blasted patterns. They evoke dynamic brushwork solidified into a forceful three-

dimensionality. As one critic has observed: 'Chamberlain uses colour to dress the wounds of his violence so that they seem festive, but the primitive force with which they were made remains evident.' Yet the artist's own interpretation of the early 1960s sculptures is equally illuminating: 'they're self-portraits. The portraiture had more to do with the balance and rhythms and spaces and areas and attitudes.' A. B.

Diane Waldman, *John Chamberlain: A Retrospective Exhibition*, New York, Solomon R. Guggenheim Museum, 1971.
Julie Sylvester and Klaus Kertess, *John Chamberlain: A Catalogue Raisonné of the Sculpture 1954–1985*, New York, 1986.
Jochen Poetter, *John Chamberlain*, Stuttgart, 1991.

Joseph Cornell

was born in Nyack, New York, on 24 December 1903, of Dutch ancestry. Son of a textile designer and buyer, he was educated at Phillips Academy in Andover, Massachusetts (1917–21), but received no formal art instruction. After his father's death in 1917, the family moved to Douglaston, Long Island. Following work as a salesman of woollen goods for the Whitman Textile Company (1921–30), Cornell was unemployed for several years during the Depression. He eventually gained a position as a textile designer at the Traphagen Studio (1934–40) and managed to support himself as an artist during the next decade with free-lance magazine work.

Inspired by Max Ernst's collage-novel *La Femme 100 têtes* and by the Surrealist art shown at the Julien Levy Gallery in 1931, Cornell made collages, assemblages and boxes; the boxes were first exhibited at that gallery in 1932. During the 1930s he wrote and made films, attended the opera and became familiar with French poetry. A shy, reclusive man, he was nevertheless well known for his ironic wit and humour. Cornell's reputation rests on his exquisite, small-scale (usually around fifteen by twelve inches) handmade wooden boxes. Associated with the New York Surrealists from 1939 to 1945, his idiom draws upon the Surrealist technique of irrational juxtaposition, although its tone remains highly personal and reflects a mind seemingly obsessed with memory. René Magritte and the nineteenth-century Romantic poets were among those whom Cornell admired, and his tableaux also deal with nostalgia and dream-like moods. They elude classification, however, and combine sculpture, collage and painting in ways that often result in a palimpsest of

visual/verbal play. Cornell was concerned with the romance and mystery of life, to which he gave symbolic expression in found objects, such as seashells, balls, butterflies, feathers, compasses, bottles, maps, stars, photographs and driftwood. Exploring a fantasy world, his glassed boxes were miniature theatres, stages for images of historical figures (for example, *The Medici Slot Machine* of 1942), opera singers, ballerinas and film stars. From commonplace fragments he extracted an uncommon eloquence. That he was largely responsible for the introduction of the box into twentieth-century art led Cornell to be considered as a forerunner of Assemblage, while his use of everyday imagery may be seen as one of many distant adumbrations of Pop Art. In a 1948 statement he said: 'Shadow boxes become poetic theatres or settings wherein are metamorphosed the elements of a childhood pastime.' In the early 1950s more abstract compartmentalized arrangements appeared: wooden grids with moving balls or white cubes. Simultaneously, he continued the habit of treating themes in sets of variations and, typically, named one series after French provincial hotels. From 1929 until his death on 29 December 1972 he lived in Flushing in the New York borough of Queens.

Awards received by Cornell included a Copley Foundation Grant (1954), the Ada S. Garsh Prize of the Art Institute of Chicago (1959), the Award of Merit of the American Academy and Institute of Arts and Letters, and the Creative Arts Award from Brandeis University, Waltham, Massachusetts (1968). His work was included by The Museum of Modern Art in its exhibitions 'Fantastic Art, Dada, Surrealism' (1936), 'Art of Assemblage' (1961) and 'Dada, Surrealism and their Heritage' (1968). A. B.

Diane Waldman, *Joseph Cornell*, New York, Solomon R. Guggenheim Museum, 1967.
Dore Ashton, *A Joseph Cornell Album*, New York, 1974.
Joseph Cornell, ed. Kynaston McShine, New York, Museum of Modern Art, 1980; repr. Munich, 1990.

John Covert

was born in Pittsburgh on 6 March 1882. His mother (who suffered from a mental disorder) was apparently committed to an asylum around the time of his birth, and Covert was brought up by his father, a pharmacist, in a room behind the family chemist's shop. Between 1901 and 1907 Covert studied art in Pittsburgh with the realist painter Martin Leiser, and received broad exposure to American and European painting at the annual exhibitions of the Carnegie Institute. Covert was in Munich from 1909 to 1912, and took classes under Carl Marr at the Akademie der Bildenden Künste. Little is known of his activities in Paris, where he was an art student from 1912 to 1914. He exhibited one work at the Société des Artistes Français in 1914, and had no significant contact with advanced art of the pre-war period.

Covert returned home in 1915, when he participated in the Sixth Annual Exhibition of the Associated Artists of Pittsburgh, before moving to Manhattan that summer. There he entered the modernist circle of his cousin, Walter C. Arensberg. At Arensberg's apartment in West 67th Street he became acquainted with Francis Picabia, Marcel Duchamp, Albert Gleizes, Jean Crotti and Man Ray, among other practitioners of Cubism and Dada, and contact with this community induced his sudden conversion to a modernist idiom. By 1919, in works such as *Vocalization*, *Time* and *Brass Band*, Covert had achieved an amateur's command of Picabia's mecanomorphism, joining elements of Geometric Abstraction and delicate experiments in assemblage and collage to a philosophical preoccupation with pseudo-scientific theories of time and space. Verbal and numerical inscriptions – which both invite and obfuscate interpretation – reflect a fascination with cryptography that he shared with Arensberg and Duchamp. In what amounts to a separate pictorial oeuvre, Covert also created Symbolist nudes and strange Precisionist representations of doll-like mannequins.

Covert was a founding member of the Society of Independent Artists in New York, and he submitted two pictures, including the quasi-abstract *The Temptation of St. Anthony*, to its first exhibition in 1917. The artist had his first one-man show in New York, at the De

Zayas Gallery in April 1920, and he partici-
pated regularly in exhibitions of the *Société
Anonyme*. He established the permanent collec-
tion of the *Société* by generously donating a
number of his own works.

Discouraged by the gradual dissolution of
the New York avant-garde, Covert abandoned
art and returned to Pittsburgh in 1923. There
he spent the rest of his life working for the
Vesuvius Crucible Co., a steel products firm
owned by Frank Arensberg, another cousin.
He died on Christmas Eve, 1960. J. W.

Michael Klein, 'John Covert and the Arensberg Circle:
 Symbolism, Cubism and Protosurrealism', *Arts Maga-
 zine*, vol. 51, May 1977, pp. 113–15.
John Covert 1882–1960, Washington, Hirshhorn
 Museum and Sculpture Garden, 1979.
Robert Herbert et al., *The Société Anonyme and the Dreier
 Bequest at Yale University: A Catalogue Raisonné*, New
 Haven, 1984.

Stuart Davis

was born in Philadelphia on 7 December 1892.
He was the eldest son of Helen Stuart Davis, a
sculptor, and Edward Wyatt Davis, art editor
of the *Philadelphia Press*, for which John Sloan,
William Glackens, George Luks and Everett
Shinn drew illustrations. Davis grew up with
these Ashcan School realists and from 1909 to
1912 studied under the movement's leader,
Robert Henri, at his New York-based School
of Art. From 1912 to 1916 Davis also contrib-
uted covers and drawings to the left-wing mag-
azine *The Masses*.

Davis was deeply impressed by the many
works by European avant-garde artists on view
at the 1913 Armory Show, in which he himself
participated. Subsequently, he embarked upon
an intensive investigation of modernism. His
canvases of 1915 to 1919 experimented with
colour and abstraction, inspired by Van Gogh,
Gauguin, Matisse, Picasso and Braque. Influ-
enced by Fernand Léger, during the 1920s
Davis mapped out the stylistic and thematic
territory that he was to explore for the rest of
his life. Developing an increasingly sophisti-
cated Cubist syntax, he reconciled abstraction
and the contemporary mechanized American
environment in carefully arranged images
based on vernacular subjects, including tobacco
and cigarette labels, commercial brand-name
products, street and electric signs, petrol
pumps and everyday, mass-produced objects,
such as an eggbeater. During 1928–29 Davis
lived and painted in Paris, producing his first
Cubist cityscapes.

In the 1930s Davis did four major murals as
part of the Federal Art Project and was an

active member of various politically orientated
art organizations, including the American
Artists Congress. Although a staunch advocate
of socially responsible modernism, Davis
returned in the 1940s to private, formalist
investigations, combining colour and drawing
to create an autonomous 'colour space'. He
created non-hierarchic, all-over compositions
of densely packed abstract shapes that reflected
his interest in jazz and in gestalt theory.
Although the post-Cubist approach evident in
these works has parallels in Abstract Expres-
sionism, the increasingly withdrawn Davis
rejected that dominant movement's emphasis
on subjectivity, which he thought violated
concern for objective order. A relatively spare,
broadly planar Cubist style and larger formats
characterized his final period, during which he
often reworked earlier compositions, now
informed in part by the high-keyed colour of
Matisse's cut-outs and the absolute structure of
Mondrian's paintings. The Museum of Modern
Art, New York, gave Davis a one-man show in
1945, and his international reputation grew
with a solo exhibition at the 1952 Venice
Biennale.

Shortly before his death in New York on
24 June 1964, Davis was hailed as a pioneer of
Pop Art. This view, which allegedly irritated
the artist, is now seen as an over-simplification
of a complex career spanning six decades – a
major achievement in the context of twentieth-
century American art. G. S.

John R. Lane, *Stuart Davis: Art and Theory*, New York,
 Brooklyn Museum, 1978.
Karen Wilkin, *Stuart Davis*, New York, 1987.
Lowery Stokes Sims et al., *Stuart Davis: American
 Painter*, New York, Metropolitan Museum of Art,
 1991.

Willem de Kooning

was born on 24 April 1904 in Rotterdam. His
father was a prosperous distributor of wine,
beer and soft drinks; his formidable mother
owned a bar. In 1909 de Kooning's parents
were divorced and his mother eventually won
custody of their son who, in 1916, was appren-
ticed to a commercial art and decorating busi-
ness. The owner of the firm urged de Kooning
to enroll at the Rotterdam Academy of Fine
Arts and Techniques, where he studied for
eight years. The legacy of this rigorous
academic training can be discerned in a life-
long painstaking attitude to drawing, and to
pictorial technique in general. After a stay in
Belgium, the artist embarked illegally on the
S. S. Shelley and arrived at Newport News,
Virginia, on 15 August 1926.

By 1927 de Kooning had made his way to
Manhattan. During the late 1920s and the
1930s his widening coterie of friends included
the painters John Graham, Stuart Davis and
Arshile Gorky (with whom he shared a studio),
the poet and dance critic Edwin Denby and the
critic-poet Harold Rosenberg. In 1935 he
worked on a mural in Brooklyn for the Federal
Art Project (designing further murals for the
1939 New York World's Fair and for the US
Maritime Commission in 1940), then in 1938,
began his first series of depictions of women.
That year, de Kooning met Elaine Fried, an art
student, whom he was to marry in 1943.
Dominated by figure studies and more abstract
organizations, the work of this early phase
resembles Gorky's: an amalgam of neo-classical
trends with biomorphism and geometrical
elements traceable to Miró, Picasso and other
European prototypes. It suggested an unwill-
ingness to reconcile divergent options –
whether representation and abstraction, or
tradition and innovation. As the 1940s wore
on, however, these images became increasingly

fragmented, the splinters of form seeming to whirl about in kaleidoscopic turmoil, as in *Fire Island* (1946). Nevertheless, their iconography stemmed from a recurrent underlying preoccupation with themes of eros and thanatos. The culmination were the black and white abstractions in oil and enamel paint, some of which were shown in 1948 at de Kooning's first solo exhibition, at the Egan Gallery, an event that helped to build his reputation.

As colour returned to de Kooning's art, so did the integral figure. The resurgent representationalism in the new series of 'Paintings on the Theme of the Woman' shown at the Sidney Janis gallery in 1953 caused a furore, but ultimately ensured the artist's fame as the 'gesturalist' painter *par excellence* of his generation. Altogether more abstract cityscapes also date from the 1950s – for example, *Gotham News* (1955). These gradually metamorphosed into the huge, lyrical sweeps of the brush that galvanize *Door to the River* (1960). Having taken US citizenship in 1961, de Kooning moved two years later to the coastal village of East Hampton, Long Island, where he still lives. International recognition and critical acclaim were by then well underway; they were to bring him the Presidential Medal of Freedom award (1964), election to the National Institute of Arts and Letters (1975) and the title Officer of the Order of Orange and Nassau (1979).

The last three decades have witnessed de Kooning's adding at least twenty-five sculptures (1964–74) to his ongoing, prolific activities as a draughtsman and painter. In his paintings he has tended to further weld evocations of the figure, landscape and light in an apotheosis of extreme, almost overwhelmingly voluptuous painterliness. D. A.

Thomas Hess, *Willem de Kooning*, New York, Museum of Modern Art, 1968.
Harold Rosenberg, *Willem de Kooning*, New York, 1974.
Willem de Kooning: Drawings, Paintings, Sculpture, New York, Whitney Museum of American Art, 1983.

Charles Demuth

was born on 8 November 1883 in Lancaster, Pennsylvania. His family's successful tobacco shop and snuff factory ensured his lifelong financial independence. A sickly child (a hip condition had left him lame), Demuth displayed precocious artistic talent. He enrolled in Philadelphia's Drexel Institute in 1903 to pursue a career in commercial art. Demuth transferred to the Pennsylvania Academy of Fine Arts in 1905 and remained

there until 1910, studying under Thomas Anshutz and developing an Ashcan Realist style. In 1907–8 he visited Paris and saw advanced European and American art at first hand. However, Demuth did not emerge as an innovative modernist until his second stay in the French capital (1912–14), during which he met the Steins and Marsden Hartley. His 1914 one-man show at the Charles Daniel Gallery in New York included watercolour landscapes which recall both John Marin's work in that medium and the high-keyed colour of Fauvism.

Until 1920 Demuth divided his time between Lancaster and the avant-garde circles of Provincetown and New York, where he became a regular visitor to the home of Walter C. and Louise Arensberg. His bohemian lifestyle was celebrated in simplified, semi-Expressionist watercolours of New York's cafés, dance-halls, jazz clubs and men's public baths. There are strong, if cryptic, reflections here of the artist's homosexuality. Contemporaneous depictions of flowers, as well as vaudeville, circus and literary themes, revealed his Symbolist-inspired gift for manipulating refined hues to create subtle moods and metaphorical allusions.

In 1917, while on holiday in Bermuda with Hartley, Demuth met Albert Gleizes. Hartley and Gleizes inspired him to develop further the experiments with Cubist structure that he had begun the previous year. By 1921, in images of Lancaster's historic buildings, Demuth had developed a distinctive, rigorous vocabulary in which uniform planes of colour were bounded by intersecting diagonal lines suggesting rays of light. Encouraged by his friend William Carlos Williams's call for indi-

genous modern subjects, Demuth also applied his pioneering Precisionist style (which blended Cubist elements with a certain degree of realism) to a series of provocatively titled paintings of Lancaster's industrial landscape. He made his last trip to Europe in 1921, but fell ill and was diagnosed as diabetic. The illness caused Demuth to withdraw to Lancaster in 1922, where his lush watercolours of fruit, flowers and vegetables revealed the unmistakable influence of Cézanne. From 1923 to 1929 he created emblematic portraits in oil of prominent American artists, employing evocative objects to convey their personalities. As he had earlier adapted Picabia's and Duchamp's machine aesthetic to his industrial scenes, Demuth now pursued their Dadaist approach to portraiture, as did Hartley, Marius De Zayas, Arthur Dove and Man Ray. At this time, Demuth joined Alfred Stieglitz's circle of artists, exhibiting regularly at the latter's galleries from 1926 to 1932.

One of America's most notable watercolourists, Demuth continued to paint virtuoso still-lifes in that medium, alongside oil paintings of industrial scenes, until 1934. He was featured in the Whitney Museum's 'Abstract Painting in America' in 1935 and died on 25 October of that year in Lancaster. G. S.

Emily Farnham, *Charles Demuth: Behind a Laughing Mask*, Norman, OK, 1971.
Betsy Fahlman, *Pennsylvania Modern. Charles Demuth of Lancaster*, Philadelphia Museum of Art, 1983.
Barbara Haskell, *Charles Demuth*, New York, Whitney Museum of American Art, 1987.

Arthur Dove

was born in Canandaigua in upstate New York on 2 August 1880. After graduating from Cornell University in 1903, Dove moved to New York City, where he began working as a free-lance commercial illustrator, painting in his spare time. In 1908 he travelled to Paris and there befriended the American Fauve painter Alfred Maurer. Remaining in Europe until 1909, Dove painted in a style that evolved rapidly from Impressionism, via Post-Impressionism, to Fauvism. After his return to the US, he purchased a farm in Westport, Connecticut, planning to support himself through farming and illustration work. In 1910 Dove established a lifelong friendship with Alfred Stieglitz, who included the artist in the important show 'Younger American Painters', along with Maurer and Marsden Hartley, at his 291 gallery. Dove's first one-man exhibition (1912) at 291 was of ten pastels; it constituted the first public display of abstract art by an

American. Known later as the 'Ten Commandments', these epoch-making works were organic abstractions inspired by Symbolism, Art Nouveau and Picasso, as well as by the artist's utopian attachment to nature and the vitalist philosophy of Henri Bergson. Related pastels from his *Nature Symbolized* series were shown in 1916 at the landmark Forum Exhibition of Modern American Painters.

From 1924 to 1930, when Dove was living on a houseboat at various places on Long Island, he created a group of unique assemblages with visually rich and highly evocative found objects which indicate his awareness of Cubist and Dada collage. The abstract paintings of 1927–28 with musical titles reflect the impact of Wassily Kandinsky's theories and paintings of 1910 to 1914. From the late 1920s onwards, Dove was increasingly absorbed with the study of Eastern religions and Theosophy, both of which nurtured his lifelong desire to develop forms that would express his spiritual feelings for the vital rhythms of nature.

In 1926 Dove was included in the *Société Anonyme*'s major exhibition of international modern art at the Brooklyn Museum and sold his first painting to Duncan Phillips. The collector became his principal patron from 1930 onwards, organizing two retrospectives in 1937 and 1938 for the Phillips Memorial Art Gallery. In addition to showing work regularly at Stieglitz's Intimate Gallery and An American Place, Dove was represented in such major group shows as The Museum of Modern Art's 'Painting and Sculpture by Living Americans' (1930) and the Whitney Museum's 'Abstract Painting and Sculpture' (1935).

The 1930s was a highly productive period for Dove, who was finally able to abandon his career as an illustrator. He developed further his spatially complex arrangements of biomorphic forms rendered in sensuous hues. The breadth and variety of his brushwork, incorporating accidental drips and areas of staining, suggests an awareness of Surrealism. After 1935 he abandoned nature-based abstraction for purely non-objective painting, at times based on angular, semi-geometrical motifs. After several illnesses and a heart attack, Dove died on 22 November 1946 in Huntington, Long Island. G. S.

Barbara Haskell, *Arthur Dove*, San Francisco Museum of Art, 1974.
Ann Lee Morgan, *Arthur Dove: Life and Work with a Catalogue Raisonné*, Newark, NJ, 1984.
Sherrye Cohn, *Arthur Dove: Nature as Symbol*, Ann Arbor, 1985.

Marcel Duchamp

was born near Blainville in Normandy on 28 July 1887. The son of a notary, he was one of six children, four of whom became artists. After training as a librarian, in 1903 he joined his older brothers in Paris, studying briefly at the Académie Julian. Following a year of military service in 1905, he worked as an illustrator for the *Courrier Française* and *Le Rire*. His early work, influenced by Cézanne, was first exhibited in 1909, at the Salon des Indépendants. *Portrait of Chess Players* (1911) shows the influence of Cubism, while *Sad Young Man on a Train* (1911) provides the first evidence of Duchamp's preoccupation with mecanomorphism and the representation of motion. A founding member of the *Section d'Or* in 1912, he showed *Nude Descending a Staircase, No. 2* at that organization's first exhibition. The painting, a synthesis of Cubism and Futurism, caused a sensation at the Armory Show in New York the following year. By the end of 1913 Duchamp had abandoned conventional media in favour of 'ready-mades', everyday objects presented as art, and objects in the form of non-functioning machines. His first ready-

Photo © Arnold Newman

mades were *Bicycle Wheel* (1913) and *Bottle Rack* (1914). In 1914 he met and became close friends with Francis Picabia, sharing that artist's iconoclastic wit and humorous sense of the absurd; they later became leaders of the New York Dada movement.

In 1915 Duchamp accepted an invitation to visit America: he was received in New York by the photographer Alfred Stieglitz, together with the patrons and collectors Walter and Louise Arensberg. Between 1915 and 1923 he worked on his masterpiece, *The Bride Stripped Bare by Her Bachelors, Even* (generally known as *The Large Glass*), a construction of glass, lead wire and lead foil. He also pursued literary interests, editing two magazines in 1917, *The Blind Man* and *Rrongwrong*. Continuing his attack on traditional art, Duchamp submitted *Fountain*, a porcelain urinal, to the 1917 exhibition of the Society of Independent Artists, of which he was a founding member. Two years later, during a brief stay in Paris, he contributed *L. H. O. O. Q*, a reproduction of the *Mona Lisa* to which he had added a beard and a moustache, to a Dada demonstration. Back in New York in 1920, he founded the *Société Anonyme* with the collector Katherine Dreier. In 1924 he abandoned art and returned to Paris, pursuing his abiding interest in chess and undertaking experiments in mechanics and optics. He collaborated with Man Ray on the film *Anemic Cinema* (1926). In 1941 Duchamp produced *Box in a Valise*, a multiple edition of sixty-four miniature replicas of his own work.

Returning to the United States in 1942, he remained in New York for the rest of his life. He became a US citizen in 1954, but paid annual visits to France. During one of these he died, in Neuilly on 2 October 1968. Large retrospective exhibitions were organized at the Museum of Modern Art, New York (1973), and at the Centre Pompidou in Paris (1977). Duchamp himself noted the irony of his influence on modern art: 'When I discovered ready-mades I thought to discourage aesthetics. In neo-Dada they have taken my ready-mades and found aesthetic beauty in them.' His effect on American artists was limited until the late 1950s, when Jasper Johns and Robert Rauschenberg became aware of his work. His provocative gestures and radical wit established a new aesthetic medium, and his theories challenged fundamental assumptions about the nature of art. Willem de Kooning described him as 'a one-man movement … a truly modern movement because it implies that each artist can do what he thinks he ought to'. A. B.

Arturo Schwarz, *The Complete Works of Marcel Duchamp*, New York, 1969.

Marcel Duchamp, ed. Anne d'Harnoncourt and Kynaston McShine, New York, Museum of Modern Art, 1973; repr. 1989.

Michel Sanouillet and Elmer Peterson, eds., *Salt Seller: The Writings of Marcel Duchamp*, New York, 1973.

Dan Flavin

was born on 1 April 1933 in Jamaica, New York, to a Roman Catholic family of Irish and German descent. He received his education at the Cathedral College of the Immaculate Conception in Douglastown, New York. In 1953 he entered the US Air Force Meteorological Technicians Training School in Rantoul, Illinois, and then served as an air weather service observer in South Korea. Back in New York, he enrolled at the New School for Social Research (1956) and took art history classes at Columbia University (1957–59). Self-taught as an artist, he developed in the late 1950s primarily under the influence of Abstract Expressionism and Jasper Johns. His exhibition début, at the experimental Judson Gallery in 1961, included watercolours and constructions. That year Flavin introduced light as a material in his 'icons', painted wooden boxes with light bulbs attached. More revolutionary, though, was his *Diagonal of May 25, 1963*, dedicated to Constantin Brancusi: an eight-foot-long, yellow fluorescent light tube hung at an angle of forty-five degrees to the horizontal. The simple literalness of this commercially available, ready-made tube linked him to Minimalism, as did his employment of modular units. In 1966 he participated in the seminal group exhibition 'Primary Structures' at the Jewish Museum. Yet, despite his sense of reductiveness, Flavin did not reject transcend-

ental connotations and even referred to *Diagonal* as a 'diagonal of personal ecstasy'. Moreover, the use of light has itself, of course, ancient associations with spirituality.

Employing fluorescent tubes as expressive elements – as a painter might use lines – Flavin's numerous 'proposals' (his own preferred term) combine light strips of varying size, both white and coloured. In the mid-1960s he created larger installations: total luminous environments for specific spaces.

A striking example is *Untitled (to Dorothy and Roy Lichtenstein on Not Seeing Anyone in the Room)* of 1968, whose barrier of neon closes the entrance to the room which it illuminates. Flavin's installations became steadily more complex, occasionally combining daylight and fluorescent light. Most projects were laid out in small sketches and diagrams executed on notebook pages often no larger than three by five inches.

Flavin dedicated many pieces to friends, artists or public figures. A series entitled *Monument 7*, begun in 1964, was dedicated to the Russian Constructivist Vladimir Tatlin. In 1972 an installation of two triangular wall compositions – opposing circular tubes of cool and warm white light – honoured the US presidential candidate George McGovern. The exhibition at Leo Castelli's gallery in which it was shown opened prior to Election Day, marking the artist's support for the Democratic candidate (previously, Flavin had produced a poster for his campaign and participated in an 'Art for McGovern' exhibition series). In 1977 Flavin, moving away from the art gallery context, installed several fluorescent tubes on three railway tracks in New York's Grand Central Station.

Flavin lectured at the University of North Carolina at Greensboro (1967) and was visiting professor at the University of Bridgeport, Connecticut (1973). For its reopening in 1992 the Solomon R. Guggenheim Museum displayed his large neon installations around, and within, Frank Lloyd Wright's famous ramp. Flavin lives in Garrison-on-Hudson and Bridgehampton, Long Island. I. D.

Fluorescent Light, etc. from Dan Flavin, Ottawa, National Gallery of Canada, 1969.

Dan Flavin. Three Installations in Fluorescent Light, Cologne, Kunsthalle, 1973.

Dan Flavin: Fünf Installationen in fluoreszierendem Licht, Basle, Kunsthalle, 1975.

Sam Francis

was born on 25 June 1923 in San Mateo, California. Francis's mother was an accomplished pianist and he developed an early interest in

music. From 1941 to 1943 he studied botany, medicine and psychology at the University of California at Berkeley. Injured in a plane crash while serving in the US Air Force in 1943, Francis was bedridden for several months with spinal tuberculosis. To alleviate the boredom he produced landscapes and views of the sky, which led in 1947 to his first abstractions. After a short period of study under David Park, Francis returned to Berkeley and received an MA in Fine Arts (1950). At first, he was artistically indebted to Arshile Gorky, Mark Rothko and Clyfford Still. Soon, however, a more personal style emerged: imposing fields of biomorphic, corpuscular shapes were rendered in thin layers of wash, sufficiently fluid to run and drip across the canvas.

In Paris in 1950 Francis attended the Académie Fernand Léger. Two summers in Aix-en-Provence – Cézanne country – changed his palette from subtly differentiated pale tones to intense blues, reds and blacks. Henceforth, it was to maintain a vibrant brilliance, accentuated by crisp value contrasts and calligraphic rhythms. His first one-man show, at the Galerie du Dragon in 1952, was followed by several group exhibitions in which Francis was associated with practitioners of *Art Informel*. By the mid-1950s he had gained international recognition. The Museum of Modern Art, New York, made two important purchases of work by him in 1955.

In 1957, during a round-the-world trip, Francis visited Mexico, Thailand, India and Japan. Oriental art left a lasting mark on his sensibility. Compositions became more lyrical and open, as pristine expanses of white forced irregular chromatic outbursts towards the canvas edges, as in *The Whiteness of the Whale* (1957). The Japanese, in turn, admired Francis's spare and luminous manner. They

invited him to exhibit in Tokyo and Osaka, and commissioned a 26-foot-long mural for the Segetsu School of Sofu Teshigahara. Intrigued by the possibilities of wall-painting – especially by its large scale – Francis executed other murals in the course of the ensuing decade, perhaps most notably for the Chase Manhattan Bank in New York (1959) and for the National-galerie, Berlin (1969–71). During his work on a mural for the Kunsthalle in Basle (1956) Francis had written: 'it is like filling great sails dipped in color'. Meanwhile, he explored further the expressive potential of large empty spaces. In the 'Blue Balls' series (1960–61) the blue and green swirls, akin to organic cells, float in clusters at the margins of the pictures. After another long stay in hospital in 1961 for kidney tuberculosis, Francis returned to America and settled in Santa Barbara, where he bought a house in 1963. In the 1970s colour stains again invaded the central areas of Francis's huge paintings, which he executed directly on the floor with long rollers. Inspired by Oriental mysticism, these grids of dark, multi-coloured lines, covered with splashes and drips, evoked the geometrical diagrams of the Tibetan mandala.

Besides painting, Francis has investigated a number of media, producing ceramic sculpture, lithographs, monotypes and even, in 1966, a painting in the sky, executed by five helicopters releasing streams of coloured pigments in the air. He lives in Santa Monica, California. I. D.

Sam Francis, Houston Museum of Fine Arts, 1967.
Sam Francis: Paintings 1947–1972, Buffalo, Albright-Knox Art Gallery, 1972.
Peter Selz, *Sam Francis*, New York, 1975.

Robert Gober

was born in Wallingford, Connecticut, on 12 September 1954 to working-class Catholic parents. As a child, Gober imagined himself becoming a painter. He attended Tyler School of Art, Temple University, Philadelphia, in the autumn of 1974 and studied literature and fine arts at Middlebury College in Vermont (BA, 1976). In 1976 he moved to New York and continued painting, but worked as a carpenter to support himself, making stretchers and bases for sculpture, renovating lofts and constructing doll's houses. Gober performed in the multi-media dance works of Johanna Boyce, and toured internationally with her group. He became interested in sculpture and was influenced by the work of Donald Judd, Carl Andre and that of a younger sculptor, Joel Shapiro. In 1979 he was included in a New York group exhibition, 'Amore Store', at 112 Greene Street. The Paula Cooper Gallery gave him his first New York one-man show, 'Slides of a Changing Painting' (1984). His first collaboration was with the painter Kevin Larmon in 1986; this led to joint ventures with other artists, including Christopher Wool, Sherrie Levine and Meg Webster. The Friends of the Library at the Whitney Museum of American Art, New York, commissioned him in 1989 to design a limited edition book, *Heat* by Joyce Carol Oates. The image used in the endpapers of the book appeared as wallpaper in his next show. Since 1976 Gober has lived in New York.

Everyday objects are transformed by Gober into complex symbols. His student paintings depicted interior scenes and his subsequent sculpture continued this domestic theme. In 1982–83 he painted on a wooden board above which he placed a camera: the resulting slides were part of the series 'Chests'. His series of imitation porcelain plumbing fixtures began in 1984 with a plain, pristine sink. This finally metamorphosed into *Two Baseless Sinks* (1986), which resemble tombstones. There was also a bed, *Untitled (Bed)* (1986), leading to further beds, cribs and play-pens and, finally, *Dog Bed* (1986–87) and *Plywood* (1987), a piece of laminated fir wood propped against a wall. Gober calls the sinks, beds, play-pens and doors 'emblems of transition'. 'They're objects you complete with your body, and they're objects that, in one way or another, transform you … in the sense … of moving from one space through another.' Disturbing motifs, repeated so as to become decorative patterns, first emerged in the hanged man/sleeping man wallpaper seen in a 1989 room installation at the Paula Cooper Gallery. A series of anatomical parts was initiated with *Untitled Leg* (1989), a wax cast fragment of his own leg, with realistic hair and clothing, protruding from a wall as if it had been amputated. Extending the tradition of Marcel Duchamp and the ready-made, Gober is often associated with Jeff Koons, Haim Steinbach and Meyer Vaisman. But his art is handmade, sometimes hyper-realistic and includes sexual, autobiographical and sociological implications. Taking elements from René Magritte's brand of Surrealism and from Minimalism's 'specific objects' (among many other catalysts) into a post-modern dimension, Gober appropriates and reworks familiar artefacts, turning them into strange presences which fuse abstraction and metaphor. A. B.

Robert Gober, Art Institute of Chicago, 1988.
Robert Gober, Rotterdam, Museum Boymans-van Beuningen, 1990.
Robert Gober, Madrid, Museo Nacional Reina Sofía, 1992.

Arshile Gorky

was born Vosdanik Adoian on 15 April 1904 to an aristocratic family in the village of Khorkom in Armenia. Tragedy and upheaval dominated his early life: the genocidal persecution of the Armenians by the Turks during and after the First World War led to his mother's death from malnutrition in 1919 and Gorky's own flight to America the following year. There he rejoined other exiled relatives in Providence, Rhode Island, and, subsequently, in Watertown, Massachusetts. Although essentially an autodidact, Gorky attended the New School of Design in Boston (1922–24), before teaching painting at the Grand Central School of Art (1926). Over the next decade he made contact with such emerging fellow avant-garde artists as John Graham, Stuart Davis and Willem de Kooning, joined the Public Works of Art Project (1933), entered into a short-lived first marriage (1935–36) and adopted the pseudonym by which he is now known. The inclusion of his work in a 1930 group exhibition at The Museum of Modern Art was followed by a solo début at the Mellon Galleries, Philadelphia (1934). By 1937 his reputation had become sufficiently established for the Whitney Museum of American Art to purchase his *Painting 1936–37*. That year Gorky's murals on the subject of Aviation were unveiled at Newark Airport, New Jersey.

The huge cultural shift entailed in Gorky's migration from rural Armenia to urban America seems to have been the root cause of

his obsession with self-identity. This factor lay behind his change of name, the notorious projection of his ethnic persona and the reminiscences of Armenia that pervaded his writings. On an aesthetic level, it was largely responsible for the immersion in the styles of other artists and periods which dominated his output until the early 1940s. Abandoning standard notions of 'originality', his art from the mid-1920s onwards retraced key developments in the modernist tradition. Thus, his pictorial style emulated Cézanne, Miró, Picasso's protean repertoire, Braque, Léger and others. The drawings of the 1930s, with their echoes of Ingres and of Picasso's neo-classical manner, reveal Gorky's prowess as a draughtsman.

In 1941 Gorky married Agnes Magruder and had a one-man exhibition at the San Francisco Museum of Art. His contact with nature was renewed through three weeks spent in the Connecticut countryside in 1942 and reinforced by subsequent sojourns in rural Virginia; together with the crucial impact of Surrealism, notably via the influence of André Breton and Roberto Matta, this became the catalyst for the artistic outburst of Gorky's final seven or eight years (292 drawings date from the summer of 1946 alone). Perhaps more than the work of any American artist, these later oils, drawings and pastels extend the Surrealist tenets of metamorphosis, biomorphism, unconscious association and spontaneous brushwork into new areas. Typically, billows of exotic colour intertwine with linear effects to evoke an organic world, by turns lyrical, erotic or disturbingly convulsive. A series of personal disasters cut short this artistic development. A fire in his barn-studio was followed by an operation for cancer (both 1946) and a car crash (1948), which resulted in impotence and paralysis of his painting arm. On 21 July 1948 Gorky committed suicide by hanging in his studio in Sherman, Connecticut.

D. A.

Diane Waldman, *Arshile Gorky 1904–1948*, New York, Solomon R. Guggenheim Museum, 1981.
Jim M. Jordan and Robert Goldwater, *The Paintings of Arshile Gorky: A Critical Catalogue*, New York, 1982.
Arshile Gorky 1904–1948, London, Whitechapel Art Gallery, 1990.

Dan Graham

was born in Urbana, Illinois, on 31 March 1942. Self-taught as an artist, he studied philosophy for two semesters at Columbia University in New York. In 1964–65 he worked for the John Daniels Gallery, which showed work by Dan Flavin, Sol LeWitt,

Donald Judd and Carl Andre, all of whom played a major role in shaping his own outlook. In a reversal of the procedures of Pop Art, Graham 'exhibited' his first art works in the advertisement pages of magazines (*Schema*, 1966) and thus incorporated within the art itself the conditions of its reproduction. A group of pieces from 1966 to 1969 made use of sociological data on such subjects as high-density housing and drug-taking habits. Graham also wrote a series of essays on Minimal Art and popular culture (including such subjects as Dean Martin and the Kinks), which were published in *Arts Magazine* and the rock magazine *Fusion*. Drawn to the post-Minimalist aesthetic, which had been addressing issues of artistic perception and process, Graham realized his first performances in 1969. With tape recorders, video-cameras and monitors, he investigated the reactions of performers and audience to a given situation, transforming the 'formalist' terms of Minimalism into a 'functionalist' context. His first solo exhibition was held at the John Daniels Gallery in 1969.

In his films and videos of the 1970s Graham conceived of the camera as an extension of his own body, emphasizing the instrument's mobility in relation to the objects or scenes being recorded. *Roll* (1970) was filmed by the artist lying on the floor and rolling over several times, engendering altogether disorientating images. A second camera turned towards the artist allowed the audience to compare two different perceptions – subjective and objective – of the same act. Graham was particularly attracted to the video medium on account of its

spatial and temporal immediacy – in contrast to film, which reconstructs a past reality. In a live video situation the viewer is a participant.

In 1974 came the first video installation for specific architectural contexts. Mirrors were utilized to dislocate the space and create multiple perceptual layers. Viewers became performers through their reactions to the mirrors and to video images of themselves. Several pieces treated the duality of public versus private space – *Alteration to a Suburban House* (1978), for example, in which a glass wall replaced a house facade. By the late 1970s Graham's concern for the architectural environment had led to the creation of 'pavilions', site-specific installations independent of the gallery context. Although they resemble Minimalist sculptures, the pavilions prompt intricate psycho-social interactions and encompass the spectator within their structures. Among the most recent are *Two-way Mirror Cylinder Inside Cube*, erected on a Manhattan roof-top, and *Children's Pavilion*, produced in collaboration with the Canadian artist Jeff Wall. The former work explores the urban experience of 'seeing' and 'being seen'; the latter features a domed structure inside a landscaped hill with photographs of children from various ethnic backgrounds. Both address Graham's central theme: the definition of self, which, in 1991, he described as involving 'all sorts of issues from Godard to Jacques Lacan about the other and the mirror stage'. Graham lives in New York.

I. D.

Dan Graham, *Articles*, Eindhoven, Stedelijk Van Abbemuseum, 1978.
Dan Graham, *Video-Architecture-Television*, Halifax, Canada, Nova Scotia College of Art & Design, 1979.
Dan Graham: Pavilions, Munich, 1988.

Philip Guston

was born on 27 June 1913 in Montreal to Jewish émigré parents from Odessa. His father committed suicide when Guston was twelve years old. The youngest of seven children, the artist began drawing seriously at an early age and, after the family had moved to Los Angeles, enrolled at Manual Arts High School (1927). There he became friends with Jackson Pollock, a fellow student. Following their expulsion for distributing a satirical leaflet, Guston won a scholarship in 1930 to the Otis Art Institute in Los Angeles, but left after three months. Enamoured of the Italian Renaissance masters (especially Piero della Francesca), Giorgio de Chirico and the neo-classical period Picasso, Guston formulated a

Photo © Timothy Greenfield-Sanders

sophisticated, eclectic style. In easel paintings and mural commissions – which included walls for the former emperor Maximilian's palace in Morelia, Mexico (1934; in collaboration with Reuben Kadish), and for the 1939 New York World's Fair – he added social commentary and relatively abstract spatial organization to these influences. This merger of realism, surrealism and a resurgent classicism accorded with artistic strategies that were widespread in America and Europe between the wars.

The State University of Iowa in Iowa City gave Guston a position as an instructor of art in 1941. Four years previously he had married Musa McKim, and a daughter, Musa Jane, was born in 1943. In 1945, the year both of Guston's first New York solo exhibition, at the Midtown Galleries, and of his receipt of First Prize at the Carnegie Institute Annual in Pittsburgh, he left Iowa for another teaching post, at Washington University in St. Louis, which he held until 1947. During this time a newfound admiration for Max Beckmann's work expressed itself in images of more poignant, enigmatic reverie, in which confused figures clash in a twilit atmosphere (*If This Be Not I*, 1945).

Having departed from St. Louis and gone to live in Woodstock in upstate New York, Guston became more sensitized to New York's evolving artistic scene and befriended another incipient Abstract Expressionist, Bradley Walker Tomlin. However, a Prix de Rome award from the American Academy in Rome in 1948 took him on a year's travel through Italy, France and Spain, the source of some noteworthy drawings. Once back in America, Guston's vision focused on abstraction, perhaps emboldened by his relations with such avant-

garde gurus as the critic Harold Rosenberg and the composers Morton Feldman and John Cage. Lattice-like fields of softly hued, tremulous, though quite heavily impastoed, brushstrokes typify his 'signature work' of the earlier 1950s. By 1957 the accents had congealed into broader, darker-toned masses, as the titles also became more evocative (*Cythera*, 1957). Such paintings established Guston as the lyric poet among the Abstract Expressionists. This success was vindicated by The Museum of Modern Art's purchase in 1956 of his *Painting* (1954), by a Ford Foundation grant in 1959 (which allowed him to give up teaching) and by a major 1962 retrospective at New York's Guggenheim Museum.

Yet, in 1967–68, Guston revived the figuration that he had long since cast aside. Mordant and parodistic, the Ku Klux Klansmen, colossal heads, brutish still-lifes and other existential bric-à-brac of this last period are rendered with a painterliness at once gross, cartoon-like and powerfully iconic. Their irony, strangeness and daring permeated almost all the New Image painting of the 1980s. Guston died of a heart attack on 7 June 1980. D. A.

Dore Ashton, *Yes, but…: A Critical Study of Philip Guston*, New York, 1976.
Philip Guston: Paintings 1969–1980, ed. Nicholas Serota, London, Whitechapel Art Gallery, 1982.
Robert Storr, *Philip Guston*, New York, 1986.

David Hammons

was born in Springfield, Illinois, in 1943. His childhood as an African American in the Midwest informs the dual perspective – as both insider and outsider – that he brings to bear on the culture of the inner city. At the age of twenty, he left Springfield for Los Angeles to attend the City College (for one year), the Chouinard Art Institute and the Los Angeles Trade Technical College, at which he studied advertising. At the Otis Art Institute, also in Los Angeles, Hammons then worked under Charles White, a former Works Progress Administration print-maker whose art is devoted to race issues. Hammons's work of the early 1970s included assemblages and 'body prints' that pitted the American flag against emblems of racial and cultural stereotypes.

In 1974 Hammons moved to Manhattan. From the mid-1970s onwards, he abandoned most conventional media in favour of materials culled from urban detritus, such as scraps of metal and wood, brown paper bags, African American hair, chicken bones, grease and empty wine bottles. Emerging from the

climate of post-Minimalism, he moved away from producing marketable art objects in order to pursue performance and installation. In cultivating the ephemeral and the low, Hammons places himself 'somewhere between Marcel Duchamp, Outsider art and Arte Povera'.

Important examples of his work, such as *Greasy Bags*, *Barbecue Bones* and the 'Dreadlock' series, were shown at the non-profit Just Above Midtown gallery in 1975 and 1976. Around this time, Hammons began to take his art on to the streets, vacant lots and other sites in Brooklyn, Lower Manhattan and Harlem. The temporary works produced in this context often married the handicrafts, construction techniques and ritual objects of tribal Africa to the experiences of life in black America. His recent work is highly eclectic. In *Higher Goals* (1982) – erected in front of court buildings in down-town Brooklyn – telegraph poles surmounted by basketball backboards are encrusted with bottle-tops arranged to imitate the woven patterns of African and Islamic textiles, while *Delta Spirit* (1983) recreates a southern shanty shack on a Manhattan landfill site. More explicit subject-matter includes such cultural icons as John Coltrane, Malcolm X, Jesse Jackson and Nelson Mandela.

Hammons prefers the spontaneity of a street audience to the jaded, mainstream art public, the street setting enabling him to intervene in the spectator's experience of his work. (In this regard, Joseph Beuys – who visited New York in 1974 – is a clear spiritual forebear.) Yet Hammons's installations have continued to appear in galleries, museums and alternative art spaces in both the United States and Europe. Among his commissions is *Flight*

Fantasies (1980), a group of hair constructions for the International Airport in Atlanta. In 1990, when Hammons was a fellow of the American Academy in Rome, a travelling retrospective of his work was organized in New York by the Institute for Contemporary Art and shown at P.S.1. He has since created work for an exhibition at The Museum of Modern Art, New York (1991), and for 'documenta IX' in Kassel (1992). Hammons lives in New York. J. W.

Maurice Berger, 'Issues and Commentary II — Speaking Out: Some Distance to Go …' [interview with Hammons], *Art in America*, vol. 78, September 1990, pp. 80–1.
Rousing the Rubble, ed. Tom Finkelpearl, New York, P.S.1 Museum, 1990.
Calvin Reid, 'Kinky Black Hair and Barbecue Bones: Street Life, Social History and David Hammons', *Arts Magazine*, vol. 65, April 1991, pp. 59–63.

Keith Haring

was born in Kutztown, Pensylvania, on 4 May 1958. The son of an electric power station foreman, he was encouraged to draw at an early age – cartoon characters inspired by animation programmes on television. After high school, he moved to Pittsburgh and attended the Ivy School of Art, where he began to silk-screen T-shirts. Subsequently, Haring went to New York's School of Visual Arts (1978–79), studying under Keith Sonnier and Joseph Kosuth, and received his first commercial gallery show from Tony Shafrazi in 1982.

During the summer of 1979 Haring had performed and read 'poetry-word things' at Manhattan's Club 57. The next year, however, he turned to graffiti art and drew cartoon-like

images with a marker pen directly over advertisements in the New York Subway. There followed a series of narratives done in white chalk on the black billboard paper of unused advertising spaces in the Subway, a kind of unofficial public art. The imagery mingled sexual elements with flying saucers which were apt to 'zap' dogs and people. Running figures, crawling babies ('the radiant child'), haloes, pyramids, instruments of communication (TV sets, telephones) and references to nuclear energy came to enrich the vocabulary of these images. Themes of power and force, and fear of technology, suggested angst and moral disquiet. The pictorial supports to which Haring turned were equally varied and accessible: paper, fibreglass, canvas, enamelled steel squares, badges, T-shirts, vases and plaster casts of popular works of art. From such sources as Eskimo, African, Mayan and Aboriginal art, Chinese calligraphy, Pierre Alechinsky, Andy Warhol and Mark Tobey's all-over fields Haring evolved his distinctive, semi-abstract manner. Thick black lines demarcate schematic figures within Day-Glo grounds. A *horror vacui* dominates the compositions, which pulsate with energies at once irresistible and disturbing.

Haring's style reflected the ethos of the Pop generation and the street-wise attitudes of Manhattan's East Village. It was spontaneous, direct, condensed and airless. The artist said: 'I am trying to state things as simply as possible.' Like Warhol, Haring embraced demotic culture – its fashion, dance, art and music – yet broke down the barrier between high and low art to an even greater extent. This factor, in particular, helped his world-wide commercial success in a variety of genres, including murals, sculpture, posters and body painting. In the mid-1980s Haring's large painted steel sculptures were shown at the Castelli Gallery (1985) and he also made more abstract paintings, with black outlines in jigsaw puzzle-like designs. In 1986 he opened a 'street' boutique, the Pop Shop, which sold Haring products and multiples. His populism was also directed at children and teenagers: he adorned their skateboards and created a public message in the wall-painting *Crack Is Wack* of 1986; that year, he even painted on a section of the Berlin Wall. A critic noted that, 'in order to reach the broadest audience, one's style must tend toward the lowest-common-denominator configurations, at once instantly recognizable and comprehensible'. The Keith Haring Foundation was established in 1989 to help redress social problems. Haring died of AIDS-related diseases on 16 February 1990 in New York. A. B.

Keith Haring: Future Primeval, Norman, IL, University Galleries, Illinois State University, 1990.
John Gruen, *Keith Haring: The Authorized Biography*, New York, 1991.
Germano Celant, ed., *Keith Haring*, Munich, 1992.

Marsden Hartley

was born on 4 January 1877 in Lewiston, Maine. He studied briefly at the Cleveland School of Art and at the Chase School in New York, then attended the National Academy of Design (1899–1904). Returning to Maine in 1906, he began a series of Post-Impressionist landscapes, which were followed by the 'Dark Mountain' paintings (1909) done in homage to his favourite American artist, Albert Pinkham Ryder. Under the stimulus of Cézanne, Matisse and Picasso, Hartley painted modernist landscapes and still-lifes in Maine and New York. With two shows at the 291 gallery behind him (1909 and 1912) Hartley went to Paris and became a regular frequenter of the Stein salon. In Berlin he met Wassily Kandinsky, Gabriele Münter and Franz Marc, and exhibited alongside them at the First German Autumn Salon there in 1913. Several of his large, semi-improvisational 'Intuitive Abstractions' – syntheses of Fauvism, Cubism and Expressionism – were included. The next year, Hartley arrived at bold, emblematic abstractions that combine a fascination with Germany's pre-war military pageantry with American Indian motifs. The 'German Officer' compositions (also 1914) were encoded, icon-like evocations of a close male friend who had recently died. Although among his finest works, they were condemned as being pro-German when seen in 1916 at 291.

After the war, the restless Hartley (who was also a significant poet and the author of four books) travelled to Bermuda, New Mexico and California. His search for an original, objective style to be derived from native landscapes and American Indian sources did not bear fruit and he left for Europe again in 1921. From that sojourn arose the powerful, expressionistic 'Recollections of New Mexico' landscapes (1923–24). Cézanne again underpinned the ensuing still-lifes and vistas of southern France (1925–29). These were shown at the Intimate Gallery in 1929, yet were decried as being derivative. The disappointment prompted Hartley to return to his roots. In Dogtown, Massachusetts, a brooding romantic style took shape. Blocky, sombre images of the ice-age moraine (1931 and 1934) welded Expressionist

brushwork to Cubist design. Ever the
wanderer, Hartley journeyed to Mexico (1932)
and Germany (1933–34), where he stayed at
Garmisch-Partenkirchen in the Bavarian Alps.
There, the expression of spiritual essences
came to the fore as Hartley focused on what
had been a leitmotiv of his work for almost
three decades: mountains as symbols of gravity
and endurance.

Ill and depressed, Hartley destroyed one
hundred works in 1935 because he was unable
to afford their storage. In Nova Scotia he
found some solace in the simple, rural life of
the Francis Mason family. They were to
provide the subjects for his monumental, prim-
itivizing 'Archaic Portraits' (1938) and
Fisherman's Last Supper (1940–41). Finally back
in Maine in 1937, Ryder's example again
bulked large as Hartley (who also painted a
number of implicitly homo-erotic figures)
articulated his pantheistic, Emersonian
approach to the region's coastal and mountain
geography, notably that of Mount Katahdin.
A joint exhibition with Stuart Davis at the
Cincinnati Art Museum was accompanied by
growing critical acclaim. Yet its benefits had
not fully materialized when Hartley died on
2 September 1943 in Ellsworth, Maine. G.S.

Barbara Haskell, *Marsden Hartley*, New York, Whitney
 Museum of American Art, 1980.
Gail Scott, *Marsden Hartley*, New York, 1988.
Townsend Ludington, *Marsden Hartley: The Biography of
 an American Artist*, Boston, 1992.

Eva Hesse

was born in Hamburg on 11 January 1936, the
daughter of a Jewish criminal lawyer. To escape
the Nazis, her family emigrated to New York
in 1939, settling in the city's Washington
Heights area. In 1945 Hesse became a US
citizen; that year her parents were divorced.
She and her sister lived with their father, who
remarried; their mother committed suicide the
following year. After graduating from the High
School of Industrial Arts (1952) Hesse studied
advertising design for a year at the Pratt Insti-
tute. In 1954 she took drawing classes at the
Art Students League, but also began psychi-
atric therapy (continued sporadically until her
death). That September she enrolled at the
Cooper Union, graduating in 1957 and going
on to the Yale School of Art and Architecture
(BFA, 1959). Hesse then moved back to New
York.

Hesse's early paintings were in an Abstract
Expressionist vein, influenced by Willem de
Kooning's gesturalism. In 1960 she met the
Conceptual artist Sol LeWitt, who became
both an influence and a friend; the next year
she married Tom Doyle, a sculptor. Her own
first three-dimensional constructions dated
from the summer of 1962. Sponsored by the
German collector and textile manufacturer
Arnhard Scheidt, Hesse and her husband spent
fourteen months in Kettwig am Ruhr, near
Essen (1964–65). During this transitional
phase the use of line in her drawings developed
into three dimensions, as in *Ringaround Arosie*
(1965), a wall relief made with electric wire.
Before returning to New York, she had a solo
exhibition at the Kunstverein in Düsseldorf. In
1966 (when she separated from her husband
and her father died) Hesse's work was included
in 'Eccentric Abstraction' at the Fischbach
Gallery, New York. Her hanging and
suspended organic forms, often with sexual

connotations, related to the 'soft' sculptures of
Claes Oldenburg. *Hang Up* (1965–66) is a
wrapped and painted construction which
exemplifies her unconventional formal
approach: its empty square framework has a
long, thin, looping steel tube that extends from
one corner to the floor and back. According to
Hesse, it was 'the most ridiculous structure I
have ever made'. Translucent fibreglass cylin-
ders and rods appeared in 1968, as colour was
abandoned in favour of light. That year she
held a first solo sculpture show at the Fisch-
bach Gallery and also began teaching at the
School of Visual Arts (until 1969).

Hesse was an innovator, formulating an
idiosyncratic, process-orientated post-Minimal
aesthetic which greatly influenced American
sculpture of the 1970s. It now also appears to
express a dinstinctly feminist vision attuned to
the centrality of the human body. For several
years, the circle was an important configura-
tion in her vocabulary which, indeed, focused
upon the erotic potential inherent in vessel or
cavity-like forms. Pictorialism is combined
with expressive, tactile form and materials
(such as latex, rope and fibreglass), so that
incongruous mixtures of hard and soft,
geometric and organic elements occur. Like-
wise, repetitive modular or serial systems influ-
enced by Minimalism co-exist with effects of
implicit pathos, absurdity or calculated
awkwardness. Hesse died of a brain tumour on
29 May 1970. A.B.

Lucy Lippard, *Eva Hesse*, New York, 1976.
Bill Barrette, *Eva Hesse: Sculpture, Catalogue Raisonné*,
 New York, 1989.
Helen A. Cooper, *Eva Hesse: A Retrospective*, New Haven,
 Yale University Art Gallery, 1992.

Gary Hill

was born on 4 April 1951 in Santa Monica,
California. He began making welded sculp-
tures while at High School in Redondo Beach,
California. In 1969 Hill moved east after re-
ceiving a scholarship to spend a month at the
Art Students League in Woodstock, New York.
There, inspired by the works of Picasso and
Giacometti, he fashioned complex wire mesh
pieces that initially suggested human forms,
then abstract biomorphic shapes and, finally,
took on the character of geometric configura-
tions. In 1974 Hill held his first one-man show,
at the South Houston Gallery, New York.

In the early 1970s Hill began to explore
audio and video: 'I discovered the sculptures
generated interesting sounds, lots of different

timbres...I worked with loops and multi-track audio, which later became an integral part of the sculpture.' Still living in Woodstock, he borrowed a video camera and created his first performance/environment piece with a friend. Hill then arranged to record local news events and do other videos in exchange for the use of equipment. From 1974 to 1976 he was a salaried TV lab co-ordinator at Woodstock Community Video and, from 1975 to 1977, artist-in-residence at the Experimental Television Center in Binghampton, New York. He founded the Open Studio Video Project in Barrytown, New York, in 1977.

Hill's earliest videos, including *The Fall* (1973), reflect the artist's experimentation with various electronic imaging equipment. The emphasis was on visual effect, inspired by the organization of, and sensibility evinced by, Abstract Expressionist paintings. About 1974 Hill began colouring tapes, but after a time found that 'colorizing seemed superficial, next to having access and control over the architecture of the frame in real time'. In 1977 he experimented with digital processing and created *Bathing*. This featured colour tape shot in real time intercut with stills rescanned with a colour camera and digitized. In *Windows* (1978), a study for an installation piece, Hill first mixed analogue and digital images, producing a composition of dense, layered images to be shown on several screens.

Hill had created his first video 'installation' in 1974 for the Woodstock Art Association. His *Primarily Speaking* (1981–83) was installed at the Whitney Museum of American Art, New York, in 1983: two walls of television screens that showed tapes as well as solid fields of colour; each wall alternately functioned as a 'speaking wall' that offered a monologue of verbal clichés. Hill described it as 'a different take on talking pictures – talking pictures breaking [rather than telling] the story'.

Hill has taught at the State University of New York at Buffalo (1979–80), Bard College in Annandale-on-Hudson, New York (1983), and Cornish College of the Arts in Seattle (1985–91). His work has been shown at New York's Anthology Film Archives (1976) and Museum of Modern Art (1990) and at the

Centre Georges Pompidou in Paris (1992). He has received grants from, among others, the National Endowment for the Arts, the Guggenheim Foundation and the Rockefeller Foundation. Hill lives and works in Seattle.

L. K.

Lucinda Furlong, 'A Manner of Speaking: An Interview with Gary Hill', *Afterimage*, vol. 10, March 1983, pp. 9–16.
John G Hanhardt, 'Gary Hill' (programme notes). The New American Filmmakers Series, no. 12. New York, Whitney Museum of American Art, 1983.
Robert Mittenthal, 'Reading the Unknown: Reaching Gary Hill's *And Sat Down Beside Her*', Paris, Galerie des Archives, 1990.

Jenny Holzer

was born on 29 July 1950 in Gallipolis, Ohio. The daughter of a car dealer, she spent her youth in Lancaster, near Columbus, and considered herself an artist even in childhood. After preparatory school in Fort Lauderdale, Florida, she attended Duke University (1968–70), the University of Chicago (1970–71), then the Ohio University in Athens, from which she obtained a BFA in 1972. While at Rhode Island School of Design (MFA, 1977) she was influenced by Marcel Duchamp's ideas. Holzer moved to New York in 1977 and participated in the Whitney Museum's Independent Study Program. Its reading list inspired her to create an alphabetical list of phrases. Her future concerns first emerged in a series of anonymous posters, entitled

'Truisms', which she put up on the walls of her neighbourhood, SoHo. These works play upon the fact that aphorisms that sound cogent by themselves tend to contradict each other in sequences; capital letters are employed throughout. Holzer worked as a typesetter from 1979 to 1982 and first used electronic signs in the latter year, when she displayed 'Truisms' above Times Square; subsequently, LEDs (light-emitting diodes) became a favourite medium. She married the painter Michael Glier in 1983. Seven years later, Holzer became the first woman to represent the United States at the Venice Biennale.

In common with several Conceptual artists, Holzer's primary medium is language. As in Bruce Nauman's work, the messages are displayed on diverse carriers: billboards, bronze plaques, granite benches, television, T-shirts, stadium scoreboards and, most often, electronic message boards. Site-specific installations enfold the viewer as brightly flashing words and phrases move at variable speeds in all sorts of directions. Their content is popular – including such topics as justice, love, war, money and sex – while also recognizably part of a post-structuralist, post-Foucaultian world of discourse that explores areas where private and public realms meet. The emotional tenor tends to be mordant, quizzical or disorientating.

After 'Truisms', Holzer's output divided into several series: 'Inflammatory Essays' (1979–82), street posters of one hundred words each; 'Living' (1980–82), bronze plaques and painted signs done in collaboration with Peter Nadin; 'Survival' (1983–85), electronic messages conveyed primarily on large electronic sign machines; 'Under a Rock' (1983–87), a formal installation consisting of stone benches; and 'Laments' (1987–89), messages from thirteen dead people displayed on stone benches, sarcophagi and columnar LED signs. The texts have also been made into books and video films. Using commercial techniques, Holzer has been described as 'democratic' and 'a product of the TV age and the world of advertising and billboards'. The artist herself notes: 'The individual statements may be simple, but the entire series is not, and the way single sentences play off each other is not.'

Internationally recognized, Holzer presented two granite sarcophagi at 'documenta VII' in Kassel (1982). The Dia Art Foundation in New York presented the 'Laments' in 1989, and a large, 535-foot-long electronic display and installation of benches dominated the Guggenheim Museum's interior in 1989–90. She has one daughter and, since

1985, has lived on a farm in Hoosick Falls, New York. A. B.

Diane Waldman, *Jenny Holzer*, New York, 1989.
Jenny Holzer: The Venice Installation, Buffalo, Albright-Knox Art Gallery, 1991.
Michael Auping, *Jenny Holzer*, New York, 1992.

Edward Hopper

was born on 22 July 1882 in Nyack, New York. Having demonstrated an interest in drawing at an early age, he attended the Correspondence School of Illustrating in New York City (1899–1900). He then transferred to the Chase School, where he studied painting under William Merrit Chase himself, as well as under the realists Robert Henri and Kenneth Hayes Miller (1900–6). During the next few years Hopper made three study trips to Europe. In Paris he painted city scenes in bright colours that reflected his admiration of Impressionism. Although he developed a love of French art and culture, he did not investigate the new styles of Fauvism and Cubism. Returning to America in 1910, where he remained for the rest of his life, Hopper earned his living as a commercial artist and illustrator. He exhibited in the Armory Show of 1913.

Frustrated by his inability to establish himself as an oil painter, Hopper turned to print-making in 1915. Inspired by the work of Rembrandt, Goya, Méryon, Degas and, in particular, John Sloan, he had acquired considerable mastery of the medium of etching by 1923. Hopper received critical acclaim for his widely exhibited prints; he was to return continually to their themes and compositions. In 1920 he had his first one-man show, at the Whitney Studio Club in New York. A

successful exhibition of recent watercolours at the Frank K. M. Rehn Gallery, New York, in 1924 – all items were sold – enabled him to devote himself full-time to painting. Soon afterwards, he married the painter Josephine Nivison, and for the next forty years they divided their time between New York and New England, with occasional trips to the West and Mexico. In 1933 The Museum of Modern Art presented a comprehensive retrospective of his work in all media. Also in New York the Whitney Museum of American Art organized major retrospectives in 1950 and 1964. Hopper stopped painting in 1965 and died on 15 May 1967 in his New York studio.

By the late 1920s, when Hopper was recognized as one of the major interpreters of the American Scene, he had developed the essential aspects of his mature style. Finding poetry in the commonplace as perceived in the casual glance of a motorist, Hopper frequently painted urban and rural environments with isolated, pre-modern buildings inhabited by lonely, uncommunicative figures. Often gazing out of windows, these individuals, and their milieu, evoke a bleak, disjuncted vision of modern America as a land of unfulfilled longing, of alienation and nostalgia. Hopper asserted in 1933 that 'a nation's art is greatest when it most reflects the character of its people'. He denied that his work had a specific social message, however, and defined his aim as 'the most exact transcription possible of my most intimate impressions of nature'. Yet he painted with considerable breadth and with attention to the underlying abstract structure of his compositions, developing an outstanding ability to transform light and shadow into interesting patterns. In his later work, which was executed less directly from nature, Hopper often eliminated detail still further. After his death, Hopper's wife bequeathed his artistic estate of over 2,500 works to the Whitney Museum of American Art. G. S.

Lloyd Goodrich, *Edward Hopper*, New York, 1983.
Gail Levin, *Edward Hopper*, New York, 1984.
Robert Carleton Hobbs, *Edward Hopper*, New York, 1987.

Jasper Johns

was born on 15 May 1930 in Augusta, Georgia, and grew up in the homes of relatives in South Carolina. He moved to New York at the age of nineteen, spending six months at commercial art school prior to two years of Army service. In 1954 he met Robert Rauschenberg; together they created window displays for New

York department stores, including Bonwit Teller and Tiffany's. That year Johns made constructions from such prosaic materials as wood, plaster and paper; the majority of these were destroyed a few months later. Inspired by a dream, Johns painted an American flag in 1955, the first of a series to explore an imagery of 'things the mind already knows' – flags, targets, numbers and letters. The familiar subjects allowed him to concentrate on how the creative process communicates or, alternatively, denies meaning. As the two-dimensional flag engulfed the canvas surface, it undermined distinctions between figure and ground. Objects and their representation were caught in an ambiguous flux. Johns revived the ancient technique of encaustic (wax) painting, which he applied in layers to a collage of newspaper to give the erstwhile banal images a rich, sensuous texture. When shown at the Leo Castelli Gallery in New York in 1958, these highly original paintings – radical alternatives to the prevalent Abstract Expressionist style – won the artist instant fame.

During the 1960s intellectual complexity pervaded Johns's art. An interest in Marcel Duchamp (whom he met in 1959) and in Ludwig Wittgenstein's philosophy led to more hermetic themes that explored the relationship between language, thought and vision. Testing assumptions about identity and the making of art, he introduced real objects – casts of anatomical fragments, household artefacts and schematic patterns – into paintings such as *According to What* (1964). These combined verbal and visual puns yet stressed the concrete self-referentiality of the work. Such tableaux, often of several joined canvases, lead the viewer

to search for the logic that connects their disparate, emblematic leitmotivs.

In the late 1960s and early 1970s Johns added two further elements: flagstones and cross-hatching. At first seen as part of a move towards increased abstraction, the motifs actually again came from a repertory of impersonal images that, though tied to the everyday world, were replete with private and art-historical allusions. The latter sometimes had existential overtones. Thus, the hatchings may evoke Johns's own handprints, while also recalling details in a grim self-portrait by Edvard Munch. Personal references became more insistent in the 1980s, along with an interest in mimesis, evident in several paintings depicting the artist's studio walls with *trompe l'œil* methods. In a series treating the Four Seasons as metaphors for the Ages of Man, Johns drew his own shadow outline within an array of art-historical 'quotations' extending from Grünewald to Picasso and Duchamp.

Apart from paintings, Johns's oeuvre includes numerous sculptures (for example, *Two Beer Cans* of 1960) and graphics of great technical accomplishment. They, too, explore connections between seeing, knowing and the human condition. Since 1967 Johns has been artistic adviser to the Merce Cunningham Dance Company, and now lives in New York and Saint-Martin. I. D.

Richard Francis, *Jasper Johns*, New York, 1984.
Roberta Bernstein, *Jasper Johns' Paintings and Sculptures*, Ann Arbor, 1985.
The Drawings of Jasper Johns, Washington, National Gallery of Art, 1990.

Donald Judd

was born on 3 June 1928 in Excelsior Springs, Missouri, the son of a Western Union Telegraph Company official. It was in connection with his father's job that the family first moved to Nebraska, thence back to Missouri, and then to Texas, Pennsylvania and New Jersey. In 1946–47 Judd served in the US Army Corps of Engineers in Korea. After a year at the College of William and Mary in Williamsburg, Virginia (1948–49), he enrolled at the Art Students League in New York and also attended evening classes at Columbia University, gaining a B. Sc. in Philosophy (1953). Subsequently, he pursued graduate studies at Columbia under Rudolf Wittkower and Meyer Schapiro, receiving his MA in Art History in 1962. During the 1950s, meanwhile, he had experimented with several styles of painting, encompassing both figuration and abstraction. His first one-man show, at the Panoras Gallery in

1957, emphasized the latter idiom, with images consisting of flat, irregular, dark shapes on a light background.

From 1959 to 1965 Judd earned his living as a critic for *Arts Magazine*. He thus became familiar with the contemporary avant-garde, reviewing early exhibitions of work by Jasper Johns, Frank Stella and the emerging Pop artists. His descriptive, concrete prose evinced the same rigorous immediacy as his sculpture. Judd wrote that 'Actual space is intrinsically more powerful and specific than paint on a flat surface', and the eschewal of even vestigial illusionism led him to abandon painting in 1961–62 for heavily textured monochrome reliefs. Such objects as a pipe or a baking-dish were attached to the centre of these. At the same time, he also made free-standing objects: simple wood and metal constructions standing directly on the floor. These were shown at the Green Gallery in December 1963 and established the artist as one of the foremost figures in the new movement of Minimalism.

Judd developed his wall reliefs in two series, which came to dominate his output: 'stacks', vertical arrangements of identical rectangular boxes cantilevered on the wall, and 'progressions', horizontal bars cut to size in accordance with mathematical sequences. Most were polychrome and combined two materials, such as metal and Plexiglass, aluminium and lacquer, brass and enamel. Through repetition and the use of mathematics Judd bypassed traditional notions of compositional hierarchy, which he associated with the legacy of European art and, as such, rejected. After 1963 all these 'Specific Objects' (Judd's own term) were machine-made to avoid any sense of craftsmanship by eliminating evidence of the artist's touch. Their hallmark is a static, monumental clarity.

Since 1970 Judd has shown more concern for the environment, creating works in response to specific spaces, such as a ring-shaped sculpture for the Guggenheim Museum

or outdoor nesting boxes that echoed the topography of their location (both 1971). Through its association with architecture and furniture, his idiom became less absolute. In 1973, wishing to escape the 'art crowd' of Manhattan's SoHo, Judd purchased a block of buildings in Marfa, western Texas, and converted two First World War aircraft hangars into studio and installation spaces. He designed and built their furnishings, which share the formal severity of his sculpture. More recently, Judd has further explored box-like structures, making larger versions in heavier materials, such as concrete. Some of these were included in a major retrospective held at the Whitney Museum in 1988. Judd lives in Ayala di Chinati and Marfa, Texas. I. D.

Donald Judd, ed. Brydon Smith, Ottawa, National Gallery of Canada, 1975.
Donald Judd: Complete Writings 1959–1975, Nova Scotia, Canada, 1975.
Barbara Haskell, *Donald Judd*, New York, Whitney Museum of American Art, 1988.

Mike Kelley

was born in Detroit, Michigan, on 27 October 1954 into a Catholic working-class family. He was educated at the University of Michigan, Ann Arbor (BFA summa cum laude, College of Architecture and Design, 1976), where he studied under John Baldessari. In 1978 he began as a performance artist with 'Poetry in Motion' at the Los Angeles Contemporary Exhibitions and then staged 'Poltergeist' (in collaboration with David Askevold, 1979), which alluded to invisible energies made visible. His early performances were plotless works of illogical, meandering chants with

Photo © Timothy Greenfield-Sanders

manipulated props and drawings. He has continued with performance art, first appearing in New York at Metro Pictures in 1986 and, more recently, creating *Beat of the Traps* (1992) with Anita Pace and Stephen Prina. His first one-man show, held in Los Angeles at the Mizuno Gallery in 1981, included props from performances. He received a Visual Artists Fellowship from the National Endowment for the Arts (1985). In 1992 Kelley exhibited a gallery-size afghan rug, *Riddle of the Sphinx*.

Based in Los Angeles, Kelley is a conceptual artist working in various media. As Amada Cruz has noted, 'Kelley's art is confrontational. His particular fusion of high and low culture is heavily weighted toward the low.' Inspiration has come from cartoons, church banners, stuffed toys and hand-crocheted blankets. In the words of one critic, 'Ferdinand de Saussure meets Sesame Street! Semiotics meets the theater of the absurd!' Burlesque, philosophy, juvenile pranks, eroticism and perverse social commentary are all combined. In his early paintings and drawings Kelley adopted a direct, flat, cartoon-like style, often using black acrylic on paper. He recalls how he began 'like an expressionist painter, I liked Francis Bacon and de Kooning, those real tortured painters. But at the same time I liked Basil Wolverton, he used to do bubble gum cards, he did Lena Hyena, he did grotesques for Mad Magazine, he was funny.' A darker side is also evident: 'I have sort of a morbid outlook on life. All my comedy is about morbid subjects.' Since 1986 he has made sculpture and installations with found objects: soiled soft toys and teddy bears bought in second-hand shops. The messages have grown more direct and simplified, his adolescent-like black humour stemming from the human predicament. The 'Half A Man' series (begun in 1987) addresses gender, modernism and sexuality. Dishevelled dolls and animals are sewn or tied together, then placed on or under blankets or hung from the wall or ceiling. Sexual overtones and scatological references undermine the adult notion of childhood innocence. According to Kelley, 'the stuffed animal is a pseudo-child, a cutified sexless being which represents the adult's perfect model of a child – a neutered pet'. These marginal domestic items of popular culture are employed to create handmade tableaux, which Kelley introduces into a gallery setting. Traditional crafts are transformed and re-presented as art. His installation at the 1992 'documenta' combined instructional and narrative text with drawing inspired by bodily functions. Kelley says he is basically a humorist with an interest in antagonistic content. A.B.

Mike Kelley, Cologne, Galerie Jablonka, 1989.
Thomas Kellein, *Mike Kelley*, Basle, Kunsthalle, 1992.
William S. Bartman and Miyoshi Barosh, eds., *Mike Kelley*, New York, 1992.

Ellsworth Kelly

was born on 31 May 1923 in Newburgh, New York, and had a peripatetic upbringing in and around Hackensack, New Jersey. He showed an affinity for art as a youth and, with parental support, attended the Pratt Institute in Brooklyn, where he studied under Maitland Graves. In 1943, after less than two years at the institute, Kelly was called up. Together with a number of other artists, he served in the 603rd Engineers Camouflage Battalion at Fort Meade, Maryland, where he executed didactic silkscreen posters dealing with camouflage techniques. In 1944–45 a tour of duty with the battalion took him to England and France, including a summer near Paris.

After the war, he continued his art education at the School of the Museum of Fine Arts in Boston, where he worked during 1947–48 under Karl Zerbe and Ture Bengtz. Kelly returned to Paris as an art student in 1948 (initially enrolling at the Ecole des Beaux-Arts) and lived in France until 1954. The artist's French years were saturated with visits to museums and monuments, marked in particular by a strong preference for the Byzantine and Romanesque styles dominated by abstract clarity of shape. Kelly visited Jean Arp, Constantin Brancusi and Georges Vantongerloo at this time, and converted the 'anonymous' aspects of their work – purified or abstract form, and collage and chance tech-

niques – into a principle of seeing; in this way, composition is elicited from the observation of objects and sites, rather than fabricated. In sketches, photographs, paintings and constructed reliefs he formulated a flat, geometrical manner that is spare, but not austere. Kelly created his first shaped-panel and multi-panel 'painting/objects' during this period, notably *Window, Museum of Modern Art, Paris* (1949), *Window V* (1950) and *Colors for a Large Wall* (1951). He exhibited at the Galerie Arnaud and the Galerie Maeght.

Kelly left Paris for Manhattan in 1954. From 1956 to 1963 he lived at 3–5 Coenties Slip in Lower Manhattan, where his neighbours included Robert Indiana, Agnes Martin, James Rosenquist and Jack Youngerman (he was to leave the city for a house upstate in 1970). Initially somewhat alienated from the New York art scene, Kelly's reputation grew through solo exhibitions at the Betty Parsons Gallery; beginning in the late 1950s, he was increasingly represented in group and survey shows at museums around the country. By 1960, in works six to eight feet in height, the primary elements and concerns of his oeuvre had been fully established: elemental shapes in black and white or unmodulated colour explore the autonomous identity of separate hues and the tensions and equivalences of figure and field. Throughout the decade, Kelly often employed angularly shaped canvases and multiple monochromatic panels; in his sculptures, large-scale cut-out planes opposed flatness and frontality to actual space. He introduced broadly curving edges during the 1970s; colour was de-intensified or eliminated in favour of black, white and grey; and the sculptures evinced a new interest in textured surface. The 1980s saw a return to brighter hues and biomorphic form.

Kelly has been a prolific print-maker since the 1960s, having produced 133 editions over a fifteen-year period in co-operation with the studio of Gemini G.E.L. He began showing with the Leo Castelli Gallery in 1973. Touring exhibitions of his work have originated at New York's Museum of Modern Art and Metropolitan Museum of Art and at the Stedelijk Museum, Amsterdam. He has executed public commissions in New York, Chicago, Paris and Barcelona. Kelly lives in Spencertown, New York. J.W.

E.C. Goossen, *Ellsworth Kelly*, New York, 1973.
Barbara Rose, *Ellsworth Kelly: Paintings and Sculptures 1963–1979*, Stedelijk Museum, Amsterdam, 1979.
Ellsworth Kelly: The Years in France, 1948–1954, National Gallery of Art, Washington, 1992.

Franz Kline

was born on 23 May 1910 to Anglo-German parents in Wilkes-Barre, Pennsylvania. When he was three years old his mother remarried, to the chief of a railway round-house. Marked by a mixture of engineering, the coal mining industry and the Appalachian landscape, Kline's childhood experience was to retain a prominent place in his imagination. After Girard College in Philadelphia, Kline attended LeHighton High School (1925). At Boston University he studied painting (1931–35) and then left for Paris (1937), going on to London, where he received training in illustration and draughstmanship, and married Elizabeth Vincent Parsons. Returning to America, Kline chose to live in New York. Inspired by its ambience, he painted oils and watercolours indebted to Ashcan School realism, as well as murals for a bar (1940) that reflected his admiration for the painterliness of such predecessors as Goya, Manet and Sargent. Kline was already seeking a pictorial equivalent to his animated subjects in quick, rudimentary brush-strokes.

In 1946 Kline began to approach abstraction, hastened by his awareness of similar developments in the work of Willem de Kooning, Robert Motherwell and Bradley Walker Tomlin. Forms were reduced to an almost academic armature of lines and planes which ultimately gave rise to a faceted pictorial mosaic (*The Dancer*, 1946). As his handling became more fluidly dynamic over the next three years, the compositions stressed the primacy of calligraphic marks (*Untitled, c.* 1948). Concurrent studies in ink on paper revealed a growing taste for a palette reduced to black and white alone. When de Kooning enlarged some of these drawings with the aid of a Bell-Opticon projector in 1948 (or perhaps 1949), this convinced Kline of the great potential inherent in the small sketch. Using wide house-painter's brushes, black and white as the only 'colours' and monumental formats, Kline arrived at his quintessential image in 1950. The works in his solo exhibition at the Egan Gallery in October and November of that year displayed its essential traits. Monolithic black wedges (frequently executed in commercial enamel paint) career across the canvas, seeming to thrust beyond its limits. Arcs or loops sometimes enliven the rough grid patterns, or configurations are reduced to utter simplicity (*Wotan*, 1950). To many critics, they suggested Oriental brushwork. Yet Kline himself emphasized his fascination with the raw urban beauty of New York and the equipoise of his chiaroscuro effects: 'I paint the white as well as the

black, and the white is just as important.' Moreover, the aura of tough spontaneity was, in fact, well rehearsed in the many preparatory sketches that he executed on telephone directory pages. The titles allude to diverse personal enthusiasms and nostalgias, from the names of favourite places (*Delaware Gap*, 1958) to those of locomotives (*Cardinal*, 1950).

The instantly appealing drama of Kline's mature art ensured its rapid success. In 1958 Kline (who had been teaching at a number of institutions, including Black Mountain College in North Carolina and Brooklyn's Pratt Institute) was among those included in The Museum of Modern Art's canonical exhibition 'The New American Painting', which toured eight European cities. Although dazzling, even consciously garish, hues had returned to his pictures by 1959, the direction of Kline's artistic vision was uncertain at the time of his tragically premature death from a rheumatic heart condition on 13 May 1962. D. A.

Fielding Dawson, *An Emotional Memoir of Franz Kline*, New York, 1967.
Harry F. Gaugh, *Franz Kline: The Color Abstractions*, Washington, The Phillips Collection, 1979.
Harry F. Gaugh, *The Vital Gesture: Franz Kline*, New York, 1985.

Jeff Koons

was born in York, Pennsylvania, on 21 January 1955. The son of a furniture store owner, he attended the Maryland Institute of Art in Baltimore, where a student programme in his final year took him to the Art Institute of Chicago (1975–76). There, he was impressed by Ed Paschke's notion of the street as an information source for art. A job selling museum memberships at New York's Museum of Modern Art followed. For some five years thereafter he had a successful career as a Wall Street commodities broker.

By 1979 Koons was encasing gaudy inflatable toys in Plexiglas boxes and mounting them

on pedestals. His first sculpture series, 'The New', presented appliances, such as a new vacuum cleaner (*Hoover Convertible*, 1980), in a case with fluorescent lighting, complete with advertising posters printed in ink on canvas. His first one-man show (1985) set forth the 'Equilibrium' series. It included basketballs submerged in aquariums and bronze casts of water-related items, such as *Snorkel*, with posters of sports celebrities on the wall. 'Luxury and Degradation' (1986) focused on alcohol. As a reflection of the consumer society, these works addressed such issues as class structure, the commodification of art and the desire for luxury. A fourth series, 'Statuary', dealt with artistic symbols: the famous *Rabbit* – a cast stainless steel sculpture reproducing an inflatable toy – stood for aesthetic fantasy and *Louis XIV* for power in art (both 1986). A kitsch carnival of colossal knickknacks, Disney-like animals and souvenir-type figures came next, created in triplicate for concurrent exhibitions in Chicago, New York and Cologne. As much as the objects, Koons himself became the star in the accompanying art magazine advertisements. Among the items were polychrome hand-carved wooden sculptures made by Italian and German artisans to Koons's specifications. A photographer whose postcard picture of puppies Koons had used as a model for a sculpture (*String of Puppies*) took legal action against Koons for infringement of copyright in 1989. At issue were the strategies and ethics of appropriation.

Married in 1991 to the Italian porn star Ilona Staller (alias Cicciolina), the artist keeps apartments in Munich and New York. A

product of mass-media and popular culture, his images come from soft porn, film, rock music and television. Themes of sex, religion and culture all announce Koons's interest in 'the morality of what it means to be an artist'. Yet his work is also indebted to the tradition of Duchamp's ready-mades, Warhol's soup cans and Oldenburg's soft sculptures. On account of his 'cool' attitude to artificiality, to the banal and to the simulation of experience in general, Koons was reckoned to belong to the Neo-Geo artists of New York's East Village by the mid-1980s. Nevertheless, he toys with Conceptualism ('I am an idea man'). Communication with the masses is an ongoing, if quixotic, ambition. According to Koons, 'the trick is to be outrageous but not offensive', which seems to imply a value-free aesthetic. Thus, critical scandal greeted his 1992 display 'Made in Heaven', which consisted of sexually explicit, silk-screen photographs and glass sculptures of Koons and his wife that suggested a contemporary Adam and Eve, surrounded by the trappings of camp sentimentality: flowers, butterflies, Yorkshire terriers. Despite the artist's fame and fortune, critical opinion is divided. On one hand, Koons is deemed 'slick, facile, cynical', someone who carries 'the love of kitsch to a new level of atrocious taste'. On the other, he has been called the most important artist of the 1980s. A.B.

Klaus Kertess, 'Bad', *Parkett*, no. 19, March 1989, pp. 30–43.
Jeff Koons, San Francisco Museum of Modern Art, 1992.
The Jeff Koons Handbook, London, Anthony d'Offay Gallery, 1992.

Sol LeWitt

was born on 9 September 1928, in Hartford, Connecticut, into a family of Russian Jews. In 1949 he graduated with a BFA from Syracuse University. While serving in the US Army in Japan and Korea in 1951–52 he visited and studied Oriental shrines, temples and gardens. After attending the Cartoonists & Illustrators School in New York (1953), he became a graphic designer, working for a time in I.M. Pei's architectural firm (1955–56). Although LeWitt was already painting in the 1950s, his artistic career did not really take wing until the early 1960s, when he produced his first sculptures, or, as he prefers to call them, 'structures'. In 1962 a group of wall reliefs in which wooden squares were attached to canvases revealed his interest in geometrical configurations. Influenced by Eadweard Muybridge's sequential photographs of horses and human

figures in motion, LeWitt investigated the idea of a serial system, creating pieces in which the hidden parts can be inferred from the exposed elements, following a regular sequence of intervals or projections. He thus became a leading exponent of Conceptual Art, a major development of the late 1960s and 1970s in which the idea behind a work of art is more important than its actual realization. Such art is supposed to appeal to the viewer's mind rather than to the eyes alone. LeWitt's best-known pieces were begun in 1964: modular structures in wood or metal, at first in black, later painted white. The module – a square or a cube – was repeated in accordance with mathematical progressions; each unit could become part of a complex set of variations on a theme, as in *47 Three-part Variations of three Different Kinds of Cubes* (1967). In the second half of the 1960s LeWitt was also active as a teacher, at the Museum of Modern Art School (1964–67), the Cooper Union (1967–68), the School of Visual Arts (1969–70) and the New York University Art Department (1970–71). In articles for *Artforum* and *Arts Magazine* LeWitt propounded his Conceptual ethos. On the other hand, he has rejected the label 'Minimalist' as applied to his art.

LeWitt's open, modular, cubic structures were first exhibited at the Dwan Gallery in 1966. A year later, he began producing wall drawings, which can be regarded as ideas rather than as objects, since they are overpainted at the end of each exhibition and can be executed by different draughtsmen, on different walls and in different sizes. Like the floor structures, they follow a directional system established by the artist. Because it is a text which defines the drawings on the basis of geometrical laws, the genesis of these works is primarily linguistic and mathematical. Although gossamer lines – straight, broken, short, diagonal, parallel and so forth – were the main element in the early wall drawings, executed in black pencil, by the 1980s these had become more colourful, with large geometrical figures in unmodulated colours and occasional illusionistic perspective effects. The small and private counterpart of the often exhilaratingly beautiful large public graphics are the books of drawings and photographs which LeWitt has been producing since 1966. They evince a similar systematic approach in order to reach beyond the exclusive audience of the art world. LeWitt lives and works in New York. I.D.

Sol LeWitt, ed. Alicia Legg, New York, Museum of Modern Art, 1978.
Sol LeWitt: Wall Drawings 1968–1984, ed. Susanna Singer, Amsterdam, Stedelijk Museum, 1984.

Sol LeWitt: Wall Drawings 1984–88, Berne, Kunsthalle, 1989.

Roy Lichtenstein

was born on 27 October 1923 in New York City. His artistic training began in 1939 with summer classes at the Art Students League under the instruction of Reginald Marsh. While a student at the School of Fine Arts at Ohio State University in Columbus, Lichtenstein was called up, and spent three years with the US Army in Europe (1943–46). On his return to the United States, he completed his studies, receiving a BFA in 1946 and an MFA in 1949. His early paintings explored subjects drawn from American history and the Far West in a figurative style influenced by Cubism. After his first one-man show, at the Carlebach Gallery in New York in 1951, Lichtenstein moved to Cleveland, where he worked as an engineering draughtsman and a graphic designer. Returning to New York in 1957, he taught at the New York State College of Education at Oswego (1957–60) and at Douglass College, Rutgers University (1960–63), where he met Allan Kaprow, who introduced him to Happenings and environments, and stirred his interest in American consumer culture. Lichtenstein gave up the gestural Abstract Expressionist style that had characterized his work in the late 1950s to find new inspiration in everyday life and popular imagery. In 1961 he produced six epoch-making, large-scale paintings of comic-strip images – *Look Mickey*, for example – which he had reproduced by hand, including the lettering, balloons and Ben Day dots. Impressed by their originality, Leo Castelli

exhibited them at his gallery the following year, thus launching the career of one of the major Pop artists. Along with the comic strips, Lichtenstein painted black and white close-ups of household objects, based on images culled from newspaper advertisements. In 1963 he began using an opaque projector to transfer his small pencil sketches to the canvas. His images became more and more closely cropped, in order to emphasize dramatic effect as a contrast to the seemingly impersonal and mechanical rendering. Advertising imagery, consumerism and popular culture remained at the core of Lichtenstein's art, and were explored in a succession of themes: foodstuffs, war and violence, science fiction, love and romance, landscapes, explosions. Playing on the distinction between 'high' and 'low' art, Lichtenstein adapted paintings by famous artists to the stylistic idioms of popular imagery. The 'Brushstroke' series of 1965–66 further investigated the theme of art in an ironic mode, displaying as a mechanical image the symbol *par excellence* of artistic spontaneity and subjectivity.

In the 1970s Lichtenstein, who in the meantime had moved to Southampton, Long Island, widened the range of his sources: in more complex compositions, based on those of such modern masters as Cézanne, Matisse, Léger and Mondrian, he questioned assumptions about the originality and reproduction of works of art. At the same time, his paintings became increasingly self-referential, as in the *Studio* series. Two large murals executed in New York in the mid-1980s (at Leo Castelli's gallery in Greene Street and in the Equitable Building) summed up his replicative system with their obsessive quotation of earlier motifs.

As early as 1963 Lichtenstein was able to give up teaching and support himself as an artist. A large retrospective was held at the Guggenheim Museum, New York, in 1969. In 1981 an exhibition devoted to his art of the 1970s opened at the St. Louis Art Museum and travelled in the United States, Europe and Japan. Lichtenstein lives in Manhattan and Southampton, Long Island. I. D.

John Coplans, ed., *Roy Lichtenstein*, New York, 1972.
Jack Cowart, *Roy Lichtenstein 1970–1980*, St. Louis Art Museum, 1981.
Lawrence Alloway, *Roy Lichtenstein*, New York, 1983.

Robert Mangold

was born on 12 October 1937 in North Tonawanda, New York, and was brought up in the rural environment of upstate New York. His

father worked in the Wurlitzer Organ factory. Mangold was encouraged to draw at High School and subsequently studied art at the Cleveland Art Institute (1956–59). He won a summer fellowship to Yale University, and in 1962 completed his BFA there. At Yale the influence of Josef Albers left its mark on Mangold and he went on to post-graduate work, receiving an MFA in 1963. Mangold has described this period thus: 'What was interesting is that throughout my experimenting, there was a sense of structure – a two-dimensionality. Everything was kind of right angles to the sides.' At Yale he met the painter Sylvia Plimack; they married in 1961.

In 1962 Mangold moved to New York, where he found a position as an apartment house superintendant. At The Museum of Modern Art he worked first as a gallery attendant and then in the library. In 1963 the artist began to teach painting at the School of Visual Arts in New York. His work was included in the 1962 exhibition 'Hard Edge Painting' at the Fischbach Gallery.

Mangold's first one-man show took place at the Thibaut Gallery (1964) and was followed by one at the Fischbach Gallery (1965). At both, Mangold showed his 'Walls' and 'Area' paintings, constructed of Masonite-faced plywood, their surfaces spray-painted so as to blend colour and tone, lending an atmospheric quality to the monochromaticism. Superficially, Mangold's work at this stage of his career appeared closely related to Minimalism. A 1967 exhibition at the Fischbach Gallery featured works based on the section of a circle, painted on Masonite; these simple, sharply defined creations were intended to be read as a sequence adding up to a geometric whole.

After receiving a Guggenheim grant in 1969, Mangold moved with his family to upstate New York. He continued to work in a hard-edged, Minimalist style but, reacting against his earlier, architectural pieces, began

to produce more emblematic paintings. In the late 1960s Mangold changed from oil to acrylic, rolling the paint on to the surface of shaped canvases and using a single, intense hue to define each one. For the first time, the artist made preparatory drawings, brushing his colour on to the paper's surface. These textured surfaces became an integral part of Mangold's pictures: 'There was a need for the surface of the paintings themselves to be more tangible, more tactile, more *there*.'

In the 1970s Mangold again shifted his stylistic emphasis towards more specifically geometrical forms. He created X-shaped canvases, followed by illusionistic 'Frame Paintings' whose centres were cut away. As he had explored ambiguous colour in his earlier works, so Mangold now experimented with equally ambiguous shapes.

In recent years Mangold has again turned his attention to matters of textural variation and touch – allied to a palette that is still restrained, yet more lyrically evocative – creating canvases with agitated brushwork, such as *Brown Frame/Gray Ellipse* (1987), a bi-partite composition uniting a 'Frame Painting' and an image of an ellipse inscribed upon a highly expressive painted field. Mangold lives in New York City and Washingtonville, New York. L. K.

Diane Waldman, *Robert Mangold*, New York, Solomon R. Guggenheim Museum, 1971.
Robert Mangold: Gemälde, Bielefeld, Kunsthalle, 1980.
Robert Mangold: Schilderijen/Paintings 1964–82, Amsterdam, Stedelijk Museum, 1982.

Brice Marden

was born in Bronxville, New York, on 15 October 1938, spent his youth in Briarcliff Manor, New York, and attended Florida Southern College, Lakeland (1957–58). He then studied at Boston University School of Fine and Applied Arts (BFA, 1961). While at Yale University School of Art and Architecture (MFA, 1963) Marden did chequerboard-like abstractions. In New York from 1963 onwards he took various part-time jobs, including one as a gallery attendant at the Jewish Museum when it was holding a Jasper Johns retrospective. Soon Marden began painting in subtly inflected grisaille. To achieve a dull yet evocative surface, in 1965 he combined beeswax, turpentine and pigment (the ingredients of encaustic), thus also creating resonant tones of a densely layered appearance. He received his first New York one-man show at the Bykert Gallery in 1966. A series of vertically joined diptychs and triptychs, each panel of a single

Photo © Timothy Greenfield-Sanders

colour, had evolved by 1968. Taken by the atmosphere of the Mediterranean, Marden first visited Hydra in Greece in 1971 (he now spends summers in his house there). The grey-green *Grove Group* (1973) was inspired by a Greek olive grove. Primary hues emerged in a painting in the *Figure* series (1974); that year also saw the publication of his *Suicide Notes*, a book of pen and ink drawings.

The *Annunciation* series (1977) invites comparisons with Barnett Newman's *Stations of the Cross*: its titles are the Latin words for the stages of the Virgin's spiritual progress. The eighteen-panel *Thíra* triptych (1980), named after that Greek island, invokes the post-and-lintel architecture of Greek temples. In the early 1980s Oriental calligraphy and Eastern thought influenced Marden as his style became more freely gestural. Preparatory designs for stained-glass windows in the medieval cathedral of Basle during the late 1970s and 1980s were never fully executed. The large *Cold Mountain* canvases (1988–89, 1990–91) drew upon the verse of the Tang dynasty poet of that name. The recipient of the Skowhegan Medal for Painting in 1989, Marden has been called a 'painter's painter'. He is held in high critical esteem and has had frequent exhibitions at an international level.

In using a limited chromatic range – one colour on a panel, and black and white in his drawings – Marden recalls Minimalism. Yet his is a more personal and mystical sensibility. In particular, his palette tends to 'off-key' choices; the pictorial surfaces at once absorb and radiate light. The conjunction of meditative colour fields and references to subjective states relates his approach to Abstract Expressionism. The artist has said: 'The paintings are made in a highly subjective state within Spartan limita-

tions. Within these strict confines … I try to give the viewer something to which he will react subjectively. I believe these are highly emotional paintings not to be admired for any technical or intellectual reason, but to be felt.' The balance that Marden establishes between colour, surface and shape expresses a connoisseur's sensibility, which is also evident in his discerning art-historical knowledge. However, the artist concludes: 'The rectangle, the plane, the structure, the picture are but sounding boards for a spirit.' A. B.

Brice Marden: Paintings, Drawings, and Prints 1975–80, London, Whitechapel Art Gallery, 1981.
Klaus Kertess, *Brice Marden: Paintings and Drawings*, New York, 1992.
Jeremy Lewison, *Brice Marden: Prints 1961–1991, A Catalogue Raisonné*, London, 1992.

Agnes Martin

was born in Macklin, Saskatchewan, Canada, on 22 March 1912 to Scottish pioneers originally from the Isle of Skye. The daughter of a farmer, she spent her youth in Vancouver, British Columbia. After moving to the United States in 1932, she attended Western Washington State College, Bellingham, from 1934 to 1937. Studying history and fine arts at Columbia University Teachers College in New York City, she received a B.Sc. (1942) and an MA (1952). Martin attended the University of New Mexico, Albuquerque, during 1946–47, and taught there briefly. From the late 1930s to the early 1950s she held various teaching posts at schools in Washington, New Mexico and Oregon. In 1950 she became an American citizen. Following a number of sojourns in Taos, New Mexico, in the mid-1950s, and after meeting Betty Parsons, Martin returned in 1957 to New York and Manhattan's Coenties Slip area, where Robert Indiana, Ellsworth Kelly, James Rosenquist and Jack Youngerman also had studios.

Her first solo exhibition, held in December 1958 at Betty Parsons's Section 11 Gallery,

brought favourable reviews for her 'wide fields softly and evenly painted'. Her next exhibition at Parsons's gallery was compared to the paintings of Barnett Newman and Mark Rothko. In 1961 Martin was included in the *Pittsburgh International Exhibition* at the Carnegie Institute and subsequently in the Whitney Museum's 'Geometric Abstraction' (1962). Her first important exposure in Europe was in 1972 at the Kassel 'documenta V'. In 1966 she received a grant from the National Endowment for the Arts. The following year, after a ten-year absence, she returned to New Mexico to build her own adobe house on a mesa, and stopped painting until 1974, concentrating instead on writing. As a critic has noted, 'In the beautiful desert, she found a landscape to suit the art rather than the reverse'. A portfolio of prints – *On a Clear Day* – was published by Parasol Press (1973). Her work was included in the US Pavilion at the 1976 Venice Biennale. Membership of the American Academy of Arts and Letters came in 1989, and in 1992 she received the Oskar Kokoschka prize from the Austrian government. Since 1977 she has lived and worked in Galisteo, New Mexico.

Martin's reputation rests on a coherent body of paintings characterized by meditative sensuousness. Her work remained representational until the mid-1950s, when she developed a biomorphic abstract style. From about 1958 onwards, rectangular shapes (often drawn in pencil) of light-filled pale colour dominate her paintings. After 1964 a systematic vertical and horizontal grid of delicate tonalities prevails. In a 1967 statement to Lucy Lippard, she said: 'My forms are square, but the grids are never absolutely square … when I cover the square surface with rectangles, it lightens the weight of the square, destroys its power.' There is a timeless quality about her images that, going beyond their superficially Minimalist character, reflects an interest in nature and poetry as well as in the Chinese philosopher Chuang Tzu. A. B.

Agnes Martin, Philadelphia, Institute of Contemporary Art, 1973.
Agnes Martin: Paintings and Drawings 1957–1975, London, Hayward Gallery, Arts Council of Great Britain, 1977.
Agnes Martin, New York, Whitney Museum of American Art, 1992.

Robert Morris

was born in Kansas City, Missouri, on 9 February 1931. From 1948 to 1950 he studied engineering at the University of Kansas City while attending that city's Art Institute. After a

term with the US Army engineers in Arizona and Korea (1951–52), he began his multi-faceted artistic career in San Francisco with theatrical improvisations, dance performances and paintings. Influenced by Abstract Expressionism, Morris's early canvases were executed on the floor in a gestural style reminiscent of Jackson Pollock's 'black pourings' of the early 1950s. In New York in 1961 Morris enrolled in the Hunter College art history course and received an MA in 1963; his thesis was on Constantin Brancusi. Meanwhile, he had abandoned painting for sculpture, producing small ironic and subversive constructions indebted to Marcel Duchamp's Dadaist spirit. Morris's fame, however, accrued more from Minimalist pieces executed between 1961 and 1967. In these large regular polyhedrons, usually made of plywood and painted grey, he challenged the viewer's preconceived notions of form by highlighting differences in the conditions of perception: scale, proportion, light, space and so forth. Two identical L-beam forms, for example, placed in different positions, established a contrast between the kindred conceptual identity of the two pieces and their striking visual dissimilarity. Like many dance and theatre performances in which Morris participated in the early 1960s, such sculptures encouraged the beholder to experience the work in relation to his or her own body and movements. Morris formulated a theoretical rationale in a cluster of articles published in the late 1960s and now deemed 'manifestos' of Minimalism in general. His first exhibition of sculpture was at the Green Gallery, New York, in 1963. By 1970 he had been given several museum shows, both in the US and Europe.

Reacting to the conception of sculpture as an end-product, Morris further stressed the art-making process in his 'antiform' creations of the late 1960s – accumulations of debris, mounds of dirt, clouds of steam. (Their precursors were works such as the 1961 *Box with the Sound of its own Making*, which contained audiotapes of the noises produced by its fabrication.) These, in turn, led to an expansion of contextual considerations in several

site-specific outdoor installations related to Earth Art. In the summer of 1967 Morris also began to address the inherent properties of felt, a material that could be piled on the floor or hung on the wall in temporary arrangements. At first, chance played an essential part in the constant remaking of the piece; in later examples, however, the disposition of the felt was more controlled to suggest sexual connotations.

In an unforeseen *volte-face* Morris returned to painting in 1983, creating emotive figurative visions in radical contrast to the lean geometry of his previous sculpture. Tragic themes (the Holocaust, fire-storms) dominate these violent, expressionistic images, and references to past art (including Goya and Turner) abound. The most recent employ inscriptions and deceptive mirror images bearing forthright political messages: the subversiveness of Morris's art, a lurking ingredient from its beginnings, was here made explicit. The artist lives in New York. I. D.

Annette Michelson, *Robert Morris*, Washington, Corcoran Gallery of Art, 1969.
Maurice Berger, *Labyrinths: Robert Morris, Minimalism, and the 1960s*, New York, 1989.
Terrie Sultan, *Inability to Endure or Deny the World. Representation and Text in the Work of Robert Morris*, Washington, Corcoran Gallery of Art, 1990.

Gerald Murphy

was born in Boston on 26 March 1888 into a privileged environment. His father was a successful Irish-American leather and luggage merchant. After attending Hotchkiss school in Andover and Yale University (from which he graduated in 1912), Murphy worked for several years in the family business, the Mark W. Cross Company. His interest, however, waned and he turned to studying landscape architecture at Harvard. Yet, restless and seeking freedom from family pressures, Murphy and his wife, Sara Sherman, née Wiborg, moved to Europe in 1921. After a few months in England, the Murphys went with their three children to Paris. There he discovered modern art and decided to become a painter.

Through his lessons with the Russian Constructivist Natalia Goncharova, Murphy became acquainted with Sergei Diaghilev's Ballets Russes and repainted that company's fire-damaged scenery under the guidance of its designers, artists such as Picasso and Braque. His own 'American Ballet', entitled *Within the Quota*, with a score by his college friend Cole Porter, received its première on 25 October

1923 at the Théâtre des Champs-Elysées as an opening act for *La Création du Monde* with sets by Fernand Léger. Soon Léger became a close friend and a seminal influence. Murphy shared the French painter's enthusiasm for machine-made objects, advertising and shop-window displays, as well as for graphic and product design in general.

Between 1924 and 1929 Murphy created a small body of paintings whose subjects were things that he found admirable in their combination of ordinariness and beauty: fountain pens, matches, a watch and its interior, a corkscrew, a safety razor, a cocktail shaker and glasses. His bold, precisely schematized, iconic treatment earned him the highest praise from Léger as 'the only American painter in Paris'. Murphy's friend Picasso also admired the peculiarly American, forthright simplicity of his approach. He and Léger were frequent guests at the Murphys' summer retreat in Antibes, which they named the 'Villa America'. Among its renowned expatriate visitors were Cole Porter, Scott and Zelda Fitzgerald, Ernest Hemingway and the poet Archibald MacLeish.

Murphy's unfortunately brief artistic career ended in 1929, when his youngest son developed tuberculosis. In 1932 the family returned to America. During and after the tragic deaths of both his sons, in 1935 and 1937 respectively, Murphy managed the New York-based family business. Not until 1947 was he able to recover some of his paintings, which had been stored in Europe. In 1960, owing to the efforts of Douglas MacAgy at the Dallas Museum of Contemporary Arts, he was rediscovered and received a first comprehensive exhibition in the United States. Murphy died on 17 October 1964. Since then, his ten known paintings have

won recognition as significant contributions to the cultural epoch of the 'lost generation' – Gertrude Stein's term for the diverse group of American expatriates who had come to Paris by the early 1920s in search of freedom of expression. G. S.

William Rubin, *The Paintings of Gerald Murphy*, New York, Museum of Modern Art, 1974.

Honoria Murphy Donnelly and Richard N. Billings, *Sara and Gerald*, New York, 1982.

Rick Stewart, *An American Painter in Paris: Gerald Murphy*, Dallas Museum of Art, 1986.

Bruce Nauman

was born on 6 December 1941 in Fort Wayne, Indiana. He studied mathematics, physics and then art at the University of Wisconsin, Madison (B.Sc., 1964). After moving to California, he attended the University of California at Davis, studying under William Wiley, Robert Arneson and Manuel Neri. Nauman stopped painting in 1965, turning to film-making, performance art (his first use of fluorescent light) and to sculptures in rubber and fibreglass. The rough, unfinished look of these works revealed a concern with process. In 1966 he moved first to nearby Vacaville and then to San Francisco, where he became an instructor at the San Francisco Art Institute (1966–68). In May of that year he received his first one-man show, at the Nicholas Wilder Gallery, Los Angeles. During this period Nauman's main

preoccupation was with the body as object, as exemplified by the photograph *Self-Portrait as a Fountain*, a witty parody of Marcel Duchamp's *Fountain*. In 1967 he took up residence in Mill Valley, California. His first visit to New York in 1968 was on the occasion of his solo exhibition at the Leo Castelli Gallery. This included body moulds, neon sculpture and photographs, and received considerable critical acclaim. In the spring he showed holograms, video and sound works at the Nicholas Wilder Gallery. That year he also received a Visual Artists Award from the National Endowment for the Arts, spending the winter making videotapes in Southampton, New York. In 1969 his first European one-man show was held at the Konrad Fischer Gallery in Düsseldorf. He moved to Pasadena in the autumn of that year and visited Paris for his first solo exhibition there, at the Ileana Sonnabend Gallery.

Throughout the 1970s Nauman investigated issues relating to behaviour patterns, concealment, dislocation, enclosure and time. In 1970 he presented a video surveillance installation at the Nicholas Wilder Gallery, taught sculpture at the University of California in Irvine and received a grant from the Aspen Institute for Humanistic Studies to spend the summer in Aspen, Colorado. In 1979 he moved to Pecos, New Mexico. In the 1980s he returned to sculptural pieces, adding more overtly political allusions in a 'hanging chair' series. Satirical social commentary characterized a 1985 series of neon works treating the themes of sex and power. In 1991 Nauman was awarded the city of Frankfurt's Max Beckmann Prize.

Nauman's sculptural objects – in a remarkably wide range of forms and materials – tend to have been more concerned with the properties of objects than with their intrinsic form. Their post-Minimalist inventiveness is considered pivotal to developments in the medium since the late 1960s. His oeuvre also includes holograms, performances, videotapes, books, films, audio tapes, fibreglass and rubber objects, neon signs, photographs, installations and drawings. Underlying this heterogeneity is a fundamental focus upon the self, language and experience, and on the ways in which these categories may be manipulated, analysed and recorded. The artist lives in Galistel, New Mexico. A. B.

Coosje van Bruggen, *Bruce Nauman*, New York, 1988.

Christopher Cordes, *Bruce Nauman: Prints, 1970–89*, New York, 1989.

Jörg Zutter and Franz Meyer, *Bruce Nauman: Skulpturen und Installationen 1985–1990*, Cologne, 1990.

Barnett Newman

was born in New York on 29 January 1905 to Jewish immigrants from Russian Poland. He studied at the Art Students League (1922 and 1929–30) and the City College of New York (1923–27), then joined his father's clothing company. Having destroyed most of his early output, Newman ceased painting in about 1940 and thereafter his writings embraced a tragic content appropriate to the cataclysmic events of the age. They reflect the German art historian Wilhelm Worringer's ideas by contrasting 'order' with 'chaos' and 'man' with 'nature'. Their eloquence helped establish Newman – a lifelong anarchist who even stood for election as mayor of New York in 1933 – as an unofficial spokesman for the emerging Abstract Expressionist avant-garde. In 1944 he began small graphics evoking insectile, plant and spermatozoid forms. Sharper presences emerged in such paintings as *Death of Euclid* (1947) until, the following year, a breakthrough came with *Onement I*, in which a luminous red vertical bisects a darker field.

Newman's first one-man shows, held at the Betty Parsons Gallery in 1950 and 1951, revealed the scope of his vision. Typically, one or more bands, termed 'zips' by Newman, punctuate stark chromatic expanses. These elements were to be subjected to complex, manifold variations. The composition might remain symmetrical, as in *Onement I*, or the zips stand at its outermost edges. Five verticals span the huge crimson panorama of *Vir Heroicus Sublimis* (1950–51), whereas *The Wild* (1950) is a tall but very narrow picture. Colour ranged from the intense indigo of *Cathedra* (1950) to the all-black *Abraham* (1949) and the white *The Voice* (1950). Evocative titles suggest sublimity behind this austere manner. Indeed, Newman considered 'the sublime' to be his ultimate subject-matter.

Newman was highly active in the New York art world during the 1940s as an organizer of such exhibitions as 'Pre-Columbian Stone Sculpture' and 'The Ideographic Picture'. In 1949 he was also a founding member of the 'Subjects of the Artist' school. Yet by the mid-1950s his audaciously spare idiom and uncompromising stance had isolated him from colleagues, critics and the dominant 'gestural' styles. Financial problems exacerbated this crisis and in 1956 Newman again stopped work. He suffered a heart attack the following November.

A one-man show at Bennington College, Vermont, in 1958 announced Newman's resurgence. Inclusion in The Museum of Modern Art's international travelling show 'The New

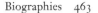

American Painting' soon followed, as did a request from Clement Greenberg to exhibit at French and Company (1959). The year 1958 also saw the first of the fourteen monochrome *Stations of the Cross* (completed 1966). During this final phase Newman's output was prolific. He did several large steel sculptures (including *Broken Obelisk*, 1963–67, the *18 Cantos* lithographs, 1963–64, and the *Who's Afraid of Red, Yellow and Blue* series, 1966–70) and two innovative triangular canvases (*Chartres*, 1969, and *Jericho*, 1968–69); he was also chosen as the United States representative at the 1965 São Paulo Bienal. Younger artists and critics in the later 1960s saw Newman as the catalyst of a radical, path-breaking type of abstraction. He died on 4 July 1970. D. A.

Thomas Hess, *Barnett Newman*, New York, Museum of Modern Art, 1971.
Brenda Richardson, *Barnett Newman: The Complete Drawings 1944–1969*, Baltimore Museum of Art, 1979.
John P. O'Neill, ed., *Barnett Newman: Selected Writings and Interviews*, New York, 1990.

Georgia O'Keeffe

was born on 15 November 1887 near Sun Prairie, Wisconsin. Her lifelong worship of nature reflected early years spent on a dairy farm in that state. During 1905–6 she studied at the School of the Art Institute of Chicago, where her instructor, John Vanderpoel, drew analogies between the beauty of the human body and natural forms. O'Keeffe then moved to New York, where she attended the Art Students League (1907–8) and encountered modern European art, including Rodin and

Matisse, at Alfred Stieglitz's 291 gallery. Yet, temporarily discouraged, she pursued a commercial art career for two years until inspired to continue her own work by studies under Alon Bement at the University of Virginia in Charlottesville (1912). He expounded the decorative principles of Art Nouveau and Oriental art, and O'Keeffe adopted his stress on simplifying form to reveal its essence. Kandinsky's writings confirmed her in this, as did Arthur Dove's organic compositions. Determined to give visual expression to her emotions, O'Keeffe did original, nature-based abstractions in 1915–16. These charcoal drawings impressed Stieglitz, who gave her her first solo exhibition in 1917. The following year O'Keeffe moved back to New York, joining Stieglitz's circle of avant-garde artists. She and Stieglitz were married in 1924.

Although New York remained her main place of residence, O'Keeffe spent long periods in the countryside every year, especially in the Lake George region. In that setting many of her best-known canvases were painted – monumental, subtle arrangements of flora whose magnified scale recalls Paul Strand's photographs. A 1923 retrospective at the Anderson Galleries, New York, revealed O'Keeffe's range – from abstractions to more representational landscapes and still-lifes. Yet she left abstraction behind in 1924, partly to pre-empt further sexual readings of her art. O'Keeffe turned to the man-made, burgeoning New York skyline from 1925 to 1929. Struck by the views from her thirtieth-floor Shelton Hotel apartment, she painted Precisionist vistas of the Manhattan skyscrapers and the East River.

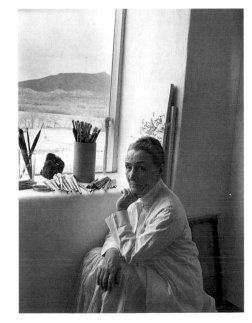

Other architectural subjects included barns in the Lake George region and in Canada (late 1920s–1932) and the adobe Ranchos Church, New Mexico (1929–30).

The wide-open solitude of New Mexico's scenery lured O'Keeffe to the West for six months every year until, in 1949, after Stieglitz's death, she settled in Abiquiu, New Mexico. During the 1930s and 1940s her prime subjects were bleached animal bones and the exotically coloured desert with its mountains and geological formations seen in a crystalline light. Juxtapositions of the latter sometimes have a surreal aura.

Extensive foreign travel in the 1950s and 1960s prompted O'Keeffe's late images of abstracted clouds and rivers. Her growing reputation as an iconically American artist resulted in a retrospective at the Whitney Museum of American Art, New York, in 1970. After becoming partially blind a year later, O'Keeffe stopped painting, until her assistant and companion, Juan Hamilton, encouraged her to start again in 1975. Yet she did relatively little work in the remaining years before her death on 6 March 1986 at the age of ninety-eight. G. S.

Georgia O'Keeffe: Art and Letters, Washington, National Gallery of Art, 1987.
Lisa Mintz Messinger, *Georgia O'Keeffe*, New York, Metropolitan Museum of Art, 1988.
Barbara Buhler Lynes, *O'Keeffe, Stieglitz, and the Critics 1916–1929*, Ann Arbor, 1989.

Claes Oldenburg

was born on 28 January 1929 in Stockholm, the son of a consular official. At the age of five he emigrated with his parents to Chicago. After graduating from Yale University in 1950, he attended the School of the Art Institute of Chicago while working as a reporter. In 1956 he moved to New York and soon met artists working in environmental and theatrical fields, such as Jim Dine, Red Grooms, Allan Kaprow, George Segal and Robert Whitman. During the next decade Oldenburg composed and participated in numerous 'Happenings', for which he also created the costumes and props. His first sculptures – constructions of burlap, cardboard, newspaper and other found materials – related directly to everyday life and consumer culture. Shown in 1960 at the Judson Gallery, *The Street* was a total environment in which figures, buildings and cars were recreated from urban detritus. As a further bid to break down the frontier between art and life, Oldenburg opened The Store in

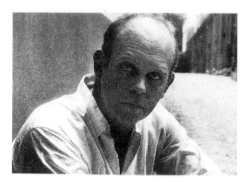

December 1961 in a rented shop space. There he displayed hand-made replicas of mass-produced objects: bread, cake, shoes, sausages, shirts and dresses, all made of plaster, muslin and chicken wire covered with drips of bright enamel paint. This manipulation of everyday objects found its most famous expression in the giant 'soft' sculptures exhibited in 1962 at the Green Gallery. Made of sewn canvas stuffed with foam rubber and painted with liquitex, these pieces – ten-foot-high ice cream cones, a hamburger seven feet in diameter and a pair of trousers of hallucinatory proportions – helped to launch the Pop Art movement in New York. A repertoire of commonplace objects was evolved – a Ray Gun, three-way plug, type-writer, rubber, cigarette ends – which Olden-burg reproduced in different sizes and materials. The subjects were chosen for their multifarious visual associations, as the artist played on the disjunction between the famil-iarity of the item and the scale, material and situation in which it was presented. At the same time, by eliminating the texture of the original objects through the use of soft mater-ials, he emphasized their human, often sexual, connotations.

Displacement and metamorphosis became more dramatic in the projects for colossal monuments, begun in 1965. Highly imagina-tive, these drawings and watercolours, such as that of a giant electric fan proposed as a replacement for the Statue of Liberty, bring home the poetic quality of commonplace objects when enlarged to a size that renders their surroundings lilliputian. The first to be realized was a giant lipstick erected on the Campus of Yale University in 1969. Typical of Oldenburg's multi-referential and metamor-phical imagery, this once small, private object, now colossal and erected on caterpillar tracks, became a phallic, red-tipped warhead. Rather than stressing the potential humour of such pieces, the artist proclaims 'enlarging the boundaries of art' as his aim.

Since 1976 Oldenburg, in partnership with his second wife, the Dutch author Coosje van Bruggen, has concentrated almost exclusively

on large-scale public works involving complex relationships between the object and the site, its history and the customs of its inhabitants. Their most recent work is the seventy-foot-high *Match Cover* in Barcelona's Vall d'Hebron (1992). The Oldenburgs live in Manhattan.

I.D.

Barbara Rose, *Claes Oldenburg*, New York, Museum of Modern Art, 1970.
Germano Celant, Claes Oldenburg and Coosje van Bruggen, *A Bottle of Notes and Some Voyages*, Sunder-land, Nothern Centre for Contemporary Art, 1988.
Coosje van Bruggen, *Nur ein anderer Raum/Just Another Room*, Frankfurt, Museum für Moderne Kunst, 1991.

Jackson Pollock

was born on 28 January 1912 in Cody, Wyoming, to Scottish-Irish parents. Throughout his childhood and youth (Jackson was the fifth and youngest son) the family shifted restlessly between various farms in Wyoming, Arizona and California. By the time Pollock was eight years old his father, who did surveying work besides farming, had drifted away from his redoubtable wife. In 1927 Pollock enrolled at Riverside High School, some sixty miles east of Los Angeles, but was expelled the following March. He next went to Manual Arts High School in Los Angeles itself, was soon asked to leave again and, by late 1930, was at the Art Students League in New York, studying under Thomas Hart Benton. During the 1930s Pollock took assorted jobs, perhaps most notably as an assistant in David Alfaro Siqueiros's workshop (1936) and in several federal art relief schemes. Chronic emotional problems had already expressed themselves in alcoholism before Pollock first received psychoanalytic treatment in 1939. Two years later, an acquaintance with Lee Krasner (the couple had met in 1936) blos-somed; they were married in 1945.

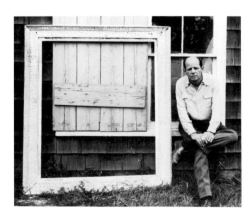

Pollock's art had evolved from a darkly gothic interpretation of Benton's Regionalism (*Going West*, c. 1934–38) to a more abstract, violent expressionism by the early 1940s. Manifold influences marked this development, among them a melodramatic dynamism that drew upon Benton's own energetic pictorial rhythms, Albert Pinkham Ryder, El Greco and Rubens; the emotive imagery and styles of the Mexican muralists Siqueiros, José Clement Orozco and Diego Rivera; and, supremely, Picasso. Adding ideas from Jungian and Freud-ian psychology, from native American Indian art and the Surrealist technique of automatism (especially as practised by Joan Miró and André Masson), Pollock arrived at such works as *Pasiphae* (c. 1943). Their raw painterliness impressed critics such as Clement Greenberg and the dealer Peggy Guggenheim. The former nurtured Pollock's career through his friendship and laudatory reviews; the latter gave him his first one-man show, at her Art of This Century Gallery (1943). After Guggen-heim returned to Europe in 1947, Pollock signed a contract with Betty Parsons. Between 1948 and 1951 he held annual shows with Parsons before finally switching to Sidney Janis's gallery.

In November 1945 Pollock had left Manhattan for a farmhouse at Springs, Long Island. The move coincided with a climactic change in his work: the genesis of the so-called 'drip' paintings (1947–50). These extraordinary images – the prime cause of Pollock's notoriety, acclaim and, finally, position of vast artistic influence – consist of intricate arcing traceries of pigment flung, poured and dribbled on to canvas laid flat on the studio floor. They vary from small formats to the almost eighteen-foot-long *Autumn Rhythm* (1950), from mono-chromatic to strikingly unusual hues and from utter abstraction to the nascent representation-alism of *Out of the Web* (1949). This figurative drive resurfaced in the black 'pourings' (1951–52). With the simultaneous return of his alcoholism, Pollock's artistic vision faltered, as did his psychological stability. Isolated pictures, such as *Easter and the Totem* (1953), however, continued to break new ground before the artist died in a car crash in Springs on 11 August 1956. Posthumously and swiftly, Pollock became the most famous American artist of the century.

D.A.

Francis V. O'Connor and Eugene V. Thaw, eds., *Jackson Pollock: A Catalogue Raisonné of Paintings, Drawings and Other Works*, New Haven, 1978.
Ellen G. Landau, *Jackson Pollock*, New York, 1989.
Steven Naifeh and Gregory White Smith, *Jackson Pollock: An American Saga*, New York, 1989.

Martin Puryear

was born on 23 May 1941 in Washington, the first of seven children. He pursued art throughout his youth and was adept at both drawing and handicraft. At Catholic University he studied studio art and aesthetics under Nell Sonneman, an important formative influence. Colour-Field painting was prominent in Washington at the time, but Puryear's early output remained representational. Graduating in 1963, he entered the Peace Corps, teaching biology, French and English at a mission school in Sierra Leone. There Puryear encountered a highly developed indigenous craft tradition and learned joinery techniques from local carpenters. Attending the Swedish Royal Academy on a Scandinavian-American Foundation grant during 1967–68, he worked independently with the cabinet-maker James Krenov. A heightened appreciation of the materials and tools of the woodworking artisan encouraged him to abandon the print-making he had been practising in favour of three-dimensional objects. In Europe Puryear profited from exposure to modern and contemporary art. At the Venice Biennale in 1968 Donald Judd, Robert Morris and Tony Smith impressed him with the power of primary form in their Minimalist sculpture.

From 1969 to 1972 Puryear was a graduate student at Yale University. The faculty included James Rosati and Al Held, as well as such visiting artists as Morris, Salvatore Scarpitta and Richard Serra. Close proximity to New York brought continued contact with

Minimalism and related trends in sculpture. During 1972–73, while teaching at Fisk University in Nashville, Puryear had two one-man exhibitions at the Henri 2 Gallery in Washington. The severity of the first, which included stacked geometrical configurations of wooden planks, gave way in the second to irregular or informal objects incorporating rope and leather.

Puryear taught at the University of Maryland between 1974 and 1978, but spent most of the time at a warehouse studio in Brooklyn, where his mature idiom emerged in large, refined biomorphic pieces in treated wood that vary in shape from the attenuated to the compact. Titles, such as *Bask*, *Circumbent* and *Some Tales*, are metaphorically allusive, often punning. After a devastating studio fire in 1977, he moved briefly to Washington and completed sculpture for an exhibition there at the Corcoran Gallery of Art. In 1978 he took a post at the University of Illinois, Chicago. By the late 1970s the artist had become proficient in the conceptual application of crafts – those of the joiner, the wheelwright and the cooper – that are generally associated with functional design. The utilitarian object became a conspicuous reference point in his work, though suggestions of myth and ritual hint at larger meanings. While the formal and poetic parameters of Puryear's art also reflect a profound debt to Constantin Brancusi, dramatic changes in scale between works and a surprising range of materials and techniques ultimately set him apart from his predecessors and contemporaries alike.

In outdoor projects Puryear has worked on an architectural and environmental scale. Public commissions of this kind include *Knoll for NOAA* (National Oceanic and Atmospheric Administration) in Seattle and *Bodark Arc* at the Governors State University in Illinois. Exhibited widely throughout the 1980s, his work was included in the Whitney Biennial in 1979, 1981 and 1989. In 1989 Puryear also received a MacArthur Foundation Fellowship and was awarded the grand prize at the São Paulo Bienal. He lives and works in Accord, New York. J. W.

Martin Puryear, University of Massachusetts, Amherst, 1984.
Michael Brenson, 'Maverick Sculptor Makes Good', *New York Times*, 1 November 1987, sec. 5, pp. 84, 88, 90, 92–3.
Neal Benezra, *Martin Puryear*, Art Institute of Chicago, 1991.

Robert Rauschenberg

was born Milton Rauschenberg on 22 October 1925 in Port Arthur, Texas. (In the late 1940s he adopted the name 'Bob', which subsequently became 'Robert'.) Drafted into the US Navy in 1942, he worked as a neuropsychiatric technician. His brief attendance at the Kansas City Art Institute (1946–47) was followed by further studies the next year at the Académie Julian in Paris. More important for his future development were several periods of study at Black Mountain College from 1948 to 1950 (under Josef Albers) and again in the early 1950s. There he met the choreographer Merce Cunningham and the composer John Cage, both of whom greatly influenced him. Following their lead, Rauschenberg incorporated a residue of the outside world in his works and allowed chance to play a fundamental role in the creative process. A series of all-white paintings exhibited in his first one-man show, held at Betty Parsons's New York gallery in 1951, revealed Rauschenberg's debt to Abstract Expressionism, albeit in an ironic and subversive appraisal of that style. By the mid-1950s Rauschenberg had embarked on the creation of his highly innovative 'combine paintings', in which he challenged all previous assumptions about the nature and the making of art. Assemblages of bespattered paintings, photographs and found objects, the 'combines' displayed the most unexpected juxtapositions: in *Monogram* (1955–59), for example, a stuffed goat wears a car tyre around its belly and stands on a collage of wood and metal. Although these works abound in visual puns and hidden meanings, no self-contained or sequential narrative informs

them. They incorporate objects from everyday life: *Bed* (1955) consists of Rauschenberg's own pillow, sheet and patchwork quilt hung on the wall and covered with paint. This controversial piece was included in the artist's first exhibition at Leo Castelli's gallery in New York in 1958.

In 1963 Rauschenberg was given an important retrospective exhibition at the Jewish Museum in New York and – heralding his international fame – was awarded the Grand Prize at the Venice Biennale the following year. Just prior to this, Rauschenberg had experimented with new techniques, such as rubbing newspaper prints on to canvas or transferring photo-silk-screens to it, the latter a procedure that had already been used by Andy Warhol. Like the 'combines', these two-dimensional works united disparate images in a way that was to remain characteristic of Rauschenberg's work.

From the outset, Rauschenberg's activity was not limited to the visual arts. In 1951 he participated with John Cage in what may have been the first 'Happening' of all and subsequently created theatre pieces in which he himself acted. Between 1955 and 1965 he was manager, stage designer and technical director of the Merce Cunningham Dance Company. In 1966, together with the scientist Billy Klüver, he formed Experiments in Art and Technology (EAT) in order to investigate the possible uses of advanced technology in the arts. With the collaboration of engineers and technicians he created pieces such as *Mud Muse* (1968–71), a basin of mud that bubbles in response to gallery noises.

In 1985 Rauschenberg launched Rauschenberg Overseas Cultural Interchange (ROCI), an exhibition of his work that toured the world and included pieces created specifically for each place visited. Dedicated to world peace, the project began in Mexico and travelled to China, Tibet, Cuba, Malaysia and other countries, ending in 1991 with a large retrospective at the National Gallery of Art in Washington. Rauschenberg lives on the island of Captiva, Florida. I.D.

Robert Rauschenberg, Washington, National Collection of Fine Arts, Smithsonian Institution, 1976.
Calvin Tomkins, *Off the Wall: Robert Rauschenberg and the Art World of Our Time*, New York, 1980.
Mary Lynn Kotz, *Rauschenberg: Art and Life*, New York, 1990.

Man Ray

was born Emmanuel Radinski on 27 August 1890 in Philadelphia, the son of a Russian-Jewish immigrant tailor. He began to paint at

the age of five. In 1897 his family moved to Brooklyn, where he went to school. Although he won a scholarship to study architecture, Ray chose to abandon formal education. In New York he worked as an engraver and then in an advertising office, simultaneously taking night classes at the National Academy of Design; he later joined a publicity firm and drew maps for a publisher.

Visits to Alfred Stieglitz's 291 gallery stimulated Ray's feeling for photography. After living with the Belgian poet Adon Lacroix in an artists' colony in Ridgefield, New Jersey, he married her in 1914. The Daniel Gallery gave the artist his first one-man show of paintings in 1915. Meeting Marcel Duchamp that year was to prove seminal; together with Francis Picabia, they became founders of New York Dada. In 1918 Ray first made 'aerographs', paintings executed with an airbrush on photographic paper. In 1920 he helped Katherine Dreier and Duchamp found the *Société Anonyme*. Two years later, he moved to Paris, remaining there until 1940. In Paris he found himself at the centre of the Dada movement. Unable to sell his art, Ray turned to photography. Experiments with photographic techniques led in 1921 to the 'Rayograph', an abstract image created by arranging objects on light-sensitive paper which is then exposed and developed. Ray also became a portrait photographer, documenting the cultural personalities of the era.

When Surrealism developed out of Dadaism in 1924, Ray was one of its founders and was included in the first Surrealist exhibition. Inspired by his model and mistress, Alice Prin – known as Kiki of Montparnasse – he photographed her in the nude painted with violin sound holes: *Le Violon d'Ingres* (1924). Kiki also prompted another of his hallmark images, *The Lovers, or Observatory Time*

(1932–34), in which enlarged lips hover in the sky of a placid landscape.

Ray made several classic avant-garde films, including *L'Etoile de Mer* (1927). Among his best-known Dada objects is *Object to be Destroyed* (1923), a metronome with the photograph of an eye clipped to its arm. The 'solarizations', photographic negatives exposed to light, date from the 1930s. Living in Hollywood between 1940 and 1951, Ray supported himself by teaching and lecturing, and married Juliet Browner in 1941. His autobiography, *Self Portrait*, was published in 1963. Although an American, Ray received greater recognition in France than in his native country. His iconoclastic dictum was that 'everything is art'.

Ray's fertile output eludes neat categorization and reflects his agile, humorous sensibility. Besides painting and photography, it includes films, objects, collages, prints, drawings, commercial design and fashion advertisements. As a pioneer of both Dada and Surrealism, his approach is characterized by the irrational and incongruous, seeking out eroticism and scandal: 'The pursuit of liberty and the pursuit of pleasure – that takes care of my whole art.' Ray returned to Paris in 1951, and remained there until his death on 18 November 1976. A.B.

Roland Penrose, *Man Ray*, Boston, 1975.
Neil Baldwin, *Man Ray, American Artist*, New York, 1988.
Merry Forresta et al., *Perpetual Motif: The Art of Man Ray*, Washington, National Museum of American Art, Smithsonian Institution, 1988.

Ad Reinhardt

was born on 24 December 1913 in Buffalo, New York, to Russian-German parents who moved, two years later, to New York City. At Columbia University (1931–35) he studied art history under Meyer Schapiro, followed by classes with the abstract painter Carl Holty and at the National Academy of Design (1936–37). Joining the American Abstract Artists group in 1937, Reinhardt was also hired by the Federal Art Project that year (for which he continued working until 1941). His collages and paintings of the 1930s are essays in the contemporary international Cubist-cum-Constructivist modes, employing, as in *Number 30* (1938), bright colours and precise biomorphic or geometric shapes. By the mid-1940s the forms had become more fragmentary. Their increasingly calligraphic, all-over disposition suggested a knowledge of Mark Tobey's pictures and of Arabic and Oriental art. Indeed, Reinhardt specialized in the latter field as a student at the Institute of Fine Arts, New York University (1946–50). His first one-man

show was held at Columbia (1943), his commercial début ensued at the Artists Gallery, New York (1944).

During the war Reinhardt drew cartoons for the New York newspaper *PM*. These heralded his many subsequent scathing broadsides aimed at the contemporary art world, its mores and aesthetics. Throughout his life, this critique was abetted by cartoons and written statements. Its corollary lay in an equally insistent definition of the parameters of art itself. This he defined in language resembling that of a mantra – by turns exclusionary, witty, absolutist and self-reflexive: 'The one thing to say about art is that it is one thing. Art is art-as-art and everything else is everything else. Art-as-art is nothing but art. Art is not what is not art.' The practical side of Reinhardt's morality led him to support an array of left-wing and humanitarian causes. Treating art and life as separate but equal, his self-written 'Chronology' juxtaposes world-historical political events, personal trivia and the schematic 'progress' of his work with dead-pan irony. At the professional level, a teaching post at Brooklyn College provided financial support from 1947 to 1967, backed by shorter appointments at Yale (1952–53), Syracuse University (1957) and Hunter College of the City University of New York (1959–67). Betty Parsons exhibited his work between 1946 and 1965. Reinhardt's noteworthy entry on to the European scene came with an exhibition at the Galerie Iris Clert in Paris in 1960. Keen to pursue his Oriental studies by seeing original works, the artist undertook substantial tours of the Near and Far East in 1958 and 1961.

The most significant stage of Reinhardt's career dawned around 1950. From then onwards, all the components of his pictures were systematically refined, regularized or pared down, as if subservient to a single ineffable thought (his 'pure-painting idea'). The small, electric-hued rectangular blocks that appeared in the late 1940s grew larger, more symmetrical and more homogeneous in their chromatic values. The twelve-foot-long *Red Painting* (1952) was succeeded by vertical canvases and, finally, by a five-foot-square format divided into nine equal squares. Predominantly red fields gave way to blue ones and then to almost total blackness. Such were the self-styled 'ultimate' paintings which, in conjunction with his aesthetic ethos, seemed to affirm the precepts of Minimalism and Conceptualism. Reinhardt died on 30 August 1967. D. A.

Lucy Lippard, *Ad Reinhardt*, New York, 1981.
Ad Reinhardt, New York, Museum of Modern Art, and Los Angeles, Museum of Contemporary Art, 1991.
Barbara Rose, ed., *Art-as-Art: The Selected Writings of Ad Reinhardt*, Berkeley, 1991.

James Rosenquist

was born on 29 November 1933 in Grand Forks, North Dakota. His parents both worked in the aviation industry. In 1948, as a High School student, Rosenquist won a scholarship to study art at the Minneapolis School of Art. He enrolled at the University of Minnesota in Minneapolis in 1953 to study painting and drawing, completing his associate degree the following year. During this time he supported himself as a commercial artist, painting billboards. He later recalled walking into the factory of the Outdoor Advertising Company in 1954 and seeing 'sixty-foot long paintings of beer glasses and macaroni salads sixty-feet wide. I … decided I wanted to work there.'

In 1955 Rosenquist obtained a scholarship for study at the Art Students League in New York. There he met Robert Indiana, Jasper Johns, Robert Rauschenberg and others who, like himself, made use in their art of everyday images borrowed from the media. He continued to paint while working as a butler and chauffeur in Irvington, New York, before returning to commercial art. From 1958 to 1960 Rosenquist painted huge hoardings over

Times Square in New York for the Artkraft Strauss Sign Corporation. His experiences working with advertising images prompted him to draw on such basic marketing techniques as 'sublimation', 'hard sell' and 'visual bombardment' in his paintings.

Rosenquist's first one-man show was held at the Green Gallery in 1962 and included the canvas *I Love You with My Ford* (1961), a composition with larger-than-life images of spaghetti, a Ford car and a woman whispering into a man's ear. In 1963 the artist was commissioned to paint a mural for the New York World's Fair and was featured in The Museum of Modern Art's exhibition of Pop Art, 'Americans 1963'. Rosenquist began to show at the Leo Castelli Gallery in 1965. His panoramic *F-111* (1965) presented a fighter plane and pictures of annihilation juxtaposed with such mundane images as a hair-drier, an umbrella, light bulbs, spaghetti and a portrait of the child star Shirley Temple. This enormous work, which covered four walls, epitomized Rosenquist's use of commercial techniques to create a visual overload involving a complex train of meanings based upon metamorphosis and puns; it was shown at the São Paulo Bienal (1967) and at The Metropolitan Museum of Art in New York (1968). For his dynamic compositions, the artist's preferred working method was to tear printed advertisements from old magazines and pin them to his studio wall, creating huge collages of unrelated pictures and words. With paint on canvas, Rosenquist transformed such banal flotsam and jetsam into larger-than-life pictorial elements, symbols of the banality and the vicissitudes of contemporary life. Nevertheless, he also stressed the interrelation of form and meaning: 'color and form are the same thing.'

During the 1970s Rosenquist experimented with print-making, but continued to produce his characteristic large-scale works, expanding their subject-matter to include surrealistic views of the natural world. More recent monumental efforts include *Four New Clear Women*, shown at the Castelli Gallery in 1983, which presented the artist's view of American culture in the late twentieth century – faces of smiling young women against a heavenly background. Rosenquist lives and works in New York and Aripeka, Florida. L. K.

Marcia Tucker, *James Rosenquist*, New York, Whitney Museum of American Art, 1972.
Elayne H. Varian, *James Rosenquist: Graphics Retrospective*, Sarasota, FL, Ringling Museum, 1979.
J. Goldman, *Rosenquist*, New York, 1986.

Mark Rothko

was born Marcus Rothkowitz at Dvinsk in
Russia on 25 September 1903, the youngest of
four children. At the age of ten he emigrated
with his mother and sister to America, where
the family settled in Portland, Oregon. A
scholarship took him to Yale University in
1921, but he left without completing the
degree and in 1924 enrolled at the Art
Students League in New York. There Rothko
studied under Max Weber – an influence on his
early oils, whereas his watercolour style echoed
John Marin's more limpid manner. Another
inspiration was the art of the children whom
Rothko instructed at Brooklyn's Jewish Center
Academy (1929–52). When his graphic work
for an illustrated biblical history was not duly
credited, he instituted – unsuccessful – legal
proceedings against its author and its publisher
(1928). In 1932 he married Edith Sachar; it
proved a difficult match and, thirteen years
later, they were divorced.

Throughout the 1930s Rothko concentrated
on figure scenes, evolving from a turbid
expressionism to more tightly organized views
of the New York Subway. Much later, he
alluded to such pictures as images from 'a
tableau vivant of human incommunicability'.
With eight others, including Adolph Gottlieb
and Ilya Bolotowsky, he formed the group
known as The Ten in 1935. They held
frequent shows in New York and, in November
1936, had an exhibition at the Galerie Bona-
parte, Paris. While employed for two years by
the Works Progress Administration Rothko
took American citizenship (1938) and by 1940
had begun using the familiar shortened form of
his name.

Elements from Surrealism and mythology
typify the new style embodied in *The Omen of
the Eagle* and *The Syrian Bull*, both first shown
in 1943 and backed by a statement in the *New
York Times* in which Rothko spoke of 'tragic
and timeless subject matter'. The calligraphic
presences which came next yielded, in turn, to
hazy colour patches until, around 1949–50,
these resolved themselves into the idiom of
rectangular fields most closely associated with
the artist. Their thin, radiant surfaces looked
back to the watercolours that Rothko had done
in the preceding years. Despite endless, diverse
critical interpretations, the 'classic' Rothko
canvas eludes any single reading. Rather, it
fulfils what the artist had already called 'the
simple expression of the complex thought'.

As a prominent Abstract Expressionist,
Rothko's activities burgeoned after his 1945
debut at Peggy Guggenheim's Art of This
Century Gallery. That year, he married Mary

Alice Beistel; a daughter and a son were born
in 1950 and 1963 respectively. At Clyfford
Still's invitation, he taught at the California
School of Fine Arts, San Francisco (summers
of 1947 and 1950); this was followed by posts
at Hunter College in New York (1951–54) and
Tulane University, New Orleans (1957).
Sidney Janis replaced Betty Parsons as his
dealer, and in 1961 The Museum of Modern
Art, New York, gave him a retrospective.
Three commissions to paint murals were also
forthcoming: for the Seagram Building in New
York (1958), Harvard University (1961) and a
chapel in Houston (dedicated 1971). Yet
Rothko was plagued by growing depression
and had a heart attack in 1968: both facts cast a
shadow over his severe late works. These
culminated in two novel departures – dazzling
acrylics on paper and black and grey canvases
with stark white borders, an extraordinary
series cut short by the artist's suicide in his
studio on 25 February 1970. D. A.

Mark Rothko, 1903–1970: A Retrospective, New York,
 Solomon R. Guggenheim Museum, 1978.
Dore Ashton, *About Rothko*, New York, 1983.
Anna Chave, *Mark Rothko*, New Haven, 1989.

Edward Ruscha

was born on 16 December 1937 in Omaha,
Nebraska, grew up in Oklahoma City and
moved to Los Angeles in 1956. There he
enrolled at the Chouinard Art Institute with
the aim of becoming a commercial artist.
However, the bohemian atmosphere of the
school and the influence of the artist-teachers
Robert Irwin, John Altoon and Billy Al Beng-
ston diverted Ruscha towards collage and
painting, with experiments in the Abstract
Expressionist idiom of Franz Kline and Willem
de Kooning. After graduation (1960), he prac-
tised graphic design in an advertising
agency – a job which he disliked and which,
after a year, he left to embark upon several

months of European travel. The small pictures
that resulted from this trip contained words
and urban images. On his return to Los
Angeles, that city's film and automobile culture
became Ruscha's main source of inspiration:
signs and words invaded his imagery, which, as
in *Actual Size* (1962), was rendered in a coolly
hard-edged and geometrical manner. *Trompe-
l'œil* effects underpin angles of vision familiar
from photography and film. The outcome was
Ruscha's own distinctive version of Pop Art.
Concurrently, this interest in photography
(and printing techniques) drew him to book
production: his first volume, *Twenty-Six Gaso-
line Stations* of 1962, focused upon petrol
stations that he had seen on a drive to Okla-
homa City. That year Ruscha participated with
Andy Warhol, Roy Lichtenstein and other
young Pop artists in a group exhibition at the
Pasadena Art Museum.

In 1965 Ruscha moved his studio to
Western Avenue in Hollywood, where the view
of Mount Hollywood and its famous sign
inspired one of his best-known images, *Holly-
wood* (1968). In the late 1960s his 'word
paintings' eliminated conventional notions of
'representation'. In their resemblance to credit
lines, these words and phrases set within vast
empty spaces still echoed the world of Holly-
wood. Yet their reliance on puns, puzzles and
clichés also looked back to the Dada cult of
absurd humour and capricious invention.
Often, traditional pigments were replaced by
vegetable and organic substances – cherry juice,
spinach, egg yolk, blood, ketchup, choco-
late – whose staining powers fascinated Ruscha.
Occasionally, as in *Very Angry People* (1973),
they were applied to unusual fabrics, such as
moiré silk, or employed in screen prints.

Since the mid-1970s Ruscha has divided his time between Los Angeles and a property he acquired in a remote part of the California desert, where he executed a series of 'grand horizontal' paintings (sometimes as wide as 159 inches): landscapes of horizon lines under dramatic skies interspersed with words adding further layers of meaning. After a trip to Bali, Singapore and Manila in 1978, Ruscha introduced realistic objects – as in the exotic *Bamboo Pole* (1979) – into his horizontal formats, while retaining his taste for meditative, deserted vistas of sky and land. In all this, American culture is his root preoccupation.

Ruscha's popularity reached an initial peak in the second half of the 1960s, when he represented the US at the 1967 São Paulo and Paris biennales. During the past decade he has been accorded two travelling retrospectives, in America (1982–83) and Europe (1989–90).
 I. D.

The Works of Edward Ruscha, San Francisco Museum of Modern Art, 1982.
Edward Ruscha, Paris, Musée National d'Art Moderne, Centre Georges Pompidou, 1989.
Yve-Alain Bois, *Edward Ruscha: Romance with Liquids, Paintings 1966–1969*, New York, Gagosian Gallery, 1993.

Robert Ryman

was born in Nashville, Tennessee, on 30 May 1930. He attended Tennessee Polytechnic in Cookville (1948–49) and the George Peabody College for Teachers in Nashville (1949–50). A jazz tenor saxophonist, he moved to New York in 1952 'for the music', but soon developed an even greater interest in painting. As one of the various odd jobs by which he made a living in the 1950s, Ryman worked for several years as a gallery attendant at The Museum of Modern Art. This, together with a temporary position in the Art Division of the Public Library, comprised his 'art education'. From 1961 to 1966 he was married to the art critic Lucy Lippard.

From the outset, Ryman was not interested in realistic representation. In his first paintings and collages, from the mid-1950s, he experimented with material, colour and brushwork, embarking on an exploration of the painting process which was to remain central to his entire production. In the late 1950s Ryman opted for the square as the ideal format for avoiding questions of proportion. Although his palette at first included a wide range of colours (purple, rich orange and green), by the mid-1960s it had been reduced to white: 'white enables other things to become visible'. The

consistency, transparency, tone and luminosity of the paint varied with the quality of the support used – cotton cloth, linen, cardboard, copper, steel, wood, Plexiglas, fibreglass, vinyl – and with the type of brushstroke: thin or thick, horizontal or vertical, regular or agitated, controlled or spontaneous. In 1965 Ryman adopted a systematic and thematic working method. For the sake of differentiation, he began giving titles to his series, often in reference to the brand or maker of the paint.

Comparing the painter to a research scientist, Ryman investigated all the possible visual effects that could be obtained from permutations of hard and soft surfaces, smooth and rough textures, straight and jagged edges, the reflection and absorption of light. Every visual detail counted in the perception of a piece. In the early works Ryman used his signature as a compositional element. Soon he was also devoting a great deal of attention to the way the paintings were attached to the wall. In unstretched canvases and in steel he discovered, in 1967, thin materials that could be placed directly against the wall so that the paintings seemed to become a part of it. Such considerations led Ryman to take into account the marks left by adhesive tape after a piece had been removed from the wall on which it had been painted. Similarly, since 1976 black, white or transparent fasteners have been systematically integrated into the compositions. Thus, the works exist, phenomenologically, only when fixed to the wall. In some cases, Ryman paints directly on the wall or lets the paint overlap from a panel to the wall behind. In sum, a conceptual approach is wedded to an extreme emphasis on the sheer physical facts of art.

Ryman has exhibited regularly since the mid-1960s in America and, especially, in Europe, where his reputation is perhaps even greater. He has participated in several Kassel 'documentas' (1972, 1977, 1982), and was given large retrospectives in Amsterdam in

1974, and in Zurich, Paris and Düsseldorf in 1981. He lives and works in New York. I. D.

Naomi Spector, *Robert Ryman*, Amsterdam, Stedelijk Museum, 1974.
'Dossier Ryman', *Macula*, nos. 3/4, Paris, 1978.
Robert Ryman, Paris, Musée National d'Art Moderne, Centre Georges Pompidou, 1981.

Julian Schnabel

was born in Brooklyn on 26 October 1951. The son of a Jewish businessman, his family moved to Brownsville, Texas, in 1965. After studying at the University of Houston (BFA, 1972), he moved to New York and participated in the Whitney Museum's Independent Study Program (1973–74). He did odd jobs and worked as a taxi driver, then returned for eight months to Texas, where the Contemporary Arts Museum in Houston mounted his first one-man show in 1976. Back in New York that year, he worked as a cook, then travelled twice to Europe; he was particularly impressed by Antonio Gaudí's mosaic-strewn architecture in Barcelona. Two shows at the Mary Boone Gallery in New York ensued (both 1979). The second of these presented 'plate' paintings: heavily impastoed canvases with pieces of broken plates embedded in them. Incongruous materials (antlers, oil and wood in *Exile*, 1980) turned the succeeding pictures into three-dimensional conglomerates, dense with esoteric references. By 1981 Schnabel was considered an art world super-star and had an exhibition that ran concurrently at the Boone and Castelli galleries; it included a composition on pink velvet (*Death*). Such works manifested a strikingly inventive imagery and, by the following year, he was being reckoned a Neo-Expressionist, along with several European painters. In 1983 he began to make sculpture, progressing to large, patinated bronze pieces. Five 'Tomb Panels' (1989) in homage to Joseph Beuys conveyed a sense of antiquity and religious power. Schnabel's paintings continued to exploit unusual materials, ranging from linoleum to modelling paste and velvet. Incorporating words in his imagery from 1986 onwards, the artist combined literary and religious references in the *Recognitions* series (1987–88). Inspired by the fourteenth-century El Carmen building in Seville, which he visited in June 1987, he painted 'signs' or words (taken from a novel by William Gaddison) on tarpaulin supports that were often cruciform. Language also pervaded the *Fox Farm* works

(1989), executed in oil, gesso and marker pen on velvet. They were based on the phrase 'There is No Place on this Planet More Horrible than a Fox Farm during Pelting Season', which, for Schnabel, referred to the AIDS epidemic.

Theatrical and expressionistic, Schnabel's art reflects a wide-range of influences, notably Jackson Pollock and Joseph Beuys. Large-scale and unexpected juxtapositions are important factors; found objects such as driftwood and candlesticks are brought together on unconventional grounds, which, besides broken plates and velvet, include rug pads and tarpaulin drop cloths. The general mood is romantic and violent, expressing the fragmentary relations between the self and history, life and death. The imagery is charged with fragments and symbols from Greco-Roman history, contemporary culture and Christian and Jewish religion. Schnabel's drawings are equally diverse, including hand-coloured etchings framed in cowhide, delicate lines on antique maps and large collages with scraps of suede and fabric. The artist's international fame is offset by a frequently mixed critical response to his work. Schnabel lives with his wife, Jacqueline, and their two children in Manhattan and Long Island. A. B.

Julian Schnabel: Paintings 1975–1986, London, Whitechapel Art Gallery, 1986.

Julian Schnabel, *CVJ: Nicknames of Maître D's and Other Excerpts From Life*, New York, 1988.

Jürg Zutter, ed., *Julian Schnabel: Works on Paper 1975–1988*, Munich, 1989.

Richard Serra

was born in San Francisco on 2 November 1939, the son of a Spanish immigrant factory worker and a Russian-Jewish painter. At the age of seventeen he began working in steel fac-

tories to pay for his education. After studying English literature at the University of California at Berkeley and at Santa Barbara, he gained a BA (1961), then an MFA (1964) from Yale University School of Art and Architecture, where he worked under Josef Albers. Serra spent 1965 in Paris, sharing a studio with his first wife, Nancy Graves, and 1966 in Florence. His first one-man exhibition, of farmyard materials and live as well as dead animals – reflecting an involvement with *Arte povera* – was held that year in Rome at the Galleria La Salita.

In 1967 Serra began making abstract formations from old vulcanized rubber and neon tubing, then, in the 'Splash' series, in cast lead – 'process art' involving molten lead thrown or poured into the corners of rooms. 'In all my work the construction process is revealed', he has said. A series of lead rolls and props followed. *One Ton Prop (House of Cards)* (1969) is a cube suggested by four lead plates poised in dramatic equilibrium. An aura of danger and 'imminent imbalance' characterized these explorations of sculpture's most basic properties – its weight, its sense of gravity and its raw materials. From 1968 to 1979 Serra made several 16mm films investigating simple, everyday tasks. By 1970 he was using large steel plates as building materials to create 'anti-environments', art conceived almost as engineering. After the early 1970s the industrial materials and gigantic scale of his pieces led Serra from studio production into public spaces. From 1971 onwards, Serra spent the summer at Cape Breton in Nova Scotia, making drawings on canvas with black oil stick that constitute severe analogues to his preoccupation in sculpture with site and context: 'Every site has an ideology … what I try to do is expose the ideology.' At that time, he was better known in Europe than in his home country. Serra angrily withdrew from a major public sculpture commission for the Pennsylvania Avenue Development Corporation in Washington in 1978 following a dispute with the architect, Robert Venturi. In 1981 (the year

he married Clara Weyergraf) two of his works located in Manhattan, *TWU* and *St. John's Rotary Arc*, met with public criticism. *Tilted Arc* (1981), an enormous wall of Cor-Ten steel, commissioned in 1979 by the General Services Administration for Federal Plaza, New York, was the subject of fierce controversy and highly publicized legal proceedings (1986) before it was destroyed in 1989. *Twain* (installed in St. Louis in 1982) sparked off a similar battle in 1986. In 'confronting the site', Serra has stated that he wishes to create 'a field force … so that the space is discerned physically rather than optically'.

International honours received by Serra include the Skowhegan Sculpture award (1976), the Kaiserring award for sculpture from the city of Goslar in Germany (1981) and the title of Officier de l'Ordre des Arts et des Lettres from the French government (1991). A Post-Minimalist, he is especially well known for his large-scale, site-specific projects in Canada, Europe, Japan, Iceland and the United States. Serra lives in New York. A. B.

Richard Serra: Interviews, Etc. 1970–1980, Yonkers, NY, Hudson River Museum, 1980.

Rosalind E. Krauss, *Richard Serra/Sculpture*, New York, Museum of Modern Art, 1986.

Ernst-Gerhard Güse, *Richard Serra*, New York, 1988.

Charles Sheeler

was born in Philadelphia on 16 July 1883. After attending the School of Industrial Art of the Philadelphia Museum (1900–3), he went to William Merrit Chase's studio at the Pennsylvania Academy of the Fine Arts (1903–6). Several European trips – in the summers of 1904 and 1905, and during 1908–9 with his fellow student Morton Schamberg – completed his artistic training. A few painterly city and landscapes survive from these early years. In 1910 Sheeler and Schamberg rented an eighteenth-century farm in Doylestown, Pennsylvania. This move initiated a lifelong interest in indigenous architecture and in early American artefacts. Two years later, Sheeler turned to commercial photography, specializing in architectural subjects. He soon produced photographs of the highest quality, pioneering the use of sharp-focus effects in images of stairwells and barns that anticipated his paintings of similar subjects by several years. His photography brought him into contact with New York avant-garde circles: Alfred Stieglitz, the Arensbergs and Marius De Zayas. Having moved to Manhattan in 1919, Sheeler found in

Photo © Arnold Newman

greater complexity in the layering of geometric shapes, related to the photographic technique of multiple exposure. In 1959 a paralytic stroke ended Sheeler's active career. He died on 7 May 1965. I. D.

Martin Friedman, *Charles Sheeler: Paintings, Drawings, Photographs*, New York, 1975.
Carol Troyen and Erica E. Hirshler, *Charles Sheeler: Paintings and Drawings*; Theodore E. Stebbins, Jr., and Norman Keyes, Jr., *Charles Sheeler: The Photographs*, Boston, Museum of Fine Arts, 1987.
Karen Lucic, *Charles Sheeler and the Cult of the Machine*, Cambridge, MA, 1991.

the city's skyscrapers the inspiration for a new series of photographs and paintings. The latter, such as *Church Street E1* (1920), combined the sharp contours and daring perspective of the camera's view with a planar space inherited from Cubism. They thus defined a new style – later to be called Precisionism – whose strict order and geometry seemed to mirror modern urban America; a one-man show at Charles Daniel's Gallery in 1922 established Sheeler as one of its main exponents. With a commission to photograph the Ford Motor Company's River Rouge Plant in Michigan (1927–28), technology became Sheeler's dominant theme. These celebrations of American industrial power brought him international acclaim and an invitation to participate in the 1929 'Film und Foto' exposition in Stuttgart. They also formed the basis of several paintings – *Classic Landscape* of 1931, for example – that were at once realist in the detailed rendering of each part and abstract in their underlying structure.

During the 1930s Sheeler, now affiliated with Edith Halpert's Downtown Gallery, gave up advertisement photography to concentrate on painting. His growing success and critical acclaim culminated in a retrospective at The Museum of Modern Art (1939). Unaffected by the Depression, Sheeler's idiom was still characterized by a strong sense of architectonic order, while his subjects, whether still-lifes, farm buildings or industrial structures, remained deeply rooted in American life.

Two artist-in-residence appointments, at the Phillips Academy in Andover (1946) and at the Currier Gallery of Art in Manchester, New Hampshire (1948) respectively, ushered in Sheeler's final phase. His depictions of New England's abandoned industrial sites showed

Cindy Sherman

was born in Glen Ridge, New Jersey, on 19 January 1954. The daughter of an engineer and a teacher, she spent her youth in Huntington Beach, Long Island, where her family moved in 1957. From an early age she drew, watched television and played at dressing up, transforming herself with elaborate make-up and costumes. Sherman studied art at the State University of New York at Buffalo (1972–76) and made a series of narrative photographs, *Cutouts* (1975); she worked at Hallwalls, an artist-run exhibition space that presented her first solo show in 1976. After moving to lower Manhattan in 1977 with her artist friend Robert Longo, Sherman began making 'Untitled Film Stills', or 'one-frame-movie-making': black and white photographs of herself in stereotyped imaginary Hollywood roles, taken by friends or using delayed-action shutter release. *Untitled Film Still No. 48* (1979) shows the artist in the role of a hitch-hiker. Employing 'backscreen' projection and a motor-drive camera, Sherman began taking colour photographs in 1980; the result was a transitional series with close focus and tight cropping. That year she had her first solo exhibition in New York at Metro Pictures. By 1981 formats had been enlarged and colour become luminous in the *horizontals* (1981), based on a *Playboy*-style centrefold. Considered a postmodernist because of her appropriation of media imagery and deconstruction of cultural conventions, she has achieved broad international recognition and critical success. In 1982 Sherman was included in 'Aperto 82' at the Venice Biennale, 'documenta VII' in Kassel and 'Image Scavengers' in Philadelphia. A brief time in the fashion advertising business inspired her theatrical 'costume dramas', nightmarish gothic fictions. With a 1985 series, originally intended as illustrations to a fairy-tale for *Vanity Fair*, she turned to mythical creatures as a subject. False body parts and bizarre masks here explore gruesome themes of disease, filth and death, blown up to a six-foot-high format. Fascinated by ugliness and fear, she recreated scenes from imaginary horror films. She was awarded the Skowhegan Medal for Photography in 1989. Executing them primarily in Rome, Sherman made over thirty fake 'history portraits' (1989–90); they constitute a witty *tableau vivant* based on the concept 'Memories of Art History', as in *Untitled No. 224* (1990), a Caravaggio self-portrait *performed* by Sherman.

Sherman's work is dominated by the image of woman, although she also portrays men and androgynous beings, dealing with issues of identity in the form of gender ambiguity, multiple selves and simulation. Sherman is both artist and model. She uses the photograph to document performance in a multiplicity of guises, ranging from female role models to characters from fairy-tales and fables. Working with large-scale Cibachrome colour prints, she is considered less an 'art photographer' than an 'image maker', who subsumes elements from film, performance and photography into a pictorial mode. In a 1987 statement Sherman said: 'I just want to be accessible. I don't like the elitism of a lot of art … where you must get the theory behind it before you can understand it.' She is married to the video artist Michel Auder and lives in New York. A. B.

Peter Schjeldahl and Lisa Phillips, *Cindy Sherman*, New York, Whitney Museum of American Art, 1987.
Cindy Sherman, Basle, Kunsthalle, 1991.
Arthur C. Danto, *Cindy Sherman: History Portraits*, New York, 1991.

In the second half of the 1960s the dazzling 'Protractor' series more adamantly revived the notion of abstract art as decorative. The semi-circular shape of a technical drawing tool was their basic module, from which Stella created ninety-three variations on three basic motifs. Vibrant Day-Glo colours enliven the complex interlacing of patterns and bold contours which reflect the artist's admiration of Islamic and Hiberno-Celtic art. The logic and rigour of mathematical design balances the impro-vised air of the colours themselves.

The early 1970s marked a new departure as Stella shifted from painting to relief. The 'Polish Village' series of 1971–73 combined felt, paper, canvas, plywood, masonite and aluminium in low-relief assemblages of inter-locked irregular polygons. Individually named after Polish synagogues destroyed by the Nazis, these works echo Russian Constructivist precepts and return (albeit at a highly sophisti-cated level) to compositional modes – based on relationships between distinct parts – that Stella had earlier eschewed.

Since the mid-1970s and the exuberant and popular 'Exotic Birds', Stella has favoured a very high relief that redefines the border between painting and sculpture. These grand projecting arabesques and asymmetrical forms are executed after small metal maquettes, before being hand-painted in a spontaneous, almost graffiti-like manner. Despite the apparent coolness of Stella's resolutely abstract art, the titles sound an autobiographical note: they recall his extensive travels, his interest in ornithology and his passion for racing cars. In 1983–84 Stella delivered the Charles Eliot Norton Lectures at Harvard University, in which he argued for continuity, in pictorial terms, between Renaissance and Baroque art and contemporary abstract painting. He lives in New York. I. D.

William Rubin, *Frank Stella*, New York, Museum of Modern Art, 1970.
Frank Stella, *Working Space*, Cambridge, MA, 1986.
William Rubin, *Frank Stella 1970–1987*, New York, Museum of Modern Art, 1987.

Joseph Stella

was born in Muro Lucano, a mountain village near Naples, on 13 June 1877. As a child, he displayed a gift for drawing. Stella was brought up in Italy, and received a classical education in preparation for a professional career. He emigrated to the United States in 1896, joining his father and four older brothers on New York's Lower East Side. Following in the foot-

steps of his brother Antonio, Stella studied medicine and pharmacology for about a year, before embarking on a career in art. From 1897 to 1901 he studied at the Art Students League and the New York School of Art, where he worked under William Merritt Chase. Stella was a brilliant draughtsman, and produced numerous Realist drawings of subjects taken from immigrant and working-class life. Between 1905 and 1909 a number of these were published in the magazines *Outlook* and *The Survey*, for which he recorded steel mills in Pittsburgh and a mine disaster in Monongah, West Virginia.

Stella returned to Italy in 1909, where he studied the techniques of the Renaissance masters. In Paris, during 1911–12, he became acquainted with avant-garde art – a shocking revelation, he later claimed – and exhibited at the 1912 Salon des Indépendants. Back in New York, Stella's work was included in the Armory Show of 1913. He did not adopt a modernist idiom, however, until 1913–14, in the painting *Battle of Lights, Coney Island, Mardi Gras*. This densely fragmented nocturnal vision of a crowded amusement park betrays the influence of Italian Futurism, which had deeply impressed Stella at the celebrated group exhi-bition at the Galerie Bernheim-Jeune in Paris in 1912. Over the next ten years he continued to employ certain structural elements derived from Cubism and Futurism in expansive, visionary images of New York, such as *Brooklyn Bridge* (1918–20) and *The Voice of the City of New York Interpreted* (1920–22). Stella also produced a small but remarkable group of abstract collages and some Symbolist pastels

that recall the biomorphism of Arthur Dove. His modernism was influenced by close contact – through Katherine Dreier and Walter C. Arensberg – with avant-garde circles. Stella exhibited with the Society of Indepen-dent Artists and the *Société Anonyme*, and was active in the administration of both organiza-tions.

During the 1920s and 1930s, Stella divided his time between the United States, Italy and France, living in Paris from 1930 to 1934. The artist was sympathetic to neo-conservative aesthetic trends between the wars. Retreating from abstraction, he applied a new, reductive realism to portraiture, landscape and still-life, although this was offset by highly program-matic religious compositions of obsessive intri-cacy. An unmistakably sentimental strain pervaded his treatment of these mystical and sacred themes. His most striking later achieve-ment was a sequence of luxuriant tropical fantasies, which were largely inspired by trips to North Africa in 1930 and to Barbados in 1938. Stella worked intermittently for the Works Progress Administration between 1935 and 1939. He had a number of one-man shows during the last two decades of his life, culmi-nating in a retrospective at the Newark Museum in 1939, but his reputation waned. In 1942 declining health forced him to give up his studio. He died of a heart attack on 5 November 1946. J. W.

Irma B. Jaffe, *Joseph Stella*, Cambridge, MA, 1970.
John I. H. Baur, *Joseph Stella*, New York, 1971.
Johann Moser, *Visual Poetry: The Drawings of Joseph Stella*, Washington, 1990.

Clyfford Still

was born in Grandin, North Dakota, on 30 November 1904 to parents of Canadian origin. The following year his family moved to Spokane, Washington, and soon afterwards took a farm near Bow Island in southern Alberta, Canada. Harsh conditions there had a profound impact on Still's temperament. His youth was divided between the prairie home-stead and an education at Spokane University (1926 and 1931–33) – during which time he married Lillian Battan – followed by an MA degree at Washington State College, Pullman, where he also taught fine arts (1933–41). In 1925 Still briefly attended the Art Students League but, except for two summers at the Trask Foundation (now 'Yaddo') in Saratoga Springs (1934–35), his sensibility developed largely in isolation. A rugged practical exist-ence was thus combined with intellectual

rigour. He worked in war industries in the San Francisco Bay Area (1941–43) prior to a two-year teaching post in Richmond, Virginia. The San Francisco Museum of Art gave him a retrospective in 1943.

Still's initial output focused upon scenes of prairie life. *Row of Grain Elevators* (1928) evokes Regionalism and Thomas Hart Benton's vigorous academic approach. Cézanne and Van Gogh were other early influences. Figure studies from 1934–35 preceded a powerful, later 1930s phase during which knowledge of European modernists, such as Picasso, blended with primitivism and mythical or symbolic content. Palette knife effects and chiaroscuro established a distinctive, semi-abstract manner that was further intensified by the larger formats he adopted from around 1944 onwards.

A move to New York in the spring of 1945 sparked off Still's association with Abstract Expressionism. He exhibited first with Peggy Guggenheim's Art of This Century Gallery (1946), held four shows at the Betty Parsons Gallery (1947–51), helped conceive 'The Subjects of the Artist' school and remarried, to Patricia Garske. Despite being an outsider, a few key friendships arose with colleagues, notably Mark Rothko. At this time, Still proved influential as an instructor at San Francisco's California School of Fine Arts (1946–50). In these years his art reached a peak. Ragged monoliths leap or descend from the canvas edges. Frequently, a single colour predominated, chosen from a gamut that pitted nocturnal shades against fiery tones. Textures were by turns aggressively earthen or glinting, as if to echo Still's own caustic vision. Indeed, growing alienation from the New York art world prompted his permanent departure for rural Maryland in 1961.

Nevertheless, Still held occasional retrospectives, while scorning galleries, dealers and critics in his moralistic statements. The Albright-Knox Art Gallery, Buffalo (1959), was chosen for the first and New York's Metropolitan Museum of Art for the last (1979–80). Moreover, he donated entire clusters of pictures to both institutions, as well as to the San Francisco Museum of Modern Art. Strong vertical emphases marked the huge later works, which sometimes exploited radiant fields of bare canvas. Still also did many pastels in these final years. He received several honorary awards, including membership of the American Academy and Institute of Arts and Letters (1978), before his death in New Windsor on 23 June 1980. D. A.

Clyfford Still, New York, Marlborough-Gerson Gallery Inc., 1969.
Clyfford Still, ed. John P. O'Neill, New York, Metropolitan Museum of Art. 1979.
Thomas Kellein, ed., *Clyfford Still: The Buffalo and San Francisco Collections*, Munich, 1992.

James Turrell

was born in Los Angeles on 6 May 1943. After studying experimental psychology at Pomona College in Claremont, California (BA, 1965), he attended the University of California, Irvine (1965–66), but dropped out and moved to Los Angeles, renting a studio in Ocean Park. Turrell became an enthusiastic pilot and did assorted jobs, including restoring antique cars as well as teaching at several California universities between 1967 and 1978. His 'Projection Pieces' were shown at the Pasadena Art Museum in 1967.

All Turrell's work has been involved with defining space by using ambient light, neon or xenon light projections. 'What interests me is the quality of light inhabiting a space', Turrell has said. In the *Mendota Stoppages* (1969–70) he first created responsive spaces, studio rooms or 'sensing spaces' interacting with adjacent exterior areas. In collaboration with another Los Angeles light artist, Robert Irwin, and the Garrett Aerospace Corporation, Turrell participated in the Art & Technology programme (1967–71) of the Los Angeles County Museum of Art. In 1974 he received a Guggenheim Fellowship, which he used to begin the *Roden Crater Project*, near Flagstaff, Arizona, and was commissioned to make six *Skyspace* installations for Count Panza di Biumo's villa at Varese in Italy. The following year he received a National Endowment for the Arts Matching Grant and funding from the Dia Art Foundation for his crater project. Located over 5,000 feet above sea level in the Painted Desert, the project aims to reshape an extinct volcano into a natural observatory. A combination of earthwork, sculpture and architecture, it is the largest work of art under construction in the world.

In 1976 Turrell moved to Sedona, Arizona, and his work was introduced to Europe through an exhibition organized by the Stedelijk Museum, Amsterdam. *Roden Crater* was purchased by the Dia Art Foundation the following year. Moving to Flagstaff (1979), he received a Visual Arts Fellowship from the Arizona Commission on the Arts and Humanities (1980) and the Lumen Award, New York Section, of the Illuminating Engineering Society with the International Association of Lighting Designers (1981). Having set up the Skystone Foundation (1981) to support the crater project, he was awarded a MacArthur Foundation fellowship in 1984 and has subsequently received awards from the Lannan Foundation (1987) and the Andy Warhol Foundation for the Visual Arts (1990).

Associating his light works with painting, Turrell said, 'Because I work space plastically, it is really a painter's vision in three-dimensions'; he has also made etchings, aquatints, drawings and photographs. The recent *Irish Sky Garden* is a series of three earthworks on the Liss Ard Estate in western County Cork, sponsored by the art dealer Veith Turske as part of a project bringing together the conservation of nature and contemporary art. At root, Turrell is concerned with the perception of the universe and a sense of the infinite, creating a dialogue between illusion and reality with light as his material. He lives in Flagstaff and Inishkeame West, Ireland. A. B.

Julia Brown, ed., *Occluded Front: James Turrell*, Los Angeles, 1985.

Craig Adcock, *James Turrell: The Art of Light and Space*, Berkeley, 1990.

Jiri Svestka, ed., *Perceptual Cells: James Turrell*, Stuttgart, 1992.

Cy Twombly

was born in Lexington, Virginia, on 25 April 1929, the son of a professional baseball player. He studied at the Boston Museum School of Fine Arts (1948–49), the Art Students League, New York (1950–51), and at Black Mountain College (1951–52) under Robert Motherwell and Franz Kline. In 1952, having been awarded a Travelling Fellowship from the Virginia Museum of Fine Arts, he spent several months in Spain, North Africa and Italy with his friend Robert Rauschenberg. Twombly's first pictures owed their spontaneous, graffiti-like motifs to a study of Paul Klee, to the Surrealist technique of automatic writing and to the calligraphic elements in Abstract Expressionism as developed by Kline and Willem de Kooning.

In 1957, after two years as Head of the Art Department at the Southern Seminary Junior College in Buena Vista, Virginia, Twombly moved to Rome, where he still lives. There he felt in closer contact with the ancient art and mythology which had fascinated him since childhood. While most American artists of his generation sought their inspiration in contemporary popular culture, Twombly turned to the traditional sources of Western art: Greek and Roman antiquity and the Renaissance. Characters from Classical mythology and Antique figures and sites (Apollo, Venus, Leda, Ovid, Virgil, Arcadia) became the focus of his abstractions. They were evoked by cryptic scraps of words, pictorial metaphors and allusive signs. With oil paint, pencil and graphite on canvas or paper, Twombly formulated a rich repertoire of marks, scrawls, scribbles, doodles and scratches – at once expressive of a gestural approach and of cultural symbols. These traces hovered between purely formal notations and narrative implications. Inscribed words and phrases stressed the analogies between painting, drawing and writing. Several phases characterized the growth of this painting/poetry amalgam. In the early 1960s erotic symbols, whose colours suggest both blood and flesh, emerged in an ambience faintly evocative of architecture and landscape. The 'Blackboard paintings' (1966 to the early 1970s) employed chalk and oil paint, and acquired an increasingly lyrical feel as their thin white lines looped and ran across a grey background.

From the mid-1970s onwards, Twombly's technique became even more diverse. Relying on collage and carefully juxtaposed surface textures, he created several polyptychs, such as *Hero and Leander* (1981–84), in which a wave of thick pigment flows over three canvases, or the ten-part *50 Days at Iliam* (1978), an ambitious cycle inspired by Homer's *Iliad*.

In the 1950s, and again since 1976, Twombly also made a few sculptures: small constructions of found objects, wood, strings and cloth. Often painted white, they display, on a more intimate scale, the same blend of emotional expansiveness and intellectual sophistication as the paintings.

Since his first one-man show, at the Kootz Gallery in New York in 1951, Twombly has exhibited regularly both in America and in Europe. His imagery, linking personal experience to myth and history, found a strong echo in the work of the young Italian and German painters who came to prominence in the 1970s.

I.D.

Cy Twombly: Paintings and Drawings 1954–1977, New York, Whitney Museum of American Art, 1979.

Harald Szeemann, ed., *Cy Twombly: Paintings, Works on Paper, Sculpture*, Munich, 1987.

Heiner Bastian, ed., *Cy Twombly: Catalogue Raisonné of the Paintings*, vol. 1, Munich, c. 1992.

Bill Viola

was born in New York City on 25 January 1951 and spent his youth in Flushing, New York, where he showed an early talent for drawing and played drums in a rock band. He was educated at Syracuse University (BFA, College of Visual and Performing Arts, 1973). In the summer of 1973 in Chocorua, New Hampshire, he formed the Composers Inside Electronics Group with John Driscoll, Linda Fisher and Phil Edelstein. From then until 1980 he studied and performed with the composer David Tudor and the new music group Rainforest. His first solo video and sound installation was presented at the Kitchen in New York (1974). From 1974 to 1976 he spent much of his time in Europe, as technical director of Art/Tapes/22 in Florence. Viola's work was included in every Whitney Biennial between 1975 and 1985 (excluding 1977). *Red Tape* (1975) dates from his period in residence at two New York State Production Centres: ZBS Media, Fort Edward, and Intermedia Art Center, Bayville. In 1976 Viola returned to New York.

For Viola travel is a way of life and an integral part of his art. From 1976 to 1987 he undertook a series of trips to Fiji, the Himalayas and the southwestern United States, recording and videotaping traditional music and culture. He also lived in Japan during 1980–81, where he was artist-in-residence at the Sony Corporation's Atsugi Laboratories. Since 1981 he has lived in Long Beach, California.

Viola is known for highly controlled videotapes and technically virtuoso installations dealing with the more mystical aspects of physics and optical transformations: quantum physics, metaphysics, perceptual psychology, phenomenology, mythology and mysticism are among his sources. Inspired by the videos and performances of Vito Acconci and Bruce Nauman, Viola is influenced by the power of the natural landscape. 'My work is about finding those places on earth where I need to be to have those ideas I'm carrying with me best expressed' (1985). As Barbara London has noted: 'Viola's primary subject is the physical and mental landscape…. He is concerned with exploring the interaction of his image with the viewer's memory, as well as with the subconscious and its dreams and imagination.' According to one critic, his first tape, *Wild Horses* (1972) – containing alternating images

of violent, wild horses and trained ones – already addressed 'the issue of presence which informs all of Viola's work'. In 1979 he made *Chott el-Djerid* (A Portrait in Light and Heat), his first collaboration with Kira Perov, an Australian photographer, and his first landscape-dominated work, in which location becomes part of the medium itself. It is a magical deployment of electronic impressionism that explores the light and diffractions created by extreme heat and cold in such places as the Sahara, Saskatchewan and Illinois. Perov has collaborated on all Viola's subsequent projects. *Anthem* (1983) concerns a single piercing scream of a young girl standing in the Union Station in Los Angeles. According to the artist, 'The real investigation is of life and being itself. The medium is just the tool in this investigation.' A. B.

Bill Viola, Paris, Musée d'Art Moderne de la Ville de Paris, 1984.
Bill Viola: Installations and Videotapes, ed. Barbara London, New York, Museum of Modern Art, 1987.
Bill Viola: Survey of a Decade, ed. Marilyn Zetlin, Houston, Contemporary Arts Museum, 1988.

Andy Warhol

was born Andrew Warhola in Pittsburgh, Pennsylvania, on 6 August 1928, to Czechoslovakian parents. As a child, he collected photographs of film stars, read comics and drew. After attending the Carnegie Institute of Technology, Pittsburgh (1945–49), he moved to New York and changed his name. From 1949 until 1960 Warhol did various jobs: among them, commercial artist, illustrator and window display designer. A talented draughtsman, he worked in a 'faux naïf' style and twice received the Art Directors Club Medal for newspaper advertising art (1952, 1957).

In 1960 Warhol started to create paintings based on comic strips and Coca-Cola bottles, followed two years later by images of dollar notes, Campbell soup cans, 'Disasters', Elvis Presley and Marilyn Monroe, as well as his first silk-screens. With reference to the adoption of repetitious, 'serial' imagery – used in his sculptures, prints, films, and also in such paintings as *100 Soup Cans* (1962) – Warhol made the notorious remark: 'The reason I'm painting this way is because I want to be a machine.' Taking his subject-matter from commercial art and the mass media in general, he became a founder of Pop Art. In a large studio ('The Factory'), and with a band of assistants, Warhol manufactured art in quantities more appropriate to industrial goods,

using the impersonal silk-screen process to represent the icons of popular culture in a mechanical fashion. The 'Brillo boxes' (1964) and other box sculptures were appropriated from cardboard cartons, recreated in wood with silk-screened logos. The Castelli Gallery in New York began to exhibit his work in 1964.

Warhol's first, experimental, silent 16 mm films (*Eat*, *Sleep*, *Kiss*) were made in 1963 with a stationary camera. They documented ordinary lives for extended periods of time. The next year he received the Independent Film Award from the underground magazine *Film Culture*. Thereafter (1964–65) he added synchronized sound and made his first public 'hit', *Chelsea Girls* (1966). Warhol's cinematic achievement is often considered a redefinition of the medium's boundaries; certainly, he was a founder of the underground film movement. His cinematic style highlights sexual frankness and verbal obscenity, the casual, wandering camera and relentless monotony. After he had achieved further notoriety with multi-media presentations (including a night club for 'superstars' and 'beautiful people' featuring the influential Velvet Underground rock band), Warhol was shot and seriously injured in June 1968 by Valerie Solanis. His mother died in 1972, the year in which Warhol became interested in commissioned portrait painting: with wealthy patrons, actresses and statesmen as their subjects, the resulting works amounted to a revival of the 'swagger' portrait, albeit in an almost post-modern context. He published *The Philosophy of Andy Warhol* in 1975. After years of 'collaborating' with assistants, in 1984 he collaborated on paintings with Jean-Michel Basquiat and Francesco Clemente. Fascinated by the star cult, Warhol became an international star himself, at once the embodiment and the manipulator of popular taste. Addressing concepts of gender, originality, appropriation, consumerism and 'high' and 'low' culture in a variety of media, Warhol, in terms of influence and historical import, perhaps ranks second only to Jackson Pollock

among artists of the second half of this century. He died in New York on 22 February 1987.
 A. B.

Rainer Crone, *Andy Warhol*, New York, 1970.
Kynaston McShine, ed., *Andy Warhol: A Retrospective*, New York, Museum of Modern Art, 1989.
Charles Stuckey, *Andy Warhol: Heaven and Hell are just one Breath Away! Late Paintings and Related Works 1984–1986*, New York, Gagosian Gallery, 1992.

Lawrence Weiner

was born in the Bronx, New York, on 10 February 1942. He attended Stuyvesant High School in Manhattan and studied philosophy at Hunter College. Having decided to be an artist, he went to California, where he did paintings and undertook a number of outdoor projects, including a series of explosions in the soil in Mill Valley (1960). He returned to New York and had a first solo exhibition of abstractions at Seth Siegelaub's gallery (1964). By 1966 Weiner had chosen to paint with the help of other people, whom he allowed to instruct him as to matters of size, colour and execution. Next he began to concentrate on the concept rather than the physical qualities of the work of art in an attempt to free the message of any intervening medium. True to Conceptualist tenets, Weiner stressed the viewer's participation and the role of the germinal idea, the process whereby art comes into existence. In order to communicate solely by means of language, from the late 1960s onwards Weiner applied texts in capital letters to walls, using

either paint, stencil or Letraset. In this respect, his approach is related to those of Robert Barry, Jenny Holzer, On Kawara, Joseph Kosuth and Barbara Kruger. Weiner has observed that, 'Without language, there is no art' and, indeed, his methods effectively turn language into sculpture.

Since 1968 Weiner's 'declaration of intent' has maintained that '1. The artist may construct the Piece 2. The work may be fabricated 3. The piece need not be built. Each being equal and consistent with the intent of the artist the decision as to condition rests with the viewer upon the occasion of receivership.' A statement such as 'Red as well as green as well as blue' (1972) yields multiple meanings in a variety of contexts over time. Brackets and parentheses indicate an 'either/or' condition, allowing viewers to replace his words with those of their own choosing. The logical

consequence was manifest in the artist's remark that, 'once you know about a work of mine, you own it. There's no way I can climb into somebody's head and remove it.'

Awards received by Weiner have included a grant in connection with the Berlin Artists Programme of the Deutscher Akademischer Austauschdienst (1974) and the Laura Slobe Memorial Prize at the 73rd American Exhibition, held at the Art Institute of Chicago in 1979. In 1969 he exhibited at the Konrad Fischer Gallery in Düsseldorf, and from 1971 onwards has shown regularly at the Leo Castelli Gallery, New York. International recognition came with the inclusion of works in 'documenta V' in Kassel, the 36th Venice Biennale (both 1972) and 'documenta VII' (1982), and with one-man shows at ARC – Musée d'Art Moderne de la Ville de Paris (1985) and the Stedelijk Museum, Amsterdam

(1988). In 1991 the Dia Center for the Arts in New York presented an installation entitled *Displacement*. It incorporated the sentence 'Bits and pieces put together to present a semblance of a whole' among the interrelated linguistic fragments displayed on the walls, doors, floor and columns of the space. In addition to the large-scale, site-specific 'statements' on walls for which he is best known, Weiner has produced many books, posters, performances, videos, films and audiotapes. He lives in Amsterdam and New York. A. B.

R. H. Fuchs, *Lawrence Weiner*, Eindhoven, Stedelijk Van Abbemuseum, 1976.

Benjamin H. D. Buchloh, ed. *Posters, November 1965–April 1986: Lawrence Weiner*, Halifax (Canada) and Toronto, 1986.

Dieter Schwarz, *Lawrence Weiner: Books 1968–1989* [catalogue raisonné], Cologne and Villeurbanne, 1989.

Selected Bibliography

See 'Biographies of the Artists' (pp. 439–77)
for literature on individual artists

Books

Albright, Thomas, *Art in the San Francisco Bay Area 1945–1980: An Illustrated History*, Berkeley, 1985.

Alloway, Lawrence, *American Pop Art*, New York, 1974.

Alloway, Lawrence, *Topics in American Art Since 1945*, New York, 1975.

Amaya, Mario, *Pop Art and After*, New York, 1966.

Andersen, Wayne, *American Sculpture in Process: 1930–1970*, Boston and New York, 1975.

Anfam, David, *Abstract Expressionism*, London, 1990.

Ashton, Dore, *The New York School: A Cultural Reckoning*, New York, 1973.

Ashton, Dore, *American Art Since 1945*, New York and London, 1982.

Baigell, Matthew, *Dictionary of American Art*, New York, 1982.

Baigell, Matthew, *The American Scene: American Painting of the 1930s*, New York, 1974.

Baigell, Matthew, *A Concise History of American Painting and Sculpture*, New York, 1984.

Baker, Kenneth, *Minimalism: Art of Circumstance*, New York, 1988.

Battcock, Gregory (ed.), *The New Art*, New York, 1966.

Battcock, Gregory (ed.), *Idea Art: A Critical Anthology*, New York, 1967.

Battcock, Gregory (ed.), *Minimal Art: A Critical Anthology*, New York, 1968.

Battcock, Gregory (ed.), *Superrealism*, New York, 1975.

Battcock, Gregory, and Robert Nickas (eds.), *The Art of Performance: A Critical Anthology*, New York, 1984.

Baur, John I. H., *Revolution and Tradition in Modern American Art*, New York, 1967.

Beardsley, John, *Earthworks and Beyond: Contemporary Art in the Landscape*, New York, 1984.

Beckett, Wendy, *Contemporary Women Artists*, New York, 1988.

Berman, Greta, and Jeffrey Wechsler, *Realism and Realities: The Other Side of American Painting 1940–1960*, New Brunswick, 1976; rev. 1982.

Brown, Milton W., *American Painting from the Armory Show to the Depression*, Princeton, 1955.

Brown, Milton W., et al., *American Art: Painting, Sculpture, Architecture, Decorative Arts, Photography*, New York, 1979.

Brown, Milton W., *The Story of the Armory Show*, New York, 1988.

Buettner, Stewart, *American Art Theory, 1945–70*, Ann Arbor, 1977.

Burnham, Jack, *Beyond Modern Sculpture*, New York, 1968.

Burnham, Jack, *Great Western Salt Works: Essays on the Meaning of Post-Formalist Art*, New York, 1974.

Celant, Germano, *Unexpressionism: Art Beyond the Contemporary*, New York, 1988.

Chase, Linda, *Hyperrealism*, New York, 1975.

Clark, D. J., *The Influence of Oriental Thought on Postwar American Painting and Sculpture*, New York and London, 1988.

Colpitt, Francis, *Minimal Art: The Critical Perspective*, Ann Arbor, 1990.

Compton, Michael, *Pop Art*, London, 1970.

Contreras, Belisario, *Tradition and Innovation in New Deal Art*, Lewisburg, 1983.

Coppet, Laura de, and Alan Jones, *The Art Dealers*, New York, 1984.

Cox, Annette, *Art-as-Politics: The Abstract Expressionist Avant-Garde and Society*, Ann Arbor, 1982.

Crane, Diana, *The Transformation of the Avant-Garde: The New York Art World, 1940–1985*, Chicago and London, 1987.

Craven, Wayne, *Sculpture in America*, Newark, 1984.

Dachy, Mark, *The Dada Movement 1915–1923*, New York, 1990.

Danto, Arthur C., *Beyond the Brillo Box*, New York, 1992.

Davidson, Abraham, *Early American Modernist Painting: 1910–1935*, New York, 1981.

Doss, Erika, *Benton, Pollock, and the Politics of Modernism: From Regionalism to Abstract Expressionism*, Chicago, 1991.

Elderfield, John (ed.), *Collage and Assemblage*, New York, 1992.

Foster, Stephen C., *The Critics of Abstract Expressionism*, Ann Arbor, 1980.

Frascina, Francis (ed.), *Pollock and After: The Critical Debate*, New York, 1985.

Friedman, Bernhard H. (ed.), *School of New York: Some Younger Artists*, New York, 1944.

Geldzahler, Henry, *New York Painting and Sculpture, 1940–1970*, New York, 1969.

Godfrey, Tony, *The New Image: Painting in the 1980s*, Oxford and New York, 1986.

Green, Jonathan, *American Photography: A Critical History, 1945 to the Present*, New York, 1984.

Greenberg, Clement, *Art and Culture*, London, 1973.

Guilbaut, Serge, *How New York Stole the Idea of Modern Art: Abstract Expressionism, Freedom, and the Cold War*, Chicago and London, 1983.

Guilbaut, Serge (ed.), *Reconstructing Modernism: Art in New York, Paris and Montreal 1945–1964*, Cambridge, MA, and London, 1990.

Harris, Mary Emma, *The Arts at Black Mountain College*, Cambridge, MA, 1987.

Heller, Nancy, and Julia Williams, *The Regionalists*, New York, 1976.

Hendricks, Jon (ed.), *Fluxus Codex*, New York, 1988.

Henri, Adrian, *Total Art: Environments, Happenings and Performance*, New York, 1974.

Hess, Thomas B., *Abstract Painting: Background and American Phase*, New York, 1951.

Hess, Thomas B., and Elizabeth C. Baker, *Art and Sexual Politics: Women's Liberation, Women Artists and Art History*, New York, 1973.

Homer, William I., *Alfred Stieglitz and the American Avant-Garde*, Boston, 1977.

Hunter, Sam, *American Art of the Twentieth Century: Painting, Sculpture and Architecture*, New York, 1974.

Hurlburt, Laurance P., *The Mexican Muralists in the United States*, Albuquerque, 1989.

Janis, Sidney, *Abstract Art and Surrealist Art in America*, New York, 1944.

Johnson, Ellen H. (ed.), *American Artists on Art from 1940 to 1980*, New York, 1982.

Kaprow, Allan, *Assemblage, Environments and Happenings*, New York, 1966.

Kingsley, April, *The Turning Point: The Abstract Expressionists and the Transformation of America*, New York, 1992.

Kirby, Michael (ed.), *Happenings: An Illustrated Anthology*, New York, 1965.

Kozloff, Max, *Renderings: Critical Essays on a Century of Modern Art*, New York, 1968.

Kramer, Hilton, *The Age of the Avant-Garde: An Art Chronicle of 1956–1972*, New York, 1973.

Krauss, Rosalind E., *Passages in Modern Sculpture*, New York, 1977.

Krauss, Rosalind E., *The Originality of the Avant-Garde and Other Modernist Myths*, Cambridge, MA, and London, 1986.

Kuenzli, Rudolf E. (ed.), *New York Dada*, New York, 1986.

Kuspit, Donald, *Clement Greenberg, Art Critic*, Madison, 1979.

Lane, John R., and Susan Larson (eds.), *Abstract Painting and Sculpture in America, 1927–1944*, New York, 1983.

Levin, Gail, *Synchromism and American Color Abstraction 1910–1925*, New York, 1978.

Levin, Kim, *Beyond Modernism: Essays on Art from the '70s and '80s*, New York, 1988.

Lippard, Lucy R., *Six Years: The Dematerialization of the Art Object from 1966 to 1972*, New York, 1973.

Lippard, Lucy R., *Changing: Essays in Art Criticism*, New York, 1971.

Lippard, Lucy R., *Pop Art*, London and New York, 1966; rev. 1970.

Lippard, Lucy R., *Mixed Blessings: New Art in a Multicultural America*, New York, 1990.

Livingstone, Marco, *Pop Art: A Continuing History*, New York, 1990.

Lucie-Smith, Edward, *Art in the Seventies*, Ithaca, NY, 1980.

Lucie-Smith, Edward, *Art Now: From Abstract Expressionism to Superrealism*, New York, 1981.

Lucie-Smith, Edward, *American Art Now*, Oxford, 1985.

Lucie-Smith, Edward, *Sculpture Since 1945*, New York, 1987.

Mackie, Alwynne, *Art/talk: Theory and Practice in Abstract Expressionism*, New York, 1989.

McKinzie, Richard D., *The New Deal for Artists*, Princeton, 1973.

Mahsun, Carol Anne Runyon, *Pop Art and the Critics*, Ann Arbor, 1987.

Mahsun, Carol Anne Runyon (ed.), *Pop Art: The Critical Dialogue*, Ann Arbor, 1989.

Mamiya, Christin J., *Pop Art and Consumer Culture: American Super Market*, Austin, 1992.

Marling, Karal Ann, *Wall to Wall America: A Social History of Post-Office Murals in the Great Depression*, Minneapolis, 1982.

Meyer, Ursula, *Conceptual Art*, New York, 1972.

Motherwell, Robert (ed.), *The Dada Painters and Poets: An Anthology*, Cambridge, MA, 1989.

Noel, Bernard (ed.), *Marseille – New York: Une Liaison surréaliste*, Marseilles, 1985.

O'Brian, John (ed.), *Clement Greenberg: The Collected Essays and Criticism*, 4 vols., Chicago, 1986, 1993.

O'Connor, Francis V., *The New Deal Art Projects: An Anthology of Memoirs*, Washington, 1972.

O'Connor, Francis V., *Art for the Millions: Essays from the 1930s by Artists and Administrators of the WPA Federal Art Project*, New York, 1973.

O'Doherty, Brian, *Inside the White Cube: The Ideology of the Gallery Space*, Santa Monica, 1986.

O'Doherty, Brian, *American Masters: The Voice and the Myth*, New York, 1988.

Pincus-Witten, Robert, *Postminimalism*, New York, 1977.

Pincus-Witten, Robert, *Postminimalism into Maximalism: American Art 1966–1986*, Ann Arbor, 1987.

Plagens, Peter, *Sunshine Muse: Contemporary Art on the West Coast*, New York, 1974.

Polcari, Stephen, *Abstract Expressionism and the Modern Experience*, Cambridge, MA, 1991.

Robins, Corrine, *The Pluralist Era: American Art 1968–1981*, New York, 1984.

Rodman, Selden, *Conversations with Artists*, New York, 1957.

Rose, Barbara, *American Art since 1900*, New York, 1968; rev. 1975.

Rose, Barbara (ed.), *Readings in American Art, 1900–1975*, New York, 1975.

Rose, Barbara, *American Painting: The Twentieth Century*, New York, 1986.

Rose, Barbara, *Autocritique: Essays on Art and Anti-Art, 1963–1987*, New York, 1988.

Rosenberg, Harold, *The Tradition of the New*, New York, 1959.

Rosenberg, Harold, *The Anxious Object: Art Today and Its Audience*, New York, 1966.

Rosenberg, Harold, *Artworks and Packages*, London, 1969.

Rosenberg, Harold, *The De-Definition of Art: Action Art to Pop to Earthworks*, New York, 1972.

Rosenberg, Harold, *Art and Other Serious Matters*, Chicago, 1985.

Rosenblum, Robert, *Toward a New Abstraction*, New York, 1963.

Rosenblum, Robert, *Modern Painting and the Northern Romantic Tradition: Friedrich to Rothko*, New York, 1975.

Ross, Clifford, *Abstract Expressionism: Creators and Critics, An Anthology*, New York, 1990.

Rubin, William S., *Dada and Surrealist Art*, New York, 1968.

Rublowsky, John, *Pop Art*, New York, 1965.

Russell, John, and Suzi Gablik, *Pop Art Redefined*, London, 1969.

Saltz, Jerry, *Beyond Boundaries: New York's New Art*, New York, 1986.

Sandler, Irving, *The Triumph of American Painting: A History of Abstract Expressionism*, New York, 1970.

Sandler, Irving, *The New York School: The Painters and Sculptors of the Fifties*, New York, 1978.

Sandler, Irving, *American Art of the 1960s*, New York, 1988.

Sayre, Henry M., *The Object of Performance: The American Avant-Garde Since 1970*, Chicago and London, 1989.

Schimmel, Paul, *The Interpretative Link: Abstract Surrealism into Abstract Expressionism*, Newport Beach, 1986.

Seitz, William C., *Abstract Expressionist Painting in America*, Cambridge, MA, and London, 1983.

Shapiro, David (ed.), *Social Realism: Art as a Weapon*, New York, 1973.

Shapiro, David and Cecile, *Abstract Expressionism: A Critical Record*, New York, 1990.

Siegel, Jeanne (ed.), *Art Talk: The Early 80s*, Ann Arbor, 1988.

Solomon, Alan R., and Ugo Mulas, *New York: The New Art Scene*, New York, 1967.

Sondheim, Alan (ed.), *Individuals: Post Movement Art in America*, New York, 1977.

Steinberg, Leo, *Other Criteria: Confrontations with Twentieth Century Art*, New York, 1972.

Tashjian, Dickran, *Skyscraper Primitives: Dada and the American Avant-Garde, 1910–1925*, Middletown, CT, 1975.

Taylor, Paul (ed.), *Post-Pop Art*, Cambridge, MA, 1989.

Tsujimoto, Karen, *Images of America: Precisionist Painting and Modernist Photography*, Seattle, 1982.

Tuchman, Maurice, *The New York School: Abstract Expressionism in the 40s and 50s*, London, 1971.

Vries, Gerd de (ed.), *On Art: Artists' Writing on the Changed Notion of Art After 1965 / Über Kunst: Künstlertexte zum veränderten Kunstverständnis nach 1965*, Cologne, 1974.

Waldman, Diane, *Collage, Assemblage, and the Found Object*, London, 1992.

Walker, John A., *Art Since Pop*, London, 1975.

Wallis, Brian (ed.), *Art After Modernism: Rethinking Representation*, New York, 1984.

Wasserman, Emily, *The American Scene: Early Twentieth Century*, New York, 1975.

Weber, Nicholas Fox, *Patron Saints: Five Rebels Who Opened America to a New Art (1928–1943)*, New York, 1992.

Wechsler, Jeffrey, *Surrealism and American Art, 1931–47*, New Brunswick, 1976.

Wechsler, Jeffrey, and Greta Berman, *Realism and Realities: The Other Side of American Painting, 1940–1960*, New Brunswick, 1981.

Wheeler, Daniel, *Art Since Mid-Century: 1945 to the Present*, New York, 1991.

Exhibition catalogues

Amsterdam, Stedelijk Museum, *Op Losse Schroeven: Situaties en cryptostructuren*, 1969.

Amsterdam, Stedelijk Museum, *'60–'80: Attitudes, Concepts, Images*, 1982.

Baden-Baden, Staatliche Kunsthalle, and Zurich, Kunsthaus, *Drawing Now / Zeichnung heute*, 1976.

Berkeley, University Art Museum, University of California, *Made in USA: An Americanization in Modern Art, The '50s and '60s*, by Sidra Stich, 1987.

Berlin, Akademie der Künste, Gesellschaft für Bildende Künste, *Amerika: Traum und Depression 1920/40*, 1980.

Berlin, Martin-Gropius-Bau, *Zeitgeist*, ed. Christos M. Joachimides and Norman Rosenthal, 1982.

Berlin, Martin-Gropius-Bau, *Metropolis*, ed. Christos M. Joachimides and Norman Rosenthal, 1991.

Berne, Kunsthalle, *Life in Your Head: When Attitudes Become Form*, 1969.

Bordeaux, CAPC-Musée d'Art Contemporain, *Minimal Art I: De la Ligne au parallélépipède*, 1985.

Bordeaux, CAPC-Musée d'Art Contemporain, *Minimal Art II: De la Surface au plan*, 1987.

Bordeaux, CAPC-Musée d'Art Contemporain, *Art conceptuel I*, 1988.

Boston, Institute of Contemporary Art, *Endgame: Reference and Simulation in Recent Painting and Sculpture*, 1986.

Boston, Institute of Contemporary Art, *American Art of the Late 80's*, ed. Jürgen Harten and David Ross, 1988.

Brussels, Palais des Beaux-Arts, *American Art in Belgium*, 1977.

Buffalo, Albright-Knox Art Gallery, *Mixed Media and Pop Art*, by Gordon M. Smith, 1963.

Buffalo, Albright-Knox Art Gallery, *Abstract Expressionism: The Critical Developments*, ed. Michael Auping, 1987.

Buffalo, Albright-Knox Art Gallery, *Abstraction, Geometry, Painting: Selected Geometric Abstract Painting in America Since 1945*, by Michael Auping, 1989.

Cologne, Museen der Stadt Köln, *Westkunst: Zeitgenössische Kunst seit 1939*, ed. Laszlo Glozer, 1981.

Cologne, Museum Ludwig, *Europa/Amerika: Die Geschichte einer künstlerischen Faszination*, ed. Siegfried Gohr and Rafael Jablonka, 1986.

Detroit, Institute of Arts, *Automotive Form 1925–1950*, 1985.

Fort Lauderdale, Museum of Art, *An American Renaissance: Painting and Sculpture Since 1940*, ed. Sam Hunter, 1986.

The Hague, Gemeentemuseum, *Minimal Art*, 1968.

Houston, Museum of Fine Arts, *New York and Paris: Painting in the Fifties*, 1959.

Indianapolis, Museum of Art, *Perceptions of the Spirit in Twentieth-Century American Art*, 1977.

Ithaca, Cornell University, Herbert F. Johnson Museum of Art, *Abstract Expressionism: The Formative Years*, by Robert C. Hobbs and Gail Levin, 1978.

London, Arts Council of Great Britain, *The Modern Spirit: American Painting 1908–1935*, by Milton W. Brown, 1977.

London, Hayward Gallery, *Pop Art*, 1969.

London, Royal Academy of Arts, *A New Spirit in Painting*, 1981.

London, Royal Academy of Arts, *Pop Art: An International Perspective*, ed. Marco Livingstone, 1991.

London, Tate Gallery, *The New American Painting*, 1959.

London, Tate Gallery, *New Art*, 1983.

Los Angeles, County Museum of Art, *Post Painterly Abstraction*, by Clement Greenberg, 1964.

Los Angeles, County Museum of Art, *The New York School: The First Generation, Paintings of the 1940s and 1950s*, ed. Maurice Tuchman, 1965.

Los Angeles, County Museum of Art, *American Sculpture of the Sixties*, ed. Maurice Tuchman, 1967.

Los Angeles, Museum of Contemporary Art, *Individuals: A Selected History of Contemporary Art, 1945–1986*, ed. Howard Singerman, 1986.

Los Angeles, Museum of Contemporary Art, *Hand-Painted Pop: American Art in Transition, 1955–62*, 1992.

Milwaukee, Art Museum, *Word as Image: American Art 1960–1990*, 1990.

Minneapolis, Walker Art Center, *The Precisionist View in American Art*, by Martin Friedman, 1960.

Munich, Städtische Galerie im Lenbachhaus, *New York Dada: Duchamp, Man Ray, Picabia*, 1973.

Newport Beach, Newport Harbor Art Museum, *Action – Precision: The New Direction in New York, 1955–60*, 1984.

Newport Beach, Newport Harbor Art Museum, *The Figurative Fifties: New York Figurative Expressionism*, by Paul Schimmel and Judith Stein, 1988.

Newport Beach, Newport Harbor Art Museum, *L.A. Pop in the Sixties*, 1989.

New York, Brooklyn Museum, *The Machine Age in America, 1916–1941*, 1986.

New York, Cultural Center, *Conceptual Art and Conceptual Aspects*, 1970.

New York, Institute of Contemporary Art, The Clocktower Gallery, *Modern Dreams: The Rise and Fall and Rise of Pop*, 1988.

New York, Jewish Museum, *Toward a New Abstraction*, by Ben Heller, 1964.

New York, Jewish Museeum, *Primary Structures*, by Kynaston McShine, 1966.

New York, Jewish Museum, *Software: Information Technology, Its New Meaning for Art*, 1970.

New York, Metropolitan Museum of Art, *New York Painting and Sculpture: 1940–1970*, by Henry Geldzahler, 1969.

New York, Museum of Modern Art, *Abstract Painting and Sculpture in America*, by A. C. Ritchie, 1951.

New York, Museum of Modern Art, *The Art of Assemblage*, by William C. Seitz, 1961.

New York, Museum of Modern Art, *The Responsive Eye*, by William C. Seitz, 1965.

New York, Museum of Modern Art, *Dada, Surrealism and their Heritage*, by William S. Rubin, 1968.

New York, Museum of Modern Art, *The Art of the Real: USA 1948–1968*, by E. C. Goossen, 1968.

New York, Museum of Modern Art, *The Machine as Seen at the End of the Mechanical Age*, 1968.

New York, Museum of Modern Art, *Information*, ed. Kynaston McShine, 1969.

New York, Museum of Modern Art, *The Natural Paradise: Painting in America 1800–1950*, 1976.

New York, Museum of Modern Art, *High & Low: Modern Art and Popular Culture*, ed. Kirk Varnedoe and Adam Gopnik, 1990.

New York, Museum of Modern Art, *Art of the Forties*, ed. Riva Castleman, 1991.

New York, Museum of Modern Art, *The Art of Assemblage*, 1991.

New York, New Museum of Contemporary Art, *Bad Painting*, 1978.

New York, Solomon R. Guggenheim Museum, *American Abstract Expressionists and Imagists*, 1961.

New York, Whitney Museum of American Art, *Geometric Abstraction in America*, by John Gordon, 1962.

New York, Whitney Museum of American Art, *The 1930's: Painting & Sculpture in America*, by William C. Agee, 1968.

New York, Whitney Museum of American Art, *Anti-Illusion: Procedures/Materials*, by James Monte and Marcia Tucker, 1969.

New York, Whitney Museum of American Art, *200 Years of American Sculpture*, 1976.

New York, Whitney Museum of American Art, *New Image Painting*, 1978.

New York, Whitney Museum of American Art, *William Carlos Williams and the American Scene, 1920–1940*, by Dickran Tashjian, 1978.

New York, Whitney Museum of American Art, *Dada and New York*, 1979.

New York, Whitney Museum of American Art, *Developments in Recent Sculpture: Lynda Benglis, Scott Burton, Donna Denis, John Duff, Alan Saret*, by Richard Marshall, 1981.

New York, Whitney Museum of American Art, *Minimalism to Expressionism*, 1983.

New York, Whitney Museum of American Art, *Blam! The Explosion of Pop, Minimalism, and Performance 1958–1964*, 1984.

New York, Whitney Museum of American Art, *The Third Dimension: Sculpture of the New York School*, by Lisa Phillips, 1984.

New York, Whitney Museum of American Art, *Made in the Sixties*, 1988.

New York, Whitney Museum of American Art, *The New Sculpture 1965–75: Between Geometry and Gesture*, by Richard Armstrong and Richard Marshall, 1989.

New York, Whitney Museum of American Art, *Image World: Art and Media Culture*, 1989.

New York, Whitney Museum of American Art, *Mind Over Matter: Concept and Object*, by Richard Armstrong, 1990.

Paris, Centre National d'Art et de Culture Georges Pompidou, *Paris – New York 1908–1968*, 1977.

Paris, ARC Musée d'Art Moderne de la Ville de Paris, *L'Art Conceptuel: Une Perspective*, 1989.

Pasadena, Art Museum, *Serial Imagery*, by John Coplans, 1968.

Pasadena, Art Museum, *Painting in New York 1944 to 1969*, 1969.

Ridgefield, Aldrich Museum of Contemporary Art, *Postminimalism*, by Richard E. Anderson and Dorothy Mayhall, 1982.

Roslyn Harbor, Nassau County Museum of Fine Art, *The Shock of Modernism in America*, 1984.

San Francisco, Museum of Modern Art, *Abstract and Surrealist Art in the United States*, by Sidney Janis and G. McCann Morley, 1944.

San Francisco, Museum of Modern Art, *Bay Area Figurative Art, 1950–1965*, by Caroline A. Jones, 1990.

Santa Monica, James Corcoran Gallery, *Lost and Found in California: Four Decades of Assemblage Art*, by Sandra Leonard Starr, 1988.

Stockholm, Moderna Museet, *Amerikansk Pop-Konst*, by Alan R. Solomon, 1964.

Tokyo, Setagaya Art Museum, *Beyond the Frame: American Art 1960–1990*, 1991.

Turin, Galleria Civica d'Arte Moderna, *New-Dada e Pop Art Newyorkesi*, 1969.

Turin, Galleria Civica d'Arte Moderna, *Conceptual Art, Arte Povera, Land Art*, 1970.

Turin (Lingotto), Fiat Works, *Arte Americana 1930–1970*, 1991.

Washington, Gallery of Modern Art, *The Popular Image*, 1963.

Washington, Hirshhorn Museum and Sculpture Garden, *Probing the Earth: Contemporary Land Projects*, by John Beardsley, 1977.

Washington, Hirshhorn Museum and Sculpture Garden, *The Fifties: Aspects of Painting in New York*, by Phyllis Rosenzweig, 1980.

Washington, Hirshhorn Museum and Sculpture Garden, *Content: A Contemporary Focus 1974–1984*, 1984.

Washington, Hirshhorn Museum and Sculpture Garden, *Culture and Commentary: An Eighties Perspective*, by Kathy Halbreich, 1990.

Washington, National Gallery of Art, *American Art at Mid-Century: The Subjects of the Artist*, by E. A. Carmean and Eliza E. Rathbone, 1978.

Williamstown, Sterling & Francine Clark Institute, *Cubism and American Photography*, by John Pultz and Catheline B. Scalista, 1981.

Wilmington, Delaware Art Museum, *Avant-Garde Painting and Sculpture in America 1910–1925*, 1975.

The Authors

BROOKS ADAMS (born 1954) is a contributing editor of the magazine *Art in America*. He has written numerous articles on twentieth-century American art.

DAVID ANFAM (born 1955) is an art historian and critic. He is the author of *Abstract Expressionism* (1990), and is currently preparing the catalogue raisonné of Mark Rothko's work for the National Gallery of Art, Washington. He contributes regularly to *The Burlington Magazine*.

RICHARD ARMSTRONG (born 1949) is Curator of Contemporary Art at the Carnegie Museum of Art, Pittsburgh. He was formerly a curator at the Whitney Museum of American Art in New York. He co-organized the exhibition 'The New Sculpture 1965–75: Between Geometry and Gesture' at the Whitney Museum (1990) and is the author of *Richard Artschwager* (1989).

JOHN BEARDSLEY (born 1952) is a curator and writer based in Washington. He is the author of *Hispanic Art in the United States* (1987) and *Earthworks and Beyond* (1989).

NEAL BENEZRA (born 1953) is Chief Curator at the Hirshhorn Museum and Sculpture Garden, Washington. He was curator of the exhibition 'Martin Puryear' at the Art Institute of Chicago (1991) and is currently co-curating a Bruce Nauman retrospective for the Museo Nacional Reina Sofía in Madrid.

ACHILLE BONITO OLIVA (born 1939) is Professor of Contemporary Art History at Rome University. He has organized numerous exhibitions, most recently 'Tutte le strade portano a Roma' (1993). He has been a curator of the Venice, Paris and Sidney biennials and director of the Venice Biennale (1993). Among his many books on recent art are *The Italian Transavantgarde* (1980) and *Dialoghi immaginati* (1992).

ARTHUR C. DANTO (born 1924) is Johnsonian Professor of Philosophy at Columbia University, New York, as well as art critic for the magazine *The Nation*. He is the author of numerous books on art and philosophy, including *The Transfiguration of the Commonplace* (1981) and *Beyond the Brillo Box* (1992).

ABRAHAM A. DAVIDSON (born 1935) is Professor of Art History at Temple University, Tyler School of Art, Philadelphia. He is the author of *The Eccentrics and Other American Visionary Painters* (1978) and *Early American Modernist Painting 1910–1935* (1981).

WOLFGANG MAX FAUST (born 1944) is an art historian and art critic. He has taught in Berlin, New York and San Francisco, and was Chief Editor of *Wolkenkratzer Art Journal*. He is the author of *Bilder werden Worte* (1977), *Hunger nach Bildern*, with Gerd de Vries (1982), and *Dies alles gibt es also: Alltag, Kunst, Aids* (1993).

MARY EMMA HARRIS (born 1943) is an independent art historian, landscape designer and horticulturalist. She is the author of *The Arts at Black Mountain College* (1987) and of several articles on Black Mountain College and the people who studied and taught there. She lives in New York.

CHRISTOS M. JOACHIMIDES (born 1932) is an exhibition organizer and art theoretician who lives in Berlin. He has organized numerous exhibitions, including, in co-operation with Norman Rosenthal, 'Art into Society – Society into Art' at the ICA, London (1974), 'A New Spirit in Painting' at the Royal Academy of Arts, London (1981), 'Zeitgeist' at the Martin-Gropius-Bau, Berlin (1982), 'German Art in the 20th Century' at the Royal Academy of Arts, London (1985), and 'Metropolis' at the Martin-Gropius-Bau, Berlin (1991).

THOMAS KELLEIN (born 1955) is director of the Kunsthalle in Basle. He has organized numerous exhibitions of twentieth-century art, including 'Ad Reinhardt' at the Staatsgalerie in Stuttgart (1985) and 'Mark Tansey' at the Kunsthalle in Basle (1990).

DONALD KUSPIT (born 1935) is Professor of Art History and Philosophy at The State University of New York at Stony Brook and Professor-at-Large at Cornell University, Ithaca, NY. He is a contributing editor of the magazines *Artforum* and *Sculpture*, as well as editor of *Art Criticism*. He has written extensively on twentieth-century American art and art criticism, including the book *Clement Greenberg, Art Critic* (1979). He is currently working on a volume entitled *The Cult of the Avant-Garde Artist*.

MARY LUBLIN (born 1953) received her Ph.D. in American art from Columbia University, New York, and is currently director of research at the Jordan-Volpe Gallery in New York.

KARAL ANN MARLING (born 1943) is Professor of Art History and American Studies at the University of Minnesota, Minneapolis. She is the author of numerous books and articles on twentieth-century American art, including *Iwo Jima: Monuments, Memories, and the American Hero* (1992) and *Edward Hopper* (1992).

BARBARA MOORE (born 1936) is an art historian, curator, writer and rare-book dealer who lives in New York. She has written several articles on experimental art since the 1960s.

FRANCIS V. O'CONNOR (born 1937) is an independent art historian who has specialized in American art and culture of the New Deal and Abstract Expressionist periods. He was co-author of the catalogue raisonné of Jackson Pollock's work (1978) and is currently writing a history of the mural in America from native American times to the present.

STEPHEN POLCARI (born 1945) is Director of the New York branch of the Archives of American Art. He is the author of *Abstract Expressionism and the Modern Experience* (1991).

CARTER RATCLIFF (born 1941) is a contributing editor of the periodical *Art in America*. He is the author of *Andy Warhol* (1983) and *Robert Longo* (1985).

NORMAN ROSENTHAL (born 1944) is Exhibitions Secretary of the Royal Academy of Arts, London. He has organized numerous exhibitions, including 'British Art in the 20th Century' (1987), 'Italian Art in the 20th Century' (1989) and, in co-operation with Christos M. Joachimides, 'A New Spirit in Painting' (1981) and 'German Art in the 20th Century' (1985).

IRVING SANDLER (born 1925) is Professor of Art History at The State University of New York at Purchase. He is the author of *The Triumph of American Painting: A History of Abstract Expressionism* (1970) and *American Art of the 1960s* (1988).

WIELAND SCHMIED (born 1929) is Professor of Art History at the Akademie der Bildenden Künste in Munich. He is the author of a series of books focusing on Giorgio de Chirico and Metaphysical Painting and on *Neue Sachlichkeit*. He organized an exhibition of 1920s German Realism at the Hayward Gallery, London (1978), co-organized the exhibition 'The Artist as Social Critic' in Minneapolis and Chicago (1980) and co-operated with Christos M. Joachimides and Norman Rosenthal on the exhibition 'German Art in the 20th Century' at the Royal Academy of Arts, London (1985).

PETER SELZ (born 1919) is Curator Emeritus of The Museum of Modern Art, New York. He is the author of many books and articles, including *American Painting* (1970) and *Art in Our Times: A Pictorial History, 1890–1980* (1981).

GAIL STAVITSKY (born 1954) received her Ph.D. in art history from the Institute of Fine Arts, New York University. She wrote her doctoral thesis on 'The Development, Institutionalization, and Importance of Albert Eugene Gallatin's Museum of Living Art'. She is the author of the exhibition catalogue *Gertrude Stein: The American Connection* (1990).

DOUGLAS TALLACK (born 1950) is Lecturer in American Studies and Head of the Postgraduate School of Critical Theory at the University of Nottingham. He is the author of *Twentieth Century America: The Intellectual and Cultural Context* (1991).

Photographic Acknowledgments

Catalogue illustrations

Most photographs were provided by the owners or custodians of the works of art reproduced

© The Art Institute of Chicago Cat. 40, 44

R. Bloes, Whitney Museum of American Art, New York Cat. 247

Scott Bowron, New York Cat. 73

Martin Bühler Cat. 164

Rudy Burckhardt Cat. 212

Eduardo Calderón Cat. 140

Richard Carafelli Cat. 109

Michael Cavanagh, Kevin Montague Cat. 19, 21, 22, 24

Geoffrey Clements, New York Cat. 141

Lee Clockman Cat. 183

Ken Cohen Cat. 46

Giorgio Colombo, Milan Cat. 203, 205, 207, 218

Courtesy Paula Cooper Gallery, New York Cat. 251

Peter Cox Cat. 154

© The Chrysler Museum, Norfolk, VA Cat. 177

Courtesy Dallas Museum of Art Cat. 229

Courtesy John van Doren Cat. 82

G. R. Farley Cat. 85

Thomas Feist Cat. 104

Joachim Fliegner Cat. 219

Gamma One Conversions, New York Cat. 105, 153

Courtesy Marian Goodman Gallery, New York Cat. 223

Tom Haartsen, Ouderkerk a/s Amstel Cat. 11, 168

Robert Hashimoto; © The Art Institute of Chicago Cat. 67

David M. Heald Cat. 146, 240; © Solomon R. Guggenheim Foundation, New York Cat. 93, 99

Biff Henrich Cat. 7

Paul Hester, Houston Cat. 48

Bill Jacobson, New York Cat. 47

Bruce C. Jones Cat. 4; courtesy Knoedler Gallery, New York Cat. 156

Carl Kaufman, New Haven Cat. 31

© Walter Klein, Düsseldorf Cat. 121

Courtesy Knoedler Gallery, New York Cat. 157

Studio Yves Langlois Cat. 27

Rafael S. Lobato, Madrid Cat. 209, 210, 216

Paul Macapia Cat. 227

Geraldine T. Mancini Cat. 88

Courtesy Matthew Marks Gallery, New York Cat. 200

Herbert Michel Cat. 125

Karl-Siegfried Mühlensiep, Neu-Ulm Cat. 181

Courtesy Museum of Fine Arts, Boston; © MFA, Boston Cat. 53, 57

Paolo Mussat-Sartor Cat. 196, 197

Don Myer Cat. 87

Courtesy National Gallery of Art, Washington, DC Cat. 147

Courtesy National Museum of American Art, Smithsonian Institution, Washington, DC Cat. 152

Wolfgang Neeb, Hamburg Cat. 252

Henry Nelson Cat. 61

Courtesy Anthony d'Offay Gallery, London Cat. 224

Edward Owen Cat. 35, 52

© Douglas M. Parker Cat. 179

Kira Perov and Squidds & Nunns Cat. 241

Adam Reich; courtesy Mary Boone Gallery, New York Cat. 192

Rheinisches Bildarchiv, Cologne Cat. 182

Philipp Scholz Rittermann Cat. 134

Friedrich Rosenstiel, Cologne Cat. 187

Adam Rzepka, Paris Cat. 171

Courtesy Salander-O'Reilly Galleries, Inc. Cat. 3, 42

Lothar Schnepf, Cologne Cat. 226

Roger Schreiber Cat. 112

Thomas Simpfendoerfer, New York Cat. 34, 83

Steven Sloman, New York Cat. 101, 190

Courtesy Sotheby's, New York Cat. 100

Squidds & Nunns Cat. 114, 120, 139, 165

Lee Stalsworth Cat. 49, 50, 63, 103, 127, 176, 238

Strüwing Cat. 132, 208

Levente Szepsy Szücs, Budapest Cat. 184

Courtesy Alain Tarica Cat. 5

Courtesy Jack Tilton Gallery, New York Cat. 246

Courtesy The Toledo Museum of Art Cat. 64–6

Susanne Trappmann Cat. 13, 16, 17

Michael Tropea Cat. 170

Malcom Varon, New York Cat. 39, 41

Archie Webb, Des Moines Cat. 58

John Webb Cat. 81, 91, 108

Dorothy Zeidman Cat. 191; courtesy The Pace Gallery, New York Cat. 116

Text illustrations

Berenice Abbott p. 159 (bottom)

Courtesy Mitchell Algus Gallery, New York p. 114

F.lli Alinari, Florence p. 87 (top)

Jörg P. Anders, Berlin p. 185

Das Anudas p. 103 (bottom)

AP Association Press GmbH, Bilderdienst, Frankfurt am Main p. 171

© The Josef Breitenbach Trust; courtesy Center for Creative Photography p. 93

Rudolph Burckhardt; courtesy Leo Castelli Gallery, New York p. 125

Claude Caspari; courtesy Galerie Maeght, Paris p. 178

Leo Castelli Gallery, New York p. 161

Collection City and County San Francisco; courtesy San Francisco Art Commission p. 64 (bottom)

Geoffrey Clements, New York, p. 69; courtesy Babcock Gallery, New York p. 70

John Cliett; © Dia Center for the Arts, New York p. 135

Courtesy Paula Cooper Gallery, New York pp. 120, 140 (bottom)

Cultural Heritage Board p. 109

Richard Ells p. 128 (bottom)

Trude Guermonprez Elsesser; courtesy Lisa Jalowetz Aronson p. 97

Walker Evans; courtesy Schirmer/Mosel Verlag, Munich p. 33

Archiv Konrad Fischer, Düsseldorf p. 193 (bottom)

Flint Institute of Arts, Flint, Michigan p. 75 (bottom)

Giséle Freund p. 154

Courtesy Barbara Gladstone Gallery, New York p. 142 (top)

Gianfranco Gorgoni, New York p. 134

The Adolph and Esther Gottlieb Foundation, Inc., New York p. 72 (bottom; photo Otto

E. Nelson, New York)

Peggy Guggenheim Collection, Venice p. 159 (top)

Galerie Max Hetzler, Cologne p. 169 (bottom)

Hirshhorn Museum and Sculpture Garden, Smithsonian Institution, Washington, DC pp. 39 (bottom), 122

Nancy Holt p. 135 (bottom)

Courtesy of Hope National Medical Center, Durate, California p. 66

Galerie Jablonka, Cologne p. 141 (bottom)

Jeanne-Claude p. 136 (bottom)

Bruce Jones; courtesy Leo Castelli Gallery, New York p. 167 (top)

© Walter Klein, Düsseldorf p. 18

Hiroshi Kobayashi, Tokyo p. 113

Kunsthalle Basel, Basle p. 21

Nina Leen, LIFE Magazine © Time Inc. p. 77

Courtesy Galerie Lelong, New York p. 137 (right)

Library of Congress, Washington, DC pp. 29, 33 (LC HN 57.D221973), 67 (LC TR 820.5.S87)

Jerry Mathiason, Minneapolis p. 67

Archive Georges Mathieu, Paris p. 189

Barbara Melosh p. 65

Metro Pictures, New York p. 170

Robert McElroy, New York pp. 100 (left), 102

Moeschlin & Baur, Basle pp. 190, 191

Peter Moore, New York pp. 100 (right), 103 (top), 104, 105

Ugo Mulas p. 193

Jürgen Müller-Schneck, Berlin p. 196

The Museum of Modern Art, New York p. 27 (bottom)

Hans Namuth, New York p. 145

Nathanson p. 137 (left)

Courtesy North Carolina State Archives p. 96

Philadelphia Museum of Art, Collection Société Anonyme Archive p. 153

The New School for Social Research, New York p. 36

The Isamu Noguchi Foundation, Inc., Long Island pp. 75 (centre; photo Soichi Sunami), 179

Nathan Rabin p. 176

H. Rekort p. 184

Rheinisches Bildarchiv, Cologne p. 121

Courtesy Michael Rosenfeld Gallery, New York p. 72 (right)

John Schiff, New York p. 129 (top)

Shunk-Kender, New York p. 110 (left)

Courtesy Monika Sprüth Galerie, Cologne p. 142 (centre)

Lee Stalsworth p. 119 (bottom)

UPI/Bettmann Newsphotos p. 30 (top)

Courtesy Gallery John Weber p. 135 (bottom)

Ellen Wilson p. 141 (centre)

Beatrice Wood p. 152 (bottom)

Photographs of the artists

Richard Artschwager: Richard Leslie Schulman, New York, 1984

Jean-Michel Basquiat: Courtesy Galerie Bruno Bischofberger, Zurich

Jonathan Borofsky: *Self-Portrait*. Photo Megan Williams; courtesy Paula Cooper Gallery, New York

James Lee Byars: Lothar Schnepf, Cologne; © Galerie Michael Werner, Cologne and New York

Alexander Calder: Hans Namuth, New York

John Chamberlain: Peter Foe; courtesy Galerie Karsten Greve, Cologne

Joseph Cornell: Hans Namuth, New York

Stuart Davis: Hans Namuth, New York

Willem de Kooning: Hans Namuth, New York

Marcel Duchamp: Arnold Newman

Sam Francis: Jim McHugh, Los Angeles

Arshile Gorky: Xavier Fourcade Inc.

Dan Graham: Self-portrait

Phillip Guston: Renée McKee

David Hammons: Timothy Greenfield-Sanders, New York

Keith Haring: Gianfranco Gorgoni, New York

Marsden Hartley: Geoffrey Clements, New York

Eva Hesse: © The Estate of Eva Hesse; courtesy Robert Miller Gallery, New York

Gary Hill: Courtesy Donald Young Gallery, Seattle

Jenny Holzer: Michaela Zeidler; courtesy Barbara Gladstone Gallery, New York

Edward Hopper: Hans Namuth, New York

Jasper Johns: Richard Leslie Schulman; courtesy Leo Castelli Gallery, New York

Donald Judd: © Todd Eberle; courtesy The Pace Gallery, New York

Mike Kelley: Timothy Greenfield-Sanders, New York

Ellsworth Kelly: Gianfranco Gorgoni, New York

Franz Kline: Hans Namuth, New York

Jeff Koons: Courtesy Jeff Koons Studio, New York

Roy Lichtenstein: © 1992 Laurie Lambrecht, New York

Robert Mangold: Richard Leslie Schulman, New York, 1993

Brice Marden: Timothy Greenfield-Sanders, New York, 1993

Agnes Martin: Gianfranco Gorgoni, New York

Robert Morris: Marcia Hafif; courtesy Leo Castelli Gallery, New York

Gerald Murphy: © Mrs William M. Donnelly

Bruce Nauman: © Donald Woodman, Canyon Santa Fe; courtesy Leo Castelli Gallery, New York

Barnett Newman: Jon Holstein, 1952

Georgia O'Keeffe: © 1981 Laura Gilpin Collection, Amon Carter Museum, Fort Worth, Texas

Jackson Pollock: Hans Namuth, New York

Martin Puryear: Ron Bailey, 1987; courtesy Donald Young Gallery, Seattle, and The Art Institute of Chicago

Robert Rauschenberg: © 1991 Christopher Felver; courtesy Knoedler & Company, New York

Man Ray: © Man Ray Trust, Paris

Ad Reinhardt: Hans Namuth, New York

James Rosenquist: Hans Namuth, New York

Mark Rothko: Hans Namuth, New York

Edward Ruscha: © 1986 Christopher Felver; courtesy Leo Castelli Gallery, New York

Robert Ryman: Manfred Roth; © Hallen für neue Kunst, Schaffhausen

Julian Schnabel: Hans Namuth, New York

Richard Serra: © 1980 Sidney B. Felsen

Charles Sheeler: Arnold Newman

Cindy Sherman: © 1990 David Seidner; courtesy Metro Pictures, New York

David Smith: Dan Budnik

Frank Stella: Hollis Frampton; courtesy Leo Castelli Gallery, New York

Joseph Stella: Man Ray; courtesy Virginia M. Zabriskie, New York

Clyfford Still: © Sandra Still; courtesy Patricia Still

James Turrell: Christian Vogt

Cy Twombly: © Plinio de Martiis, Galerie Karsten Greve, Cologne

Bill Viola: Kira Perov, 1987

Andy Warhol: © Richard Leslie Schulman, New York

Lawrence Weiner: © 1992 Caspari de Geus

All uncredited illustrations are taken from the publishers', editors' or authors' archives

Index of Names

Numerals in italics refer to pages with illustrations